FOOD STYLING

FOOD STYLING

THE ART OF PREPARING FOOD FOR THE CAMERA

DELORES CUSTER

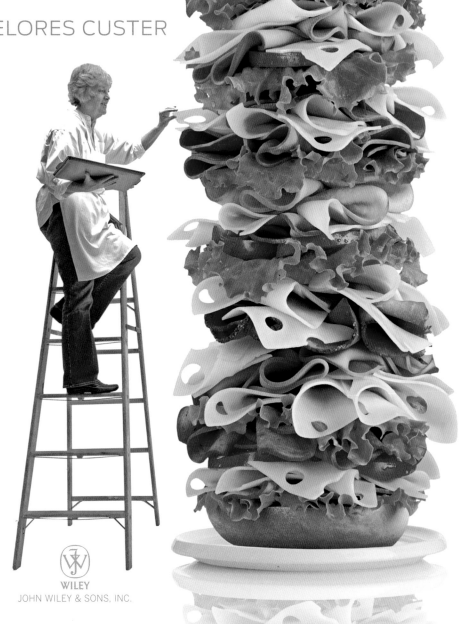

WILEY

JOHN WILEY & SONS, INC.

Tall sandwich photo on page iii copyright © 2010 by Dennis Gottlieb
Author on ladder photo on page iii and chapter and part opener photos copyright
© 2010 by Jim Scherzi

Published by John Wiley & Sons, Inc., Hoboken, New Jersey

Published simultaneously in Canada

For general information on our other products and services or for technical support, please contact our Customer Care Department within
the United States at (800) 762-2974, outside the United States at (317) 572-3993 or fax (317) 572-4002.

Wiley also publishes its books in a variety of electronic formats. Some content that appears in print may not be available in electronic
books. For more information about Wiley products, visit our web site at www.wiley.com.

Design by Vertigo Design, NYC

LIBRARY OF CONGRESS CATALOGING-IN-PUBLICATION DATA

Custer, Delores.
Food styling : the art of preparing food for the camera / Delores Custer.
p. cm.
Includes index.
ISBN 978-0-470-08019-1 (cloth)
1. Photography of food. 2. Food—Pictorial works. I. Title.
TR656.5.C87 2009
778.9'6413—dc22
2009011991

Printed in China

10 9 8 7 6 5 4 3 2 1

To my parents, whose love and guidance gave me a wonderful foundation.

To my late husband, Arthur, who always knew I could long before I knew I could.

*To my daughter, Chef Danielle, who skillfully cooks "real food for real people."
I joyfully watch her contributing deliciously to the food world.*

*To my family and many friends, who each in his or her own way
patiently encouraged and helped me through.*

*To my former and current assistants, who always gave 150 percent
and whom I so enjoyed working beside.*

CONTENTS

Acknowledgments xi

Introduction xv

THE BASICS OF FOOD STYLING

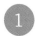

FOOD STYLING: AN OVERVIEW 3

From home economist to food stylist: a history 4

The smorgasbord of food styling 5

What is food styling? 7

ANATOMY OF A FOOD STYLING ASSIGNMENT 7

FIRST STEPS: FINDING THE FOOD AND PROPS AND SELECTING EQUIPMENT 7

PREPARING THE FOOD 8

ARRANGING THE FOOD 8

KEEPING THE FOOD BEAUTIFUL AND ADDING FINAL TOUCHES 8

Is food styling for you? 8

THE ATTRIBUTES OF A GOOD FOOD STYLIST 9

EDUCATION, FORMAL AND INFORMAL 14

WORK EXPERIENCE: VERSATILITY HELPS 15

Business ethics: to enhance, stretch, or cheat? 16

AS THE PHOTOGRAPHER SEES IT 17

SHOOTING FOOD WE DON'T ENDORSE, AND OTHER ETHICAL CONFLICTS 17

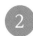

THE MEDIUM IS EVERYTHING 19

Editorial food styling versus advertising 21

WHO IS THE AUDIENCE? 21

WHAT ARE WE SELLING? THE FOOD STYLIST'S ROLE IN PRODUCING A FOOD'S LOOK 22

Types of media we work in 23

EDITORIAL FOOD STYLING 23

ASSIGNMENTS FOR PUBLIC RELATIONS FIRMS 24

WORKING FOR MARKETING FIRMS 25

WORKING WITH ADVERTISING ASSIGNMENTS 26

FOOD STYLING FOR PRODUCT-PACKAGING PHOTOGRAPHY 26

FOOD STYLING FOR CATALOGS 27

OPPORTUNITIES VIA THE INTERNET 28

FOOD OPPORTUNITIES IN TELEVISION 28

FOOD AT THE MOVIES 30

YOUR FOOD STYLING TEAMMATES 31

Who hires food stylists? 32

Who will you work with? 32

TELEVISION AND FILM PRODUCTION CREWS 33

THE JOB: FROM GETTING THE CALL TO INVOICING

YOU GOT THE JOB! NOW WHAT? 37

Setting a schedule and keeping records 38

GATHERING ASSIGNMENT DETAILS 38

Bidding and budgeting for the job 41

YOUR FEES 42

HIRING ASSISTANTS 42

FOOD EXPENSES: EVERYTHING BUT THE KITCHEN SINK 42

TRANSPORTATION COSTS 43

NONFOOD MATERIALS COSTS 43

SPECIAL EQUIPMENT COSTS, FROM FRYERS TO FREEZERS 43

PROPS: BUDGETING COSTS 44

MISCELLANEOUS COSTS 44

PREPPING THE ASSIGNMENT 45

Starting off: the job folder 46

How to read recipes, layouts,
storyboards, and scripts 47

 DECODING RECIPES 47

 VISUALIZING LAYOUTS 50

 READING STORYBOARDS 50

 BREAKING DOWN SCRIPTS 51

Brainstorming at the preproduction meeting 51

Getting it together: gathering food,
equipment, and props 53

Shooting on location: hidden details 57

 PLANNING FOR FOREIGN LOCATIONS 58

AT THE SHOOT 59

Arriving and Organizing 60

 CHOOSING PROPS FOR THE SHOOT 62

 DISCUSSING THE SHOOTING SCHEDULE 63

Preparing the food for the shoot 63

Styling for visual appeal and
mouthwatering factor 64

 MAKING FOOD VISUALLY APPEALING 65

 MAKING FOOD MOUTHWATERING 70

Working on the set 72

The shot: it's time to shoot the food 75

Back to the office: things to
do after the shoot 76

ABOUT PHOTOGRAPHY 79

The photographer's role in a food shot 80

 SAME ASSIGNMENT, DIFFERENT LOOKS 80

The evolution of the camera 81

 STYLING FOOD FOR THE CAMERA 81

Making a food image work 86

Finding the camera angle 87

THE BASICS OF PROPPING 89

The prop stylist in action 90

Determining the style: getting the right look 92

 ONE RECIPE'S JOURNEY 94

THE BASICS OF TV AND FILM PRODUCTION WORK 99

Food styling for television 100

 COMMERCIALS 100

 COOKING SHOWS 100

 HOME SHOPPING PROGRAMS 100

 INFOMERCIALS 101

 TALK-SHOW SEGMENTS 101

 TELEVISION SERIES 102

 SATELLITE MEDIA TOURS 102

Food styling for film 102

 INDUSTRIALS 102

 MOVIES 102

The cast of characters in TV
and film production 103

Shooting: Studio versus Location 105

Money issues: food budget and your fees 105

Shooting a storyboard out of sequence 106

THE FOOD STYLIST'S TOOLS OF THE TRADE 107

The kit and the set tray 108

The food stylist's knife roll 118

Other basic equipment: everything
and the kitchen sink 119

Tools and equipment at the
photographer's studio 125

Homemade equipment to the rescue 128

Contents in bottles, cans, and
packages: a wealth of uses 130

 11

WORKING WITH THE FOOD: OVERCOMING CHALLENGES 147

Food science: the basics of how food works 149

Fruits and vegetables: finding
the perfect produce 149

 TO BLANCH, STEAM, SAUTÉ, MICROWAVE, GRILL,
OR ROAST? THAT IS THE QUESTION 169

 TRANSPORTING PRODUCE FOR A SHOOT 170

 SEASONAL AVAILABILITY CHART:
FINDING FOOD AT ITS PEAK 170

A glossary of herbs 173

Edible flowers: what to know before using 177

Dairy products: from cheese to creams 178

 CHEESES 178

 MILK, YOGURT, CREAM, AND NONDAIRY
WHIPPED TOPPINGS 179

 FROM BUTTER TO MARGARINES: STYLING
AS PATS, SPREADS, OR MELTS 182

Breakfast foods: troubleshooting
tips for the food stylist 184

 CEREALS 184

 TOAST, MUFFINS, BAGELS, AND DONUTS 187

 PANCAKES AND WAFFLES 188

 EGG DISHES: HOW DO YOU WANT 'EM? 193

 BACON AND SAUSAGES 196

Sandwiches: how to build layer by layer 197

 YOUR TYPICAL (OR NOT) COLD CUT SANDWICHES 198

 BUILDING A BETTER HAMBURGER 201

 GRILLED SANDWICHES: FROM A GRILLED
CHEESE TO A PANINI 206

 PEANUT BUTTER SANDWICHES 207

Soups: types and techniques 210

 WORKING WITH WHAT YOU'VE GOT 210

 TEMPERATURE 210

 SERVING SIZES 211

 GARNISHES 211

Meat, poultry, fish, and shellfish:
styling the main course 214

 RED MEATS 214

 WHITE MEATS: PORK AND VEAL 215

 HOT DOGS 216

 POULTRY 217

 FISH AND SHELLFISH 225

Grilled food: simulating the look in a shot 227

 HOW TO MAKE GRILL MARKS 227

 FOODS DIFFICULT TO GRILL 228

 KEBABS 228

Starches: from pasta to potatoes 229

 PASTA 229

 POTATOES 230

 RICE 232

Pizza: timing is everything 234

 THE CRUST 234

 THE SAUCE 234

 THE CHEESE 235

 THE TOPPINGS 235

 THE CHEESE PULL 235

Sauces: from thick to thin, from
sweet to savory 237

 WHITE SAUCES, CHEESE SAUCES, AND HOLLANDAISE 237

 GRAVIES, PAN JUICES, AND AU JUS 238

 TOMATO SAUCES 238

 FRESH SALSAS 238

 MUSTARD, MAYONNAISE, AND KETCHUP 239

 SALAD DRESSINGS 239

 SMOOTH VEGETABLE AND FRUIT SAUCES (COULIS) 239

 FRUIT COATINGS 239

 DESSERT SAUCES 240

Garnishes: the many, the colorful,
and the troublesome 240

 THE SWEET SIDE OF GARNISHES 241

Baked goods: some basic rules 241

 DETERMINING THE TYPE OF SHOT 242

 CONTROLLING THE BAKING PROCESS:
THE PATH TO PERFECTION 242

 VOLUME BAKING 243

 PREPARING YOUR BAKING PANS 243

 BAKING TOOLS AND EQUIPMENT 245

Cakes: the pleasures and pitfalls 247

 LAYER CAKES 248

 BUNDT CAKES 252

 CHEESECAKES 253

 ANGEL FOOD CAKES 253

 POUND OR LOAF CAKES 253

 CUPCAKES 253

 CAKES THAT ARE HARD TO SLICE THROUGH 254

Pies: making them picture perfect 254

 FRUIT PIES 257

 LATTICE-TOPPED PIES 258

 TARTS 260

 PUMPKIN PIES 261

 QUICHES 262

 PIES WITH GRAHAM CRACKER
 OR CRUMB CRUSTS 262

 CREAM PIES 263

 ICE CREAM PIES 263

 MERINGUE-TOPPED PIES 265

Cookies: aiming for consistency 266

 DROP COOKIES 267

 DECORATED SUGAR COOKIES AND
 GINGERBREAD COOKIES 268

Other baked goods: overcoming
unique styling obstacles 269

 BARS AND BROWNIES 269

 PHYLLO PASTRY 270

 MUFFINS 270

 PURCHASED BAKED GOODS: ADDING PIZZAZZ
 TO STORE-BOUGHT DESSERTS 272

 THE FINISHING TOUCHES: FROM
 DOLLOPS TO DUSTINGS 272

Photographing ice cream: the differences
between real and artificial 274

 REAL ICE CREAM 274

 ARTIFICIAL ICE CREAM: FAKING THE REAL THING 279

Chocolate: the problem child
for the food stylist 284

 MELTING CHOCOLATE 284

 CHOCOLATE SAUCES 285

 CHOCOLATE CANDIES 286

Cold and hot beverages: food styling
techniques in the presentation 286

 COLD BEVERAGES 101 287

 THE MAJOR COLD BEVERAGES: WHAT THEY
 ARE AND THEIR UNIQUE FEATURES 294

 THE MAJOR HOT BEVERAGES:
 FROM COFFEE TO TEA 297

The lowdown on spreads: producing
mounds, swirls, and ridges 298

Ethnic foods: doing the research
for authenticity 299

Volume food: shooting family style 300

Unattractive food: how to
beautify it for a shot 301

PULLING IT ALL TOGETHER

THE BUSINESS OF FOOD STYLING 305

The entrepreneur: beginning your
food styling business 306

 HOW TO BE A GOOD FOOD STYLING ASSISTANT 307

 HOW TO FIND ASSISTING JOBS: LOOK
 FOR US IN THE GUTTER 308

Testing: its many values to the food stylist 310

 WHY PHOTOGRAPHERS TEST 311

 WHY FOOD STYLISTS TEST 312

 THE PROCESS OF TESTING, FROM
 START TO FINISH 313

Self-promotion: the five Ps of a successful
business: passion, packaging, persistence,
promotion, and production 316

 PASSION: FOOD AND WORKING
 WITH IT CREATIVELY 316

 PACKAGING AND MARKETING YOURSELF 316

 PERSISTENCE IN YOUR PURSUIT 319

 OTHER TECHNIQUES FOR SELF-PROMOTION 320

 PRODUCTION: CREATE WORKS THAT SELL YOU 321

Networking and sharing: helpful organizations
and conferences for the food stylist 321

BEYOND FOOD STYLING: EXPANDING YOUR OPTIONS 323

Recipe development and writing 324

 COOKBOOK WRITING 325

Articles and other writing assignments 325

The joys of teaching 326

Media escort or spokesperson:
becoming a food emissary 327

 TELEVISION VERSUS A LIVE AUDIENCE: HOW
 TO BRING FOOD TO THE PEOPLE 327

 FOOD DEMONSTRATIONS: TIPS AND TECHNIQUES 331

Product development 334

Food photography and other related careers 334

TIPS FOR CHEFS, CATERERS, AND OTHERS WHO WANT TO STYLE THEIR FOOD 335

Tips for small businesses: creating
visual materials that sell your
food-related services 336

A chef's guide to preparing and shooting
beautiful food photographs 338

 DO YOUR HOMEWORK BEFORE TAKING
 THE SHOT 339

TRENDS: FOOD AND FOOD PRESENTATION

REVIEWING THE LAST FIFTY (Now Sixty) YEARS OF FOOD STYLING AND PHOTOGRAPHY 345

The 1950s: postwar conformity, casseroles,
Elvis, and James Beard 347

The 1960s: convenience, domestic engineers,
granola crunchers, and Julia Child 348

The 1970s: nouvelle cuisine, the feminist
revolution, vegetarianism, and Alice Waters 349

The 1980s: decadence, take-out
gourmet, and celebrity chefs 350

The 1990s: return to basics, fat reduction,
fusion cuisine, and Martha Stewart 351

The 2000s: time-saving meals, adventuresome
eating, green concerns, and the internet 352

Glossary: The vocabulary of food styling 365

Resources 374

Index 389

Acknowledgments

This book began because an editor at the then Van Nostrand publishing company, Karen Hadley, believed that the subject of food styling could become an interesting and useful book and encouraged me to believe that I could write it. Fifteen years later, with the help of many people, here it is. I want to thank the very talented team at Wiley whose dedication and hard work on this project has been overwhelming: Pam Chirls, executive editor, who took on the project, supported my vision, and gave the book the gift of her many skills; the organized, persistent, and patient editorial assistant Rebecca Scherm, who took on the early mammoth project of organizing all the art; and Ava Wilder, senior production editor, who, with her keen eye and knowledge, shaped the book, hired a dedicated team, and pushed me to meet deadlines. Thank you to Alison Lew, the book designer, who along with Gary Philo gave the book their expertise in design and layout to produce a beautiful and professional-looking book. Thanks to Ann Rolke, developmental editor, and Deborah Weiss Geline, the copy editor who polished my words. And thanks to Lisa Story, who tirelessly and painstakingly entered hard-copy edits into the layout files; Helen Chin, headings copy writer; Bronwyn Collie, and, especially, Catherine Bielitz, proofreaders of meticulous and professional care; Marilyn Flaig, the indexer; and Brent Savage and Laura Campbell, photo lab technicians, who had, as you can see, just "a few" photographs to work with. This book is an intensive look at the world of food styling and required an extraordinary effort on the part of all the above mentioned.

The book actually represents thirty years of experience and experiences with the people in my life. I thank my late husband, Arthur, who believed in and supported me as I stepped into the world of food styling, teaching, and writing. He led by example with his very prolific life. My daughter, Danielle, now a fantastic chef in Seattle, at an early age learned to cook up a better meal than I would have made from what she found in the refrigerator (because Mom was going to be late getting home yet again). I thank two loving parents who taught me about the source and pleasures of food.

Julia Child led me, along with thousands of others, into the joyful world of serious cooking. I feel privileged to have eventually worked with her. I continued to learn from her throughout her eighties as she willingly and gleefully tackled career and life challenges.

I owe my career in food styling to Marianne Langan, who introduced me to this hidden career, and also to my mentors Helen Feingold and especially Zenja Cary, who hired me fresh out of college and trained me. I want to thank all of those at Cary Kitchens who helped me through our many assignments. Fran Shinagel and I became partners as I stepped out on my own and we developed our business, C/S Food Communications. She was a joy to work with and a true friend and foodie.

Then there are all the people who have supported me as assistants and costylists. I look back at all our jobs and so appreciate your hard work, talent, and friendship. Thank you, Mariann Sauvion and Grady Best, Hilary Fishman Huaman, Linda Olson Alfano, Vincent Beckley, Mina Cho, Liz Duffy, Jan Fort, Mary Grapsas, Hiromi Hayashi, Marie Haycox, Bianca Henry, Lisa Homa, Kristy Hood, Motoko Huang, Lynn Miller, Judi Orlick, Sally Jo O'Brien, David Pougal, Sara Schumacher, and the hundreds of interns, clients, art directors, and others who have made teamwork so rewarding.

Barbara Albright, former editor of *Chocolatier* magazine, encouraged me by saying, "If I can write, you can write," and gave me my first professional writing assignment. Pam Hoenig, an editor for whom I had food styled several books, helped with her "you can do it" attitude and pointed me in the right direction. Thanks also to Terry Frishmann for her early guidance and suggestions.

There are many talented people I have worked with on photography and film production assignments—way too numerous to name them all—but in particular I want to thank Dennis Gottlieb, who generously helped shoot many of the photographs in this book, as did Kelly Kalhoefer, who also helped me with producing and sending images to the publisher; Colin Cooke; Jim Scherzi, who helped with part and chapter opener photos; and Jim Ong. Please note the credits of the many others whose photographs appear throughout the book. I thank them all for their kindness in giving me permission to use their work. I also want to thank the various agencies, food companies, and publishers that allowed me to use photographs and ads, especially Rick Zullo of Zullo Associates, Inc., for permission to use their sandwich for our wonderful cover shot.

Next, there are those who made my teaching experiences such a pleasure: Bill Reynolds, who hired me as the first adjunct instructor at the Culinary Institute of America; and Peter Kump, who hired me to teach at his school (now the Institute of Culinary Education). I taught for many years at the New School Culinary Arts Program: Thank you, Gary Goldberg and staff. Thanks to the staff at the Chef School at George Brown College in Toronto and to Sara Labensky, Cheryl Brown, and staff at the Culinary Arts Institute at the University of Mississippi for Women. Thanks to all who made teaching assignments abroad a joyful adventure in Korea, Japan, Norway, Argentina, and especially in Chile, with photographer Miguel Etchepare. In the Philippines, a heartfelt thank-you to my loving, talented, and generous friend Norma Olizon-Chikiamco. I so appreciate your hard work and strong belief in me and repeated requests for yet another workshop. Thanks also to the students who made my teaching time so meaningful. Your interests and questions are the basis for this book.

In every country I visited, I made lasting and important friendships. I would like to thank the many people who worked so hard to make the food styling seminars possible and those who offered us such wonderful hospitality in *every* country. Also, a big thank-you to the participants and sponsors who made it possible through their interest and generosity. I also want to thank the enthusiastic, inquisitive, and hardworking assistants who accompanied me on these journeys and made every teaching experience a joy. I learned from each of you.

Copresenters at various conferences also contributed their thoughts to the book: Rick Ellis ("The Art in Food Styling"), Polly Talbott, CCP ("The Last Fifty Years of Food, Food Photography, and Food Styling"), Jim Rude ("Things in Bottles, Cans, and Packages"), Jim Scherzi ("Becoming a Food Photo Critic"), Jim Scherer ("Photographer and Food Stylist, Working as a Team"), and Shirley Corriher ("How to Control Foods That Misbehave").

Thank you to those who physically helped me put the book together: Lisa Homa, who, with her editorial experience, helped me find a computer and begin to use it; Judi Orlick, who, with her skills at the computer and knowledge of what I wanted to share, helped type out the book's first outline (to this day, she patiently answers my computer questions); and Kelly Kalhoefer, who was wonderful help with additional needed photography and photo processing as well as helping with the PowerPoint presentations put together with patience and care by Joy Whitley. A

special thank you to Jim and Holly Scherzi for their hospitality and continued help with the photography and presentation and promotional projects. I so appreciate the help of Cathy Lee Gruhn, who did much of the later typing and research and shared her publishing and publicity knowledge; my dear friend and early "editor," my morning support Ruth Myers ("Pass it to Mother"), who continued to encourage me; and Sharon Tyler Herbst and her book *New Food Lover's Companion*, which was a constant companion next to my computer. As all foodies know, one does not find a lot of food terms in Webster's or spell check. Not only did Sharon provide me with correct spellings and tell me when to capitalize, but she was a wonderful source of food information. I worked with Sharon once as a media escort while she was promoting her book and remember her joyful personality and admire and appreciate her contributions to the food world.

Shirley Corriher, friend, copresenter, and author of *CookWise* and the then-in-the-process-of-being-written *BakeWise*, whom I could call or who (with her husband, Arch) would call me when we needed a "book break" and encouragement. As Shirley put it, "If you put one pork chop in a pan it doesn't cook well, but if you put two in a pan, they grease each other (or produce enough grease to fry each other)." Thanks for being a pork-chop friend.

I thank Nach Waxman of Kitchen Arts & Letters in New York for guidance and encouragement and a gentle postcard inquiring as to my progress every once in a while.

Last, but not least, there are the supportive and loving family and friends in my life who just made the long days of writing and years of putting a book together possible: Thank you, Gail Kunreuther, Sally Wright, Janet Congdon, Marj Enneking, Gene Wild, and others, for your calls; thank you, Jim McMurry and Vic Hugo for your pictures of early food photography and articles of interest; and thanks to the many friends who shared the New York food and culture scene, Sheila Charney in particular, who also shared space in her refrigerator when I was in desperate need. All of you have made your contribution to this book.

Introduction

The evolution of a career is not usually a straight path, and mine certainly wasn't. Six months before I started working as an assistant to a food stylist, I didn't even know that the career of food styling existed. I had always been drawn to beautiful food pictures, but I hadn't given much thought to how these pictures came into being. Unknowingly, from an early age, I had been on the path to food styling.

I grew up surrounded by and very connected to food and the soil. We lived in a small farming community in the fertile Willamette Valley of Oregon. My family raised chickens, and we had a garden and small orchard. I helped my dad plant the garden each year, and my mom and I always cooked and baked together. My dad and I also fished, and I would flush pheasants for him in our back fields in the fall. We also enjoyed wild duck and venison fresh from his hunting trips.

I knew from the time I would "help" my first-grade teacher, Mrs. Murphy, with her class that I wanted to be a teacher. So, with a degree in elementary education in hand, at the age of twenty, I began teaching fifth and sixth grades at a school just outside of San Francisco. I also had a strong desire to travel, and soon I took a job with the Department of Defense, teaching military children on the island of Okinawa. It was there that I took my first cooking class. With these classes, along with eye-opening trips to Thailand, India, Hong Kong, and Japan, my love for and curiosity about food began to flourish. In 1966, I married a man whose love for food and knowledge of wines encouraged my own culinary growth. We entertained a lot and belonged to a gourmet cooking group. After our daughter was born in 1968, I furthered my culinary education through Julia Child's television show *The French Chef*. Eventually, to keep my sanity and have time with adults, I started a cooking school in our home one night a week.

Encouraged by my success, when our daughter started school, I went to the owner of a soon-to-open restaurant and offered my services. To my surprise, I was given the job of putting together the whole restaurant, with the exception of choosing the professional equipment in the kitchen. I hired staff, planned the lunch and dinner menus, and chose the decor; I even made the tablecloths and parts of the uniforms. When we opened, I did all the baking, in addition to managing lunch service and stepping in for anyone who was absent that day. That experience was quite a learning curve for me.

When my family moved to New York City in June 1976, I decided (at the age of thirty-six) that if I wanted a career in food, I needed to go back to school. As there were no professional cooking schools in the city at that time, I worked toward my master's degree in foods and nutrition at New York University. Two years into the program, I was still uncertain as to what I would do when I graduated. All that changed one fateful day. I was in charge of the kitchen (our lab) at NYU and was asked if I would help someone who would be there the next day to work on a project. A production company had rented the kitchen for a commercial that it was shooting, and the person preparing the food needed an assistant. It was then that I met my first food stylist, Marianne Langan, who had been hired to prepare foods for a commercial for aluminum foil: "The Best Wrap Around." As we worked together, she told me about her career. It sounded like something that would engage many of my interests—especially working with food in a creative capacity. When it was time to do my externship for my degree, I worked with three food stylists; one of them, Zenja Cary, asked me to join her organization, Cary Kitchens, and work with her full-time. Thus began my career as a food stylist, just as I was stepping out of graduate school.

One of the indications that I was always visually attracted to the food world began with a frantic search (way before the Internet) for an out-of-print cookbook called *Great Dinners from LIFE*, which was first published in 1969. My eyes first feasted upon this tome at a friend's house in the early 1970s, and I thought it was one of the most profoundly visual cookbooks I had ever seen. Later I found out that the recipes were quite delicious as well. When the cookbook was revised and reprinted in 1979, I finally got my copy.

One of my early assignments as a food stylist at Cary Kitchens was to style food shots for the newly revived *LIFE* magazine, which was planning another cookbook—this time on foods of the world. There I was on Twenty-seventh Street in New York City (not France or Italy), producing photographs of the foods of Provence, Milan, and New England with the stylist, editor, and one of the marvelous photographers, John Dominis, all from the *Great Dinners* cookbook. What a small and glorious world, I thought. The cookbook stopped in midstream because *LIFE* ceased publication. But I have my pictures and memories of the thrill of those assignments.

Cary Kitchens was a wonderful facility. Zenja was a home economist who had worked as a food stylist and consultant for more than twenty years. She had two floors in an office building at Columbus Circle in the middle of Manhattan. Wisely, she had hired a television and movie prop designer to design four very flexible kitchen spaces where we prepped our jobs. Photographers and television production companies rented the kitchens for shoots. We also rented the space to cooking schools (such as James Beard's and Peter Kump's) when they needed larger spaces for their classes (classes taught by the likes of Julia Child, Simone Beck, Diana Kennedy, and Paula Wolfert). Magazines that needed extra testing space for cookbook production and product developers also used our studios. We worked as consultants to food companies and in every medium, including movies. We were so busy that we had five lead food stylists and about seven assistants. Several assistants eventually became editors of major food magazines, and some of us are still in the business of food styling. Eventually, I went out on my own, incorporating recipe development and teaching into my career. Now, after more than thirty years as a food stylist, I continue to teach—which is where it all began.

This book has been long in coming. In fact, when I was first approached to write a book about food styling, about fifteen years ago, I declined because I felt that there were so many possible answers to common questions, such as how much food to order for a job or what a typical assignment was like, that it seemed impossible to write. But as I attended conferences and continued to teach, I kept getting requests for a book. Finally, I agreed to write one because there really were no books on the market that encompassed all that I teach about food styling.

I have written this book not only for those interested in working in the field of food styling, but also for those who may be working in areas related to the world of food styling, such as chefs, food company personnel, photographers, prop stylists, students in culinary schools, cookbook and food writers, bloggers, and professionals involved in food advertising, marketing, public relations, and publications.

From the teaching that I do, I know the most important things that my students always want to know are:

- What is food styling and will I like it?

- Do I have the skills?

- What do I need to know beyond basic cooking and baking skills?

- How do I find jobs, is the field competitive, and can I make a living at it?

I attempt to answer all of these questions in this book.

Each profession has its own vocabulary, and food styling is no exception. You will run across words that may seem strange or out of place. An example is the use of the word *hero*. In our everyday language, a hero can be a mythological descendant of gods, an exceptionally brave warrior, or a male protaganist in a literary work. In the food world, as explained in Sharon Tyler Herbst's *New Food Lover's Companion* (see Resources, page 377), a hero is a huge sandwich, which "goes by many names, depending on where it's made. Among its aliases are *submarine, grinder, hoagie,* and *poor boy* (or *po'boy*)." In the world of food styling, though, a hero is the food that is to be photographed. It is a plate of "perfect" cookies, or a casually but beautifully arranged dish of food. It is the food that is ready to be shot. Before we place the hero on the set, we often put in a *stand-in*, a version of the food to be shot—but not the hero, the more perfect example and the final food. For words such as these, I have included a glossary of food styling–related terms (see pages 365–373). You may wish to become acquainted with these terms before delving into the text.

Food styling is a career that offers challenges, creativity, variety, and the never-ending joy of being able to play and "paint" with your food. The profession is ever changing, so keep abreast of what is happening by looking at current magazines and reading about the latest food trends.

LEFT: With a stand-in cereal bowl placed on the set, the photographer can work on the arrangement and lighting.

RIGHT: When everything is ready, the stand-in bowl of cereal is switched for the hero. It is the same cereal but now carefully arranged. Notice how the lighting has changed to make the food more attractive.

Diane Padys

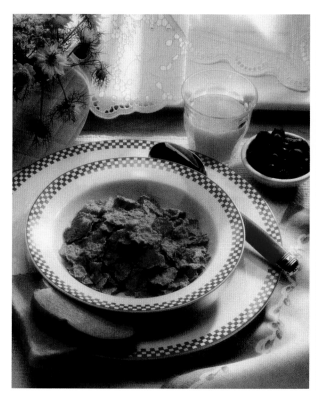

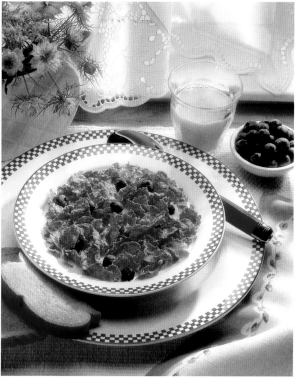

THE BASICS OF FOOD STYLING

FOOD STYLING
an overview

from HOME ECONOMIST to FOOD STYLIST

A History

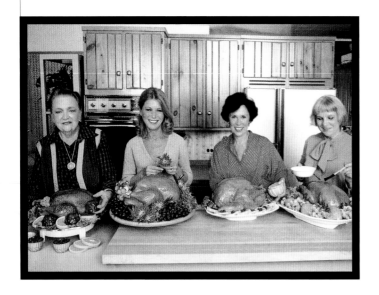

The first generation of food stylists. FROM LEFT: Grace Manney, Zenja Cary, Sylvia Schur, and Helen Feingold. *Dan Wynn for* New York

The term *food stylist* was probably used first in the mid-1950s. Before that, anyone who prepared food for the camera (whether for pictures in magazines, on food packages, in cookbooks, or for other visual purposes) was called a home economist. Home economists were the women with university degrees who worked in the test kitchens of women's magazines and major food companies. Before 1950, but even into the 1960s, food pictures and ads were often illustrated. When the trend shifted from illustration to photography, more food had to be prepared for the camera. Many home economists stepped out of their test kitchens and began working independently as freelancers and calling themselves food stylists. It took a while for the term *food stylist* to catch on. In fact, even today, many television and movie production houses still request a "home ec" when they need a food stylist.

The career of food styling developed in major advertising, television production, and publishing cities such as New York and Los Angeles, as well as in the headquarters locations of major food companies. These jobs were very gender specific. The early food stylists were all women and all home economists. In fact, a major food company would not hire anyone without a home ec degree to style food.

This first wave of food stylists was self-taught. They were good technicians but not necessarily artful culinarians. They were creative, entrepreneurial women who strode with courage into this new profession. Then as now, most of them worked out of their homes, but a few of them established small production centers. They struggled with early live television commercials. You hear about how their refrigerator doors wouldn't open, food would burn or fall on the floor, and ovens would open to reveal the food from the previous day's shoot still there. They worked with hot tungsten lights that wilted lettuce and melted ice cream. All the while, they were creating many of the techniques we use today when working with food. They discovered many of the tools to make styling work, and they trained the next generation. In November 1979, *New York* magazine ran one of the earliest articles on the career of food styling and shared with its audience just what this strange career was all about.

I was working at Cary Kitchens when this article was written. The photograph above was shot in one of our kitchens. We were a company devoted to providing food styling services, and we also worked as consultants on food-related assignments. Today, I find that fewer companies such as Cary Kitchens exist and that the food stylist's work is more independent. However, some food companies now shoot in-house, which means that they have staff photographers and even staff stylists, or a list of stylists that they hire regularly.

When I first began styling in 1979, nearly all photographers were male and, of course, all food stylists were female. Today, about one-third of the photographers are

female and about one-third of the stylists are male. The number of food magazines and food segments on television has greatly increased. Web sites belonging to food companies, magazines, and other media use large numbers of food photographs. Digital photography has changed the way everyone in the business works and also allows for easy retouching (using software such as Photoshop) of any food shot. Also, vast quantities of food pictures are available as stock photography now. Trends in the look and type of food have changed significantly over the years: Today, our presentations of food are much less controlled and more natural and casual (see pages 345–364 for more on photography and styling trends).

Another change that has occurred over the years is that food styling has become less invisible. Today, because of print articles and television segments about this career, more people know about food styling and, with the explosion of trained culinary professionals, more people are interested in it as a career.

the SMORGASBORD of food styling

When the public thinks of food styling, they often think that what we do is to prepare food for the beautiful photographs in cookbooks and magazines. That is definitely part of what we do, but for me food styling has included assignments such as the following:

PRINT MEDIA (MAGAZINES, NEWSPAPERS, CATALOGS)

- Getting succulent ribs ready for an article on great grill menus for *Bon Appétit* magazine.

- Decorating a cake to look like the White House for a newspaper article.

- Finding beautiful rhubarb stalks with leaves in December (see the photograph on page 148) for a spring article on cooking with rhubarb, and finding medium-size pumpkins in May for a Halloween magazine story.

- Making a Tweety Bird waffle for a catalog shot, cutting a steak into the shape of Texas, making a whole roasted chicken with three legs, decorating a meat loaf to look like Groucho Marx, shooting an empty salad-dressing jar, and putting the perfect twist of lemon in a martini.

COOKBOOKS

- Preparing 150 pies to be photographed for a cookbook on perfect pies.

- Cooking in the basement of the restaurant "21" Club for a press party.

- Shooting a decadent chocolate cheesecake for the cover of a cookbook.

- Rewriting forty different chefs' recipes and then testing and preparing them to be photographed for a small cookbook on phyllo dough.

ADVERTISING AND FOOD INDUSTRY

- Removing all the hairs from a raspberry to be used as a garnish on a goblet of white chocolate mousse.

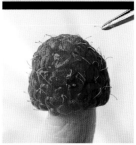

FROM TOP: *Beth Galton; Dennis Gottlieb; Keith Ferris*

fried chicken with diamonds and other stories

I have arranged a platter of fried chicken with diamonds, rubies, and pearls scattered in the arrangement. I have shot an ice cream cone piled high with nineteen scoops of different flavors of ice cream for a commercial. I have shot a "perfect" ice cream cone being held by a hand model wearing a $250,000 bracelet, with a bodyguard standing just off the set. I have had to make ice cream cones where the color of the ice cream had to match the color of several models' outfits. I have shaped the word *Jell-O* out of Jell-O and made it wiggle and giggle. I have made an alcoholic drink called the green iguana with a real iguana in a blender next to it.

- Developing recipes to show the versatility of a set of cookware and preparing the recipes to be photographed in the cookware.

- Making a pizza with a perfect stringy cheese pull or shooting a hot dog with just the right squiggle of mustard or a hamburger with a mustard frown (see the photograph on page 205).

- Testing sixty recipes from contestants competing for a trip to New York and having a tasting of each recipe for the client.

- Sorting cereal all day for flakes with "character" or finding Goldfish crackers with the most "smile definition."

- Grilling chicken in the snow on the street below a photographer's New York studio.

- Preparing a sandwich for a commercial in a dressing room with the Dallas Cowboys.

- Shopping for two 5-pound lobsters and an eighteen-inch red snapper at 3:30 A.M. at the Fulton Fish Market for a 7:00 A.M. shoot with Paul Newman—who was a hundred miles away (see page 56).

- Arranging the food for a series of package shots of frozen entrées.

- Sitting at a table of executives at an ad agency and being asked if "nooks and crannies" are acceptable food terms to use when describing an English muffin.

TELEVISION AND FILM

- Receiving the winning recipe for America's Best Pie contest at 3:00 P.M. and showing up with the pie the next morning at 5:30 A.M. for its appearance on *Good Morning America*.

Providing the perfect lemon twist to three colorful martinis

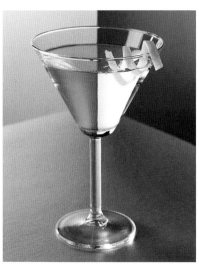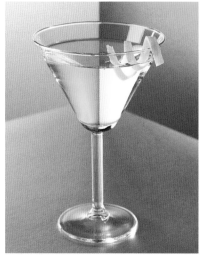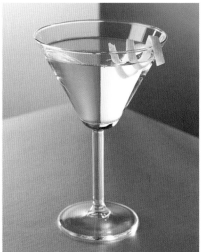

Jim Scherzi

- Preparing six luscious cookbook desserts and setting up the ingredients so that the author could demonstrate making them on the *Today* show.

- Teaching the "butler" on the movie set of *Trading Places* how to flambé crêpes suzette.

- Spreading margarine on slices of bread in a tree house in a Mexican rain forest, in a château in Prague, and on the Brooklyn Bridge at midnight, all for television commercials.

what is FOOD STYLING?

While most people prepare food to eat, the food stylist prepares food to feed the eyes and the imagination. Just as we primp to look our best for the camera, food to be photographed needs to look its best, too, and making it look its best is the job of the food stylist. How that is done is a complex and interesting series of steps.

As a food styling instructor, I have heard many misconceptions about our work. Beginning students often arrive in class thinking that all a food stylist does is show up at the studio, find pretty plates, make an attractive table arrangement, and put food (prepared by someone else) on the plates. Then, the photographer shoots it. Well, one in every thousand assignments might come close to this idea, but the reality is often much different. A food shot is a team effort that takes preplanning, clear communication, thoughtful shopping for food and props, proficiency at food preparation (yes, we cook the food), and a sense of artful presentation. Photo sessions can take hours, and the photographed food must look freshly made and so appetizing that whoever sees it wants to eat it immediately.

Anatomy of a Food Styling Assignment

The first thing a food stylist does when he or she gets a job is to begin to gather information about it. Who is the client? Is the work for print or television? How many days is the shoot and are there prep days? Will an assistant be needed? Are there recipes, a photo outline, layouts, or storyboards and tear sheets? The latter will spell out how the food is to be shot and how it should look. The food stylist must organize all this information and put together a game plan.

First Steps: Finding the Food and Props and Selecting Equipment

Once the assignment is set, you make a shopping and equipment list. How much you need depends on a number of factors. For example, sometimes you have to make a dish twice—once as a stand-in (not the final food) and once as a hero (the final food). Because the food needs to be not just attractive, but just the right size and color and in the correct amounts, I always get ingredients for twice the recipe and sometimes for up to thirty times, depending on the fragility of the food and the type of assignment. If you are also propping the job, you must shop for plates, glasses, flowers,

tablecloths, flatware, and any other nonfood items that will be shown in the shot—and you must have plenty of options from which the client and the photographer can choose. You also must make sure that all the cooking and styling equipment needed for the job is packed or is at the studio. Then you must transport everything to the studio in perfect condition.

Preparing the Food

After you have unpacked and organized your work space, following a shooting schedule, you prepare the food so that it looks its best just when the photographer needs it. As a food stylist and good cook and baker, it is your ultimate job to make the food look mouthwatering. Depending on the food, it should look fresh and crisp or smooth and soft, grilled or hot and juicy, and so on.

Arranging the Food

Next, the job is to arrange the food so that it looks appealing *to the camera*. Just because it looks good to your eyes, does not mean it will translate well through a lens. You must be aware of how the camera sees the food (how close or far away, the angle, and how the lights hit the food).

Keeping the Food Beautiful and Adding Final Touches

After the food is arranged and put on the set, you must keep it looking gorgeous and fresh until the photographer is ready to shoot. Herein lies the constant challenge of food styling: Food "dies" or changes over time. It is affected by heat and cold, by moisture or dryness, and by light and the air around it. You must know how to control or adjust these conditions so that your food will not "misbehave." You must also know when to add final touches such as garnishes, sauces, and fragile food just before shooting.

is FOOD STYLING for you?

Most people think of food styling as a possible career choice because they love food and they want to work with food in a creative capacity. Some have strong cooking skills gained from work in restaurants or at a culinary school. Others may have spent time working in advertising or in production, and also have a love of food and are good home cooks and want to combine those interests.

People often approach me for information on just what skills you need to be a successful food stylist. But before you decide on food styling as a career, you should think about where you live or want to live, because you must live near the work—near photographers who shoot food, near book and magazine publishers, near television production companies, or near large food companies with in-house production capabilities. The majority of the work is in major cities, such as New York, Los Angeles, Chicago, and Minneapolis. Other cities with some food-styling work are Orlando, Miami, Seattle, Atlanta, Boston, Des Moines, St. Louis, Dallas, and San Francisco, to

name a few. Then there are cities with special opportunities, such as Birmingham, Alabama—the home of *Southern Living* and *Cooking Light* magazines. If you have the skills and the work permit, work may also be available in foreign countries.

Next, you should think about the fact that this is almost entirely freelance work and ask yourself whether you have a freelance personality. Just what does this question mean? Are you a self-motivator? Do you feel comfortable not knowing when or where the next job is? Do you have financial support (income from another source, such as a flexible second job, a rich and giving parent, a husband or wife with a secure job, savings, or the ability to live on almost nothing) while you assist experienced food stylists on your way to establishing this new career? You will be working in many different settings (not going to the same office). You will have to put together your own savings and retirement plans and take care of your own health and disability insurance. You will need to put together materials to promote yourself and get out there and look for job opportunities.

These are some of the challenges of the freelancer, but let's look at some of the pluses of the freelance world: *not* having to go to the same office every day, working for yourself, setting your own goals and going for them. I like the fact that the jobs have a beginning and an end (often in two to three days). Then I am off to the next new and interesting job. The work itself calls for a tremendous variety of skills. No two days are the same, and no two jobs are alike. You need to be able to "go with the flow" and enjoy the ride.

The Attributes of a Good Food Stylist

Following is a list of skills and attributes that will be most helpful to you as a food stylist. No one starts out with all of these skills, and you may need to fill in the gaps by strengthening certain areas. Although this list may seem daunting, you will gain knowledge as you work; the stronger your foundation and knowledge in these areas, the better. Because what is the most important skill on one job may not be on the next job, the list is *not* necessarily in order of importance.

You'll need to be:

- **Well organized.** You will need to be a good communicator and ask pertinent questions. You will need to collect information and be able to get a grasp on the job, figuring out who, what, when, where, and

food styling's main rule:
it all depends

One thing in food styling that is consistent is that nothing is consistent. There are general "rules," but each day and each assignment is different from the previous one. I'm often asked such questions as How much food will you need to get? or How many shots do you do in a day? My answer is typically, "It all depends." Knowing how to figure out what it depends on takes experience and practice.

Let me give you one example: If we are shooting a turkey, I may be able to do that job with two turkeys—one for the stand-in and one for the hero. However, let's look at a few of the possible questions and job options that can become "it all depends" issues:

Is this a close-up of the turkey or is the turkey part of a larger setting and therefore less significant?

Is this for the cover of a magazine or for a story on Thanksgiving foods?

Are we showing leftover ideas, such as turkey hash?

Is this an advertisement for a particular brand of turkey?

Is this a television commercial?

Do we need to show the turkey being sliced?

Is this a test shot with a photographer?

Are we showing a turkey TV dinner?

Is there a large budget or a small one?

Will the client be supplying the turkeys?

Any one or more of these factors will determine how many turkeys I need for the job. For the test shot with the photographer, one turkey breast may be sufficient; for the magazine cover, two to three handpicked fresh turkeys may be necessary.

Now let's look at advertising for a specific brand (and a larger budget). Usually, the client would send the turkeys and may ask how many you need. Again, it all depends on the shot. You may need five to ten for a print ad. If you are slicing a whole turkey for a TV commercial, though, you may need up to twenty-five turkeys, just for the perfect slice shot alone. Each assignment is a unique job.

in which order things will need to be done. When you arrive at the shoot, you will need to be able to set up your work space so that you can work comfortably and efficiently. Often the photographer will take your lead as to the order of the shooting schedule.

- **A good cook and a good baker.** I can't stress enough the importance of being able to prepare foods correctly (making adjustments, if necessary) and to make the food look as good as it possibly can. Your food knowledge and skills are extremely important. Of the two skills, cooking and baking, the one you can't "fudge" is being a good baker. Understanding the science of baking is invaluable, because baking is chemistry in action. If you need to develop that knowledge, read cookbooks and bake, bake, bake; take private lessons; or go back to school. That may mean going to cooking school for a degree or taking courses at a local cooking school or community college. You can't take a pie job, for example, and learn how to make pie dough the night before your shoot (see page 149 and Resources, page 378, for valuable information on food science).

 A fellow food stylist and one of my mentors, Helen Feingold, once said as we taught a class in food styling together, "Food is like children. It doesn't like to behave in front of company." The longer I've been in the business, the more I've come to appreciate that statement.

- **A problem solver.** While food is out there not "behaving," you need to be able to figure out how you can take control and whip it into submission. Just what kind of food mischief are we talking about? Ice cream that melts and cheeses that congeal (once they are melted) are two common problems that come to mind. But then there's cereal that gets soggy when milk is added, and lettuce and fresh herbs that wilt while waiting for the photographer to shoot or the art director to make decisions. There are also slices of fruit pie that collapse, salad dressings that separate, and sauces that are too thick or thin or get a skin as they cool. Meat that looks dry, not juicy, or too rare or not rare enough are other problems. Syrups soak into pancakes, brownies stick to the pan, chocolate blooms, muffins won't dome, bread dries and curls, whipped cream weeps (and you will want to join in the weeping as well). How do you deal with these problems, and also figure out how to build a sandwich that is fifteen inches tall without the weight of the food pressing down all those lovely cold-cut folds? How do you crack a coconut with just the "right look" or make a walnut explode on cue for a commercial? Each day has its challenges. If you have assisted a food stylist for a while, many of the "problem" foods may already have been handled by him or her, and you can apply this knowledge. However, you can't know everything, and you need to know where or to whom to go for information if you need it. Just remember that all these challenges don't come at once and that you will, I hope, have a team of problem solvers to work with you.

- **A good team player.** A photo shoot, television commercial, or movie is never a solo undertaking. You will always work with at least one other person. More often you will work with a team of at least four people: an art director, a photographer, the client, and a prop stylist. The list of players can get longer with more clients or agency people, the talent, or the model. When you get into television or movies, you will notice that the list crediting the team players can go on and on. Your major contri-

bution to this team will be your skills and knowledge about food. However, you can be called upon or may want to share nonfood-related information that you have found helpful from previous jobs which will make this job work better.

- **Someone who knows when to lead and when to take direction.** Helpful suggestions are almost always welcome. However, there are some jobs (mostly in television) where there are already a few egos in the room, and adding yours just prolongs the job. When you do see problems or blatant mistakes—such as directors who want to shoot baking powder biscuits being baked in a muffin tin rather than on a cookie sheet (see page 12), or the wrong spoon or wineglass being used—you should step forward. The important thing is to know to whom to make your suggestions and to make them tactfully.

- **Confident.** Confidence is something we each have in varying degrees, and we may have more or less of it depending on the day. You will be hired for a job because the photographer is confident that you will be able to find beautiful food and prepare and arrange it attractively. The client is confident that you will be able to produce the desired results. You'll become more comfortable and confident with experience. A beginning assistant food stylist should value his or her time assisting. The time spent working with a lead food stylist will give you invaluable knowledge and experience, which eventually will allow you to work confidently on your own.

- **Able to deal with stress.** Yes, even though you may have lots of experience, there will always be stressful days. You may be asked to make food do things it doesn't like to do, or you may have difficulty finding the food required for the job. There may be times when everyone is waiting for you to produce the food and the clock is ticking. Or you may have an audience watching you do a difficult swirl, dollop, pour, or scoop. (It is helpful to get used to having people watch you work, because often your work is the most interesting thing happening in the studio—and then there are the aromas that draw people around.) You have come to this career because you have found your passion—food. Don't let your work spoil your joy and love of food. Love what you do, and it won't feel like work (most of the time).

typical challenges:
from melting margarine to a mango search

There was the time I was in a *warm* tropical rain forest in Mexico, shooting a commercial for heat-sensitive margarine. Beforehand, I had requested three refrigerators. I was provided with one Coca-Cola machine. When I turned on my hot plate to sauté some food, it blew the fuse to everything. Thus, no refrigerator, no stove, and no one to help me schlep the sixty pounds of melting margarine and all my equipment to a hotel restaurant. At the hotel, my "refrigerator" was the machine in which they stored ice for sale. Then there was the time a job required mangoes, and all of them (in the whole world) had been destroyed by a hurricane. Of course, the client couldn't believe there were *no* mangoes, so he had his office staff calling everywhere. No mangoes! So we shot a basket of other fruits. Another time, I brought in beautiful cookies with heart-shaped centers, but the photographer didn't like the hearts. I had to carve the hearts into circles.

- **Patient and tolerant.** Patience and tolerance are sneaky little attributes that may seem insignificant, but they are very important. I can't begin to tell you the number of times someone has said to me at the end of the day, "I could never do what you do; I don't have the patience for it." There have been jobs where I might spend hours sorting for just the right cereal flakes or moving rice grains in certain directions (because "those two grains are parallel" or "this one is sticking out just a little too much" or "the two here are too close together"). You may work for an hour developing a certain texture on the side of a cake slice or getting just the right design of mustard on a hot dog or the correct arrangement of ice in a glass. Also, everyone has his or her idea of how food should be arranged. I have learned that if someone asks, "What if?" it really means, "Can we change that?" Be prepared to make changes or even start over again. As I said before, learn to go with the flow (or, in some situations, the flood) and think on your feet. Then there is the patience required to develop your skills

making baking powder biscuits in muffin tins:
lessons learned the hard way

I was fairly new to food styling, and it was the first time I had worked with this director. We were shooting a commercial for a strawberry jam product. The director asked me to meet with him the day before the shoot. He wanted to look at as many different muffins or biscuits as I could come up with to determine which he would like for the "break open and steam" shot and the "spread the jam on the surface of said items" shot. I brought in fifteen different kinds of muffins, as well as some baking powder biscuits. He loved the biscuits. I'm sure that in his mind's eye he could see the glistening red jam gliding over the steaming white and beautifully textured just-broken-open biscuit.

That decided, it was now time for me to go home and bake 250 biscuits for the job the next day. On my way out of his office, however, he mentioned that he had some beautiful antique muffin tins that he wanted to use in the commercial. I told him that baking powder biscuits are not made in muffin tins; instead, the dough is patted out on a floured surface, cut with a biscuit cutter into circles, and then placed on baking sheets and baked. I said I had some new, unscratched baking sheets that I would bring with me. But we were not listening to each other.

At 6 A.M. the next morning, the crew, food, and equipment were gathered into vans and we headed for the house two hours out of New York City where we would shoot the commercial. I was able to use the location kitchen because we were not scheduled to shoot in it. I organized my space and began gathering the items I needed for the first shot. When I walked into the dining room where they were setting up that shot, I was shocked to see my biscuits stuffed into the director's antique muffin tins. I blurted out, "But you don't make baking powder biscuits in muffin tins!"

Lesson 1: Even in shock, you walk up to the director and *quietly* discuss any issue between the two of you. As a food professional, it is your responsibility to be a food adviser on critical food-related issues. This is important because any home cook who makes biscuits will know that something such as baking biscuits in muffin tins is wrong. If the director does not understand, however, then you should quietly bring the problem to the attention of the client. If the client says it is fine, then you step back.

What actually happened was that several people heard my concern. Now we had a big issue. The client called the test kitchen and the legal department. The director, furious, of course, refused to give up his preconceived vision of biscuits cooling in antique muffin tins by the grandma's-style kitchen windowsill, sunlight shining through wafting cottage curtains. After an hour of discussion and decision making, the verdict was that I would bake biscuits in muffin tins, and we would use those for the shot. You can imagine this was not a happy moment. Nonetheless, I began making biscuits in muffin tins—not very pretty biscuits, I am afraid.

Lesson 2: The director normally rules, but it is important that the client, who is paying for everything, be informed of food issues that occur, because you are the food expert on the set.

Lesson 3: You will probably never work for that director again. (Many years later, I did get a call from that production company for a job—I guess everyone had forgotten, or it had been a client request. The next issue is, do you take the job?)

and career. In the book *Becoming a Chef*, there is a quote by Michel Richard that is pertinent to food stylists: "You need time and dedication. Be patient (and persistent). Don't take the elevator—take the stairs."

- **Personable.** A food stylist usually gets hired for a job because he or she is a good cook and baker, a good problem solver, and has a certain "artful" flair with presentation. If all these things are equal, then one stylist is hired over another because he or she is fun to be around, calm, has a positive attitude, and is a team player. Wouldn't you rather spend your day with someone like that?

- **Professional.** Every job deserves a 150 percent effort, and anyone who hires you expects that you have the skills to accomplish the job. Even if you are best friends with the photographer or client, treat each assignment with the care and expertise it deserves.

- **Creative and artistic.** Many food stylists have an art background or have an interest in the arts. However, you will be hired for your presentation skills. Some people style in a very formal, controlled way, while others style in a looser and more casual manner. For some jobs, one style works better than the other. (Often, in advertising, the look is more controlled and precise, while in magazines, the food should look natural and doable.) Being able to interpret the client's desire for a particular style is an important skill, and being able to produce a variety of styles is an asset.

- **Physically healthy.** As food stylists, we spend most of the day on our feet. You'll schlep (lift and carry) a lot of heavy things, such as groceries, cooking equipment, props, and tools, to new locations all the time. You can find yourself deep-frying chicken for ten hours. When you work on a set, you may be standing or kneeling in awkward positions. (A photographer, while lighting the set, may make it almost impossible for you to reach the food, placing stands, reflector boards, lights, and cameras in your way.) Giving the food its final touch-up can therefore be a backbreaking experience. It is very important to have comfortable shoes, physical stamina, supporting equipment, and assistants.

- **Able to see the humor.** As in every job, you need to be able to step back and take a look at the big picture. This is just one day, and you are not doing open-heart surgery or solving the problems of the universe. Some people around you may think you are, but I assure you, you are not. So if someone is requesting the almost impossible, or the stupid, or if you will be two hours later than you had hoped in getting home, it is best to try to relax and find perspective. Some of the strangest or "worst" days become the ones we remember with humor later on.

- **Versatile.** As a food stylist, I have been asked to work on assignments that were not specifically related to food styling. I have developed recipes for many clients. I've been asked to help prepare and set up food presentations for press parties or food shows. I've written magazine and newspaper articles, and taught classes and seminars from Norway and Japan to the Disney Institute in Florida and the prison cells of New York's Rikers Island. I've worked on restaurant menus and helped restaurants in their food presentations. I've taught professional recipe writing skills to the sales staff of food-service companies. I've demonstrated recipes at a national garden show and developed a cooking class for the American Heart Association. All of these assignments were food related and sometimes food styling related, but because of a variety

of learned skills, I was able to say yes to all of them. And that led to many interesting assignments. It is important to have strong food styling skills, but it is also helpful to know how to develop and write clear and delicious recipes. Good communication, management, and marketing skills are an asset as well.

This brings me to another topic—careers and educational experiences that are useful in our business. Just remember that having a variety of skills can allow you to say yes to a variety of jobs.

Education, Formal and Informal

Do you need to be a graduate of a culinary school to be a food stylist? No, and many stylists are not, but you do need to be a very good cook and baker for this career. The very first food stylists were home economists who worked in the test kitchens of major food companies or magazines, and it was imperative to have a home economics degree to get those jobs. I have a degree in foods and nutrition and have found that many of the courses I took were extremely helpful: for example, food science, organic chemistry, nutrition, sensory evaluation of foods, food demonstration, culinary communications, and recipe writing and development. I do wish that I had had the opportunity to attend a culinary school, though. Most schools now offer a two-year program. Some schools and continuing education programs will allow you to put together your own class list so you can work on areas where you are the weakest. For myself, I would have taken professional baking classes.

Along the way I did take many cooking classes and avidly watched every segment of Julia Child's *The French Chef* with my then-infant daughter. (Thank you, Julia, from both of us.) Life's lessons and formal and informal classes have all come in handy at one time or another, even Josef Albers's theory of color, which was a class I took at the Rhode Island School of Design, just for the fun of it, long before I became a food stylist. I learned the principles of how colors affect each other, either in a positive or negative manner. Today, courses in food styling are beginning to be offered throughout the country and in some culinary schools. These are a helpful way to gain a lot of information about techniques used in the field, because food styling techniques differ from some culinary techniques. Courses are a wise investment if they are taught by practicing food stylists.

Whenever I visit a foreign country, one of my best learning experiences is to go to a grocery store. I consider groceries to be cultural museums because they tell me so much about the country and its people. I look at what foods are popular, and how they are displayed and packaged. When I teach my food styling classes, I have students do some shopping in the hope that they will begin to look at food from the perspective of a food stylist. What is seasonal and beautiful (or not) in produce and which stores have the best? Are there new fruits or vegetables to be aware of? What new products have become available recently—is there a trend developing? What new colors are being used in packaging and who has changed their packaging? As a stylist, you'll need to notice which bakery has a certain shape of bread in dark rye or where to find dried chickpea flour, for instance. If you prop as well, you should always be aware of what interesting and useful props could be utilized in your work.

Other educational experiences that can prove useful are courses in design, art, photography, publishing, communications, business, and marketing. Continue to

grow and learn: Read (books, newspapers, and magazines), take classes, and always try new foods in restaurants (a hard assignment!), as well as at home. Travel and volunteer to work in interesting food environments. The food stylist's world is a visual world. If you are like me, you are drawn to visual beauty. I have found that one of the best ways to improve my skills is to look, look, look. Look at inspiring magazines, books, movies, art shows, nature, fashion, and architecture. (Notice that I didn't say only food magazines and cookbooks.) Look at the results of what you have just cooked or baked. Compare photographs or advertisements of similar foods and think about what makes one work better than another. Pay attention to current chefs' presentation techniques. Identify trendy colors in fashion. You can and should always teach yourself.

Work Experience: Versatility Helps

Several food stylists I have talked to have said that they find their best assistants have had other work experience before entering the field of food styling.

Restaurant kitchen work is wonderful training for food styling. Not only do you gain hands-on experience with a variety of foods, but you learn to be organized (often in small spaces), work as part of a team, and deal with stress. You also learn to deal with long hours, hot kitchens, and being on your feet all day.

Previous work with food companies or in marketing and advertising can be very helpful in understanding the job from the client's viewpoint. Many freelance food stylists started by working in the test kitchens of food companies. There they learned about the various branches of the company and the responsibilities of each branch. They learned to develop products and recipes for their target audience. They learned presentation techniques and may have done some food styling as well. They attended shoots for print or television to give helpful advice and make sure a product was properly represented. All of this gives these professionals a strong background for food styling and an understanding of product marketing.

Jobs in publishing and photography or with a production company give you valuable insight into how these parts of the business work. Food stylists are hired by both food magazines and cookbook publishers. If you have worked in the test kitchen of a magazine, you will have a greater understanding of how to develop recipes that will look good when photographed. Shooting commercials or sitcoms with food in them and working on home shopping shows or news shows

five pieces of advice for the food stylist

I was recently asked, If you could give just five pieces of advice to beginning and advanced food stylists, what would they be? Being forced to condense my thoughts on the subject was a good thing. My advice is as follows:

1. **Have good cooking and baking skills.** You can't fake these skills, and you will need to be knowledgeable, as well as have hands-on experience in the kitchen.

2. **Be resourceful.** Develop a good source list and a good network of fellow "foodies." You can't know everything, so you need to know where or to whom to go for information when you need it.

3. **Be flexible.** The greater your knowledge base in a variety of related fields, the greater variety of jobs you will be able to accept or develop (and as an entrepreneur, it can be important to create jobs). Be flexible on the job as well. You are working with a team. It is often important to think outside the box. Adapt to new situations. Gather as much information as you can pertaining to a job, but keep in mind that there will always be a few surprises, so learn to go with the flow and think on your feet.

4. **Build a knowledge base.** I have mixed feelings about this advice. It is important to push yourself, but it is also essential to have the knowledge and skills to be able to do the job well. I began working as an assistant at the age of thirty-eight. This was not my first career, and I had also taken off six years to be a mother. I went back to school, and then I patiently worked as an assistant for five years before I began working on my own. I found the knowledge I gained as an assistant invaluable.

5. **Enjoy your work.** You have come to this career because food is your passion. Again, don't let your work spoil your joy and love of food.

that have food segments, for companies that produce satellite media tours or for TV's Food Network all have connections to what we do.

Finally, whatever career you choose, take the advice offered in Jack and Suzy Welch's book *Winning*. In the book, the Welches suggest that you keep asking the questions: Does this job allow me to be myself? Does it make me smarter? Does it open doors? Does it represent a compromise I accept? Does it touch my inner being? The authors feel that if you listen closely enough, with time, patience, and the courage to act, the answers will lead you to the very place you were always meant to be (see also pages 323–334).

business ETHICS
To Enhance, Stretch, or Cheat?

It does happen, both in print and film, that we are asked to "improve" the look of a particular food. If we are shooting prebaked packaged chocolate chip cookies, we may produce cookies for the shoot by sorting through many packages of product to find the best-looking cookies. We could brush off any crumbs and shoot them. Or we may be asked to warm the chocolate chips slightly before shooting to give them a little glisten (enhance). If the chocolate chips are broken or not showing, we may be asked to add new or more chocolate chips, using either the client's product or purchased chocolate chips (stretch). We may be asked to make fresh cookies using either dough prepared by the client or a recipe and raw ingredients sent to us by the client (stretch). We may be asked to make the best-looking chocolate chip cookies we can using our own recipe and adding chips in just the right places partway through the baking process so they will not blister (cheat). Any of these things can happen on a chocolate chip cookie shoot.

Some of the techniques we call editing, some enhancing, some stretching, and some cheating. Before you begin your career as a food stylist, it is important that you think about where you stand on such issues. Some food companies and magazines want only the real food or recipe shown. Other companies feel perfectly free to "cheat." Over the years, I have watched as the accepted rules regarding truth in advertising have become both tighter and looser. If a major company is sued for false advertising, things tend to tighten for a while. Currently, it seems that many companies are quite liberal with the rules, but because of the trend toward the natural look, many may not need to enhance as often either.

As food stylists, we naturally want food to look great and be presented as beautifully as possible. If they are to be used, enhancements are generally requested by an art director, photographer, or director. I feel that the food stylist should get permission from the client for any enhancements, since if a problem does occur, such as consumers complaining or competitors suing, the client is the one who has to deal with it. Most large companies have a legal department to consult. Usually we will be told one of four things: we cannot enhance, we can enhance to a limited extent, we can do whatever is necessary, or "I am not in the room." The last I don't like to hear because it puts all the responsibility on me.

Magazine or cookbook publishers will want the food to represent the recipes. We will not add multicolored bell peppers in place of a single-color pepper because they look prettier or make muffins larger or smaller unless the recipes are revised to reflect these changes. We can, however, suggest changes as long as they do not alter the integrity of the recipe. Each publisher has their own standard of naturalness: Some prefer the more perfect look, some want everything to look real. Some will use garnishes liberally and some will not.

As food stylists and as good cooks and bakers, we will still make food as beautiful as possible, but if we make it impossibly beautiful, the consumer may feel defeated or think that the recipe doesn't look doable. I cannot tell you the number of times I have heard someone comment that his or her food never looks as good as the picture. There are many reasons for this: The carefully chosen props we use to present our food enhance its appearance. Also, there is magic in the camera and the photographer's lighting. Most people have never looked at their food from a camera's point of view, without the distractions of peripheral vision. Try it sometime. Either cup your hand over one eye and look at your salad or cut a small square hole in a piece of paper and look at the salad through the hole. You may be surprised at how appealing your homemade salad looks when that is all you see.

Some magazines do choose to stretch by producing the perfect (undercooked and painted) turkey or by putting freshly cooked cranberries on top of a cranberry upside-down cake. But if they overstretch, consumers do call or write in to complain.

As the Photographer Sees It

With the development of digital photography, it has become increasing possible to produce the "perfect" picture. No longer do we stylists have to find a totally unblemished banana. We still try, but if the banana has a bruise or is not quite the right shade of yellow, that can be easily corrected. If we need a drink to be a little darker or we want to add a splash coming from the glass, that can be done in Photoshop. If we liked the garnish on the stand-in better than on the final dish, we can cut it from the stand-in photo and paste it onto the hero photo. In the past, expensive and lengthy retouching would have been required to make these changes. Not with digital. With this ease in manipulation, however, come ethical questions for both the photographer and the client. Making a prettier picture is one thing; changing the product is another. As my dear friend photographer Jim Scherzi says, "It is important that we are responsible with our power."

Shooting Food We Don't Endorse, and Other Ethical Conflicts

Some ethical questions that come up for food stylists include the following: Do you accept assignments for food that you would not eat? Vegetarian food stylists cannot keep busy without shooting some meat products. You may personally choose not to eat some processed foods, but do you accept assignments promoting them? If another stylist refers you for a job and then you are asked to do another job for that client, do you suggest that the client call the stylist who recommended you first? What do

you do if you have accepted a one-day editorial shoot and a three-day advertising job (much more money) comes up for the same date? As an assistant, do you pass out your card at shoots or talk to photographers about working for them? (These are both considered very bad form. Most of my assistants have been very good about approaching only photographers I have not worked with. However, I will suggest that a photographer work with one of my assistants if I am booked when he or she needs me and if I feel that the assistant is up to the assignment.) Do you take an assignment if you don't feel your skills are up to the job? If you have come up with a concept and provided the food and your time for a test shot and the photographer sells the shot, should the photographer share the income? If you send your invoice to the photographer and you later learn that the photographer raised your fee but did not pay you the increased amount, should you bring this up? (Keep in mind that if the photographer raises your fee on the invoice, the client may choose not to work with you again, preferring to hire someone who charges less.) What is a reasonable amount of time to wait to get paid? When should you get credit for your work?

I have chosen only to bring up these issues and not to answer them. It is important to know that you will have to decide for yourself how you will deal with them.

The food stylist has the opportunity to work in two very different media: print and production (video or film). When you work on a print job, usually nothing moves—neither the food nor the camera. The photographs created are used in materials that are printed, including editorial photographs (cookbooks, magazines, and newspapers) and promotional photographs (public relations, marketing, advertising, catalogs, Web sites, and packaging). In production food styling, often both the food and the camera move. These types of shots include those for television shows featuring food spots, dedicated cooking shows, satellite media tours, commercials, and movies.

THE MEDIUM
is everything

There is a vast difference between food styling for production and food styling for print. Each medium requires specific approaches and skills. Even certain personalities seem to be better suited to styling in one medium than in the other. Production work is more physically demanding, the days are longer, the stress level is often higher, and it requires a person who adapts to fast changes and is comfortable with improvising. In production, you will need to produce multiple heroes (the perfect final food) when someone is eating, slicing, cooking, saucing, pouring, or frosting the food on camera. You may need to make at least thirty perfect hamburgers so that when the actor takes a bite and forgets his or her lines or when sauce dribbles

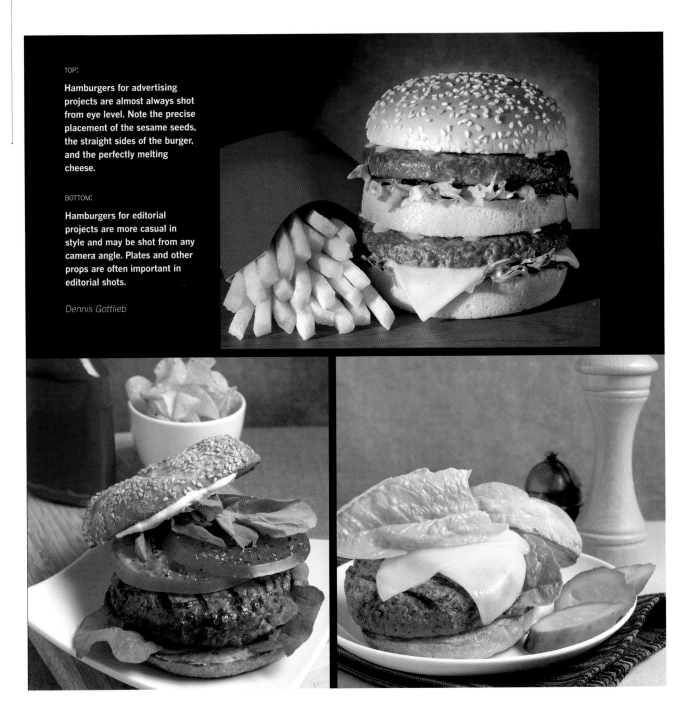

TOP:

Hamburgers for advertising projects are almost always shot from eye level. Note the precise placement of the sesame seeds, the straight sides of the burger, and the perfectly melting cheese.

BOTTOM:

Hamburgers for editorial projects are more casual in style and may be shot from any camera angle. Plates and other props are often important in editorial shots.

Dennis Gottlieb

down his or her chin, you'll have another hamburger to give the actor right away for the next take. Each hamburger will need to look exactly like the others because the hamburgers may need to match in different shots. In print, you may shoot anywhere from one to ten shots in a day, but you will usually have to produce only one stand-in and one hero (sometimes only the hero) for each shot. In print, you'll usually have a more normal workday (but it is not infrequent that you might work until 8 or 9 P.M.). When you are shooting commercials, ten- to fifteen-hour days are not unusual.

EDITORIAL food styling versus ADVERTISING

Editorial styling usually requires a look that is more casual and artful, and the stylist has more freedom. The advertising look is usually a little more perfect and controlled. In either situation, you need to understand the demographics of the client's audience and style to that audience. For example, if you are preparing a hamburger for a certain magazine, you will need to match the style of the food with the style of the magazine (loose and casual, or more precise). If you are styling the hamburger for a fast food chain (an advertising or marketing assignment), you will need to prepare it to the exact specifications of the client, using their food. If you are working on a package shot for a precooked frozen hamburger patty, you will use the actual product and follow a layout exactly because there may be more than one flavor of product in the brand. Other packages may already exist, and each new package shot must be consistent with the others.

Who Is the Audience?

There is one question you will always have to consider when propping and styling a shot: Who is the intended audience? If the assignment is to style food for the average home consumer (as in a women's magazine, for example), the presentation and props will need to have a look that is realistic for that audience, while if you are styling for the food professional (restaurants and food service), the styling will require a more commercial look. The professional's will look as if it might be presented in a restaurant by the chef,

FROM LEFT:

Dollop 1 is casually styled for the home consumer.

Dollop 2 is the gold standard presentation required for advertising.

Dollop 3 is styled for food professionals, with piped cream and a sprinkled garnish.

Dennis Gottlieb

which can be vastly different from the home presentation. Take, for example, whipped cream. For the home consumer, I will usually put a spooned dollop of whipped cream on a dessert; for the food professional, I will pipe a beautiful swirl of whipped cream; and for advertising, I will create their "gold standard," their signature or ideal look.

What Are We Selling? The Food Stylist's Role in Producing a Food's Look

Recently, I worked on a series of test shots (see photograph below) with photographer Colin Cooke. We wanted to take several simple food combinations (crackers and cheese, turkey and gravy, muffin and margarine) and show how we could best feature one of the food items in that combination and then the other. In other words, the photos would answer the question, What are we selling? Whether we are visualizing the presentation of a recipe for a magazine or cookbook or styling food for an ad or commercial, it is our job as food stylists to produce food that best represents our client's standards or "look." If we are selling a particular product, we need to ask ourselves how we can best feature it in a prominent fashion.

If we are producing a test shot to attract a particular client, we want to feature the client's product. We need to determine what their gold standard is, and find or produce food that meets that standard.

For example, with the cheese and crackers, if we are selling the cracker, we must consider the size, shape, color (brownness and evenness); the amount of salt, herbs, or grains (if pertinent); and the correct thickness of the product. Then, if we are showing it with another ingredient, such as cheese, we want to make sure that we still see enough of our client's product and that the cheese (supporting food) is a good complement and doesn't distract from the product. If we are selling the cheese, we must determine if we want to show it smooth or with texture. Is it prominent? Does it look freshly sliced? We could melt it or show it mixed with other ingredients. What are the possible mouthwatering presentations? Other considerations would include:

- Camera angle that best displays the product
- Amount of product to be shown
- How close to shoot the product
- The best type of lighting to show off the product
- Colors that complement the product
- Props that complement (color, shape, and size)
- Arrangement of the food in an interesting and artful manner

How can we best attract the viewer, and who is the audience? Do we want an upscale presentation or an "average home consumer" look? Are we directing the image to adults or children, male or female?

Visually emphasize the product being advertised. If you are selling crackers, choose a cheese of a similar color that will not draw away the eye from the cracker. If you are selling a white cheese, choose a cracker with a contrasting color to frame the cheese.
Colin Cooke

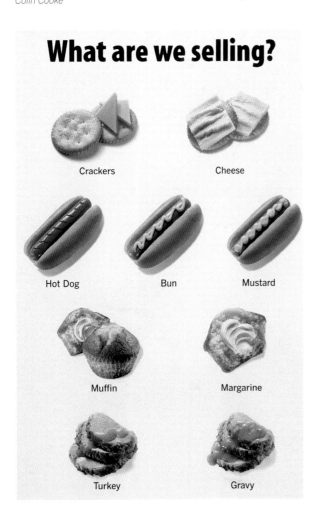

What are we selling?

Crackers · Cheese

Hot Dog · Bun · Mustard

Muffin · Margarine

Turkey · Gravy

A client will always appreciate the fact that the stylist has considered how best to present their food and what makes it most appealing. What words best describe the food? We as food stylists need to take those adjectives and "produce" them.

TYPES of MEDIA we work in

You can see that a good understanding of the medium is necessary when you are styling for different assignments. The ability to be flexible in your presentation skills is essential. Sometimes you will be allowed to be very creative, and the work will be very much yours; other times you will need to follow the look that a client or art director suggests, and your skill with food will show.

The most important consideration in any medium is how you present a recipe or food product so that it is true to that recipe or product. Does it have strong visual appeal, is it mouthwatering, and is it in the style of the medium in which you are working?

Editorial Food Styling

Editorial food styling is for magazines, newspapers, and cookbooks. Generally speaking, the food preparation and style are determined by the look of the particular client. *Good Housekeeping* magazine, for example, has a look that is different from the look of *Saveur*, *Martha Stewart Living*, or *Food Arts*. Each magazine has a specific audience and a visual appearance that are determined by the art director and staff. The number of cookbooks and food magazines has proliferated over the years, with more than eight hundred cookbooks being published each year and new food magazines being introduced not only by publishers, but also by grocery stores and food companies. Each cookbook and magazine has its own look or style (see the photograph below).

When you style editorially, you need to be familiar with the style or mood of the book or article. Often a magazine or publisher will use a team (photographer, prop stylist, and food stylist) repeatedly if it is pleased with the results of their work. This is where the "art" in each member of the team can be expressed, and it is often your best opportunity for creative work. Editorial styling usually pays less than styling for advertising, but the work can be steady, and you can work with a team of people you enjoy being with.

FOOD STYLING FOR MAGAZINES

In addition to food magazines, there are lifestyle magazines that devote a portion of their publications to food. Working in this area can represent a large part of your work. There are some stylists who prefer to specialize in this field because it allows them to be more creative and natural than when they work in advertising. When you work for a magazine, it is important to understand the demographics of that magazine and to style accordingly. For example, if the magazine's audience is female, works outside the home, is middle income, is aged thirty to fifty, and

Although these magazines share holiday-themed cookie covers, each presents the cookies very differently. The *Better Homes and Gardens* cover is homey, with many colors and cookie designs. *Cuisine,* from New Zealand, shows a model wearing the cookies. *Better Homes and Gardens; Cuisine*

TIP *Volunteering to assist photographers at a local newspaper or magazine may lead to paying jobs. Usually the photographers don't have a budget to hire a stylist, but if they know you and a job with a budget comes along, they may hire you.*

has a family, you will probably work with easy-to-prepare recipes in a simple, family-oriented fashion. If you are hired by a magazine with an audience of "foodies" between the ages of twenty-one and thirty-five, both male and female singles, then the magazine will probably want lots of shots with young singles in them. The food style will likely tend toward easy entertaining with high energy and be creative and fun.

Become aware of the demographics of any magazine that hires you and adjust to its style. Look at recent issues of the magazine. Often magazines have a written description of their demographics. In addition, the shot outline from an art director should include the style, type, and mood of the photography needed.

WORKING FOR NEWSPAPERS

Newspapers get some of their photographs from syndicated sources and public relations firms. Other photographs are shot by staff photographers, but seldom is there a budget for a food stylist. If you are styling pictures for a newspaper, it is best to keep them simple and graphic, since newspaper printing doesn't show detail well. Remember that your food may be shown in black and white.

THE SPECIFICS OF FOOD STYLING FOR COOKBOOKS

Cookbooks come in many forms (mini to coffee table) and are produced by a publisher or a packager. (A packager is a person or company working freelance to produce a cookbook for a restaurant, chef, magazine, food company, or publisher.) Each cookbook has a theme and a desired style. It is important that the food stylist have a clear understanding of the look required. Unlike with a magazine, which already has a style and a certain demographic, the style of the book you are working on will be new (unless the book is one in a series of cookbooks and there is an established style) and will be determined by the art director in conjunction with the author. Some cookbooks are shot in a style that is very clean and tight on the food. There may be a color theme that runs throughout the book as well. Other cookbooks are illustrated with lots of how-to shots, maybe in a kitchen environment or with a little white background. As with magazines, each cookbook will have a likely demographic, such as an upscale audience or a food-knowledgeable audience. Sometimes the food will be shown as a double-page spread (one shot that covers both pages of the open cookbook), while other times it might be as little as a 1 x ¼-inch dot on a page. The possibilities are endless; it is just important that you be aware of the style required and that you stay consistent with it when you prepare and arrange the food for the shots.

Working on a cookbook can be a long assignment—up to two weeks or more. Some photographers and stylists prefer to break up the shooting time so they can also work on other jobs. It is always pleasant, though, to be able to stay in one studio and work with the same team over a period of time.

Assignments for Public Relations Firms

Public relations (PR) agencies solicit media attention by providing material (recipes, articles, pictures, or products) for newspapers and magazines, or a spokesperson with a creative message for television and radio. However, this is not a paid placement.

The PR team offers the media something free to help fill their pages or their time on the air. Press packets that include pictures and information about a product and a spokesperson (if there is one) are opportunities for food stylist work. The packets also often contain brochures with recipes and food photographs and sometimes a mini cookbook. The PR agency may also produce articles with photos that are sent to editors and can be simply dropped into a newspaper's food section. Companies such as Family Features and Eces color pages help produce these.

As a food stylist, I have helped PR firms by developing recipes and shooting pictures using their clients' products (food and equipment). I have helped with press parties by giving demonstrations or getting the food ready for demonstrations. I have worked behind the scenes of television shows getting the props and food ready for a spokesperson to cook. I have also developed recipes and promotional material for food shows.

When you food style for a public relations assignment, it is very much like working in advertising because there will always be a product that is being promoted. Assignments I've had include developing recipes and pictures for the then-unknown kiwifruit, Michigan dried tart cherries, and shiitake mushrooms, and providing recipes and photographs for promoting equipment such as All-Clad cookware and Vita-Prep blenders. For these assignments, you will usually be hired directly by public relations firms or by food and equipment companies.

Working for Marketing Firms

There are independent marketing firms as well as marketing branches within large food companies and PR agencies. Packaging, placement, and advertising are all part of marketing campaigns, which are all types of "incentive purchasing," or ways to convince the consumer to buy a product. Food stylists are seldom hired directly by a marketing firm, but if you know how to work with a particular product, the company may request that the photographer or production company hire you.

Examples of work produced by marketing firms include freestanding inserts (FSIs), which are the ads you see in the coupon supplements of newspapers. FSIs first appeared in the mid-1970s and are a very popular form of incentive purchasing. There are also point-of-purchase (POP) coupons, which are available at the store, and coupons that are sent through the mail or can be downloaded from Web sites. Marketing firms also run recipe contests, which are very popular.

The one mistake I often see marketing firms make with these contests is that they advertise a contest to one audience and then market the winning recipes to a different audience. An example of this would be to run the ad for a contest in a professional publication for chefs and then place the chefs' recipes in a home consumer's publication or produce a mini cookbook full of chefs' recipes for the home consumer. The result is often that the recipes are too difficult, expensive, and time consuming for the average cook to make, and the recipes never get tried. If resources are available, it is always wise to have any contest recipes tested and rewritten in a style consistent with the audience.

Large food companies and some PR agencies have test kitchens that develop ideas for ways that their product can be used in recipes, or served in a new way. If a company is small, it may hire freelancers for this work, and this is an opportunity for food stylists with recipe development and writing skills. First, the food product is tested, then recipes using that product are developed. Sometimes there will be food shots to go along with these recipes, and those will also require a stylist.

Working with Advertising Assignments

Advertising is paid placement of a print advertisement or commercial that promotes a product. We are all aware of examples of advertising in magazines and newspapers, and on television or the radio. When working with advertising agencies, food stylists produce foods for print ads, billboards, posters, and television commercials, and it is important that you be aware of exactly what is expected of you.

You will need to determine the product's gold standard. How does the client want the food to look? By referring to existing package shots of the food, you will find a good representation of how it should be presented. Sometimes the advertising agency will send tear sheets, which are literally torn from a publication, showing how the ideal product looks. Tear sheets for shots of butter, for example, will show you how the client likes the spread to look, how much of the product to use, how it should be presented, and the amount of melt the client would like to see.

Each brand manager has a very specific look that he or she wants a product to have: It might be pasta with no ends showing, dollops of cream with a particular swirl, a sauce with a certain thickness, or chocolate chips with a straight tip or curved in just the right way. To arrive at an understanding of what the client has in mind, there are questions to consider. Let's take one product as an example: refrigerated cinnamon rolls that need to be baked and frosted. Questions to consider:

- How much does the client want the center to be elevated?
- How much cinnamon should be showing?
- How much icing does the client want?
- Should the icing drips reach the surface of the pan or plate?
- Does the client want the ring of the roll coming from the right side or the left side?
- Should the rolls be baked touching one another or separately?
- If there is support food, what does the client want to use and how much of it?

It is your responsibility to produce the look the client wants.

When you work in advertising, you need to be a very skilled stylist. This area of styling pays the most, but clients also expect the most.

Food Styling for Product-Packaging Photography

Packaging is the most exacting of all food styling work. When you style for packaging, each new-product photograph needs to match exactly the rest of that product line (the placement of the plate, the height of the food, the position of a fork or spoon). Packaging work includes working on a new product line, changing the look

LEFT: The two chocolate chips on the left meet the company's gold standard; the chips on the right are flawed and do not.

RIGHT: The gold standard varies among food companies. Here, the two chips on the left are one company's gold standard, and the chip on the right is another's.

Kelly Kalhoefer

truth in advertising versus u.s. government standards

In the United States, there are governmental guidelines on how food can be advertised. Advertisers selling a product must use that product. For example, if our assignment is to sell a chocolate sauce, we must use that chocolate sauce. However, we can put it over fake ice cream since the ice cream is not the product. If we are selling cereal, we must use the client's cereal (carefully sorting through for beautiful flakes), but we can use a product other than milk to pour over the cereal so the cereal will last longer—a fake plastic splash can be used as well. If we are selling butter, it must be butter, not margarine. Large companies have a legal department that sets the rules for working with their products. Some companies are more lenient than others. Many years ago, for example, several companies put clear marbles in the bottom of their bowls of soup so that the vegetables would stand up

and show. A competitor spotted the marbles in one company's shot and sued. After that, most companies became more careful about what they allowed. Over many years of styling, I have seen policies and standards become both firmer and more lenient.

Currently, companies are very concerned about showing actual portion sizes, not overpromising, and making foods look approachable (not perfect). Many companies are also reformulating their products to remove trans fats and add whole grains and other "good for you" ingredients. The government is keeping an eye out for how advertising addresses children because of a national concern about childhood obesity.

A 1968 lawsuit against Campell Soup Company changed how we style food. *Steve Musgrave for Advertising Age*

of the package for a better design or a reformulated line of products, and adding new products to a product line that already exists.

The look of the package is very important to a company. It is its identity. Companies are very careful about making changes, and these changes are often gradual.

It is your job to gather any information you can about a product and then, if it is a new product or one you haven't worked with before, test it to see how it looks and behaves. When working with a product, and especially packaging, I always bring a digital scale. This is because sometimes you'll get component parts of the product— gravy in one package, frozen peas, chicken, and mashed potatoes in other packages. Sometimes you'll be sent the product as it arrives in the store and you must take it apart and select components you want for the shot. You are often instructed, for example, that for the shot you can use only 2 ounces of gravy, 4 ounces of mashed potatoes, 3 ounces of peas, and 5.5 ounces of chicken. So when you find the pieces you want to use, you must weigh them to comply with the amount the consumer would get. Again, work in packaging is very specific.

Food Styling for Catalogs

The use of catalogs to promote and sell food and cooking equipment became very popular in the mid-1970s and continues today, though the emergence of Web sites and online purchasing has reduced the use of catalogs somewhat. When you style for a

catalog, the budget may be large or small, and when it is limited, you will have to do a lot of shots in one day. This work can vary tremendously. For instance, if you are working with a premade food item, you may simply have to find the best-looking product that you can, clean it up, and shoot it. Other times, you may have to prepare a recipe using the particular food item. Sometimes the food is just support for cooking equipment or gadget promotions. Examples include a partially peeled apple next to a vegetable peeler or coffee beans next to a coffee grinder.

If you are just starting out in the food styling business, catalogs are an area in which to look for employment. When an assignment doesn't have a big budget, a client is a little more willing to take a less experienced person for less money. The days will be long with lots of shots and you will need to be very organized, but the learning experience will be invaluable.

Start collecting catalogs and note their quality. Learn who produces them in order to approach those companies for possible work. You can also study catalogs for display ideas for your own shots, such as clever cookies next to the tea you are selling or interesting cheese cuts for a cracker promotion.

Opportunities via the Internet

More and more, with its phenomenal use of food photography, the Internet has become the medium of growth for food stylists. Much of our work gets placed on the Internet, even if it was not originally shot with that in mind. However, some assignments are specifically for the Internet, such as those for *Chow* magazine, which has given up the hard-copy magazine format. When food pictures are used online, they are often small and so should be simple shots. Some of the work for the Internet is shot outside the company, while some is shot in-house.

As food stylists, we should also use the Internet as a helpful resource. Web sites abound with samples of work by food photographers and stylists. There are sites for many hard-to-find foods, recipes, and equipment specific to food styling (see Resources, pages 382–388). One enterprising photographer has put together a blog called 101cookbooks.com, where she promotes herself with food photographs, but also critiques cookbooks and shares recipes (with pictures, of course). There are many opportunities for promoting yourself online.

Food Opportunities in Television

In 1980, when I first started working in television production, food stylists basically worked only on commercials or provided the food for a TV series. Over the years, television's use of food has changed dramatically, so it now offers countless opportunities for food styling work. Today, in addition to commercials, there are half-hour and hour-long food shows, as well as whole networks devoted to food. Many live talk shows have food segments.

too good for campbell:
how one company views
its packaging

I was in the meeting at which the **CEO** of Campbell Soup announced that the company was changing its famous plain red-and-white label and would now have an illustration of ingredients or a bowl of soup on its label (eventually the illustration became a photograph). It was a major change for them and a decision that had been years in the making. (The interesting book *America's Favorite Food: The Story of the Campbell Soup Company* looks at the beginning of this icon in American food and the changes and developments that have occurred over the years.) There is probably not a more famous package design and food company. While working on a series of packages for the company's frozen entrées, I was told that we would have to reshoot one of the shots we had done the day before. When I asked why, the reply was, "It looks *too* good." This is a company that strongly enforces its truth-in-advertising policy.

fine-art food and the graffiti artist

One of my favorite assignments was for a product that was being tested by a major food company. It was for a line of refrigerated entrées (a new concept at the time) that you could purchase in the grocery store. The product had won an award for packaging design, and the food was prepared using only top ingredients—filet mignon, large shrimp, wild rice, asparagus—and with the look of a chef's presentation.

This assignment was such fun, because the food was beautifully presented in its plastic oval tray and the advertising agency had come up with a terrific campaign. Their idea was to compare their product with foods that you normally take out or that come frozen. Why eat a soggy slice of pizza, a bland frozen dinner, greasy Chinese food, or messy ribs when you could have our delicious and easy dinner? We shot the "bad food" very simply on a white background (limp pizza, an oily container of Chinese food with chopsticks sticking out) and then we shot our entrée. These shots were blown up to poster size with wonderful copy ("Why commit Chop Sueycide when you can enjoy...") and hung at bus and subway stops throughout New York City. The plates of the client's food were so appealing that graffiti artists barely touched them, which was very unusual at that time in the city's history.

One day at a subway stop near Macy's, I did spot one with some graffiti. Someone had drawn wonderful, detailed baby faces on each pea in the frozen TV dinner, but the client's plate of food remained untouched.

There are satellite media tours (SMTs), and home purchasing and shopping shows, such as QVC, that have food segments. All of these outlets may also include work styling food shots for Web sites that accompany the television shows. Infomercials selling food products, as well as equipment and gadgets, require food stylists, as do training and industrial films and videos produced for corporate purposes. Cooking contests and regional cook-offs are videotaped and aired. Often, when winners are announced, a stylist is given the assignment of making the food camera ready for drop-in shots, single beauty shots that can be edited as needed for a TV show. In television, you can work as a freelancer or sometimes as part of the full-time production staff. When working in the video world, the video is either shot live or taped and then edited.

THE CHALLENGES OF STYLING FOR LIVE TELEVISION

The work for live television includes styling for cooking segments on news and talk-variety shows, any segment that has a call-in component (such as QVC), and satellite media tours. When shooting live, you must be very organized. If the person on television doesn't have a knife for slicing the cake or a hot pad for taking something out of the oven, he or she (and you) are in trouble. Also, you need to be very flexible. The show may change the amount of time allotted for your segment or move the segment up or back because of scheduling issues. I have prepared food for TV with no stove or water, in hallways, and outdoors. Thank goodness for water in the bathroom and the invention of the hot plate and portable oven. Most of the time, the producer and staff are helpful, but they are always very busy and under a lot of pressure; sometimes the production staff is less helpful, and you must beg for information. Production staff may suddenly want the food immediately, when you have been requesting a work-table in order to set up for half an hour. Then again, there are other times when you'll have beautiful facilities, someone providing props, everything set up the night before, and time for a run-through before the segment. Be prepared for anything.

food with a view: *working with the dallas cowboys*

Once, in the 1980s, I was hired to style the food for a commercial promoting a brand of cold cuts. Although I had the flu, there I was. We shot the commercial and did the final product shot of a tall sandwich sitting next to a package of the product. The next day, I got a call saying we would have to reshoot the final product shot because of lighting problems, and I was asked to go to a soundstage where the production company was now shooting a shaving cream commercial with some of the Dallas Cowboys, including defensive end Ed "Too Tall" Jones. The production company would slot my sandwich in at the end of the shoot. The only work space they had for me was the dressing room where the players (stripped to the waist) were getting ready. There I sat at the makeup table with a mirror in front of me, building a cold cut sandwich and enjoying the scenery that one sees in an all-male dressing room, flu or not!

When you assist an author or chef on a live television show, you are called a media escort. You supply the props as well as the food and sometimes even the kitchen "dress" (foods for the background).

SHOWCASING FOOD ON VIDEOTAPED TELEVISION

Examples of videotaped television include commercials, most food shows, industrial (business-use) videos, infomercials, and TV series. Taping allows for several (or many) takes and editing for the best version. This type of work uses a lot of food. When you shoot for television or film, things happen to the food: The cake is frosted, someone bites into the chicken, or the sausages are frying in a pan. You may need twenty or thirty cakes for the frosting shot or just as many perfect pieces of chicken for the "bite and smile" shots. Even though the shots go by in fractions of a second, the food for commercials must still be perfect.

When shooting commercials, a lead food stylist always has one assistant and sometimes as many as five, depending on the difficulty of the shots. If you are called to assist on a commercial, be prepared to do repetitive tasks. You might sort breakfast cereal for perfect flakes all day (see page 184) or find perfect hamburger buns and add sesame seeds to even out their placement (see pages 201–202). Production shoots are a good place to find assisting jobs, and they are a good place to learn about production work.

TV and film work always includes interesting and demanding days. You may be shooting a commercial in five different outdoor locations on one day, or teaching an actor how to slice a roast. You might be in the back studio at NBC getting food ready for a celebrity or preparing food for the audience of a talk show. Some food stylists prefer to stay in this area of the profession, while others like the variety of print work as well.

Food at the Movies

Food styling for movies requires you to be quite flexible in your schedule and a good problem solver. The person who is responsible for hiring you is the prop master or set decorator. Sometimes, if the prop master feels that the food-related work is quite simple, such as background bowls of fruit or someone eating peanut butter sandwiches, a food stylist won't be needed. However, if the food is very specific and important to the movie, he or she will want to hire one.

But even movies in which the food goes almost unnoticed may require food stylists because the food is difficult to produce or there are dietary requirements or restrictions. Sometimes movies require unusual or nonexistent foods such as ten-pound hamburgers, cheese that flies, or nonchocolate "chocolates" because of melting problems or an actor's food allergies.

WHEN THE FOOD YOU MAKE GETS STAR BILLING

Some examples of movies in which the food plays a big role are Julie and Julia, Tampopo, Who Is Killing the Great Chefs of Europe?, Eat Drink Man Woman, Babette's Feast, Chocolat, Fried Green Tomatoes, No Reservations, Waitress, Big Night, Dinner Rush, Ratatouille, *and period pieces* The Age of Innocence *and* Marie Antoinette.

We have looked at the various types of work food
stylists do, and now it is time to think about how
you will be hired and whom you will work with.

your food styling
TEAMMATES

WHO HIRES food stylists?

Food stylists and prop stylists are usually hired by photographers for print work and by producers at production companies. If you are known for working well or artfully with certain types of food, then someone from a food company, magazine, advertising agency, or marketing company may recommend you for a job. If a photographer or director is comfortable with you and feels confident in your skills, then he or she may select you for jobs. Remember, potential clients want to work with someone who is enjoyable to be with and who enriches the creative team. Photographers may know you from testing work you have done together. Production companies may have seen your work as an assistant.

WHO will you WORK with?

The "who" will depend on the type of job. Your first communications will be with the photographer, studio manager, producer, or sometimes the director. As the job develops, however, you may need to talk to the prop stylist, the test kitchen, the brand manager, the creative director, or the art director. The number of people who show up at a shoot will vary, depending on the size and importance of the job and who is available. When I was working in the 1980s, the studio was often full, with several representatives from the client and agency in attendance. This has changed, and today fewer people show up for a shoot. Sometimes the shots are finished and then just e-mailed to the client for confirmation.

Following are flow charts indicating whom you might see in a photo studio and who is involved in producing cookbooks and magazines. There is also a basic flow chart of the hierarchy in an advertising agency and a food company. The actual hierarchies will vary from company to company, depending on their size, but the basics are here.

People You Might See in a Photo Studio

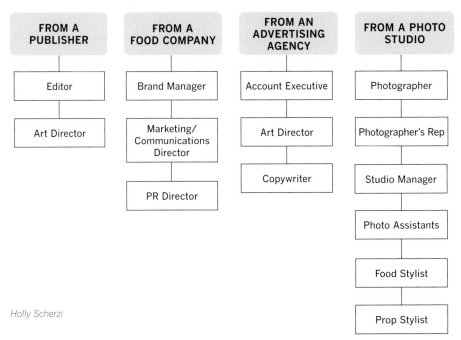

FROM A PUBLISHER	FROM A FOOD COMPANY	FROM AN ADVERTISING AGENCY	FROM A PHOTO STUDIO
Editor	Brand Manager	Account Executive	Photographer
Art Director	Marketing/ Communications Director	Art Director	Photographer's Rep
	PR Director	Copywriter	Studio Manager
			Photo Assistants
			Food Stylist
			Prop Stylist

Holly Scherzi

Editorial-type Food Images

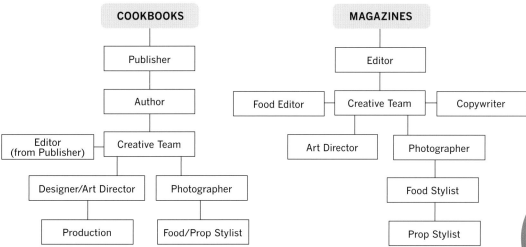

Advertising, Marketing, and Public Relations Images

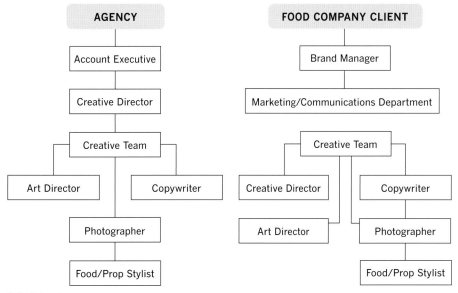

Holly Scherzi

Television and Film Production Crews

The list of personnel (crew) involved in TV and film production is a lengthy one (see pages 103–105). The crew for most commercials ranges from a dozen to four dozen professionals, and the talent and the crew for a film can number even more. Once hired for the job, you will be contacted by the production manager, producer, or prop master. After you have seen storyboards, scheduled time, and asked questions, you will work with the director or assistant director (AD). If you need to get your work area set up, you will talk to the location manager and the "electric" (the person responsible for getting electricity to you for your equipment). If the food needs to fly, fall in slow motion, or bubble and steam, you will work with special effects.

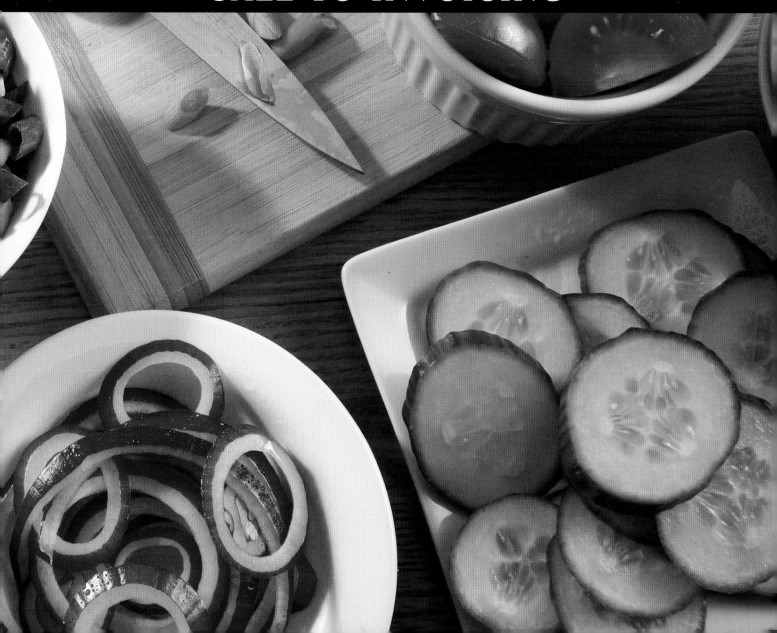

THE JOB: FROM GETTING THE CALL TO INVOICING

Now that you know more about what food styling entails, you need to learn the specifics of what accepting a job requires. When you are called to see if you are available for a job, you need to get a lot of details to help you determine whether you can accept it. The first things to discuss are the dates of the shoot. Next, you will want to know if this is a definite project: If it's a photographer calling, you want to find out if he or she has the job and the dates are set, or if he or she is bidding for the job, along with other photographers or production companies. If the assignment is definite, it is important that you have a good scheduling system so that you know whether you have the time for the project.

you got the job!
NOW WHAT?

setting a SCHEDULE and KEEPING RECORDS

Each of us organizes and keeps information differently. In styling work, it is important that you keep an accurate calendar and good records of the work you do. I will share with you what works best for me. The essential thing is that you have information in place and that it is easy to retrieve. With all of today's electronic gadgets, I am sure my system will seem old-fashioned, but you can learn what basic information you'll need to gather and figure out your own way of storing and retrieving it.

I like 8 x 10-inch monthly At-A-Glance notebook calendars because I can easily see the whole month and what is already scheduled. When I am called for a job, I enter the pertinent information on the calendar first: shoot dates, photographer, phone numbers, client, and, if needed, prep dates. When you are hired for a job, the shoot days are the ones of main concern to the photographer, but you must look at the total job and decide if you will need prep time and how much time that will be. You need to discuss these dates as well. Prep time can include organizing the job; going over recipes; putting grocery, equipment, and possibly prop lists together; and deciding on a shot list and shooting schedule. You may need to test a product to see how it behaves or try recipes if you are not sure of what the results will be. Shopping may take all day for some jobs, and, in some cases, you shop not only for groceries, but for special equipment and props as well. If you need to do baking ahead of the shoot, this is also prep time. For other jobs you will need one or two days of prep with an assistant. These are usually jobs that involve a two-, three-, or four-day shoot and lots of shopping, recipe testing, or baking. However, there are jobs where there is no prep time—maybe a one-day shoot with just a few groceries to pick up on the way or less than an hour of your time the evening before.

Once you have the necessary information about the job, it is essential that you let the photographer know the amount of prep time you will need and the fees involved for this. I usually charge the same for a prep day as I do for a shoot day. If the budget is tight, I may have an assistant do most of the prepping or adjust my fees accordingly. Once the dates and prep time have been set, you will need to gather the job details.

Gathering Assignment Details

Just what details you need in order to bid accurately or work well on a job will depend on the specifics of each assignment. This information should be available from the photographer or production manager who contacts you. Because you will need different information depending on whether the job is still photography or production (TV), I will discuss each medium individually.

QUESTIONS FOR THE PHOTOGRAPHER

Not all questions will apply to all jobs, but following is a list of helpful and pertinent suggestions.

- **Are there recipes available?** Collect the recipes and evaluate them. With experience, you will be able to read a recipe and visualize it in the soup bowl or frying pan, or on the platter or plate. Read through it thoroughly and note any questions you need answered. Do you see any particular problems with the recipe? If so, you may want to test it and use the test food the day of the shoot as a stand-in and

guide. Two other questions to ask are, Were the recipes well tested and are these the final versions? Once I worked for a half-day trying to make pies behave, only to learn that the company had not sent me the final recipe. And are the ingredients readily available? Try finding fresh tart pie cherries in February or huckleberries anytime.

- **What is the product like?** If you are shooting a particular product, you want to see the company's gold standard—check tear sheets from the client, example ads you have tucked away, or packaging to see how the product is presented. If you are shooting a piece of equipment, you want to receive it ahead of time and test it. The client should send a new piece of equipment to the photographer for shooting.

- **How will the food be shot?** Let's take an apple pie as an example. Will the pie be whole or will there be a tight shot of a slice? If it is a slice, what size plate will it go on and will it be à la mode, using real or fake ice cream? Will it be the whole pie with a slice on a plate to the side? Will it be shown as a work in progress (bottom crust in place with apple filling in the pie plate and raw ingredients around the pan)? Will it be shot from overhead or at a low camera angle? Will the shot be tight or shot from a distance? Will it be propped or not? Will this be an old-fashioned pie, a contemporary pie, a professional pie, or a European-style pie baked free-form as a galette? (Deep-dish pie plates may require more crust and filling than an eight-inch pie plate.) Each of these shot options will require different techniques, amounts of time, and numbers of pies. Some pies may be more problematic than others, so you may need to make more of them as heroes; add additional thickeners for a slice shot; bake it just before shooting; or bake it the day before for easier slicing. Often you will need to make a baked item once just to see how the recipe behaves.

- **Who is propping?** Will you need to prop the shot or will someone else prop it?

- **What is the budget?** Is there a set amount for the food or do you determine this? What is the budget for an assistant, if needed?

- **What is the general studio information?** What is the address and where is the nearest parking? What is the work space (kitchen) like? If you are baking, is the oven calibrated? Is the stove gas or electric? This is important to know for grilling purposes, for example, since electric burners don't get hot enough to heat skewers for grill marks. How much counter space is available? Not only do you need to ask if there is a refrigerator or freezer, but what kind it is and how much room it has inside. When you get to the studio, you could find that the refrigerator is full unless you ask for room. (When you are working with a lot of frozen product, chest freezers work best because they hold their temperature.) Do they have standard kitchen appliances or do you need to bring them? Even if they say they have a food processor, your next questions need to be, Does it work? Does it have the type of blade that you need? The studio may need to rent additional appliances. It is always good to have rental sources for these in case the studio is not familiar with them.

how an effective layout can be a time and cost saver

On a recent job for a package shot I was told that I would be preparing a sandwich with the product (cheese), tomatoes, and lettuce on whole wheat bread. On my prep day, I shopped for the ingredients, going to several stores to get sliced and unsliced breads. I selected round, square, and typically shaped loaves. I purchased dark multigrain and lighter whole wheat breads. I probably purchased twelve different loaves of breads and spent two to three hours doing it. When I got to the shoot, there was a picture of the package design with the sandwich on the front. The bread needed to be square to fit the design. If I had been sent the layout of the shot, it would have saved a lot of time and money. Because I was not given a drawing, I had assumed that the layout was "in progress" (typical of today) and would be determined later at the shoot.

finding the right man for the job

For this assignment, I received a recipe for gingerbread, and it worked beautifully. I baked several shapes of gingerbread men and sent them to the art director, but she didn't like any of them. The hardest part of this job ended up being trying to find a gingerbread cutter in June in a shape that would be approved. As you can see, the search was worth it.

The art director's layout suggests the cookie type, arrangement, and camera angle.

The final shot is styled to match the art director's layout.

This is the ad made from our shot.

Lou Wallach for Domino Sugar

- **Is there a layout?** If you are shooting an ad, a marketing piece, or a package shot, a layout is very helpful. It can be e-mailed to you. When I first started working as a food stylist, layouts were automatically sent once the job was awarded. Remember, however, that the layout may be almost an exact drawing of what the shot will look like, including spaces for copy, or it may be a suggestion. Today, I find that sometimes just a description of the shot or a recipe is provided.

- **Is the studio open and kitchen available?** If you would like to prep at the studio or get foods into the studio before the day of the shoot, you need to know this.

- **Who are the people you will be working with?** What do they do? Whom you will be working with depends on your assignment (see pages 32–33). Get phone numbers or e-mail addresses, if needed. Sometimes conference calls bring everyone together to discuss the job before the shoot. Sometimes you might have a preproduction meeting (see pages 51–52).

- **What is the shooting schedule?** Each day's schedule may be determined by you because you want to be able to get started with a quick shot first, or by the photographer, because different shots require different equipment and camera moves. The schedule may also be determined by the art director, because he or she needs a certain shot first. Sometimes the products that you are working with can be sent only at certain times, and then the client determines the schedule.

- **What is the call time?** Most often, the photographer decides this; it is usually 8:30 or 9:00 A.M.. There are times when the amount of work requires the food stylist to get in earlier, and you need to make arrangements for this.

QUESTIONS FOR THE TV PRODUCTION MANAGER

Most of the questions you'll need to ask for still photography assignments are pertinent to production assignments (see pages 38–40), but there are additional questions that pertain to video production. These include the following:

- **Is there a storyboard?** When you work on commercials, you use storyboards as the starting place rather than layouts, which are used for ads. A typical storyboard might look like the one on page 52. With the storyboard, you will need to discuss the sequence in which you will be shooting and the approximate time of each sequence.

- **What action takes place with the food?** Will the food be shown being baked, cut open, or frosted? Will a bite be taken out of it? Will you need to show a coffee pour or a platter of pasta steaming?

- **What are the facilities and prep area?** Will you be shooting on a soundstage or on location, and just what is the location—a home, the beach? You may need to discuss equipment needs and rental possibilities. Transportation for you, the food, and the equipment needs to be arranged.

If you are doing media escort work, additional questions might include:

- **Who are the contacts at the TV station and for the talent?** You must find out who will take care of your needs and who will take care of the spokesperson.

- **What are the date, time, and length of the segment?** Remember that one or all of these may change. Be prepared to be flexible.

- **Will a recipe need to be demonstrated and will the food be shown in stages?** What type of prep space is there, and when must everything be set up? With some television companies, there is a kitchen or prep space where everything can be set up the day before, except for the food that will die, and there is a run-through. For other companies, you just arrive two hours before the taping and find a work space (hallway, green room) and put the food together. I like to get the dimensions of the demonstration area ahead of time. I also need to know if there is a cooking surface on the demonstration island, if it is gas or electric, and whether the camera works from right to left or the reverse.

- **Will people be eating the food?** Is there a setup needed for the introduction and a tease? With live television, there is often eating, and the camera people love it when they have beautiful food to shoot before or after the segment.

- **Are there special instructions on getting to the studio?** How do you get to the facility? Is there any special information about gaining entry?

BIDDING and BUDGETING for the job

When photographers or production companies are competing for a job, they must submit a bid to the client. To complete the bid, they call all the people involved in the job and ask them for an estimate on fees and expenses. You can begin to determine your costs and what you need to charge for the job once you have all of the assignment details.

Your fees and expenses can include your time shooting and prepping, your assistant's time, all food costs, transportation costs, unusual equipment needs, and props. Additional expenses may include travel days, kit fees (for replacement of supplies),

office expenses (such as long-distance phone calls, photocopies, and postage), lunch when on the job, rental of large equipment such as freezers, and time testing a product or attending preproduction meetings.

Your Fees

What you are paid for each job depends on the type of job you are doing and where you live. Some of my students from other countries report that they get paid by the photograph. In the United States, stylists are paid by the day. In print and production, you are hired for an eight- or ten-hour day. You are paid overtime (time and a half) for the time worked past the agreed-upon standard day. You will usually get paid less for editorial work than you will for advertising work. In New York, Los Angeles, Chicago, and Minneapolis (and a few other areas), the average pay for editorial work is $450 to $650 per day for top stylists. For advertising work the fees range from $900 to $1,200 per day. Some stylists also charge a kit fee for production work, which helps replace items from your kit or toolbox (see the photograph on page 108) that are used up. In production work, you usually have to follow union rules, even if you are not a member: You earn regular overtime (time and a half) for between ten and twelve hours of work; then you go into double time between twelve and fifteen hours; and after fifteen hours, you are into triple time. (In the business, this is known as golden time.)

If you live outside the "big four" cities, then your fees may need to be less in order to be competitive. Also, a few production companies do not hire union workers, and the fees may be lower in this case as well.

eighty salads, fade to black

On one assignment two assistants and I were asked to produce a photograph that is easy to dream up but hard to produce. It was an ad for bacon-flavored pieces that are added to salads. The art director wanted to show eighty *different* salads, all topped with the product. The only saving grace was that we were shooting the salads in wooden bowls rather than glass. With wooden bowls, we could cover a completed salad with plastic wrap or a damp paper towel and refrigerate it until needed. With glass, we would have needed more time to style (both sides and top of the salad) and condensation would have formed on the glass if we had refrigerated it.

You can imagine we needed a large variety of produce to make eighty salads. We worked together at a long table assembling the salads for the entire day. Finally, all the salads were ready. We put them on the set, rearranged them until everyone was happy, and shot them, all still alive.

Disappointment came, however, when we saw the ad in a magazine. We could see only the first four rows of salads, about 20 percent of our work. The rest of the salads faded to black.

Hiring Assistants

Sometimes a job does not require an assistant. Other times, the lead stylist may have as many as five or six assistants, if the job is a commercial with lots of food work required, for example. Assistants' fees vary depending on the type of work. An assistant will work anywhere from for free (for the experience and to get their foot in the door) to $450 a day (for an experienced assistant working on a commercial or major ad). Remember that fees and rates vary according to the type of assignment and where you live. Assistants work using the same overtime schedule as the lead stylist.

Food Expenses: Everything but the Kitchen Sink

When you are shooting a brand of food, the client often provides the product. However, you, as the food stylist, will have to let the client know the amount of product you will need. Having the product provided will reduce your food budget, but you will be supplying all of the other foods and materials. Your food expenses will also

include paper towels, vegetable oil for cooking, aluminum foil, and anything else you need from the grocery store. A frequent question I hear from beginning stylists is how much food to buy. For editorial assignments, I always buy at least twice the amount required for the recipe. For a commercial, I may need as many as fifty times the item, because someone will be slicing or biting into something every take that we do. Remember that the food is probably the cheapest part of the budget when you are shooting a commercial, and it is never good not to have enough. However, if the expenses are coming out of the pocket of a cookbook author or chef who is shooting a promotional piece or cookbook, be considerate. Expenses will also depend on the type of food you are shooting (crown roast shots cost more than a platter of vegetables). If you are shooting a commercial, it is not unusual for food expenses to be $1,000 or more. When I am asked to determine food costs, my rule of thumb for print is $100 per shot of normal food. If the shots include something expensive, such as lobsters or champagne, then, of course, the food costs are greater. I have been asked to determine food costs before I even knew what we were shooting. In such cases, it is better to bid higher than lower.

Transportation Costs

In New York, we rely on taxicabs and car services to get ourselves (and our stuff) around the city. If we do have a car, parking is expensive. These fees are all part of your transportation expenses, as are tolls and mileage when you drive considerable distances (more than twenty-five miles). If you are flying to a shooting location, that is also an expense. When traveling long distances, most food stylists charge for their travel time as well. It is charged as part of the day rate or prep time. If you are traveling short, reasonable distances, that is not an additional charge.

Nonfood Materials Costs

Anything that is not a food item is a materials expense. This can include garbage bags, plastic tablecloths, or special cooking utensils that the stylist could not be expected to have. If you have to purchase a cookbook for recipes you will need, it is a materials expense. If you need thirty specific Bundt pans for a cake commercial, the pans go in the materials budget. All materials not used up ultimately belong to the client who is being billed for these items. Sometimes the client wants them, sometimes not. The food stylist and crew are next in line. I often put leftover food out for anyone to take, or it goes to City Harvest (see Tip on page 75).

Special Equipment Costs, from Fryers to Freezers

On some assignments, you may need to work with fifty gallons of ice cream or prepare thirty turkeys. For large quantities of food, you may need to rent extra freezers and additional stoves. If you are slicing lots of cold cuts or cheese, you may need to rent a professional slicer. You may need professional deep-fryers for a shoot. All items such as these need to be in the special equipment budget. Most of the time the studio or production company is responsible for getting these, but you must let them know what you need.

Props: Budgeting Costs

If you are providing the props, the approximate cost of these should be budgeted for, including your shopping and return time. Props can be purchased to keep, purchased and returned, borrowed for credit, or rented. If you own props, you charge for their usage as a rental.

Miscellaneous Costs

Any additional, unusual, or unexpected items, such as delivery charges to send your kit and equipment to a location, long-distance phone calls to finalize a job, or copy service to get materials printed for several participants, are miscellaneous charges that have to be budgeted for. Just remember to keep receipts for everything, or you will have just spent your own money. (See page 76 for information on dealing with invoices and records.)

when more is way too much: fifty chickens and flakes galore

When you start an assignment promoting a product, always have enough product to work with. The amount of product needed will depend on the assignment and the fragility of the product. More is always better than less, but I have had a couple of jobs where the amount of product was unbelievable.

One assignment was to shoot a paper plate of food (2 pieces of grilled chicken, a side of baked beans, and a side of coleslaw) for a fast food chain located in California. For this job we were sent a 500-pound grill, plus propane tanks (how they got those across a bridge or through a tunnel into New York City I will never know). We got a 30-gallon marinating tub with gallons of the marinade mixture (their chicken gets marinated in special brine for a number of hours), along with 50 whole chickens, 5 huge bags of chopped cabbage, a bag of chopped carrots, and a 10-pound jar of slaw sauce. We also received five 10-pound cans of baked beans.

The client sent the grill because they believed that the only way to get their grilled look was to use their grill. The only problem with this was that we had to set it up on the street below the photographer's third-floor walk-up studio in Soho because we could not grill in the studio. Oh yes, and it was snowing! We tried using the grill, but it was so cold that the chicken wouldn't cook properly. How could we solve this problem? I asked to see sample shots of chicken the client had cooked, then I put ten pieces of marinated and pinned (see pages 222–223) chicken in the studio oven. I removed the chicken at two-thirds done, added more color and some grill marks with a torch and skewer, and plated the chicken with the beans (which are delicious) and a side of slaw. We had the shot and lots of leftover food, which went to City Harvest (see Tip on page 75).

Another example of excess product being sent was for two package shots for a cereal company. Each package had to show a spoon filled with cereal and a little milk dripping from the spoon. We were sent five barrels (yes, the big ones) full of cereal, *plus*, just in case we couldn't find enough perfect flakes in those, four more cases of each cereal. That was one sorting day! We went through all the cereal, looking for the most fabulous flakes; we didn't want to miss one. And, of course, the second spoonful of cereal I arranged did not have a flake on it with the same beautiful twist as the first spoonful did. There are days! Again, lots of leftovers for City Harvest.

Prepping the job involves all you do to get every-thing ready before the shoot actually happens. It involves preproduction meetings, organizing the job, shopping, and, if necessary, baking or testing recipes or a product. Let's take a look at examples of how assignments differ and what we can learn about prepping from each.

PREPPING
the assignment

A typical print shoot could consist of creating several photographs for a magazine article. I receive the recipes (sometimes accompanied by test kitchen photographs) and often a description of how the food is to be shot. Take a cake shot. Will we show the whole cake, a close-up of just one slice, or a slice with the remaining cake in the background? Maybe the cake will be shot as a work in progress, with raw ingredients around? However we are to shoot the cake, we need to learn: Will a prop stylist provide the cake plates? If so how many, what kind, what size, and when? If we need just one slice, how big is the plate? A large plate means that we will be able to get just one slice out of the cake, so we will have to make multiple cakes. A plate with high sides may require a taller piece of cake. Are there color considerations? At what camera angle will the food be shot and how will the cake be facing the camera? Will we be able to bake the day before? If so, at home or at the studio? If at home, how will we transport the cakes safely? If at the studio, how good are the ovens, are they gas or electric, were they recently calibrated, and how many are there?

STARTING off

The Job Folder

The job folder. *John Montana*

As soon as I have accepted an assignment, I begin a job folder using a typical file folder. On the tab I put the name of the job, the name of an important contact person, and the phone number. If I need additional addresses, fax numbers, or e-mail addresses, I include them on the inside cover. Inside the folder, I put a job envelope. This is a letter-size envelope that I use to store receipts. On the front of the envelope, I record amounts of money spent on food, transportation, props, materials, office expenses, and the hours of work spent on prep and the shoot, by me and by my assistants.

Other items that get put into the job folder are recipes, layouts or storyboards, and swipes or tear sheets showing pictures of the gold standard for the product or the desired presentations. I also include any information sent via e-mail or gathered from phone conversations, as well as notes from previous similar jobs or jobs with the same product.

These folders are invaluable for keeping myself organized, with everything together on a job. When the job is done and invoiced, the folder goes into a filing cabinet for possible future reference. Knowledge from previous similar jobs is always very helpful.

how to read RECIPES, LAYOUTS, STORYBOARDS, and SCRIPTS

The "reading" discussed here means looking over pertinent material and analyzing everything to help ensure that the job goes smoothly.

Decoding Recipes

With most assignments, you will receive recipes for the foods you will be shooting. It is your job to learn how to "read" the recipes in order to estimate the amount of food you will need and the equipment you will use. You also will need to "read" a recipe to look for problems and visualize the recipe's presentation. Think about color, texture, arrangement, size of ingredients, possible props and garnishes, how and in what order you will prepare the ingredients, and whether you will need to alter the cooking methods. Also note questions you need answered, such as, How are we showing the recipe? Will we show the whole recipe or an individual serving? Will we need raw ingredients in the shot? Are there accompanying dishes? Has the camera angle been determined in the preproduction meetings?

Let's "read" a fairly straightforward recipe that I was given for a job (at right). This was one of six recipes I received. Five of them were fine, but as I read over this recipe, I spotted a major problem immediately and several minor ones as well. The major problem from a styling point of view is the sauce. If it sits for any amount of time, it will congeal and look unappetizing. The rice will look gummy and stuck together as well. Other problems and questions I noted were:

- What size should the broccoli florets be? Should all pieces in the dish be bite size? Will the broccoli need a longer cooking time than the zucchini and mushrooms? Will it cook evenly and hold its bright green color if sautéed rather than blanched and shocked?

- Will the cherry tomatoes shrivel or get smashed if I follow the recipe exactly?

- Will the parsley lose its color if added in the beginning? Which type of parsley—flat-leaf (Italian) or curly leaf—would look best?

- Do we need the garlic in the dish for visual purposes? It might burn and will take extra time.

- Will the black pepper look like fly specks if I leave it in the recipe and we are shooting the food from a distance?

- What type of rice will look best in this dish?

Creamy Rice with Spring Vegetables

MAKES 6 SERVINGS

2 tablespoons olive oil
2 garlic cloves, minced
2 cups broccoli florets
1 cup sliced zucchini
1 cup sliced fresh mushrooms
2 tablespoons snipped fresh parsley
½ cup fresh or thawed frozen peas
1 cup halved cherry tomatoes
4 tablespoons (½ stick) butter
¾ cup heavy cream
⅔ cup freshly grated Parmesan cheese
3 cups hot cooked rice
¼ teaspoon freshly ground black pepper

Heat the olive oil in a large skillet. Add the garlic, broccoli, zucchini, mushrooms, and parsley and cook until almost tender and crisp. Add the peas and tomatoes and cook for 1 to 2 minutes longer. Transfer the vegetables to a mixing bowl.

Melt the butter in the same skillet. Stir in the cream and Parmesan cheese and cook over medium heat, stirring constantly, until smooth. Add the rice and toss to coat. Stir in the vegetables, season with pepper, and heat gently.

- Is the photographer using digital or film? If digital, we can shoot right away and not worry about the sauce congealing. If we are shooting on film, I might want to add the sauce at the end.

- Will we show food on a platter or as a single serving?

Depending on the client, I would do one of two things: If this were an editorial assignment, I would follow the recipe exactly, and we would need to shoot it immediately. If this were an advertising or promotional assignment, we would need a more perfect look with individual grains of rice showing and a very fresh sauce. That

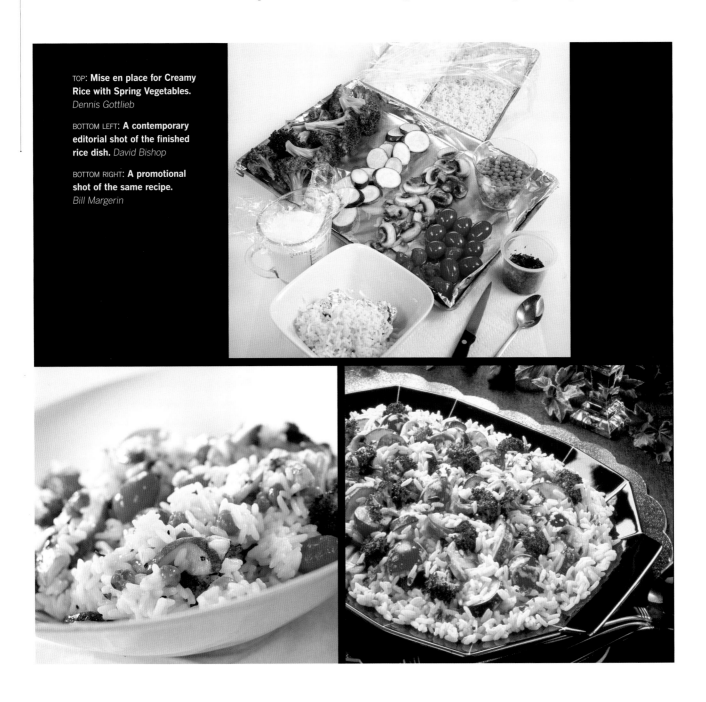

TOP: **Mise en place for Creamy Rice with Spring Vegetables.** *Dennis Gottlieb*

BOTTOM LEFT: **A contemporary editorial shot of the finished rice dish.** *David Bishop*

BOTTOM RIGHT: **A promotional shot of the same recipe.** *Bill Margerin*

would require changing ingredients or techniques in the recipe. In both cases, we would need to give the photographer and art director a stand-in, requiring me to buy at least twice the amount of ingredients listed in the recipe.

This assignment was for promotional purposes, so it required the more "perfect" appearance. I prepared the recipe at home (on my own time) the night before so I could see what it should look like.

I took the test recipe to the studio the next morning, and it became the stand-in. We used it to decide the prop it should go on and later for lighting purposes. At the studio, I decided to cook all the ingredients separately and then combine them just before shooting the final shot. When you do this, you need to start with those ingredients that will last the longest and end with the most fragile. I prepared the rice first, cooking it like pasta so that the grains would remain separate.

To use this technique, add double the amount of rice needed to a large pot of boiling water (no oil, no salt) and cook until the rice looks done to the eye and is done to the tooth. Pour the cooked rice into a colander and rinse it under cold water until cool. Shake off the excess water and pour the rice onto a jelly-roll pan. Cover the pan with a plastic bag or plastic wrap. The rice will stay prepped for the day. (Each brand of rice has a different look. You or the art director may want to choose a more golden rice whose grains remain separate or a fluffier white variety.)

Next, I prepared the sauce (probably double in quantity) and let it cool with plastic wrap on the surface to prevent a skin from forming.

Then I blanched the broccoli, thawed the frozen peas in room-temperature water, and snipped the parsley, covering it with a damp paper towel to maintain its freshness. Finally, I sautéed the zucchini, mushrooms, and tomatoes separately right before we were ready to plate the final food. (I would include the garlic and pepper only if we were shooting a very tight shot of the dish.)

To plate it, I tossed the rice with a little of the sauce, which I thinned with additional milk. I arranged the vegetables and parsley in the rice piece by piece to give it a tossed appearance (which means having some rice on top of the vegetables), using the stand-in real recipe as a guide to the amounts of vegetables. When everyone was happy with the final food on the set and was ready to shoot, the sauce (warmed and thinned to the desired consistency) was drizzled and brushed over the dish.

Some recipes you will receive for jobs are well written and well tested, and you can prepare them as written. Others are not clear, or don't work or taste good. These you will want to talk to the client about. Sometimes you can retest them and rewrite them. It is very helpful, as a food stylist, to have good recipe writing and development skills as well as a good understanding of food chemistry. The ability to visualize a recipe develops with practice.

"Reading" recipes to be used for TV demonstrations is quite different. If you are getting a recipe ready for someone who is appearing on television, you will need to break it down into demonstrable parts (and finished food swap outs; see definition on page 372), depending on how much time you have for the presentation. I once worked with Julia Child when she appeared in a five-minute segment on *The Rosie O'Donnell Show* to

becoming your own recipe tester

One question I frequently get from my students and beginning stylists is, "Do you try the recipes ahead of time?" There are times when you will want to test new products before you get to the studio. You may run across recipes that might be problematic, and it would be good to try them first. These are legitimate tests and should be included in your prep fee. Most of the time, I don't make recipes ahead if I don't see a problem. If I do prepare them, it is just for my comfort level, so I don't charge for this time. I do charge for the ingredients.

This layout shows that we will be shooting a tossed salad in a large clear glass bowl and that the camera will be at eye level.

promote her new book *Baking with Julia* (see page 101). She prepared crêpes suzette, a dessert that consists of a hot orange-butter sauce in which crêpes are warmed, and then the sauce is doused in an orange liqueur and ignited, or flambéed. We chose to have the batter for the crêpes already made so that Julia and Rosie could make a crêpe. Then we went to (swap) a stack of crêpes already made, which were added to the already-made hot sauce. Then came the warm orange liqueur, which was ignited with great fanfare and added to the sauce. Finally, Julia dished up crêpes for them both to eat.

If the segment had been a half-hour, the crêpe batter, crêpes, and orange sauce could all have been made in real time, but we still would have had to do one swap because the batter needs to rest for thirty minutes before making the crêpes. How you read each recipe will be determined by the complexity of the recipe and the amount of time allowed to demonstrate and produce it. Usually TV producers will also want to shoot the beauty shot (final finished recipe or serving) at the beginning or end of the segment, so you must plan for that, too. Swap outs are helpful not only when streamlining the time to present a recipe, but also if the demonstration time gets shortened. You have a way to move the demo along with a finished beauty to go to.

Visualizing Layouts

Layouts are drawings or photo samples produced by the art director to help everyone visualize the desired final results. Some layouts are very exact in detail, and the final shots don't deviate from them much. Other layouts are suggestions—starting places from which everyone on a team contributes to get to the final result. Layouts help the food stylist know the camera angle and the importance of the food in the overall scheme. They indicate the volume of food desired in a sandwich and the shape of the bread, for example. From layouts, we can begin to ask questions and communicate needs (also see page 40 for a layout sample for Domino sugar).

Reading Storyboards

Storyboards are used in commercials and movies. They help all the participants in the project see the total vision, even though, practically, you often shoot out of sequence—for many reasons (availability of actors, costs, location, lighting changes, etc.). The boards tell you the name of the commercial or movie, how long you have for the shots, and the audio (spoken words) you will hear under the shots. Storyboards are sent via e-mail or a hard copy is delivered. The important thing to remember when receiving a storyboard is to get a shooting schedule from the director so that you will know which shots you will be doing and when. The schedule strongly affects how many assistants you will need, how you will prep the job, and when you need to get to the studio or location.

Storyboards help the stylist understand how the camera will look at the food and what action is happening to the food (see illustration on page 52). One thing that makes working with food on a commercial or movie very different from print is that something is always happening to the food. Will it be cut into, eaten, baked, or frosted? Will it be falling in slow motion, or steaming and bubbling? All this action uses up

food, so the food stylist must be ready to supply new, perfect food again and again for the next take (shot). In addition, the camera is usually not locked in one place as it is in print photography, so the food needs to look good from many angles.

Breaking Down Scripts

When you're shooting a TV show, the producer puts together a breakdown of the show from beginning to end. The breakdown includes the segment, which is a description of the show; suggested script; recipe, ingredients, and kitchen instructions; and additional director notes. The section that you have to pay particular attention to is the recipe and ingredients portion. You will need to find out the time allotted for the demonstration of the recipe and then break it down into demonstrable sections. You will need to be aware of the message points (what is being promoted with the demo) and tips and think about the most effective and clear way to show the recipe. You will also want to know how the producer wants the beauty shot to be presented and when it will be shot (at the beginning or end of the segment or both), as well as if anyone will eat the food (see pages 331–334 for detailed information on food demonstrations).

BRAINSTORMING at the PREPRODUCTION MEETING

For television and cookbooks, once the job is scheduled and the details determined, there is a preproduction meeting that the client, agency, and major production staff attend (as a food stylist, you are considered part of the production staff). When I first began food styling, it was quite common to have a preproduction meeting even for print assignments. The major players would gather prior to the job to discuss the shots in detail. Today, this meeting often takes place on a conference call. The disadvantage is that oftentimes not everyone has the same visuals to refer to, and it prevents you from meeting any new people you will be working with until the day of the shoot. It is always helpful to get to know the players and discuss specifics with people who can be of assistance before the shoot.

When there is a preproduction meeting rather than a conference call, I find it helpful to bring samples of food products to the meeting. That way, everyone is looking at the food to see its size, color, shape, and what it can and cannot do. Sometimes this is the first time some of the participants are seeing the actual food. If the prop stylist is at the meeting and has a variety of props, we can select the ones we want then. If something unusual is happening in the shot or commercial, we can begin to figure out how to approach that ahead of time.

However, it is good for everyone to stay open to ideas and not set everything in stone at the preproduction meeting. Interesting shots sometimes happen by accident, and solutions are found by brainstorming. Strong team players often produce work that far exceeds expectations.

getting on the same page: a successful preproduction meeting

Consider this example of a preproduction meeting for a shoot of an ice-cream commercial. Ahead of time, I received storyboards, which helped me establish certain facts and determine my questions for the preproduction meeting. My notes:

The client was a newspaper, not an ice-cream company.

The length of the commercial was thirty seconds.

We were shooting an ice cream sundae being made.

There would be a hand model involved.

The camera would be "locked down" (it would not move).

There would be three scoops of ice cream with a sauce drizzled over the ice cream and whipped cream coming out of an aerosol can. We would need a maraschino cherry with a stem.

My questions:

Did they want real or fake ice cream?

What flavors of ice cream?

What type of sauce?

What size container for the sundae? (That would determine the size of the scoops to be used.)

Would we shoot in real time or stop the camera between takes?

Who was the hand model?

When I talked to the production manager, I asked if we could use fake ice cream rather than real since we were not selling ice cream. He wanted to know how much difference it would make. I replied that if we used real, I would need at least three assistants rather than one. If we used real, we would need to rent several chest freezers and get lots of ice cream in three-gallon tubs. The freezers needed to arrive and be set at the proper temperature two days before the shoot, and the ice cream needed to be mellowed for at least a day before the shoot. If we used real, the shoot day would probably run longer because we would need more takes to get the perfect shot. It would be helpful if we could keep the studio cold, or at least the set area, and we would need to shoot in real time because the ice cream would melt each time we stopped and started the camera.

I was asked to bring fake ice cream to the preproduction meeting so I could show it to the client. The flavors were strawberry, chocolate, and vanilla. I attended the meeting with a variety of scoops in different sizes. The prop stylist brought about ten sundae boats to choose from. I also brought several brands of aerosol whipped cream and the chocolate sauce I wanted to use. (I have found that it is best for everyone to see what we are working with so that there are no surprises. The product's size, shape, color, and texture will be important for the prop person, cameraperson, director, and art director to see. Also, if we have the actual food to work with, we can try different techniques with it.)

At the end of this preproduction meeting, everyone liked the fake ice cream (but it would need to be sent in the boat that was selected to the publisher for final approval). The director approved an aerosol nondairy product and the chocolate sauce. I was asked to recommend a hand model, which I did. She was someone with whom I had worked many times and was used to working with food, which is tremendously helpful. As a result of the meeting, we were able to begin the commercial with all the main participants well informed about how the day would proceed—once we got permission to use fake ice cream.

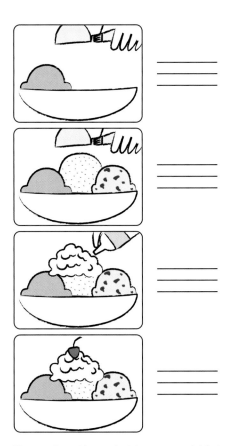

The storyboard for a television commercial featuring an ice-cream sundae.

getting it TOGETHER
Gathering Food, Equipment, and Props

When you have gathered all the information for the job, you will begin to put together lists (see my sample grocery and equipment lists, pages 54–55, which I find convenient). You'll need to list all the groceries you will need for the job and the amounts. These are determined by how you have interpreted the recipes, layouts, or storyboards. The list can also contain foods needed for background fill on sets. The grocery list should include an area for foods that need to be very specific and beautiful. I call this section the handpick area. For example, if I am going to chop parsley, parsley goes in the produce column and reads *1 bunch curly leaf parsley*. However, if I am using parsley as a garnish, then it goes in the handpick column and reads *curly parsley for garnish* or *small flat-leaf parsley sprigs*. When determining amounts of groceries to buy, take special note of problem foods (such as mushrooms to be cooked) or foods that are fragile (such as bananas or berries) and increase their amounts. As I've said, I always order twice what is needed and often more. If we are showing a whole pie, I may make two pies for the shot. If it is a problem pie, if we are taking a slice out, or if we are promoting the pie filling or piecrust, I will make many more (see pages 254–266). Always include a standard list of dry goods, such as aluminum foil, plastic wrap, plastic bags, and paper towels, as needed. In New York, there are grocery stores that specialize in delivering basic grocery items (from vegetable oil to tomato juice to Parmesan cheese) and heavy or bulky items to studios. I always choose the handpick or fragile items myself.

When you are shooting a particular brand of food, contact the food representative (client) to order and ask questions about quantity, quality, shipping, and storage. Review what food the client is sending versus what you will need to purchase. Get a list of what will be sent and make sure that whoever is responsible for receiving the food gets one, too. Give clear instructions to the receiver about what needs to be frozen or refrigerated, no matter whether it is client food or food you order from a local grocery store.

As I read recipes, I begin my equipment list as well. If you know the studio kitchen where you are shooting

hold the fire! *shooting in a firehouse for Cuisine magazine*

Cuisine magazine was a terrific publication to work with, and a favorite assignment of mine involved shooting at a firehouse that was known for its delicious Italian fare. At the time, there were no female firefighters, so when I arrived, I was the only female in the station.

The photographer had decided that one of our shots would consist of two men standing with food in hand in front of their glistening truck. We set up the lights and were about to shoot when—you guessed it—they got a call. So our lights were quickly removed, the food placed back on a table, and off they went.

When the firefighters came back from the call, we set up everything again—and, yes, another call. Again we had to quickly break down everything. When the men returned for the second time, the photographer decided that we would shoot them on the back of the truck (so they'd be ready to go if called again). Of course, now they didn't get the call. The shot was improved because two firemen are standing on the back of the truck with food in hand and under their arms, and it looks as if they are racing off to a fire. Sometimes creative changes are forced upon us for the better.

Food styling on a fire truck for *Cuisine*.
Neal Slavin, Cuisine

Shopping List

Client _____ Date _____

Qty	Produce	Qty	Grocery	Dairy		Frozen	Meat
				Breads	**Spices**	**Qty**	**Handpick (need perfect)**
				Special Equipment			

The Job: _____

Equipment Checklist

EQUIPMENT

- ☐ Forks
 - __ 3-prong
 - __ dinner
- ☐ Spoons
 - __ serving
 - __ regular
 - __ long, tea
 - __ slotted, frying
 - __ slotted
 - __ wooden
- ☐ Knives
 - __ paring
 - __ large
 - __ cheese
- ☐ Spatulas
 - __ rubber
 - __ melting
 - __ frosting
 - __ pancake
- ☐ Brushes
 - __ small
 - __ medium
 - __ large
- ☐ Atomizer
- ☐ Tweezers
- ☐ Scissors
- ☐ Vegetable peeler
- ☐ T-pins
- ☐ Q-tips
- ☐ Picks
 - __ long
 - __ short
- ☐ Toothpicks
- ☐ Can opener
- ☐ Ruler
- ☐ Eye dropper
- ☐ String
- ☐ Bottle opener
- ☐ Needle
- ☐ Thread
- ☐ Filament
- ☐ Mixing bowls
 - __ metal S M L
 - __ plastic S M L
- ☐ Measuring spoons

- ☐ Measuring cups
 - __ liquid
 - __ dry
- ☐ Pyrex bowls
- ☐ Colander
- ☐ Strainer S M L
- ☐ Egg beater
- ☐ Plastic pouring cup
- ☐ Steamer
- ☐ Trivets
- ☐ Rolling pin
- ☐ Hand mixer
- ☐ Pastry bag
 - __ tips
- ☐ Whisk
- ☐ Grater
- ☐ Timer
- ☐ Tongs
- ☐ Ice-cream scoop
- ☐ Skewers

POTS AND PANS

- ☐ Saucepans S M L
 - __ lids
- ☐ Double boilers
- ☐ Frying pans S M L
 - __ lids
- ☐ Frying pan, electric
 - __ lid
- ☐ Deep fryer
- ☐ Electric grill
- ☐ Tea kettle
- ☐ Tea kettle, electric
- ☐ Roasting pan
- ☐ Jelly-roll pan
- ☐ Cookie sheets
- ☐ Muffin pan
- ☐ Bread pan
- ☐ Cake pan
- ☐ Pie pan
- ☐ Blender
- ☐ Heating rod
- ☐ Hot plate, burners
- ☐ Microwave
- ☐ Turbo oven
- ☐ Toaster oven
- ☐ Thermometer, oven
- ☐ Thermometer, meat

CONDIMENTS

- ☐ Kitchen Bouquet
- ☐ Oil
- ☐ Vinegar
- ☐ Soy sauce
- ☐ Angostura bitters
- ☐ Food coloring
- ☐ Fruit, fresh
- ☐ Karo syrup
- ☐ Honey
- ☐ Spices

MISCELLANEOUS

- ☐ Plastic containers
- ☐ Trays
- ☐ Cooling racks
- ☐ Tablecloth
- ☐ Aprons
- ☐ Pot holders
- ☐ Cutting board
- ☐ Cheesecloth
- ☐ Towels
- ☐ Paper towels
- ☐ Glad wrap
- ☐ Detergent
- ☐ Handi Wipes
- ☐ Foil
- ☐ Waxed paper
- ☐ Baggies
- ☐ Garbage bags
- ☐ Scouring pads

PROPS

and know it has certain equipment, then you'll know exactly what you need to bring. You may not need to bring more bowls, trays, or measuring cups, but if a piece of equipment is very important, say a mixer, check again to make sure that it is there and that it works. There are jobs where you may need just one or two knives, while there are others where you may need to bring the whole knife roll (see the photograph on page 118). If you need to put grill marks on meat, you will want to know if there is a gas stove or if

cooking in hell with paul newman

At 5:30 P.M., I received a phone call from my producer stating that Paul Newman would need, in addition to all the foods I had already procured, two 18-inch red snappers and two 5-pound lobsters for the shoot we were doing with him the next day. He also wanted some jumbo cabbages. My assistant and I needed to be in Westport, Connecticut, about two hours out of New York, at 7:00 A.M. I called my sources for all things marine and was told that the largest lobsters they had were two pounds, and no red snappers were to be had at that time of the day. What to do?

I asked my assistant to arrive at my apartment at 2:30 A.M. so we could go downtown to the Fulton Fish Market to find the needed seafood. On our way to the fish market, we passed an open greenmarket and found large

The poster for Newman's Own Diavolo Sauce.
Newman's Own

and pretty cabbages! Yes, the gods were possibly on our side. I had never visited the fish market, but I knew they set up and started selling at about 4:00 A.M. I was later to learn that the fishmongers take a coffee break after they are set up and are ready to sell between 3:30 and 4:00, so again, unknowingly, I was lucky. During their coffee break, they had time to enjoy the two floundering (pun intended) women looking for *pretty* fish and lobsters and were willing to take time to help us. After 4:00, forget it. That was time devoted to the hustle and bustle of selling to their regular, large-volume customers. So by 4:30, we were heading north on I-95 in a car filled with equipment and groceries; two "pretty" 18-inch red snappers, ungutted and "without those ugly gashes under their gills"; and two 5-pound lobsters with both claws and a lovely, even dark red coat.

At 6:45, we arrived at our shooting location, a huge empty warehouse that the photographer had rented for the day. I was asked where I wanted my "table" set up. We were scheduled to shoot the first shot at the far end of the

warehouse, so they took a forklift and drove it there. How high did I want my "table," they asked. Up went the forklift to the desired height and a large board was placed over the forks—thus, my table. We had brought a hot plate, and a cooler was my refrigerator. Water was in the restroom about a half–football field away.

That day we were scheduled to shoot three posters for Newman's Own. The first shot was Mr. Newman juggling a variety of vegetables, including the cabbage, in the air. The second shot was Mr. Newman reclining on a chaise longue, holding a platter of our lobster and snapper, a chicken, and pasta—a temptress standing behind him with his new spaghetti sauce, Diavolo Sauce. Around them would be real flames produced by a gas pipe that surrounded three sides of the set (thus the need for the warehouse and the fire department standing by).

I had been told that I could pick up a whole roasted chicken at a local specialty store because the shot "was not a close shot of the food." When my assistant came back from the store with the best-looking store-roasted chicken she could find, the photographer was not happy, and neither was I. Thank goodness we were about to take a lunch break. I asked the manager of the warehouse if she knew anyone with an oven who lived nearby. Her mother lived two miles away. I asked her to call her mother, get permission to use her kitchen for an hour, and ask her to turn on the oven to 350°F. In an hour and a half, we were back with two "perfect" roasted chickens, and we had a happy photographer. We were now ready to shoot Mr. Newman and his sauce in hell. I handed the large platter of food to be sauced to Mr. Newman, temptress looking tempting, firemen at the ready, gas pipeline ignited—and the photographer got two shots before we had to turn off the gas because it got so hot in hell.

you must bring a propane torch. There are also times when you must bring everything, including the kitchen sink (large plastic bowls)—if you are shooting in a park or even sometimes in a home location and you don't have access to a kitchen. I have a dozen canvas bags that I use for packing the food, equipment, and props I will need for each job. Sometimes I need only three bags, but there are times that I use all twelve, and then I hire a messenger to help me get the items to the job.

Having just the right tool to do the job is very important, so go over the recipes carefully and thoughtfully with this in mind. Each food stylist has certain pieces of equipment that work beautifully for him or her. I bring a specially designed ice chest for ice-cream shots and specific spatulas with certain flexibility for frosting cakes or flipping pancakes. I have favorite griddles or toaster ovens and ice cream scoops that work best for the look I need. Even having good, thick but flexible hot pads on a heavy baking day makes the day go smoother (see pages 107–146 for more information on tools).

If you are propping the job as well, you will also need a prop list, and in propping having more rather than less is better. You should have received clear information from the art director as to the type of shot(s) you are doing, the style of the shot(s), and a color scheme. You may be responsible for surfaces, too. It is always good to think of additional items, such as salt or pepper mills, flowers, utensils, baskets, and napkins, that might be needed in a shot for fill. Sizes of dinnerware or cookware will be very important (see pages 89–98 for more on propping).

shooting ON LOCATION
Hidden Details

As food stylists, we shoot on location every time we go on a job. Sometimes we are at a studio just a short distance away. Other times we may be in "location homes" or outdoors, on an empty soundstage, or working in another state. At times we find ourselves in a foreign country with food and equipment that perform differently from what we are used to. How can you make these assignments as successful and hassle free as possible, whether they be for print, television, or film?

If you are traveling to another city, state, or country, make sure you have a contact person who has a car and who is familiar with food sources in that location. Often the studio or production company will provide an assistant. Try to make sure that he or she is food savvy. If possible, interview prospective assistants to determine their skill level and willingness to take direction and do the work. (Production assistants, PAs, do not usually fit the bill.) If the budget allows for it, I bring my own assistant as well.

If you need to travel to a job, it's important to ask for all the details. For short distances, will you use your own vehicle or rent one? Who will be responsible

the checklist: don't leave home without it

When you are working away from home, it is wise to have a handy checklist of items that will make your trip more pleasant. The list might include personal ID, address book and contact information, business cards, cash and credit cards, medical information and prescriptions, cosmetics and toiletries, alarm clock, cell phone recharger, comfortable shoes, snacks, vitamins, reading material and reading glasses, camera, calculator, wine bottle opener and small knife (in checked luggage), resealable plastic bags in various sizes, tape measure, scissors, and tape (in checked luggage). For foreign travel, additions would include your passport and several copies of it, guidebooks and maps, foreign-language dictionary, electric adapter, luggage key, fanny pack, stationery with letterhead, gifts, flashlight and radio (extra batteries), sunblock and sunglasses, and insect repellent.

for the cost of the rental? Are you charging for mileage, gas, and tolls? If you're flying, who is responsible for making arrangements? Remember, these costs should be worked into your budget for transportation.

If you have a lot of equipment to transport, consider overnighting it in a hard suitcase. In accordance with airline baggage restrictions, you will need to check almost everything, so be sure to protect equipment with good packing. I have my normal kit that I use for local jobs, and I used to be able to carry that on board. But now I have a kit just for traveling on airplanes and I check it with my other equipment. Remember that you can't lock your luggage due to current security regulations; quick-release straps are helpful because they make your luggage easy to identify and more secure. Also, it is illegal to fly with many types of chemicals or aerosols. If you are unsure about anything you are packing or carrying, check with the airline.

Generally, most arrangements (ordering extra freezers, having extra tables, transportation to locations of some distance, overnight accommodations) are taken care of by the studio manager or the producer. Your job is letting that person know all of your specific needs. This can be done verbally, but it is always good to have a written list to fall back on. This forces you to make sure you have covered everything. If you have cake pans, muffin pans, cookie sheets, or any equipment that is essential for good results, you will have to bring or ship it.

Planning for Foreign Locations

When traveling any distance, it is important to plan carefully and in advance. These are some questions to consider:

- Is your passport up to date and is there any special paperwork necessary to work in the particular country? Are there restrictions on food or equipment that can be brought into the country?

- If you do not speak the language, can you get a local assistant who is familiar with food sources, is a good cook, has equipment you might need, and speaks English?

- Will you be billing someone there? If so, who? Will you be paid in cash? U.S. dollars are preferable.

on location in prague

Some jobs take you to unusual and beautiful locations. An especially memorable assignment for me was shot just outside of Prague in the Czech Republic. We were shooting in February in an unheated ancient château that had been turned into a museum (I had no trouble keeping the product cold). Outside one of the windows were ice skaters on the river Vltava, a view very reminiscent of a seventeenth-century Dutch painting. Inside, the model Fabio posed as a sculpture in the museum that came to life when offered a taste of the product we were selling.

The winter riverscape in Prague with our château to the left.

locations close to home

Another memorable commercial was shot on the Brooklyn Bridge—just minutes from my apartment in New York City. However, it provided the crew with an experience even many born-and-bred New Yorkers have never had. We began setting up at 4:30 p.m. and shot through the night from the middle of the bridge. How spectacular the skyline of New York was that evening, especially because the World Trade Center was in full view. I had walked across the bridge before, during the day, but I'd never spent the entire night there and was amazed to discover that there was foot and bicycle traffic crossing all through the night. Not all commercials are shot in such stunning locations, but when they are, the experience is to be savored.

at the
SHOOT

ARRIVING and ORGANIZING

When you shoot for print, you usually will work in a photographer's studio. If you are shooting production work, such as a commercial, you will work on an empty soundstage. However, if you are shooting on location, for print or production, you could be set up in someone's home kitchen, at the beach, in a firehouse, or on the Brooklyn Bridge—in other words, it could be anyplace. Sometimes, special "kitchen trucks" or RVs are rented for large jobs for the stylist to use to set up. At others you will improvise your space outdoors.

When you get to any shoot, the first thing to do is scope out your work space for anything that you might need. At a photographer's studio, I often need more counter space or extra tables to hold equipment and groceries. In production, all needs should be discussed in advance. You must think of everything because you will likely be shooting in an empty space. Refrigerators, freezers, and stoves can be rented. Tables can be made from sawhorses and boards, and garbage bags can be clamped to the tables for impromptu trash bins. Electric lines are run for electrical appliances. The sink may be the ladies' room or the slop sink or water brought in buckets. For production work, I often bring plastic tablecloths to cover worktables and plastic tubs to hold water. Try to get your work space set up as close to the shooting area as possible.

After you have looked at your work area, taken care of getting extra tables, and cleared counter space, unpack and put all your groceries away, first putting perishables in the refrigerator, and storing dry goods last. Put fresh herbs in containers of water, cover them with plastic bags, and place in the refrigerator (except basil, which seems to like room temperature best). Some lettuces need to be washed or spritzed and refrigerated. I ask the assistant, if there is one, to organize the groceries because then he or she will know what we have, how much we have, and where it is.

LEFT: Extra work space can be created with sawhorses and flat boards. Here, the equipment is divided between two workstations near the sink, stove, and refrigerator. A stack of paper towels is ready for use.

RIGHT: Knives and cups of utensils are kept within easy reach. Stacks of pans lined with aluminum foil will hold prepped foods. The set tray is ready to go to the set at a moment's notice.

John Montana

Next, place the equipment where you can find it: Position your kit and cutting boards strategically (damp paper towels underneath the boards will prevent skidding) and take out the knives you will need that day. Tear paper towels into sheets and stack them for use.

Line 11 x 15-inch jelly-roll pans with aluminum foil (shiny side down to protect eyes from glare). Place containers of foil, plastic wrap, and plastic bags, as well as open garbage cans, in a convenient place for everyone. If there is a professional baker's rack with shelves available, use it. This is great additional storage and counter space, and the racks are movable.

While the assistant is doing the setup, or when I've finished it myself, I discuss the shooting schedule (shot list) with the photographer or director and art director. Sometimes this has been done previously, sometimes not. If the schedule is up to me, as the first shot I will choose something that will produce a striking image but that can be done fairly quickly. If I have made brownies the day before, I might choose them as the first shot because I will just need to cut them and maybe frost them or work on the sides a little. In the meantime, the assistant can begin prepping the food for the next shot. The first shot often takes the longest, and if we are only getting to the first shot after lunch and have four more shots to do, everyone is very anxious. If there is a particularly difficult food to be shot, I put it in the middle and don't save it for last. I like to finish with a beautiful and not too difficult shot so everyone leaves happy, with that image in mind.

Another thing that I consider is the food. If we need a shot showing a basket of whole peppers and another shot with sautéed peppers, I will want to shoot the basket first and then cut up the peppers for the sauté shot.

TIP *One food stylist has a sidelight with a clamp that she brings with her and uses at her workstation to duplicate the light that will hit the food on the set. This way she can see how the food will look ahead of time in similar lighting.*

LEFT: Open shelves and rolling professional baker's racks are useful for storing groceries and prepped foods.

RIGHT: The shot list, recipes, layouts, grocery list, and any visual references sent by the client, such as tear sheets, are hung for easy reference.

John Montana

61

finding the unexpected

As a food stylist, leave yourself open to creative possibilities when you are preparing foods. It might be cutting the item in an unusual way or spotting something interesting in the food preparation stage that leads to a new or more enticing shot. For example, I once made some bread sticks for a shot and, to keep the soft bread straight, I ran a skewer through part of the bread. After I finished baking the sticks, I was about to remove the skewers, but then thought they would add interest to the presentation.

Another time I was doing a test shot and wanted to make *frico* (lacy, crispy, thinly baked or fried Parmesan cheese wafers) as a garnish for a salad. I brought Parmesan cheese and a grater to the job, but in the photographer's refrigerator noticed some pregrated thick strands of Parmesan. I used those instead of the finer cheese my grater would have produced. The outcome was a beautiful, more lacy frico than the more solid disk that would have resulted from my finer grate. Remember that creativity + innovation + resourcefulness should be part of the preparation process. (See the photograph on page 90 at left.)

TOP LEFT: This photograph, taken at a distance to show all the props, is useful for a prop stylist's portfolio.

TOP RIGHT: The shot taken from closer in is suitable for the photographer's portfolio.

BOTTOM: The close-up of the food best promotes the food stylist's work.

Colin Cooke, prop stylist Phyllis Asher

When working in production, the shooting schedule is usually set by the director ahead of time and should be something you know before you arrive so you can shop and prepare for it.

Once the shot list is determined, I hang up the layout or storyboard, recipes, and shooting schedule in the kitchen area (usually on the kitchen cupboards or refrigerator) so that everyone has access to them (see the photograph on page 61). I use black paper tape from the studio to hang things because it does not leave marks or pull paint off the wall. If the assistant needs to know which is the next recipe, he or she checks the shooting schedule and then takes the recipe and places it above his or her work space. This way the layout, recipe, tear sheets, shooting schedule, etc., are up, stay clean, and are available to anyone who needs them. At the setup stage, I also request additional lights for my work area if I need them.

I have found that taking the first fifteen minutes of the day to get everything organized pays off in big dividends later. If the assistant needs a food item or piece of equipment, he or she knows where it is and how much of it we have. Everything is out and in sight so it is easy to find. We have arranged our space so we can work comfortably and efficiently.

Choosing Props for the Shoot

When the prop stylist gets to the shoot, he or she unpacks all the props onto tables set up specifically for props. As this is usually the first time others have seen them, it is then that the art director, photographer, client, and food stylist work with the prop stylist to determine which props will be used in each shot. To choose props, stand-in food is often placed on or in various props to see which work best. Sometimes there are surprises, such as plates that are too large or glasses that are too small, but most of the time we can make adjustments. Usually, though, we end up having many wonderful choices (see the phtographs on page 91).

If you live in a location where the food stylist is also the prop stylist, besides bringing the food and equipment, you will bring and set up the props. The major advantage to this is that there are no surprises. You know what you have to shoot with.

Discussing the Shooting Schedule

When I arrive at a studio for a print assignment, the major items I will want to discuss with the photographer and art director are the shooting schedule and how we are going to set up each shot and make it work. The shots can be as traditional as shooting a simple slice of upside-down cake or a bowl of soup or more complicated, involving splash shots or food on a grill with flames. We have to take into account whether we're shooting a vertical or horizontal shot. I will want to know how close we will be on the food, how the food will be lit, and the camera angle. I can observe these things while others are setting up. Do they need a stand-in and when? Sometimes I arrive at the studio with stand-ins already made (baked goods); sometimes I need to get busy making something for them to use.

When doing production work (shooting a commercial or movie), after the work space is organized, I discuss the shooting schedule with a time frame for each segment to be shot. I will need to know the approximate number of takes for each segment and to be aware of the camera moves and angle, as well as lighting. I will discuss any special effects and how we are going to accomplish them. I ask what I can do to help special effects. Good, clear communication is important for all of these issues.

When you are working on a live television cooking segment, the producer is the contact. It is lovely if there is time to go over the steps and swaps with the talent and the camera crew. Sometimes this happens, sometimes not. Two important things to remember: First, everything needs to be laid out in order of use or demonstration. Second, the talent and interviewer will probably eat the food during the segment, and the crew will enjoy eating the food after the segment is shot, so bring plenty.

> **TIP** *A beautiful, mouthwatering food shot is a three-step process. First, you must be able to cook or bake the food so that it looks its very best. Then, you must arrange it attractively for the camera. Third, you must add any last-minute touches at the set so that the food looks crisp, flowing, chilled, steaming, or fresh, as desired.*

PREPARING the FOOD for the shoot

Once the shooting schedule has been determined, it is time to begin preparing the food for each shot. If it is a baked good that has been made the day before, I choose the least appealing example and use it as a stand-in so the shot can be set up. If I need to cook the item, I follow the recipe exactly and use that as a stand-in. When I make the recipe as written, I can see if there are any problems and can accommodate or make adjustments for them when I make the final food, or hero.

For editorial purposes, the food must look as it might when it is prepared by the publication's readership (professionals or consumers). Today, the look is natural and doable.

Several things that make food visually appealing in the preparation stage are bite-size pieces of ingredients,

> **HANDS OFF THE FOOD**
> *I was working on a commercial for fried chicken, and the assistant director insisted that I give some of the chicken to the child actors in the commercial when they were off camera. The result was that when it came time to shoot the scene of a happy family sitting around the table enjoying the fried chicken, the children were too full to eat and look like they enjoyed it.*

consistency in thickness of slices of ingredients, and bright, fresh ingredients, whether cooked or raw. Whenever possible, cook the food as directed in the recipe and present it in an attractive manner as close to the finished cooking time as possible. There are many times, however, when you will need to break down a problem recipe into its component steps; then, you will have to arrange the food to look like the real recipe. If you have previously made a stand-in, you can use it as a guide to help you with the look of the final food.

If you are shooting baked goods, some items are best prepared the day before (most pies, brownies, some cookies, and unfrosted cake layers, for example), while other things look fresher if prepared the day of the shoot (such as chocolate chip cookies, fruit tarts, and chocolate desserts). Prepare all food items starting with those that will last the longest and finishing with the most fragile ones. It is great if the prepped ingredients for each recipe can fit on one or two lined trays. This is the mise en place (see the photograph on page 48). For food styling, the ingredients should be cooked and ready to be arranged before shooting.

styling for VISUAL APPEAL and MOUTHWATERING FACTOR

Just as a painter starts with an empty canvas and a writer starts with an empty page, food stylists begin with an empty plate, fork, frying pan, or bowl. It is their job to fill that empty object with a pleasing arrangement of food. How they do that is the artistic part of the job.

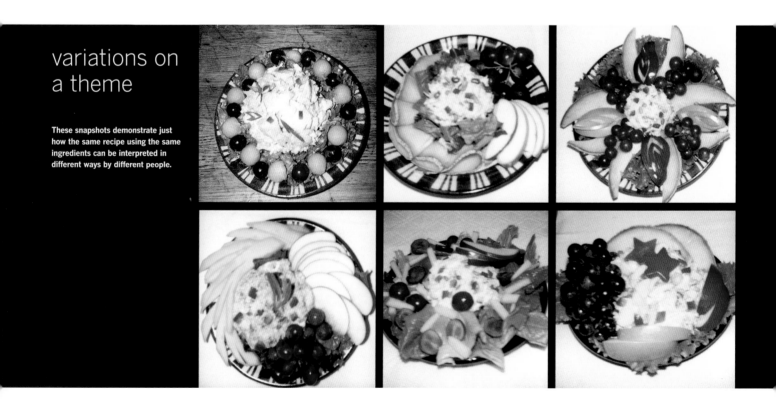

variations on a theme

These snapshots demonstrate just how the same recipe using the same ingredients can be interpreted in different ways by different people.

Over the years, I have given the same assignment for a tuna fish salad to more than a hundred students. Each student has the same recipe, plate, and ingredients, yet no two have produced the same presentation for that salad (see the photographs on facing page). That is how it should be. We have different amounts of artistic talent, and we each will have a different vision for a presentation. Food stylists are hired for their presentation skills. Some stylists have a very perfect, consistent, and controlled presentation style, while others have a freer, more "artful" style. In the best of all possible worlds, it is helpful if you can adjust your style to the assignment and client. However, even within any confinements, you will still have your own style, your own sense of balance. Your work may be bold or delicate. You will arrange with control or with a sense of flair.

Making Food Visually Appealing

Below is a list of "rules" for presenting foods for visual appeal. Remember: There are always exceptions.

- Always know what the camera angle is, the sources of light, and where camera front is located on the prop to be styled. Arrange the food while looking at it as the camera will see it. Don't arrange all the flakes, potato chips, chicken, lettuce leaves, and so on, facing the camera. The food will have no dimension or texture.

- Know the gold standard that the client wants for a product and then separate out the most attractive examples (see the photographs on page 26).

- Balance, flow, use of negative and positive space, and movement all increase a food picture's appeal. A feeling of natural composition or casualness suggests comfort. Consistency in thickness, size, and placement of food in an arrangement produces a feeling of order. Scattering and randomly placing items versus grouping like food items will each produce a different effect. It is good to break up strong geometrical food shapes, such as the circles made by slices of radishes, onions, or olives, or the triangles of tomato wedges, by partially covering the shape with another food or by rotating the food so that it doesn't face directly into the camera. Also, two like items going in the same direction (parallel lines) draw the eye toward them. Change the direction of one. Arranging sliced foods going toward or away from the camera produces two different looks (see the photographs at right). Ask yourself which direction works best for the lighting and shows off the food.

- Watch for strong contrasts in dark and light foods or props. The camera has trouble exposing for both. A white item will look bigger and bolder on film. Think about softening it, reducing it, or breaking it up. A perfect example is whipped cream on a dark chocolate cake. You can soften the effect by dusting the whipped cream with cocoa powder or cinnamon; you can reduce it by making the dollop smaller; or you can put a raspberry, mint sprig, or other garnish on the cream to break it up. Another example is found in the photographs on page 66, where we softened the contrast of light ice cream and dark cocoa powder.

- Smooth strokes in frostings, dips, peanut butter, or spreads usually look better than busy movements (see the photograph on page 298).

- Think of the edge of the plate as a picture frame. Common mistake: too much food overlapping the edge of the plate.

TOP: These tomato slices are arranged moving away from the camera.

BOTTOM: Here, the tomato slices move toward the camera.

Colin Cooke

LEFT: **When shooting foods with high contrast, such as vanilla ice cream on a chocolate dessert, we need to help the camera, which can expose only for lights or darks. (The food stylist receives the Polaroid and recipe before the shoot.)**

RIGHT: **By making the dark dessert lighter with an interesting pattern of cocoa and the ice cream darker with a dusting of cocoa, we achieve a happy medium. Now let's do something interesting with the sauce.**

Michael Harris for Chocolatier

PRIMARY COLORS
SECONDARY COLORS

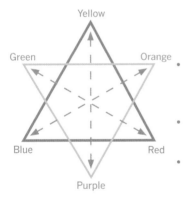

PRIMARY COLORS are yellow, red, and blue.

SECONDARY COLORS. If we combine yellow and red we get orange. If we combine red and blue we get purple, and if we combine blue and yellow we get green.

COMPLEMENTARY COLORS. The colors opposite on the color chart are complementary colors. Yellow makes purple look good (and vice versa); red makes green look good; blue makes orange look good.

- Vegetables and fruits with interesting curves and shapes are more appealing than straight ones. For example, you can leave hooks on cut sticks or strips of bell peppers, look for green beans that curve, and find apples with stems that are not straight. Even foods such as cereal or potato chips are more appealing with curves and twists than when they are "perfect" flat flakes (see the photographs on page 185). Try to use interesting new cuts for vegetables and fruits, such as slicing onions into wedges rather than circles, and cutting foods on a bias (see the photograph on page 167).

- Keep food integrated. If foods are tossed or mixed, they should look tossed, not placed or too arranged. The peas should be *in* the rice, not sitting on top of it. Chopped fresh or dried herbs also give foods an integrated look.

- Balance food composition, either formally (symmetrically) or informally (asymmetrically). Uneven numbers of things are usually more appealing than even.

- Contrasts in texture, shape, height, and color add dimension. Consider surprises. Ordinary food can seem extraordinary when it is in a new shape or arranged in an unusual way. Height in arrangements and a light hand often give foods a feeling of freshness. Lettuce that is lying down looks tired. Lettuce with texture that is standing up looks fresh (see the photographs on page 71).

- Be aware of the effects of color. Art directors and prop stylists use color to increase the effectiveness of a shot. Using complementary colors (the colors that are opposite one another on the color chart) can make each food or product stand out. For example, if you are selling orange juice, the complementary color of orange is blue, so using blue in a background heightens the look of the orange product. However, remember that there are many shades of blue, and using the right shade is important. Colors can also suggest moods, such as coolness and calmness (blues, purples, and greens) or warmth and energy (oranges, yellows, and reds). See the photographs on pages 68 and 69 for more about color choice.

- Besides color complements, there are monochromatic color schemes, where you use the same color in several shades. These can be effective and interesting visual

Food color chart

The color of a fruit or vegetable often can suggest a possible complementary side dish or garnish.

Red Foods	Orange Foods	Yellow Foods	Green Foods	Brown Foods	Purple-Scarlet Foods	White Foods and Interiors
Apples	Acorn and butternut squashes	Apples	Anjou pears	Barley	Beets	Apples
Beets	Apricots	Bananas	Apples	Black beans	Boysenberries	Bamboo shoots
Blood oranges	Cantaloupes	Bartlett pears	Artichokes	Blackberries	Cabbage	Bananas
Bosc pears	Carrots	Butter	Asparagus	Black (purple-black) foods	Cranberries	Bean sprouts
Caviar	Cheddar cheese	Cheese	Avocados	Blueberries (interior)	Eggplants	Casaba melon
Cherries	Clementines	Comice pears	Basil	Caviar	Figs	Cauliflowers
Crabs	Crenshaw melons	Corn	Broccoli	Chocolate	Grapes	Celeriac
Currants	Kumquats	Grapefruit	Brussels sprouts	Coconuts (husk)	Plums	Coconut
Edam cheese rinds	Mangoes	Lemons	Cabbage	Croutons	Purple peppers	Dried white beans
Fontina cheese rinds	Nectarines	Mangoes	Celery	Eggplants	Radishes	Endive
Gouda cheese rinds	Oranges	Pineapples	Cucumbers	Figs	Red cabbage	Fish fillets
Lobsters	Papayas	Turnips and rutabagas	Fennel	Fried foods	Red onions	Leeks (interiors)
Pink grapefruit	Peaches	Wax beans	Figs	Fried onions		Lichees
Plums	Persian melons	Yellow bell peppers	Gooseberries	Grapes		Mushrooms
Pomegranates	Persimmons	Yellow squashes	Grapes	Kiwis (skin)		Onions
Radishes	Pumpkins	Yellow tomatoes	Green bell peppers	Lentils		Parsnips
Raspberries	Sweet potatoes		Greengage plums	Meats		Pears
Red bell peppers	Tangerines		Greens for salad: Boston, romaine, iceberg, escarole, etc.	Mushrooms		Potatoes
Red endive			Honeydew melons	Mussels		Rice
Red leaf lettuce			Kiwis (flesh)	Nuts		Scallion bulbs
Red lentils			Leeks	Olives		Scallops
Red onions			Limes	Prune plums		Turnips
Red snapper			Olives	Prunes		Water chestnuts
Rhubarb			Parsley	Raisins		White radishes
Salmon			Pea pods	Seckel pears		
Shrimp			Peas	Truffles		
Strawberries			Pistachio nuts	Wheat berries		
Tomatoes			Scallions			
Watermelons			Spinach			
			String beans			
			Watercress			
			Watermelon			
			Winter melon			
			Zucchini			

tools. Remember that there are many shades of white as well. Some whites are warm and some are cold. Ask yourself which works best with your food.

- The color on a plate of food often comes from the produce on the plate. You want to make sure the food colors on the plate are bright and fresh looking. Are the green beans overcooked to a drab olive color, is the broccoli so dark it appears almost black, or do they both glisten with their bright greenness?

- White food "grows" or looks bigger on camera. Think about softening it, reducing it, or breaking it up.

- Find interesting garnishes that complement the food, that add to the eye appeal, and that don't overwhelm the food.

- The food placement in or on the prop is important. Often the edges of the plate form the picture frame. If we can't see the vessel, the food is not grounded, but if there is too much plate, the recipe or food seems lost. Even the height of the soup in a bowl can make a difference (see the photographs on page 212).

- Large exposed surface areas look bare. If you are seeing too much tablecloth (the fifties look; see the photograph on page 346), you can put more props on the tablecloth or move the camera in tighter. If you see too much plate, move the food on the plate closer to the camera, move the camera in tighter on the food, or expand the size of the food. Generally, shooting food close up produces a more visually appealing and mouthwatering image (see the photographs on page 71).

Notice how different the colors of the food seem on different-colored plates. Which shade of blue makes the food look good?

Amy Reichman

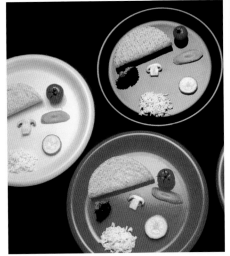
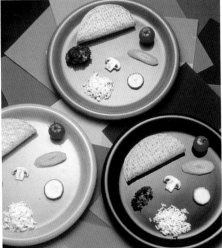

Even white plates vary in shade.

Jim Scherzi

Now look at the photographs of the student tuna salads on page 64. Which salads are visually more appealing? Which ones followed some of these rules? For example, which used plates as a frame for food and which didn't? Which salads show off what we were selling (the tuna)? You should begin to critique all food pictures you see.

It is helpful to make a stand-in of the food you are shooting. The stand-in allows you to play with the food arrangement on the set until everyone is happy with the placement. With a stand-in, you can determine where the food is to go, how much food will be used, the height the food should be, and how the lighting is affecting the look of the food. You can determine how much sauce to use and where it goes. You can determine where the garnish will go, if you are using one. Then, when you arrange the final food, there should be no surprises (see the photographs on page 72).

It will move things along if there are two of the same prop items, or doubles. While the photographer is doing the final lighting on the set using one prop, you can begin working on the hero with the second prop. If you are using fragile food, however, don't begin until the photographer is close to needing the final food.

To arrange final food, start with an impeccably clean plate, platter, etc. Place paper towels under the prop to make sure the bottom of it stays clean as well. Then, sitting or standing so that you are looking at the prop from the same angle as the camera will see it, begin to arrange the food. Sometimes I place the meat on the plate and then add a mound of green beans beside it; sometimes I arrange the green beans one at a time. Sometimes I place a handful of greens in a salad bowl; sometimes I arrange the salad one leaf at a time. It will depend on the assignment

Frozen margaritas made with ice powder.

FROM LEFT:

A brown background conveys warmth—perhaps not the best choice for this frozen margarita.

Deep cobalt is a dramatic choice.

A bright green background looks fresh and lively in this monochromatic color scheme.

Colin Cooke

food magic at work

Once I was asked to make a pyramid of peppercorns. Getting even two layers of peppercorns to stay in place was nearly impossible. However, I made a pyramid out of moist instant mashed potatoes dyed with Kitchen Bouquet, and the peppercorns adhered nicely to the sides.

Pyramid of peppercorns.
Dennis Gottlieb

food on forks and spoons

Food on forks and spoons is sometimes shot solo, as pictured here, and sometimes over a bowl or plate of the same food.

Food styling such small quanitites of food in fine detail is a challenge. The food must adhere without visible pins or other attachments. The photographer should clamp the fork or spoon in place and at the angle it is to be shot. You might need to arrange the food on set.
Dennis Gottlieb

and the desired look, whether casual or very balanced and formal.

Once in a while when I arrange food, I need a support to hold the food in place or "fill" underneath the hero food. Instant mashed potatoes work well as a base. For example, I might fill a saucepan three-quarters full of instant mashed potatoes and then arrange the hero food on top of them. If we are shooting at a low camera angle, I might have a mound of instant mashed potatoes toward the back of a plate and arrange the food over it to give height to the food. The potatoes hold the food in place.

You must help the camera, which has only one eye, to see shapes, texture, and contrasts. A platter of fried chicken is hard to arrange because to the camera it often looks like "a mound of brown." If you arrange it from the exact angle the camera is looking at it and leave spaces between pieces, that will help. The photographer's lighting will also help by casting shadows to highlight individual pieces.

If you are working with several different containers (props) of food that will go on the set at the same time, work first with the food item that will last the longest and work last with the most fragile.

One of the most difficult concepts for the beginning food stylist to understand is that often not everything is finalized before being brought to the set. We frequently do some final work on the set, for example, adding the sauce or syrup just before shooting. We melt butter on the set as well as brush the surface of cooked meat with a little oil if it is needed when the food is placed under the lights. Fragile foods, such as an herb garnish, are replaced on the set just before shooting.

Making Food Mouthwatering

Before we can make anything appear mouthwatering, we need to think about what makes a particular food inviting. There is an old adage that says, "You can't claim it

LEFT: This chili has little mouthwatering appeal without melted cheese. It looks cold, dry, and uninviting.

RIGHT: By holding a clothes steamer over the chili, we melt the cheese and give the surface a moist appearance. Now the chili looks fresh, warm, and inviting.

Jim Scherzi

until you can name it." Well, you can't produce it until you know the look you want. Visual clues in food images are stronger than we realize.

Each food item has its own criteria for lusciousness. Just for fun, let's take a couple of foods and choose adjectives that would describe their mouthwatering appeal.

First, a basic tossed salad: We like a salad to look fresh, cool, and crisp, with vibrant colors, interesting textures, bite-size pieces of familiar ingredients, and with just the right amount of dressing glistening under the lights. Sometimes we learn as much by thinking about what we wouldn't want, however: warm, soggy, old, wilting, flat, uninteresting ingredients; pieces too big for comfortable eating or so thin that they are almost transparent. A salad with too much dressing and no crunch left in either the vegetables or the lettuces will be visually rejected.

It is food stylists who produce the positive visual cues of the salad and prevent the negative visuals. We do this by working with very fresh, unblemished ingredients cut into interesting bite-size shapes and with lettuce that is fresh, crisp, and standing up, showing contrasts in shape, texture, and color. We arrange the ingredients so that they have visual appeal. We may add moisture droplets to suggest "cool and crisp." And if we are adding dressing, it will be in small amounts that don't weigh down the ingredients. We'll add the dressing just before we are ready to take the shot, so that it doesn't wilt the carefully chosen and arranged produce.

Let's take another food item: steak. Words that describe a mouthwatering steak are *hot, sizzling, juicy, crisp outside, tender inside, medium rare* (usually). We want the surface to be a warm brown, possibly with dark crispy bits of seared meat and fat as if it just came off the grill, and with grill marks adding visual appeal. What we don't want is a dry, cold, overcooked, flat, too gray or too dark hunk of meat with too much or not enough fat, and we don't want the fat to be congealed. We don't want meat that looks tough. Rather, we like to see seasoning on a surface that glistens under the lights and the meat partially sliced, instead of just a slab of beef that resembles a round brown lump. Garnishes that complement the meat or a sauce drizzled over the meat add visual appeal. Juices slightly flowing from the cut, moist slices suggest freshness and juiciness. You can take any food and verbally describe what makes it mouthwatering (or not). This is something that you should do before you style any food. Once you've decided what mouthwatering effects you want, you need to think about how to make the shot visually appealing.

FROM LEFT:

Not very appetizing, is it? This steak and flat salad are a blank canvas for the food stylist.

With grill marks and coloration, the same steak now looks juicy and mouthwatering and the salad light and fresh.

The moistness of the exterior, the texture of the peppercorns, and the contrast in coloration plus its closeness to the camera all add to the steak's mouthwatering appeal.

Colin Cooke

WORKING on the set

TOP ROW:

On the set, we begin by trying different plates and background surfaces.

Once the plate is chosen, the photographer adjusts the lighting.

Then stand-in food is placed on the plate.

BOTTOM ROW:

We change the background surface and select other props.

We try a different napkin and change the position of the fork. The photographer adjusts the lighting one more time.

We block the plate, remove it from the set, and clean it. Arranged and garnished, the hero is placed back on the set for the final shot.

Dennis Gottlieb

We might begin work on the set by helping the photographer arrange the shot with stand-in food. Sometimes the photographer wants help and sometimes not. Surfaces are chosen, props selected and arranged, and lighting is perfected with stand-in food. We make decisions on how to alter the food by looking through the camera and at Polaroids if we are shooting film, or looking at the monitor, if we are shooting digitally. The Polaroids or the monitor show you exactly what the camera is seeing. (I also used Polaroids at my workstation when I arranged the final food before bringing it to the set so that I could easily duplicate the camera angle, but today, almost all food is shot using digital cameras.) On the set, you should work from the side so that you are not in the way of the photographer, who is looking through the camera and making decisions about placement and lighting. If the photographer wants something moved, follow his or her direction. "Move it to camera front [forward toward the camera]," or "camera left" or "camera right," and "clockwise it" or "counterclock it" are some of the directions you might get. When the photographer is refining the shot, move things ever so slightly until you are asked to stop.

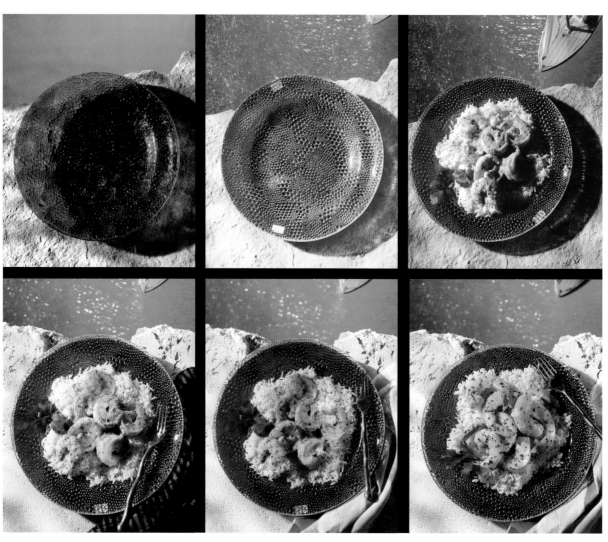

TOP LEFT: **We always work from the side of the set.** *Dennis Gottlieb*

TOP RIGHT: **We may need tweezers to adjust the placement of ingredients or add herbs.** *Corrine Colen*

BOTTOM: **Just before shooting, we make last-minute touch-ups, such as brushing or spritzing the hero with water or vegetable oil and replacing any "tired" food.** *Michael Waine*

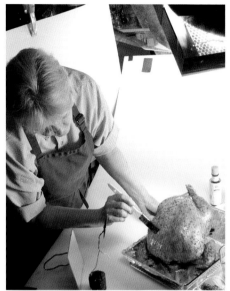

You will do the most work on the set when you are ready to shoot the final food and make last-minute touch-ups or additions. Put together a set tray (see the photograph on page 108) that includes brushes, spritzers, tweezers, small scissors, long-handled spoons, eyedroppers, a small sharp knife, wooden skewers, Q-tips, paper towels cut into quarters, and plastic cups of water, light vegetable oil, Windex, and any food, sauce, or garnishes that will be needed for final touch-ups or additions.

If you have major work to do on the set for a shot, such as pouring syrup, remind the photographer while he or she is setting up the lighting that you will need room to get to the set. Ask the photographer for a small table or surface where you can put your tray while working. When you try to actually get to the food on the set, things such as cameras, lights and light stands, reflector boards, and stands holding forks or spoons in place can hamper your ability to reach the food. Carefully work around these. If you do happen to tap a stand or dribble oil on a tablecloth, confess. If you don't, the photographer may shoot it without a correction. With digital photography, this is less of a problem because he or she will immediately be able to see if something is wrong. With film, however, any problem won't be visible until the film is developed, and you may have ruined the shot.

It is your job to keep the food "alive" until the photographer is ready to shoot it. This may mean brushing or spritzing foods with water or vegetable oil to keep them

step by step: how we get to the final shot

A shot for a calendar became a good step-by-step example of how food stylists and photographers tackle a shot and work together to bring it to something everyone is delighted with. The shot for December was an overhead of ginger-bread cookies (one with a bite out, which was a theme of the calendar) on a plate, with a mug of hot chocolate.

TOP ROW:

Our first choice of props is a plate with snowflakes and a standard-size mug.

We reconsider the shot with a different set of props, but we decide we like the first set better.

Once we place a decorated cookie on the snowflake plate, the composition is too busy and the plate detracts from the cookie.

We switch to the plain plate and wider mug. But this plate might be *too* plain. What if I pipe a few white frosting snowflakes on it?

MIDDLE ROW:

I pipe snowflakes on the plate and decide to cut the marshmallows for more visual interest. Now the mug is too large and is overwhelming the cookies.

The proportions of a smaller mug are right, and we like the contrast of the mug's bright white interior.

BOTTOM ROW:

We think we are getting close to the final shot. I take a bite out of the gingerbread girl—too big!

If I had a bite taken out of me, I would not be smiling. I change the piping so that the gingerbread girl is saying, "Uh oh!" I take a smaller bite, but this time it's too small.

I take a bigger bite, reduce the number of marshmallows, and add more foam to the drink to make it look fresh. We have the final composition.

Jim Ong and Dennis Gottlieb

from drying out. You can also keep some things covered with plastic wrap or use stand-in foods and replace them with fresh hero foods just before the shot.

When the final food has been placed on the set, small refinements may have to be made: Rice may need to be plumped, or the side of a brownie smoothed. Items might need to be moved for better lighting or replaced with brighter, fresher ones. Bubbles are often added to beverages to give them the "just poured" look. Soups may be topped off with hot broth and herbs added or moved. Vegetable oil may be brushed on the surface of meat and poultry to give the food the juicy, "just off the grill" look. Grapes may be spritzed so they look chilled, and sauces may be added to just-dished-up pasta. Finally, with the client's and director's approval, the shot is ready.

the SHOT
It's Time to Shoot the Food

After all the refinements are completed, you are ready to shoot. However, there are still a few things that have to be so last minute that you will do them when the photographer has the shutter in hand. You might pour syrup and the photographer shoots it as it runs down the side of a stack of pancakes, for example. You might produce a splash that is captured in midair. You might melt butter to be shot as it oozes down an ear of corn. On some of these shots, you will need to be prepared to immediately do another take. Usually it will take eight to ten stacks of pancakes to get the desired shot because there is only one take per pour.

If you are shooting film, the photographer will want to "bracket" (take several exposures), and that will take time, so you may need to be on the set to refresh or plump something between takes.

When you have finished a shot, ask the photographer if you can remove the food—never take anything off the set without asking. You may want to wait for client approval if they are not in the studio. If you are shooting film, cover the food and place it in a safe environment until the film comes back from being developed.

When all the shots are finished, it is time to clean up. You are tired and probably have had a long day, but it is important that you leave the kitchen and prep areas as clean as or cleaner than you found them. You will need to pack up all of your equipment. If an assistant is not sure if something is yours (this is where marking your equipment and having the assistant unpack it when you arrive helps), have him or her put it aside and ask. When I pack up, I have one canvas bag that always holds my kit, knives, aluminum foil, plastic wrap, plastic bags, and Q-tips because I usually bring these to every job. That bag gets repacked and is ready to go to the next job.

Make sure the oven and all burners on the stove are turned off. There are a couple of places where things can be accidentally left behind: an oven thermometer in the oven, bowls or trays in the freezer, and brushes and tweezers near the set. Double-check.

If you want samples of the day's work (tear sheets of the ad, or actual ads, posters, or packages), ask for them. People are often happy to send you something.

TIP *If there is a lot of food left over from a shoot, think of shelters and food banks. Organizations often will pick up food if you call them ahead of time. New York City has a program called City Harvest that started with one station wagon, way back when I first began styling. Now it has many refrigerator trucks and feeds thousands.*

Find out when they will be available and get a business card from the person who will send the samples to you, in case you need to send a reminder or want to send a thank-you note.

If there is food left over, it belongs to the client. If the client does not want it, the assistants working in the studio usually do. Save some plastic bags from unpacking groceries, and let people know what food is available.

back to THE OFFICE
Things to Do After the Shoot

When you arrive back at your base, unpack and note in your job folder anything you want to remember about the job: for instance, how you worked with this particular food or whom to contact with questions or for samples of the work. As soon as you have the time, complete your invoice.

Usually the invoice goes to the photographer who hired you, but not always. At the end of the job, ask the photographer whom to invoice and get all the pertinent information. I usually ask for a business card from the person who will receive the invoice. Check to see if there is an assigned job number, as this often helps facilitate movement at the client's end.

Your invoice should include your name, address, and employee identification number (called an EIN; you will have one of these if you are an LLC or are incorporated) or your Social Security number (fewer people like to give out SS numbers these days, but you must if you don't have an EIN). You will also want to have an invoice number, a job number, the project title or description, the dates of the job, and your rate. Expenses should be separated out into food, transportation, materials, and miscellaneous, with a place for total expenses and total fees separated out at the end. You will need to send receipts for all expenses. Circle the total on each receipt and tape them on an 8½ x 11 sheet of paper. Make a copy of all receipts and your invoice for your records. See a sample invoice on the facing page.

Besides keeping a copy of my invoice and receipts, I have found that maintaining an invoice log is invaluable for keeping records of when I was paid and by whom, what I paid my asisstants, and for tax purposes. A sample follows.

Your Name
Food Stylist
Your Company's Name

INVOICE

Bill to: _____ Date _____

Company_____

Address _____ Invoice _____

Address *cont.* _____ Job # _____

Project Title: _____

FOOD STYLING SERVICES

Date	Description	No. of Days	Rate	Total
				$
				$
				$
				$
				$
				$
				$
			SUB TOTAL	

EXPENSES

Food (receipts attached)	$
Transportation (receipts attached)	$
Messenger (receipts attached)	$
Phone/Fax/Copies (receipts attached)	$
Materials (receipts attached)	$
EXPENSES SUBTOTAL	$

TOTAL FEES & EXPENSES $

Thank you for your prompt attention.

Please make checks payable to:

Your Name
Your Address
Your EIN or SSN

Invoice Log

Date of Job	Invoice Number	Job Title	Client/Payer	Invoice Amount	Expenses	Fees	Date Paid / Check Number	Disbursements

Photography is one of the most powerful visual tools of persuasion we have, and the photographer's skills in producing an image through the use of lighting and techniques with camera and equipment, as well as his or her creativity, are always interesting to observe. Even the personality of the photographer often appears in the work. A good photographer who understands the needs of the client and brings experience and creativity to an assignment can produce stunning final images that meet or exceed the client's expectations.

about
PHOTOGRAPHY

When looking for a photographer to work with as a stylist or client, you will want someone whose strengths match your needs. The American Society of Media Photographers has a database at www.findaphotographer.org where you can search for food photographers by location. In addition, the *Workbook* and *The Black Book* offer images of various photographers' work. Most photographers have Web sites. You can always ask to see photographs of assignments that are similar in scope to the project you have in mind.

the PHOTOGRAPHER'S ROLE in a food shot

Same Assignment, Different Looks

Over the past years, I have gone to about a dozen different photographers and asked them if they would do a test shot with me. The assignment has been the same each time—to photograph a fantasy salad. The salad is always arranged in the shape of a bouquet and contains edible flowers. The photographers could shoot it any way they wanted, and they could shoot it in the environment of their choice. I was the stylist each time, but that was the only constant. Before I went shopping for the ingredients, the photographer and I discussed the type of shot we wanted. Sometimes we sketched a look or looked at possible props. As you can see from the photographs on pages 82 and 83, the results represent a tremendous variety of looks. It is that difference in creativity from one photographer to another that an art director is looking for.

Photographers bring technical knowledge of the camera and lighting to a shoot. They also bring their artistic sensibilities and their personalities. Some have strong personalities and give strong direction, while others work more as a team. They also try to provide a pleasant and functional environment in which to work.

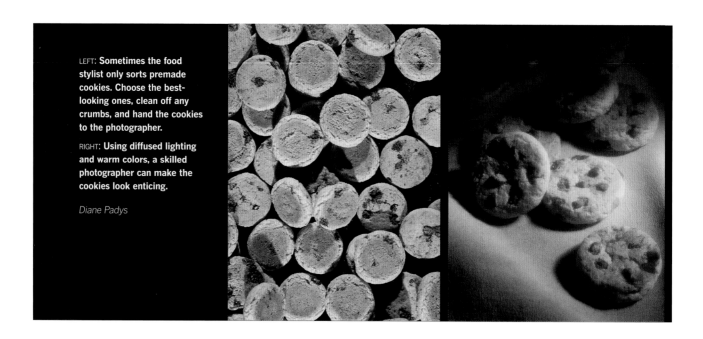

LEFT: **Sometimes the food stylist only sorts premade cookies. Choose the best-looking ones, clean off any crumbs, and hand the cookies to the photographer.**

RIGHT: **Using diffused lighting and warm colors, a skilled photographer can make the cookies look enticing.**

Diane Padys

the EVOLUTION of the CAMERA

My, how photography and equipment have changed over the years. When I began styling, large-format cameras were the norm, and we shot black-and-white as well as color, each of which required different styling techniques. Photographers used hot tungsten lights as well as strobes. Eventually, we shot almost exclusively in color with 8 x 10-inch film and Polaroids. Later, selective focus and diffusing became popular. Hosemasters were used to direct stronger light to a specific area of the shot, and tungsten lights fell out of favor. The 1990s brought a preference for natural light, influenced greatly by photographs shot in Australia, where good natural light is abundant. The major change, which gradually moved from the West Coast to the East Coast, with New York City being the last significant holdout, was the use of digital photography. And what a change that was!

Today, most jobs are shot with digital cameras. Digital allows us to shoot without the use of expensive Polaroids and without the lengthy process of film development. When we shoot with digital, we can see on a monitor almost immediately what the shot will look like. We now know for certain when we have the shot that we want, so we don't have to save the food until the film is developed. Photographers are willing to shoot our food as soon as we put it on the set because adjustments can easily be made and displayed on a monitor. When everything is perfect, we shoot the final shot and save it to a computer.

Digital photography also allows for easier manipulation of the image. The photographer can work on the computer to take something from an earlier image and place it in the final one because he or she preferred an aspect of the food or arrangement in the earlier image. Photographers can work on or change the lighting or reflections in a specific area of the image by retouching one, two, or more images. There is often more postproduction work to be done on a digital image (digital enhancing), but that's when magic can happen. For example, if a banana skin is blemished, the blemish can be removed. If the drip of sauce going down the side of a slice of cheesecake has become too long, it can be shortened. If the tomatoes need to be reddened, that can be done. Digital images can also be easily sent anywhere at any time for approval—such as to an off-site client (sometimes a good thing and sometimes not).

Styling Food for the Camera

Students often ask if it is important to understand photography in order to be a food stylist. We learn a lot just by working in a studio. I find it very helpful to understand some principles of photography, but the most important things for stylists to understand are how the camera sees the food differently from how our eyes do, how camera angles determine how we need to style, and how we can take advantage of the photographer's lighting. Any additional knowledge is terrific. (I have always felt that using a camera forces us to look at things a little more closely and also teaches us composition.)

It is imperative that we understand that the camera sees food differently from how our eyes do so we can correct for what the camera can't do. The camera has one eye, which means it needs help seeing depth and texture. In addition, it does not have peripheral vision. When we look with two eyes directly at an object, we see things to

the photographer as an interpreter

The following test photos illustrate how different photographers, given the same assignment and working with the same food stylist, contribute to the look of the final shot.

FACING PAGE
TOP ROW:

Having once taken a shot of a broken egg on white Plexiglas, this photographer suggested we test a salad using this technique.
Corrine Colen

We shot this fantasy salad on a reflective surface with no visible props for a clean look. *Corrine Colen*

For this salad shot, the prop stylist provided gradient background, the plate, and the butterflies. I used unusual white chervil, along with the usual green chervil.
Michael Waine

MIDDLE ROW:

Whenever time allows, try to shoot variations. Here, we chose an orange color scheme. *Michael Waine*

Here, the photographer supplied unusual asymmetrical bowls.
Deborah Denker

I call this the Fourth of July salad, with its all-American propping and bright, bold colors.
Amy Reichman

BOTTOM ROW:

This photographer reproduced an outdoor picnic environment in his studio. *Bill Margerin*

This scene was created by a photographer who also builds miniature sets. *Nora Scarlett*

Here, the photographer wanted to make a very simple, contemporary salad. *Dennis Gottlieb*

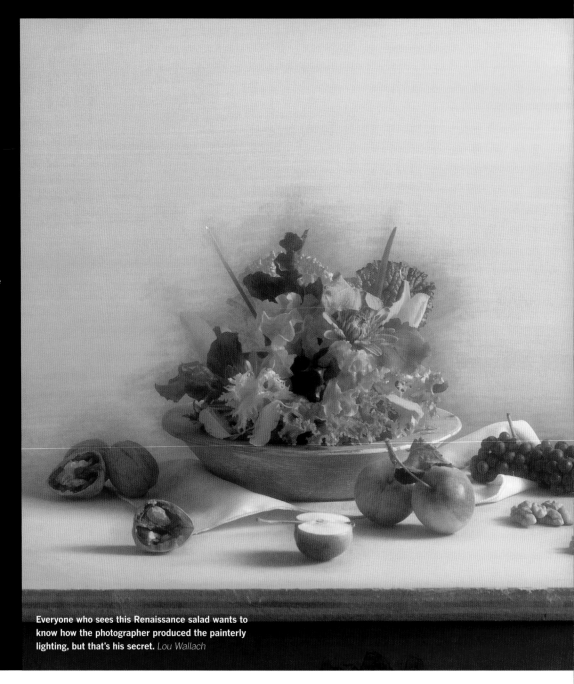

Everyone who sees this Renaissance salad wants to know how the photographer produced the painterly lighting, but that's his secret. *Lou Wallach*

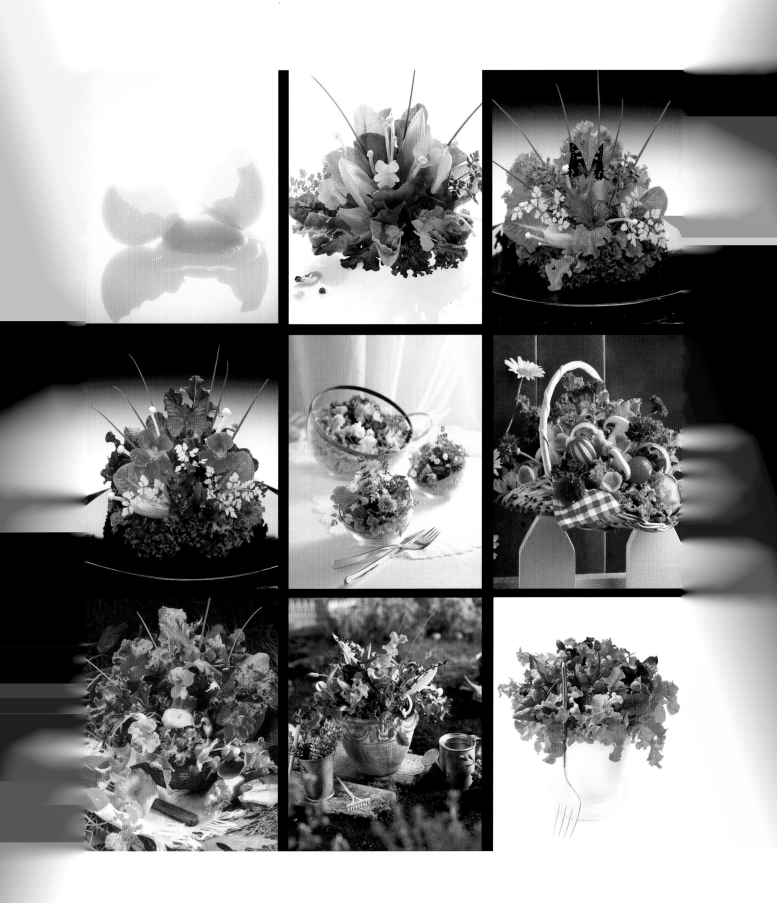

the sides of that object as well. The camera can't. It usually will see things in a rectangular format and only in the area determined by how close or how far away it is from the object. The photographer has lenses that will change the dimension of objects,

step by step: a shot of lemonade

The final shot of a glass of lemonade is the result of a combination of several layers of digital photographs.

TOP ROW:

Here, we shoot the naturally made lemonade splash against a yellow reflector card.

Next, we shoot the glass full of lemonade with moisture and lemon twist garnishes against a reflector card.

We remove the reflector card and allow the "sky" background to be seen.

BOTTOM ROW:

We add a slice of lemon to the rim of the glass.

Two more slices of lemon go on the other side of the glass.

We insert a decorative pick into the lemon slices. *Colin Cooke*

but the camera still has these limitations. The camera is also often locked down at a particular angle, and we must know that angle and arrange the food while looking at it from that angle (see the photographs on page 88).

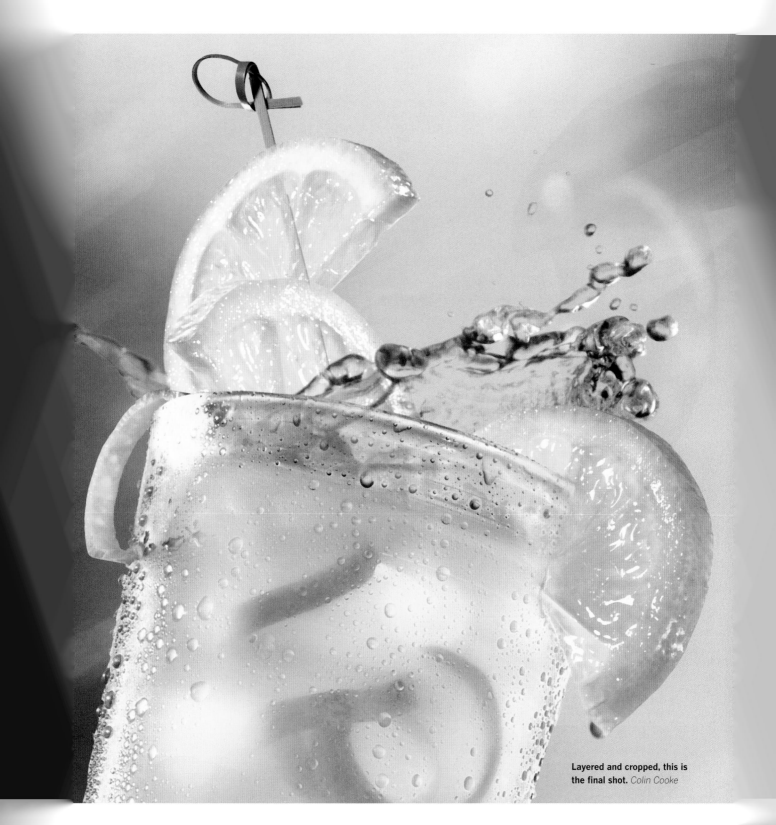

Layered and cropped, this is the final shot. *Colin Cooke*

Cookies arranged for a vertical and a horizontal shot.

Kelly Kalhoefer

In the days of film and Polaroids, food stylists would take a Polaroid to their work area and use it to judge the camera angle exactly. Today, we can ask the photographer to make a print of the stand-in image and we can use that as our guide. However, some photographers have monitors in the kitchen area for us to use for visual reference or, when we work right on the set, we can view the monitor as we arrange the food.

Photographers use any lighting technique available, but natural light is still very popular. The lighting style often used today in some editorial work is more severe, pulling in shades of blue and gray.

Digital photography makes our work easier, but it can also make it more time consuming. Often the client, photographer, or stylist may suggest, after we have the shot, that we try a slightly different look. Sometimes great creative shots come from "playing." While it is fun to experiment, it does lengthen the day, and we may need additional fragile food.

A monitor is helpful for arranging food on the set. The composition will always look different through the lens of the camera from the way it looks to the naked eye.
Colin Cooke

making a FOOD IMAGE work

There are certain food commercials, cookbooks, or advertisements that make a lasting impression. One example that everyone seems to remember is the first Red Lobster commercial with the lemon squeeze. Memorable images are those that say, "Wow...I have never seen that before" or "Doesn't that look luscious and inviting?" The image makes you want to eat that food, or buy that cookbook, or try that recipe.

I have been asked to judge cookbook photography for several culinary awards programs. What do the judges look for in good food photography? We look for a feeling of consistency and continuity in the photographs. The type of focus and the lighting are very significant. Do the pictures represent the theme of the author or the style outlined by the art director? If the book is titled *Simple Food*, do the pictures represent simplicity? If the foods are "retro," do the shots look retro? Does the food look fresh and invit-

ing? One of the major things we look for is creativity on the part of the photographer. Is there something new? We look at the skills used in the overall arrangement and in the selection of props. We look to see if the food stylist has made the food look mouthwatering and visually appealing. Yes, these are two separate concepts. To learn how to make food visually appealing and mouthwatering, see pages 64–71.

finding the CAMERA ANGLE

Always, always arrange the food looking at it from the angle at which the camera sees it. If you don't, for example, the dish you've arranged while looking at it from over-head and presented to the photographer who is shooting it from a low angle will not work. There is always a camera angle and a camera front.

While I was teaching at the Culinary Institute of America, we arranged a ham-burger and other food items on a set and then shot from three different angles: 0° (or eye level), 45°, and 90° (or overhead). Only the camera moved; the food did not (asee the photographs on page 88).

step by step: one kebab, different lighting styles

TOP ROW:

These kebabs were shot using several different lighting approaches. The first shot shows use of basic lighting before any adjustments.

In this shot, the lighting has been adjusted for greater contrast. Note the darker shadow.

Here, the lighting has been changed for a dramatic look with very high contrast.

BOTTOM ROW:

Nuances in lighting are vital to the success of the photograph. These kebabs suffer from flat, uninteresting lighting.

This photograph was taken using only natural light, which is often preferred for digital shots.

Colin Cooke

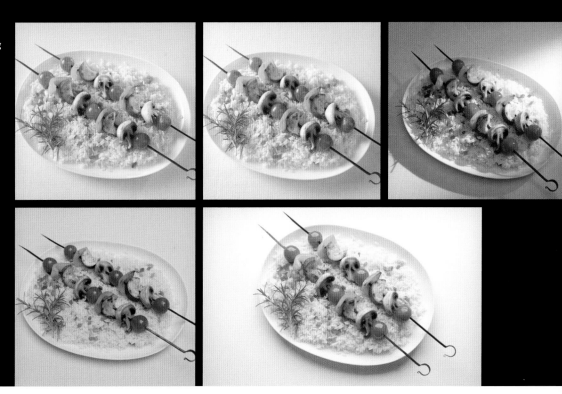

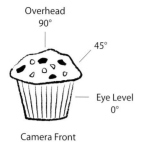

Overhead
90°

45°

Eye Level
0°

Camera Front

The food was arranged for a 45-degree shot. If we wanted to use the eye-level shot, we would work on the potato chips a little more and have photo descriptions or a recipe in the empty space on the upper left side. If we wanted to make it an overhead shot (90 degrees), we would need to terrace the ingredients on the hamburger and move the bun to the side, as well as fill in all the empty space around the hamburger.

same food—only the camera moves

TOP ROW:

Photographed at eye level.

The same arrangement photographed at 45 degrees above eye level.

BOTTOM ROW:

You can see that this arrangement doesn't work if we want to photograph at 90 degrees above eye level, or overhead.

To make the overhead shot work, the components need to be rearranged.

Lorna Smith for The Culinary Institute of America

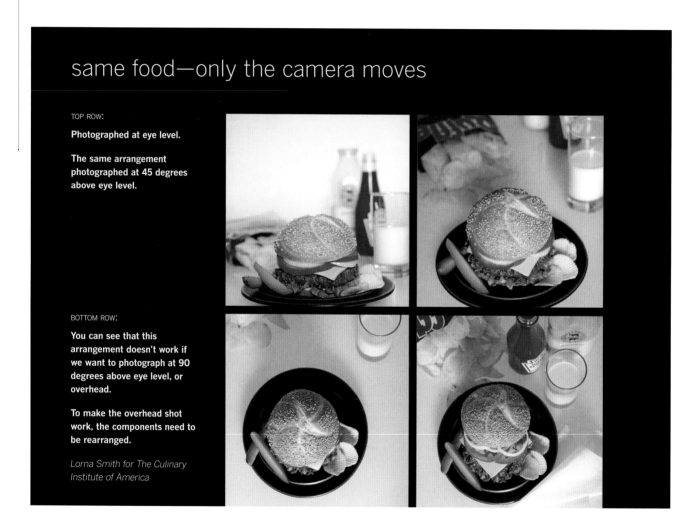

The ingredients in a photograph that are *not* food are called props. A prop can be anything from a simple white surface to a complex setting that includes a table, chairs, linens, candles, and flowers. Just the right props can add much to the image, even in the simplest of shots.

the basics of
PROPPING

the PROP STYLIST in action

In New York and other large cities, the person who supplies the props for a food shot is called a prop stylist or a photo stylist; in the credits, he or she is sometimes referred to simply as the stylist. Most of the time, especially in major cities, prop styling is a job separate from food styling. There are exceptions, however, such as when the food part of a photo shoot is not too demanding; then the prop stylist will do the food as well. Another exception is when the food stylist escorts someone who is appearing on television; then he or she will frequently supply both the food and props. Outside of major cities, the same person usually does both jobs.

There are advantages and disadvantages to doing both jobs. The advantages are that there are no surprises. You know what props you have to shoot with. You know the food and know what props will work best with each food item. The disadvantage is that you may not have the time or resources to get all the prop items or the variety you might want. In addition, if the props are not approved when you arrive at the shoot, you must go out for more and so lose time for the food. At some shoots, the prop stylist is expected to help select props and arrange the shot on the set. Again, you may not have the time needed to prep the food. At the back of the book, you will find listings of sources in New York used by both food stylists and prop stylists (see Resources, pages 387–388). Many have Web sites; however, it is important that you develop your own sources near where you live as well.

A good exercise for the beginning stylist is to look at shots that involve food and see what is included besides the food. Notice, too, that prop styling is more than just finding a bowl; the bowl needs to be the right size, color, style, and shape for the particular assignment (see the photographs on pages 208 and 209 for examples of how a simple peanut butter sandwich can take on different looks, depending on the props used).

LEFT: A single salad shot all in white draws the eye and holds it to the salad.

RIGHT: With another salad and additional props, the salads are less significant.

Dennis Gottlieb

Prop stylists need to be aware of the color scheme, the mood of the shot (whether romantic, old-fashioned, playful, upscale), and the audience for whom the shot is intended. They need to be creative, enjoy shopping, and have many sources. Sometimes the art director or photographer will give strong direction as to the style or mood he or she wants for a photograph, while other times it can be up to the prop stylist to determine the look. Most days, the prop stylist delivers props, unpacks, and leaves when things have been approved. On shoot day, he or she might stay to help arrange the set and perhaps give a napkin a special twist.

Early communication between the prop stylist and the food stylist is important, especially when certain foods are involved. If we are shooting a whole roasted turkey or crown roast, the prop stylist will want to know the size of the item so he or she can find an appropriately sized platter. Desserts, cakes, and pies have a specific circumference, and the prop stylist will need to know what it is. The prop stylist will also need to know if the bowl for the shot needs to hold ten servings or just one. I like to make sure that for desserts, the prop stylist can find flat serving plates or cake stands, which make for easier styling when we are showing a cake with a slice cut out. It is also important to let the prop stylist know when something needs to be oven-proof or when we need multiples of things. That way, we can work on the hero while the photographer works with a stand-in.

Prop styling is a job where more is often better than less. Have a variety of items to choose from. It is not uncommon, if the budget allows, to have a choice of ten plates and ten napkins for one shot.

Prop stylists need to develop sources for the things they may need. They may rent, buy, borrow, or promise photo credits to get props. Prop stylists must be organized and get items back to their source promptly and in good condition. They must develop the skill of returning purchased items without losing a store or supplier as a future source. Some prop stylists own large quantities of commonly used props and rent other items as needed. The hours can be long and physically demanding. In New York and some other areas, stylists may be hired for certain "looks" they are known for.

A very helpful resource on the topic of propping is *Photo Styling: How to Build Your Career and Succeed* by Susan Linnet Cox (see Resources, page 377).

TOP: **On this prop table, items are grouped together for each shot, with plenty of extra props for on-set adjustments.**

BOTTOM: **Each group of props is labeled for its corresponding shot. Identification tags are left on props that will be returned to a prop supplier.**

John Montana

DETERMINING the STYLE
Getting the Right Look

Prop stylists use the same tools and information as food stylists to get ready for a shoot. They may attend preproduction meetings and gather layouts, storyboards, and recipes. They may be shown items from tear sheets for the desired "look" in a shot. It is their job to ask questions and then procure the required items.

Food prop stylists should have a good general knowledge of food and know how to read a recipe for information they will need, such as what the finished dish may look like (its size or volume, color, and texture). Good prop stylists always ask questions if they are uncertain about the food. They should know the utensils with which the food is typically cooked and how it is usually served. Often it is very helpful if they can get doubles of things.

It is important that prop stylists understand the desires of the client and the art director. They need to check with the studio on when and where props can be delivered and arrange for a place for their display. The size of plates will be important for the food stylist to know so he or she can plan the volume of food or what the size of a slice of dessert will need to be. Sometimes the prop stylist will be the one to purchase ten specific pie plates; sometimes that will be the responsibility of the food stylist.

LEFT: Sometimes a colored plate works, but in this case, white is the best choice. The green and yellow plates both cause the pasta to visually recede.

TOP RIGHT: The serving looks small on this large plate.

BOTTOM RIGHT: On a small plate, the same serving looks much more substantial.

Dennis Gottlieb

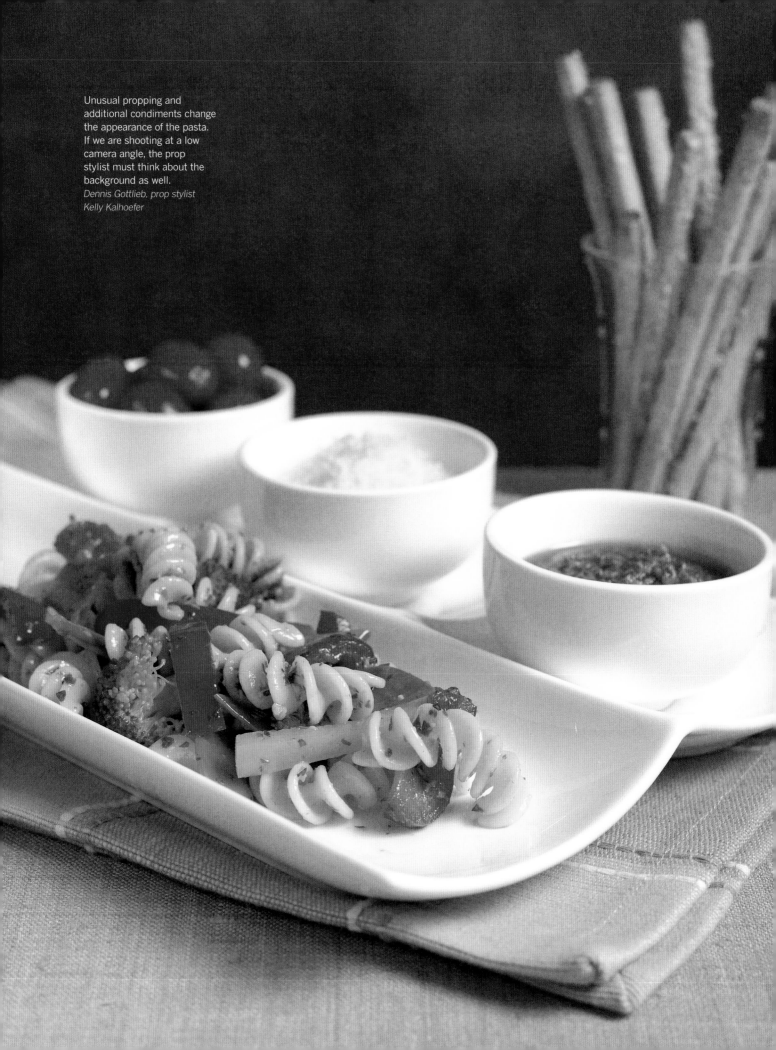

Unusual propping and additional condiments change the appearance of the pasta. If we are shooting at a low camera angle, the prop stylist must think about the background as well.
Dennis Gottlieb, prop stylist
Kelly Kalhoefer

LEFT: Some colors enhance the food more than others. Here, the green plate and the green tablecloth complement the red in the food and make the food stand out.

RIGHT: With this bright yellow plate and red tablecloth, the eye is drawn more to the props than to the food.

John Montana

A good prop stylist knows that:

- The color of a prop will either enhance the food or pull color away from the food.

- Bold prints on plates and surfaces distract from the food.

- There are many shades of white, and usually a warm white rather than a blue white makes food look best (see the photograph on page 68).

- Small plates make food look larger and allow us to shoot the food more closely.

- Flat plates are important if a whole cake with a slice out is being shot. The cake has a flat bottom and will cave inward if placed on a plate with an elevated rim.

- Plates that have tall sides or rims are difficult to style in if the camera angle is low.

- Prop stylists may need to save the food stylist with creative props if the food is not all that attractive.

- Food stylists appreciate the efforts of prop stylists when beautiful props make the food sing.

One Recipe's Journey

I once worked on a cookbook called *Perfect Pies*, for which we produced fifty shots of every variety of pie imaginable. We shot breakfast pies, fruit pies, chocolate pies, cream pies, country pies, tiny pies, and puff pies. We also had to come up with a large variety of decorative crust flutes and were given as many as forty different recipes for crusts. The editor of the book asked me for a couple of my own recipes. I gave her a recipe for a rhubarb-strawberry galette, a zucchini quiche, and a family favorite—an apple puff pancake pie.

The apple pancake recipe was one that I came to in a roundabout way. When I was a student at New York University, one of my professors, Dr. Ruth Linke, told the class about a wonderful breakfast pancake she made for houseguests, but she never

gave us the recipe. One day, while looking through a cookware catalog, I spotted a recipe next to a frying pan that was for sale. It was a recipe called Dorothy's Real Apple Pancake. The picture looked like the pancake Dr. Linke had described, so I gave it a try, but I found one huge mistake. The recipe served two and called for two tablespoons of cinnamon. Right away I knew this was not right. I played with the recipe and finally got it to its present delicious state.

My family loves the recipe, and I have prepared it through the years as we visited friends from Maine to Oregon. In addition, each year for more than thirty years, our family has sent out recipes as a holiday card at Christmas. Sometimes it is the recipe and a letter, sometimes it is a recipe and a picture taken by a photographer friend. This recipe is one of those holiday recipes.

Delores's Apple Puff Pancake Pie

MAKES ONE 10-INCH PIE | PREP TIME: 20 MINUTES | BAKE TIME: 25 MINUTES

¼ cup granulated sugar

½ teaspoon ground cinnamon

3 large eggs

½ cup whole milk

1 teaspoon grated lemon zest

½ cup all-purpose flour

8 tablespoons (one stick) unsalted butter, divided

2 tart apples, such as Granny Smith, peeled, quartered, and cut into ¼-inch slices

Sifted confectioners' sugar

Preheat the oven to 450°F and set out a deep 10-inch ovenproof skillet (a cast-iron one is best). Mix the granulated sugar with the cinnamon in a small bowl and set aside.

Lightly whisk the eggs, milk, and lemon zest in a medium bowl. Whisk in the flour until just mixed (the batter will be slightly lumpy).

Melt 4 tablespoons of the butter in the skillet over medium heat. Add the apples and sauté for 5 minutes, or until tender. Pour the batter over the apples and transfer the skillet to the oven. Bake for 20 minutes, or until the apples are tender and the pie puffs up high.

Meanwhile, melt the remaining 4 tablespoons butter in a saucepan or microwave. Remove the skillet from the oven. Drizzle the pie with the melted butter and sprinkle with the cinnamon sugar. Return the skillet to the oven for 5 minutes, or until the sugar mixture is bubbly.

Sprinkle the pie with a little confectioners' sugar and serve immediately, right from the skillet.

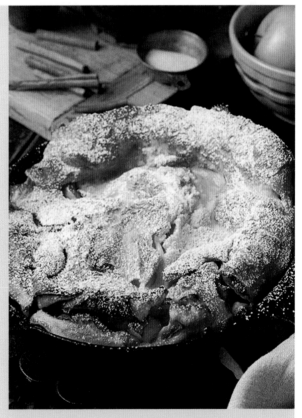

My apple pancake as it appears in *Perfect Pies*. *Beth Galton.*
Perfect Pies by Beth Allen (Reader's Digest, 1998)

A couple of years after the book came out, I was asked by a client, All-Clad, to develop ten recipes using All-Clad pans. (We would later shoot photographs of these recipes for promotional purposes.) As I looked at their wonderful skillets, I asked myself what these skillets could do better than most others. Besides holding heat beautifully, they could go directly from stovetop into a hot oven (which most home skillets cannot do because of wooden or plastic handles). Then I thought of the apple pancake pie, which needs to do just that, so I adapted the recipe for them.

Finally, for teaching purposes, I wanted to do some test shots with a photographer showing how props and color can change the mood of a shot. I thought the

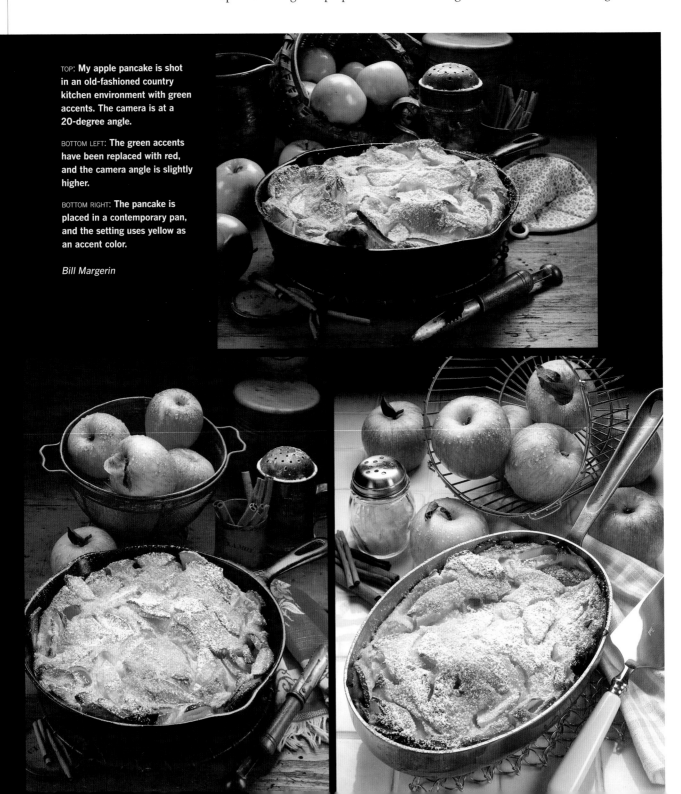

TOP: **My apple pancake is shot in an old-fashioned country kitchen environment with green accents. The camera is at a 20-degree angle.**

BOTTOM LEFT: **The green accents have been replaced with red, and the camera angle is slightly higher.**

BOTTOM RIGHT: **The pancake is placed in a contemporary pan, and the setting uses yellow as an accent color.**

Bill Margerin

apple pancake would be a good recipe to use. We photographed three shots that day: one shot in an old-fashioned environment with shades of green, one in an old-fashioned environment with shades of red, and one in a contemporary environment with shades of yellow. Each shot has its own mood that has been totally determined by the propping.

Parenthetically, while working on photography for this book, I made an apple pancake as a snack for the crew. When they finished enjoying it, I looked at the pan and the one slice left in it and said, "That looks like a shot you'd see in a magazine today." So we took this photograph.

The apple pancake is shot in the contemporary casual style of high-end food magazines.

Dennis Gottlieb

eclectic plates for an eclectic palate

I was in the middle of reading the autobiography of James Beard, called *Delights & Prejudices*, when I got an assignment from art director Keith Mascheroni, who had been asked to produce a poster for the second annual James Beard Foundation Awards presentation, which was to be held that spring at New York's Lincoln Center. The poster's sponsor was Villeroy & Boch, Ltd., so we would be using their beautiful plates. Mascheroni envisioned twenty different plates filled with foods that James Beard would like.

Each plate was to be shot from overhead during our one-day prep and two-day shooting assignment. It was up to me to decide on the food that would work well with the design and color of each plate. James Beard had an eclectic palate. I was told that I could choose any food, just as long as it was "good," so I had many choices. There was one other delightful request from the art director: Since James Beard always wore a bow tie, Mascheroni wanted to see a bow tie in some shape or fashion on each plate. We shot each plate separately; in fact, we shot twenty-one of them, just to be safe.

When I received the last plate to style, I was baffled as to what food to produce. It was a very graphic plate of black, red, and white with the designer's name written across it. Then I remembered James Beard's story about how he began his food career catering parties on New York's Upper East Side. He became famous for two hors d'oeuvres: One was his little tea sandwiches called onion rings, made from brioche or challah rounds and filled with thin slices of onion. The edges were rolled in mayonnaise and then in chopped fresh parsley (the recipe is on page 286 in *Delights & Prejudices*). The other hors d'oeuvre was cornucopia-shaped slices of salami piped with flavored cream cheese. Remember, this was in the 1950s. I decided to arrange these hors d'oeuvres in the shape of a bow tie, and that plate ended up being my favorite (see the plate at bottom left).

Other plates in the poster have special meanings for me. Mr. Beard and I both grew up in Oregon, and we share a great respect for the bounty of the area. On one plate, I have a salad with walnuts from my parents' walnut tree. In another shot, I produced an apple pie much like the ones my mother often made. Another plate contains green and white asparagus: James Beard's mother always served the season's first asparagus, which he looked forward to eating.

This was one of those assignments where I was allowed creative freedom, and it was a joy to work on.

LEFT: Arranging one of the bow tie–themed plates for the James Beard Foundation poster.

BELOW: The poster for the 1992 James Beard Awards.

Bill Margerin

THE JAMES BEARD AWARDS

CELEBRATING CULINARY EXCELLENCE · MAY 4TH 1992 · ALICE TULLY HALL · NEW YORK

As I said earlier, food styling for film or television is quite different from that for print because instead of producing just one hero shot at a time, you are working with food that something is happening to. You have more variables to take into consideration. When shooting commercials, you need to produce multiples of exactly the same food for multiple takes.

There are many areas in television and film production that use food stylists. Some of the work is done by freelance stylists, and some is done by full-time staff stylists. Let's first look at the various areas of television where the food stylist can find work.

the basics of
TV AND FILM PRODUCTION WORK

food styling for TELEVISION

Commercials

Commercials use freelance stylists exclusively. For each commercial, you will work from a storyboard (see the photograph on page 52). When shooting a thirty-second commercial, you will probably work at least a twelve-hour day and shoot many takes of the same scene. Even if the production company has one perfect shot, they will want another one or two for backup. You will need to know the shooting schedule and determine the number of assistants you will need. When you look at a story-board, you note the type of food you are working with. You look at the action taking place with the food. You check the shooting sequence. All this helps you determine the amount of food needed and the number of assistants. For example, if you are shooting pizzas, you may need one person making and shaping the dough, another cutting and sautéing vegetables and meats, and a third person grating and placing the cheese on each one. Another assistant will do the baking, and you will do the final touch-ups on the pizza before it is shot either as a whole pie hot from the oven or with a slice being lifted with a perfect stringy cheese pull. Sometimes you will shoot in a soundstage (a large empty studio space), and then you will need to rent all the major appliances you will need. Other times you will shoot on location (which can be anyplace from a beach to a fast food shop closed for the day to a rented house). In every case, there needs to be lot of communication between you and the producer ahead of time.

Cooking Shows

Cooking shows are an area of television that started in the early sixties with James Beard and Julia Child and blossomed into whole networks devoted to cooking shows. They can be from a half-hour to a full hour and are seen on the Food Network, public television, or on local TV. Ranging from educational and instructional to mostly en-tertaining, cooking shows have created a greater interest in the diversity of food and have made some chefs into stars. Very few of these shows are shot live, as they once were. Now they are taped and edited. Some shows use freelance stylists, while others develop full-time staff.

Home Shopping Programs

Home shopping programs are usually shot by a home shopping production company working with a small staff that deals just with food segments. The production com-pany hires freelance food stylists as needed. As a stylist on a home shopping program, you may get foods ready for authors who are there to sell their cookbooks or for peo-ple who are selling cooking equipment or a food product. The work is fast paced, and if the product is not selling, it is taken off the air on the spot. To start, you will need to become familiar with the cookbooks or products and decide how best to show them off. Perhaps you will produce a display of foods to illustrate what is in a cookbook or you will provide foods to demonstrate how a piece of equipment or a gadget works. Often people

TIP *One finishing technique is to spray a nonstick cooking spray on foods such as cooked meats and pizzas. It helps the food keep a fresh look over long periods of time.*

eat the food or prepare something during the segment. One of the unique problems of working with display food is that it must stay fresh looking over a period of at least thirty minutes. Choosing foods and garnishes that will do this is essential.

Infomercials

Infomercials are segments shown either at the point of purchase—in a grocery or kitchen supply store—or on television as paid fifteen-, thirty-, or sixty-minute commercials that highlight the uses of a food product or food equipment. As a food stylist, you work on these in very much the same way as you would on a home shopping program.

Talk-Show Segments

Work on talk shows can be either in-house or freelance for major networks or local TV. Much of the time when the work is freelance, you will be a media escort and act as the go-between for a producer and a spokesperson.

styling with julia

I have given Julia Child credit for my increasing interest and knowledge of food, which eventually led to my career as a food stylist. You can imagine the thrill I felt when I was asked to assist Julia during her appearance on *The Rosie O'Donnell Show* to promote her new book, *Baking with Julia*. Julia was eighty-six at the time, and what a trooper she was! I remember her saying, "Delores, I don't know why they want me to demonstrate crêpes suzette. I guess it is for the 'draw-maa' of it all!" Of course, the drama of crêpes suzette is flambéing them at the end.

Never one to walk away from a challenge, she discussed the recipe and then trusted me to get the demonstration ready. The producer not only wanted to show the step-by-step making of crêpes suzette, but she also wanted us to prepare, in advance, about five recipes from the book to put on the demo table. We had a fairly small demo table, so it was crowded with the five desserts, plus we had two hot plates, one for making the crêpes and one for the sauce and to keep the liqueur warm for the flambé. Neither Rosie nor Julia had had a walk-through. They just met on the set and it was showtime!

It was wonderful to watch two pros entertain and enjoy each other. I was standing off to the side praying that neither of them would go up in flames during the grand finale.

When it was time to ignite the liqueur, at first the flames did not show. This is not unusual, because the flame is so blue that in real life it is hard to see. (When we food style a flambé shot, we usually use lighter fluid because it produces a yellow flame that you can see.) Julia stepped in and added some more liqueur to the pan, and as Rosie moved the pan to pour the liqueur onto the sauce, up went the flame above their heads. The audience *oohed* and *aahed*, and the spot was a wonderful success.

Later, when reviewing the spot on video, I realized that the camera hadn't really shown the desserts that had taken my assistant and me a day to prep. We had put everything together in the hallway of the studio, with the only source of water being in the ladies' room. But none of that mattered. I was able to help Julia, and I was still learning the joys of meeting challenges from this gracious and talented lady.

I hope *you* will try the crêpes sometime; they are an incredible dessert and quite dramatic. Just be careful to heat the liqueur in a pan. "Do not pour the liqueur into a heated pan from the bottle," Julia said on the set. "The flame can jump back into the bottle and *whoosh*, you are gone!"

Rosie asked, "Has that ever happened to you, Julia?"

"Not yet!"

Television Series

Working on a television series is usually full-time work, and you are part of the production staff. You get all the food ready for any cooking or eating segments in the series.

Satellite Media Tours

A satellite media tour (SMT) is where an author promotes a cookbook from a studio with satellite hookup for TV interviewers around the United States—one interview at a time. This involves a very different type of styling because it means giving the same demonstration repeatedly. The work for food stylists in this medium falls into the media escort category, which is freelance work. You may be hired by a public relations firm that is promoting an author, food company, chef, or restaurant or you may be hired by the producer of the SMT. You will be responsible for all of the food and usually all of the props used (see page 332).

food styling for FILM

Food stylists also work in the film world, preparing food for industrial films or movies. The amount of work can vary from a one-day assignment to sporadic work over several months.

Some production companies are well-established companies with a full-time crew of basic personnel. Others form as jobs come about and the crew grows as more people are needed. Most companies shoot with a union crew, but if budget is a major issue a non-union crew can be put together.

Food stylists, as a group, do not belong to a union. However, when we work with a union crew we follow union rules. A source for locating production companies in New York City is the *New York Production Guide*. It also lists food stylists who work on commercials and in film. Other major film cities have production guides as well.

Industrials

Industrials are minifilms used by companies to train employees or used by salespeople. They are shot in-house by a full-time production staff, or a client hires an outside production company. As food stylists, we might work with a particular piece of equipment related to food or share recipes or techniques for preparing a food product. Industrials differ from educational films in that they are paid for by a particular company that wants the consumer to purchase its product, while educational films are there to provide information about a topic and may or may not be sponsored by a company.

Movies

When we work on a movie, we work with a prop master who places the food on the set, while you are not allowed to. Movie schedules change frequently, so food stylists must be flexible: The day production has scheduled the outdoor picnic shot may

be rainy, or the indoor kitchen shot may be changed to next week because the weather today is perfect for the outdoor shots. Because of the need for flexibility, it may be difficult for a stylist to combine the more rigid world of print with film work. However, some stylists have solved this by having several assistants available or a partner so they can juggle jobs. Basically, on a movie set you prepare foods as the prop master needs them; you take direction from him or her.

the cast of characters in TV and film production

The list of personnel (crew) involved in television and film production is a lengthy one. The crew for most commercials may range from a dozen to four dozen professionals, while the talent and crew for a film may number even more.

all loxed up with dan aykroyd

The most interesting film I have worked on was *Trading Places* with Dan Aykroyd and Eddie Murphy. I worked mostly with the butler, character actor Denholm Elliott, teaching him how to make and flambé (without going up in flames) crêpes suzette. I also made numerous servings of lobster thermidor for a dining scene. The most interesting part of this assignment was having to match a side of lox.

Part of this movie was filmed in Philadelphia (where the movie takes place), but many of the interiors were shot in New York City. In Philadelphia, Dan Aykroyd, playing a destitute Santa Claus, crashes a party, fills his pockets with rolls, and stuffs a whole side of lox down his Santa costume. Then he escapes on a bus. The next scene, which shows him removing the lox from his costume and gnawing on it hungrily in the moving bus, was shot in New York. The prop master had shot a Polaroid of the lox and measured it. It was my job to go to Murray's Sturgeon Shop and find four 15-inch lox cut from the left side of a salmon that matched the one in the Polaroid. I also needed to match the rolls, in case they were needed as well. That meant my calling a girlfriend in Philadelphia, who located the baker and sent the rolls. Of course, the shoot day was rescheduled twice. Thank goodness for the freezer.

Producer works within the production company on a commercial or film from the initial bidding process to completion of the spot. He or she needs to have the experience to estimate the costs of completing a commercial or film and knowledge of the creative abilities of possible crew. The producer may be part of the production company or a freelancer.

Director is responsible for the creative and technical aspects of the shoot. The director orchestrates the talent and controls the camera movement, lighting, and sound that make up the final look of the commercial or movie.

Executive producer is in charge of the overall production and oversees, with the director, the business, creative, and technical aspects of the production. Sometimes the director is also the executive producer.

Property master, or **props,** selects items for surfaces, such as tables and table-cloths, in a commercial. He or she works under the assistant director (see page 104). The food stylist may be hired by and work under the prop master on films.

Production manager supervises all the administrative and other details of the commercial or film, from budgeting to overseeing the activities of the crew. Any changes in food expenditures are reported to the production manager.

Location manager oversees the location and is the liaison among property owners, neighbors, and local authorities. He or she is responsible for securing insurance

papers, property releases, shooting permits, and special waivers. The location manager is a good person to help set up working space for the stylist.

Special effects work with us when our walnuts need to explode out of a shell in slow motion, or a newspaper needs to fall flat on top of an ice cream sundae at precisely the right second, or steam needs to be rising from a platter of spaghetti. Special effects helps us produce pouring shots, flambéing, steaming, and smoking grill shots.

Sound department records all the sound that takes place during filming. It is important for the stylists to know when the crew is rolling with sound and not to make kitchen noises during a take. Sometimes we shoot "MOS" (motor only shot), which means sound is not being recorded, so we can continue to work normally, but it is always best to work as quietly as possible.

Gaffer and team works with lighting and anything needing electrical power, whether it is provided in-house or by a generator on a truck. Always check with the gaffer before plugging in major appliances. If you need the refrigerator to stay on overnight, be sure to notify the gaffer because when a soundstage is closed, the electricity is usually shut off.

Director of photography (DP) creates the mood and visual style of the shots, including selecting the lenses and filters and lighting the set. Some commercials have a food DP specifically for food close-up shots and another DP for nonfood images.

Set decorator "dresses" the set. This job overlaps with props.

Production assistant (PA) is a gofer, or runner. Usually several work on a production; they will be assigned to specific departments.

Assistant director (AD) keeps the production schedule moving. He or she handles all the noncreative aspects of the shoot, allowing the director to be creative. The AD needs to be updated on the status of food preparation, sets call times for the stylist, and is the voice saying "Quiet on the set" and "Rolling."

Art director establishes the look of the commercial or film and the construction needed to achieve it. The art director meets with the producer and the director to determine the look and then does detailed sketches of sets. He or she has a team that includes set decorators, props, scenic painters, and a construction crew.

Set designer acts as the art director's right hand.

Greensman handles trees, plants, and shrubs on the set.

Makeup and hair get the talent ready for filming. Usually two different professionals, they stay near the set and continually adjust the hair and makeup.

Wardrobe gets clothes (and fittings) and accessories for the talent.

Production coordinator administrates the production office for the shoot.

Camera operator operates the camera.

Assistant cameraperson keeps the camera in order, loads and unloads the film, and adjusts and changes lenses. "Assistant focus puller," "second assistant clapper boy," or "loader" are other names for this person.

Video assistant provides the video equipment for viewing the footage or playback as it is being filmed.

Grip builds platforms, lays dolly tracks, places scrims (devices used in lighting) and screens, moves set walls, and does light carpentry. There are usually several grips on the set, and they work under the key grip, who receives instructions from the DP.

Location scout finds and documents location possibilities. Hired by the production company, the location scout and location manager are often the same person.

Script supervisor keeps records of all shots. The script supervisor helps keep continuity when shots are not done in sequence.

SHOOTING
Studio versus Location

Because production work can be in a studio or practically anywhere else, as the food stylist you need to be aware of what space you will have for working. When you work on a soundstage, you are basically in an empty room, but protected from the elements. There is electricity and sometimes running water or a sink (once in a while this is in the restroom). After talking to the producer about what is available, you need to let him or her know all of your needs so that arrangements can be made.

When you shoot on location, once again you must be flexible. In New York and Los Angeles, you can rent trucks with kitchens or sometimes use catering trucks. Other times and in other places, you may need to make a working kitchen from scratch. If you are working outdoors, you'll need to ask for shelter to protect your food from the sun and wind as much as possible. The location manager can help with this. As you get toward the end of the shooting time, get as much as possible cleaned up, because when shooting wraps up, you are expected to be ready to leave.

MONEY issues
Food Budget and Your Fees

When you work on a commercial, the budget for food is usually generous. Everyone realizes that it is better to have too much than not enough. It is always difficult to calculate the exact number of takes you will need to get the perfect shot, so plan on plenty of supplies. In production work, it is always wise to have an assistant and sometimes up to five or more, depending on the food and the type of shots. An example would be if you were shooting a Thanksgiving scene. If the shot is just a turkey being brought to the table, two or three beautiful turkeys would be fine. If the com-

mercial is selling turkeys (the product) and slicing into one on a tight shot, then you might need up to twenty turkeys, almost fully cooked and ready on garnished platters or cutting boards. In this case, you would require more assistants, many rented stoves, more props, and a hand model. Do insist on a food assistant rather than a production assistant (PA). Often a PA is not trained in food selection and doesn't have strong cooking skills.

The fees paid for working in production are usually higher than they are for editorial work. Food stylists follow strict union rules even if they aren't union, so if the production is working on a ten-hour day, you go into time and a half after ten hours. At twelve hours, you go into double time, and after fifteen hours you are in triple time. At the end of the day, everyone fills out a time sheet and gives it to the production manager. Your expenses, if you haven't been given petty cash in advance, should also be taken care of by the production manager at the end of the day.

SHOOTING a STORYBOARD out of sequence

Generally, the shots on a storyboard are shot out of sequence. The shots using the most number of the actors are usually done first for commercials, but not always. Sometimes the weather or time of day (location of the sun) will determine the sequence. If there is a lot of food in the first shot, you will need to do a lot of prepping at home, arrive very early, or have several assistants to help get things together.

The director and the AD determine the sequence of shots and approximately when each shot will happen. The assistant director usually relays any changes in schedule. You must always be flexible and able to change your prep, if needed. Even if you have one shot prepped, there is always something that can be done to get ready for the next. Often the product shots are saved for the last because they can be done without an actor.

As an instructor, I have found that everyone is interested in learning about the tools we use while food styling. In this chapter I have organized the tools I use into groups: those I have in my kit (which goes with me to most jobs), those in my knife roll, and those that perform specific functions. As you will see, the same tool may be listed three or even four times because of its many uses. Sometimes I discuss a tool in detail and other times, when its function is more obvious, I mention the tool in less detail. My tools were gathered over years of working as a food stylist. It is important to remember that the right tool *assists* the food stylist; it does not make a good food stylist.

the food stylist's
TOOLS OF THE TRADE

the KIT and the SET TRAY

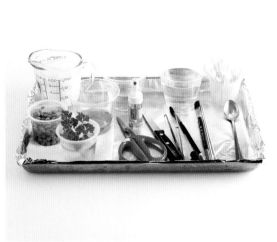

My first kit.
Jim Scherzi

LEFT: The set tray.
RIGHT: My kit.

Dennis Gottlieb

"Why do you have those perfect walnut halves in your kit?" This is a question I have been asked when working on many a job. The food stylist's toolbox, or kit, filled with unusual and unique items, is often a conversation piece in the studio. The kit may be in the form of a fishing tackle box or an artists' supply box. Some food stylists have their kits specially designed for them; some come to the job with one box, and some roll in with two or three. Whatever the volume, the kit is full of basic supplies and tools a stylist feels may be needed on any job.

When I first started out as an assistant food stylist, I put together a little orange Tupperware box of essential tools. I know I had tweezers, wooden skewers, Q-tips, a spritzer or atomizer, artists' paintbrushes, a can opener, scissors, a ruler, and some straight pins. Over the years, my kit has grown to what you see in the photograph below. I am a believer in having just the right tool for the job. I have watched people struggle while working with food. You can't get good results with a dull or incorrectly sized knife, a spoon too large for the job, or a spatula without the correct flexibility. Trying to place a garnish in just the right place while the food is on the set can be difficult unless you have tweezers. Applying a light glaze of vegetable oil with a brush with bristles that are too stiff causes carefully arranged food to move around.

Your tools can come from many different sources. My kit holds conventional cooking implements (oven thermometers, zesters, vegetable peelers, measuring spoons and cups), but it also contains dental and medical tools, sewing equipment, floral supplies, and pharmaceutical items. I have even purchased styling items from automobile and hardware stores. However, I have seen some food stylists work without any of these tools—just forks, spoons, tongs, and fingers—and they get beautiful results. Each stylist works differently, and each has his or her favorite tools.

Following are the tools I find support me best. But before I begin listing them, I would like to discuss something that I have mentioned several times, and that is the set tray. I cover an 11 x 15-inch jelly-roll pan with aluminum foil (shiny side down).

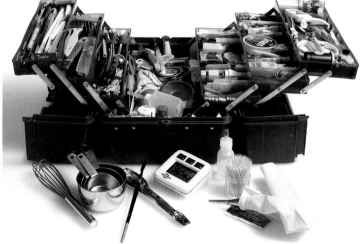

On this tray I put anything I think I'll need for last-minute touch-ups or additions to the shot we are doing. This way, when I go to the set, I will have what I need instead of having to run back and forth between the kitchen and the set. There are basics that always go on the tray: brushes, Q-tips, bamboo or wooden skewers, needle-nose tweezers, a small spray spritzer, long-handled spoons, Joyce Chen scissors, an eyedropper, a small sharp paring knife, and small containers of water, Windex, and vegetable oil. I also have containers with last-minute food additions, such as sauces or fresh garnishes.

MEASURING ITEMS: FROM SPOONS TO TIMERS

Measuring spoons. These are essential on most jobs, especially when working from recipes. I usually have two sets in my kit so assistants don't have to share one set.

Measuring cups. I carry only one set of metal stacking cups used for measuring dry ingredients. If I need glass (liquid) cups for measuring wet items or additional dry measuring cups for baking assignments, I pack them separately for each job.

Digital timer. I love my digital timers. They can time up to three things at once. I have one in my kitchen, one in my kit, and one in my cottage in Rhode Island. I have purchased them as gifts for friends and family. However, when I gave one to my eighty-six-year-old mother and explained the benefits to her (that I could time several things at once and also set the timer to remind me that I needed to make a phone call at a certain time), she said to me, "Delores, at my age, I only do one thing at a time." So much for our multitasking younger generation.

Compared with typical mechanical timers, which can be off by several or many seconds (or minutes), a digital timer is accurate to the second. It times cookie baking so accurately that each tray of cookies comes out exactly the same color. As we develop or prepare recipes, it is important to give specific times so that home consumers get consistent results.

Thermometers. If I need to use the oven in the studio where I am working, I always check the accuracy of its temperature with an oven thermometer I keep in my kit. An oven with severely fluctuating or inaccurate temperatures will *greatly* affect the results and look of

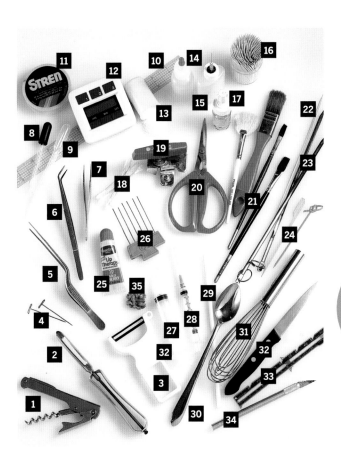

Typical items in a kit: **1** Corkscrew **2** American-style peeler **3** European-style peeler **4** T-pins or wig pins **5** Tweezers with long point **6** Needle-nose tweezers **7** Very fine-pointed tweezers **8** Glass eyedropper **9** Pipette **10** Transparent plastic ruler **11** Fishing line or filament **12** Digital timer **13** Film container holding sodium bisulfite **14** Small plastic bottle of Photo-Flo **15** Glue applicator with needle syringe **16** Toothpicks **17** Handheld spray atomizer **18** Cotton swabs **19** Small can opener **20** Joyce Chen scissors **21** Variety of brushes **22** Bamboo skewers **23** Metal skewers **24** Cocktail skewers **25** Petroleum jelly **26** Metal comb **27** Syringe for adding and subtracting sauces, liquids, etc. **28** Syringe for injecting liquid to produce steaming foods **29** Plastic straws **30** Long-handled iced tea spoon **31** Small whisk **32** Thin paring knife **33** Sewing gauge **34** X-Acto knife **35** Sanity walnut.
Dennis Gottlieb

TIPS *A digital timer is sensitive to wet hands and dust (flour), so keep it covered with plastic wrap at all times. Set the timer through the wrap.*

To measure flour or most dry ingredients, gently spoon the ingredient into the metal cup and then level off the top of the cup with a spatula or knife.

TIP *The oven thermometer is one piece of equipment that is often left behind when a job is finished.*

your food. If I have a job that requires a lot of baking and don't like the studio oven, I will prep the job at home.

There are some jobs where the temperature of the freezer (for ice cream and frozen desserts) or the refrigerator is important, too. I bring freezer and refrigerator thermometers specifically for these jobs; I do not carry them in my kit.

Instant-read thermometers. When you are cooking meat or reading the temperature of ice cream, instant-read thermometers are always necessary. They are long stemmed and come in digital or analog versions. I bring candy and deep-frying thermometers on jobs only when they are specifically needed.

Ruler. A 12-inch clear plastic ruler is handy for measuring the sizes of props, preparing templates of cake and pie slices that will go on certain-sized plates, and determining the best size to cut such things as brownies. The plastic makes it easy to see through and easy to clean.

Sewing gauge with a movable slider. I use this helpful gadget, normally used to measure hems and seams, when it is time to cut perfect, consistently sized bars or brownies. It works like a T square. I used to measure with my plastic ruler and place straight pins sticking out where I needed to cut the brownies; now I just use this device.

Tape measure. If you can find small lightweight tape measures, get two—one for your kit and one to carry with you always. I can't begin to tell you the number of times I have found a tape measure handy when I am out shopping. I have needed it to measure the length of a turkey or whole fish, as well as the sizes of plates, pans, platters, and cooking pots.

CUTTING ITEMS: FROM SCISSORS TO PEELERS

Scissors. I always have two pairs of scissors. One I use for cutting paper, plastic, thin cardboard, or film card, and the other is my Joyce Chen scissors and is the one I really love. These scissors were first available in the early eighties, and all food stylists began using them. I carry two pairs in my kit. They are strong enough to cut through chicken bones, but they will also do very fine work, such as snipping off one little leaf of dill that is too long. I always have Joyce Chen scissors on my set tray.

X-Acto knife (and blades). I use my X-Acto knife most often when I have to slice through very fragile items, such as pie crusts. I also heat the blade to slice through the outside layer of chocolate-covered candy bars before I break them open. You will find many other uses for this knife, I am sure.

Mat knife. This is just a heavy-duty version of the X-Acto knife. Most studios will have these, so if you don't want to carry one, it is not usually necessary. I have used them to cut out different thicknesses of cardboard shapes to use as support behind or under fragile foods, such as soft white bread and sliced wedges of desserts.

Vegetable peelers. Vegetable peelers are notorious for being dull. I once took a bag of carrots to a shop and tried out the peelers before committing to buying three of one kind. I like the A. Aronson brand for general peeling, but I have a cou-

ple of other brands in my kit as well. Each peeler will give you a different thickness, and sometimes I need a thicker or thinner look for chocolate curls or carrot curls. I also use a European or Y-style peeler for making large strips of citrus zest. Other tools that cut and strip include corers, zesters, strippers, and scoops. Buy good-quality peelers and make sure they are sharp.

USEFUL BRUSHES: FROM ARTISTS' BRUSHES TO TOOTHBRUSHES

Artists' brushes. I use top-quality artists' brushes for tasks such as brushing food with vegetable oil or water. I like brushes with blunt or flat tips ¼ to ½ inch in width and with dark bristles. The dark bristles are better because if a bristle does come loose, I will spot it more easily than a blond bristle, which is hard to see with the naked eye, but which you can be sure will show up in the shot. I have a variety of different-size brushes, but they all have very soft bristles (test them for softness on the back of your hand). If the bristles are too stiff, they will move your food as you add a little moisture or glisten to the lime garnish on the margarita or to the green beans that were just perfectly placed.

Pastry brushes. I carry several sizes and qualities of pastry brushes. The larger brushes get used for pastry items (of course), but also for enhancing the color of poultry, brushing shortening evenly on baking pan surfaces, and putting moisture on large food surfaces. The smaller ones are reserved for more detailed work.

Toothbrush. This item deserves special mention. I use a toothbrush to spritz bottles, glasses, and cans with moisture droplets to give a cold or chilled illusion (see the photograph on page 289). I have several of these brushes in a variety of sizes, but *all* of them have stiff bristles. With today's dental recommendations, stiff-bristled toothbrushes can be hard to find; check in the denture section of your pharmacy.

SKEWERS AND STICKS: FROM STRAIGHT PINS TO Q-TIPS

Bamboo or wooden skewers. When I was teaching in Japan at the Japan Food Coordinator School and made an instructional video, called *How to Food Styling*, that was going to be sold there, I was asked to name seven of my favorite or most-often-used tools. Besides knives, brushes, spritzers, Q-tips, long-handled spoons, and tweezers (which I discuss later), I mentioned bamboo or wooden skewers. This simple little item gets used in so many ways that several of them are always on my set tray. I use them most often to move small items on plates that are already on the set. I use them to carefully plump up individual rice grains and other foods that have settled with time. I use them to support the backs of buns and rolls when I make sandwiches and to support garnishes in opaque beverages. I use them to hold food items together and to hold up the legs of poultry during roasting. It doesn't hurt to have these in a variety of lengths and thicknesses.

Metal kebab skewers. These skewers are used primarily for putting grill marks on meats and vegetables. My favorites come from France and have a wide flat surface and a thin side surface. I like them because they hold the heat well when I place them over a gas flame and because I can use the wide surface for strong grill marks on large pieces of meat and the thinner side surface for more delicate grill marks on chicken, shrimp, and smaller items.

Toothpicks. The shorter version of the wooden skewer is the toothpick. Although a toothpick has many uses, a major one is to hold cold cuts and tomatoes in place in sandwiches or to anchor lettuce on hamburger buns and sandwiches.

Cocktail picks. I always carry a few unusual picks, and every once in a while they become just the perfect garnish holder for a beverage shot.

Matches. Don't forget to carry matches to light fussy gas stoves or propane torches as needed.

Straight pins and T-pins or wig pins. Straight pins are used to hold chicken and turkey skin together where it has been torn, to attach citrus zests to straws, or to attach a tomato top "borrowed" from another tomato. The T-pin is primarily used to pin chicken (see the photographs on page 222), which is what we do when we take extra skin and hold it in place. When the chicken is cooked, the skin tends to shrink, leaving some flesh exposed. You will find lots of other uses as well.

Plastic straws. I always have a couple of straws in my kit. I use them most often to make citrus curls by taking long strands of citrus zest and pinning one end to the straw, then twirling the strand around the straw and attaching the loose end to the straw with another straight pin (see the photographs on pages 161 and 294). Straws can also be used for taking the chill off ice cream that has been under dry ice—blowing hot air over the area softens it—or for blowing smoke (preferably cigar smoke) on specific areas of food for a steaming effect.

Q-tips. I prefer the Q-tip brand because they fuzz less and seem more absorbent. I use them constantly. I carry a small number in a compartment in my kit for easy access and have a full box on the side, as well as some in a cup on the set tray. Q-tips are used along with water, saliva, or glass cleaner for cleanup. I also use them to move fragile foods, scoop up sauces that have spread more than desired, clean up foods that weep, and remove extra bubbles in beverages.

SPATULAS AND SPOONS: SPREADERS AND SCOOPERS EXTRAORDINAIRE

There is a large variety of spatulas available from both cooking supply and art supply stores (they are the source for palette knives, for example). I have at least one of just about every size and shape and have found that having just the right one for the job makes a big difference.

Flexible palette knives. I use palette knives mostly for spreading frosting, peanut butter, and cream cheese. These knives come with tapered, offset, and baker's blades. I use the tapered blade (which comes to a narrow point) or the small dental spatula for getting frosting between cake layers or adding just a little of something, such as mayonnaise or rice, to a certain area. Offset and baker's blades can be used for margarine spreads or frosting smaller surfaces (these spatulas should have good flexibility), as well as for placing just the right-sized butter square at just the right angle in just the right place (see the photographs on page 233). I also use one exclusively for melting butter and chocolate: I heat it with a propane torch on the set just before we shoot. I call it my melting spatula (it looks as if it has been through wars).

Flexible slotted spatulas and spoons. I use these for deep-frying and also for lifting anything that I am blanching or cooking in large amounts of water, such as shrimp and vegetables. I use a Kitchamajig by Ekco for removing small amounts of food from boiling water or when deep-frying. I like this tool better than tongs because it is gentler on the food.

Rubber spatulas. Rubber spatulas have changed over the years. Besides traditional rubber spatulas, which are used for scraping out bottles and bowls, some now are heat resistant. "Spoonulas" are slightly cupped and heat-resistant as well.

Wooden spatulas and spoons. I use these for frying and sautéing because they are soft and don't damage the food as much as metal tongs or spatulas. I don't carry my longest spatulas and spoons in my kit—I pack them as needed.

Long-handled iced tea spoons. I have a collection of iced tea spoons with differently sized and shaped bowls. Each bowl allows for a different volume, pouring surface, and spreading surface. For example, if I want a dollop of whipped cream to be a certain size and shape, I will choose a corresponding spoon for the job. If I want to pour just the right width and amount of gravy down a slice of turkey, I will choose another spoon. I also use baby spoons and have spoons that give me just the right measure to create swirls of pudding on a spoon, in a small cup, or in a large bowl (see the photograph on page 299).

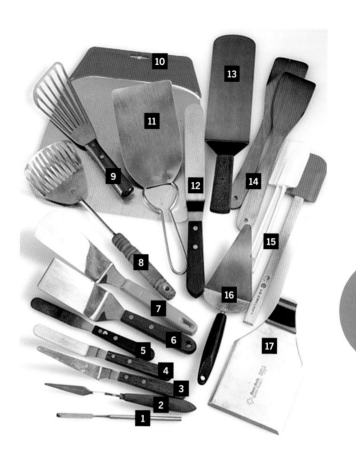

Spatulas for every job: **1** Dental spatula **2** Small pointed offset spatula **3** Artist's palette knife **4** Regular offset spatula **5** Melting spatula **6** Small stiff turner **7** Thin, flexible turner **8** Slotted spoon **9** Slotted spatula **10** Large stiff turner for transporting cakes and pizzas **11** Large flexible spatula **12** 11-inch offset spatula for smoothing frostings **13** Large turner good for lifting and transporting cakes **14** Wooden spatulas **15** Rubber spatulas, both regular and heat resistant **16** Pie and cake lifter **17** Wide stiff pancake turner. *Dennis Gottlieb*

Items Packed as Needed

Larger offset spatulas. The 10-inch and longer blades are used for frosting larger surfaces or smoothing chocolate on cake surfaces or onto a cool flat surface prior to pulling chocolate curls.

Turners. The turners with a 3 x 8-inch blade are extremely helpful in lifting cakes and large items onto a surface. A friend from Germany sent me a very large spatula that measures 10½ x 9½ inches. It is called a Universal-Kuchenlöser and it is wonderful for lifting whole cakes, pizzas, or other large foods. Flat cookie sheets also work for this purpose.

Pancake turners. Instead of a traditional turner, I have found that pancakes turn beautifully with a wide (4½ x 5½-inch), stiff putty spatula that I found at a hardware store.

Fiskars small turner. With a 5-inch, extremely thin blade, a Fiskars turner easily slides under cookies without damaging the cookies' sides.

Cake and pie lifter. I use a very pointed one (just a cheapie) that gives support to the tip of the cake or pie wedge, which is very important.

HOLDING THINGS IN PLACE: FROM WAX TO WIRES

Things that hold objects in place range from straight pins to twine, thread, fishing line or filament, hairpins, thin wire, rubber bands, and armature wire. I will give you just a couple of examples of how these things come in handy: I thread carrot curls onto a long thread with a needle and place the threaded curl in iced water to get consistent and tight curls. I use fishing line or filament to tie the legs of poultry together before roasting. It holds up well to the heat and is often invisible when shot at a distance. U-shaped hairpins hold shaped cold cuts or lettuce leaves in place. Here come other favorite things that hold things in place:

Fun-Tak/BlueStik and mortician's wax. BlueStik, once known as Fun-Tak, is a reusable adhesive that is sold in most office supply stores and, along with mortician's wax, in photo supply stores. Most photographers have these adhesives on hand to use for any number of jobs, but most often to hold reflector cards in place or to hold an object, such as a fork, at a specific angle to the light. Food stylists use the adhesives to hold sliding or moving objects, such as crackers or cookies, in place on a plate. We also use a wad of it to lift the back edge of a food item to improve its height or angle to the camera. Fun-Tak/BlueStik seems to work better than other reusable adhesives. It is stickier and adheres to food items best, so try to find that brand. We use mortician's wax when we need a clear support and the blue-green Fun-Tak/BlueStik might show in the shot. Even though photographers usually have a supply of these products, have some in your kit, particularly for television and film jobs or for the occasional photographer who doesn't.

Flower-Fix. This is another sticky thing that comes in a small round can and never hardens; I use it in spatula shots to keep pizzas or pie slices from sliding. Just smear some on a spatula or tilted plate and food stays where you put it. There is a similar product used to hold candles in place.

Zap-A-Gap and Jet Set. Zap-A-Gap and Jet Set are glues that come in small bottles that are easy to carry in your kit. The glue of choice among food stylists seems to be Zap-A-Gap because it bonds almost anything (including your fingers, so be sure to also carry a debonding agent—usually found in the glue section of the store). Food stylists often use it to hold poultry wings close to the breast while cooking.

Elmer's Glue-All. A small bottle of Elmer's comes in handy when you have to attach additional sesame seeds to the tops of buns. The good thing about this glue is that when it dries, it is invisible.

Vaseline or petroleum jelly. I take a wooden skewer and pick up a little Vaseline, place it in a hole on the surface of a slice of cake, and then top the Vaseline with a chunk of cake crumb. I have patched up graham cracker piecrusts with Vaseline mixed with crumbs; I have filled in holes on the surfaces of sliced bread and attached crunchy flakes to bare spots on a piece of fried chicken. In addition, when

I want the moisture droplets to really sit up on the surface of a tomato, I rub the surface with Vaseline first.

Floral foam. I use it to hold ice cream cones upright when working on the ice cream topping.

ODDS AND ENDS: FROM TWEEZERS TO CORKSCREWS

These items are no less important for your kit (everything becomes important when you don't have a needed tool), but they don't belong in one of the other groups. The first few items in this list are used constantly.

Tweezers. The tweezers I use most are found in dental or medical supply stores. They are the long needle-nose type called college pliers. They have a very small pointed tip that picks up most items easily. The only negative aspect of these tweezers is that they can leave a mark on some soft foods, such as cooked mushrooms. If you can find tweezers with a broad, flat surface for soft foods, it is helpful. I have one other type of tweezers. It has the smallest, finest point, and I might use it for removing just one piece of lint from the surface of a chocolate glazed dessert. Although with digital retouching lint, crumbs, and small imperfections are easily removed, this was not always the case.

Small spray atomizer. If rice needs to glisten and salads and fruits need to look refrigerator crisp, the small atomizer is the answer. I check the size of droplets as well as how wide the spraying area becomes on the back of my hand. I prefer a spritzer that doesn't spray too large an area or produce too fine a mist. At one time, we food stylists discovered a spritzer in the pharmacy that we all loved. It was an atomizer containing an eye refresher called Eyegenic, and we each had at least two. We also all ran out to find more when we learned it was being taken off the market. We didn't use the contents, but we loved that spritzer. Every once in a while I run into a prop master on a TV shoot who still has one and guards it carefully. Probably the best place to find small atomizers is a drug store or perfume counter, and they might also be available from companies that are promoting products with small samples in spritz bottles.

Glue applicator with a needle syringe. This tool is used for fine gluing and is found in craft and hobby shops. It can add one drop of moisture at a time for extreme close-up shots of a slice of tomato and lettuce on a cheeseburger, for example (see the photograph on page 205). Sometimes I use a mixture of water and glycerin for a beaded effect.

Eyedroppers and plastic pipettes. Eyedroppers and pipettes are available at your pharmacy. We use them to add a little ketchup coming out from under the melted cheese on a cheeseburger or to strategically place a little sauce, gravy, or salad dressing. I also use an eyedropper and a little detergent or Photo-Flo to put bubbles in beverages to give them that "just poured" look (see the photograph on page 297).

Syringes. Various sizes of syringes come in handy when we need to add a sauce or milk to a very small and specific area. I have used them to inject moisture into meat or prepared baked potatoes before microwaving them for steam shots. I have also used them to remove excess liquid from a beverage.

Can opener. Let's think of five ways to open a can if you are shooting in Central Park and forget this tool. (1) Pray the prop master or caterer for the crew brought one. (2) Use a bottle opener (church key) to punch the top open, being careful not to cut yourself on the spikes. (3) How about a saw? Does anyone have one? (4) If you're desperate, maybe a handy rock will smash it open. (5) Best yet, *always* carry a can opener in your kit. I found a very small lightweight one while I was traveling in Europe. This is also where I found my first very sharp vegetable peeler. Tip: You can find some interesting gadgets that are not normally available in the United States while traveling in other countries. Keep an eye out.

Corkscrew. You might think a corkscrew is found in any kitchen, but often it is not.

Metal comb. The long metal spikes of these combs, commonly used for teasing hair, are good for adding texture to breads and cakes and also for opening English muffins.

Cheesecloth and a small strainer (sieve). Cheesecloth, strainers, and sieves are handy for straining anything or smoothing sauces. You can remove large particles from sauces so the sauce can go through a squeeze bottle or a syringe. Sometimes, I strain the herbs from salad dressing and place them later (these herbs are called "particulates" in the business). In some cases, coffee filters can be substituted for the cheesecloth that lines the sieve. I also use an unlined sieve for dusting foods with confectioners' sugar or spices. A variety of mesh sizes are available, from fine to coarse. Finding just the right-size mesh can make a big difference in a dusting presentation. I keep one small strainer in my kit and bring larger ones as needed.

Pastry bags and pastry tips. I carry a variety of pastry bags and tips in my kit. In addition to the usual uses for these tools—decorating cakes and cookies, piping doughs and mashed potatoes—I have used the tubes to cut extra holes in Swiss cheese, small circles of cookie dough for decorations, or perfect pimiento circles for stuffed olives. I have also used the bags as funnels. Some people like the plastic disposable bags, but I prefer the flexible cloth bags, except when using foods that will stain them.

Plastic squeeze bottles. I use plastic squeeze bottles almost as one would use a pastry bag for items such as mustard, ketchup, syrups, sauces, and gravy. As I work, I store filled bottles upside down in a tall glass to get rid of the air bubbles.

Funnels. You need a funnel to fill the squeeze bottles; however, I usually don't include it in my kit. Having several sizes is handy. One that I got at an automotive store (normally used for changing oil) has a very long snout and is useful when I pour vegetable oil into cruets or liquids into tall glass containers and I don't want to get splashes on the glass walls. I also use a funnel when I am adding liquids to a glass on the set and don't want splashes or for the liquid to run over plastic ice cubes (see the photograph on page 288).

Squeeze bottle tops. I carry several squeeze bottle tops in my kit (cut to different width openings), and they act just like round pastry bag tips. Having the right-sized opening on a bottle top will make a big difference in producing the look you want. I often test different openings before choosing one (see the photograph on page 186).

Glass bulb basters. Found in medical supply stores, the bulb baster can be used to remove excess, unwanted, or tired liquids from a glass or coffee cup and then refill the glass with fresh liquid. I like medical basters because they have good suction and don't dribble like the ordinary kitchen ones. The medical basters come in a variety of sizes, but I carry the small one in my kit.

Fruit-Fresh. This product is found in most grocery stores (it is used for canning foods that turn brown, such as peaches) and can be used to keep many foods from browning.

Sodium bisulfite. This is an antioxidant that can be found at chemical supply stores and some pharmacies. Sodium bisulfite can be one of a food stylist's best friends for keeping food looking fresh. One *major note of warning,* though: Some people are very allergic to sodium bisulfite, and if they eat or drink anything that has been touched by it, they may die. So, if you choose to use it, please be very careful. It keeps lettuces and herbs fresher longer. It keeps foods that brown when you slice or grate them (potatoes, mushrooms, apples, peaches, bananas, avocados) from browning much better than lemon juice and water will (see page 133). You need only a little—½ teaspoon to 3 cups water—and you can either dunk the food in the water briefly or brush exposed cut surfaces with water mixed with sodium bisulfite. Just remember that no one should eat this food!

Emery boards. While you are at the pharmacy, buy some emery boards for smoothing the rough edges of cookies or dog biscuits (yes, I have been known to style pet food as well).

White cotton gloves. Often photographers have gloves, and they are used for handling anything you don't want to get fingerprints on, such as silverware, glasses, and chocolates.

I carry a small whisk, two flat handheld graters that produce a variety of shreds, melon scoops of various sizes (also good for coring apples and pears), a butter curler, a lemon stripper and zester, and a decorating knife or zigzag cutter. I carry two small packages of soy sauce (from takeout food) in case I need to "brown" something, and liquid food colors of various hues. I have a couple of packets of gelatin and a small plastic film canister full of cornstarch for thickening sauces. A bottle of lemon extract (and a Q-tip) are used for removing brand names stamped on produce (for example, on citrus fruit).

Finally, I always have Band-Aids (for the usual kitchen accidents), aspirin (for the not-so-wonderful days), hand cream (because my hands are in water a lot), and fingernail polish. The fingernail polish I use to mark my equipment. It is a good idea to mark everything you own because your brush, tweezers, or measuring cups often look just like those the photographer has.

The tools and equipment I have mentioned above are the items I find most useful, but I am sure some

walnut halves: *a source of healthy perspective*

What about the perfect walnut halves that I mentioned I carry in my kit? The walnuts are there to remind me from whence I came. They are from my parents' tree in Oregon. When I was young, each fall we would harvest and dry our walnuts. Then, in the evenings after Thanksgiving, Dad would crack the walnuts (he had his special way of cracking them so we got perfect halves), and the rest of the family would shell them. The walnuts were then packed up and sent in our Christmas boxes to our relatives in the East.

When a job gets a little crazy, I have the walnuts to remind me of the *important* things and help me put a little perspective on the day.

stylists have other items they find essential and they never use some of my items. You will build your own kit to fit *your* needs and style, and the needs of the jobs you have. Today, more and more styling is very natural and fewer and fewer specialty tools are used or needed.

the food stylist's KNIFE ROLL

I carry only one knife in my kit—my paring knife; the rest of my knives go in the knife roll. A variety of good-quality knives is essential. This is not the place to skimp. Invest in top-quality knives that are comfortable for you to hold. I happen to like F. Dick, Wüsthof, and J. A. Henckels, but there are other good brands as well. I buy stainless steel because carbon steel discolors some foods. You need four or five basic knives to get started, and you will add knives as you need them. These are the ones I have found I rely on.

Chef's knife. My 6-inch-blade (yes, 6-inch) chef's knife is the one I use the most. I know that professional chefs are used to longer knives, but for food styling, I find this the most comfortable size for me. Its smaller size allows for more control when I am slicing and chopping. Consistency in size and thickness is often important to produce just the right look, so you need good knife skills and good control.

Paring knives. These are the knives I use second most. I have them in several different lengths; again, it is what feels comfortable to you. One of my favorites has an extremely thin blade, and this one I do carry in my kit (with a shield). I love this knife because I can do extremely fine work with it.

Slicers. Once again, the length of these knives should be based on what is comfortable for you. I have 6-inch, 8-inch, and 10-inch slicers. I probably use the 6-inch most often, but I rely on the 10-inch slicer when I am cutting cookie bars or slicing cakes into layers. I also have a very thin-bladed sushi-quality hollow ground knife that works beautifully for slicing cream pies or other foods when I need a smooth release.

I started my career with four basic knives: paring, chef's, serrated, and slicing. Now, my knife roll also includes a sushi knife, a wide-blade chef's knife, a cheese knife, tongs, offset spatulas, and pie servers, as well as a sharpening steel, a hand-held knife sharpener by Chantre, and other useful items. Your knife roll will grow as your jobs demand different tools.
Dennis Gottlieb

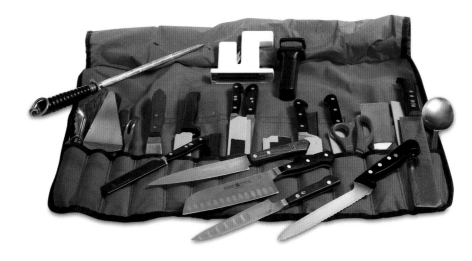

Serrated knife. I have a 10-inch serrated bread knife—it's wonderful for breads, of course, but also great for slicing tomatoes or other fragile fruits.

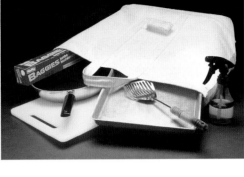

My canvas bag holds tools such as 3-gallon clear plastic bags, jelly-roll pans, and lightweight plastic cutting boards.
Amy Reichman

Beyond the basic four knives, I would add a boning knife and cheese knives. I have two cheese knives: one with one handle, which I carry in my knife roll, and one with two handles, which I bring on jobs requiring me to cut through wheels of cheese. Cheese knives also work well for slicing through whole frozen pies or other frozen foods. They do a beautiful job of slicing unmolded trays of Jell-O into cubes or making very clean-cut cookie bars. Another knife that most food stylists swear by is an electric knife. Electric knives are most often used for very clean, thin cuts of meat (roasts and hams), as well as for bread. To keep all these knives extremely sharp, I carry a round steel, which comes in sizes from 12 inches to a small pocket size that fits in the kit. I also love my Chantre Knife Sharpener, which does a good job of easily sharpening and realigning the knives' edges. There is no substitute for a stone-sharpened knife, however, and if you are not proficient at using one, find a professional to sharpen your knives. Good, sharp knives are essential.

Other items in the knife roll or case can include roast forks, kitchen shears, cleavers, flexible and offset spatulas, melon ballers, tongs, whisks, flexible slotted spatulas, and turning spatulas. A very good mail-order source for professional-quality equipment is JB Prince (see Resources, page 387), which ships internationally.

What do I use for carrying my kit, knives, and other essential equipment? I use canvas carry bags. These bags were originally used to haul coal, so they are well constructed (see Resources, page 385). When you shop for the bags, make sure that they are made of good-quality canvas and have handles that are comfortable to grasp and not too long. I have about a dozen of these bags, and for some jobs I need them all. A couple of the bags I own were purchased from a different source and are just a little too small for my kit. Make sure they are the right size for *your* equipment. I also have one extra-large canvas bag for toting larger equipment. One of my canvas bags stays packed with the things I will need on every job. It contains my kit, knife roll, aluminum foil, Saran wrap, boxes of 1- and 3-gallon Baggies, a box of Q-tips, and my apron, side towel, and comfortable shoes. The other bags are packed with equipment as needed.

other BASIC EQUIPMENT
Everything *and* the Kitchen Sink

I consider my hands one of my most important tools. I use my hands constantly. For me, it is imperative that I touch (often gently) the food I am working with. I plate most of my food with my hands (this habit can become a little embarrassing if I forget my manners at home or at a restaurant). My hands tell me the texture of the food, they separate and place hero foods, they crimp pies, and they tell me temperatures.

Two times in more than twenty-five years I felt nude when I arrived at a job because I forgot to bring my apron and side towel. I seldom wear an apron when I cook at home,

TIP *Turning a plate upside down and placing it over sorted food on another plate of the same size will help protect your hero food by forming a dome over it. You can even tape the two plates together.*

but for some reason when I am on a job, it grounds me. It is the first thing I unpack when I arrive at a job, and when it is on, I am ready to work. Some food stylists place their logos on their aprons as a subtle promotion. When I worked at Cary Kitchens, we also gave out aprons with our logo as gifts. Side towels are absorbent cotton towels used for drying anything and often as a hot pad as well.

What follows is what I call my list of "everything but the kitchen sink," but I am afraid it also includes the kitchen sink (or large plastic tubs or bowls). The list begins with the equipment I use most often. It has taken me many years to accumulate all the things I have. I have added items as the jobs require them. If it is equipment that I should have (such as 8-inch glass pie plates or four 9-inch cake pans), then it is my expense. If it is equipment that will be unique to the job, such as 5-inch heart-shaped tart pans, then I charge the client for it, and it belongs to the client. The list may seem daunting, but remember that you add things as you need them.

Plastic cutting boards. I bring a cutting board for each of my assistants and one for myself. I like them because they are lightweight and also because they can go into the dishwasher for a good cleaning. I put a damp paper towel under each one before I start working to keep it from slipping.

11 x 15-inch jelly-roll pans. I pack as many jelly-roll pans as I think I might need for a job; I have a dozen. One of these is used as my set tray (see the photograph on page 108). Others are used to organize food for shots. (An assistant will put all the prepared and sorted foods that I need in order to plate an assignment on one or two trays. That way, as I need them, the foods are available in one area.) Before I begin the day, I line the trays with aluminum foil (shiny side down, which prevents glare) and stack them for easy use. Try to find pans that are not too lightweight, since lightweight pans tend to buckle when used in the oven. But avoid the very heavy ones—remember that you will be carrying them. The pans also go into the oven, freezer, or refrigerator. When I store things on them in the refrigerator, a 3-gallon plastic bag fits nicely over one, and if I happen to need an additional pan, I can just pull the pan out, leaving the food and aluminum foil base behind in the bag.

Disposable aluminum sheet pans and plastic plates. Some stylists prefer to use disposable sheet pans or plastic plates for sorted food. I use them, too, if we need more than my usual twelve jelly-roll pans or if I need to save space by using the smaller plastic plates.

Plastic cups. I like 8-ounce plastic cups for holding small quantities of chopped or prepared food as well as the water, vegetable oil, and Windex on my set tray.

Stainless steel nesting bowls. Stainless steel bowls are lightweight and don't break. Food photographers usually have them in their studio kitchens, but when I work on location or when I go to a studio for the first time, I bring several if I know they will be needed for the job.

COOKING EQUIPMENT

Stainless steel saucepans. I use stainless steel saucepans (because aluminum pans may discolor foods) in a variety of sizes. Sometimes I bring the lids, but often I don't.

Frying pans. My frying pans are nonstick. Get good-quality pans so they will last. When you are searing food (particularly meats and seafood), the food doesn't stick or tear. I can use an almost greaseless pan to produce a seared or grilled look.

Cast-iron grill. If I have a lot of grilled items to produce (and if I don't need a certain size grill mark), I use a cast-iron grill.

Electric 8-quart saucepan. I use this large pot (Dutch oven, stockpot, casserole— they go by many names) for deep-frying and also as a cooking pot in studios without stoves.

Electric hot plates or portable propane burners. When working on location without a kitchen, these come in handy.

Electric frying pan. I use an electric frying pan in locations without a kitchen or, for example, when someone is appearing on television or on a satellite media tour and there are no stoves.

Farberware electric griddle. I love this griddle. It gives me very even heat; I use it almost exclusively for making pancakes. Look for the aluminum griddle made in the 1980s and 1990s. The new ones are quite different. Contemporary griddles that have good ratings are BroilKing and West Bend.

Portable oven. I have a small portable oven that I use right next to the set when I need to get a food to the set immediately—for example, soufflés and oven-baked pancakes that deflate.

Portable microwave oven. Most studios have microwaves or can get them. I use the microwave next to the set when I need to produce steaming food for a shot.

Toaster oven. I use a toaster oven for evenly browned English muffins, bread, frozen waffles and pancakes, nuts, and seeds, and for heating small food items. Try to find one that stays on when the oven door is open. That way you can continue browning food while turning or working with it.

Propane torches. I have propane torches in three sizes. My largest is a Bernz-Omatic with a helpful push-button starter. This is very easy to use; no matches are required. I use this to reheat the outside surface of meat that has become chilled. It gives hamburgers, hot dogs, and ribs that "I've been on the grill" look. I do not use it to give a grilled look to vegetables because the result looks very spotty and fake; I use a hot nonstick pan for that purpose. I can brown meringues with the torch, but I prefer the more even look from the oven. The torch does brown the sugar on the top of a crème brûlée nicely. I also

TIP *I have always had trouble getting the propane torch I need when I am shooting in foreign countries. I have arrived to find everything from a huge propane tank for a stove in Chile to something about the size of a cigarette lighter in Japan. Before I travel, I try to send pictures of a torch I want, but it seems each country has its own version and it is not like ours.*

use a torch to heat a spatula on the set just before we shoot a butter melt. I have a smaller torch, called a Rekrow electronic instant ignition micro torch, that I use for browning small areas or for directly melting margarine or butter (see the photograph on page 142, number 5).

Pencil torch. I found this torch when teaching in Chile. It works much like a continuous match, but it is hotter and will heat or sear very small areas. You can't carry a torch when you travel by air. (If you will need one when you are working in distant locations, make sure you request it.)

Liquid measuring cups. I bring liquid measuring cups in a variety of sizes as needed. The 4-cup liquid measuring cup is good for holding large bunches of herbs in water in the refrigerator. I also have some plastic liquid measuring cups (1- to 4-cup capacity) that are lightweight and don't break, but are harder to read accurately. My favorite plastic measuring cup has a 2-cup capacity and a spout that doesn't dribble when I stop pouring. I use this cup on the set when I am adding liquids to beverages or soups and don't want to dribble on the paper or cloth surface. I call this my "pouring cup" (see the photograph on page 207, number 12).

Colanders. In addition to their use in draining hot foods, colanders can substitute for steamers or be used to blanch large amounts of vegetables at once. I use a slotted spoon or Kitchamajig by Ekco for removing small amounts of food from boiling water or when deep-frying. I like this tool better than tongs because it is gentler on the food.

BAKING EQUIPMENT

For baking jobs, it is imperative that you have good-quality (and the right color) baking pans. When baking, everything matters. Dark-colored pans tend to make dark-bottomed cookies, crusts, and sides of cakes. Glass bakes differently from metal, and each metal (aluminum, stainless steel, copper) produces a different result.

Nonstick cookie sheets. Nonstick cookie sheets produce darker and thinner cookies; they work beautifully for lace cookies or brandy snaps, but for little else. I prefer the plain, old-fashioned, heavy-duty-aluminum cookie sheets with only one raised side.

Silpat nonstick baking mats. Silpats, as well as parchment, prevent cookies from sticking to a pan. I test a batch of cookies on several surfaces (greased, ungreased, Silpat, and parchment) to see which gives me the best results.

Cake pans. Cake pans need to be straight sided and of good quality. I use cake pans that are 2 or 3 inches deep, and I have several in various diameters (8, 9, and 10 inches).

9-inch glass pie plates. I use glass pie plates for most jobs because they are the size used in most recipes and because glass heats hotter than metal and gives me a crisper crust. If a job requires that you show a pie in a particular pie plate with more "character," get several from the prop stylist before you begin baking. Many of the pie plates with interesting character are deeper than the traditional 9-inch plate, and you may have to increase the volume of the recipe for them. I once worked on a cook-

book about pies. We shot fifty different pies, and I am sure that the prop stylist found every possible type of pie plate around. They all had different capacities, which in itself added interest to the assignment.

Tart molds. These molds, which have removable bottoms, come in a huge variety of shapes and sizes. Get them as needed.

Springform baking pans. Try to find commercial quality when you purchase springform pans because they hold up better and last longer. (See page 244 for tips on lining springform pans.)

Bundt pans. It is helpful if Bundt pans have a non-stick surface, but often that makes the sides of the cake darker. Again, I have several types, sizes, and shapes. (See page 244 for tips on preparing Bundt pans.)

Muffin tins. I have muffin tins in a variety of sizes. If possible, get professional-quality tins because they are deeper than the home consumer type and produce muffin sides that are taller and browner. However, when you are testing and writing recipes for home consumers, be sure to use the equipment that they would use. (See page 245 for tips on preparing muffin tins.)

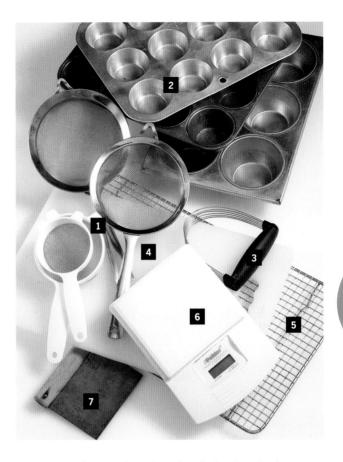

Useful tools: **1** Sieves with a variety of mesh sizes from fine to coarse **2** Cupcake and muffin tins in various sizes and materials **3** Pastry blender **4** Lightweight plastic cutting boards **5** Gridded cooling racks **6** Digital scale weighing ounces and grams **7** Flexible bench scraper. *Dennis Gottlieb*

Baking pans. You'll need several 9 x 13-inch rectangular pans for cakes, bars, and gelatin cubes, as well as 8- and 9-inch square baking pans. A standard loaf pan is 9 x 5 x 3 inches. Having loaf pans in a variety of sizes is important as well. (See pages 243 and 244 for tips on lining baking pans.)

Cookie cutters and biscuit cutters. Cutters in a variety of sizes and shapes are often needed. It is helpful to have at least one set of round pastry cutters, as well as a few shapes of holiday cookie cutters. These are especially handy when you get a holiday job in June, when the cutters are a little more difficult to find. You will accumulate many cutters over time.

Cooling racks. My preference is for the sturdy rectangular racks that are called "grid" or "mesh". They prevent the deep grooves that you get on cakes when they are cooled on ribbed racks. I use cooling racks to cool everything, including pancakes, waffles, and toast. They allow all exposed areas to cool evenly and prevent curling toast or moist bottoms on foods. If I am concerned about the rack leaving grid marks on a surface, I put paper towels or waxed paper on the rack before the baked item goes on. Round cooling racks are useful for cakes, and I have several cooling racks that are the perfect size (10 x 15^1/$_2$ inches) to be used as dividers between cake pans when I have to transport lots of cakes to a job in my canvas bags. I also have one cooling rack that has rods that are about 3/$_4$ inch apart and

feet that are about 1 inch high; I use it as a bacon rack. I weave room-temperature bacon over the rack, put the rack on a jelly-roll pan, and bake the bacon at 350°F until it is crisp—and I have perfect bacon with beautiful waves (see the photographs on page 196).

Mixers. I have lightweight handheld mixers that I take to jobs. I also have a couple of stand mixers, including a Sunbeam that I use frequently for prepared mixes (cakes and other baked goods). I think that most mixes are tested and give the best results with this type of mixer. I also have a heavy-duty KitchenAid, which gets used for other baking assignments and is wonderful for creaming, beating egg whites, and mixing bread batters. You'll get very different results from mixer to mixer and from brand to brand.

ADDITIONAL EQUIPMENT

Food processor. My food processor is used most frequently for making fake ice cream, but many food stylists like processors for making piecrusts and pureeing soups. When you puree soups, you get one look and texture with a processor and another with a blender.

Professional-grade blender. I have a professional-grade blender that I use for drink shots. However, for some jobs where there are multiple drinks in one photo, you may need to have several blenders. (Because blenders and processors are heavy to transport, call the studio to see if they have them. It is also important to ask if the blenders or processors work and, in the case of processors, if they have the metal or plastic blades, lids, etc.) The professional Vita-Pro blender makes incredibly smooth soups and makes slush drinks that have a very fine, smooth, icy appearance. It produces a look that you will not get with other blenders. However, whenever I develop recipes for the home consumer, I use the type of blender found in the average home. I also have a miniature handheld Aerolatte whisk for blending soups or sauces right in the pan they are cooked in.

Digital scale. A digital scale is one piece of equipment that is a must when developing recipes at home or for doing jobs where you weigh ingredients. (For example, the scale is used in weighing portions of frozen entrées—2.3 ounces of peas, 5 ounces of mashed potatoes—or for baking something by weighing rather than measuring ingredients.) I have one in my kitchen and a smaller version for jobs. They can weigh either ounces or grams. Sometimes I do need to convert one to the other.

Graters. Several with a variety of surface openings produce a variety of looks for cheeses and zests. I have a favorite but unusual tool called a Moulinex (made in France), which produces long, round shreds of cheese for tacos, pizzas, and other foods requiring cheese toppings (see the photograph on page 179). Also, the carpenter's Microplane has made it into the kitchen; it finely grates cheese, chocolate, ginger, and citrus zest.

Whisks or whips. Have a few whisks or whips in a variety of sizes and shapes.

Ice cream scoops. I prefer the Hamilton Beach brand of ice cream scoop, particularly the early ones made in the United States and now found at garage sales. They produce the best bark, or ridges, on the scoops of ice cream. I bring a variety of

THE FOOD STYLIST'S TOOLS OF THE TRADE

sizes to a job, since it is difficult to know which size will produce just the desired look for a pie à la mode or which will be the size needed for a prop bowl chosen at the studio just before the shot (see the photograph on page 277). Small scoops are ideal for making drop cookies a consistent size.

Plastic containers. I use plastic containers to protect foods when getting them to the studio or location. Having been in the business for more than twenty-five years, I have four Tupperware Pie Takers (I don't think they still make these, but you can find them online), as well as a couple of their Cake Takers. Many types of plastic containers can be found in the average grocery or housewares store. Other sources are suppliers to caterers and food-service professionals. It is best to get containers a little larger than a 10-inch cake or pie will need.

Plastic tablecloths. When I go on location (outside of a typical studio), I bring a few plastic tablecloths to protect my work surface and also to claim the area as mine.

Trivets or flame tamers. I take trivets or other heat diffusers to location shoots in case I need to bring hot things to the set or just need a place to put a hot pan.

Hot pads. Don't forget these, but if you do, side towels work almost as well.

Large plastic bowls or tubs. Remember that at the beginning of this section I said we would discuss everything including the kitchen sink? Now it is time for the kitchen sink. On location we are often shooting in the kitchen, so I can't work in there. But we always need water. I bring along a couple of large bowls or tubs and use them as my sink when other sources of water (the restroom or washroom) are not handy.

Garbage bags. You can create trash cans by attaching garbage bags to the side of a table with clamps.

I know these lists look daunting, but remember that these are tools you will accumulate over time. The lists are not all-inclusive, and other stylists may have basic tools they find particularly useful that I haven't mentioned. A good source for descriptions and pictures of kitchen equipment is a book called *The New Cooks' Catalogue*, first published in 1975 but revised in 2000 (it is out of print, but you can find copies online).

TIP *Putting double-sided tape on the bottom of cakes or pies in their pans keeps them from moving during transportation.*

TOOLS and EQUIPMENT at the PHOTOGRAPHER'S STUDIO

The items in this section are useful tools and equipment that you can usually count on the photographer to have. They have been creatively repurposed by stylists over the years to add effects to food.

Armature or aperture wire. This wire is used by sculptors and sold in photo supply and art supply stores. It comes in many thicknesses. Photographers usually have some because they use it to hold small reflector boards and other objects in place

125

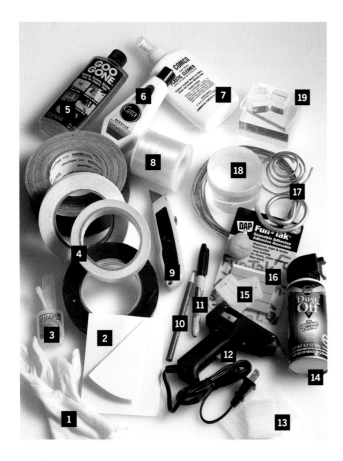

Things you will typically find in a photo studio: **1** Cotton gloves **2** Film card **3** Zap-A-Gap **4** Various kinds of tape **5** Goo Gone **6** Fingernail polish remover **7** Plastic cleaner **8** Fishing line or filament **9** Mat knife **10** Grease marker **11** Permanent markers **12** Glue gun **13** Mortician's wax **14** Dust-Off **15** Plastic wedges **16** Fun-Tak/BlueStik **17** Armature or aperture wire of various thickness **18** Round plastic disks **19** Square plastic disks.
Dennis Gottlieb

on the set. I use it to run through hot dogs so that I can shape them to hold a bend. I also attach it to the backs of some foods to hold them upright.

Photo-Flo. Photographers use Photo-Flo for cleaning developed film. Stylists have found that it can be squeezed into beverages to produce bubbles for that "just poured" look (see the photograph on page 297).

Film cards. You can get your hands on these if the photographer is still shooting film. Film cards are thin but supportive pieces of white cardboard that separate unexposed sheets of film. I use them to prop up fragile foods, such as a slice of pie. I also use them under fragile foods that must be arranged in layers, such as slices of eggs or meat loaf, or underneath pancakes so they will lie flat when stacked. I can make butter spreads on them and then place the butter where needed (see the photographs on page 183). I use them to make templates for sizes of pie and cake slices, so my hero slice of pizza, cake, or pie is the same size as the stand-in (see the photograph, number 2). These are becoming antiques as everyone now shoots digital.

Plastic cubes or blocks. Plastic cubes or blocks come in a variety of sizes. We use them to mark or place around stand-in props before taking the stand-in from the set so that the final food and prop can be placed in the exact same spot. We also put them in opaque drinks and other liquids, such as soups and puddings, to provide support for garnishes that we want to rest in the center of the drink or food. When foods need additional height, plastic cubes or blocks can be slipped under the foods.

Black masking tape. Photographers cover unwanted reflecting sources with black masking tape. Stylists use it to hang recipes, layouts, and shooting schedules for easy reference. We also use it behind holes in food arrangements (see the photograph on page 200) and to mark camera front on props.

Mortician's wax and Fun-Tak/BlueStik. Most photographers keep a supply of these adhesives on hand to use to hold objects in place (see the photograph, numbers 13 and 16).

Apple boxes. Heavy-duty wooden boxes are used by photographers to stand on or to place under table legs to raise a table to counter height. Apple boxes come in different sizes. They can be placed on a counter to lift the food being styled to a comfortable eye level if that is our camera angle.

Extra tables. Photographers usually have extra tables on hand that can be set up to give stylists additional counter space.

LEFT: Small plastic blocks indicate the placement of the stand-in so that the hero can easily replace it. The front black tape marks camera front. *Dennis Gottlieb*

RIGHT: Instead of using plastic blocks to mark stand-in food, photographer Jim Ong uses a carpenter's laser marker. *Jim Ong*

Professional baking racks. These are tall racks on wheels that hold a lot of professional-size sheet pans. They are a wonderful source of additional storage space and can be moved to a handy location.

Work lights. Photography studios have lots of lights, which are sometimes needed in the kitchen area either to duplicate the light we will be using on the set or for additional light to work by. Never feel shy about asking for additional light if the light provided is not sufficient. Some stylists bring their own clamp-on lights, but the studio should be able to supply them.

Professional clothes steamers. Studios generally use clothes steamers to remove wrinkles from prop fabric. However, stylists can use them to heat food on a plate or to add steam just before shooting. I've also found them handy for melting processed cheese.

Ice chests. Most studios will have a couple of large chests. We can use them as additional freezer space and to hold dry ice, if we are using it for the assignment. Never put dry ice in a refrigerator or freezer because it destroys the internal regulating thermometer.

Dust-Off. A product that removes dust from camera lenses, Dust-Off is also handy for clearing the set of any unwanted crumbs. Turned upside down, it can act as a coolant for small areas of ice cream.

Spray Mount. Caution: noxious fumes; use in a ventilated area. Most photographers have a can of Spray Mount among their supplies. It produces a sticky surface when sprayed. If I have to attach a lot of seeds to a bun, I often spray the top of the bun and sprinkle on all the seeds at once.

Krylon Crystal Clear spray. This spray is often used to hold surface moisture in beverage shots.

Dulling spray. Dulling spray reduces the amount of glare or shine on foods.

Paint sprays. Aerosol paints normally used for painting cars can be used to change the color of props, such as plates and bowls. They won't chip.

You can usually find bottles of Kitchen Bouquet (for "browning" effects) and light Karo corn syrup in a photographer's cupboards. Some photographers have a good supply of cooking equipment and some do not. When working in a studio for the first time, it is good to bring what you will need, just in case.

HOMEMADE EQUIPMENT
to the rescue

There are some tools we need that don't exist, and other tools that just need to be modified for our purposes. Many of the tools we use were originally designed for other specific purposes, but we have found wonderful ways to adapt them—such as taking a sewing gauge with a movable slider and using it as a T square for measuring uniformly sized dessert bars, or heating metal kebab skewers to use for searing grill marks on foods. Remember that if there is a problem, there is often a solution. Sometimes it just means creating the tool to solve it. The following list is not exhaustive; be open to your own creative solutions.

Ice cream scoops. The problem: how to pull a beautifully barked or ridged hollow circle of ice cream. Ice cream scoops with releases, or dishers, break the thin pull of a hollowed scoop of ice cream. The solution was to remove the release. Many stylists who work with ice cream file a sharp edge on one side of the scoop and some add length to the handle for easier scooping.

Electric charcoal starter. The problem: how to quickly put grill marks on volumes of food. The electric charcoal starter has a coil that produces a continuous high heat, but it often produces grill marks that are too wide or thick for some foods. Food stylists have had the coils pounded to a thinner shape by a blacksmith for a more natural look.

Heating pad. The problem: how to prevent melted chocolate from returning to a solid state. Placing a pan or bowl of chocolate on a heating pad can keep chocolate in a liquid state until needed.

Styrofoam ice chests. The problem: how to easily work with real ice cream in a cold, controlled environment. Many stylists have taken large Styrofoam chests that were used to ship frozen products to the studio and modified them so they can place them near the set and have time to work with frozen foods (see the photograph on page 276).

Pizza delivery boxes. The problem: how to keep cooked pizzas from becoming cold and cheese from congealing quickly. The delivery boxes that you want are cloth-covered Styrofoam, not cardboard. Styrofoam boxes keep pizzas warm for a good while, so they are handy for holding pizzas until they are ready to be shot.

Grid-covered cutting boards. The problem: how to get perfectly and consistently sized cubes of gelatin squares or cookie bars. Draw a grid on a large piece of paper, cover the paper with plastic wrap, and put it on a plastic cutting board. You can use the lines as cutting guides.

Revolving cake stand. The problem: how to get even circular swirls on the tops of pudding and margarine tubs. Place the tub in the center of a cake stand. Fill a large spoon with the product, making sure the surface on the spoon is totally smooth, and slowly spin the stand as you release the product, forming an even outside circle. Repeat for the next inner circle, starting from the back of the tub each time.

Heating element. The problem: how to heat or reheat small areas of food, or add a toasted or charred look to some foods. My former partner, Fran Shinagel, invented my much-coveted heating element by attaching a heating unit (used in old-fashioned wall heaters) to a long 1 x 2-inch board. This works better than paint strippers, which have a metal plate covering the top of the element. With my heating element, it is easy to see the food below, and the element puts out a very hot, concentrated heat (see the photograph on page 142, number 1). For example, I can use it to reheat a pizza slice (but not the whole pie).

Guide for slicing cakes. The problem: how to easily cut layers of cake the same thickness. I have a series of 2 x 4 and 1 x 2-inch boards that I use as a guide for slicing cakes. Simply decide how thick you want the cake layers to be and choose a board of that thickness. Then, run a long slicing knife over the board and across the cake circle, producing two even layers (see the photograph on page 250). (Professional tools that do the same thing are available.)

One stylist who specializes in cakes had a three-sided square box built just large enough to hold an 8- or 9-inch cake round. She cut many cardboard squares to exactly fit in the bottom of the box. She then filled the bottom of the box with cardboard squares until the cake reached the height she wanted. Using a tight wire held along the top of the wooden box, she pulled it across the top of the cake, slicing the top off and giving each layer a consistent height.

Ruler for finding the center of pies and cakes. The problem: how to get a slice of cake or pie cut to the exact center of the circle. For this I found plastic sheeting with grid lines. I cut strips 1 inch wide and 18 inches long and attached two of them together in the exact center with a brad. I could then turn the strips at right angles to each other and find the center of the cake or pie. Also, the brad left a hole in the center of the measuring device so that I could place a toothpick in the center of the dessert as a guide.

Branding iron. The problem: how to make a lot of hamburgers with identical grill marks for commercials. One food stylist had a branding iron made with grill strips on it; she could quickly and accurately produce an assembly line of perfectly grilled burger patties.

Hand steamer. The problem: how to get a steamer to direct steam to small areas. One photographer filled in all the openings but the center one in a steamer and placed a straw in that opening to direct steam to a specific point. It worked wonderfully for adding a last-minute melt to cheese on a hamburger.

contents in BOTTLES, CANS, and PACKAGES

A Wealth of Uses

As a food stylist, you are confronted with all types of situations that require innovative thinking. You will be amazed at all the things—many of them household items—at your disposal that will help answer your needs and will prove indispensable in your arsenal of food styling solutions. Following are some of these items and how to use them.

GLUES AND OTHER THINGS THAT STICK

Zap-A-Gap versus Jet Set or Krazy Glue. Caution: bonds skin instantly; keep solvent on hand. Use these to patch torn poultry skin and to hold the wings to the body of poultry if the wings are not going to be tucked under. Zap-A-Gap seems to work best and is not affected by oven temperatures.

Elmer's Glue-All. Elmer's dries clear and is often used for putting sesame seeds on buns. Some stylists use it as a substitute for milk in cereal shots.

Vaseline, peanut butter, cream cheese, piping gel, K-Y jelly. All of these products are used as glues and have different thicknesses and colors. Vaseline (petroleum jelly) is what I call my pastry glue. It holds together broken piecrust pieces and graham cracker crusts. Cream cheese holds lettuce in place on sandwiches.

Spray Mount. Caution: noxious fumes; use in a ventilated area. Spray it on buns as an adhesive and add poppy or sesame seeds.

Fun-Tak/BlueStik versus Holdit. These products are useful for holding food and utensils in place. Fun-Tak/BlueStik, a blue-green sticky substance, is found in most photo studios. It is used to mark the front of plates, to hold reflector cards in place, and to keep such things as crackers from moving on a plate. Holdit is a white adhesive that doesn't adhere to food and is less useful.

Glue dots and glue strips. Double-faced sticky dots or strips on a release strip of paper are used to hold foods such as chocolate chips and cereal in place on boards for shots of individual or floating foods. They can be found at craft shops.

Mortician's wax and museum gel. Clear clay or sticky substances used when you might see the blue-green reflection of Fun-Tak/BlueStik.

Flower-Fix. This sticky substance is found at florists' shops and can be used to hold a slice of cake on a spatula, for example.

Gaffer's tape. Found in all studios and production sites, gaffer's tape is used many ways, especially when you need a strong tape for heavy items.

Black masking tape. Photographers use black masking tape to cover areas where there might be a shiny reflection. I like to use it when hanging recipes, shooting schedules, etc., on walls because it doesn't peel the paint away when removed (see the photograph on page 61).

GELS AND OTHER THINGS THAT THICKEN

There are many different gels and thickeners. The ones I use most often follow, but see Resources, page 386, for other gels and starches.

Piping gel. These clear gel powders come in dry form and need to be cooked with a liquid or, if instant, just mixed with a liquid. These are products with many uses; once you have learned how to work with them, they seem indispensable. Added to pasta sauces, piping gel thickens, if needed, and holds a beautiful fresh luster. You can brush a thin, diluted coating over meats and vegetables to maintain a fresh look and add it to pie filling to make fruit pies stable and glossy (open a can of cherry pie filling to see a sample of red clear gel). Diluted and stirred into cooked rice or tossed with cooked pasta, it helps maintain a fresh, moist, but not greasy look. Add it to cheese, chocolate, and cream sauces or gravies to keep them fresh and glossy, and to achieve the desired viscosity. You can make fake melted cheeses for oozing cheese fillings: For mozzarella, add cream to the piping gel, or combine piping gel with yellow food coloring and Kitchen Bouquet or soy sauce for a melted Cheddar.

You can purchase prepared piping gel from cake decorating stores or your local bakery (open one container at the store to make sure it is fresh and clear—gels have a limited shelf life).

Many stylists prefer to make fresh gel when they need it. Stylist Mary Holloway buys 1-pound bags of Mira Clear Gel from Glenn's Bulk Food Shoppe of Hutchinson, Kansas (see Resources, page 386). Holloway makes the gel by mixing about 2 rounded tablespoons of powder per cup of water and cooking it in a microwave until bubbling and thick. It can be thinned with a little hot water to the desired consistency. The mixture gets thin and watery if stored in the refrigerator for more than a few days, so prepare it as needed.

The recipe below was supplied by the *Tweezer Times*, a newsletter for food stylists.

Knox gelatin. This clear gelatin stabilizes whipped cream, Jell-O, cheesecakes and chilled pies, and meringues.

Aqua Gel. Aqua Gel is the thickest, clearest water-based fluid available. It makes realistic-looking spills and can be used as a thickener in sauces and gravies. It also colors well to become a sauce with good viscosity. It is available from Trengove Studios (see Resources, page 386).

Ice powder versus ice crystals. Caution: toxic; do not swallow or pour down drainpipes. Use these for making frozen drinks and making small ice crystals adhere to glasses and bottles. The powder and crystals each produce a different size "crushed ice." They are available through Trengove Studios.

Cherry goo. This is the gummy, shiny sauce strained from canned pie cherries. Use it for cheesecake toppings or other red fruit to add glisten. This sauce will hang down the side of a slice of cheesecake forever.

Decorating or Piping Gel

MAKES 2 CUPS

2 tablespoons unflavored gelatin (Knox)
2 tablespoons cold water
2 cups light corn syrup (Karo)

Soak gelatin in water. Heat over low heat until clear and dissolved. Do not boil. Stir in corn syrup and cook just until simmering, but not boiling. Cool completely. Store refrigerated up to 2 months.

Swiss Chalet food stabilizer. Swiss Chalet adds thickness and texture to soft foods (see Resources, page 386).

THINGS THAT COLOR OR ADD BROWNING

Kitchen Bouquet (KB in the biz). Just about any food photography studio will have a bottle of Kitchen Bouquet in its cupboard. It is often used as fake tea or coffee because, when real coffee or tea sits for a while, an oily skin appears on the surface of the beverage and is not photogenic. Combining just the slightest amount of KB with some water will make sauvignon blanc; add a little more and you get a sauterne; still more and you have whiskey and bourbon; and finally, if you add enough, you've made tea or coffee. Mixed with Angostura bitters, yellow food coloring, and dishwashing detergent, KB will enhance the color of poultry. You can also thin it with water and lightly brush it on toast to even the color (see the photograph on page 296).

Gravy Master. A product similar to KB, Gravy Master is a slightly darker brown and is a little thicker.

Soy sauce. Thinned and lightly brushed on toast, soy sauce will even the color of browning. It is a little more yellow than KB.

Angostura bitters. Besides using Angostura as a flavoring in mixed drinks, we use this reddish-brown liquid to add color to poultry—usually about 85 percent bitters to 10 percent KB, plus a couple of drops of yellow food coloring and a couple of drops of dishwashing detergent (to allow the oily poultry to blend with the water-based browning mixture). Brush the mixture on poultry as soon as the bird comes from the oven (see the photographs on pages 218 and 219).

Lea & Perrin's Marinade for Chicken. A blend of white wine and herbs, this marinade is used on chicken breasts for a moist, light brown, glossy look.

Teriyaki sauce. Teriyaki sauce adds glisten and color to meats and poultry, and it gives a rich look to barbequed foods.

Maillose. This browning accelerator will add color to any already-baked item, such as cookies and crackers (see Resources, page 385). To activate it you must heat the food.

Micro Brown and Micro Brown Chipotle. These products will add brown to poultry and meats. Micro Brown Chipotle is redder in color.

Aerosol car paint. You can use spray car paint if you need a particular color for prop plates or bowls that you can't find otherwise. Will not chip like other spray paints.

Liquid food coloring versus gels, pastes, and powders. Each brand of food coloring has its own shades of the four basic colors. The liquids are great for coloring frosting and fake ice cream, making red wine, or enhancing the color of foods. I recently

worked with Vibrant Neon food colors from McCormick. Food colorings also come as gels, pastes, and powders. Use the one most appropriate for the food you are working on.

Maraschino cherry juice. This juice can enhance the redness of ham and juices of rare meat.

Dark Karo syrup. Substitute dark for light Karo syrup to make fake coffee ice cream. Mixed with honey, the dark version becomes a thick syrup for a pancake shot that is not selling a brand of syrup.

THINGS THAT PREVENT FOOD DISCOLORATION

Sodium bisulfite. Caution: very toxic; do not swallow. Sodium bisulfite prevents sliced foods (mushrooms, apples, artichokes, potatoes) from turning brown (see the photograph below). Use about ½ teaspoon of the powder to 3 cups water. Use with extreme care. Do not let anyone eat foods treated with sodium bisulfite. Some people with allergies have died from eating foods containing bisulfites.

Lemon juice and water. Briefly dip sliced foods into a mixture of one part lemon juice to one part water to keep them from browning.

Fruit-Fresh. This product is often used when canning peaches and other fruits because it helps keep colors bright.

Ascorbic acid tablets. Crushed and added to liquid, ascorbic acid helps prevent browning.

Water versus ginger ale. Some stylists feel holding foods in ginger ale will keep them from browning. When testing this, I found putting foods such as sliced apples in a water bath did the same thing. Test for yourself.

Saran wrap. Surround hot cooked red meats (not poultry or fish) with plastic wrap to prevent a cooked surface from getting darker. Some stylists also submerge cooked red meat in room-temperature vegetable oil to hold the color (see the photograph on page 214).

Vegetable oil. Submerged sunny-side-up or poached eggs will not dry out or discolor when covered in room-temperature vegetable oil.

Butcher paper. Use butcher paper between raw slices of meats to prevent discoloring. Waxed butcher paper may be treated in some way to help prevent red meat from turning gray-brown. The waxed surface keeps air from getting to the meat.

The grated potatoes and sliced apples at the right have been exposed to air; those toward the middle have been put in a solution of lemon juice and water; and those at the back were brushed or briefly dipped in a solution of sodium bisulfite and water.
Dennis Gottlieb

THINGS THAT CREATE STEAM OR FLAMES

Hot food dries quickly and is hard to arrange, but go for real steam when you can. It looks best, but you will have to replace the food after a while. I like to shoot sauces, coffee or tea, and soup broth hot for a more natural look. Other techniques we use to give food a steaming appearance follow. Warning: Never use any of the chemicals discussed here on or near food that is to be consumed.

A and B solution. This is a term used in production. In reality it is hydrochloric acid and ammonium hydroxide. Extreme caution: toxic; do not swallow; noxious fumes; use in a ventilated area. Don't place these chemicals near each other, mix them, or get them on your skin or near your eyes. These are very strong chemicals used particularly in television production to produce steam if needed whenever the camera is rolling. One chemical is dropped with an eyedropper or put on a Q-tip and placed in hidden spots. The second chemical is placed near, *not on,* the first when the photographer is ready to shoot. If they are mixed, they will neutralize each other and not produce steam.

Steam chips or Z-Smoke Tablets. Caution: toxic; do not swallow; noxious fumes. Make a small boat out of aluminum foil. Pour a small amount of steam chips into the boat. Hide the boat within a food or beverage and use an eyedropper to add drops of water to the chips when you want steam. (Z-Smoke Tablets may not be available any longer.)

Microwave. When we need steam rising from food for a shot, I cover prepared and arranged foods with Saran, then zap them in the microwave. For some foods, I place *wet* paper towels on the prop, arrange the food over the towels, cover the food with with plastic wrap, and microwave it. On the set, I remove the Saran and quickly clean up moisture droplets before shooting. For baked potatoes, prepare them with the look you want, inject them with water, cover them with Saran, and microwave. Bring the potatoes to the set and have sour cream or butter ready. Remove the Saran, top the potatoes, and shoot.

Steamer. Many food stylists own a professional steamer (for removing wrinkles from clothes) because it produces more steam and is hotter than the handheld type used at home. To produce steam, hold over food, heat, and remove or hold the steamer hidden behind and below the plate (if shooting at eye level). The professional steamer is also wonderful for melting cheeses just before shooting (see the photographs on pages 70 and the photograph on page 142, number 8).

Tampons. Known in the business as T-28s, tampons produce localized steam. Soak them in water, zap them in the microwave, and place them behind food.

Cigar and cigarette smoke. Caution: toxic; noxious fumes; use in a ventilated area. Use a straw to blow cigar or cigarette smoke on food just before shooting. Cigar smoke reads best.

Rubber cement for flames. Extreme caution: toxic; do not swallow; use in a ventilated area. Place a small amount of rubber cement on a metal tray under a barbecue grill and light the adhesive. Have a fire extinguisher handy and another tray nearby to cover and put out the flame after the shot (see the photograph on page 225).

Lighter fluid versus alcoholic beverages for flambé. Extreme caution: toxic; do not swallow; test and use only small amounts. Lighter fluid reads better in flambé shots than alcohol, which flames blue.

THINGS THAT PRODUCE A CHILLED OR MOIST APPEARANCE

Water. Use a hand spritzer to spray a food with water to create droplets just before shooting. Coating the surface of tomatoes, apples, etc., with a very thin layer of Vaseline (use TurtleWax car wax for glasses, cans, and bottles) will produce larger droplets.

Glycerin. Glycerin was used very frequently in early food photography to produce moisture droplets. It works well with clear beverages, but I find that if you spritz a tomato, for example, with glycerin, the droplets are not a clear water color but take on a reddish cast. I use a mixture of one part water to one part glycerin in my glue applicator with a needle syringe to put droplets on sliced tomatoes or lettuce leaves. Glycerin tends to pull water out of foods, so use it right before shooting.

Thinned piping gel. Thinned piping gel can be brushed or sprayed onto food to give it a moist appearance (see page 131 for a recipe).

Arrid Extra Dry Deodorant Spray. The spray-on powdered deodorant can produce a bloom on grapes. Arrid spray will also create mist on a glass.

Ice powder. Caution: toxic; do not swallow or pour down drainpipes. Ice powder mixes instantly with water, but it doesn't work as well with liquids containing acids. Wonderful for frozen drinks or a crushed ice effect (see the photographs on page 69, top).

Crystal Ice. Caution: toxic; do not swallow or pour down drainpipes. This product makes "ice" crystals in various sizes.

Aqua Frost. Caution: toxic; do not swallow or pour down drainpipes. Brush or spray Aqua Frost on anything you want to have a frosty appearance, such as beer mugs. The frosty effect develops as the mixture dries.

THINGS THAT PRODUCE LUSTER

Piping gel. Brush or spray piping gel on foods to produce a lustrous appearance (see page 131 for a recipe).

Vegetable oil versus olive oil. Brush a light coating of a light vegetable oil instead of olive oil on cooked foods. The thicker viscosity of olive oils can look too oily.

Citré Shine or göt2b Dazzling. Spray these hair products on rice or other items you don't want to move by brushing with vegetable oil.

TIP *To prepare moisture on glasses, use a mixture of light Karo syrup and water and a stiff toothbrush. The ratio of water to syrup will be up to you; it depends on the look you want. The more syrup, the thicker the drops; the more water, the drippier the appearance. Undiluted glycerin or light Karo syrup can be used to produce more prominent droplets by applying individually with a toothpick (see the photographs on pages 289 and 293).*

Glycerin. Use glycerin with care; it draws moisture from foods. I use a mixture of 50 percent glycerin and 50 percent water and apply droplets of "moisture" using a glue applicator with a needle syringe.

Light Karo corn syrup or clear glucose. These syrups thicken and add luster to sauces and gravies (test and watch for color changes or thickening).

Water. Use water right before shooting. Spritz water on salsa and tomato-based sauces to prevent them from looking dry. Brush it on the cut surfaces of fruits and vegetables. Spritz it on rice or pasta for a fresh look. When asked what magic things I use to give foods their fresh appearance, my reply, ninety-nine out of a hundred times, is that I use water or vegetable oil.

Chicken broth. Brush chicken broth on cut or torn pieces of chicken just before shooting to give a very moist appearance.

Natural juices and uncooked meat juices. For a juicy appearance, cut and squeeze a slightly cooked piece of red meat and collect its natural juices. Brush the juices on cut surfaces of cooked red meat just before shooting. If cut slices of red meat appear too rare, you can reduce the redness by brushing the cut surfaces with water. Don't use vegetable oil on cut surfaces, only on cooked surfaces.

Vaseline. Spreading a thin layer of Vaseline on tomato surfaces and spritzing with water enhances the droplets.

Glue applicator with a needle syringe. The glue applicator I prefer is the Hypo-200 from Gaunt Industries. It puts water/glycerin droplets exactly where you want them (see Resources, page 385).

Dulling spray. Caution: noxious fumes; use in a ventilated area. Sometimes we have too much luster. When there's too much shine on your poultry, you can use dulling spray to reduce it.

THINGS THAT KEEP FOODS MOIST

Corn Huskers Lotion. Caution: toxic; do not swallow. Spread Corn Huskers Lotion on both sides of a tortilla and rub it into the surface to keep it moist and keep it from cracking when rolled. Store tortillas in plastic bags until ready to use.

Armor All Protectant. Caution: toxic; do not swallow. Although Armor All is intended for rubber, plastic, and vinyl, you can spray it on English muffins after toasting to keep them from drying out, cracking, and curling.

Vegetable oil. Submerging cooked red meat and sunny-side-up eggs in room-temperature vegetable oil helps hold their color and keeps them fresh until needed.

Sodium bisulfite. Caution: toxic; do not swallow. Quickly dip lettuce into water with sodium bisulfite to keep it from wilting.

Saran versus other plastic wraps. Saran used to be the only plastic wrap that did not allow air through its surface, which was very helpful when we were trying to keep foods from drying out or keep oxygen from getting to the surface for enzymatic

browning. It still may be the least permeable of the plastic wraps. Place it directly on the cut surface of many foods, including cooked meats.

Baggies and Ziplocs. Use these resealable plastic bags in various sizes to prevent air from getting to foods and drying them out.

Bounty white paper towels. Bounty towels hold water well. Place a damp towel over any food that might dry out.

THINGS TO USE WHEN SHOOTING BEVERAGES

Kitchen Bouquet. Kitchen Bouquet mixed in varying amounts with water produces coffee, tea, white wine, and brown "alcoholic" beverages.

Rain Dance and Turtle Wax car wax. Caution: toxic; do not swallow. Rub these waxes inside and outside a glass. They keep any liquid poured inside from leaving a liquid line. They also help make good moisture droplets and water beads on the outside.

Krylon Crystal Clear. Caution: noxious fumes; use in a ventilated area. When shooting carbonated beverages, spray inside glasses to hold bubbles. Spray the outside of the glass to produce a tension that holds moisture droplets well.

Ice powder. Caution: toxic; do not swallow or pour down drainpipes. Ice powder allows you to make frozen margaritas that hold for one or two hours. Color the liquid before adding it to the powder. Acids in some liquids, such as lime juice in margaritas, reduce the effectiveness of the powder; you will just need more powder (see the photographs on page 69).

Ice powder. *Colin Cooke*

Crystal Ice. Caution: toxic; do not swallow or pour down drainpipes. Crystal Ice is a coarser version of ice powder. To adhere the "ice" to the sides of bottles, cans, or beverage glasses, use a drop of light Karo corn syrup applied to the container with a toothpick. Add Crystal Ice and spray with water to make the ice "grow."

Aqua Frost. Caution: toxic; do not swallow or pour down drainpipes. Brushed on glasses and mugs, Aqua Frost produces a frosty look as it dries.

Steamer or iron with steam blasts. Either of these appliances adds a very nice, fine, natural moisture to glasses.

Mini spritz bottle. Use a spritz bottle filled with water to spray droplets on beverage glasses. Some people like to add glycerin to the water for a stronger beading effect.

Tap water versus distilled water versus vodka. Unlike tap water, neither vodka nor distilled water develops unwanted air bubbles when it sits in a glass for a long time.

OILS AND FATS AND THEIR USES

Olive oil and extra virgin olive oil. Different kinds of olive oil have different colors and viscosities. Use it appropriately, such as in a cruet next to Italian bread. Don't brush on cooked food; it is too thick.

Vegetable oil. Use a light vegetable oil to brush on the surface of cooked foods to freshen their appearance. It won't congeal as it cools.

Shortening. Add shortening rather than butter in cookie recipes for less spread (see the photographs on page 267). Use it for fake ice cream (see page 280 for a recipe) and as a base for showing cereal in bowls (see page 185).

Butter. Adding butter when frying some foods will enhance the browning during cooking. I dot some foods, such as salmon, with butter before placing them under the broiler to add a more natural "grilled" appearance.

Stick margarine. Yellower than butter, margarine holds its shape better than butter. Unless we are selling a brand of butter, we usually use margarine for pats and spreads. Find a brand of margarine that works well for you.

Nonstick cooking spray. Cooking spray adds shine to some foods. Spray it on the cooking surface of a griddle for lacy pancakes.

Paraffin wax. Caution: flammable if overheated or exposed to open flame. Always melt paraffin by heating it in a pan over boiling water. Never melt it directly in a pan over fire, on a hot plate, or in a hot oven. To prevent soggy hamburger buns, brush melted wax on bread surfaces that might absorb sauces or on the inside of taco shells before filling to prevent them from becoming limp. Paraffin becomes white and shiny as it dries, so use it only where it can be hidden.

THINGS IN AEROSOL CANS: UNEXPECTED USES

Dust-Off. Dust-Off cools small areas of ice cream or other frozen products when sprayed upside down. The aerosol removes dust and crumbs from the set.

Chewing gum remover. An aerosol gum remover sprays very cold air and freezes small areas of ice cream or other frozen products.

Krylon Crystal Clear. Caution: noxious fumes; use in a ventilated area. Sprayed in and on the surface of a beverage glass, Crystal Clear produces a tension to hold moisture droplets.

Spray Mount and Spra-Ment. Caution: noxious fumes; use in a ventilated area. These artists' adhesives can be sprayed on top of hamburger buns before affixing poppy or sesame seeds.

Nonstick cooking spray. Cooking sprays provide even coating in hard-to-reach areas of baking pans. When sprayed on cooked foods, such as pizzas and meats, they add a light shine and glisten.

Preval sprayer gun. This empty bottle with an aerosol sprayer attached can be filled with your own tinted mixtures to be spray painted on foods such as poultry or toasted breads.

Baker's Joy. Flour and oil are combined in this spray for baking pans.

Spray paint versus car paint. Caution: use in a ventilated area. Spray paints for cars chip less than household spray paints when sprayed on props for which you are trying to achieve just the right color.

Scotchgard. Spray Scotchgard on pancakes and breads to keep sauces from soaking into the food.

THINGS THAT PRODUCE FOAM

Foam Booster. Add Foam Booster to a beverage and whip or whisk the mixture vigorously to create long-lasting foam. When using it as a beer foam, make sure it matches the type of foam your beverage produces.

Bartender's Friend (foamy). You can get a little extra foam with Bartender's Friend.

Photo-Flo. Caution: toxic. Apply Photo-Flo with an eyedropper to create "just poured" bubbles on beverages. Squeeze a very small amount into a drink while pumping the dropper to produce bubbles.

Clear dishwashing detergent. Combine detergent and a small amount of beverage in a bowl; whisk to create foam, and spoon the foam onto the beverage.

Egg whites. Beat egg whites slightly and spoon them into beverages; watch for possible color changes in the beverage.

Skim milk versus whole milk versus soy milk. Skim milk works better than whole or soy for producing a long-lasting foam on top of cappuccino. Use whole milk or half and half when shooting milk for a rich, creamy appearance.

Salt. A pinch of salt reinvigorates bubbles in beer, Champagne, and other carbonated beverages.

Glycerin. Whisked in with dishwashing detergent, glycerin makes bubbles larger and foam last longer.

THINGS THAT HELP ORGANIZE AND HOLD IN PLACE

Sharpies. Use Sharpie markers on your equipment to identify it. Label containers of food when testing ingredients or for identifying mise en place ingredients.

Fingernail polish. Mark your equipment with a polish dot or letter to identify it.

Masking tape. Masking tape has many uses, but it is often used to mark the backs of plates on the set and to cover areas on glasses before adding moisture for chilled beverages (see the photograph on page 289).

Black tape. Among the multiple uses of black tape are to prevent shine or reflection of lights in a shot; to block the position of stand-in plates before replacing them with hero food; and to hang recipes, shot lists, and layouts in kitchen areas.

Gaffer's tape. A cloth tape stronger and stickier than most, gaffer's tape has "thousands" of uses. Usually found at the studio.

Toothpicks and wooden skewers. Toothpicks and skewers keep lettuce and cold cuts in place when you are building a sandwich. They are used on the set to carefully move food or to add chocolate curls, for example.

T-pins versus straight pins. T-pins hold skin in place on poultry. Straight pins can be used for small things such as holding a transplanted strawberry top in place on a strawberry.

Armature wire, filament, or florist wire. When inserted into a food such as a hot dog or shrimp, the wire gives shape and curve.

Plastic cubes in a variety of sizes. Photographers have these (see page 126 and the photographs on page 127). We use plastic cubes to mark stand-in props before we take the props from the set and fill them with the final food. Then the prop is returned to the exact same spot on the set. We use cubes in opaque drinks and other liquids, soups, and puddings, to provide support for garnishes to be placed in the center of a drink or food. We use them under foods when they need additional height.

Fun-Tak/BlueStik versus Holdit. Fun-Tak/BlueStik (blue-green) holds food and utensils in position. Holdit (white) is not as strong. Holdit is good for attaching recipes to cupboards and holding a pencil on the wall for ready use. It detaches from the wall without leaving marks.

Mortician's wax. A clear sticky substance, mortician's wax holds foods in place or gives height (see Resources, page 386).

Flower-Fix. Flower-Fix is very sticky and pliable. Use it on a spatula or pie server to hold food in place.

Instant mashed potatoes. Mashed potatoes are the clay of the food styling world. It is always good to have some handy for bases in fruit pies and to build up the bottoms of bowls, plates, and pots of food. I was once asked to build a pyramid of peppercorns, which would never work in the real world. Attaching the peppercorns to a pyramid of soft mashed potatoes worked beautifully (see the photograph on page 69).

Soft spread cream cheese. Soft cream cheese will hold lettuce in place on a sandwich.

Shortening. Use shortening as a flat base in cereal bowls. Before adding cereal flakes, fill the bowls almost to the milk level. Shortening holds flakes in place wonderfully.

Vaseline. Use Vaseline as a clear "glue" to add crumbs to or fill in gaps in cakes and piecrusts.

COOLING AGENTS

Dust-Off. Sprayed upside down, a can of Dust-Off provides instant cold in specific spots and helps slow down melting of ice cream.

Chewing gum remover. Gum removers that spray a very cold mist are used for instant chilling of small areas.

Poop Freeze. This is just what it sounds like—an aerosol that, when sprayed on items, freezes them. It can be found in pet stores.

Dry ice. Crushed or in blocks, dry ice is placed *over* and around foods that need to stay chilled. To use it to keep ice cream from melting, form dry ice into a ball, cover the ball with foil, and shape the ice cream over it. Do not store dry ice in the refrigerator or freezer.

THINGS THAT REMOVE WHAT YOU DON'T WANT: CLEANING AGENTS FROM WINDEX TO SALIVA

Windex. Use Windex with a Q-tip to clean spots off plates, glasses, and other props.

Bar Keepers Friend. Caution: toxic; do not swallow. Bar Keepers Friend renews scratched plates and silver.

Saliva. A natural and always available cleaner, saliva is applied with a Q-Tip to clean spots off surfaces.

Bounty versus Viva versus other paper towels. Bounty white paper towels are a favorite with food stylists, although some stylists prefer Viva. Both are stronger than other brands and leave less lint. On a job, tear the towels into individual sheets and have a stack handy for easy access.

Lemon extract. Lemon extract removes brand names stamped on lemons and other citrus fruits.

Alcohol. Grease, fingerprints, and some inks can be removed with alcohol.

Goo Gone. Caution: toxic; do not swallow. This product removes stickers and their residue.

Goof Off. Caution: toxic; do not swallow. Stronger than Goo Gone, Goof Off removes stickers, their residue, and markers. Note that it will leave marks on plastic.

Stainless Steel Magic. Caution: toxic; do not swallow. Use Stainless Steel Magic to shine pans and flatware.

Acetone. Caution: toxic; do not swallow; avoid contact with skin. Acetone removes stickers and some inks.

Fingernail polish remover. This beauty product removes pricing stickers, labels, and sticky residues.

EYEDROPPERS AND OTHER THINGS FOR LAST-MINUTE TOUCH-UPS

Squeeze bottle. Use squeeze bottles to apply sauces, syrups, mustard, etc. Store them upside down in a heavy glass so that any air bubbles go to the top (which is the bottom) of the bottle. This also keeps the item in the bottle near the tip and ready to be applied.

Eyedroppers. Eyedroppers are very versatile. Use them to add sauces and other liquids to small areas or to remove extra sauces. They also produce bubbles for beverage shots.

Sources of heat: **1** Homemade heating element **2** Electric charcoal starter **3** Paint stripper **4** Heat gun **5** Culinary or medium size propane torch **6** Pencil propane torch **7** Easy-to-light large propane torch **8** Steamer, handheld. *Dennis Gottlieb*

Tweezers. Needle-nose tweezers are used constantly to do fine work that would be difficult to do with your fingers, such as replacing or moving food on the set or adding sesame seeds to hamburger buns. Use them to add texture to foods. Needle-nose tweezers are considered one of a food stylist's most important tools.

Skewers. Wooden or bamboo skewers are another tool we use constantly. We use them to add texture on cake slices and to fill holes with Vaseline and cake crumbs. They are used to place small foods accurately.

Glue applicator with needle syringe. I use the Hypo-200 glue applicator for jobs such as placing one or two drops of moisture onto a tomato slice or lettuce leaf.

Atomizers, spritzers, and misters. These everyday applicators add moisture droplets to food and glasses.

Glass bulb baster. The glass bulb baster, available from medical supply stores, removes flat beverages from glasses and adds sauces or gravy to just the right spot.

TORCHES AND OTHER THINGS THAT PROVIDE CONTROLLED HEAT

Heating element. This homemade element concentrates heat for use in small areas of food.

Charcoal starter. Charcoal starters are pieces of equipment with heating coils and a handle and are used to start charcoal fires. Some stylists like to use the starters to put grill marks on food. If the coils are too large or round, they can be pounded into a more desirable thickness. I prefer to use metal skewers heated over a gas flame for my grill marks, but the constant heat of the starter is nice for large-volume work.

Paint stripper. Extreme caution: produces intense heat and will burn or melt nearby objects; unplug when not using. The paint stripper consists of a heating element covered with a metal top. It is often used to melt cheese on pizza or to heat cooled foods quickly.

Heat gun. Not just any heat gun: The best heat guns have temperature-controlled heat and don't produce excessive air flow (in other words, they will not blow your food all over the set). They are wonderful for carefully adding a shine to chocolate or, with a little more heat, giving it a melted look. Heat guns can be used to toast bread or add a toasted look to crackers, to touch up an underbaked area of a pie, and to melt natural cheeses (processed cheese seems to like a moist heat, such as that produced by a steamer). The one I prefer is the Master-Mite heat gun from Master Appliance Corp. (see Resources, page 385).

Culinary torch. Torches are used to scorch sugar, sear meat, reheat fat, and heat melting spatulas used to melt butter pats or soften chocolate. They also are used in a studio when there are only electric stoves with which to heat metal skewers for grill marks. Never use a torch to sear vegetables for the "I've been on the grill" look. The searing will always look fake.

Pencil torch. A pencil torch is a very small and controlled heat source with attachments for melting butter, etc. I prefer Solder-It's SolderPro-100 Kit (see Resources, page 385). The pluses: It will heat small areas with even and controlled heat; it's good for removing bloom from chocolate. Here's a tip I learned from stylist Lynn Miller: After removing the bloom from chocolate, try putting the chocolate in the freezer for a minute or two to keep the bloom from reappearing.

Upright butane torch. The upright torch browns meat to give it the grilled look (see Culinary torch above for additional uses). I prefer the easy-to-light BernzOmatic. You can now get these torches with a large propane base that will not tip over.

Steamer. Steamers produce moist heat. Food stylists often use a steamer to melt processed cheese in sandwiches or to keep macaroni and cheese looking fresh. A steamer also produces enough heat to "cook" the area where slices have been removed from undercooked turkey breasts. There are two types of steamer—professional and handheld for the home consumer. The strength of the professional steamer is best.

SUBSTITUTIONS THAT HELP SOLVE FOOD PROBLEMS

Milk versus Wildroot versus Elmer's Glue-All. Instead of milk, which causes cereal to get soggy and collapse, we use Elmer's glue or the one that I strongly prefer, Wildroot hair grooming lotion. (Caution: toxic; do not swallow.) Wildroot is getting harder to find, but you can find it in some Rite Aid drugstores or you can purchase it online (see Resources, page 386).

Distilled water versus tap water. Distilled water contains no bubbles and is a cleaner and clearer beverage than tap water.

Real ice cream versus fake ice cream. Today, most clients want to shoot real ice cream. Fake ice cream makes the same color as real and works well as a long-lasting stand-in until you are ready to shoot the real product (see pages 274–283).

Real ice versus fake ice versus ice sculpting ice. Real ice reads very cloudy, so when shooting beverages most photographers use fake cubes. These come in varying degrees of quality. The best ones are hand carved and very clear, but they don't float. Floating Pyrex cubes are also available (see Resources, Trengove Studios, page 386). Most photographers have a variety of cubes and wedges that allows for more interesting arrangements. If someone wants to shoot real ice, try to purchase sculpting ice, because it is very clear. You will need to locate companies that specialize in ices.

Kitchen Bouquet versus wine, coffee, and tea. Kitchen Bouquet is a handy source for making instant fake white wine, coffee, or tea. Real coffee and tea will get an oily skin on their surfaces as they sit.

Cool Whip or other nondairy toppings versus whipped cream. If you are using whipped cream, just prepare the whipped cream as close to shooting time as possible, then shoot quickly. Nondairy toppings will hold much longer at studio temperature.

Fully cooked versus partially cooked poultry. When you cook poultry for the full amount of time, the bird doesn't brown evenly, the skin often pulls away from the knuckle bones, and as the bird cools, the skin wrinkles. We avoid these results by cooking poultry for only a short while and adding brown coloring to give the poultry a cooked appearance.

Real versus fake food. Some fake foods look real. Model makers can produce some great looks for difficult foods. Also, foods that are hard to get out of season, such as blackberries and cherries, are available online and from Trengove Studios.

Ficus leaves versus apple or peach leaves. Many photographers grow a ficus plant in their studio so that they have "apple" leaves when they need them. If you want the authentic look, contact a florist for the real thing or look for the leaves at farmers' markets in season.

Cheese product versus real cheese. When working with cheese product, we melt or keep it soft with a moist heat. Real cheese usually melts with dry heat. Part-skim milk mozzarella, *not* fat-free or whole milk, is usually better to use for pizzas because it doesn't become transparent but still melts well.

Splashes. If shooting real pour splashes of coffee, milk, etc., you can make the base firm in a cup or glass by first heating the liquid with gelatin and cooling it to a solid state. Then pour cold coffee or milk onto this firm base to produce the splash. Beautiful fake splashes can be made to your design by Trengove Studios or by other model makers. You can also shoot the surface of the beverage with a strong air gun, or shoot a separate splash to add as a layer to the shot (see the photographs on pages 84 and 85).

FOOD IDIOSYNCRASIES TO BEAR IN MIND

As stylists, we are using products of all types all the time, either promoting them or relying on them to produce certain foods. Products can vary tremendously from brand to brand, and they can change if they are reformulated. It is important that you stay informed about and aware of new products or changes that have been made within product lines. For example, with the removal of trans fats from products, the formulas for many products are changing. As they do, the look of the products as well as how they behave may change. Following is a list of similar products that behave differently or have different looks.

Low-fat versus full-fat products. Dairy: Low-fat or fat-free milk, cheeses, sour creams, and ice creams all perform differently. In general, low-fat sour cream tends to hold its shape better, doesn't separate, and has a shinier appearance than full-fat sour cream. Salad dressings: Low-fat salad dressings include gums for texture, mouth feel, and suspension. If you need to shoot a dressing in a cruet, consider low-fat or fat-free dressings because the particulates stay suspended and the oil and vinegar do not separate.

Canned beans. If you compare four different brands of red kidney beans, you will find four different looks and textures. It is important for you to know what is in each can so you will know which brand to purchase. Stay aware of products and use whichever is best for the job. Each assignment needs a specific look. Bright red and crunchy beans work well for a three-bean salad; lighter red and softer for chili with beans (see the photograph on page 154).

Butter versus margarine. Each product has a different color and frying quality: Margarine is more yellow than butter and salted butter is more yellow than unsalted. Butter produces a nice brown on foods that are fried. Margarine is used most often for melted "butter" pats and spreads because it has a brighter color and a more controlled melt (see the photograph on page 182).

Shredded cheeses. Various brands of packaged shredded cheeses look different, have different butterfat content, and are different thicknesses. If you need to melt the cheese, it's best to test and compare different brands for meltability.

Chocolate sauces. Hershey's Syrup and Smucker's Magic Shell are thin and dark in color. Smucker's Chocolate Fudge Topping, at the time of writing, has a good thickness or viscosity. Smucker's Hot Fudge is the thickest. Compare other brands for color and viscosity.

Ice creams. Cheaper brands of ice cream have more air, added gums, and produce a nicer barked or ridged surface when scooped than high-fat brands.

Ketchups. Ketchup color and thickness vary with brands. Generally, Heinz is brighter, shinier, and holds its shape better than most other brands.

Canned diced tomatoes. Judge canned diced tomatoes by their color and the size of the dice.

Chicken broths. Many new brands of broth are now available, so compare brands to see which provides the richest look for using as a base in your soups and sauces. Use chicken broth warm to keep its fat suspended.

Dried rices. Uncle Ben's rice grains have a good golden color, uniform length, and individual separation. Carolina is whiter with less-even grains. Uncle Ben's is most often used in generic dishes, while Carolina is often used in Latin dishes. You may want to cook both and see which looks best with the food and plate you are shooting. If a specific rice is called for, of course, then use that rice.

Donut sugar versus confectioners' sugar. Food-service powdered sugar, called donut sugar, lasts when sprinkled on baked goods, but it doesn't have quite the same appearance as the home consumer's confectioners' sugar, which has a lot of cornstarch. When using these sugars, bring sifters with a variety of mesh openings. How fine or coarse the sprinkling of sugar is can make a big difference in appearance.

KNOW YOUR EQUIPMENT

Digital scales. Look for scales that measure both grams and ounces. Lightweight compact scales are great to take on jobs where you are shooting a specific product

and must show 3.5 ounces of peas or 5 ounces of gravy, for example. These scales are also useful when you are developing recipes for clients and everything needs to be measured exactly, or when you need to let the consumer know what weight to buy when you need 2 cups of shredded cheese.

Digital timers. These timers come in many forms. I have one that can measure three times at once. Some count backward and forward. Find the one that works best for you. They are also important for their exactness when developing recipes, so you can give exact baking times for consistent coloration.

Reynolds Wrap Release Non-Stick Aluminum Foil. Reynolds Wrap's Release non-stick foil works well for baking and cooking foods that will tend to stick to regular aluminum foil. Food stylists love this product.

Regular aluminum foil. Line all jelly-roll pans with aluminum foil for use during a shoot. Line greased baking pans for making bars with a double thickness of foil. Fold the foil to fit into the bottom and up the two long sides of the pan. Grease the foil and fill the pan with batter. After the bars have cooled, use the overhanging foil to lift and remove them from the pan for easier cutting. In a pinch, aluminum foil can be shaped into a funnel.

Parchment. Use parchment for baking, lining cake or cookie pans, and making paper cones for piping.

Tote bags. When choosing a tote bag, watch for quality, size, and good handles; make sure they're comfortable to carry. A good source is State Supply (see Resources, page 385).

Handtrucks. For getting your equipment and food to the studio, rolling carts are very handy and help prevent aching shoulders. Some stylists have designed stackable rolling kits and bins. There are a lot of options out there. I have found a folding handtruck by Wesco that is lightweight but very sturdy and easy to store (see Resources, page 386).

Over the years I have heard or read about some of the myths concerning food styling and food stylists, how we work, and the food that we use. Early on, fake ice cream was made with mashed potatoes, but this is no longer the case. People think we often use plastic food rather than real. Not true. Hot lights are still used sometimes when shooting slow motion, but rarely do we use them on regular shoots. We don't use shellac or motor oil on meat or poultry, though I did see a shot of a Cornish hen taken in the 1960s that looked like motor oil was used. I have never seen subliminal messages in our work; in fact, just the opposite. If the foam on the coffee unintentionally takes the shape of a face, we change it. Probably the most widely held myth is that food stylists are just people who like to cook and bake and throw parties, but that we have no particular training.

WORKING WITH THE FOOD
overcoming challenges

finding the food

Magazines often shoot about six months ahead of publication, which adds interest (and sometimes stress) to the food stylist's search for food. This is especially true for produce, because a food may be out of season and difficult or impossible to find—or, if it is found, it may not be in good condition. When I first started food styling, even raspberries were hard to find out of season (we once sent to Australia for a flat of raspberries when we needed only three for a yogurt commercial), but they are now available year-round. In my experience, the more difficult foods to find out of season include pumpkins, cherries, Concord grapes, some tropical fruits, and rhubarb.

While on a December shooting assignment featuring eight rhubarb recipes for *Fine Cooking* magazine, I needed to locate fresh rhubarb, which is in prime season in May. I could have used frozen rhubarb if I could find that, but the results would not have been as nice. Thanks to *The Food Professionals Guide* (this was before Google), I located and called the Washington Rhubarb Growers' Association. They informed me that I was very lucky. They had rhubarb growing in their hothouse that was a little ahead of schedule. I asked them to send me thirty pounds, which they did. I received a box of beautiful, deep red stalks with leaves attached. Thus the resulting picture and one fortunate food stylist.

Mark Thomas for Fine Cooking

This chapter contains some detailed information about how food stylists work with various foods. It is important that you understand the chemistry of foods (how and why recipes work or why foods behave as they do when they are prepared for consumption). It is a good idea to test recipes and products before you work with them on a shoot, or at least look for potential problems. You need to be a good problem solver and understand how to control foods that want to misbehave.

When I asked a group of eighty veteran food stylists which foods they considered the most difficult to work with, besides real ice cream and pizza, the responses were sauces; foods with cheese; meats; and baked goods, particularly cakes and pies. On the following pages I discuss the problems of working with these foods as well as others. Knowing about potential concerns and some solutions to them will always be helpful as you work.

Much has been written about the "tricks" food stylists use to make food look wonderful in print and advertising. Some of what you read is true and some not. Most food stylists prefer to use the word *techniques* rather than *tricks*, and I find myself in that camp. I think the reason that everyone thinks that all we do is use tricks is that every article that is written about food styling and every TV interview that takes place, talks about the "tricks of the trade." It would probably not be as exciting an interview if we were asked, "Where did you find such beautiful rhubarb?" We generally use techniques only when we run across problem foods or when we work with foods that have to stay beautiful longer than they naturally would.

As you work on various jobs, there will always be something you learn that you can add to your collection of dos and don'ts when working with food. Make a list on your computer and add things as you go, or jot them down on note cards and organize them by type of food, but do try to put them someplace.

food SCIENCE
The Basics of How Food Works

Without an understanding of basic food science and practical cooking and baking techniques, there can be no creativity or problem solving in the kitchen. A strong understanding of how food works and why is imperative in our business. Courses exist in this area. Books have been written on the subject: everything from the "bibles," such as Harold McGee's *On Food and Cooking* and Shirley Corriher's *CookWise* and *BakeWise* to entertainingly written books on food science, such as *What Einstein Told His Cook, How to Read a French Fry*, and *Why Does Popcorn Pop?* These have become popular reads, even for the novice cook (see Resources, page 378).

As food stylists, we need to understand why yogurt separates and how we can keep it from doing that for its hour on the set, or what causes green beans to turn olive, or why red meat turns darker after it is cooked and sits out. As food stylists, we have a couple of issues to deal with that the average cook or chef doesn't. For example, when you order food in a restaurant, the food is cooked and brought to you right away. When you are food styling, the food sits there for a period of time exposed to the studio elements. If we are not getting the results we want when preparing the food, we need to know what we can do to get them. It goes back to a knowledge of food science. One of the treats about working with food is that we will never know everything about it, but the more we understand about why foods behave the way they do, the more we can control them.

FRUITS and VEGETABLES
Finding the Perfect Produce

Fruits and vegetables are often the color in food arrangements, and it is this color that food stylists want to make the most of. Finding "perfect" produce may not sound too difficult, but it can be deceiving and has, at times, been the hardest part of a job. (It is also a part of the job for which we receive little recognition. "Oh good, you found large, beautiful, perfectly textured, unblemished, bright yellow lemons" is not the response we hear from photographers or clients when we begin unpacking our groceries.) When I am putting together a grocery list for a job, the produce will go under either my general list or my handpick list, depending on how important the item is or how it will be used. For example, if I am using chopped zucchini in a dish such as ratatouille, I would put the zucchini on the general produce list because the zucchini I use will blend into the dish and is not featured. If the zucchini is used as a side dish vegetable or shown whole as a raw ingredient, I put it on the handpick list because its color (if it is a dark green, it will look almost black when printed), shape, and size are very important. This zucchini will need to be blemish free and look fresh.

What is "perfect" for one job may not be so for another job. For example, with a lemon, I need to ask how it is going to be used. Is it to be arranged in a bowl and just sitting in the background? Will it be used as a garnish on a glass of iced tea (how

big will the tea glass be and what will be the shape of the lemon garnish—a wedge, circle, etc.)? Or will we use the lemon as zest (as a big long twist in a drink, as a stack of little glacéed strips over a dessert, or as an ingredient in a baked item)? All of these variables determine the look, color, texture, size, and number of lemons I choose.

An autumn pumpkin filled with creamy vegetable soup.
Dennis Gottlieb

What follows is a discussion of common fruits and vegetables, along with some of their varieties. We will look at the qualities to be considered when these produce items have to be handpicked for a specific look or use. We will also look at some specific transportation, preparation, and care considerations. With fresh raw ingredients, it is important to store them appropriately.

When arriving at a job, one of the first things to do is to take care of fragile produce and herbs. Get produce that needs to stay fresh and crisp into the refrigerator as soon as possible. Some produce is best not refrigerated, such as tomatoes, onions, potatoes, and melons. If you are lacking refrigerator space, items such as citrus fruits and apples can remain outside the refrigerator in plastic bags.

Two wonderful sources for additional information on fruits and vegetables are Elizabeth Schneider's *Uncommon Fruits and Vegetables: A Commonsense Guide* and her more recent *Vegetables from Amaranth to Zucchini: The Essential Reference* (see Resources, page 378). Macmillan's *The Visual Food Encyclopedia* covers most foods and is also a good source of information; it includes visual representations of many fruits and vegetables. The Web site foodsubs.com is a good source, too.

the stylist's search for perfection

When I teach my courses in food styling, one assignment that I always give is to bring in a "perfect" pineapple, orange, raspberry, tomato (with top), etc. No one thinks it will be difficult, but the stories I hear the next day! "I went to five stores, and this is the best they had." "I guess they got a little smashed getting here." "The bananas didn't have those spots last night." "I went back to the storage area with the produce man, and we went through everything they had." "People in the store were staring at us as we looked at every apple." "I found this beautiful bunch of grapes and then the checkout person put my box of rice on top of it." "I just couldn't find blueberries." "None of the tomatoes were really red." "What is the 'perfect look' for a lemon? I didn't think about it until I saw all the choices."

Apples. I look for apples that have an interesting coloration and a shape that is typical of that variety. Farmers' markets are a good source for beautiful, natural-looking apples and unusual varieties, while grocery stores provide the more "perfect" and common varieties. Some apples have a natural bloom on them. I try to leave this on the apple. Don't wash or polish the apples unless specifically requested, because the apples can get too shiny. Try to find them without bruises. (To keep them that way, I put them on the scale at checkout time and pack them myself.)

When we are showing the apple whole, photographers love it if we can find apples with leaves. When it is not possible to find the real thing, we attach the leaves of a ficus plant (often found in food photographers' studios) or another plant with applelike leaves. Sometimes apples are misted with a little water to give them a chilled and crunchy look. Make sure the whole apples you are showing in the shot represent the variety of apples called for in the recipe. I look for apples with long stems that have a slight curve to them (if that is typical of the variety). When I have to slice an apple in half, I take advantage of the curve of the stem by slicing just in front of it, with the stem curving either to the right or the left. Sometimes the apple half is acceptable with its seeds showing and sometimes not. If you are slicing apples into halves for a shot, be sure to bring many. Apples turn brown after they have been sliced and their flesh is exposed to oxygen. As soon as they are sliced, I brush the flesh (only) with a mixture of sodium bisulfite and water (see page 117), acidulated water (one part lemon juice to one part water), or Fruit-Fresh (see the photograph on page 133) diluted in water. Then I place the two halves back together again until they are needed. Just before shooting a sliced apple, I brush the cut

the importance of keeping contacts

A tart with perfect raspberries. *Beth Galton*

It is important to develop a variety of sources for produce. Make friends with the produce department in the stores where you shop. One time I needed, and couldn't find, large, bright red raspberries to cover a chocolate tart. I searched the city, and the only raspberries available were dark and small. I asked my friend Charlie at Balducci's, an upscale grocery store, if he could get some for me. Two days later, a beautiful flat of perfect raspberries arrived, flown in from California. The next time I was in Balducci's shopping, I brought along an 8 x 10-inch Polaroid (those were the days) of the raspberry tart, with a thank-you note for Charlie written on it.

surface with some water to give it a juicy appearance. When arranging apple slices on a plate, it is important to know the camera angle and to slice and arrange the apples in such a way that you can take advantage of the colored skins. To be able to see the skin of the apple on slices, you may need to cut into the apple at an unusual angle rather than directly into the center, as is typically done.

Apple varieties number into the hundreds; below are the basic varieties and their suggested uses.

Cortland. A good apple for baking whole. It remains firm and keeps its shape.

Golden Delicious. Best September through early June, but generally available all year long. This is an apple that resists turning brown and holds its shape when it is used in baking. I often use these to make apple pies for photography because the pies don't collapse and the slices keep their shape.

Granny Smith. Commonly found year-round in grocery stores. These make good pies for eating, but the slices do not hold their shape as well as Golden Delicious. Probably the second most popular apple. If showing whole, try to find some interesting color deviation.

Lady. A tiny apple that can range in color from brilliant red to yellow with a generous red blushing. This apple has a limited availability, but when you can find it, it is lovely as a garnish with hams or turkeys.

McIntosh. A very popular apple that is good for applesauces. Its red and green skin makes it lovely as a diced fruit in salads (see the photograph on page 159).

Red Delicious. In season September through April, but generally available all year long. This is the apple used to represent typical apples. It has an elongated shape with five distinctive knobs at its base. Usually a brilliant red, but sometimes it can be a very deep red. Deep red will read almost black on film, so choose apples that are a lighter red in color. If you can find them with streaks of yellow or green, this gives them more interest.

Apricots. Apricots are available for a very limited time, May through July (and December and January from the southern hemisphere). They need to be handled with care because they tend to spoil rapidly. If the apricots for a recipe are to be peeled and cooked, it is possible to use canned whole apricots when the fruit is out of season.

Artichokes. The peak season is March through May. The major concern with artichokes is that their color changes drastically when they are peeled, cut, or cooked. Rub cut surfaces with lemon as soon as they are exposed. Cook them in water that has been acidulated.

Asparagus. The peak season is March through May. Their size is important to consider when you are choosing asparagus for a shot. Pencil, or thin, asparagus is usually the least attractive. Choose asparagus with firm, crisp stalks and compact, brightly colored heads. For upscale shots, you may want to peel the lower portion of the stem. Cutting the base of the asparagus on a diagonal adds interest.

Avocados. Available year-round. The most common variety, the Hass avocado, is pear shaped and has a rugged black or dark skin when ripe. If you need slices of avocado, it is best to work with a fruit that is fairly firm and underripe since it will hold its shape and not be mushy. Brush the cut or exposed surface with diluted sodium bisulfite or lemon juice immediately to keep it from browning. To make guacamole, use a ripe fruit, add lemon juice to help hold the color, and keep it covered with plastic wrap placed directly on the surface until needed. Prepared guacamole purchased in a grocery store holds its color well and works just fine. Add chopped onions or tomatoes if additional texture is needed. You may need to restore the color of guacamole by stirring it during a shoot.

Bananas. Available year-round. One of the harder fruits to find in perfect condition. They blemish easily and ripen quickly. A peeled banana's white surface browns almost immediately. Today, with computer retouching, these imperfections are easy to correct. However, you still need to find the best example for the assignment. Purchase slightly underripe bananas the day before and *carefully* transport them to the studio. Store at room temperature and, if you need to accelerate the ripening process, put them in a closed paper bag. On the day of the shoot, purchase a few more hands (bunches). In New York, the best are often found in the stands of street vendors. Considerations: size, shape, single whole banana versus hand of bananas, sliced versus whole versus bitten into.

Beans, fresh. Fresh beans are those that are consumed whole. The basic types are snap green and yellow wax, but baby French beans are also becoming more widely available.

Snap green. Of all the cooked green vegetables, green beans seem to turn to olive most easily. When I asked "America's Food Sleuth," Shirley Corriher, why this might be, she said that if you cook *any* green vegetable more than five minutes, or if you cook it covered, it will lose its bright green color and turn olive. Later, I did notice that I blanched green beans longer than other vegetables to get an even cooked appearance. I have since cut the blanching time considerably, even

if the color looks uneven when cooking. After I have shocked the beans, they appear an even, bright green color and hold it much longer (see page 169). When handpicking green beans, pick for freshness, color, and size (avoid large green beans, called culls in the business, because they are tough, stringy, and collapse when cooked). If you are showing the beans whole with tip included, look for fresh-looking tips and beans that are curved as well as beans that are straight. Some curved whole beans look much more attractive in an arrangement than all straight ones.

Yellow wax. More seasonal and harder to find than green, but beautiful as a side dish or in salads. Farmers' markets are a wonderful source for the freshest yellow beans with the greatest variety of shapes and sizes.

Beans (legumes). The large variety of seeds from bean pods can be found fresh, dried, or canned. White beans include kidneys, Great Northern, cannellini, navy, and cranberry. Other beans include pinto, roman, red kidney, flageolet, and black. It is most often easier to work with the canned varieties rather than cooking them from the dry stage. Just remember that each brand and type of bean will have its own look and degree of "perfection."

Purchase several different brands of the bean type you need, open the cans, and select the brand with the look that works best for you (see photograph below). For example, if you are shooting a bowl of chili with beans, which brand would you use? The answer is D: The beans are lighter in color so will show up in dark chili, and also they are tender. If you are shooting a three-bean salad with yellow wax beans and bright green beans, which brand of red kidney bean would you use? A or C: bright red and crunchy for a three-bean salad. If you are selling a specific brand, you must use the product. When I am shooting canned beans, I always rinse first, saving some of the can juices. Sort for the best beans, arrange them, and, just before shooting, resauce them with the reserved can juices.

Beets. Beets come in a wonderful variety of colors, from yellow to purple. Purple beets tend to stain foods they touch, so be careful working with them and arrange them just before you need them. Their color can be enhanced with the use of an

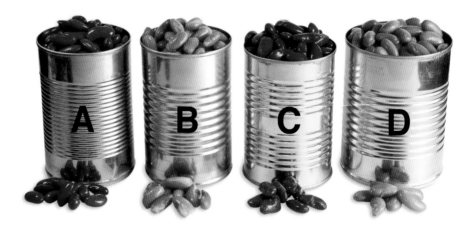

Four brands of red kidney beans. Besides color and texture differences, some brands have beans that are less broken. *Dennis Gottlieb*

acid (see page 170). Roasting beets in aluminum foil packages, cooling them, and then peeling them produces the smoothest look. Canned beets are sometimes used as a time-saver.

Blackberries. A very seasonal summer fruit, but now becoming more available throughout the year. Blackberries are not always of good quality, but beautiful fake blackberries are available online for rental or purchase. Sometimes frozen blackberries can be used just as they get to the thawed stage.

Blueberries. Originally a very seasonal fruit, June through September, but now found just about any time of the year. Look for blueberries that have a lot of white "bloom" on them so they will not appear black when photographed. Get a variety of sizes. Don't wash or handle manually; I usually use tweezers because they will not remove the wanted bloom. Blueberries are usually photographed with the blossom end, not the stem end, toward the camera. Some photographers use fake blueberries when the fruit is hard to find or too dark.

Broccoli. Choose broccoli that is firm, evenly colored, with light green, compact bud clusters. Avoid selecting clusters that are dark green or purplish because after you have blanched these stalks, the clusters will look almost black rather than a bright green. When arranging the florets, make sure some of the stem is showing and not only the heads. This makes for a more interesting food shot when you contrast the shiny, smooth, light green stalks with the darker, frilly tops. I usually cut the stalks longer than I might need. I can always make them shorter. Blanched and shocked broccoli holds up well covered with a damp paper towel.

Brussels sprouts. Brussels sprouts make a pretty fall vegetable dish. They are beautiful whole or sliced in half. Look for sprouts that are equal in size and have fresh, bright green outer leaves. If a couple of leaves are damaged, they can be easily removed.

Cabbage. The basic three cabbages are green, red, and savoy. All can be cooked or eaten raw. Buy fresh-looking lightweight cabbages rather than the heavier ones with tight, flat leaves. If you are slicing for coleslaw, this allows for the internal leaves to have more interesting shapes. Make sure you have some good dark green outer leaves for color contrast for the slaw, as well. Adding an acid, such as vinegar or lemon juice, to red cabbage helps preserve its color. I substitute savoy cabbage for the regular green cabbage sometimes because the leaves are very curly when sliced.

Carrots. You can purchase carrots year-round as whole baby, regular with tops, in one-pound bags without tops, and loose as horse (large) carrots. If you will be showing whole baby carrots, it is nice to leave a little of the green tops on.

Always peel carrots before cooking. If the carrots are to be shown as a raw ingredient with tops on, you may want to cut off some of the tops, remove part of the stem, and "transplant" the shorter stem into the top of the carrot. Most carrot tops have a very long stem before you get to the leaves, which are the part that photograph more attractively. I just place them in—the other stems will hold them in place. For upscale presentations, carrots come in many colors and can be cut into a myriad of shapes and sizes. Be creative.

One treat working in other countries is the unusual produce you find. I found these huge and tiny carrots in a Lima, Peru, farmers' market.

Cauliflower. If you are using cauliflower as a cooked vegetable, cook it for the least amount of time possible. Try cooking it in a fifty-fifty solution of milk and water for a whiter appearance. The florets look pretty when sliced in half. Look for undamaged heads that are as white as possible.

Celery. When choosing celery for an assignment, consider the width you want the stem to be. If you want to show small whole slices, you will need celery with thin stalks. The stalks should be firm and a bright green. The inner celery leaves make a nice garnish if they are small.

Cherries. Cherries have a short period of availability: May through the end of July. They are also in the market from November to January, shipped from the southern hemisphere. Sweet cherries are the most popular, and the dark red Bing is the most commonly known. However, other varieties are becoming popular as well, such as the yellow and red Queen Anne. Sour cherries are used for making pies and are found fresh and canned. Maraschino cherries are used as garnishes in drinks and on desserts. Try to find maraschinos with whole stems of medium length and as unblemished as possible. When using maraschino cherries, wash and drain them well on paper towels so the red dye doesn't bleed into your other food.

Coconut. Select coconuts that are heavy, round, and fairly dark brown in color. Some "hairs" on the exterior add interest. If you want to open the coconut to make fresh shavings or shreds, the heating process (see sidebar) for cracking it also allows you to remove the flesh from the outer shell a lot more easily. Gently pry the coconut flesh out of the shell using a strong, blunt knife, such as a butter or dinner knife, in as large pieces as possible. If you want fresh coconut shavings, use a vegetable peeler to shave the flesh into long, flat pieces. You can peel off the brown skin first, if you prefer, but the shavings are usually more attractive with the thin line of brown skin, which is soft and edible. For shredded fresh coconut, carefully scrape a citrus zester along the white flesh to make long, thin strands or use a grater. Shredded coconut of a variety of types is often available in health food stores. Toasting fresh shavings makes an attractive presentation.

Corn. A late-summer vegetable, but now usually available throughout the year. Corn on the cob is shown as a side dish, husked, or with the husk still on (if grilled). It is also often pictured as the food on which to demonstrate a "perfect" butter or margarine "spread and melt" in advertisements. Select corn with large full kernels that fill the husk to the end. Sometimes it is important that the rows of kernels be very straight as well. You may need to husk the corn in the store to make sure you are getting what you need. Herb butter or paprika butter spread on the cob make for an interesting and different visual effect. In a pinch, when corn on the cob is not available fresh, frozen can be substituted. Do not cook; just thaw

cracking the coconut

Dennis Gottlieb

Many times we may want to show a cracked coconut as an ingredient or just as an item of interest in a shot. The coconut looks best if it is broken horizontally somewhat in the center with an irregular crack. The best way to do this is to find the soft, indented third eye of the coconut. Pierce the eye using a skewer or ice pick. Drain the juice. Place the coconut(s) on a tray in a preheated 400°F oven for 10 to 15 minutes. Often the coconut cracks or begins to crack on its own. If not, hold the warm coconut with a towel and use a heavy, blunt tool, such as the back of a heavy knife or a hammer, to break the shell around the middle. Once you have opened the coconut, put a damp paper towel over the flesh of the coconut and store it in a plastic bag until ready to use.

in room-temperature water and keep in water until needed. If using just kernels for a shot, use canned sweet niblet corn rather than frozen. It has a firmer and brighter kernel. If showing corn in its husk, carefully and partially peel back the leaves one at a time and remove all the silk. Straight pins come in handy to hold a couple of leaves twisted and pulled to the back of the husk. Spritz the kernels with water to give them a fresh, crisp appearance.

Cranberries. Cranberries are available only September through December, but they freeze well. If you have room in your freezer, freeze several bags for future use. Try to find cranberries that are bright red, not dark red. To prepare cranberry sauce for a photograph, you can follow the package directions. For a more whole and glazed look, try cooking the cranberries in a simple syrup (one part sugar to one part water) until they just begin to open. Remove them with a slotted spoon. In a pinch, cranberries that have been frozen can be carefully thawed and used as fresh.

Cucumber. The two popular varieties of cucumber are the American, with seeds and a darker, smoother skin, and the long and semiseedless English cucumber. For photographic purposes, the English cucumber, unpeeled and sliced or cubed, makes an attractive presentation. The American cucumber is usually used as a whole raw ingredient. Be sure it is very fresh and not a dark green color. If using the American cucumber for slices, remove the seeds with a melon baller.

Currants. Fresh red and white currants are available June through August. They are often used as a garnish with poultry or with desserts (see sunflower tarts in the photographs on page 310).

Eggplant. Since the flesh of eggplant discolors quickly when it is cut, cook it soon after cutting or sprinkle it with lemon juice. This is one of the hardest foods to work with as a stylist because deep purple eggplant photographs very dark and gets soft when cooked. We usually undercook it slightly. There are several varieties. The long Asian or Japanese eggplant is usually lighter in color and may be easier to work with. Pick firm-fleshed eggplants.

Endive. A beautiful upscale, cigar-shaped vegetable used in salads or as a base for hors d'oeuvres. Choose firm heads with unblemished leaves. Do not wash. Endive should be cut and arranged at the last minute. New varieties of endive are being developed. Red endive, which is a cross between white endive and red radicchio, is becoming increasingly available, and recently a white endive with green-tinged leaves became available.

Fennel. Used more and more today, cooked and raw in salads; fennel tops are also used as a garnish.

Figs. Fresh figs are available June through October and are very attractive garnishes, particularly when sliced in half. There are many varieties, ranging in color from purple-black to almost white and in shape from oval to round. Figs are extremely perishable.

Grapefruit. Choose grapefruit that are heavy for their size, firm, and have a tight and shiny skin. If the grapefruit are light in weight, then the interior will not be juicy. We usually show grapefruit sliced, so the amount of skin to flesh is important. If

Iceberg, romaine, and green leaf lettuces are most often used for recipes geared to the average home consumer. Lettuces such as endive, radicchio, and Bibb are more often used in upscale shots.
Colin Cooke

showing sections, peel the grapefruit and then cut along the top of each section with scissors. Carefully hand peel the sides and bottom of each section. Grapefruit varieties are white or red.

Grapes. When buying grapes, try to find those that are sold loose rather than in plastic bags so that you can examine them closely. Depending on how the grapes are to be shown, you will be selecting them for shape, size, color, and freshness. They should still have their bloom (dusty white yeast coating) and be firmly attached to the stem. Photographers love it when we find beautiful bunches with tendrils and attractive stems. Do not wash the grapes; handle them very carefully to retain the bloom. Spritz them with water just before shooting to suggest "cool and crisp." If the bloom has been lost, you can try spraying the grapes from a distance with an aerosol powder deodorant.

Greens. The history of greens in the United States for the past fifty years can be summed up thus: iceberg, iceberg, iceberg until the 1980s. Then came arugula, followed by endive, radicchio, and frisée. In the 1990s we discovered the three *M*s: mesclun, mâche, and microgreens. In the early 2000s, a wedge of iceberg with Roquefort dressing came back on many restaurant menus. Today, chefs increasingly use microgreens and sprouts.

When you are styling a salad, it is important to match the salad greens to the audience. If you are preparing a basic tossed salad for the average home consumer, lettuces such as curly green leaf, romaine, and iceberg, as well as curly chicory and spinach, might be appropriate. If you are preparing a tossed salad for a more upscale presentation, greens such as red leaf lettuce, frisée, oakleaf, radicchio, arugula, Bibb, watercress, or the popular mesclun mix may be the choice. When

building a salad, achieve visual appeal by using crisp greens with a variety of textures and colors (use the interior light leaves in heads of lettuce as well). Stand the leaves up for a fresh look rather than having them lie flat, which will give the salad a tired appearance (see the photographs on page 71). Some stylists dip the leaves very briefly in a solution of sodium bisulfite to extend their freshness. Keep washed greens refrigerated and covered with damp paper towels until ready to arrange. Lettuces will tend to be more fragile in the spring and firmer in the fall. Keep fragile greens whole. Refrigerate them, covered with a damp paper towel, and wash them just before arranging. Sometimes, just arrange them without washing.

Butter (green Bibb, red Bibb, deer tongue). A little on the fragile side, these lettuces make wonderful cups for holding chopped salads. Keep the leaves moist and remove them from the head just before arranging.

Crisphead (iceberg). Buy heads that have fresh, bright green leaves and are light in weight. Heads that are lightweight usually have interestingly shaped internal leaves. Iceberg can be used broken open in a display, sliced into wedges for dressing shots, torn into pieces arranged in basic salads, and sliced thin into shreds to top hamburgers and tacos.

Arugula. A popular salad lettuce, arugula is fairly fragile. Also known as rocket lettuce and Italian cress, it is available in baby form.

Chicory. Also known as curly endive. A very hardy green, used in many salad shots because it lasts and also has pretty leaves and texture.

Kale. Mostly used in food styling as a garnish. The ornamental kale is particularly attractive. Watch that the green of the leaves is not too dark. Also in purple.

Leaf or loose leaf (oak leaf, green leaf, red leaf). Green leaf lettuce is probably the second most used lettuce in food styling. We see it used in sandwich shots because of its beautiful curly ends. When shopping for this lettuce, handpick for pattern of curl on the tips of the leaves. Some lettuces have tight pointy curls, while some have round and curvy shapes. Pick the type that will look best on your sandwich (see the photographs on page 197).

Mâche (corn salad). A relatively new green. Quite fragile. Keep it refrigerated and arrange it close to shooting time. Use in upscale presentations.

Mesclun (salad mix). The mix varies depending on the source, but typically included are arugula, dandelion, frisée, mizuna, red and green oak leaf, mâche, radicchio, and sorrel. Other greens and herbs that you might find in a gourmet mix include baby green leaf, Italian parsley, lollo rossa, baby chard, chervil, cilantro, baby mustard leaves, nagoya kale, green curly kale, dinosaur kale, red Russian kale,

Waldorf salad with Bibb lettuce. *Colin Cooke*

159

pea greens, baby romaine, spinach, and tango—a leaf lettuce with distinctive curly leaves. These mixes are becoming more readily available and are beginning to appear in average home consumer shots as well. When choosing the leaves from a bin or bowl, choose only the freshest. If buying bagged leaves, get several bags and sort for the best leaves. Keep moist.

Pea vines. Very popular with chefs and used in upscale salads. These are baby greens with a beautiful shape, but they are quite fragile. Available at specialty stores in the spring. You may need to special order them.

Radicchio. Became known in the United States in the late 1980s. With its glossy red leaves and white veins, radicchio is added to tossed salads for color. Most commonly found as a round head, but one variety is long.

Romaine (long leaf). Romaine finds its way into many salads; the light green internal leaves are the most attractive.

Spinach. Used to be eaten mostly as a cooked vegetable. With the introduction of baby spinach, it has become a popular salad ingredient. The larger leaf spinach has more shape and interest visually, but it is usually a very dark shade of green and reads almost black when reproduced in print. The most popular spinach comes in baby form with flat leaves that are lighter in color. This spinach can be difficult to arrange as a salad ingredient because the leaves don't have interesting shapes. If tossing it with a dressing, add the dressing just before shooting since the greens are fragile. When arranging baby spinach, try to stand some of the leaves up and find some with curves for more interest. If showing it as a cooked item, steam it just until it begins to wilt and then arrange it with some texture.

Watercress. Watercress can be a beautiful addition to a salad, but it has a very short life span once it is out of the refrigerator and topped with dressing. It is also used as a garnish. Keep it submerged in cool, not ice cold, water until ready to use.

Kiwis. Kiwis became popular in the early eighties because of their flavor and the beautiful pattern the slices make when topping desserts. For photography, buy kiwis that are very firm and round. Ripe kiwis have a bruised appearance when sliced. Select kiwis that have a dark green skin under the brown furry exterior. Carefully peel kiwis with a sharp vegetable peeler.

Leeks. Available year-round, but freshest in early summer. Looking like giant scallions, leeks are related to both onions and garlic. Slicing across the white and light green part of the leek and then blanching or sautéing the rings produces a beautiful vegetable accent. If leeks contain dirt, slice through the bottom white toward the green leaves and rinse under running water.

Lemons. When shopping for lemons, think first about their final use. Will you need their zest or juice for a recipe or slices for garnish? Look for a close-grained, slightly glossy, bright yellow peel. Heavy lemons will be juicy, and the outer skin should not be too thick if you slice into it. The shape should be oval with no blemishes. One lemon yields about 3 teaspoons of grated zest and about 3 tablespoons of lemon juice. If you are cutting a circle of garnish for a glass of iced tea, cut from the stem end of the lemon (or any citrus fruit), where there are fewer pits. This cut also allows you to see some of the yellow skin on the edge of the circle. If you cut in the center, you will not be able to see the skin or peel as well (see the photographs on page 288).

A variety of lemon sizes, colors, and peel textures. Most of the time, the texture and color of the second lemon from the top are desirable.

1 Slice circles from the end of the lemon if you want some of the peel to show, or from the center of the lemon for less. **2** Half wagon wheel cut **3** Typical chef's cut **4** For twists, use a Y-shape vegetable peeler to remove a wide strip of zest from the center of the lemon. **5** With a sharp knife, cut thinner strips for twists. **6** Pin one end of a lemon strip to a straw; twist the strip around it, pinning the end in place. Cover the straw with a damp paper towel for at least 15 minutes before unpinning.

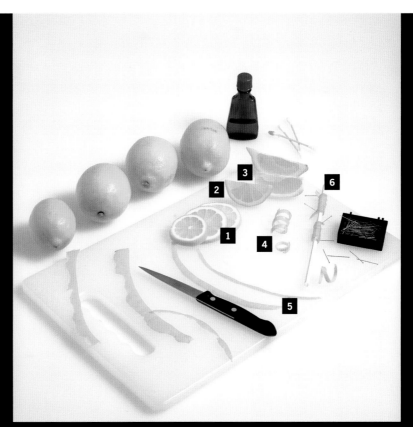

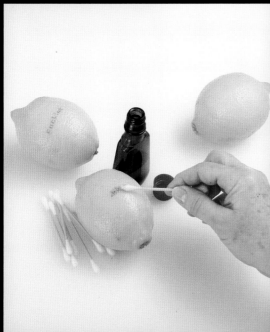

Remove stamped-on brand names with lemon extract or alcohol-based liquid.

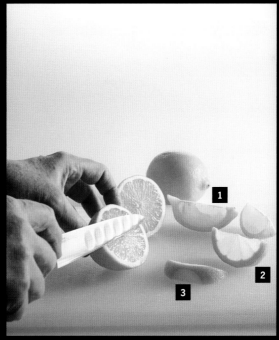

1 Lemon slices cut lengthwise can be too long and unattractive. **2** A more attractive way to slice a lemon is to slice the lemon in half horizontally and then cut a wedge. **3** Cut a small piece from the bottom to make the lemon wedge stable on a flat surface.

Dennis Gottlieb

Lettuces. See Greens, page 158.

Limes. The lime that is most often found in the American market is the Persian lime. The color of a lime is significant. If the skin is a very dark green, it will appear almost black when it is reproduced on film. Limes that go from a bright green to lighter green have visual interest. Choose limes that are firm, plump, and heavy for their size. If you will be slicing them, get extra because you can never be sure just how thick or thin the skin will be. Also consider the size. If you will be garnishing a margarita, the glass can be quite large, so you need to shop for very large limes. Besides the Persian lime, Key (or Mexican) limes can be found in some markets. One country's lime is not necessarily another country's lime, so choose correctly when styling ethnic cuisines. In Thai cooking, the Kaffir lime, with its dark, wrinkled, bumpy skin, is used. While teaching in the Philippines (see pages 328–329), I found that the tiny, tart calamansi (calamondin) is the lime of choice there. They also have a green lemon that looks very much like our limes on the outside, but it is yellow inside and quite tart.

Mangoes. More and more, as the American palate acquires a taste for Asian, African, and Indian foods, we use tropical fruits in photography. It has become important to know how to identify and work with these fruits. When choosing a mango, look for beautiful coloring and firm, fresh skin and flesh. The mango has a large flat stone; to remove it, cut the mango in half from top to bottom and slide the knife along each side of the stone. The height of the mango season is between June and September, but new varieties are being introduced, extending the season.

Melons. With all melons, you can't know the exact internal color of the pulp and rind until you cut into them. If you need to show chunks and wedges, buy fruits that are already halved, so you will not be surprised with inferior color and texture. Cut fruit close to the time needed or place plastic wrap directly onto cut surfaces. Do not spritz with water until just before shooting.

Cantaloupe. Best May through October, but the season has been extended, and cantaloupes are now usually available year-round.

Honeydew. Available mostly May through November. A bright green pulp looks best in photos.

Persian. Available July through October. This large green muskmelon has a rich salmon-colored flesh. The rind should be pale green with a delicate netting.

Watermelon. Available almost year-round, but best between April and October. Found with and without seeds. We have been known to place seeds in strategic spots when needed: Use tweezers to hold a seed and insert it gently into the flesh. Yellow watermelons have become available both with seeds as well as seedless. Usually, we want the seeds to appear, so we seldom buy seedless.

Mushrooms. The common white button mushroom is the one most often used—fresh in salads, sautéed, and even grilled. Try to find mushrooms with tight heads and few gills. They stay whiter longer and have a nicer sliced appearance. The white mushroom's cousin, the coffee-colored cremini, is less popular. Both are very porous and change color when sliced. Cut or cook them just before they are needed.

Lemon juice or sodium bisulfite help hold the color for a little while. Get to know the other varieties of mushrooms as well, because they have become more commonly used. There are many other varieties besides the ones that follow (chanterelle, morel, oyster, and wood ear are just a few).

Enoki. Very popular in the 1980s, when they were "discovered" here. Used in Japanese cooking, enoki mushrooms have long stems and tiny caps. Fragile, but visually lovely.

Portobello. Often grilled and usually used in sandwiches. Portobellos have become popular as a meat substitute; they should be put in the category of ugly (but delicious) foods. However, they turn very black and mushy when cooked. Not a food stylist's friend. Run when you get a recipe calling for these. Try to work with smaller porcini and cook them as little as possible.

Shiitake. Always remove the stem before cooking shiitake because it does not become tender. Often the gills of larger mushrooms are removed to prevent the dish from turning black.

Nectarines. Available mid-spring through late September, with yellow or white flesh. Look for interesting skin coloration, which goes from deep red to yellow. Nectarines are quite fragile, so handle and transport them with care. It is best to buy them when ready to use. Store at room temperature.

Okra. Available March through October. You may need to search specialty markets to find it.

Onions. Onions sound like a simple thing to find; everyone uses them, and they are available year-round, but it is not always easy to locate "beauties." To show whole onions with outside skin, you will want them round, with a dry, smooth, crisp outer skin and a small neck, possibly a few roots. You can peel away the first outside layer of skin if it is not attractive, but do not peel down to the shiny under layers. Round is important because if you are slicing into the onion or making rings, unless you begin with a very round onion, the shapes will be irregular. One of the newer food styling looks is to cut onions into wedges rather than the usual rings. Include a little of the root end to hold the wedge together.

Red onions. Sometimes referred to as purple onions, these are added to salads, often sautéed in stir-frys, or cooked on a grill. Brushing red onions with lemon juice after cooking or grilling brings out the red or purple color. If using red onion rings in a salad, cut through the rings so that you can place the halves through other foods and they blend in.

Scallions (green onions). There is some confusion here because scallions and green onions are not the same plant. (However, when someone in the South is referring to a green onion, he or she means a scallion.) Scallions do not form a bulb as such, while a green onion, also known as a spring onion, does. When showing either of these as a raw ingredient, look for beautiful fresh tops and onions with the roots still attached. If the tops are too long, trim them, cutting them at an angle.

Spanish onions. A yellowish onion and the most common.

TIP *A disk of sliced onion rings wants to fall apart during grilling, so hold them together with T-pins.*

White onions. Mild, sweet and very white in color.

Pearl onions. Round baby onions, best lightly blanched and then peeled.

Oranges and other citrus fruits. Choose oranges that are firm and heavy for their size, because they will tend to be juicer. The texture (neither too smooth nor with large visible pores), as well as the color and shape, are important if you are showing oranges whole. Even the little stem end should be intact. If you are using oranges as a garnish, consider the size and texture (see pages 161 and 294 for directions on making citrus twists and wedges). If you are slicing an orange in half, the thickness of the skin is important. You will want large, even segments and a center that is not open or dry looking. Sometimes a juice orange works better than a navel, and it is smaller. Keep the sliced surface moist by brushing it with water or by covering with very damp paper towels until ready to shoot. It is important to know when the more unusual citrus fruits are available.

Blood oranges. These are a bit more common today than they once were. The flesh, and sometimes the outside skin, is red. An interesting upscale garnish.

Kumquats. These are available November through March and make an attractive garnish. They are also delicious when eaten fresh, skin and all.

Mandarin oranges. Depending on the variety, mandarin oranges can be found November through June. Members of the mandarin family include clementine, dancy, satsuma, and tangerine.

Pummelo. A grapefruitlike citrus found in China, Thailand, and Indonesia, and now more available in North America. Commonly cooked or candied.

Tangelos. A cross between a tangerine and a pummelo. Available November through March.

Papaya. Available year-round. These are coming into more common use as the American palate explores the foods of Brazil, Mexico, Thailand, Indonesia, and India. If slicing or dicing, purchase the fruit on the firm side. When papaya is used raw, sliced in half, the seeds are often left in. Otherwise, seeds are removed.

Peaches. Very fragile. Purchase on the firm side without blemishes. If a shot requires that you slice a peach or show it in wedges, try to find freestone or semi-freestone peaches so that the pit can be removed without damaging the fruit. Ficus leaves are used as a stand-in for real leaves when you can't get them. If you want the real thing, contact a florist or become friends with the farmers who bring peaches to the farmers' markets and ask them for leaves and branches. Some peaches in season will peel easily. If they don't, place them in boiling water for a few seconds, remove with a slotted spoon, and peel.

Pears. As with apples, it is important to be aware of the many varieties of pears and to have an understanding of the cooking properties of each. The Bartlett is probably the best known of the pear varieties. It is a good eating and cooking pear. The red variety, Red Williams, is very attractive and becoming more available. For poaching, the Bosc pear is most commonly used because it holds its shape well and has a lovely stem. The Seckel pear is a small, lightly spotted yellow, red, and green pear that, when available, works beautifully as a garnish. Brush pears with a solution of sodium bisulfite after slicing them and do not eat them.

Peas. No need to shell peas for a shot unless you will be showing them as a raw ingredient. Buy frozen shelled peas (I prefer a store brand to a more expensive brand name because the peas are larger and more consistent in size). Thaw peas in a bowl of room-temperature water with a little vegetable oil poured on the surface so that as you remove the peas from the water, a little oil clings and adds a glisten to each pea. If mixing peas into a dish such as paella, place just a few peas in the dish until ready to shoot because peas quickly shrivel when out of water. When ready to shoot, remove the shriveled peas and replace them with the correct amount of plump peas.

Pea shoots and sprouts. Both started out in restaurants, but they have become available in many grocery stores. Shoot are used in salads or as garnishes. Sprouts are used in "healthy" sandwiches. Both are fragile, so keep them in cool, not cold, water until ready to shoot.

Snow peas. Can be very beautiful in a stir-fry or made into a salad. You can give them an upscale appearance by snipping a V-shape from the tip. It's best to blanch them for a few seconds and then shock them. Hold them under damp paper towels. They also work well in crudités arrangements.

Sugar snap peas. A spring treat, this is a pea pod meant to be eaten whole.

Peppers, bell. Bell peppers are available in red, green, yellow, purple, and orange varieties. You can tell when a chef, not a food stylist, has sliced a bell pepper into sticks. The chef cuts off each end of the pepper, opens up the pepper, and cuts it into straight sticks. A food stylist first finds bell peppers that are not too long and turn in at the ends. He or she carefully trims around the stem, removes it, cuts the pepper in half lengthwise, and cuts sticks that have a hook on both ends. The shape of this cut is more visually appealing than just a straight stick. A food stylist looks for smooth-skinned fresh peppers with a fairly dense color (except the green, when a lighter rather than darker shade is preferred). The color in red bell peppers is very sensitive to heat and hot oil and will go from bright red to an orange-red when cooked, so buy the darkest red you can find.

Peppers, chile. Chile peppers are an ingredient that food stylists need to be familiar with because we are styling more and more foods in which they are used. The following is a list of the basic chiles, mild to hot.

Anaheim. Mild; usually sold green. Typically roasted and peeled; used in salsas and chiles rellenos.

Banana wax. Mild; sold yellow-green. Add raw to mild salsas and roasted to tacos and as a topping.

Poblano. Mild to medium hot; sold dark green. Usually roasted and used in sauces and enchiladas or fried to make chiles rellenos. In the dried form, they are known as ancho or mulato chiles.

Fresno. Mild to medium hot; sold red. Spicy and sweet, try them raw in slaws, dips, and soups.

Jalapeno. Medium hot; usually sold green, but occasionally sweeter reds are available. An all-purpose hot chile used raw in salsas and guacamole.

Serrano. Very hot; sold green and red. Use raw in hot salsas or cooked in curries and chili.

Thai bird. Very hot; sold red, green, orange, or yellow. Used in Southeast Asian curries, soups, and salads.

Habanero. Very, very hot; sold orange, red, yellow, or green. Used in fruit salsas, hot sauces, and marinades.

Pineapple. Thank goodness for the development of the golden pineapple. Now, when we slice into a pineapple, it is bright yellow inside. Before the golden pineapple, food stylists had to brush the cut surface of a pineapple with diluted yellow food coloring. This is a technique that can still be used if the flesh is not as yellow as desired. Just remember that when brushed with food coloring, the flesh will get brighter upon setting. When buying a fresh pineapple, look for a firm, beautifully textured skin with the desired coloring (golden brown with tinges of green is usual). The body should be in good proportion to the stalk or leaves.

Finding a beautiful pineapple can be difficult, particularly because of its leaves. If some leaves are damaged, they can be removed (you can replace the leaves by borrowing some from another pineapple if necessary). Some leaves have dry tips: Remove the tips by trimming them with a sharp scissors following the shape of the leaf. If the bottom is beautiful but the top is not, then the offending top can be replaced with a more attractive top from another pineapple. Another thing to look at is the underside of the leaves (which often show in fruit bowl arrangements). There is a bloom on the underside that you want to keep undamaged.

Plums. There are many varieties of plums and they are very seasonal, mostly available in summer and early fall. Buy firm plums for photography. To keep the natural bloom of whole plums, don't wash them.

Potatoes. Not all potatoes are created equal. You will want to use various varieties for specific dishes. Always choose potatoes that are very firm. Size will be very important when selecting potatoes to be shown whole as baked or quartered in oven-roasted dishes. The color and texture of the skins will vary by the season. If you have to hold cut potatoes for a while, submerge them in water or brush the cut surfaces with sodium bisulfite and water (but don't eat these potoatoes).

California long white, Katahdin, Yukon gold, Yellow Finn. Medium-starch potatoes with a creamy texture. They hold up well in chowders, potato salads, and when roasting and frying.

Red potatoes (Red Bliss, Red Pontiac). Low-starch potatoes with thinner skins and a denser texture. They are often referred to as waxy or boiling potatoes and are best sautéed, steamed, or roasted. Red-skinned potatoes turn pink when cooked, so buy them as dark red as possible.

Russet, Belrus, and Kennebec. High-starch potatoes with a dry texture that makes them good for baking and mashing, as well as using in gratins.

Sweet potatoes. Come in a number of varieties and colors, from a deep orange to a light yellow. For styling purposes, they are usually best roasted rather than boiled because they hold their shape and color better.

Pumpkins. Pumpkins are another difficult vegetable because they are very seasonal, and it not uncommon to have to try to find a pumpkin in May for an editorial shoot. The baby, or mini, orange and white pumpkins are lovely as garnishes or for holding individual servings of soup. Model makers will make pumpkins for out-of-season shoots.

Radishes. Gone are the days of radish roses, for now at least. Find radishes as round and unblemished as possible for use in salads and sandwiches. They are often shown as a raw ingredient, if the leaves are blemish free. Also use as crudités with some of the stem still attached.

Raspberries. Mostly found as red or rose colored, but also available in season as golden. Raspberries used to be very seasonal, but they are now available throughout the year. Select berries that are plump and bright in color. Buy a variety of sizes if you are using them as a garnish; sometimes small works best, sometimes large is needed. Some raspberry varieties have longer "hairs" than others; avoid those or else you may end up having to remove the hairs with a tweezer, as I had to do for one job (see the photograph on page 5).

Rhubarb. Available in late spring in most parts of the United States. The color of a sauce, pie, etc., will depend on the variety you choose. Some varieties have a bright pink flesh, while others are more muted. You may need to go to a grower to find rhubarb with leaves (see page 148).

Squash. Now available year-round. Most varieties are categorized as summer or winter depending on their storage life.

Summer squash. These squash have thin edible skins and soft seeds. Look for unblemished bright skins and think about the many ways they can be sliced, depending on the audience and the recipe. Varieties of summer squash include crookneck or yellow, pattypan, and zucchini. These are also available in baby

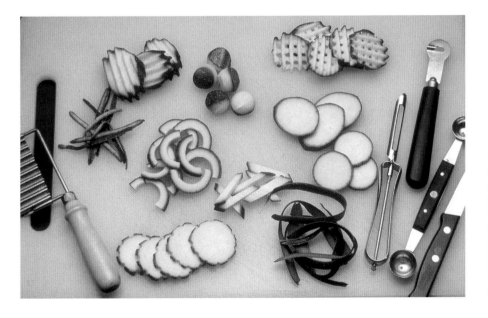

We are always looking for new ways to present produce. With zucchini, the typical round cut on the bias reveals more peel. More exotic looks include matchsticks, crescents, and waffle cuts. For food professional shots, balls or peels can be used to interesting effect. The presentation should fit the audience. *Amy Reichman*

wanted: perfect strawberries

I once had a job where a cup of yogurt was to be photographed surrounded by mounds of strawberries. Luckily, when I got to my produce store, they had beautiful strawberries. I bought a flat and that was that. A few years later, however, I had a full-page ad featuring one beautiful strawberry dipped in chocolate. For that, I ended up buying from twelve different stores, and the photographer sent out an assistant for more. The assignment determines the importance placed on any fruit or vegetable selection.

form early in the season. A fairly fragile produce that is best sautéed, baked, or grilled just before needed for a shot. Be sure not to select zucchini that have a dark green skin; the skin will look even darker when seen in print.

Winter squash. These squash have thick, hard shells and seeds. The common varieties include acorn, buttercup, butternut, Hubbard, spaghetti, and turban. Best if baked.

Strawberries. We swirl them in yogurt, slice them and put them on top of tarts, and show them whole dipped in chocolate. If they are the main feature in a shot, you may need to shop many sources to find the ultimate strawberry. The top, stem, and leaves need to be fresh; the correct size and shape vary according to the variety and the weather during the growing season. The fruit portion should be an even bright red in a rounded V shape. The seeds will be yellow or brown, depending on sun exposure. If you are slicing it, check the inside of the strawberry: Is the strawberry red and full throughout or is it whitish and hollow in the center? Some stylists have used lipstick to add color to areas of a strawberry that were not evenly red. Buy strawberries close to the time of use and refrigerate them until needed. Near the time of the shoot, I sort for size and shape and put the strawberries I select stem side down on a damp paper towel.

Tomatoes. In the early days of food styling, it was almost impossible to find tomatoes with beautiful, fresh green stems and leaves. Today, with farmers' markets and the development of hydroponic tomatoes, they are easier to find. If you are showing whole tomatoes in a shot, the photographer or client will always want to see the tomatoes with tops or as a cluster on a stem. If the tops become a little dry, put the tomatoes upside down in a cup of room-temperature water to refresh them. Also, keep stems and leaves covered with a damp paper towel until ready to shoot. Traditionally, we spritz the tomato skin with water droplets before shooting because the moisture suggests "cool and fresh." Unfortunately, however, it also suggests the tomato has been in the refrigerator or chilled. Never refrigerate tomatoes, for home use or for food styling purposes, because refrigeration causes the tomato to lose its firm texture. New varieties become available constantly. Look for unusual (heirloom) tomatoes at local farm stands in season.

Cherry. Mini tomatoes, including the grape and currant varieties; available in red, yellow, green, and orange. Size is important when using small tomatoes for styling. For example, a salad with cherry tomatoes and cantaloupe balls will look better if both fruits are about the same size.

Hydroponic. Bright red, round, and "perfect"; usually several on a stalk. Transport carefully since the stems can puncture other tomatoes. Usually not as bright red in the center as a plum tomato when sliced. When available, use other varieties, such as beefsteak, for slicing.

Plum or Roma tomatoes. Oval in shape and less juicy, these tomatoes work well when diced for salsas because their interior color is a bright red.

To Blanch, Steam, Sauté, Microwave, Grill, or Roast? That Is the Question

Always cook produce in small batches. Prepare foods that will last longest first and save the more fragile foods until right before you need them. There are assignments where steaming or microwaving may be necessary, but usually a sauté or blanch method is used because we can control the look and get the best results. Knowing how to cook your produce for the greatest visual appeal takes some time and thought about how you want the end result to appear. Is it a watery food? Then blanching will only make it look more watery. Instead, consider sautéing, microwaving, or steaming gently. Vegetables can be cooked directly on a grill or grill pan or first sautéed and grill marks added after cooking. Roasting vegetables has become very popular; always roast for real.

GREEN VEGETABLES

Green vegetables tend to lose their bright color and turn a drab olive when cooked for longer than five minutes. If blanching them, cook for the least possible amount of time. Each vegetable's cooking time will depend on the density and size of the vegetable. Drop a few pieces at a time into a large pot of *unsalted* boiling water (salt will soften the vegetable). Once they are cooked, remove them with a slotted spoon and immediately shock them in ice water until cool. Store on a tray lined with paper towels, cover with damp paper towels, and refrigerate. If the vegetables are high in water content, such as zucchini or green bell peppers, they are best cooked by sautéing and kept covered with a damp paper towel at room temperature. (I don't shock sautéed vegetables.) Green vegetables should not be cooked in a covered pot and should not be stored in airtight containers; they need to "breathe" or be exposed to oxygen, or else they turn olive green—thus the damp paper towels.

in search of beautiful tomatoes in the fields of florida

We were shooting a commercial for a sandwich chain in Florida. Normally, the chain provides all the food. Tomatoes, however, are notoriously problematic. They have to be a certain size or count to the case. They also need to be a bright red and, if we are shooting a raw ingredient shot, they need to have beautiful tops. Today, this is not such a problem because we now have hothouse tomatoes on the vine available year-round. However, when we were shooting this commercial, these were not readily available. I ordered fifty pounds of beautiful tomatoes sent to New York City from Israel, our only source for bright red tomatoes at that season. We were shooting in Florida, so, after I sorted for the best tomatoes, I shipped them there. However, the tomatoes in those days did not have tops, or calasks; model makers had to make them. For the raw ingredient shot, we needed a basketful of tomatoes with tops. When I arrived in Florida, I asked if there were tomatoes growing nearby. Yes, I was told, but they were not ripe yet. So into the fields I went and picked green tomatoes with beautiful tops and transferred the tops to the red tomatoes from Israel. Produce availability has certainly changed over the years.

TIP *Shocking is a technique that involves removing cooked vegetables from boiling water and placing them immediately into a bowl of ice water to stop the cooking process. If you are shocking vegetables in ice water and have only a limited amount of ice, cool the vegetables in cold tap water before putting them into the ice bath until completely cold.*

RED VEGETABLES

Red vegetables have pigments that are sensitive to heat, hot oil, and water and lose or change color when cooked. The addition of an acid ingredient (vinegar, white wine, or lemon juice) during cooking enhances the color in some red and purple vegetables. Vinegar will also enhance the color of uncooked red cabbage and red onions. Test first to see if you like the effect. Buy vegetables that are dark red and cook them as little as possible.

WHITE VEGETABLES

White vegetables react to contact with iron and aluminum, which causes them to turn yellow or brownish in color. It is best to use stainless steel, enamel, or glass utensils. Adding an acid, such as vinegar, white wine, or lemon juice, during cooking enhances their color. Cauliflower cooked in half milk and half water seems less transparent than if it were cooked in water alone.

Transporting Produce for a Shoot

Getting the produce to the job in good condition is as important as finding beautiful produce. Each stylist has his or her own techniques for transporting fragile items. Such techniques can include wrapping the food in paper towels or bubble wrap or blowing up plastic bags containing the fragile produce and securing the top. I sometimes bring plastic containers with lids with me when I shop and place the more delicate produce in them for protection. I ask the checkout person to pack them carefully, explaining that I need the foods to be photographed. Sometimes I just pack the items myself. It is a good idea to invest in equipment that will help you get the food to the job in good condition, such as coolers and specially shaped containers and bags. Most grocery or housewares stores have a large variety of plastic containers.

Seasonal Availability Chart: Finding Food at Its Peak

Most produce is available year-round now. However, there are some foods that are seasonal and very difficult to find at other times of the year. The following chart is a basic one for vegetables from the northern hemisphere. It is a good reference because it is important to know when things will be available locally at produce stands and also when that food is at its height of flavor. The reverse of this chart would note when those same vegetables are available from the southern hemisphere. For example, asparagus is grown here from February through June, so it would be shipped to the United States from the southern hemisphere from October through January.

Newspapers and magazines publish features about produce when it is at its peak of availability and taste. To get those features, some magazines work two months ahead of publication, some six months ahead, and some a year ahead. Whatever the production schedule, the food will need to be found whenever a shot is scheduled.

Tropical fruits, such as mangoes, have only one season. They are grown just above and below the equator and are available at specific times and then that is it.

the right look: sautéed, grilled. or blanched

To achieve the sautéed look, use a nonstick pan over medium heat. Add a couple of tablespoons of vegetable oil. When it is hot, add a few vegetables and cook, stirring constantly, until the desired look is reached.

For the grilled look, you can use a cast-iron grill pan. However, if you want more control over the look or need the grill marks to be closer or farther apart than the grill pan will produce, heat a nonstick pan over medium-high heat. Add very little oil and wipe the pan with a paper towel. Add a few vegetables and leave them on the surface of the pan until you have the desired charred appearance. Remove the vegetables from the pan and add grill marks with a metal skewer that has been heated over a gas flame. Don't use a torch to give vegetables the grilled look. The edges of the food become burned, but the interiors don't look cooked.

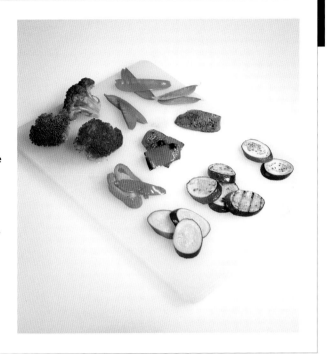

FRONT ROW, FROM LEFT: Sautéed, grilled, and torched zucchini. SECOND ROW, FROM LEFT: Sautéed, grilled, and torched bell peppers. TOP ROW: Broccoli and snow peas are raw or blanched and shocked. *Dennis Gottlieb*

Some plants, such as lime, coconut, and papaya, produce fruit throughout the year, which is helpful. Tropical fruits and vegetables are becoming increasingly popular as interest in the ethnic foods of the tropics grows. You may want to look for your own fruit and tropical produce availability charts.

Vegetable Availability

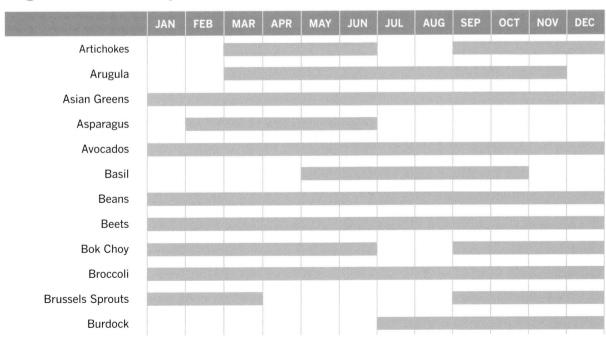

	JAN	FEB	MAR	APR	MAY	JUN	JUL	AUG	SEP	OCT	NOV	DEC
Artichokes			▓	▓	▓	▓			▓	▓	▓	▓
Arugula			▓	▓	▓	▓	▓	▓	▓	▓	▓	
Asian Greens	▓	▓	▓	▓	▓	▓						
Asparagus		▓	▓	▓	▓							
Avocados	▓	▓	▓	▓	▓	▓	▓	▓	▓	▓	▓	▓
Basil					▓	▓	▓	▓	▓			
Beans	▓	▓	▓	▓	▓	▓	▓	▓	▓	▓	▓	▓
Beets	▓	▓	▓	▓	▓	▓	▓	▓	▓	▓	▓	▓
Bok Choy	▓	▓	▓	▓	▓	▓	▓		▓	▓	▓	▓
Broccoli	▓	▓	▓	▓	▓	▓	▓	▓	▓	▓	▓	▓
Brussels Sprouts	▓	▓	▓	▓					▓	▓	▓	▓
Burdock						▓	▓	▓	▓	▓	▓	▓

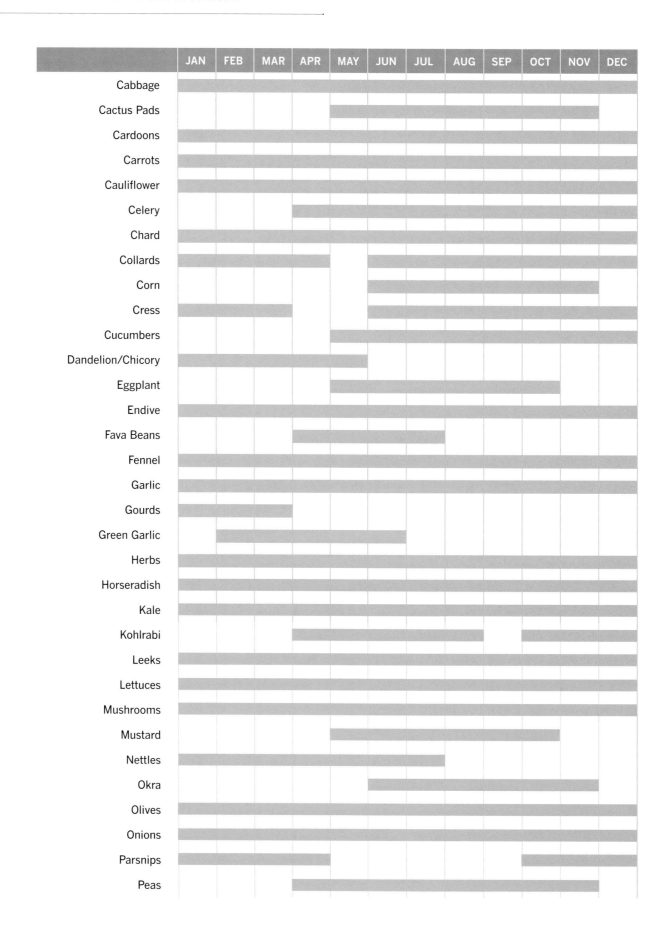

	JAN	FEB	MAR	APR	MAY	JUN	JUL	AUG	SEP	OCT	NOV	DEC
Cabbage	███	███	███	███	███	███	███	███	███	███	███	███
Cactus Pads					███	███	███	███	███	███		
Cardoons	███	███	███	███	███	███	███	███	███	███	███	███
Carrots	███	███	███	███	███	███	███	███	███	███	███	███
Cauliflower	███	███	███	███	███	███	███	███	███	███	███	███
Celery				███	███	███	███	███	███	███	███	███
Chard	███	███	███	███	███	███	███	███	███	███	███	███
Collards	███	███	███	███		███	███	███	███	███	███	███
Corn						███	███	███	███	███	███	
Cress	███	███	███			███	███	███	███	███	███	███
Cucumbers					███	███	███	███	███	███		
Dandelion/Chicory	███	███	███	███	███	███						
Eggplant					███	███	███	███	███	███		
Endive	███	███	███	███	███	███	███	███	███	███	███	███
Fava Beans				███	███	███	███					
Fennel	███	███	███	███	███	███	███	███	███	███	███	███
Garlic	███	███	███	███	███	███	███	███	███	███	███	███
Gourds	███	███	███									
Green Garlic		███	███	███	███	███	███					
Herbs	███	███	███	███	███	███	███	███	███	███	███	███
Horseradish	███	███	███	███	███	███	███	███	███	███	███	███
Kale	███	███	███	███	███	███	███	███	███	███	███	███
Kohlrabi				███	███	███	███	███		███	███	
Leeks	███	███	███	███	███	███	███	███	███	███	███	███
Lettuces	███	███	███	███	███	███	███	███	███	███	███	███
Mushrooms	███	███	███	███	███	███	███	███	███	███	███	███
Mustard					███	███	███	███	███	███		
Nettles	███	███	███	███	███	███	███					
Okra							███	███	███	███	███	
Olives	███	███	███	███	███	███	███	███	███	███	███	███
Onions	███	███	███	███	███	███	███	███	███	███	███	███
Parsnips	███	███	███	███	███					███	███	███
Peas				███	███	███	███	███	███	███	███	

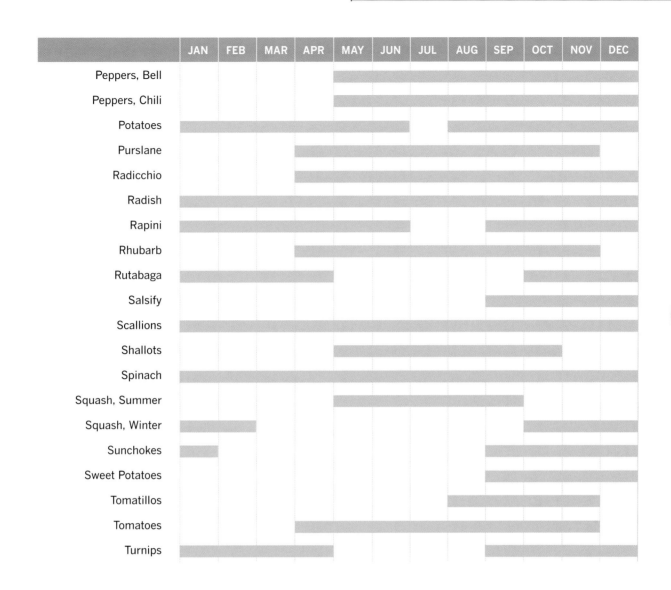

a GLOSSARY of HERBS

Fresh herbs are becoming increasingly popular, because of their use in chefs' recipes and cookbook and magazine recipes. They are now available throughout both summer and winter. When I first began styling, parsley and mint were about the only fresh herbs we used as a garnish. Today, sprigs of a wide range of fresh herbs are used as garnishes if they appear in the dish being photographed, or they are chopped and sprinkled over the dish and plate (which was the fashion in restaurants in the mid- and late nineties). Finding beautiful fresh herbs can still be a challenge in the winter months, though. During growing season, most food stylists in New York depend on the wonderful supply available from the farmers' markets. After that, it is packaged herbs in the grocery store or, if you are lucky, potted plants from the windowsill.

Herbs go into the handpick column of your grocery list. Whenever they are to be used as a garnish, it is important that you find fresh, unblemished herbs of just the right size. Small is usually better than large. When you garnish a plate with a sprig of herb, use the worst-looking sprig for a stand-in and replace it just before shooting. You should usually place the sprig with the leaves facing toward the camera and have

TIP *Pesto made from basil photographs very dark; you may want to use half basil and half parsley when making pesto sauce to get a brighter green.*

the light shining through them from the back. This is not a hard-and-fast rule; there are always exceptions. A tweezers is a great help in placing the garnish just right.

Some cut herbs are best stored with their stems freshly recut and placed in a "vase" (a 2- or 4-cup glass measuring cup works well) of water with a drop of liquid dishwashing detergent added to help the water be absorbed. Sometimes we mist (but not dill), cover gently with a plastic bag, and refrigerate. Woody herbs, such as rosemary and thyme, can be covered with damp paper towels and refrigerated.

Basil. Basil is one of the easier herbs to find, but one of the more difficult herbs to find in good condition because it is so fragile. It bruises easily, fades quickly when out of water, and is sensitive to very cold temperatures. Many stylists put cut basil in a container of water and leave it in a cool location out of the refrigerator (the refrigerator temperature is often too cold). Basil comes in many varieties, such as purple, Thai, and lemon. If possible, bring a couple of types to the shoot. If using basil minced or as a chiffonade (the leaves rolled and cut into thin strips), do this just before shooting because the basil turns dark and bruises immediately.

Chervil. Used more in Europe than in the United States, but increasing in popularity, chervil is a beautiful feathery herb that is a member of the parsley family (see the photographs on page 83 for unusual white chervil).

Chives. Although not officially an herb, chives are much used as a garnish, either as stalks or chopped and sprinkled over dishes. Cutting the stalks on a diagonal adds interest to chopped chives. The flower of the chive, available in early summer, is also a beautiful edible garnish.

Coriander. Also known as cilantro and Chinese parsley, coriander is another member of the parsley family. We are using this herb more frequently as the cuisines of Mexico, India, and Asia become more widespread. This is a very fragile herb that needs to be stored in water and placed in the shot just before shooting.

Dill. Dill is a very delicate herb frequently used to garnish seafood. When it is to be used as a garnish on a platter of hors d'oeuvres, try to find sprigs that are very similar in shape and size. Don't spritz. Store with cut ends in water.

Marjoram. This beautiful purplish-green herb is used frequently in Mediterranean cooking.

Mint. Mint comes in more than thirty species, but spearmint and peppermint are the two most popular, and spearmint holds up particularly well. Never go on an assignment where you are shooting a dessert without bringing along mint, raspberries, and strawberries as possible garnishes, even if they haven't been requested. Someone is bound to say, "What if we used a little mint as a garnish?"

Oregano. A member of the marjoram and thyme family, oregano is ubiquitous in Mediterranean and Latin cooking. When it flowers, it is lovely as a garnish as well.

Parsley. Parsley is one of the most frequently used herbs. If I am chopping parsley to sprinkle in a dish, I put parsley under produce on my grocery list. I get curly leaf

Parsley sprigs are like snowflakes; no two are alike. Bright green leaves in an open, not too dense arrangement is most desirable when choosing parsley. Flat-leaf or Italian parsley, at right, is most often used for upscale chef-style shots. Curly leaf parsley, at left, is more common for the home consumer. *John Montana*

parsley because it chops into a prettier shape, whether coarse or fine. I make sure it is fresh and the right shade of green. If I am using parsley as a garnish, I list it under handpick and I look for freshness, shape of leaves, and color (not too dark green or it will appear almost black when in print). I look carefully at several bunches, checking for the shape of the leaves. No two leaves have the same shape, and leaves that are in tight, clumped bunches are not as visually attractive as leaves that are more open and fan shaped. The size of the leaves is important as well. If I am shooting a chef's recipe, I will always choose flat-leaf or Italian parsley because that's what chefs use most. For food-service or average home consumer shots, I use curly leaf parsley—the most commonly used parsley—and I look for leaves that are fanned rather than tight or pointy. I often store my hero parsley in water on my set tray and remove it just before shooting, with water still clinging to it.

Rosemary. Rosemary is used as a garnish in sprig form or chopped and sprinkled over a dish. The looks of sprigs can be very different: Look for sprigs with short, fanned, fresh leaves. Rosemary sprigs also make wonderful spears for kebabs and hors d'oeuvres.

Saffron. Although saffron is seldom used in food styling, its yellow-orange stigmas are beautiful in tight shots of bouillabaisse, risotto, or paella. If the budget doesn't allow for the rice to be colored yellow with saffron stigmas, a yellow edible powder called Bijol, available in Latin grocery stores, can be used, or possibly turmeric.

Sage. Sage is frequently used as a fall garnish around poultry. It comes in many beautiful varieties: some with dusty green or purple leaves and some with variegated leaves. In the restaurant world, sage it is often deep-fried and used as a garnish.

Savory. There are two types of savory—summer (an annual) and winter (a perennial). It is increasingly available. Savory is used both fresh and dried in soups, stews, and sauces.

Tarragon. If used as a garnish, tarragon needs to be very fresh. The sprigs have lovely leaves that can be quite fragile. Store tarragon with stems in water until needed.

Thyme. There are many varieties and colors of thyme. Choose sprigs carefully. Look for full, compact sprigs—some may even contain small flowers.

This chart of frequently used herbs and spices by country can be helpful for flavoring ideas when you are developing recipes for a specific ethnic cuisine. You can give shrimp an Indian flavor with the use of saffron and chiles, or Hungarian with the use of paprika, for example.

HERBS AND SPICES BY COUNTRY

CHINESE
- Anise seeds
- Garlic
- Ginger
- Red pepper
- Sesame seeds
- Star anise

FRENCH
- Chervil
- Parsley
- Rosemary
- Tarragon
- Thyme

GERMAN
- Allspice
- Caraway seeds
- Cinnamon
- Dill seeds and weed
- Ginger
- Juniper berries
- Mustard seeds and powder
- Nutmeg
- White pepper

GREEK
- Cinnamon
- Dill weed
- Garlic
- Mint
- Nutmeg
- Oregano

HUNGARIAN
- Caraway seeds
- Garlic
- Paprika
- Poppy seeds
- White pepper

INDIAN
- Anise seeds
- Cardamom seeds
- Chiles

- Cinnamon
- Cloves
- Coriander seeds and leaves
- Cumin seeds
- Dill weed
- Fenugreek
- Garlic
- Ginger
- Mace
- Mint
- Mustard seeds
- Nutmeg
- Red pepper
- Saffron
- Sesame seeds
- Turmeric

INDONESIAN
- Bay leaves
- Chiles
- Coriander seeds
- Garlic
- Ginger
- Red pepper
- Turmeric

ITALIAN
- Basil
- Bay leaves
- Fennel seeds
- Garlic
- Marjoram
- Nutmeg
- Oregano
- Parsley
- Red pepper
- Rosemary
- Sage

MEXICAN
- Cinnamon
- Chiles
- Coriander leaves (cilantro)

- Cumin seeds
- Oregano
- Sesame seeds

MIDDLE EASTERN
- Allspice
- Cinnamon
- Cumin seeds
- Dill weed
- Garlic
- Marjoram
- Mint
- Oregano
- Sesame seeds

NORTH AFRICAN
- Cinnamon
- Coriander seeds and leaves
- Cumin seeds
- Garlic
- Ginger
- Mint
- Red pepper
- Saffron
- Turmeric

RUSSIAN
- Coriander leaves (cilantro)
- Dill weed
- Mint
- Parsley

SCANDINAVIAN
- Cardamom seeds
- Dill seeds and weed
- Mustard seeds
- Nutmeg
- White pepper

SPANISH
- Cumin seeds
- Garlic
- Paprika
- Parsley
- Saffron

edible FLOWERS
What to Know Before Using

Edible flowers were in vogue in the mid-eighties, when we used them on everything from appetizers to desserts. Now, edible flowers are used less frequently. The list provided here gives both common and unusual floral possibilities. The important thing to remember is that many flowers, leaves, and berries are *not* edible and should never be used by stylists. If things such as holly, lily of the valley, and poinsettias are used to garnish food, the consumer may try to duplicate that look. It would be very harmful, even fatal, if anyone consumed these poisonous plants. If you are using edible flowers for garnishing, be sure to get them from a reliable source where harmful pesticides have not been used. If edible flowers are consumed, they should be consumed only in small amounts. Some people may be allergic to edible flowers, so use them with caution.

EDIBLE FLOWERS

Anchusa

Anise Hyssop

Basil, Sweet

Bay Laurel

Bee Balm

Bergamot, Red

Borage

Calendula

Carnation and Clove-Pink

Chamomile

Chervil

Chickweed

Chicory

Chive

Chrysanthemum

Clover, Red

Cornflower(Bachelor's Button)

Cowslip (do not eat American equivalent)

Dandelion

Dillweed

English Daisy (do not eat American equivalent)

Fennel

Forget-me-not

Fronded Geranium

Fuchsia

Garlic

Hawthorn

Heartsease/Johnny-jump-up

Hibiscus, Rose of Sharon

Hollyhock

Hops

Hyssop

Impatiens

Jasmine (not to be confused with Carolina Jessamine)

Judas tree flower

Lavender

Lilac

Lily, Day

Lily, Tiger

Lime blossom

Lovage

Magnolia

Mallow, Common

Mallow, Marsh

Marigold

Marjoram

Meadowsweet

Mint

Mustard

Nasturtium

Onion

Oregano flower

Pansy

Passionflower

Pelargonium (not those with scattered leaves)

Pineapple Sage

Portulaca (Purslane)

Primrose

Redbud

Roquette

Rose

Rosemary

Saffron

Sage

Savory

Snapdragon

Sorrel, Common

Sorrel, French

Squash blossom

Stock

Sweet Cicely

Sweet Woodruff

Tansy

Tarragon

Thyme

Viola

Violet, Sweet

Zucchini blossom

DAIRY products
From Cheese to Creams

TIP *To keep strands of cheese from breaking, use a wooden skewer or tweezers to put them in place. When you grate your own cheese, the amount of pressure, the age of the cheese, and how you cut and hold a block of cheese will make a difference in the look and length of the grated cheese.*

Most dairy products come in whole milk, low-fat, and fat-free (skim) forms. Each has a different look and each behaves differently.

Cheeses

Cheese can be divided into three types: natural, natural processed, and American cheese derivatives. "Natural" cheese, according to the cheese industry and the Food and Drug Administration, has to be made from milk. "Natural processed" cheese is simply natural Cheddar or Colby that is ground and emulsified with water. The process denatures the proteins in the cheese, which means that the cheese will not clump up or get grainy when you melt it. "American cheese derivatives" are made from natural cheese and additives, such as sodium phosphates (acids that promote melting), nonfat dry milk, and carrageenan. In descending order of their relationship to natural cheese, they are designated "cheese food," "cheese spread," and "cheese product."

It is important to understand the characteristics of and differences among cheeses in order to know how to choose the proper cheese for the job and how best to melt it.

NATURAL CHEESE

Use natural cheese when you want to show blocks or wedges of cheese as a raw ingredient in a shot. When you are shooting blocks of firm cheese, try to give the edges an interesting texture. Sometimes this is done with a knife and sometimes the cheese is just broken. If the cheese has a rind, cut through it and then break the cheese open. If slicing a large piece, a cheese knife is very helpful since it will give you an even, smooth surface. If you are working with huge wheels of cheese, a cheese knife with two handles works best.

the **Problem**

- Semifirm and firm natural cheeses, such as Cheddar, Parmesan, and Gruyère, can change color, dry and crack, and ooze oil if left sitting out in a warm studio. Soft cheeses, such as Brie, Muenster, and Camembert, will melt and ooze, and get a dry, crusty surface as they sit.

the **Solution**

Use a stand-in and then, just before shooting, replace the cheese with the hero piece that has been covered in plastic wrap and safely stored in the refrigerator.

GRATED CHEESES

Cheeses can come pregrated, or you may want to grate them yourself for desired thickness, shape, and length. There are some pregrated brands of cheese that work very well, but you will need to sort them for the best pieces. Keep shredded cheeses covered with plastic wrap or in plastic bags and refrigerated until needed.

You will need to test to find the right grater and the right cheese to give you the desired look for each job. If you use a cheese that has not been aged a lot, it will

be softer and will not crumble, so you can get longer strands. If you draw a long block of cheese such as Cheddar down the grater, you will also get longer strands. The grater you use will make a difference. I own a Moulinex—a three-legged grater from France—just for the purpose of getting round, long strands of cheese. The company has gone out of business, but a similar grater is available at Bridge Kitchenware (see Resources, page 387).

A smooth melted cheese is easier to produce with processed cheese and cheese derivatives. These cheeses don't lump or separate and will respond well to hot water, either steaming to rewarm or by adding hot water to thin the consistency. When you are working with natural cheeses, it is wise to try different brands (unless you are selling a particular brand) and different percentages of fat. For example, with pizza, a part-skim mozzarella usually works better for photography than a whole milk mozzarella because as it melts, it is less transparent. Natural cheeses are best for producing beautiful crusts on gratins. Some cheeses, such as mozzarella and Gruyère, produce beautiful pulls (see the photographs on page 236). Again, test various products for the look that you need. Adding an acid, such as white wine, helps produce long pulls in cheese fondue.

Each cheese-grater combination produces a different shred. Mild Cheddar and a Moulinex produce long, unbroken strands. To get long strands of Parmesan, use a vegetable peeler and a young cheese. For a fluffy, grated look, use an aged hard cheese and a grater with small holes. *Dennis Gottlieb*

Milk, Yogurt, Cream, and Nondairy Whipped Toppings

MILK

When I am showing a glass of milk with cookies, I always use whole milk (4 percent) or half-and-half because the lower-fat milks don't have a rich, creamy look and sometimes have an almost-blue cast. Always pour or top off glasses of milk on the set because milk doesn't stay level and leaves a ring when moved. If the "I have just been poured" look is needed, add bubbles on the surface with Photo-Flo and an eyedropper (see the photograph on page 297). You can also add clear liquid dishwashing detergent to some milk, beat it with a whisk, and then spoon the desired amount of bubbles onto the surface of the hero for a similar effect.

TIP *I compared grated mozzarella cheese melts and found Polly-O pregrated to be best, having a nice yellow color and rich look. I melt grated cheese on a tray sprayed with nonstick cooking spray and then lift it for placement on a cooked chicken breast or lasagna. Just before shooting, I reheat the cheese with a heat gun. Some stylists produce a melted cheese look that will hold forever by adding white or yellow color to pastry gel.*

If you are producing foam for a cappuccino, use skim milk for a longer lasting, very white foam. Froth or foam made from nonfat dry milk and water (you control the amount) makes a good long-lasting product, too. Small handheld immersion blenders are great foam producers. Extra oils from coffee or high-fat cream seem to inhibit the production of foam, so make sure that you work with clean containers when producing foam.

piping cool whip

Put Cool Whip in a pastry bag just before you want to use it rather than putting it in the bag and storing it in the refrigerator until needed. Once you have piped it, the remaining product will probably be too soft to use later. Try to keep your hands as cool as possible when you are working with the pastry bag. The Regular variety seems to pipe the best because it is firmer.

YOGURT

The main difficulty that you will encounter when working with natural yogurt is that it separates. It secretes a whey—the yellowish liquid that accumulates on the surface of yogurt. If you are working with a low-fat, nonfat, or stirred yogurt, it often contains solidifying agents such as carrageenan or gelatin that make a more homogenized product and help prevent this separation. If you need to work with yogurts without these binding agents, you can drain the yogurt overnight in the refrigerator in a strainer lined with cheesecloth or in a white coffee filter over a bowl. Then, working with the unstrained product, add a little of the strained yogurt to absorb the whey and prevent the separation. If your assignment is to show a cup of yogurt with fruit stirred up from the bottom, ask the manufacturer for a separate container of the fruit. If this is not possible, you will need to cut away the bottoms of the yogurt cups and carefully remove the fruit, which can then be "swirled" into the perfect top as needed.

If you are showing the yogurt on a spoon, the yogurt will need to have some body to look appealing. You can make ridges in the yogurt (see also "The Dollop," pages 181–182) and then lift a beautiful, natural spoonful, carefully cleaning off the edges of the spoon with a cotton swab. You can also pipe successive layers of yogurt onto the spoon, finishing with a peak.

SOUR CREAM

Sour cream has some of the same styling challenges as yogurt. You will want to keep it refrigerated until close to shooting. Draining sour cream by spreading it out on a short stack of paper towels can help to thicken it by removing some of its whey. If you work with a low-fat or fat-free product, thickeners have already been added. These products have a slightly shinier appearance than natural sour cream. If at all possible, put sour cream on food, such as baked potatoes and tacos, that is at room temperature. That way the product will not melt (see the photograph on page 231).

HEAVY CREAM

When you shoot heavy cream it is usually in its whipped stage. If you whip cream yourself, be careful of two things: Don't overbeat the cream or it will not have a smooth appearance, and don't underbeat it or it will not hold its shape. Use a cool bowl and beaters and cold heavy cream when you whip cream, and whip it right before you need it; even in the refrigerator it will separate if it sits for a while. Separating or weeping are the main concerns with using real whipped cream. At room temperature, its beautiful appearance is limited before it begins to collapse and weep. One technique for a longer life span is to beat it with a little added liquid gelatin; another is to whip 1 cup heavy cream with 1 tablespoon instant vanilla pudding.

NONDAIRY WHIPPED TOPPINGS

Many food stylists like to work with food-service products such as Rich's Bettercreme, Rich's Whip Topping, and Pastry Pride. They are artificial whipped products used in commercial applications. They hold very well, even without cold temperatures, and are available in liquid form. You just whip them to the desired consistency. Some are also available in a prewhipped plastic pastry tube with a star tip.

If food-service whipping creams are difficult to find, you can use a dry whipped topping mix, such as Dream Whip, available in most grocery stores. Make with half the amount of liquid called for on the package so that the topping is very thick and stable. You can thin it with cream as needed to reach the desired consistency.

Another nondairy whipped topping, Cool Whip, comes frozen. This is a product that works very well if:

- You find good product in the store. If it has separated from the sides of the container and yellow fat has come to the surface, it will not work.

- You get it to a refrigerator right after buying and thaw it in the refrigerator.

- You keep it refrigerated until just before you need it.

- You don't overwork the product.

Rushing the thawing process ruins the texture; give Cool Whip four to six hours' thawing time in the refrigerator. Cool Whip comes in several forms: (1) Regular, which is fairly firm and very white, dollops well, and is the best one for piping; (2) Extra Creamy, which is not quite as firm and has a rich, golden white color; and (3) Free Whipped Topping, which is fat free and stays soft and flexible when using. When whipped cream plays an important part in a shot, I often buy Cool Whip in a couple of stores just in case it has not been stored properly in one. I usually get the 8-ounce size because once you have three or four dollops from a tub, it will have been stirred too much to use for more dollops.

The joy of using Cool Whip, for food styling purposes, is that it will sit out at room temperature much longer than whipped cream. However, once it has been piped or dolloped, it will become firm at room temperature in just a couple of minutes (unless it is fat free). So if you need to touch up a glitch or add a garnish, it is best to do this when it is very fresh. If you have made several dollops on a practice tray, you can choose the one you like best and move it with a lightly oiled offset spatula to the food surface. If the surface is flat, this can be a dollop that has set out at room temperature and become firm. If the surface is uneven or ridged, keep premade dollops in the refrigerator, where they will stay soft, and carefully transfer them to the hero when needed.

THE DOLLOP

Dollops can be in any shape if you are not working specifically for a food company. The look, or gold standard, of the perfect Cool Whip dollop has changed in recent

LEFT: To make dollops, you will need firm product, spoons of different sizes, and plenty of paper towels.

RIGHT: Place dollops of nondairy whipped topping on a cake round or a firm, upside-down paper plate. CLOCKWISE FROM CENTER: The casual home consumer look, the advertising swirl, and the piped food professional look. If the dollop is to be placed on a flat surface, such as a slice of pumpkin pie, let it sit out long enough to become firm and then lift and place it on the hero with a lightly oiled offset spatula. If the hero is not flat, it is best to make the dollop directly on the food.

Dennis Gottlieb

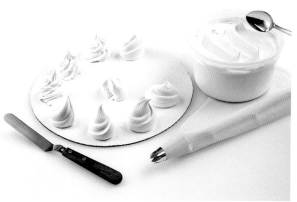

years. Look at the package label for the current look. Beautiful dollops take practice, so get some "whipped cream" and work on it.

Choose a spoon that fits the size of the desired dollop. You should always carry a variety of sizes in your kit, from baby to serving spoons. With any whipped cream, you want it to be firm enough that it will form and hold ridges. First, stir the whipped product gently, then smooth and make the surface level with the back of a spoon. Clean the spoon with a paper towel. Using the back of the spoon, form four to six deep parallel ridges across the surface of the whipped cream. Clean the spoon. Holding the spoon parallel to the ridges, with the bowl of the spoon at about a 45-degree angle to the cream, pull the spoon down and through the back side of the ridges. Lift the spoon and gently drop the cream onto the food surface or a practice tray. It is the firmness of the drop and the wrist action as you lift the spoon up that give you the dollop. As you lift up, a peak should form. The back side of the dollop will not be pretty, but the front surface should have ridges that swirl to a peak. Again, it takes practice.

From Butter to Margarines: Styling as Pats, Spreads, or Melts

If you are selling butter, you use butter, of course, and if you are selling a brand of margarine, you use that brand. If you are shooting a piece of toast or a baked potato with a generic pat of butter, though, you can use margarine. I use margarine because it is a brighter yellow than butter (this will vary from brand to brand, so get to know your brands) and it behaves for me. Butter at room temperature is very soft, while margarine holds its shape. When I melt margarine, it produces a yellow liquid, while butter separates and becomes transparent in places.

PATS

Butter or margarine pats are squares of various thicknesses and sizes that you can put on toast, muffins, baked potatoes, hot vegetables, etc. The size and thickness will depend on the item you are placing it on. If you are selling butter you will probably make the pat larger; if you are selling a muffin, you will make it smaller (see the photograph on page 22). Find a stick of the product you are using and, if the sides are not smooth, carefully smooth them with a small spatula. Cut pats into various thicknesses and place them on a lined tray. If the pats need to be smaller in diameter, slice some butter off the sides. Refrigerate the tray.

When pats are needed, let the art director or client choose the pat size. Build a home for the pat—a somewhat flat surface on a stack of vegetables or an indentation in a baked potato. Lift the pat with a lightly oiled offset spatula, sliding the spatula in from behind. Hold the pat in place while you discuss the desired location and angle. Once that has been determined, push the pat off the spatula from the back onto the surface with another spatula or your finger.

If you are giving the pat a melted look, heat a melting spatula with a torch at the set. Melt

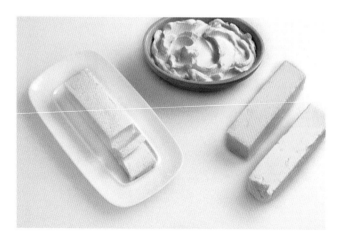

Two presentations of butter or margarine, contemporary and old-fashioned. Margarines on lower right are more yellow than butter, but brands differ in color. *Amy Reichman*

the bottom edge, sides, and top when you are ready to shoot. Sometimes you will touch the pat with the heated spatula; sometimes just the nearness to the heat of the spatula will be enough to melt it. If you need to reheat the spatula, make sure it is wiped clean with a paper towel or you will have brown butter the next time you touch the pat with the spatula. Try to shoot the melt as the margarine is running from the pat. If the pat has become too melted, remove it, clean the area, and replace it with a clean pat (see the photographs on page 233).

> **TIP** *If I have a "perfect" surface or one that will be hard to put a spread on, I build the spread on thin, firm paper cut a little smaller than the shape of the spread I need and then lift that onto the surface of the food being shot.*

SPREADS

Any spread should look smooth and soft—not cold, cracked, or busy. What do I mean by "busy"? "Busy" means that there are lots of little ridges on the surface. The reason to try to keep things smooth and simple with just a few ridges is because to the viewer's eye simple suggests "creamy." The camera and the photographer's lighting may also accentuate the ridges, so just a few beautiful ones will be visually more appealing.

To produce butter or margarine spreads, soften the product a little by working it with a flexible spatula (the size of the spatula depends on the size of the desired spread). Form a smooth area and then pull the spatula through that area and place one smooth spread on the surface, leaving a slight ridge at the beginning of the spread. Repeat with a second and third spread just a little inside the first spread. Sometimes placing the butter on thin, firm paper such as film card (see example below), which is cut a little smaller than the butter to hide the support, makes it easy to place the butter exactly where desired.

For a technique on how to produce a tub of margarine and more information on styling spreads, see pages 298–299.

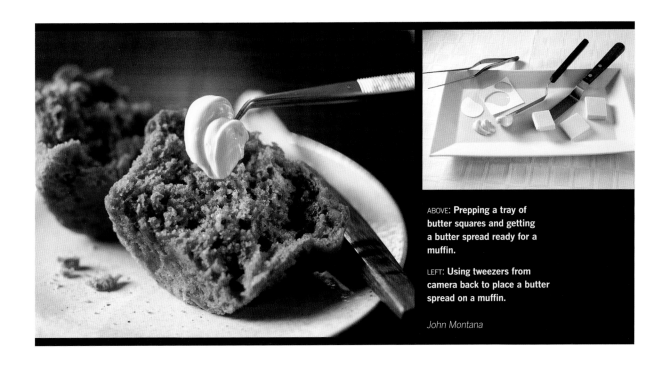

ABOVE: **Prepping a tray of butter squares and getting a butter spread ready for a muffin.**

LEFT: **Using tweezers from camera back to place a butter spread on a muffin.**

John Montana

183

MELTS

Besides the pat or spread on a product, you may want to add "melt" to a shot, as on a dollop of mashed potatoes. Melt margarine or butter over low heat just to the soft melt stage, not to the totally melted stage; you want the ingredients to stay emulsified and a bright color. Using an eyedropper, drizzle additional melted product where you want it.

BREAKFAST foods
Troubleshooting Tips for the Food Stylist

There is a large variety of breakfast foods, each presenting its unique problems and solutions.

Cereals

When you work with cereal shots, it is imperative that you arrange the cereal with a strong sense of the camera angle. Cereal is usually photographed in a bowl, and often there is a spoon in the bowl or just above the bowl. Sometimes the assignment is a single spoon holding cereal.

the Problem

- Finding the gold standard for a particular cereal.

the Solution

Cereal comes in many forms, from flakes such as Wheaties or Kellogg's Corn Flakes to strongly defined shapes such a Cheerios, Wheat Chex, or Alpha-Bits to undefined shapes such as oatmeal or Grape-Nuts. Some cereals have several component pieces such as Honey Bunches of Oats with oat clusters and nuts. You can determine the look the client would like by looking at the cereal on a current package or by checking swipes (tear sheets) the client may send. Part of your job when you work with cereal will be to sort for the "perfect" flake or pieces. Sometimes a strainer with just the right size mesh can be helpful in getting rid of small pieces of cereal such as in Grape-Nuts before you sort for hero pieces. Tweezers and patience come in handy for the sorting part.

When you are looking for good flakes, don't look for only perfect large, flat flakes. Try to find flakes with curves and interesting shapes; they look much more interesting to the camera because they develop texture and form. PFF (perfect flat flakes) tend to look boring. Sort for a variety of sizes, not only large flakes, because a perfect smaller piece is often needed on a spoon.

the Problem

- Determining the serving size and whether we need to follow it.

the Solution

Some companies are very concerned about showing only the recommended serving size, which can vary from ½ cup for Grape-Nuts and several other cereals to 1 or more cups for flake cereals. Thus, the size of the bowl becomes very important. When

serving size is an issue, pour the recommended amount of cereal into a bowl and use that as a guide for the amount that you can use when working on the hero bowl.

the **Problem**

- Controlling flakes of cereal that don't want to stay where they are placed.

the **Solution**

When you arrange cereal with flakes in bowls, it is important to know the camera angle and to determine the desired height of the cereal and the level of milk. Then (and here is the major tip!) fill the bowl with shortening to just below the milk level. Will there be a spoon in the bowl? This is the time to place the spoon in the bowl and then let the photographer arrange and light it. If there is a splash (fake, of course), this goes in next.

step by step: cereal with character

TOP ROW:

On the left are raisins and flakes with character. On the right are perfect flat flakes and raisins with less character.

A spoon with perfect flat flakes (PFF).

A spoon with flakes with character.

Setting up the cereal shot with shortening, a splash, and a few flakes. The spoon is made ready with a fake milk drop.

BOTTOM ROW:

The finished cereal bowl positioned at 10 degrees.

The same bowl shot from overhead. See how you need to fill in the empty spots that didn't show from a lower angle.

A clamp just out of view of the camera holds the spoon.

The cereal is ready to be shot at a 10-degree level.

Dennis Gottlieb

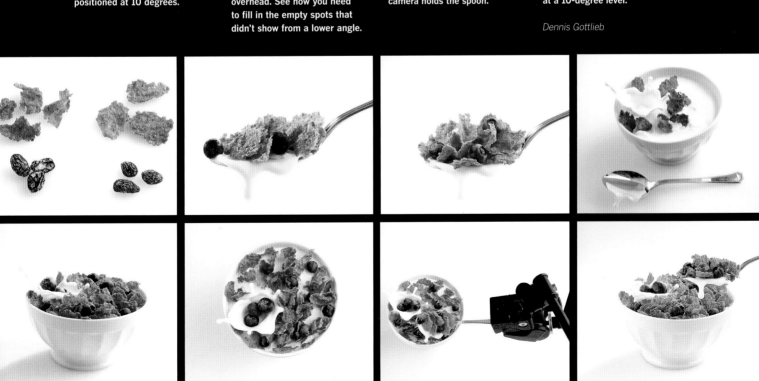

TIP *For television, when you need to show cereal pouring or falling, you can achieve the look naturally by placing the food on a wide board, releasing the food, and shooting it in slow motion. For print, you can stick the food to clear plastic, giving it the appearance of falling.*

Now you arrange all those carefully chosen flakes in the bowl, pressing them into the shortening while looking at the bowl from the camera angle. You will find that the amount of flakes you use and how you arrange them will be very different, depending on the camera angle. You will use fewer flakes for a low-angle shot but more flakes for shooting overhead. Don't arrange with all of the flakes standing up and pointing toward the camera; keep it random for a more natural look. Will there be fruit? When selecting fruit for a cereal shot, think small. Place the fruit randomly as well.

If you are arranging cereal on a spoon, have the photographer put the spoon on a stand with a clamp. Sometimes you will arrange the cereal in the kitchen, sometimes on the set. Place a small amount of shortening in the spoon and attach the "drip," if using. Looking at it from the camera angle, arrange the cereal in an attractive manner and add fruit, if using.

the **Problem**

* Cereal begins to collapse when milk is added to it.

the **Solution**

Before you add the "milk," you will want to make sure that everyone approves of the cereal arrangement. If you are selling milk, of course you must use real milk. If you are selling cereal, sometimes the company will want you to use milk and sometimes you are allowed to use a substitute, which will help prevent the cereal from absorbing liquid and collapsing. One substance that is often used as a substitute is Elmer's Glue-All. It is easy to obtain, but I like to use Wildroot hair-grooming lotion for men (see Resources, page 386), which is a white, flowing, oil-based lotion. I prefer the lotion to the glue because it is more flexible, it doesn't get a skin on it as it sets, and if I need to move flakes around, it doesn't cling and drag the way Elmer's does. Be sure to shake the lotion well before using. Put the liquid in a squeeze bottle with a small tip and, when it is close to shooting time, carefully cover the shortening with Wildroot; that should hold for about 20 minutes, depending on the cereal. The look of the cereal bowl will change slightly when the "milk" is added because less cereal will show, so be prepared for that.

Use a squeeze bottle with the correct size tip for better control when you add the "milk." The shortening forms the base for holding flakes in place. *Dennis Gottlieb*

the **Problem**

* Getting that perfect splash.

the **Solution**

You have seen those beautiful milk splashes shooting out of a bowl of cereal or drips hanging precariously on the side of a spoonful of cereal on the packages or ads for cereal. Those splashes and drips are made out of acrylic. An art director decides the size, direction, and shape of the splash or the length of a drip, and then it is handmade (see Resources, page 386). Remember that for the splash shot to look believable, a piece of fruit or a spoon needs to be in the center of the splash, as if the splash is being made by the object dropping into the milk. I have also made drips dangling

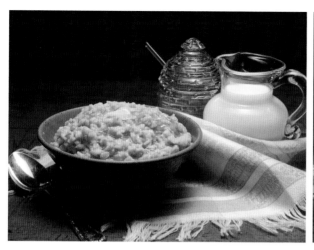

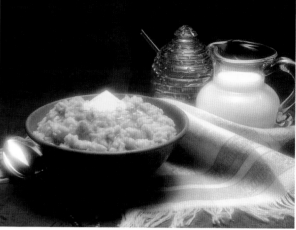

from the side of a spoon by shaping mortician's wax into the shape of the drip and covering it with Elmer's Glue-All. To use this for a photograph, you must shoot quickly, and some digital cameras will not shoot things that are moving.

LEFT: With oatmeal, there's only so much you can do. Here is the oatmeal as it appears to the eye of the camera.

RIGHT: When the photographer diffuses the shot, the effect adds a feeling of warmth.

Corrine Colen

the **Problem**

- Styling a cereal that is almost shapeless, such as oatmeal.

the **Solution**

Cereal without flakes and shape, such as oatmeal, needs to be mounded and arranged with interesting dimensions or indentations. Sort for interesting whole grains to arrange on top. Props are very important here. Melting brown sugar or butter, flowing syrup or chunks of fruit, as well as steam and soft lighting, can add appeal.

Toast, Muffins, Bagels, and Donuts

For food styling purposes, anything that would go into a toaster should go into a toaster oven (preferably one that continues to toast when the oven door is open). When you put food into a regular toaster, you can't see how evenly it is being toasted, and often there are uneven lines of less-toasted areas. With a toaster oven, you can see what is going on and can move the food to hotter or cooler areas or cover parts of the food with aluminum foil for even browning. When you toast any item, have the toaster oven on broil or top brown so that you are toasting only one surface at a time.

Toast the surface that will be the bottom first. This will dry out the bottom so it will not curl up but will lie flat when you toast the top. To keep toasted items from curling, don't lay the hot toasted item down on a surface. Rather, cool it on a gridded cooling rack with the hero side down. This allows for even cooling. If you toast food properly and cool it properly, it should last for a fairly long period of time. Just before shooting, brush the toasted item with a little melted margarine or butter or with vegetable oil to make it glisten. You can then add your butter pat or smear.

the **Problem**

- You want your toasted item to be a little darker or more evenly colored.

the **Solution**

You can thin Kitchen Bouquet with a little water and carefully brush or spray the liquid over the lighter area, or brush the area with Maillose and apply heat with a heat gun. (This method has also been successful with premade cookies and crackers that the client wanted darker.) Don't use a torch—this gives a burned appearance rather than a toasted look.

TIP *You can add "nooks and crannies" by pressing into the cut surface of an English muffin with the tip of a small chopstick.*

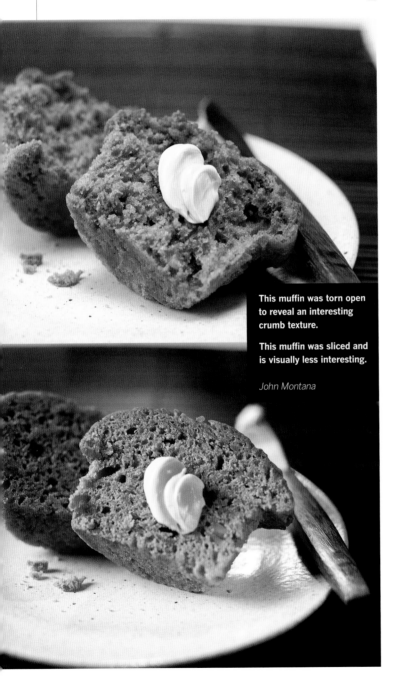

This muffin was torn open to reveal an interesting crumb texture.

This muffin was sliced and is visually less interesting.

John Montana

ENGLISH MUFFINS

When you toast English muffins, use only the bottoms of the muffins because the tops usually don't have a good shape and are thin. Look for a round shape and a good distribution of "nooks and crannies."

MUFFINS

To produce muffins with a rounded dome, you will need to find a recipe that works well or a premade product that domes well (see page 271).

A muffin that is torn in two from top to bottom looks more attractive than a muffin that is sliced, either in half horizontally through the center or from top to bottom. The rough texture produced by tearing is visually more appealing. When you are tearing a muffin apart, it helps run a wooden skewer several times through the bottom of the muffin along the area you want to split. Then carefully tear the muffin open from bottom to top.

BAGELS AND DONUTS

With both bagels and donuts, the hole is as important as the overall appearance. If you are selling a particular brand, the client will supply the product. When you slice a bagel, make sure that the center hole is round and large enough in proportion to the rest of the bagel. Once it is sliced, it is often spread with cream cheese. Use a soft cream cheese and make just a few ridges in the spread with an offset spatula rather than producing a "busy" spread.

When you work with donuts, use plain ones and keep glazes, frostings, and sugars or particulates separate. When you are ready to shoot, add the glaze and toppings so that they appear fresh and undamaged. Use a gridded cooling rack when glazing.

Pancakes and Waffles

Color, shape, and syrup pours all add interest to these breakfast foods.

PANCAKES

In 1997, there was an ad for Crisco No-Stick Spray that showed a full-page photograph of an uneven, wobbly, kid-friendly stack of pancakes. Inserted in the upper left-hand corner was a picture of a mom and four young children in the kitchen, all busy making pancakes. When we food stylists saw this shot, we all gasped and could not believe our eyes. A stack of pancakes that was not perfect! Previously, we had only produced shots of evenly browned pancakes that were slightly terraced, with a perfect butter melt and rivers of syrup just beginning to flow over the edges and down the sides of the stack. This casual stack of pancakes was a revelation. All through the eighties and most of the nineties we had been preparing precise tall stacks of pancakes with either the "flat look" (pancakes with an even brown surface) or the "lacy look" (pancakes with a spotty brown surface). It was almost the year 2000 when we entered the era of "doable" food presentations. Companies began to want their food to look approachable, like food that would be made at home rather than carefully, perfectly, and time-consumingly prepared and presented.

Even with this casual approach, we still are asked at times to do the "perfect" stack, so it is important to learn the techniques for doing both. This involves problem solving for the answers to some of the following questions: How do we produce the "flat" and "lacy" looks? How do we get pancakes that are an even color and consistent in size? How do we deal with syrup that is thin and soaks into the pancakes? How do we place the butter on the pancake, and where? Do we melt it before or after the syrup pour? How do we keep the "perfect" stack level? Well, I never said pancakes were a piece of cake. In fact, this simple-looking assignment is not so simple at all.

When assignments are for cookbooks or magazines, you will follow the recipe provided and you will want a very beautiful, natural look. If you are selling a pancake mix, you use that mix and you will tend to style for more controlled stacks. When you are working with packaged mixes, it will be important for you to test for your own results and to make comparisons. Product formulas change and new product lines are developed.

TIPS *Thin soy sauce and brush it lightly on toast to even browning; the color will be a little more yellow than Kitchen Bouquet.*

Armor All Protectant is commonly used on rubber, plastic, and vinyl. Spray it on English muffins after toasting to keep them from drying out, cracking, and curling. Caution: toxic; do not swallow.

THE NO-FAIL PANCAKE TOOLBOX

- Electric griddle that produces an even heat (preferably *without* a nonstick surface for the lacy look and *with* a nonstick surface for the flat look; see Resources, page 387)

- Large, thin, extra-wide pancake turner to help prevent splattering or tearing pancakes when flipping (see the photograph on page 113, number 17)

- Paint stripper or heating element to dry uncooked top surfaces before flipping pancakes to prevent splattering

- Scissors to cut cardboard rounds and another pair to trim pancake edges

- Liquid and dry measuring cups and one specifically for pouring batter onto the griddle

- Mixing bowls and a wire whisk

TIP *When making batter from a pancake mix, make only one back-of-the-package-recipe batch at a time. Batter thickens as it sits, and the cooked pancakes can take on an unattractive dark ring on their perimeters. In addition, some batters lose their leavening ability after 15 minutes. Using milk in place of water in a mix will produce a denser batter and a browner pancake. Lemon juice added to the batter produces a whiter interior. Fresh eggs add height to pancakes.*

- Squeeze bottles and a funnel for syrup (have various tip sizes for the bottle)
- Small offset spatula for placing butter pats and a melting spatula specifically used for heating and melting butter pats
- Torch for heating the melting spatula on the set
- Large heat-resistant pastry brush or cheesecloth for applying shortening or clarified butter to the griddle for a lacy look
- Coarse salt and shortening for producing the lacy look; vegetable oil and paper towels for the flat look
- Trays for holding butter pats and completed stacks of pancakes
- Thin cardboard or film cards cut into rounds slightly smaller than the pancakes to level pancake stacks and to give support when moving stacks
- Krylon Crystal Clear lacquer or Scotchgard spray for spraying the pancake to prevent syrup from soaking in
- Gridded cooling racks for cooling pancakes, waxed paper to prevent grid marks and to keep stacked pancakes from sticking together, and plastic wrap or plastic bags for storing stacks

the **Problem**

- How to make pancakes that are dappled and spotted (lacy) or uniform in color (flat), depending on the client's preference, and consistent in size.

the **Solution**

To make pancakes with the lacy look, preheat an electric griddle to 400°F (375°F for complete mixes). Prepare one batch of batter according to the package directions; do not overmix. Using a large heat-resistant pastry brush or several layers of cheesecloth, lightly grease the griddle with shortening, Vegalene pan coating, or clarified butter for the lacy look, using a dabbing rather than a stroking movement (some stylists also sprinkle on coarse salt at this point). Heat for 10 to 15 seconds.

The lacy look is produced when batter hits the ungreased spots on the surface of the griddle and browns. The parts of the pancakes that stay golden are those prevented from browning by the grease particles.

If you want the flat look, use a nonstick griddle and rub the surface evenly with a little vegetable oil and a paper towel. Using a ¼-cup dry measuring cup, pour the batter in a single, fast stream from a height of 6 to 12 inches above the griddle. This produces a pancake 4 to 5 inches in diameter. Flip the pancake when the side on the griddle has reached the desired color. We use

knowing your brand varieties

On a recent job that required a generic stack of pancakes, I had some time to test and compare various pancake mixes. In this case, I took one brand and compared the varieties of mixes within that brand. Here's what I found (see photograph on the facing page):

Aunt Jemima Buttermilk Complete produced the best look, with a rich color and a tall, fluffy appearance.

Aunt Jemima Original was good and held a consistent and even thickness, but the color and thickness were not as good as Buttermilk Complete.

Aunt Jemima Complete didn't work as well. The color was uneven and not rich.

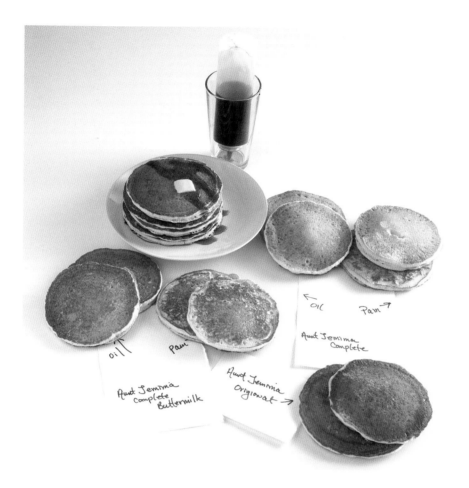

Different mixes and cooking fats result in widely varying pancakes. If you will be adding syrup, keep it in a squeeze bottle that is held upside down in a glass for even pours without bubbles.
Jim Ong

the side that is browned first for photography. Large, thin, extra-wide pancake turners help prevent splattering or tearing pancakes when flipping.

the **Problem**

* Keeping the "perfect" stack level.

the **Solution**

When the pancakes have cooled, you can produce the desired stacks, reserving the best-looking pancake for the top. Place thin cardboard rounds (film cards) cut just smaller than the pancakes beneath each pancake, to help keep pancakes level and separated. For the "perfect" look, and to help catch syrup as it cascades down the sides, you will want to terrace the pancakes slightly, with the bottom being the largest pancake and the top the smallest.

To cut a wedge out of the pancake stack, use the tines of a fork or a wooden skewer in an up-and-down motion to poke through the stack and give the cut texture. For a fork shot, press individual layers of the cut wedge onto the tines of the prop fork, leaving a small space between wedges.

the **Problem**

* Thin syrup that soaks into the pancakes.

TIP *If flipping produces strings or splatters, you may want to use a paint stripper while the bottom is browning to dry the top batter a little before you turn the pancake. Turn the pancake and continue cooking until the bottom is golden. If the pancake puffs, gently push down on the center of the pancake with the bottom of the turner to prevent a mounded or peaked center. Remove the pancake to a waxed paper–lined gridded cooling rack.*

the **Solution**

To prevent syrup from soaking into the top pancake, some stylists spray the pancake with Krylon Crystal Clear or Scotchgard; some prefer to just work quickly.

The thickness of a syrup is very important because if the syrup is too thin, it will disappear or flow too quickly for a good shot. If you are selling a brand of syrup, the best thing to do is to thicken it by chilling it. A syrup shot is easier to control if you transfer the syrup to a squeeze bottle that has a tip with the appropriate opening. If you are working with regular syrup (not lite), put the filled squeeze bottle in the freezer until needed. (Lite syrup doesn't have a sugar base and will freeze solid, so just refrigerate it.) To thicken syrup by heating, add a little corn syrup and boil to between a soft and firm ball stage (about 245°F). Don't stir unless necessary because this will introduce air bubbles into the syrup. Carefully pour the syrup into a heatproof squeeze bottle using a funnel and keep the bottle in a hot water bath until needed. The syrup will have turned more transparent than regular syrups, but when poured, it will be thicker. If it is at just the correct consistency and temperature, it will hold as a drip down the side of a stack of pancakes. Practice and develop your own technique for this type of assignment before going on a job.

the **Problem**

- Placing the butter on the pancake and when to melt it, before or after the syrup pour.

the **Solution**

Determine ahead of time on a stand-in where the "butter" pat (we usually use margarine for better color and control, unless we are selling butter) or smear will go and also determine the design of the syrup pour: Thin "legs" look like spider legs and thick ones may cover too much of the pancake surface. Use a small offset spatula for placing butter pats and a melting spatula for heating and melting them.

You'll need a propane torch to heat the melting spatula on the set. Melt the butter and then, using the squeeze bottle filled with chilled or thickened hot syrup, quickly pour around or over the butter, extending the syrup into three to five planned areas to form the "legs" of the pour. Form the back legs first and finish with the important front legs, pouring toward the outer edge and letting the legs continue to move on their own down over the sides. Move out of the frame quickly so that the photographer can shoot as the syrup is dripping down the sides and before a large syrup puddle forms on the plate.

WAFFLES

When selling a particular brand of frozen waffle, you need to toast or reheat those products (see page 187). If making waffles from scratch, you may need to purchase a waffle iron, depending on the desired look—Belgian or regular, round or square. It is best to test different packaged batters or recipes for the look you want. Test which fat

to use by brushing the cooking surface of the waffle iron with nonstick cooking spray and also melted butter to see which offers more visual appeal.

The one thing that can cause some problems with waffles is the syrup pour. The syrup follows the pattern of the indentations of the waffle, so the syrup forms a grid pattern. It is good to determine on a stand-in just what the art director would like on the final shot. Sometimes the waffles are simply dressed with fresh fruit and a dusting of confectioners' sugar. Bring the correct-size sieve for this and always be prepared to garnish pancakes, waffles, and French toast with fresh fruit, such as orange wedges, strawberries, blueberries, and raspberries—maybe even a sprig of mint.

Egg Dishes: How Do You Want 'Em?

Omelets, sunny-side up, poached, scrambled for breakfast, hard cooked and sliced, deviled, or souffled—oh, the many ways with eggs. With all egg dishes, you will want to work with very fresh eggs. To tell if an egg is fresh, put it in a deep bowl or pan of water. If it lies flat on the bottom, it is fresh; if one end of the egg wants to float toward the surface of the water, it is not fresh. The color of the yolk is determined by what the chicken eats. Often organic eggs have a deeper yellow color. With many egg dishes, such as scrambled, the yellow of the egg will turn darker as it sets and is exposed to the air. Sometimes this is desirable.

OMELETS

Determine the size the omelet needs to be and then choose the number of eggs you will need and the size of the nonstick pan to use. Beat the eggs and strain them to remove any clumps of egg pieces (don't add milk or water to beaten eggs). Turn a sheet pan upside down and cover it with plastic wrap. Heat the nonstick pan over medium-low heat. Add vegetable oil (or butter, if a browner color is desired). Tilt the pan so that the oil covers the entire bottom and part of the sides. Add the beaten eggs, tilting the pan so that the eggs cover the entire bottom of the pan (the liquid eggs should be no more than ¼ inch deep). As the eggs firm, lift up the sides gently with a silicone spatula and tilt the pan again so that the liquid runs under. Lift up gently with the spatula to loosen the eggs. When the bottom seems firm throughout but the omelet is still creamy-soft, slip the omelet out of the pan onto the plastic wrap–lined sheet pan. Place a folded damp paper towel in the center of the omelet to give it body and height and use plastic wrap to fold the omelet over the paper towel. Or you can place sautéed vegetables in the bottom half and then fold over the other half.

TIP *A trick I learned recently, while working on the shot below, is using a crisp taco shell lying on its side as the base for a small omelet. I cut the omelet in half and placed one half over the top of the taco and the other half on the inside of the taco. This gave a firm base for the omelet, the omelet was easy to move, and it stayed open while I filled it with sautéed peppers and onions.*

An omelet propped open with a hard taco shell. *Jim Ong*

SCRAMBLED EGGS

Follow the directions for an omelet, but beat in about 1 tablespoon water to each 2 eggs just before adding them to the pan. Raise the heat of the pan and quickly stir the eggs with a fork until they are cooked to the desired

Spooning hot vegetable oil over just the egg white for a perfect sunny-side up. *Colin Cooke*

doneness. Alternatively, you can do a long slow cook over a low heat, moving the cooked eggs to the center of the pan gently with a wooden spatula and letting the liquid eggs run to the outside to begin cooking. This produces larger and smoother curds in the eggs. When they are cooked, slide the eggs onto a plastic wrap–lined sheet pan and arrange them into the desired shape. As the eggs cool, they will darken in color slightly. With a large spatula, move them in one piece to a plate. To keep the eggs moist, lightly cover the plate with plastic wrap.

SUNNY-SIDE UP

This technique is used to produce the "perfect" look. The egg preparation requires very fresh eggs just out of the refrigerator: Fill a nonstick pan with enough vegetable oil to cover the white, but just to the height of the yolk (about ¼ to ⅜ inch deep). Heat the oil slowly over low heat to about 160°F (if the oil is too hot, bubbles will form in the whites; if the oil is too cold, it will take forever to cook the egg). Break the egg into the pan and, using the edge of the shell, gently move the yolk to the desired position in the white. Baste only the white of the egg with hot oil from the pan until it is firm. With a large spatula, carefully remove the egg from the pan; it is very fragile. Blot the bottom of the egg with paper towels before placing it on a plate.

Some stylists cook only the white and then, when they are ready to shoot, they add a raw yolk where they want it on the white. I don't think this looks natural.

POACHED EGGS

To prepare a poached egg, proceed as with sunny-side-up eggs, but this time spoon the pan oil over the entire egg; that will cook the outer surface of the yolk as well, producing a poached look. For the natural poached look, crack a very fresh egg into a cup. Swirl together simmering water and a little vinegar. Carefully pour the egg into the water mixture and gently cook over low heat until done. Poached eggs can be stored covered in room-temperature water until needed.

If you are making eggs Benedict, real hollandaise sauce can be problematic because it likes to break. Packaged sauces usually hold up better.

HARD-COOKED EGGS

Hard-cooked eggs seem deceptively easy, but they have many potential problems. To center the yolk in the shell, turn the egg carton on its side the night before cooking. Place the eggs in a pan and cover them with room-temperature water. Stir the eggs, rotating them, while they come to a simmer. Turn off the heat, cover the pan, and leave the eggs for 12 to 15 minutes, depending on the size of the eggs. If you boil or overcook them, they will tend to get gray around the edges of the yolks. Drain the eggs and run them under cold water. Crack them immediately and carefully peel them under cold running water. (This is a time when fresh eggs are a problem: The fresher they are, the harder they are to peel.)

TIP *Yolks of cooked eggs will wrinkle if left out in the air. If you need to store sunny-side-up eggs for a while or need to have lots of eggs ready for a shot, fill a deep baking pan half full with room-temperature vegetable oil (deep enough to cover the entire egg) and place the cooked eggs in the oil until needed.*

DEVILED EGGS

Use the method for hard-cooked eggs. Slice the eggs in half and remove the yolks. Mash the yolks with low-fat or fat-free mayonnaise, which holds better than regular mayonnaise. Spoon or pipe the yolk mixture into the white halves, which have been slightly trimmed on the bottom so they stay upright. Garnish as desired.

TIPS *Hard-cooked eggs will slice better when cold, and the yolk color will not change.*

If a soufflé has to sit out for a while, it may collapse. Carefully remove it from the soufflé dish, fill the base (instant mashed potatoes work well), and top it with the collapsed soufflé.

SOUFFLÉS

In the "olden days," soufflés were made with boxed angel food cake mix—the type of mix that had a package of powdered eggs as well as a second package of flour and sugar. With the angel food mix, we often added food coloring and fresh herbs or cheese, depending on the type of soufflé we were showing. Today, most cake mixes come combined in one package and don't look or work in the same manner.

the **Problem**

- Of course, the main problem with soufflés is that they collapse, and they collapse quickly.

the **Solution**

Several solutions besides angel food cake mix have been suggested and tried. Shirley Corriher suggests adding another egg yolk or two to the base to increase the protein and strength of the soufflé. I have baked soufflés in a portable oven next to the set so that we could shoot them immediately after they were taken from the oven. I have also shot soufflés just as they were coming out of the oven or even in the oven. Special effects people sometimes have glass ovens that make shooting soufflés especially workable. If you have not prepared soufflés before, practice and try several recipes and techniques before a shoot.

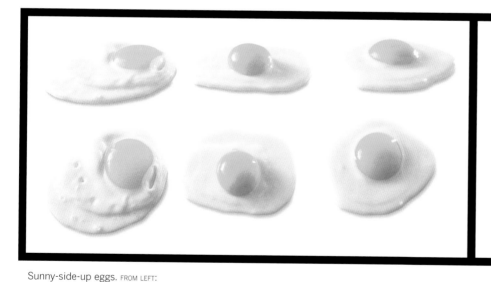

Sunny-side-up eggs. FROM LEFT: Cooked in oil that is too hot, cooked egg white with raw yolk added, and the "perfect" look.

Even the simplest garnish of coarse black pepper can substantially change the result.

Colin Cooke

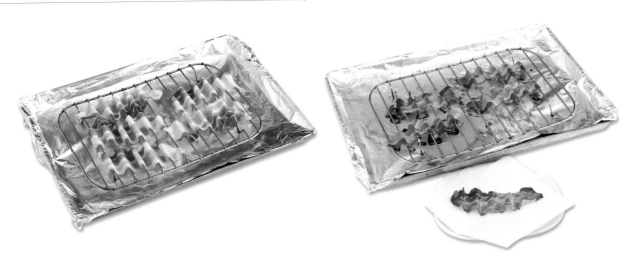

LEFT: Give bacon a wavy shape by draping it on a wire rack before cooking.

RIGHT: The bacon holds its shape as it cooks, resulting in even, consistent waves.

Dennis Gottlieb

Bacon and Sausages

Perfectly cooked *curly* bacon and evenly browned *plump* sausages—just how do we get these?

BACON

To produce beautiful bacon for a shot, select bacon that is neither too lean nor too fatty, and neither too thick nor too thin. If it sounds as if in-between would be just right, that is correct. Definitely don't use organic or high-quality bacon. I once ordered bacon from an upscale meat market in Manhattan and I was sent thick nitrite-free bacon that looked like an ugly, thick, gray slab when it was cooked up. For photography, your bacon and cold cuts need the nitrites to stay pink.

Keep bacon in the package in the refrigerator, but bring it to room temperature before cooking. When you are ready to prepare the bacon, preheat the oven to 350°F.

Now the important item: You will need a wire rack that has bars about ¾ inch apart. The rack should stand at least ½ inch above a surface. Place the rack on a sheet pan and spray it with nonstick cooking spray. Lay flexible, room-temperature bacon across the rack and press it down between the bars. This gives the bacon a wavy appearance. Exaggerate the wave because the bacon will shrink upon cooking.

Bake it to the desired doneness. As soon as you remove it from the oven, carefully lift the wavy bacon from the rack and place it on a tray lined with paper towels. See how cooked curly bacon looks on a hamburger, page 205.

Keep the cooked bacon at room temperature until needed. If the fat congeals while the bacon sits, reheat the bacon slightly in the oven. A small amount of liquid dishwashing detergent foam spooned into the indents just before shooting gives the bacon a "just out of the frying pan" look for shooting on its own—but not in a sandwich.

SAUSAGES

Sausages comes in links and patties. Some links are precooked, have no casings, and need just to be reheated. Some links need to be fully cooked. Patties need to be fried. Depending on the type of meat, each has the potential to become very dark after it has been cooked and cooled.

I tend to undercook most sausages because the meat shrinks considerably and because links in casings will wrinkle when cooled. For most sausages, I roll them with a little vegetable oil in a nonstick pan over medium heat until they are the de-

sired color. Kitchen Bouquet can be used to add a rich brown color, if needed; just make sure the color looks natural. You don't need to fully cook sausages unless you are cutting into them. With patties and precooked links, cook to the desired color and store in a bath of room-temperature vegetable oil until needed.

TIP *If you don't have a wire rack with the correct dimensions, you can improvise making waves in the bacon by laying the bacon over rounded aluminum foil strips. Using a wire rack with tightly spaced bars makes the bacon look too fake. Bacon can also be shaped on a stack of paper towels and microwaved.*

SANDWICHES
How to Build Layer by Layer

There are thousands of types of sandwiches. Sometimes you'll show them with a very natural look, while sometimes a more controlled look is preferred. It is important to remember that how you treat each ingredient will affect the look of the entire sandwich. If you are showing a tuna fish sandwich, the sandwich will look one way if you gently flake the tuna, thin the mayonnaise, and blend in fresh herbs, and another way if you overmix the tuna with regular mayonnaise.

Here are two sandwiches with the same ingredients. The sandwich will have one look if you layer the ingredients like in the first shot: (from bottom to top) whole wheat bread, large chunks of tuna mixed with mayonnaise, a thick slice of tomato, tight and pointy curly leaf lettuce, and another slice of bread. The sandwich will have another look if you begin with artisanal whole wheat bread, wide curly leaf lettuce, tomato slices, carefully flaked tuna with fresh herbs, another layer of curly leaf lettuce, and another slice of whole wheat bread. Every ingredient you select when you are shopping matters—for example, how curly or tight the ends of the lettuce leaves are. How you work with the ingredients matters. How thick or thin you slice the ingredients matters. How you choose to arrange things matters.

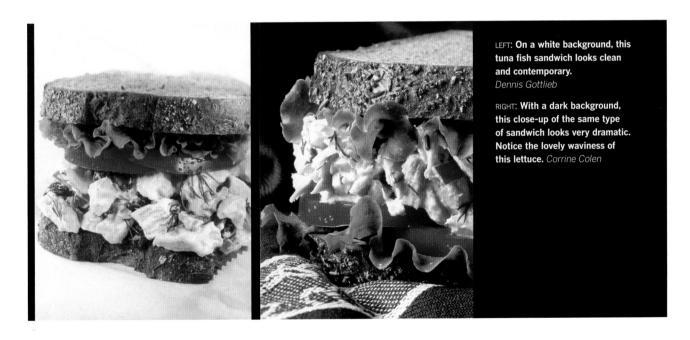

LEFT: **On a white background, this tuna fish sandwich looks clean and contemporary.**
Dennis Gottlieb

RIGHT: **With a dark background, this close-up of the same type of sandwich looks very dramatic. Notice the lovely waviness of this lettuce.** *Corrine Colen*

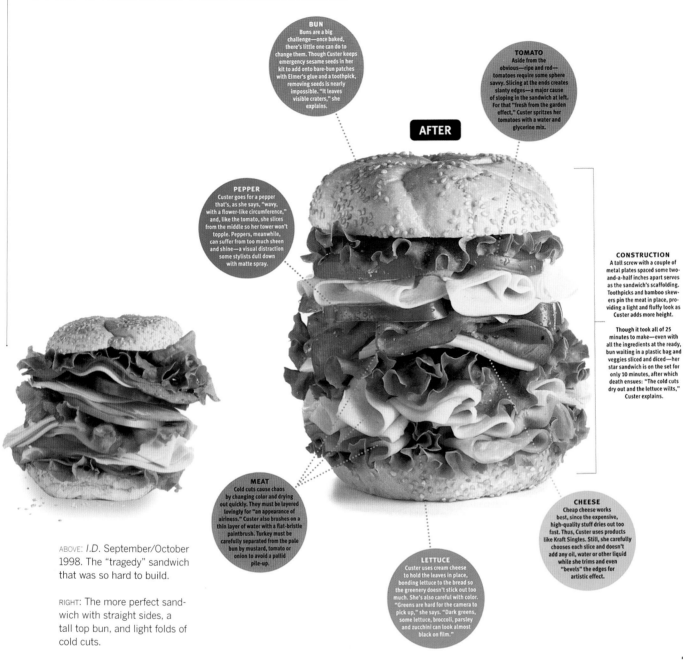

BUN
Buns are a big challenge—once baked, there's little one can do to change them. Though Custer keeps emergency sesame seeds in her kit to add onto bare-bun patches with Elmer's glue and a toothpick, removing seeds is nearly impossible. "It leaves visible craters," she explains.

TOMATO
Aside from the obvious—ripe and red—tomatoes require some sphere savvy. Slicing at the ends creates slanty edges—a major cause of sloping in the sandwich at left. For that "fresh from the garden effect," Custer spritzes her tomatoes with a water and glycerine mix.

AFTER

PEPPER
Custer goes for a pepper that's, as she says, "wavy, with a flower-like circumference," and, like the tomato, she slices from the middle so her tower won't topple. Peppers, meanwhile, can suffer from too much sheen and shine—a visual distraction some stylists dull down with matte spray.

CONSTRUCTION
A tall screw with a couple of metal plates spaced some two-and-a-half inches apart serves as the sandwich's scaffolding. Toothpicks and bamboo skewers pin the meat in place, providing a light and fluffy look as Custer adds more height.

Though it took all of 25 minutes to make—even with all the ingredients at the ready, bun waiting in a plastic bag and veggies sliced and diced—her star sandwich is on the set for only 10 minutes, after which death ensues: "The cold cuts dry out and the lettuce wilts," Custer explains.

MEAT
Cold cuts cause chaos by changing color and drying out quickly. They must be layered lovingly for "an appearance of airiness." Custer also brushes on a thin layer of water with a flat-bristle paintbrush. Turkey must be carefully separated from the pale bun by mustard, tomato or onion to avoid a pallid pile-up.

CHEESE
Cheap cheese works best, since the expensive, high-quality stuff dries out too fast. Thus, Custer uses products like Kraft Singles. Still, she carefully chooses each slice and doesn't add any oil, water or other liquid while she trims and even "bevels" the edges for artistic effect.

LETTUCE
Custer uses cream cheese to hold the leaves in place, bonding lettuce to the bread so the greenery doesn't stick out too much. She's also careful with color. "Greens are hard for the camera to pick up," she says. "Dark greens, some lettuce, broccoli, parsley and zucchini can look almost black on film."

ABOVE: *I.D.* September/October 1998. The "tragedy" sandwich that was so hard to build.

RIGHT: The more perfect sandwich with straight sides, a tall top bun, and light folds of cold cuts.

John Holderer for I.D.

Your Typical (or Not) Cold Cut Sandwiches

In the fall of 1998, *I.D.* (*International Design*) magazine ran an entire issue about the design of food. I was asked to build the "perfect" sandwich and then a "tragedy" sandwich. The author of the article was watching what I did and at one point said, "You are having more trouble with the tragedy sandwich than you did with the perfect sandwich, aren't you?" It was true. In my career, I had spent so much time building perfect sandwiches that I had to unthink everything I now did so naturally.

I have worked on all possibilities of sandwiches, from fifteen inches tall to eight feet long. The major challenge in making sandwiches is getting good bread and then keeping everything looking fresh and light, not compact.

When selling a particular brand of cold cuts or working on an assignment for a sandwich shop, you will, of course, use the client's product. You also must follow their specification sheets for amounts of ingredients and the order in which you place the

ingredients. I prefer to work with cold cuts that are sliced thinner rather than thicker because the thicker slices will not fold well. For food styling purposes, the more nitrites in the meat the better (the meat holds its color better). When you are building tall sandwiches on a bun, the trick is to keep the sides of the sandwich straight up and down and just slightly wider in diameter than the bun. If you are building a submarine-type sandwich, you want your ingredients to protrude from the sliced roll. Today, many buns and rolls are toasted. Heating sandwiches in a panini press is also popular.

the **Problem**

- The top ingredients weigh down the lower ingredients on very tall sandwiches.

the **Solution**

Tall sandwiches need physical supports hidden in or behind the sandwich to help prevent the weight of the ingredients from pressing everything flat. Many techniques have been developed to build supports, but I find the one that works best for me is to attach a large bolt vertically to the plate or surface holding the sandwich. Begin building the base of the sandwich by passing the bread down the bolt and adding ingredients until a support, such as a plastic disk, is needed. Run a nut down the bolt and place a round disk (the diameter slightly smaller than the diameter of the ingredients) on top of the bolt. Run another nut down the bolt to secure the disk and continue to build on that disk until more support is needed. Repeat the nut/disk process and continue to build until the desired height is achieved. If this is a stand-in or final food, have someone snip the top off the bolt at the correct height. Then place the top roll or slice of bread over the bolt.

Let's build our sandwich one ingredient at a time.

TOP ROW:

We used a tall rolling cart to hold the eight-foot-long sandwich base at eye level. The photographer had a steel beam custom made to hold the bottom and back of the sandwich. We spread cream cheese to glue the lettuce in place.

Toothpicks, wooden skewers, and a series of vertical rods attached the folded cold cuts, tomatoes, and cheese to the base.

BOTTOM ROW:

Having secured the top half of the bread with wooden skewers, we carefully moved the long sandwich to the set.

Judi Orlick

Safely on the set, the sandwich was held in place with side clamps and a middle support, and we got ready for the final shot.

Dennis Kitchen

199

THE BREAD

If you are working for a food company or restaurant chain that makes the sandwiches, the company should supply and ship the bread. Try to make arrangements with the company to have them bake the breads especially for photography purposes. You want bread that is free of wrinkles and is a nice, even color. If you are selling cold cuts or a cheese product, then you as the stylist will need to get the rolls. Develop good and dependable sources for beautiful breads.

Sort for the very best rolls, with an even distribution of seeds (if needed) and a good shape. Keep any bread in its package or in a plastic bag so it stays fresh until needed. If the roll is unsliced, carefully slice it to the desired thickness for the base and top of the sandwich. You can also slice one roll for the top and another for the bottom. If the bread is to be toasted, use a toaster oven or (my preference) a handheld heating element or heat gun to evenly brown

TIP *If you are shooting at eye level and need the top roll to look taller, raise the back of the bun, resting it on a wooden skewer hidden in the back, and the top will get additional height. If you need less height on the top bread, trim it or lower the back.*

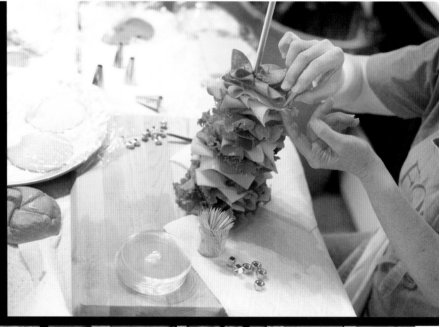

TOP: **Carefully securing folds of meat and cheese in place.**

BOTTOM ROW:

This tall sandwich was built on a long vertical bolt using disks and toothpicks to hold the components in place.

From the back, the black masking tape used to fill gaps and the toothpicks holding everything together are visible.

The finished sandwich looks perfect from the front.

Kelly Kalhoefer

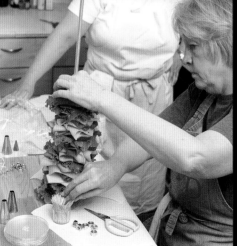
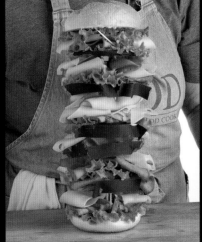
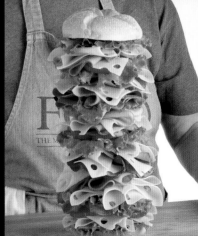

the areas that will show toasted bread. When the bread is cool, store it in plastic until needed. If you are showing the sandwich coming from a panini press, grill the bread first and then add the ingredients.

THE MEAT AND CHEESE

If you are using a presliced product, sort through it for the most attractive pieces and the ones without tears. Keep cold cuts refrigerated as much as possible. Expose only a small amount of meat at a time to room temperature because meat dries out and changes color. Keep sorted cheeses and meats on trays, covered with plastic wrap, and refrigerate until needed. It is helpful to have one type of meat per tray; that way you can pull out the type of meat you want, and the rest stays refrigerated. If you are working with a product that is not presliced, you will need to rent a professional meat slicer or go to a deli and have the product sliced for you. If you are going to a deli, it is good to arrive early in the morning, when the counterperson doesn't have a line of people to serve. Have him or her produce test slices until you get the thickness that will work best for you. Remember, thinner is better, and more-processed meat usually holds up better and holds its color longer. Work as quickly as you can when building sandwiches, and just before you shoot the sandwich, brush the meat with a little water—never vegetable oil, because it looks greasy. Spritz the lettuce and vegetables with water, then add the sauce.

When building a sandwich, you will need to fold each slice of meat and cheese attractively and then secure it with a toothpick. With cold cut sandwiches, there is definitely a camera front and a camera back in this high-fiber wonder (where black tape is used to cover any holes in the arrangement of ingredients and toothpicks and long wooden skewers hold and support ingredients out of sight).

> **TIP** *If you are using cheese in the sandwich (which adds difficulty because cheese may crack, change color, or get oily), try to work with it cold, just out of the refrigerator, unless you need to fold it. In that case, work with it at room temperature to prevent it from breaking or cracking quite as much.*

Building a Better Hamburger

When we are discussing hamburgers, it is important to distinguish between an editorial hamburger and an advertising hamburger (see the photographs on page 20). With an editorial hamburger, you can determine the type of bun you want to use and select the ground beef with the percentage of fat you want. Sometimes a recipe in a cookbook or magazine will indicate a specific cheese or lettuce to use, but often it is just important to make a burger in the style of that assignment. You also choose the order in which you place those ingredients; for example, you may want the lettuce on the bottom or top or both.

When working with an advertising hamburger, you must use the client's ingredients and in only the amounts allowed (using a spec sheet). You will also build the hamburger in the exact order as the client does when making burgers for the public.

THE BREAD

As mentioned previously, finding a good bun can be a major task. With editorial assignments, you can use a kaiser roll, a section sliced from a loaf of Italian bread, an English muffin (toasted or untoasted), or a typical hamburger bun—seeds or no seeds. In editorial, the buns don't have to be perfect, but they should be as attractive as possible. In advertising, the buns need to be perfect. If you are shooting for a specific company, you will want to get flats of buns carefully selected for the assignment by someone from the company's supplier. If possible, ask for buns that have not been

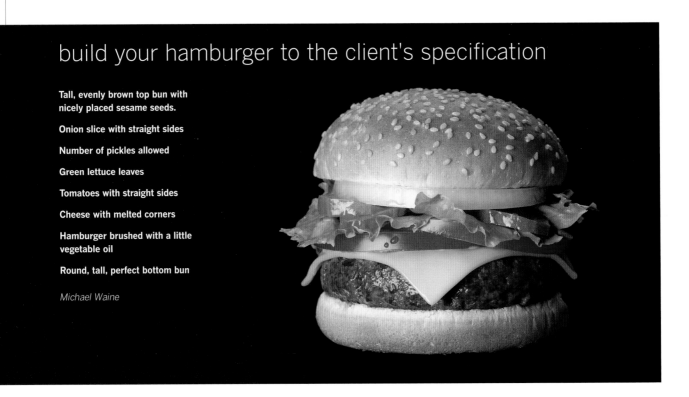

build your hamburger to the client's specification

Tall, evenly brown top bun with nicely placed sesame seeds.

Onion slice with straight sides

Number of pickles allowed

Green lettuce leaves

Tomatoes with straight sides

Cheese with melted corners

Hamburger brushed with a little vegetable oil

Round, tall, perfect bottom bun

Michael Waine

presliced. One of the things you should look for when selecting buns is tops and bottoms with some height. If the buns have not been presliced, you can slice them to the thickness you would like, slicing a thick top from one bun and a thick bottom from another, for example. You also want the buns to be round, with a good even color, and ones without wrinkles or dents. If there are seeds on the bun, an even distribution is important. You may need to add some seeds. You can do this with Elmer's Glue-All, a wooden skewer, seeds toasted to match the ones on the bun, and patience. If you need to add a lot of seeds or put seeds on a seedless bun, place the bun on a protected surface in a well-ventilated area, spray the top of the bun with Spray Mount, and sprinkle with seeds. You may need to press the seeds carefully into the bun a little for a natural look. Once you have finished working with the buns, keep them protected and in an airtight container or plastic bag so that they don't dry out and crack.

Another problem you may encounter with buns is ketchup or sauce seeping into the bun if the sauce is placed next to or on the bun. To prevent this, you can lightly brush the cut surface of the bun with a little melted paraffin wax. Be careful not to coat the bun where the camera might see the wax; the wax becomes white when it hardens again. (Caution: Paraffin is flammable if overheated or exposed to open flames. Always melt paraffin by heating it in a pan over boiling water, as in a double boiler. Never melt it directly in a pan over fire, on a hot plate, or in a hot oven. For melting, you may want to use an empty can set in a pan of water, and throw the can away when you are finished. Clean the brush by pouring boiling water over it.)

THE LETTUCE

If working on an editorial assignment, I often use curly green leaf lettuce, selecting lettuce with round edges rather than pointy edges. I usually put the lettuce on the base of the burger.

the **Problem**

- Working with the lettuce.

the **Solution**

Carefully select a leaf of lettuce that is a size that will fit just over the edges of the bottom bun; tear off any unneeded lettuce. I use toothpicks or I spread softened cream cheese on the bun to hold the lettuce in place. If you are working on an advertising assignment for a major hamburger chain, you will often use iceberg lettuce because they do. Even if they send their own lettuce, I bring some of my own. I look for iceberg lettuce with fresh, darkish green leaves. I also try to find a head of iceberg lettuce that is light in weight. The lighter the weight, the more chance that the internal leaves will be curly, and curly shreds of lettuce are more visually appealing than flat, straight shreds. Slice the lettuce (with a stainless steel knife) into shreds of the exact thickness you want as close as possible to the time you need them, because the sliced edges of the lettuce will turn brown after a time. Spritz the lettuce with water and place it in a plastic bag or on a tray, covered with a damp paper towel, and place it in the refrigerator until needed. Most hamburger chains build the burger with the sauce and lettuce under the top bun. Softened cream cheese will help the lettuce shreds stay in place; just make sure that the camera does not see it.

THE HAMBURGER PATTY

For editorial assignments, buy ground beef that is 85 percent lean. The extra fat makes the meat look juicy. Shape the patty to the desired size, giving it nice, smooth sides. Usually the patty should be just a little wider than the bun and a little thinner than desired because when you fry the patty, it will shrink and thicken. Using a nonstick pan with a little vegetable oil over medium heat, cook the edges of the meat first. Next, cook one side and then the other. Cook the meat until it is the desired color, usually a little lighter than you would want in real life; you can always make it darker with a torch just before shooting. I tend to undercook the meat so that it isn't too dark and it stays juicy looking.

the **Problem**

- Cooked red meats, such as hamburger, tend to turn very dark as they sit out and cool.

the **Solution**

As soon as you have removed the burger from the pan, place it on an inverted metal tray covered with aluminum foil (this allows you to easily add grill marks or torch the meat later to add color without the sides of the pan being in the way). Cover the patty with plastic wrap, pressing the wrap on the top and against the edges of the meat. This keeps air from getting to the meat. Exposure to the air causes hot meat to turn dark and become dry looking as it cools.

the **Problem**

- The hamburger patty needs to have grill marks.

> TIP *Some food stylists have been known to store cooked red meats immersed in a pan of room-temperature vegetable oil until needed (see the photographs on page 214).*

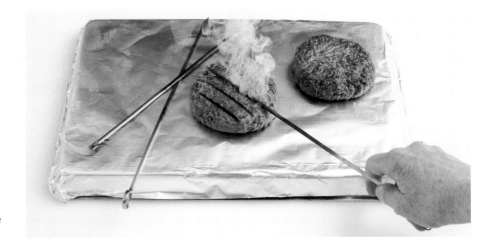

To add grill marks to food, use either the flame on a gas stove or a propane torch to heat the skewers. Try to find rectangular skewers so you always have at least two widths to choose from for the marks. Large pieces of meat will look better with the wide grill marks. Smaller foods, such as shrimp and kebabs, will look best marked with the thinner edge. *Dennis Gottlieb*

the **Solution**

Grill marks are usually best done when the patty has cooled down. I use a torch and a metal skewer. If the studio has a gas stove, you can use that to heat the skewers just as well. The skewers must be red hot, so electric stoves won't work. The skewer that I prefer has two thicknesses—a wide side and a thin side.

When I was working with a grilled hamburger for a French's mustard ad (see facing page), we were, of course, selling mustard, so I didn't want thick grill marks on the hamburger to compete with the product. On the other hand, sometimes a hamburger is shot from eye level, and you will not see the grill marks unless you slightly exaggerate them over the edge of the patty. Be careful doing this. I have seen several hamburger shots where the grill marks cover the entire edge of the patty, and this would never happen in real life.

When we are working with a fast food chain, we usually use its frozen patties, which have been sorted for the best shape, texture, and size. If you have this type of assignment, keep the patties frozen until needed. I have found the best way to cook them is to just lightly torch them on an upside-down tray covered with aluminum foil. When you are finished, cover the patty with plastic wrap until ready to use. You may want to add color with the torch just before building the hamburger. If at a particular chain the patties are grilled, you will need to add grill marks that match those that would appear at the restaurant. Visit a local franchise and make rubbings of a cooled grill using paper and a pencil. This way, you can match the thickness and distance of the grill marks when making them in the studio.

THE CHEESE

the **Problem**

* In real life, cheese is most often placed on top of a hot hamburger patty. However, food stylists are usually working with room-temperature meat and need to give the cheese that melted appearance.

TIP *One food stylist who works on most of the commercials for a particular fast food chain had a branding iron made to produce even grill marks specifically for these jobs.*

the **Solution**

Fast food chains use processed cheese slices and will generally provide these for a shoot. If they don't, you may have to compare the color, thickness, and melt-

ing properties of different brands, because cheeses do behave differently. On the set, if the cheese seems to overwhelm the patty, you may want to trim it so that the proportions are better. Processed cheese responds best to moist heat, so I dip the tips or corners of a cheese slice in a pan of boiling water and place the slice on the patty. If I want additional melt, just before we shoot I use a handheld steamer.

For editorial assignments, Cheddar, blue, or other cheeses may be used. If the photographer will shoot quickly, it is best just to build the burger as if you will be eating it and shoot the food hot. If you need to melt natural cheeses right before shooting, you will want to use dry, radiant heat (a heating element, heat gun, or possibly a torch) because that is what this cheese responds to best.

OTHER ADDITIONS

An assignment may require that you include tomatoes, onions, pickles, and sauces on your burger. For an editorial assignment, cut and place any additions as you like or whatever the recipe calls for. For advertising assignments, you will need to use the size of tomato indicated in the spec sheet. Cut the tomatoes the thickness allowed, but use only the slices from the middle of the tomato, because the edges will be straight up and down. If two slices are used, cut the slices on a slight bevel and place the two thinner edges on top of each other to produce a flatter surface. (When you are shooting a hamburger at eye level—and most ads are shot this way—clients don't want to see empty spaces or holes when they are looking into the hamburger.) If onion rings are part of the look,

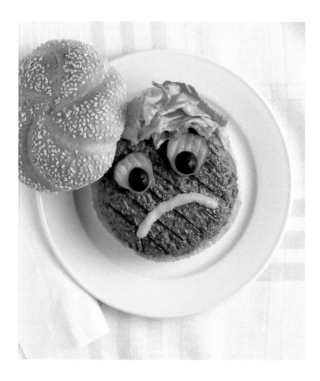

Because we were selling mustard, I used the narrow edge of the hot skewer so that the grill marks wouldn't overwhelm the product. *Beth Galton for French's*

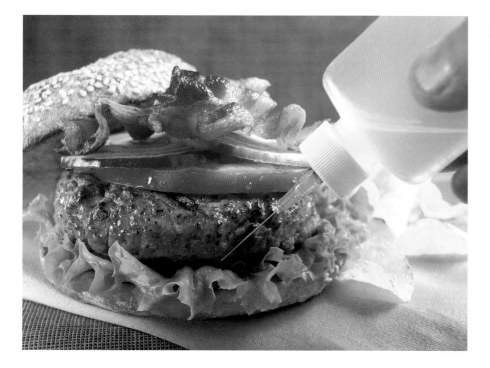

Just before shooting, add water droplets to the tomato and lettuce using a glue applicator with a needle syringe. *Dennis Gottlieb*

205

work with them in the same way as with the tomato. Use the thickness required and use rings cut from the middle of the onion. The client may use onion pieces, so add the amount allowed along the edges of the burger. Place the pieces with a tweezers.

With pickles, pick out the most attractive ones, usually those with bright green, wavy sides rather than flat sides.

Most sauces don't look fresh after a short time, so we add them, usually with an eyedropper, syringe, or pipette, after everything has been spritzed and oiled and just before shooting: Brush the exposed meat with vegetable oil. Spritz or place water droplets on the lettuce and tomato using a glue applicator with a needle syringe or a handheld spritzer. Moisten the cheese, if necessary, add the sauce where directed and shoot.

Grilled Sandwiches: From a Grilled Cheese to a Panini

With grilled cheese and the popular panini sandwiches, the desire is to show warm melting cheese oozing from between layers of toasted bread. This look can be produced by making the sandwich for real and shooting it quickly, something that is usually done in editorial assignments. In advertising, the client may have certain requests or a gold standard that we need to achieve.

A perfectly melting double-decker grilled cheese sandwich. *Dennis Gottlieb*

There are many ways to achieve a grilled cheese sandwich. Let's begin with the cheese. Certain cheeses melt better and more smoothly than others. Processed cheeses are a softer, smoother, blended cheese so there is no oil separation as they are heated. Sandwiches made with processed cheese are the ones that we, as kids growing up, associated with tomato soup (see the photograph on page 347). One way to make this sandwich is to toast or grill each bread slice on one side and to cut it into two triangles or rectangles—but keep them together. Add two or three slices of cheese to the bottom bread. Heat the cheese with a steamer or heat gun or in a toaster oven. Place the top pieces of bread over the cheese, brush the toasted tops with a little melted butter or vegetable oil, and gently pull the sandwich apart. The nice, connected cheese strands give the appearance of "just grilled and ready to eat."

Another technique is to use cheese that is already very soft and runny. The melted cheese in the individual package in Kraft Deluxe Macaroni and Cheese is the perfect consistency for spreading on grilled toast and pushing over the edges and cut section of the bread for just the desired ooze. Processed cheese responds well to being heated by wet heat (a steamer), while regular cheese usually melts best with radiant heat, such as from a heat gun or toaster oven. If using natural cheese (see page 178), you can melt the cheese in the sandwich. If this causes too much damage to other in-

gredients, melt the cheese separately on a tray covered with aluminum foil and sprayed with nonstick cooking spray. Carefully lift the melted cheese onto the bread, add any remaining ingredients, and shoot.

PANINI AND WRAPS

The panini (a pressed-together, hot grilled sandwich) became very popular in the early 2000s. To produce this sandwich, you can make the sandwich using a panini press. For a less flattened look, you can grill the bread and add the interior ingredients one at a time, melting the cheeses separately. Some stylists use hot skewers to produce the grill lines, but skewers seldom get the deeper lines "engraved" by a real panini press. The hot skewers can be used to add extra browning, though, and if you don't have access to a press, try using a cast-iron grill pan with grill bars and a weight on the sandwich.

Wraps are usually made using flour tortillas. If possible, use tortillas from food-service suppliers (go to the stores that do wraps and purchase their tortillas) because they will not crack or dry out like regular tortillas. Once the food is rolled, adhere the outside flap of the tortilla to the rest of the sandwich with a straight pin or Zap-A-Gap glue. Cutting the wrap in half on a bias shows more of the interior pattern and adds interest to the presentation. If "improving" the look of the exposed interior, keep it as natural looking as possible by slicing the ingredients before you add them.

> **TIP** *Some photographers and food stylists have actually modified steamers by closing up all the holes but one and placing a straw in the open hole to direct the steam to specific areas without wilting lettuces or heating tomatoes.*

Peanut Butter Sandwiches

The bread of choice for a peanut butter sandwich is usually the traditional white bread. You want a certain amount of thickness in the slice and an evenly browned dome. Sometimes the client will have a brand preference. Finding the correct color and shape, with the two side indentations evenly placed, can be a challenge. If the bread is packaged in an opaque wrapper, use the touch-and-feel method. Getting the bread through the grocery store checkout and to the studio undamaged is another challenge. I bring large plastic boxes to put the bread in while transporting, or I pack one loaf per bag and carry the bags carefully.

If we are selling peanut butter, we usually shoot it on an open-faced sandwich. Because of the softness of the bread, it is helpful to dry the bread a little on a gridded cooling rack to make it firmer.

Spreading the peanut butter takes some practice. You can spread the peanut butter almost to the edges of the slice of bread; you want a very smooth surface and edges. Then, with an appropriately sized (depending on the size of the bread) flexible offset spatula, spread the peanut butter's surface with smooth strokes. The more you work with the spatula, the busier the surface looks, so try to spread the peanut butter in one continuous smooth stroke (see the photograph on page 298). Look at photographs and try to duplicate the appearance. It is a matter of practice, movement, and pressure. Chunky peanut butter is more difficult, but you use the same method.

If you are using jam on the peanut butter, try to find the lightest, most transparent jam you can. If the jam is too dark, we have been known to hide aluminum foil under the jam to give it highlights.

the humble hero

The peanut butter is the star in this shot.

A single, smooth swirl looks most appetizing.

On green, the peanut butter image looks more playful.

If the food needs to have a bite taken out of it, that's our job. If a natural bite doesn't look right in shape or size, we can also use cookie cutters or knives.

By changing the shape and type of the bread and the pl and adding the cutting boar we change the look to luxur and upscale.

John Montana

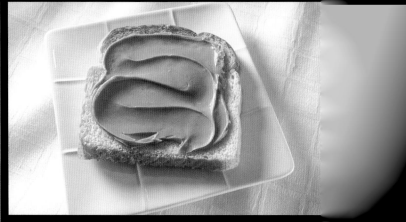

Overhead shots are increasingly popular in upscale food magazines.
John Montana

SOUPS
Types and Techniques

Up until the mid-1960s, most stylists put clear marbles in the bottom of soup bowls and then arranged vegetables and other ingredients on top of the marbles. They did this so that when hot broth was added just before shooting, the ingredients would not sink and disappear beneath the broth. Then one food company spotted the marbles in a competitor's soup advertisement and sued the offending company for misrepresentation. This resulted in a huge legal battle (see page 27).

At the conclusion of this suit, food companies became more careful about how they presented their products. They took pains to show only the portion size indicated on the package. The foods needed to be prepared exactly according to package directions. Stylists were never allowed to use items in the product that did not come from the product. Eventually, these rules softened, but many companies continue to be careful to represent their products truthfully. Two results of this suit are that today, when styling soup, we often use shallow soup bowls so that all the ingredients are visible, and spoon shots are very popular in advertising for showing off ingredients.

Here are some important questions to ask before a soup assignment:

- What is the amount and arrangement of exposed ingredients?
- Is it a soup with translucent broth? How clear is it?
- Is it an opaque soup, such as a cream soup, puree, or stew?
- How high should the soup come up in the bowl?
- Will there be a spoon shot? Will the spoon be in or out of the bowl?
- Will there be garnishes?
- Should the soup be shot at a certain temperature?

Working with What You've Got

Some food companies will allow stylists to use only the product from a single can or package, while other companies allow you to go through several and select the best of the ingredients. When you are working with a canned soup, strain the broth from the solid ingredients. Arrange the ingredients in a bowl and add the hot liquid when you are ready to shoot. You can make final touch-ups, such as moving ingredients, adding herb pieces to certain areas, and brushing exposed ingredients with a little liquid, just before shooting (see the photographs on page 73).

Temperature

With broth soups, most of the time I work with hot broth because when broth is cool, fat globules float on the surface and the broth doesn't look warm. Some canned cream soups work best if they are not heated but are thinned a little with milk or cream and blended to a smooth consistency. If you heat these soups, they tend to get a skin on the surface. Unheated, they behave beautifully.

With thick soups, such as chowders and tomato soups, it's more important to get the viscosity just right. You don't need to work with them hot. Pour the soup into the bowl on the set just before shooting.

Serving Sizes

The level or height of the broth in the bowl should be determined by the shape and size of the soup bowl. When the assignment is for a food company, the serving size will determine the amount of soup you can use. Shallow soup bowls will reveal more solid ingredients. Make sure the bowl is on a level surface.

Garnishes

If there are garnishes on top of the soup or if bread or crackers or a spoon will be in the shot, be sure to work out these issues before working with the final food. Garnishes can consist of anything from a sprig of fresh herbs or a butter pat to a swirl or dollop of sour cream, a mound of chopped vegetables, or a slice of toasted French bread. The possibilities are endless, but the garnish should complement the soup. Some garnishes may not float or sit where you would like. In these cases, a clear plastic cube or several plastic disks can be placed just below the soup level to support the garnish if the soup is opaque or the garnish hides the cubes.

how to make the alphabet in my soup float?

I once had an assignment where I was asked to use alphabet pasta to spell out a word in a bowl of minestrone soup. We were not selling a soup product. The photographer and I knew cooked pasta likes to sink to the bottom of a liquid and that uncooked pasta letters are small and don't look cooked. What were we to do? The photographer had a wonderful team of problem solvers, and one of them came up with the idea of putting a thin plastic disk just below the surface of the soup so the letters could sit on that. But when we tried it, the disk showed and the effect didn't look real. Another assistant thought that if we made the liquid extremely salty, the letters might float, just as things do in the Dead Sea. No, we couldn't add enough salt to make that happen. I had worked with a lot of gelatin products and decided to try adding gelatin to the hot broth to make it firm. I cooled the liquid just to the point that it was beginning to set, added all the ingredients (except the pasta letters) exactly where I wanted them, and then let the soup set. When we were ready to shoot, I put the bowl on the set, added a little regular cool broth on the top, and rested the alphabet pasta word on the firm soup and just below the surface of the liquid broth!

Today, with digital photography, the photographer would probably shoot the soup in one shot and the pasta in another, and then combine the two.

Working in the world of photography and film we need to problem solve daily. For fun, look through several magazines, particularly at food ads, and ask yourself, How did they do that? It will get you thinking more creatively and make you more aware of how special techniques are used to make unusual or interesting shots happen.

SEE ANSWER ON NEXT PAGE →

step by step: building a soup

TOP:

We begin by choosing props and arranging the soup.

MIDDLE ROW:

The soup seems a little high in the bowl, so we take some out.

After we adjust the chicken and some ingredients are rearranged, the chicken strip in the center is too high.

We add the spoon, trying it at different angles.

BOTTOM ROW:

The spoon is filled with soup and the ingredients are arranged again. We're getting close, but it seems something is still missing.

Adding carrots gives the soup a less monochromatic look.

We add herbs and use the tweezers to play with the placement of ingredients.

Dennis Gottlieb

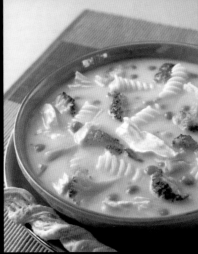

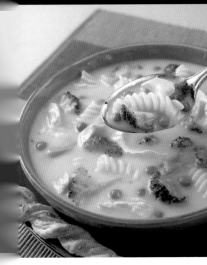

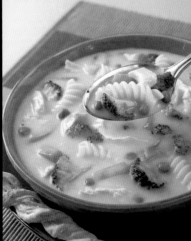

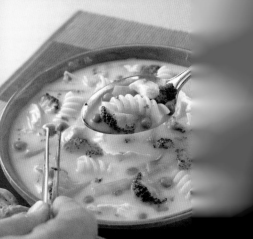

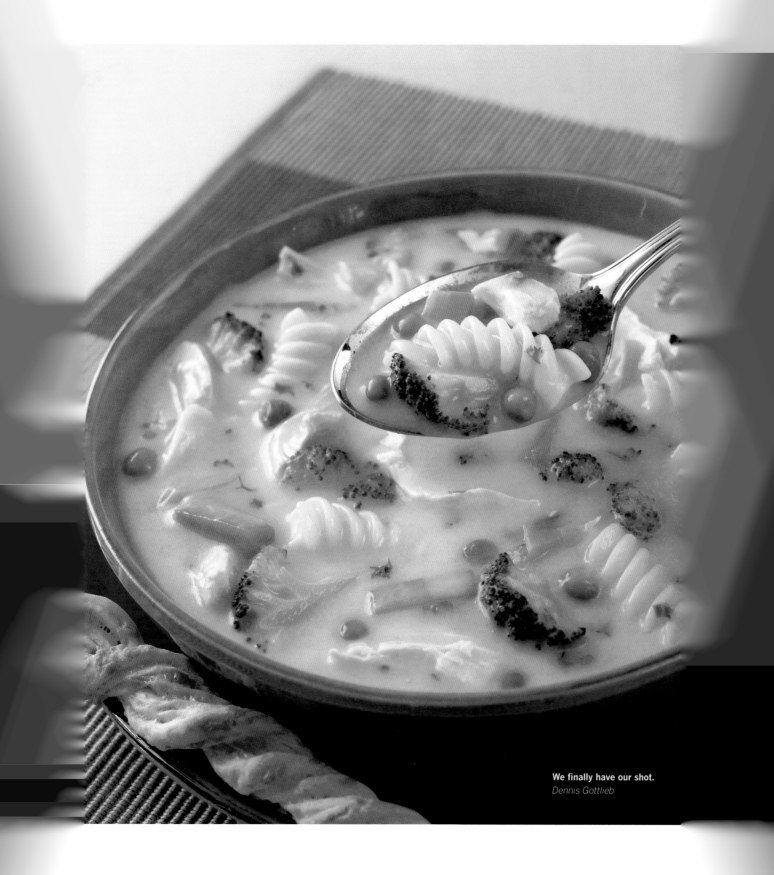

We finally have our shot.
Dennis Gottlieb

TOP: These 81 percent lean (top row) and 95 percent lean patties are being stored in three different ways: in vegetable oil, covered in plastic wrap, and left uncovered.

BOTTOM: Notice the differences in coloration produced by the different storage methods (see page 203).

Dennis Gottlieb

MEAT, POULTRY, FISH, and SHELLFISH

Styling the Main Course

Each of these protein sources has its own unique concerns and solutions.

Red Meats

The major concern when cooking red meat (beef and lamb) for food styling is that while it is hot, and as it sits, the outside surface of the meat gets darker and darker until it appears almost black to the camera. The solution is to cover the outside surface of cooked red meat with plastic wrap as soon as you remove it from the heat, until it has cooled down. Some stylists have been known to place hot cooked red meat into a bath of room-temperature vegetable oil to prevent the outside surface of the meat from getting too dark, as it will if it is exposed to oxygen. Once the meat has cooled to room temperature, it doesn't seem to get darker. If you want a darker appearance, just before shooting you can torch the surface of the meat, which also warms any congealed fat.

ROASTS AND STEAKS

In the food styling business, these cuts of meat are referred to as "slabs of brown." Unless you are going to slice into meat, particularly roasts, it is just a round brown object to the camera and is not very interesting. If you are shooting a roast or steak that is to be sliced, it is good to get at least two of them. A backup is helpful (1) if you overcook the first one; (2) if when it is sliced and it has an unattractive interior; (3) if the meat sits out too long, it loses its fresh appearance; and (4) if you want to use the less attractive one for a stand-in. The degree of doneness for the meat is usually the client's call. While some clients like medium rare, others prefer medium well. For a medium to medium-rare roast, cook the meat until it reaches an internal temperature of 125°F to 130°F. As the meat rests, the interior heat will continue to rise (called carryover) to 140°F. When slicing a roast or steak, always cut across the grain of the meat. If you slice meat while it is hot, the slices soon take on a spotted, bloody appearance. If you slice the meat after it has rested for only ten minutes (for a natural and juicy look), shoot the meat immediately. If you let the whole roast cool to room temperature, the slices will stay fresher longer; however, the meat will not be quite as juicy.

If you slice into the meat and it is too red (rare), you can reduce the amount of redness by brushing the surface of the cut with water or hitting it with a little hot steam. When the correct color is reached and you are ready to shoot, arrange the slices attractively falling from the roast and brush the outside of the meat with vegetable oil and the slices with bloody juices. Bloody juices can be saved from the cut hero roast or from another small piece of meat that is cooked to medium rare, then cut

TIP *Using an electric knife on roasts and steaks produces smooth slices.*

and its juices squeezed into a cup. Do not use vegetable oil on cut surfaces, though, because it looks greasy—use it only on the outside or cooked surfaces of the meat. If you have sliced into the meat but are not ready to shoot, keep the meat slices together against the roast until you are ready.

RIBS

You basically use the same technique with beef, lamb, or pork ribs. I have found that just following the recipe and cooking as you would for eating is best. A rack of ribs usually photographs more attractively if it has been sliced into individual or small groups of ribs. If there is a sauce, just before shooting apply a fresh coat of sauce or some vegetable oil, but to the cooked outer surface only.

HAMBURGERS

Just about every food magazine has a hamburger on one or more of its summer covers. It is one of the new popular foods. The hamburger and its presentation should match the style of the particular magazine. It is helpful to work with ground beef that is 80 to 85 percent lean. The fat in the ground beef keeps the hamburger looking juicy (see the photographs on facing page). Sliders are the 2000s appetizer version of the burger.

MEATBALLS

Meatballs can get flattened by frying, making them unattractive. They will remain round if you don't fry them in a pan, but rather cook them in a sauce, as for spaghetti; bake them on a tray in the oven; or deep-fry them for submarine sandwiches.

RAW MEAT

Raw meat is sometimes shown as an ingredient in a recipe or product. Working with raw meat may seem simple, but it is not, because raw red meat changes color as it is exposed to the air. When you first take a steak from the refrigerator and slice it into cubes, it is a very deep purplish-reddish brown. As it sits out and is exposed to oxygen, it becomes a bright red color; as it sits longer, it begins to dry and turn a little brownish. Knowing when to cut the meat and how to arrange it is important. If you have arranged cut pieces of raw meat and some of them are touching, the areas where the meat is touching and not exposed to air will remain a darker color.

If you are showing raw ground beef, try to get it ground as close to the time that you need it as possible. Keep it in its just-ground color by carefully transporting and storing it in a plastic container. Don't try to reshape it, as the internal color (without the oxygen exposure) will be brown.

White Meats: Pork and Veal

White meats include pork and veal. Both meats hold their color well, so cook them as directed without fear of changing their color when the meat is fully cooked. You may want to undercook thick pork chops a little to keep them looking juicy. Brown the sides of the meat first and then the two flat sides in a nonstick pan with a little

TIPS *Cooked fatty meats usually respond well to a warm-up by torching just before shooting.*

Teriyaki sauce gives glisten and color to meats and poultry and a rich look to barbequed foods. Micro Brown and Micro Brown Chipotle (redder in color than Micro Brown) add brown to poultry and meats.

215

This natural and juicy sliced roast has tremendous mouthwatering appeal.
Jim Scherzi

vegetable oil—you need the sides to look cooked, too. Brown until the desired color is reached, unless you need to cut into the meat, in which case you need to cook it fully.

When white meat has been cooked, *don't* cover it with plastic wrap. This tends to steam the meat, and the meat loses its color. To reheat, return it to a pan or use a torch, if you are looking for the grilled look.

Hot Dogs

The color, size, and length of hot dogs vary a lot from brand to brand. The color is also affected by the type of hot dog—whether it is all beef, pork, turkey, or chicken. For a more natural look, you can find some hot dogs with natural casings in butcher shops. When I have a "hot dog and bun" assignment and I am not working for a particular brand, I bring in a variety of buns and hot dogs (it's always hard to predict which look the art director will want).

To cook hot dogs, continuously roll one hot dog at a time in a nonstick frying pan with just a little vegetable oil until it has the look you want. This will plump the hot dogs and give them a shine. Don't overcook them, or they will shrivel after they cool down. If a hot dog is slightly dented from the packaging, the cooking and rolling method will even out the skin. To get an "I've been on the grill" look, use a hot pan and little to no vegetable oil, and leave the hot dog on the surface of the pan for a little while (instead of constantly rolling) to give it natural brown cooked lines. Cool and store it on a tray at room temperature. I have noticed that some hot dogs spot if they sit too long after cooking (it depends on the brand). If you need to add grill marks, heat a metal skewer over a gas flame. Apply the heated skewer carefully; the hot dogs need just the slightest touch. Place grill marks at a slight angle on the meat for a more interesting look. If you are showing the hot dogs on a grill, make sure the grill lines match the grill in distance apart and thickness. Just before shooting, brush the hot dog with a little vegetable oil.

To give the hot dog a curved shape, insert a thin armature wire (see pages 125–126) through the length of the hot dog and then gently bend the hot dog into the desired shape. Clip off the excess wire.

To get the perfect mustard squiggle down a hot dog, bring a funnel and a couple of squeeze bottles with a variety of tips to the shoot. Test and practice different looks on a paper towel. I store the filled squeeze bottles point end down in drinking glasses so the bottles don't develop air bubbles and the mustard is always ready to flow. When squeeze bottles are not in use, store them filled in the refrigerator to keep the mustard thick and to avoid separation. Mustards change color and dry out within about ten minutes, so apply the mustard just before you are ready to shoot. Again, you might want to bring several styles of mustard for color and thickness variations. You will have much more flexibility if you apply the mustard to the hot dog before putting it in the bun (see the photograph on page 22).

Is it yea or is it nay? If no one adores your mustard squiggle (nay), wipe it off with a paper towel or Q-tip, reapply the vegetable oil, and begin again. Some mustards have a very high acid content and will bleach the hot dog if they stay on too long, so if you have the winning perfect hot dog and you need to change the mustard pattern, do it quickly. After you have applied the "perfect" squiggle, place the hot dog in the bun. If you are adding other ingredients, do so carefully just before shooting.

THE BUN

The hardest part of a hot dog job is finding beautiful buns that are unblemished and have an even shade of brown. There are usually only one or two buns in a package that will be usable because the buns are baked attached to one another and just the end buns will work. Another consideration is how to pack the buns so that they won't get damaged before you get them to the studio. I usually try to scan them myself (with a smile) at the checkout and then carefully pack them. Explain to the checkout person that "these little guys are getting their picture taken" and you need them unsquished. You may be able to find a supplier in your area that will bake buns especially for you, or check with your grocery store and find out when it gets deliveries. The store may give you the phone number of its supplier as well. Call the bread company and explain why you need the buns and maybe they will (carefully) deliver a couple of flats to the studio for you. After you have selected the best buns, put them on trays and keep them covered in plastic bags until they are ready to be used. They dry out quickly.

How deeply the hot dog needs to rest in the bun depends on its angle to the camera. If it sits a little too low in the bun, I insert toothpicks or T-pins midway through the bottom bun into the top bun and then open the bun to just the width of the hot dog. You can move the toothpicks higher or lower, depending on where you need the hot dog to sit in the bun.

Poultry

The techniques for working with chicken usually apply to other poultry as well.

WHOLE ROASTED POULTRY

The major problem when working with whole roasted poultry is that if it is cooked fully, the skin wrinkles as it cools. Also, it browns unevenly, and the skin near the knuckle pulls away from the bone. Food stylists have developed techniques to deal with these problems. However, sometimes there are problems within the solutions, as you will see.

Choosing the bird is the first concern. If your job is to sell a particular brand, you must use that brand. The client usually sends the product. With luck, it is handpicked for the best-looking bird. You want a bird that is plump and doesn't have a thermometer stuck into its breast (unless you must show it that way). You want the wings to be in good condition, with no major tears in the skin. The knuckles should be whole, not cut into, and the skin near the neck should be long enough to pull under and secure on the back of the chicken. If you are selecting a turkey, buy a hen rather than a tom because hens have a fuller breast and shorter legs—in other words, a hen is a fuller, rounder

> TIP *Zap-A-Gap versus Jet Set or Krazy Glue: Use these products to patch torn poultry skin and to hold the wings to the body of poultry, if the wings are not going to be tucked under. Zap-A-Gap seems to work best and is not affected by oven temperatures. Caution: All brands bond instantly to skin; keep debonding agents on hand.*

step by step: working with poultry

TOP ROW:

Select poultry that is fresh, plump, free range when possible, not previously frozen, without blemishes or torn skin, and with nicely shaped wings and whole knuckles.

This turkey has its neck cavity filled, its wings tucked under, and its legs tied together with filament and raised with wooden skewers.

The turkey is baked until the skin has tightened over the surface and the fat under the skin has begun to melt.

BOTTOM ROW:

Brush the warm turkey with a browning mixture of Angostura bitters, Kitchen Bouquet, a couple of drops of yellow food coloring, and a couple of drops of clear dishwashing detergent.

Paint the turkey with the browning liquid until it reaches the desired color. Each coat makes the bird a little darker.

To give the turkey an herb-roasted look, sprinkle it with a dried herb mixture.

Dennis Gottlieb

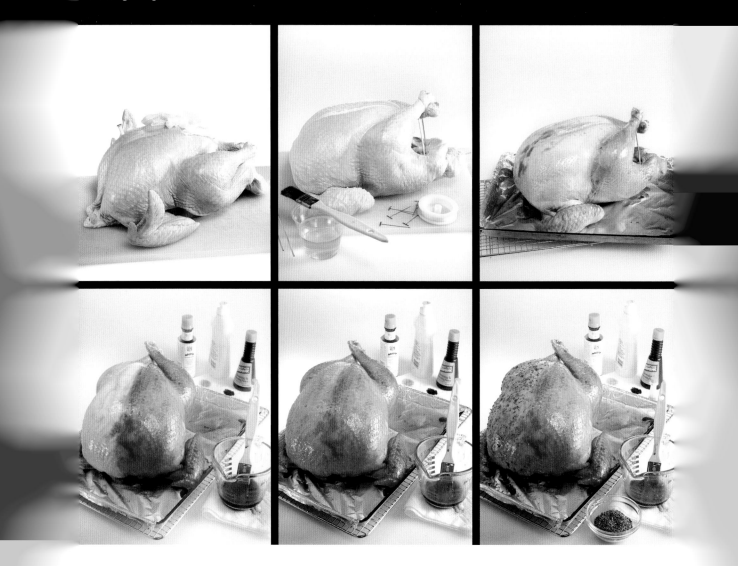

Apply one more coat of the browning mixture over the dried herbs to give them a roasted appearance and make them blend into the turkey.

Dennis Gottlieb

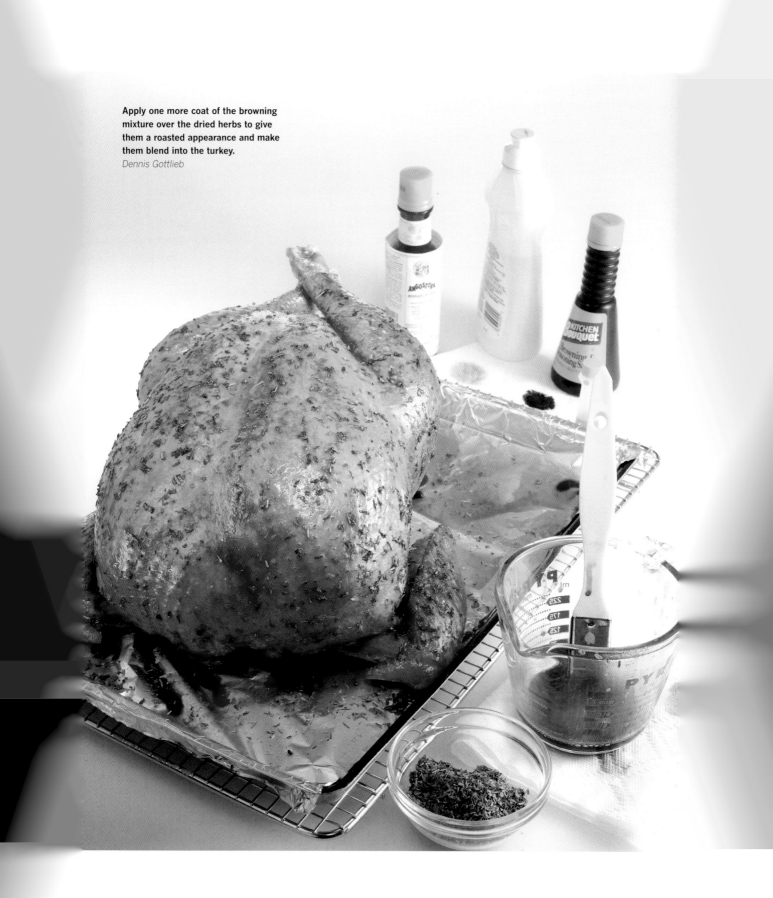

TIP *To help determine platter size, a rule of thumb is that a turkey is usually 1 inch in length for every pound. Add 4 inches to the weight of the bird and you'll have your platter size: If you have a 15-pound turkey, you will need approximately a 19-inch platter.*

bird. Keep the surface of the poultry moist by keeping the bird in its plastic bag or covering it with damp paper towels. Always keep it refrigerated until needed. Whenever possible, buy fresh rather than frozen or previously frozen poultry, because previously frozen poultry bones become very dark when roasted.

To prepare a whole chicken or turkey for roasting, remove the giblets and any pinfeathers. If the bird is not plump enough, stuff it with aluminum foil. If there is a thermometer in the breast, remove it unless it is important to show it in the shot. Most of the time the hole will seal as the bird cooks. To fill in the hollow neck cavity, fill it with damp white paper towels, pull the skin over the towels, and attach the skin to the back of the bird with a T-pin. Next, decide if you want the wings tucked under or if you want them attached to the side of the bird; these looks are very different. If you want them attached to the side, you can use Zap-A-Gap or use T-pins. If there are any tears in the skin, close them with Zap-A-Gap or small straight pins.

The next decision is whether you want the legs slightly angled up or down near the tail. Some poultry companies want the legs tucked under the tail skin, which is the way the poultry comes packaged. If the legs are to be slightly raised, you can use butcher's twine or ten-pound fishing line, sometimes called filament, to tie the legs together. Use two wooden skewers cut to length to hold the legs at the height you want. Brush the bird with vegetable oil and place it on a nonstick aluminum foil–lined tray.

Bake the bird in a preheated 350°F oven until the skin is tight and just beginning to brown. You want the fat under the skin to begin to melt. The amount of time you bake the bird will depend on the size of the bird and your oven: generally, 20 minutes total for a 2½-pound chicken, 30 to 40 minutes total for a 12-pound turkey. Remove the bird from the oven and immediately color it evenly with a mixture of about ten parts Angostura bitters, one part Kitchen Bouquet (a browning and seasoning sauce for meat, gravy, and stews), two to three drops of yellow food coloring, and a couple of drops of clear liquid dishwashing detergent. The detergent allows the water-base mixture to combine with the oiled surface of the poultry. This mixture is not exact, and each bird paints up differently. Test the color of the mixture on a part of the bird that the camera will not see until you get a combination you like. Chickens have a different coloration than turkeys or ducks, so if you are not sure, roast whichever bird you are shooting as if you were going to eat it and duplicate that color on the undercooked bird.

Brush the mixture over the entire bird, including the area where the legs are pressed against the breast. The more you brush the mixture on the bird, the darker the bird will get. If you want the "I've been roasted with herbs" look, sprinkle the bird with dried herbs—I like Italian herb seasoning—and then brush one more time with the browning mixture to make the herbs look as if they were cooked with the bird. Once you have the desired look, cool the bird and carefully remove it from the baking tray (lift the bird from the bottom and try not to touch the painted skin). Place it on the prop platter and garnish. The bird should be fine for several hours.

There are two other techniques that have been used by food stylists to cook the bird fully to a natural brown. One is to pour boiling water over the bird (by putting it on a large cooling rack over a sink) before roasting. This tightens the skin and keeps it from wrinkling as it cools after roasting. If you do get some wrinkles, you can plump (rewarm) the bird just before shooting by heating it, tented with aluminum foil, in the oven on a rack set over a pan of hot water. Some stylists have used torches to heat

the bird, but the result looks like a torched or burned bird. The second method, and my favorite, is to put the bird in brine before roasting, which helps keep it plump.

I once roasted a whole chicken that had been marinated in a sealed plastic bag in the refrigerator for 2 hours in a mixture of 3 tablespoons Chinese rice wine, 3 tablespoons honey, 2 tablespoons soy sauce, and 1 teaspoon sesame oil. I turned it in the brine occasionally before I removed it and discarded the brine. I placed the chicken on a rack and roasted it at 350°F, covering it loosely with aluminum foil when it started to brown. I roasted it for approximately 75 minutes (the timing will depend on the size of the bird and the color desired). This was a free-range chicken; it had a beautiful, even color and did not wrinkle.

the **Problem**

- Roasting, undercooking, or painting the bird produces spotty or uneven coloring.

the **Solution**

The undercooking and painting technique works very well with most turkeys, but some chickens are processed in such a way (hot scald to remove feathers) that when the feathers are removed, part of the outer layer of skin, the epidermis, is removed as well. It is the epidermis that absorbs the coloring agent. The lower layer of skin, the endodermis, is fatty and doesn't absorb the color, so the chicken can be very spotty. To prevent this, look for chickens that have an entire covering of epidermis with no spots or torn skin. Usually free-range chickens color evenly. If you are styling for a particular poultry company, you must use its product. In this case, you have several options. (1) You can cook the bird for real and shoot it quickly. (2) You can pour boiling water over the bird to tighten the skin and then bake the bird for real; the skin should not wrinkle upon standing. (3) You can brine the bird before roasting for real. (4) You can sprinkle dried herbs over the bird and give it one more bushing with the coloring agent to help hide some of the spotting. (5) You can spray the coloring agent on with an aerosol sprayer rather than brushing it on (some stylists feel this helps give the skin an even color). (6) With digital technology, the spots can be cleaned up using Photoshop.

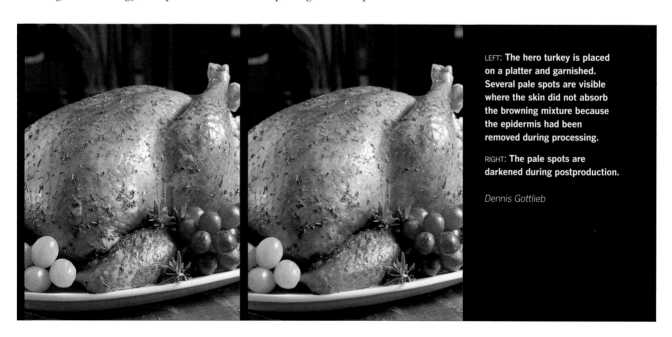

LEFT: **The hero turkey is placed on a platter and garnished. Several pale spots are visible where the skin did not absorb the browning mixture because the epidermis had been removed during processing.**

RIGHT: **The pale spots are darkened during postproduction.**

Dennis Gottlieb

221

the **Problem**

- You have to slice into a partially cooked bird.

the **Solution**

If you need to slice into a bird, slice into the breast area, which is the area that cooks first. If you know in advance that you will need to slice into the bird, cook it a little longer. After slicing, if it is not quite as done as you would like, hold a hot steamer over the area to finish the "cooking."

the **Problem**

- You remove the wooden skewers used to hold up the legs and the filament tying the legs together, and the legs move and expose lighter skin.

the **Solution**

If you have used wooden skewers and filament on the bird, sometimes you don't need to remove them before shooting because of the angle to the camera or the distance of the bird from the camera. If you do need to remove them, plan ahead for this step during painting by painting the areas between the legs and the body carefully. Remove the skewers and filament only after the bird has cooled.

the **Problem**

- You will be stuffing and garnishing the bird.

the **Solution**

If you are showing stuffing, the stuffing can be added after the bird is baked and colored. It often helps cover the wooden skewers holding the legs in place. Try not to overgarnish—remember, you want to see the bird. However, garnishes can help cover up undesirable blemishes. A whole bird is traditionally placed on an oval serving platter, but keep an open mind about other interesting possibilities, such as using a square or round platter.

CHICKEN PARTS: FOOD STYLING TECHNIQUES

Chicken is often cut into pieces and baked or fried. Some recipes will call for just four thighs, and some will ask for a whole chicken cut into eight pieces. When you show a

LEFT: Use scissors to borrow skin from the neighbor.

RIGHT: Pull the extra skin over the joint and pin in place to keep it from shrinking. The pins can be used as handles for moving the delicate pieces.

Dennis Gottlieb

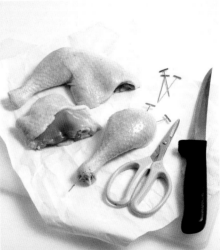

serving of chicken on a plate, you will usually show a leg and another piece because the leg reads as chicken more than just a single thigh or breast, which just looks like a brown, somewhat round object. Producing beautiful pieces takes some effort. When you cook chicken pieces, the skin shrinks as it cooks, and then we see flesh showing as well. For editorial purposes, this natural look is just fine. For advertising and product promotion, the client often wants the more perfect look, with no flesh showing and skin covering the entire surface of each piece.

To get this perfect look, you need to work a little magic or borrow from a "neighbor." If you are showing the leg you can buy legs with thighs attached and then borrow skin from the thigh. Pull the extra skin toward the leg and cut off the thigh with a boning knife. Now the leg has extra skin, which needs to be wrapped snugly around the leg and held in place with T-pins. Don't try to hide the T-pins, but leave part of the pins extending from the chicken. The pins will help you move delicate pieces and are easy to remove later, just before shooting.

You can do the same thing for breasts by buying the whole breast and then carefully borrowing skin from one half to make sure there is enough to cover the other half-breast completely. After you have prepared all the pieces in this manner, you can fry or bake the chicken.

TIPS *If you want panfried or grilled boneless, skinless chicken breasts to have interesting character, don't clean the skillet between frying the pieces. This gives the breast a good charred look and more visual appeal.*

Just before shooting, brush chicken broth on cut or torn surfaces of chicken to give the cut areas a very moist appearance.

BAKED CHICKEN PIECES

If I am coating chicken with crumbs, I usually dip the chicken into flour, then into an egg-milk mixture, and then into the crumb mixture, pressing the crumbs onto the chicken. (There is a variety of bread crumb products available, so compare them to find the one that gives you the best look.) Place the coated pieces on a gridded cooling rack set in a baking tray; you don't want it to sit in its own fat or juices. If you place the chicken directly on the baking tray, the fat from the chicken will discolor the crumbs. Spray the chicken with nonstick cooking spray for a juicer look on the crumbs and bake according to any package or recipe directions (for some products or recipes, you may need to underbake a little or reduce the temperature from 400°F to 350°F so that the chicken cooks but doesn't get too brown or spotty). Carefully remove the cooked chicken to another tray using the T-pins to help lift the chicken without losing the crumb crust. When the chicken is cool, remove the T-pins. If there is an area where crumbs are missing, use a little Vaseline and cooked crumbs to fill in the spaces.

FRIED CHICKEN

Chicken pieces can be panfried or deep-fried, depending on the desired look. If panfrying, fry at a medium to medium-low temperature. I use two wooden spatulas to carefully turn the chicken. Metal tongs tend to tear the skin. Panfried chicken will not brown evenly, and crumbs can burn. For deep-fried chicken, coat the chicken with flour, then dip it into an egg-milk mixture or buttermilk. Dip it into flour and press the flour into the chicken to give it a good coating. Deep-fry just a couple of pieces at a time in vegetable oil at 375°F. Drain the pieces on paper towels and carefully remove the T-pins.

If you are shooting an ad for a restaurant chain that sells fried chicken, then use the chicken that has been prepared at one of its locations. Just sort for the best-looking pieces.

BONELESS, SKINLESS CHICKEN BREASTS

Roasting, frying, or grilling boneless, skinless chicken breasts (BSCBs) has become very popular in the last ten years. Recipes that once took 45 minutes to make have been modified. They took 30 minutes and then 20 minutes to bake, and now take only 15 minutes (see the photographs on page 353). This has occurred because we use BSCBs, which take much less time to roast, fry, or grill than bone-in chicken pieces.

To prepare a BSCB for a grilled appearance, use a nonstick skillet set over medium-high heat and add a light mixture of vegetable oil and butter. Place the breast smooth side down (where the skin was) in the skillet and press down with a wooden spatula to obtain even browning. When the breast is sufficiently brown, turn it and cook at a lower heat until it is cooked through. Place the breast on a tray, but don't cover it with plastic wrap because that will cause it to steam and lose some of its brown color. When it is near shooting time and after you have seen the chicken arrangement, add grill marks. We usually don't have grill marks going toward the camera.

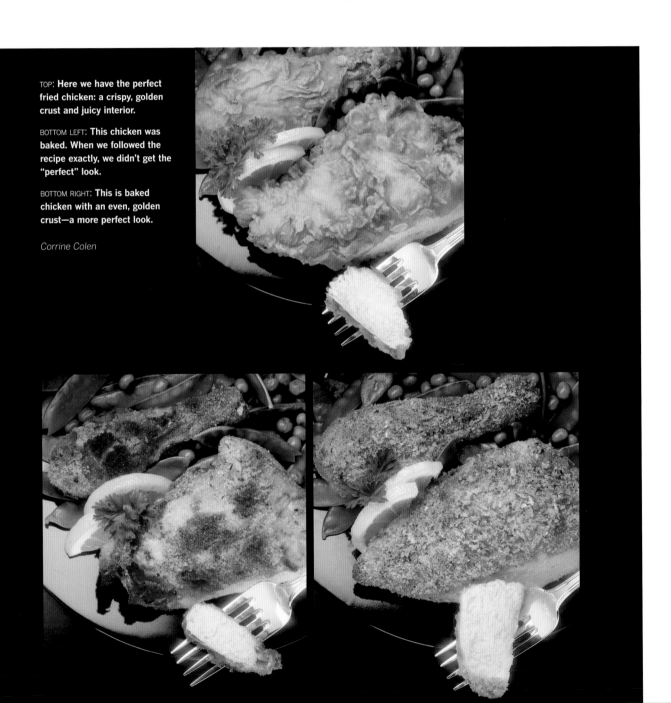

TOP: **Here we have the perfect fried chicken: a crispy, golden crust and juicy interior.**

BOTTOM LEFT: **This chicken was baked. When we followed the recipe exactly, we didn't get the "perfect" look.**

BOTTOM RIGHT: **This is baked chicken with an even, golden crust—a more perfect look.**

Corrine Colen

BSCBs are shown whole on top of casseroles, whole as an individual serving next to a starch and a vegetable, grilled on a grill or in a sandwich, or sliced on a diagonal and arranged on a plate or over salad greens. Today, chicken breasts are used in many forms because they are thought to be healthful and they cook quickly.

Fish and Shellfish

There are thousands of varieties of fish, but the ones food stylists work with most frequently are salmon and tuna (and usually tuna from a can). When you are working with tuna or fish used in fish sticks, you will need to show flakes when the fish is broken into.

WHOLE FISH

In the early days of food styling, we didn't like to cook whole fish, particularly red snapper, because it fell apart and lost its color. We just covered the eyes (people don't like to look at eyes) and garnished the raw fish. Today, we do cook the fish to varying degrees, depending on the assignment. Whole fish, however, have gone the way of roast suckling pigs; we do them, but not often. Whole fish are fragile after baking, frying, or grilling, so always provide good support by using a long wide spatula when moving them. If possible, bake any whole or fragile fish in the oven and add a grilled or fried appearance with heating elements or a torch.

FISH FILLETS AND STEAKS

Fish fillets and steaks have become more popular over the years for many reasons, including their health benefits and wider availability. In general, I cook the fillets and steaks as if I plan to eat them. The one problem is that when fish has been cooked, it tends to weep or lose some of its juices. To avoid juices flowing onto the plate, it is always good to put a double thickness of paper towels trimmed slightly smaller than the fish under the fillet or steak before you plate it for a shot.

To produce a "grilled" fillet or steak, dot the fish with butter and place it under a broiler until it browns. There is no need to turn the fish. The butter produces beautiful charred areas. Add grill marks, if desired, with a hot metal skewer.

If you are working with salmon steaks, try to get pieces cut from the middle of the fish. If they are cut near the head, the "legs" (sides) are too long, and if they are cut toward the tail, the legs are too short.

SHRIMP

Of all the shellfish stylists work with, we work with shrimp most frequently. It is important to handpick the shrimp for size, firmness, intact shells and tails, and heads when you can find them. Tiger shrimp will produce the brightest red color when cooked. To cook shrimp in water, add just a little cider vinegar to the water; it seems to produce a brighter red color.

To prepare shrimp for cooking, either remove the shell just to the last section before the tail begins (if you want to leave the shell around the tail) or peel the entire body and tail. To devein or not

When adding grill marks, try to keep the appearance natural. Perfectly even lines over the entire surface will look fake. Lou Wallach

You probably think salmon this fresh is found only in the finest seafood restaurants.

You're right.

From salmon to swordfish to trout, Red Lobster is proud to serve *only* the "Top of the Catch"—the freshest, highest quality fish there is.

Now, if you think that sounds delicious, we have just two words for you: *You're right.*

Red Lobster.

Deep-Fried Fish or Shrimp

COATS ABOUT 1 POUND OF SEAFOOD

½ cup all-purpose flour

½ cup flat beer

1 tablespoon malt or cider vinegar

½ teaspoon baking soda

Vegetable oil for frying

Whisk the flour, beer, vinegar, and baking soda in a medium bowl until well blended. Cover and let stand at room temperature. (The batter can be prepared 2 hours ahead and can be doubled.)

Heat the oil to 350°F.

Fry the shrimp or fish to the desired color. Drain on paper towels.

to devein will depend on the finished look you want. When you devein, you lose some of the smooth, curved shrimp shape. For most editorial assignments, I devein. (For advertising, I don't devein, in order to get a stronger shrimp read.) An in-between method is to put peeled shrimp in simmering water briefly, then remove and devein them and continue to cook until the desired opaqueness and curl are achieved. The shrimp are deveined, but the backs don't curl around the bodies as much.

It is best to cook just a few shrimp at a time so that you can control the amount of curl you get in the body; don't overcook the shrimp or they will curl into a tight circle. Put cooked shrimp in cool water to stop the cooking. If you want the shrimp tails to fan, here are two methods that will help with the fanning: You can insert two toothpicks into the body of the shrimp just under the middle of the tail before cooking, or you can fan the tails after cooking and use Zap-A-Gap to hold them in that shape. To keep them fresh looking, store cooked shrimp in cool water until needed.

If the shrimp are to be breaded and deep-fried, hold the shrimp by the tails with tongs and fry everything but the tails; the tails dry and curl if exposed to hot oil. Rub Vaseline on the tails to keep them fresh and shiny looking.

Above is a good recipe for deep-frying shrimp and any fish you would use for fish and chips.

LOBSTER

Lobsters are usually shown whole. Select them carefully for size, color, and condition; check that all body parts are attached and intact, including the antennae. The two problems that occur during cooking are that the bodies curl rather than stay flat and that if the rubber bands are left on the claws, they don't turn an even color. Cooking lobsters in water with a little vinegar (about 2 tablespoons to a large pot) helps enhance the red color. To keep the lobster flat while cooking, attach a serving knife, a couple of metal skewers, or a long, flat object to the underside of the lobster with thin rubber bands and cook. To prevent rubber band marks on the claws, cook the lobster for a couple of minutes, cut off the bands with scissors, and continue cooking. Spritz or brush the lobster with water just before shooting to freshen the look. Vegetable oil usually makes it too shiny unless it is rubbed into the shell.

MUSSELS

Even though they're dark, mussels are quite beautiful when photographed. Try to find them with clean shells (that is, debearded and with no barnacles). Farmed mussels are the cleanest in appearance. Cook mussels until they open and store them in a refrigerator covered with damp paper towels until needed. The arrangement of the open mussels is very important. Try to achieve a random and casual look. It is easy to transfer plump interior meat and place it where it looks the best. Moisten both interior and exterior surfaces with water just before shooting.

GRILLED food

Simulating the Look in a Shot

Grilling has always been around, but in the last ten years it has become popular again. We were introduced to backyard grills in the 1950s, but the use of the grill as an important cooking medium really took off when several chefs wrote books on grilling as a single subject. Today, we grill and see pictures of grilled foods frequently—even pizzas are baked on the grill.

When we work in a studio, we are not able to use outdoor grills, so we need to know how to simulate the look. A cast-iron grill pan over gas heat works well. However, if we need to have a more controlled look for advertising shots or if the grill marks need to look different from those produced by the grill pan, we need to know how to use other techniques.

To produce the charred look for meats, either a cast-iron pan set over a fairly high heat or a broiler works well (for fish, place the fish on an oiled surface, top the fish with small dots of butter, and run it under a broiler). To produce the grilled look on vegetables, a broiler, a heating element, or a nonstick frying pan over high heat with just a little vegetable oil will work. Once you have produced the charred look, you may want to add grill marks. This is done by heating a metal skewer over a hot gas flame until the skewer is red hot. An electric stove doesn't produce enough heat to get the skewers hot enough, so if you are working in a studio without a gas stove, bring along a propane torch (see the photograph on page 142).

How to Make Grill Marks

Adding beautiful grill marks seems deceptively easy. It is just heating a metal skewer and searing the food....wrong! I have collected some very ugly grilled food shots over the years that are hanging in my "hall of shame" collection. What makes a shot eligible for this honor? Grill marks that don't match the grill the food is placed on. Grill marks that don't match each other, so that one tuna steak has marks that are set wide apart and the piece next to it has marks very close together. Grill marks going over the entire edge of the meat, as well as on the top and bottom, which would never happen in the real world. Grill marks that are too perfect and don't look natural. Grill marks that are too wide or too thin for the food item they are on and overwhelm or underwhelm.

Try to find metal skewers that take the heat well and can become red hot. If the skewers are not hot enough when you put them on the food, they will not mark it well and will also stick to the food and tear it as they are removed. In addition, find skewers of different widths. Some foods, such as shrimp and chicken, look best with thin marks, while foods such as large steaks look best with wide marks. If the food is on a grill, the grill marks always need to match the grill. It helps to make a rubbing of the grill by placing a clean sheet of paper on the cold grill and rubbing a pencil over the paper, picking up the impressions of the grill lines. Then, when adding marks to your food, place the food on the paper and follow the lines. It is very important to think about

TIP *Do not torch vegetables if you want to represent vegetables that have been grilled. Torched vegetables look torched. "Grill" vegetables by putting them in a hot pan with a little vegetable oil and cooking them until they take on a slightly charred appearance.*

227

A good kebab is on the right; a less appealing kebab is on the left. *Colin Cooke*

the direction you want the marks to run when you arrange the final food for a shot (see the photographs on pages 205 and 225).

Some stylists take electric charcoal starters, pound the coils to the desired thickness, and use these for producing grill marks (see page 142). These work very well if you need to produce a lot of grilled foods.

Foods Difficult to Grill

Very moist foods, such as sliced tomatoes and lemons, do not like to take grill marks. A wheel of onion rings wants to fall apart during grilling, so secure them together with T-pins. Fish falls apart if turned, so it is best to broil it; we usually need to broil only one side of the fish for photography.

Kebabs

Arrange cooked food on skewers in an attractive manner. The mistake you often see with kebab arrangements is food packed too tightly on the skewer; it is very flat and uninteresting. Do something interesting with the mushrooms—cut them in half and have the cut side looking into the camera—or cut the bell peppers in curved triangles rather than flat squares. Add grill marks after arranging the food on the skewers. Sprinkle the kebabs with dried herbs or cracked pepper and brush them with vegetable oil for the final effect.

do you remember the kabob-it?

In the early 1980s, it was popular to shoot open refrigerators beautifully filled with hams, gelatin molds, pies, produce, and generic packages and bottles of food. Soufflés, cherry pies, and roasts filled the ovens. Microwave ovens (which were finally being accepted in the Northeast) were displayed with a counter full of possible foods cooked therein.

Food stylists were also asked to style food to promote utensils, plates, gadgets, and equipment related to food. I have styled food to sell silverware, baking dishes, and the annual array of new gadgets. Some are very successful, such as the reamer, which is used to grate cheese, chocolate, and lemons; the CrockPot; and the George Foreman Grill. Some are less successful, with only a year's life span. Two of these short-lived items stand out in my mind. One was an expensive countertop "oven" that rotated at a 45-degree angle as it cooked the food. Yes, a roast kerplunked as the oven revolved. The other was the Kabob-It. This machine made it possible to have kebabs not just during the summer grilling season, but year-round. I was assigned to work on some of its advertising and infomercials.

The gadget had a few design and safety flaws. It had an exposed heating element that ran up the center of a removable glass-domed cooking area. The food or cubes of food on the metal kebab spears could be no larger that 1½ inches or the food would hit the heating element or the glass as the kebabs vertically rotated. It was always a challenge to come up with food that would "grill" well and be the right size.

STARCHES

From Pasta to Potatoes

Sometimes a side dish, sometimes the entree. This is a large and important segment of our work.

Pasta

Pasta is one of our most popular foods today. For food styling and advertising purposes, cook pasta without adding salt or oil to the water and just to the al dente stage. If pasta is undercooked, it will not be flexible enough to bend and twirl; if it is overcooked, it will be too soft and will lose its texture. The reasons we do not add oil to the pasta either while cooking or when it is finished cooking are threefold: (1) The pasta will leave marks on the plate if we move it around. (2) The pasta tends to get spotty if exposed to the air for a while (one color where the oil is and another color where it isn't). (3) The sauce doesn't want to cling to the pasta but rather slides off the oiled surface. Drain the al dente pasta and cool it down completely in cold water, then drain it again. Depending on the type of pasta it is (spaghetti and penne work well), you can put it in a plastic bag until needed, keeping it from air. Or, if you are doing a "perfect" shot and using flat noodles, you can lay the noodles out on a tray one at a time, single file. Cover the layer with plastic wrap, then repeat with a second layer, and so on until you have all the pasta you will need. Pasta prepared this way, will stay a consistent color and be easy to work with when it is time to arrange the dish.

If the dish is a pasta topped with vegetables and shrimp and with a sauce that gets poured over it, place one noodle at a time on the plate until you have the amount and arrangement you need for the shot. Then add any other ingredients (shrimp, vegetables, etc.), except the sauce. Bring the plate to the set, make any adjustments, and then add the sauce, cheese, herbs, pepper, etc., just before shooting.

If you are shooting an editorial assignment with a more natural look, follow the recipe, plate the dish, and make a few adjustments after looking at it as the camera sees it. Shoot quickly, because sauce doesn't look fresh if it sits for a while.

LASAGNA

For editorial shots, you can shoot lasagna as it is scooped from the pan, but for advertising, I usually build the lasagna one layer at a time. If you are shooting a premade product, you may have to take it apart, select the best-looking pasta pieces, and then put everything back together. If the client can send component parts, so much the better. You will want to find pasta with beautiful curly edges. For support and a nice flat surface, add thin cardboard sheets under the pasta. Cut the cardboard a little smaller than the pasta as you are building. Lightly microwaving the lasagna to reheat it before adding the top layer of cheese helps give the dish a cooked look. Melt grated cheese on the top layer with a heating element. Just before shooting, spritz the tomato sauce with a little water to help it glisten and look fresh.

TIP *For sauced pasta, put a small piece of paper towel on the plate and arrange the pasta on that, eventually hiding the paper towel, of course. This prevents the pasta from sliding around.*

MACARONI AND CHEESE AND OTHER PASTAS WITH CREAMY SAUCES

Having the sauce look fresh, smooth, and not so thick that you can't get a "noodle read" is your goal with creamy sauced pastas. If you are shooting editorial assignments, follow the recipe. If you are working with a product, you will probably be using a processed cheese (see page 178). With some types of pasta (flat noodles, for example), you can dip each piece in a thinned sauce, make the arrangement, and then bring the hero to the set and quickly get the final shot just after you have added more sauce. With elbow macaroni, mix the pasta in a sauce of the correct consistency, arrange it on the plate and quickly bring the plate to the set. There are some clients who prefer that the holes at the ends of the macaroni noodle not show, so there may be some last-minute rearranging. There are also clients who don't want the ends of flat noodles showing (see below). Some clients prefer that there be no puddles of sauce, while others like them. The trick here is knowing the wishes of the client (the gold standard), working fast, adding the final sauce just before shooting, and having the sauce just the right consistency (see pages 237–238).

RAVIOLI

Put a small square of paper towel underneath each ravioli to keep it from sliding on the plate or onto another piece of pasta. Ravioli that have a little character in their shape, such as curves and curls, have a more interesting appearance. If you are showing a ravioli cut open, you may need to add a little extra filling or show some coming out of the pocket.

SPAGHETTI AND SIMILAR PASTAS

The thickness of the spaghetti makes a big difference. The color of the pasta varies from brand to brand, so depending on the assignment, you may want to select pasta that is more yellow or lighter in color. The most difficult long noodle to work with is angel hair, which is very thin. Make sure the pasta is cooked al dente. One stylist I know likes to take two strands and twirl them in a circular shape to form a visual but controlled pattern when plating the pasta. Look at pictures of spaghetti that you like and note the arrangement of the pasta. If you are serving spaghetti with a tomato sauce, add the sauce just before shooting. If the sauce needs to be thickened, pour it onto a stack of paper towels and allow the towels to absorb some of the liquid (see the photographs on page 238). Add less sauce than you think will be needed. You can always add more, but the way the camera sees it, in only two dimensions, you often need less.

food stylist challenge:
no ends showing

Sitting in a preproduction meeting of agency and production personnel, I was informed that when I was arranging the product, a side-dish pasta, the client didn't want any of the ends of the pasta to show. All eyes were looking at me to see how I would take that news. I didn't flinch. "Okay," I said. This was because I had not yet seen the product. When I looked at the product, I realized why all eyes were on me. The noodles were about ¼ inch wide and 2½ to 3 inches long. Try arranging those noodles with a cream sauce attractively on a plate with "no ends showing."

Another challenge was to arrange a macaroni and cheese product with none of the holes at the ends of the macaroni pointing toward the camera.

Potatoes

The red color of some potato skins is sensitive to hot water and vegetable oil and changes from a deep red to a light pink upon cooking. Buy the darkest red potatoes you can find. Try microwaving them, or slicing them

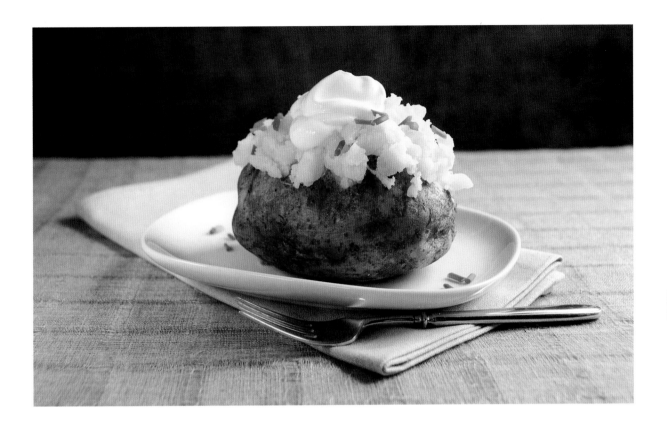

before blanching, and having them in water or oil for the shortest time possible. The sliced surface of any uncooked potato will turn brown in a short while. To prevent this, store potatoes in water until needed or brush sliced surfaces with a solution of sodium bisulfite and water—only if no one is eating the food, of course.

Working on a baked potato at room temperature allows you time to get everything just right before shooting and prevents the sour cream from melting. *Dennis Gottlieb*

MASHED AND BAKED POTATOES

Russet, Belrus, and Kennebec varieties are high in starch and have a dry texture that makes them good for baking and mashing, as well as using in gratins. Put peeled and cooked potatoes through a ricer for a very creamy, professional look for mashed potatoes. Use a potato masher or handheld mixer for the homey look. Even a fork can be used for the smashed look (skins left on). For a quick styling substitute or stand-in, use instant mashed potatoes. Do test the different brands of instant because each will produce a different look.

For baked potatoes, look for a good oval shape and attractive skins. Bake the potatoes on a baking sheet in a 400°F oven until 95 percent done to keep a firm exterior. Remove them one at a time and slice them open immediately to release the steam; this keeps them from wrinkling. Bake a couple of non heroes until 100 percent done and use their flesh as extra stuffing for the hero potatoes, to make them look full and fluffy. For a darker and more textured appearance, after removing the potatoes from the oven brush the skins with vegetable oil and then pat them dry with a dry paper towel. Present two options to the art director (see the photograph on page 232).

Once you have filled in the stuffing, cover the potatoes with plastic wrap to keep them fresh. For print, the potatoes should be at room temperature when it is time to top them with sour cream or a butter pat. You can melt the butter by touching it with a hot spatula when you are ready to shoot.

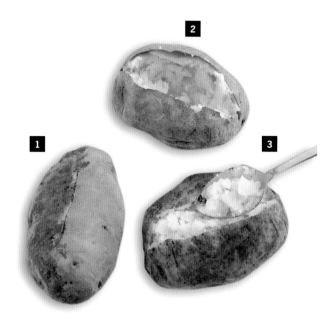

Baked potatoes: **1** A whole potato with two looks: on the right side, it was left plain and on the left it was oiled for a darker color and more texture. **2** We borrowed filling from this potato. **3** The hero with extra filling. *Dennis Gottlieb*

If I need to show steam rising and butter melting for television, I inject the plastic-wrapped potato with extra water and put it in a microwave oven until it is very hot. I place it on the set, remove the plastic, and top the potato with a pat of butter, and we shoot.

FRENCH FRIES

Make your own french fries, with or without skins, or use frozen fries, sorted for the desired length and shape. Any type of french fry needs to be fried in 375°F vegetable oil in a pan that holds a constant temperature. Electric Dutch ovens with temperature controls work well if you are unable to rent a professional fryer. Work with small batches. Oil that has been used for a while tends to produce a deeper golden color. Major food companies and restaurant chains have specification sheets that show the color they want their fries to be. Fried crisply and drained in a single layer on paper towels, the fries should hold up for several hours (see the photograph on page 20).

OVEN-ROASTED POTATOES

A popular way to show quartered red potatoes is to oven roast them. You can also get that look using a more controlled method: Panfry just the sliced sides of the potatoes in a nonstick pan with a little vegetable oil.

Rice

When you are preparing rice for a generic shot, cook it much as you would pasta. This will help to keep the grains separate and easier to place. Pour long-grain rice into a large pot of boiling water (unsalted and no oil). Cook the rice until it looks done to the eye and is done to the tooth. Pour it into a colander and drain. Rinse it under cold water until cool, drain well, and pour it out onto a tray. Cover the tray with a plastic bag, and the rice will be ready for you as needed. Unless I'm selling a particular brand, I use a long-grain rice such as Uncle Ben's because it produces a slightly golden grain that keeps its shape, doesn't clump, and forms individual grains. If you are shooting rice for a particular style of ethnic cooking, choose a rice that is typically used. For example, Carolina brand produces a very white fluffy rice that is preferred in the Latin community. If you are not sure which rice to use, make trays of several types and see if your food looks better with a slightly golden grain or a whiter grain.

Short-grain rice tends to be sticky, and it clumps upon setting. Jasmine and basmati are flavorful long-grain rices with naturally separate grains.

TIP *Just before shooting, use a wooden skewer to lighten and give texture to the arranged rice. Spritz the rice with a little water or brush it lightly with a little vegetable oil to give it highlights and a fresh appearance.*

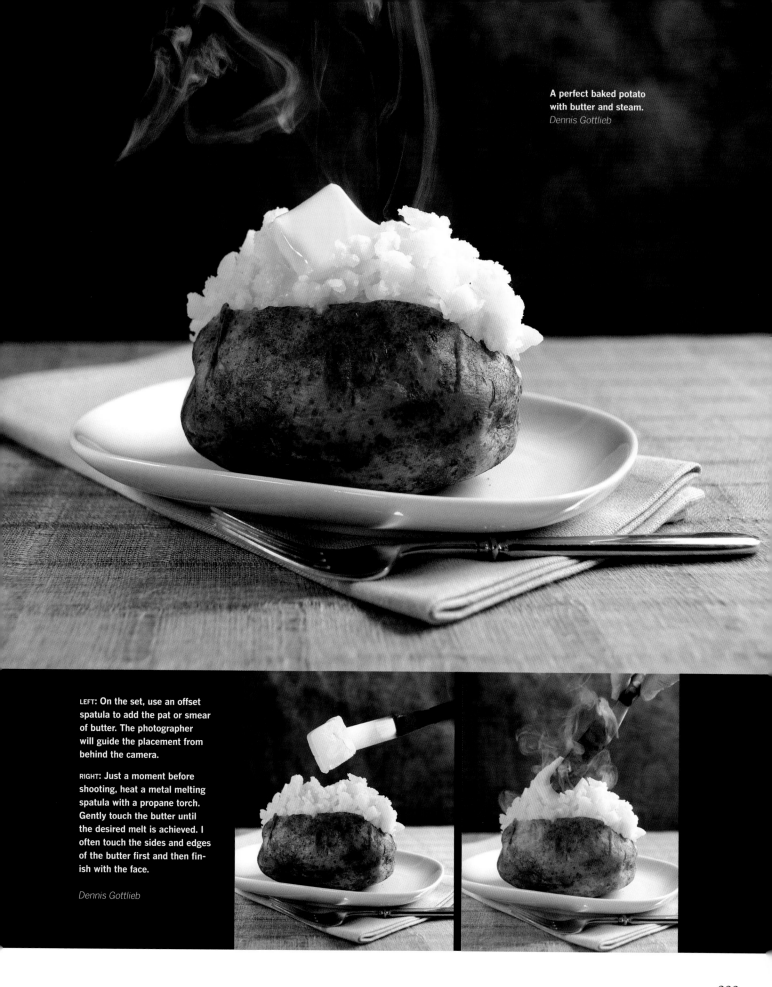

A perfect baked potato
with butter and steam.
Dennis Gottlieb

LEFT: On the set, use an offset spatula to add the pat or smear of butter. The photographer will guide the placement from behind the camera.

RIGHT: Just a moment before shooting, heat a metal melting spatula with a propane torch. Gently touch the butter until the desired melt is achieved. I often touch the sides and edges of the butter first and then finish with the face.

Dennis Gottlieb

233

PIZZA

Timing Is Everything

Pizza shots can range from an English muffin or pita topped with sauce and pepperoni for a children's cookbook to a slice cut from a large pie for a magazine recipe. It can be the classic "cheese pull shot" (see the photographs on page 236) for the package of a frozen product or an ad or commercial. Because of pizza's popularity, learning to make a beautiful pizza is an important skill. However, pizza is considered one of the more difficult foods to style because it needs to be shot quickly. Its fresh, hot, bubbly, "just from the oven" look disappears in a short time, and the pizza becomes cold, congealed, and greasy. In addition, its many parts need to come together in just the correct proportions to produce a tempting dish.

The Crust

There are several types of premade crusts available, ranging from the rimless Boboli, presprinkled with cheese, to the preshaped bases found in the fresh bread and frozen food sections of the grocery store. These are fine unless you need a specific size and shape. Also available in the frozen food section is bread dough that can be thawed and shaped into a base the size and thickness you desire. You can also make your own pizza base. (A favorite recipe for that is found at wolfgangpuck.com.) The dough can be shaped and baked in a pizza pan or shaped freeform and baked on a pizza stone or on a grill.

If you are working on an ad or commercial for a particular pizza brand, the client often supplies the premade and portioned dough. On major commercials, someone from the brand may be sent to prepare the bases for you. If it is up to you to make the bases and you are not skilled at this, hire a pizza specialist for the day.

Sometimes you may want to partially cook the bases before topping them with sauce and fillings because that way the ingredients don't have to stay in the oven as long, making them wrinkle and dry out. You will want to pretest your product to learn how best to get the look you and the client want.

If you are working on a major pizza brand, you will need to rent a pizza oven, have the client supply one, or shoot at one of the client's locations because a normal oven doesn't reach temperatures that are hot enough.

The Sauce

Sometimes you will follow a recipe for the sauce, sometimes it comes with the product, and sometimes you will purchase pizza sauce in jars at the grocery store. Compare brands (unless you need to use a particular brand) for the best bright red color and interesting particulates, as desired.

TIP *Some questions to ask the clients when you are working with brand-name pizzas: How thick do they want the edge of the base to be? What color should the finished crust be? Do they want cornmeal showing on the crust, or any sauce or cheese on the crust? Look at tear sheets of the product to see samples of previous shots.*

One of the things that you have to watch is the amount of sauce you spread on the base. For photography, you usually use considerably less sauce than if you were preparing a pizza to eat because the sauce dilutes the look of the cheese. Brush a fairly thin layer of sauce over the base. After the base is baked, for a fresh, more saucy look, you can add sauce along the edges of the pizza using a small brush or eyedropper.

The Cheese

When making a generic pizza, you can choose the
cheese you want to use. The usual cheese is mozzarella,
but recipes can call for any type of cheese. Part-skim mozzarella works better than
whole milk because the amount of fat in the whole milk mozzarella makes the cheese
gray and transparent; the part skim stays whiter. It is usually preferable to buy whole
blocks of cheese and grate your own to ensure the thickness and look you want for the
strands. I like to use my Moulinex grater (see the photograph on page 179) to get long,
roundish strands. Test various brands of cheese before you shoot because each cheese
has a different look, and companies can change their formulas. When selling a particu-
lar brand of pizza, you need to use the cheese that the client uses. If the cheese is sent
pregrated, you will want to hire someone to sort for the type of strands you want. To get
good individual strands, keep the cheese refrigerated until ready to use.

TIP *If the sauce is too thin and watery, drain it on a stack of paper towels.*

The Toppings

Toppings on pizza can be practically anything these days, but the common toppings
are pepperoni, sausage, mushrooms, green and roasted red peppers, onions, olives,
and ground beef. Sometimes pizzas are cooked with the toppings sprinkled over
the base and covered with cheese, but this can cause them to look overcooked. One
technique is to cook the toppings (just warm the pepperoni) and bake a plain cheese
pizza. When you remove the pizza from the oven, quickly cut, with scissors, into
the cheese and partially insert the toppings to make them look as though they were
cooked in and on the cheese. This prevents the pepperoni from curling, drying, and
becoming very greasy. It also prevents the sausage, ground beef, and mushrooms
from becoming too dark and dry looking and the vegetables from overcooking.

The Cheese Pull

Several techniques can be used to produce this signature look. However, you must al-
ways use a cheese that "pulls" well, which means it forms nice long strings that cling
to the slice as it is lifted from the whole pizza. Part-skim mozzarella cheese works
best for this. Test various brands.

One method used to produce the cheese pull is to prebake the base of the pizza
for 8 to 10 minutes at 350°F. Make a template to determine the correct size for the
slice and cut the crust before topping the pizza, but leave the slice in place. This way
you control the size and know where you need the sauce and where the cheese is
needed the most. After preslicing the base, brush it with a thin layer of sauce at the
base (but not near the slice lines). If the sauce is too thin, thicken it by draining on
paper towels. Once the pizza's crust is sauced, place lots of long strands of low-fat
mozzarella across the slice lines. This will create the cheese pull. Top the rest of the
pizza with any toppings and the remaining cheese and bake. When the pizza has
baked to the desired color, move it to the set and let it rest for 3 to 4 minutes. Place
a spatula that has sticky surface and is the same shape and almost the same size and
with a sticky surface under the slice and carefully lift it for the cheese pull. The pizza
must be shot while it is still warm.

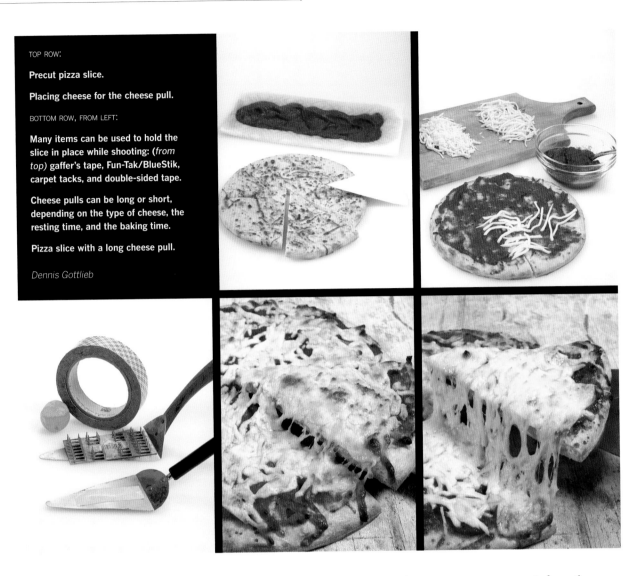

TOP ROW:

Precut pizza slice.

Placing cheese for the cheese pull.

BOTTOM ROW, FROM LEFT:

Many items can be used to hold the slice in place while shooting: (*from top*) **gaffer's tape, Fun-Tak/BlueStik, carpet tacks, and double-sided tape.**

Cheese pulls can be long or short, depending on the type of cheese, the resting time, and the baking time.

Pizza slice with a long cheese pull.

Dennis Gottlieb

Another method is to bake the pizza and, as soon as you remove it from the oven, cut the slice. Allow the pizza to rest and the hot cheese to reconnect for about 3 to 4 minutes. Then lift the slice with a spatula as described above.

Test pizza bases with different amounts of cheese to find the look that the client wants; there is such a thing as too much or too little cheese.

the **Problem**

* The pizza must be kept alive or brought back to life.

the **Solution**

Some pizzas can be reheated once, but they never look quite as good or as fresh. You can hold a heat gun or heating element over the pizza slice to keep the cheese fresh until ready to shoot. Some stylists keep a cooked whole pizza in a warm (250°F) oven or in a pizza delivery box for a short while to keep it as fresh as possible. For pizza cheese, use radiant heat such as from a paint stripper, heat gun, or grilling element on the set to keep cheese hot and bubbling. If the pizza is topped with vegetables, steam heat from a professional steamer will

TIP *Some stylists adhere small tacks or use Flower-Fix (see page 130) on the spatula to keep the slice of pizza from sliding as it is lifted.*

keep the vegetables fresher. Some stylists spray the surface of the pizza with nonstick cooking spray and use white Cheddar cheese to keep whole pizzas that will not be used for a cheese pull looking fresh longer. It is important that you test the products that are available and see which holds up the best and gives you the look you want.

> TIP *Cook a couple of pizzas as if you were going to eat them and remove the little patches of brown cheese bubbles. These can be placed on top of the hot hero pizza for that "hot and bubbly" look.*

SAUCES
From Thick to Thin, from Sweet to Savory

Sauces can make foods very inviting, with a smooth, bright, glistening, fresh, and colorful coating or topping. They can also be very uninviting, with a cold, thick, over-sauced, gummy appearance. Sauces are considered one of the more difficult foods to work with photographically, but they can make your food sparkle with appetite appeal. The problems with sauces are that they lose their fresh look quickly, they may be too thick and cover the food too heavily, or they may be too thin and not cover enough or hold their shape on the food or the plate.

Sauces need to be there, but not to overwhelm. Just how can you produce that look? Remember that in all sauce work it is important to have just the right thickness and to apply the sauce from a container (squeeze bottle, eyedropper, spoon) that is comfortable to use. Always apply sauces as close to shooting time as possible.

Styling the elements of sauced food can be as simple as a judicious squeeze of sauce from a plastic bottle. Or you may be asked to perform a complicated maneuver, such as creating a teardrop dribble of chocolate sauce hanging precariously from the edge of a cheesecake slice. A good sauce can be the ultimate finishing touch on a food photograph. Below follows information pertaining to various kinds of sauces. For syrups, see pages 191–192.

White Sauces, Cheese Sauces, and Hollandaise

There are many packaged, canned, and frozen pasta and vegetable side dishes that come with a white or cheese sauce. When you are working with a packaged product, try to get component parts so the sauce is separate. If you can't get component parts, prepare the product (noodles with a broccoli cream sauce, for example). Drain the food and save the sauce. You may want to rinse the food if the sauce is too thick. Often the sauces are made with processed cheese or gelatin bases so they respond well to hot water when you need to thin them. Arrange the food with just a light covering of sauce, even if it normally comes totally covered in sauce. You can add more sauce just before shooting. When working with sauce on the set, it is helpful to have a cup of the sauce, a cup of hot water or milk, and an empty cup. Combine the sauce and liquid in the empty cup until the desired consistency is reached. You can test this off the set on some of the non-hero food. Use a spoon, squeeze bottle, eyedropper or pipette, or brush for adding more sauce.

LEFT: Here, the sauce is used right out of the jar.

RIGHT: For this shot, I thickened the same sauce for more texture by draining it first on paper towels.

Corrine Colen

The problems with hollandaise sauce are that it can separate and that it looks flat and loses its glossy appearance after sitting for a while. Stylists have been known to use a yellowish moisturizing lotion such as Jergens hand cream as a substitute.

Gravies, Pan Juices, and Au Jus

You can make your own gravy or purchase it canned or packaged (in powdered form). It is always wise to get to know products—their color, thickness, and saucing properties—so that you know what to buy for each assignment. For editorial purposes, you can make your own, following the client's recipe; for advertising, use canned or packaged product, because they keep a sheen. Gravies and sauces thickened with corn or potato starch will usually have a sheen, while those thickened with flour will be more opaque and duller in appearance. Use the correct look with the appropriate food.

Pan juices or au jus (natural juices from sliced meat) are both thin, translucent sauces. You may thicken these slightly with cornstarch so that they will hold the desired shape and not puddle on the plate. Again, add sauce just before shooting.

Tomato Sauces

Tomato sauces for pasta and meats take on a dull appearance in a short amount of time. Stylists have been known to add corn syrup or piping gel to a sauce to help keep its glossy appearance. Sometimes that affects the color of the sauce, so test first. Another way to bring back a glossy look is to spritz with water just before shooting. If you are not shooting a specific brand of sauce, choose the brightest red bottled sauce you can find. Look for one with interesting bits and pieces. Don't heat the sauce or it will change color and separate.

Fresh Salsas

TIP *Use light Karo corn syrup or clear glucose with gravies and sauces (test the product with the syrup and watch for color changes or thickening). The syrup usually thickens and adds luster.*

Fresh salsas are very much in vogue. They are used to accompany poultry and fish or as a snack with tortilla chips. If the salsa is tomato based, use plum or Roma tomatoes when you make it; they produce a bright red

salsa. If the salsa is runny, drain it on paper towels or place a paper towel beneath it in its container. Spritz it with water to refresh it just before shooting. Fruit-based salsas are often used with fish.

Mustard, Mayonnaise, and Ketchup

The brand and type (regular or low fat) of condiment you use will make a difference. Mustard gets a dark skin when it sits out for a while; apply it at the last minute. The color, sheen, and thickness of ketchup varies from brand to brand. Generally, Heinz is brighter, shinier, and holds its shape better than other brands. Add ketchup to the hero food just before shooting. Mayonnaise changes color and looks old upon sitting; however, low-fat mayonnaise will hold its appearance longer. Add mayonnaise to a sandwich with wide eyedroppers or spread it thickly on the bread and push down to give it a natural ooze. Low-fat mayonnaise works with deviled eggs and as a sauce because it holds up well and doesn't change color. Add chopped fresh herbs to mayonnaise for interesting sandwich spreads and tartar sauces.

Salad Dressings

Salad dressings come in a large number of types, thicknesses, and colors, some with particulates (herbs and spices), some without. Some are translucent and some are opaque. Most of the salads I style are shot without dressings or with a small amount of dressing added just before shooting because the acids and oils begin to wilt produce upon contact. Try spraying a salad surface with vegetable oil just before shooting instead of using a vinaigrette. (Test a variety of nonstick sprays as well.)

Smooth Vegetable and Fruit Sauces (Coulis)

Coulis are thick purees of fruits or vegetables that are often put in a squeeze bottle and used to decorate entrée and dessert plates. The major problem with coulis is that they can separate after sitting. To prevent this, cook the puree with a little cornstarch or add a powdered thickener. Sometimes the cooking process changes the color of the puree, so test first.

Fruit Coatings

Cherry pie fillings have a sauce that is bright pink and a wonderful consistency for coating strawberries or other red fruits atop a tart or to produce lovely, controlled drips of sauce down the side of a slice of cheesecake. To coat sliced fruits that top tarts, use apple jelly that has been heated to a thinner consistency, and then spoon or brush it over the fruit just before shooting. Apricot jam can also be used, but it must be heated and strained before being put over fruit. Do compare brands of jams and jellies because the colors will vary, particularly among strawberry and raspberry varieties.

TIP *Low-fat dressings have gums and thickeners that keep the dressing emulsified and the particulates suspended, so they are good to use when you have to show dressings in a container or cruet.*

TIP *Food stylist Lynn Miller suggests using pureed steamed fruit heated with the jelly of the same fruit as a coulis that holds up well.*

Dessert Sauces

Chocolate, butterscotch, caramel, coffee, and fruit-flavored sauces are available in squeeze bottles in most grocery stores. Test these sauces for color and viscosity.

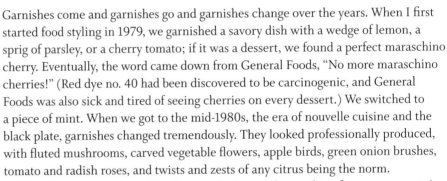

Chocolate Sauce

MAKES 1½ CUPS

1 cup heavy cream

3 tablespoons light corn syrup

10 ounces Swiss dark chocolate, finely chopped

Bring the cream and corn syrup to a gentle boil in a medium saucepan over medium heat. Remove the pan from the heat and add the chocolate. Let the mixture sit for 1 to 2 minutes. Whisk until smooth.

For beverage shots where you might show a swirl of chocolate down the inside of a glass, such as a cold alcoholic drink, a thinner sauce such as Hershey's Syrup works best. But for drizzles of chocolate over an ice cream sundae, you will want a thicker sauce that stays in place. Smucker's Chocolate Fudge Topping, which comes in a jar, has a terrific thickness for this purpose. It can be used as is, but I like to put it in a squeeze bottle for greater control (see the photographs on page 282).

At the left is a recipe that I have had good luck with for making my own chocolate sauce.

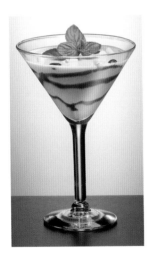

Chocolate martini.
Barry Seidman

GARNISHES

The Many, the Colorful, and the Troublesome

Garnishes come and garnishes go and garnishes change over the years. When I first started food styling in 1979, we garnished a savory dish with a wedge of lemon, a sprig of parsley, or a cherry tomato; if it was a dessert, we found a perfect maraschino cherry. Eventually, the word came down from General Foods, "No more maraschino cherries!" (Red dye no. 40 had been discovered to be carcinogenic, and General Foods was also sick and tired of seeing cherries on every dessert.) We switched to a piece of mint. When we got to the mid-1980s, the era of nouvelle cuisine and the black plate, garnishes changed tremendously. They looked professionally produced, with fluted mushrooms, carved vegetable flowers, apple birds, green onion brushes, tomato and radish roses, and twists and zests of any citrus being the norm.

Then, along came the edible flower, which graced everything from soup to entrée to dessert (see page 177). We dusted plates with chopped herbs, nuts, or cocoa powder. Books were written solely on the topic of garnishes (see Resources, page 377).

In the 1990s and 2000s, we returned to the basics and the "make it look doable" era. "Would or could the 'food provider' do this?" So we were back to a wedge of lemon, a sprig of parsley, a cherry tomato, or even nothing. However, the wedge of lemon now is not cut lengthwise, it is cut through the center of the lemon and called the half wagon wheel (see the photographs on pages 161 and 294). The sprig of parsley now could be any fresh herb, because fresh herbs became available everywhere. The cherry tomato now might be red, yellow, or orange and round or pear shaped with a lovely fresh top.

Garnishes should always complement the flavors of the dish or be a part of the dish—for example, scallions that are mixed into a dip but are also used as a garnish. Probably the biggest complaint of chefs when looking at a food picture is that the garnish has nothing to do with the dish and no purpose for being there (except for visual appeal).

Typical garnishes for savory dishes include sprigs or leaves of fresh herbs; chopped fresh herbs; a citrus wedge, circle, twist, or zest; carrot curls; cherry tomatoes; celery leaves; scallion slices, sticks, or curls; and radish, cucumber, tomato, or onion circles or wedges. But anything edible can be considered a garnish—a piece of shrimp or a sprig of dill topping a chowder, a few small slices of avocado garnishing a bowl of chili, diced eggs on top of a salad, olives and pickles dressing up a plate with a hamburger. Toasted almonds sprinkled over a fillet of fish or on a bowl of cream soup add interest, and think of the many Thanksgiving turkey platters posing on the covers of food magazines. These turkeys have been garnished with roasted potatoes, mushrooms, bundles of asparagus and baby carrots, or glazed chestnuts and bouquets of herbs. We have seen turkeys surrounded by red and green grapes and oranges; by edible flowers; or by figs, currants, pears, Champagne grapes, cranberries, and crabapples.

In the 1980s, we used a lot of complicated garnishes. *Amy Reichman*

Garnishes may be an important focal point in a shot, and it is important to take the time to find food that is the correct size and color and is fresh and unblemished. This may mean going to several stores in your search. There is usually enough of a budget that you can pick up some extra garnishing foods—items that may not have been suggested, but could work well. Even if garnishes are more basic today than they were in the eighties, you should still be proficient in making a variety of garnishes. When shopping, you should look for the freshest and most graceful herbs available. Keep up with the latest garnish trends and looks, and keep a folder of interesting garnish presentations.

See pages 293–294 for information on garnishes for cold beverages.

The Sweet Side of Garnishes

Whenever I do a dessert assignment, if appropriate, I bring along strawberries and raspberries (of various sizes), as well as mint and often confectioners' sugar and a sieve, even if no garnish has been suggested. Other basic options might be whipped cream (Cool Whip), nuts, chocolate curls, cocoa powder, or fruit or chocolate sauces. I have even seen the gradual return of the maraschino cherry as a dessert and beverage garnish.

BAKED goods
Some Basic Rules

It is well understood in the food world that cooking and baking are two very different activities. Cooks can be loose and creative, varying amounts and kinds of ingredients and still producing a delicious dish. With baking, we are talking chemistry—and when we are talking chemistry, it is important that we understand the principles of food science. Every item used to make a baked good affects the end result—the equipment used, the stove, the ingredients (type, amount, and temperature), the weather, and even the person baking it.

What is important is that as a baker you understand what can cause certain results so that you can get those results only when you want them. You need to read every kind of assignment for problems, ideas on how best to work with the food, and how the food might be best presented.

Determining the Type of Shot

The type of shot is often determined by the art director. How you work with the food and the amount you prepare is based on his or her answers to the kinds of questions that follow:

- Is it a single serving, a whole finished recipe, or a whole finished recipe with a slice or portion taken out?
- If it will be a single serving, will it be a slice, scoop, or cut or torn piece?
- Will it be broken or have a bite taken out?
- Will a fork, spoon, or other utensil be used in the shot?
- Will there be a chocolate or frosting pull (a stretch or pull of the food)?
- Will there be a how-to or step-by-step sequence of shots?
- Will the shot be close up or pulled back to show volume?
- Will there be ingredients in the shot?
- Will there be multiple recipes in one shot, as in a tray of assorted cookies?
- Are the baked goods sensitive to heat or moisture?
- Do they dry out, crack, or get crusty?
- How long will they hold? Will they slice well?
- Do the recipes need to be tested? (The first baking is usually a test to see if corrections or modifications have to be made. This can be used as a starting point, and the baked goods can often be used as the stand-in.)
- Do the recipes require equipment you don't have?
- Are there hard-to-find ingredients or will garnishes be needed?
- Will the prop stylist supply the pie plates to bake in or the custard cups you may need if they are included in the shot? If so, what kind, what size, and how many will be needed?

The type of shot will affect the number of times you need to make the recipe. For example, if you are shooting one simple cookie on a plate, then making the recipe only once will probably work. However, if you are shooting a chocolate pull on a chocolate chip cookie for an ad, you will probably want to make several recipes. Usually, if the baked item is to be shot whole, you will need to make fewer of them; once you have to slice into something, more product is required.

Controlling the Baking Process: The Path to Perfection

On the job, there are always things you can control. Things that you can't, you just pray for—such as appropriate weather, a good on-site stove with dependable

temperatures, pleasant clients, and well-tested recipes. The things you can control in baking are:

- Your food science and baking knowledge and skills

- The ingredients used (type of flour, fat, sugar, chocolate, liquids, and egg size)

- When and how things are added and in the correct amounts

- The types of tools used to fold, mix, and beat (the mixer: handheld, standard, or professional)

- The containers holding mixtures (glass, plastic, stainless steel, or aluminum), with or without lids

- The pans used for baking: both color (black, shiny, or dull) and material (metal or glass)

- The temperatures of ingredients, oven, and refrigerator

When a budget allows, always schedule a prep day if you are doing a baking assignment. This allows you uninterrupted time to bake and get the exact results you want. Also, many baked goods slice better when made the day before. Don't do any major baking on shoot days except for desserts that can't be made ahead or shouldn't be made ahead because their appearance changes for the worse. If you have several shoot days, have an assistant who can bake while you style.

Volume Baking

If you are doing a lot of baking, it's important to organize your space. First, I usually hang the recipes on the counter above my working space using black masking tape or Fun-Tak/BlueStik. Next, I put sugar, sifted flour, and salt in bowls for easy measurement. If you are going to need chopped nuts or lots of grated ginger, prepare them ahead and put them in easily accessible containers. Have eggs and butter at room temperature if that is called for in the recipes. Have lots of measuring spoons and cups (liquid and dry) available. Close at hand, keep a container of needed tools, such as rubber spatulas, offset spatulas, strainers, whisks, spoons, knives, and can openers. Have a digital timer and scale, if possible. Have counter space for cooling racks and plenty of plastic containers in which to store the cooled baked goods.

Preparing Your Baking Pans

To grease pans for baking, most of the time I like to use shortening, rather than butter or cooking and baking sprays. Butter melts too quickly and may brown foods more than desired. Sprays are often uneven in coverage. It is a personal preference. Some stylists like to use sprays, which work well on Bundt pans.

Cake pans. Use heavy, professional 8-, 9-, and 10-inch cake pans with straight sides that are 2 and 3 inches tall. I have a variety of each. Brush solid shortening inside the bottom of the pan, then cover

no two results are the same

I once read a wonderful article in *Gourmet* magazine called "The Quirky Dozen." The article was about a group of professional bakers in the San Francisco area who meet to support one another and share information. At one meeting, each baker was given the same recipe for an angel food cake. When the bakers brought the cakes to the next meeting, the display of sixty cakes was remarkable in that no two cakes looked alike. The cakes "looked more like vague acquaintances than twins or even relatives. Tall, statuesque cakes sat next to short, stubby cakes. A few sagged in the middle or slouched to one side as if embarrassed by the way they turned out. Some appeared to have been sandblasted smooth. Others had a nubby surface like the nap of a suede jacket." The article continued to discuss the reasons for the differing results and offered some tips for the home baker. "The most important discovery: There is more than one right answer. Very good results can be obtained in several different ways."

243

LEFT: Preparing a springform pan.

RIGHT: Preparing a rectangular or square baking pan.

Dennis Gottlieb

the bottom with a waxed paper or parchment round. Brush shortening on the top of the round and sides of the pan, brushing sideways, not up and down, because this helps cakes rise evenly. Sometimes you will also want to flour the pans, depending upon the look you want on the edges of the cake (see the photograph on page 250).

Bundt pans. Brush a thin but complete layer of shortening on the insides of the pan. Then spray lightly with nonstick cooking spray to prevent the cake from sticking to the pan. (Many people like to use a product called Baker's Joy.) I usually don't flour because this affects the look of the crust. The type of pan is very important for this cake. Black and nonstick pans usually produce a dark crust, while heavy aluminum pans produce a lighter crust.

Cheesecake or springform pans. Place a cardboard round cut to just fit into the bottom ring of the springform pan. Lay a sheet of aluminum foil (shiny side up) over the bottom ring. Place the side wall of the cake pan on top of the ring and aluminum foil. Press down and close the wall. The foil should extend beyond the ring. Run the remaining foil up the outside wall of the pan. Spread butter or shortening on the inside of the pan. You now have a pan that will not leak and also one that has a cake round under the cake for easy lifting from the pan.

8-inch square pans or 9 x 13-inch pans. Brush shortening on the inside bottom and long sides of the pan. Line the bottom and two opposite sides of the square pan or the long sides of the 9 x 13-inch pan with a double layer of aluminum foil, extending the foil over the long edges of the pan. Lightly brush shortening on the bottom and sides of the pan. The foil overhangs can be used as handles when the baked item is cooled and ready to be lifted from the pan. Just run a thin sharp knife along the short edges of the pan and lift the entire baked good from the pan.

Loaf pans. Brush shortening on the bottom and sides of the pan. Line the bottom and long sides with waxed paper, then brush the waxed paper with shortening again.

Cookie sheets. Line the bottom of the cookie sheet with parchment, a Silpat (silicone baking liner), or shortening, or leave the pan plain, depending upon what the recipe calls for. Each procedure will produce a different result. The type of cookie sheet (nonstick, aluminum, stainless steel, or AirBake) will also produce different

cookie looks. It is good to test. Most food stylists I talk to like the old-fashioned heavy aluminum sheets.

Muffin tins and cupcake pans. Have a variety of sizes of muffin tins and cupcake pans (see page the photograph on page 123). Heavy professional pans are usually deeper, producing taller muffins and cupcakes. (Height is often important.) If not using cupcake liners, I usually just grease the inside bottoms of the cups. If not filling all the cups, for even baking, fill alternate cups with batter and pour water into the unfilled cups.

> TIP *When not using cupcake liners, after greasing muffin and cupcake pans, line just the bottom of each cup with parchment or waxed paper rounds for easy release.*

Baking Tools and Equipment

Following is a list of useful tools and equipment to have when working with baked goods. You will acquire items as you need them, so don't be overwhelmed. Most clients assume you will have the basics, but for large numbers, such as fifteen pie plates, or unusual types of equipment, such as a Bundt pan of a certain size and look, you will bill the client.

KNIVES

- Serrated
- Slicers (both 12 inches and 8 to 10 inches)
- Very thin and flexible knives (such as a sushi knife)
- Cheese knife
- Knife sharpener

SPATULAS

- Frosting
- Offset (large and small)
- Lifting spatulas (large and wide offset)
- Dental
- V-shaped, stainless artist's spatula
- Cake and pie servers (flexible and pointed)
- Rubber scraper

GENERAL EQUIPMENT

- Cookie sheets (a variety of materials and styles)
- Cake pans (a variety of sizes)
- Pie plates
- Muffin tins (a variety of sizes)
- Baking sheets (a variety)
- Loaf pans (a variety of sizes)
- Loose-bottom tart pans

- Springform pans

- Trays or jelly-roll pans (11 x 15 inches with 1-inch sides)

- Stainless steel bowls (lots in large to small sizes)

- Glass and plastic bowls (a variety of sizes)

- Lightweight plastic cutting boards (regular size plus a small one used only for chopping chocolate, so that it doesn't have to be washed over and over again but just at the end of the job)

- Digital scale, both ounces and grams (small for easy transport)

- Digital timer

- Liquid and dry measuring cups

- Measuring spoons (these vary in volume, so get the type that is used by the average home consumer)

- Oven thermometer

- Candy thermometer

- Wire-mesh strainers (a variety of sizes and mesh, from fine to coarse), for dusting

- Pastry blender

- Whisks (a variety of sizes)

- Cake turntable (revolving decorating stand)

- Pastry bags with a variety of tips

- Plastic squeeze bottles

- Cooling racks, good-quality gridded racks (useful also to transport baked goods; place them in between stacked cheesecakes, for example)

- Hot pads (flexible)

- Pastry cloths or tea towels

- Brushes (small to pastry size, stiff to very flexible)

- Food coloring (liquid, paste, and powder)

- Wooden skewers

- Toothpicks

- Straight pins and T-pins

- Heat gun

- Ice cream scoops (a variety of sizes for ice cream; also useful for making consistent-size cookies and muffins)

- Spritzer or atomizer

- Templates (cardboard, film card, or acetate)

- Clear plastic or grid rulers

- Sewing gauge

- Cardboard cake rounds (a variety of sizes) to hold cakes before and after frosting

- Parchment rounds for lining cake pans

- Styrofoam cake bases (for fake cakes)

- Parchment paper

- Silpat pads

- Waxed paper

- Aluminum foil and nonstick aluminum foil

- 8-ounce plastic cups to hold colored frostings, decorations, and garnishes

- Containers for storage and transportation (large plastic cake and pie containers, square and round plastic containers of various sizes, cake boxes)

PASTRY GLUES

- Petroleum jelly

- Jet Set

- Paraffin (can also be brushed on surfaces to prevent sauces from soaking into pastry)

CAKES
The Pleasures and Pitfalls

You have heard the expression "It's a piece of cake," meaning it's a task easily accomplished for lack of resistance or challenge. However, cakes are *not* "a piece of cake" in the food styling world. They can be one of the more difficult or challenging assignments. With the correct equipment, good ovens, an understanding of food science, a feel for geometry, some food styling techniques, *and* a desire to problem solve, you can begin to tackle this sometimes troublesome food item.

Cakes may dome when you want them flat or they may not dome when you want them to. They may sink in the center when you want them flat or domed. They may not release from the pan easily or in one piece. They may be too dark on the sides (or too light); they may have an unattractive top or a surface that is cracked. They may look too dry or too moist. If you cut a slice out, will it have the desired texture? It may have large air holes. How will you slice the cake so the frosting doesn't drag into the crumb of the cake or the cake crumbs drag into the frosting? And how can you prevent the weight of the top layer of the cake from pressing down and making the center layer of frosting too thin?

Cake wedges often have to be a specific height, width, and length for an assignment. They must be cut very straight or they will not look right to the camera. If you don't cut into a layered cake straight, the tip of the wedge will not be straight. I often make a template (see the photograph on page 250) cut to the size of the piece of cake or pie I will need to plate and use that as my cutting guide. This is where the prop stylist can be of great help. If the dessert plates are small enough, you can get several slices from one cake. If the dessert plate is large and needs a long slice of cake, you will have to cut the slice past the midpoint of the cake and will get only one slice from a cake. If you are showing a whole cake with a slice out, the prop stylist needs to get a cake plate or stand that is the right size and flat, so the cake can sit flat.

How we style cakes has changed over the years. When I first began food styling in the late 1970s, box cake mixes were very popular, and the layered look was most often

the best mixer for the job

One time when I was teaching at a school in the South, my assistant made two cake layers for me for a demonstration. They were each no more than an inch high. I asked how the cakes had been made and learned that a professional mixer had been used to make the batter. Cake mixes are formulated for the home cook, and the typical mixer used is a handheld mixer—that is the mixer that works best. The next best thing I have found is hand mixing with a whisk. Professional mixers overbeat the batter.

presented. Our cakes needed to be perfect, not a crumb out of place. Then, as time became an issue, Bundt cakes came into greater vogue (one cake pan, little or no frosting, or just a dusting of confectioners' sugar). Today, the look is often a less perfect, more natural, homemade look. Even with the more natural look, you still need to know how to produce beautiful cakes and slices.

Layer Cakes

A layer cake is created by stacking two or more cake layers on top of each other and spreading frosting in between the layers. Most often there is frosting on the sides and top as well. Most Americans think of the layer cake as the "typical" cake. This is the cake on the packages of cake mixes. We can make layer cakes in a variety of sizes, 9 inches being the most common. It is good to get professional cake pans whenever possible. I have a couple of 8- and 9-inch pans with 3-inch sides for making taller layers. If I am working for a food company and preparing its cake mix for a shot, I follow the instructions on the box exactly. I also use a standard mixer, handheld mixer, or a whisk, not a KitchenAid, because the mixer affects the outcome. I pour equal amounts of batter into two prepared 8-inch cake pans to make the cake layers taller.

If I am *not* working for a food company that produces a cake mix, I make the cake layers according to my needs or the needs of the client.

POINTS TO REMEMBER WHEN BAKING LAYER CAKES

- Always check ovens for accurate temperature before beginning to bake.

- To make sure layers are a consistent height, weigh the batter in each pan before baking. (I often use 23 ounces of batter in an 8- or 9-inch pan.) Remember, not all pans are the same weight, so tare the scale before weighing the batter.

- Most box mixes bake best at between 340°F and 350°F. For a domed effect, raise the temperature to 375°F.

- Bake to within 5 minutes of the directed time before opening the oven and checking for doneness.

BUILDING A TWO-LAYER CAKE

Use a standard mixer, handheld mixer, or a whisk to work with packaged cake mixes. Use professional-quality baking pans greased and lined with parchment or waxed paper rounds. Pour the dry mix into a bowl and break down any lumps by using a pastry blender or by running the mixer through the dry mix. Add cool (not cold) liquids and room-temperature eggs. Follow the package directions for mixing times and baking temperatures.

To increase dome height, raise the oven temperature just twenty-five degrees. To make cakes without domes, lower the oven temperature by twenty-five degrees and use a cake collar or cake strip (a cloth band placed around the outside of a cake pan that reduces the temperature of that part of the pan) around the outside of the cake pan. Always check the oven temperature with an oven thermometer before doing any major baking.

When making a two-layer cake for a cake mix company, I use one package of mix, follow the recipe directions, and pour half the batter into each of my two pans.

For other jobs, I often use two packages of mix at once and pour one-third of the batter (about 23 ounces) into each 9-inch pan. This strategy produces added height in cake layers. I then pour the leftover batter into a third pan and bake an extra layer, which can come in handy to build a stand-in slice, to source crumbs, etc.

You may want to weigh the amount of batter in each cake pan to get a consistent height or you may want to add more batter to one pan since you will be removing the dome of at least one layer (see page 250). Add baking time to adjust for the increased amount of batter in a pan. Check for doneness only when you are very close to the end of baking time. It is better to have a cake a little overbaked than one that collapses when checked too soon. A cake layer baked in a pan that has been greased and floured has a different look from one that has been baked in a pan that has been only greased.

Cool the layers in the pans for about 15 minutes, then carefully run a thin knife around the edges of each layer. Remove the layers from the pans and cool them top side up on gridded cooling racks. Cool the layers completely, but don't leave them out too long or they will become dry. Place the layers on cake rounds and wrap each in plastic wrap. Place the wrapped layers in cake boxes or plastic containers for easy transportation. For storage and transportation, you can also return the unwrapped cake layers to the cleaned pans they were baked in, covering the tops with plastic wrap. They can be made one day ahead.

When you are ready to assemble the cake, determine the height you would like the complete cake to be and cut each layer to the thickness of half of the total cake height (trimming off the dome of the layer that will be on the bottom). Here is one technique to achieve a consistent layer height: Using a ruler and toothpicks, place toothpicks around the outer edge of the layer at the desired height. Then trim the layer, using a serrated or slicing knife. Alternatively, I find a variety of 12-inch boards (2 x 4 or 1 x 2 inches) helpful to use as a guide for slicing layers to the height I would like. For this, I use a long slicing knife.

Stack the two layers together, saving the trimmed-off dome for later use.

If you will be shooting a slice only, make a template for a slice that will be the correct size for the prop plate being used. If the plate is small, you can get several slices from one layered cake. If the plate is large, however, you will get just one slice per cake. Locate and mark the center of the unfrosted cake's diameter with a small straight pin. (Even if you are cutting short of the center or past it, use this point as a guide to get a symmetrical slice.)

a better box cake

I have had success with the Hellmann's Super-Moist Chocolate Mayo Cake recipe. It results in a cake with a nicer top, a more even and low dome, straighter sides, and fewer holes than plain chocolate cake mix.

Hellmann's Super-Moist Chocolate Mayo Cake

MAKES 12 SERVINGS

1 box (18 ounces) chocolate cake mix
1 cup Hellmann's or Best Foods Real Mayonnaise
1 cup water
3 eggs
1 teaspoon ground cinnamon (optional)

Preheat oven to 350°F. Grease and lightly flour two 8- or 9-inch round cake pans. Set aside.

Beat the cake mix, mayonnaise, water, eggs, and cinnamon, if using, on low speed in a large bowl for 30 seconds. Raise the speed to medium and beat for 2 minutes, scraping down the sides of the bowl. Pour the batter into the prepared pans.

Bake for 30 minutes, or until a toothpick inserted into the center of the layers comes out clean. Cool on a wire rack for 10 minutes. Remove from the pans and cool completely.

TIP *When using a brush to grease a cake pan, brush the grease parallel to the pan's sides rather than in up-and-down strokes; it will help the cake rise.*

RIGHT: **Standard mixer and tools for assembling layer cakes.**

MIDDLE ROW:

The cake layer on the left came from a pan that had only been greased; the cake layer on the right was baked in a pan that had been greased and floured.

Leveling the bottom cake layer with a knife and board.

Stacking cake layers.

BOTTOM ROW:

Making a template for a slice.

Removing a slice from a layer cake.

Here, we filled unwanted holes with petroleum jelly and cake crumbs. Then we cut out a wedge in the center of the slice to widen the gap for frosting. We filled this gap with extra frosting.

Dennis Gottlieb

bad cake, good cake: taking the time to preplan

A few years ago, I was asked to do a test shot consisting of a single slice of cake. Doing a shot of a slice of cake consists of a day of baking and a day of shooting. I chose to make a cake that was a childhood favorite—white cake with lemon curd filling and a seven-minute frosting. Both the photographer and I were very busy, and we didn't give the test shot the time we needed to do it well. When we looked at the shot the next day, we both agreed it needed more time and thought. The seven-minute frosting looked like plaster of Paris, and the whole shot was just bland.

The photographer wanted to reshoot (another day of baking and another day to shoot). We both agreed that the shot needed to look more interesting. It helped draw a sketch of how we could shoot it with lemonade in the foreground and something relating to lemons in the background. But I didn't like the crumb on the first cake; I wanted it more yellow and coarse (more like an angel food cake). I found a recipe for a citrus chiffon cake that sounded like something that would work, maybe as a triple layer cake showing off the curd. The seven-minute frosting that looked like plaster of Paris needed to be replaced with whipped cream. We used the same plate, but we added props.

LEFT: A bad slice of cake: pale, flat, and dull.

RIGHT: A good slice of cake: moist, vibrant, and tender. The props add interest.
Dennis Gottlieb

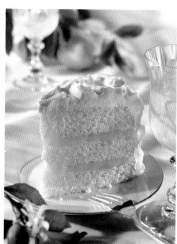

Using a sharp slicing knife (some stylists prefer a serrated knife) and the template as a guide, slice *straight* down, cutting slightly past the tip of the template (this allows you to make sure you have a clean point, and cutting down straight gives you a tip edge that forms a straight 90-degree angle to the top and bottom of the slice). At this point, insert a couple of long wooden skewers through the sliced area to hold the two pieces together. Use a pointed spatula to remove the slice; this gives the tip support. If you will be moving the remaining whole cake to a cake plate later, you can now insert two large, wide spatulas at the back of the cake for easier lifting.

Place the slice on its side and cut a wedge in its center to widen the gap for frosting. Make the wedge the width that you want the center frosting to be. With a pastry bag and small tip or a small offset spatula, fill in the cut-out wedge with frosting and smooth it to make it look as though the cake has been cut through.

There may be holes on the surface of the slice. Fill them with a little petroleum jelly on a wooden skewer and top the jelly with some cake crumbs from leftover cake. There are times we have to add texture to the surface of the cut slice. We do this by using the skewer to lift up crumbs. Clients may want the brown edges of the cake trimmed away from the sides, top, and bottom of the slice. Remove just the very edge of the browned surface that the camera will see.

Place the cake slice on a thin cardboard support cut slightly smaller than the slice. Position the slice as

TIP *If you are not using a specific frosting recipe for the assignment, use canned frostings because they hold beautifully (homemade frostings tend to dry out).*

TIP *If the slice is to be shot suspended on a cake lifter (oh, happy day!), use Flower-Fix on the surface of the lifter or glue upholstery tacks to the lifter to keep the slice in place.*

it will be photographed. Now, carefully frost the top and side of the cake slice with a smooth, thick layer of frosting. With the back of a spoon or a spatula, add swirls. Don't overwork the icing, though; just a few simple swirls look best. Work the "sliced" edges with an offset spatula or palette knife to give the edges of the frosting a sliced appearance, a smooth and even continuous line.

Lift the slice and thin cardboard support onto the prop plate with the spatula to camera back. Place the slice slightly behind the final position it will have on the plate. When the slice is on the set, you can slide it forward ("cheat to the front") to correct its position, if necessary.

PRESENTING THE WHOLE CAKE— WITH OR WITHOUT A SLICE OUT

Most often, whole, unsliced cakes are used to present the "professional cake" look because the piping and other decoration hold a lot of interest. Simpler, "homemade" layer cakes are often shown sliced because the sliced-out area adds another dimension of complexity. Otherwise, you are left with just a plain brown or white frosted circle on a cake plate.

For the "homemade" look with a slice out, there are several methods you can use. You can frost in the traditional manner: Place a cake layer on a cake plate covered with waxed paper strips. To protect the cake plate from frosting smears, frost what will be the middle, then place the second layer on top. Frost the sides and top, take the slice out (its size should be determined with a stand-in), remove the waxed paper strips, and clean up any unwanted frosting.

Another method is to cut the slice out before frosting; frost the whole cake and fill in the center frosting as described on page 251. Use a large spatula or two large offset spatulas (positioning them at the camera back of the cake) to lift and position the whole frosted cake on a cake stand or plate. There are times when I position cakes on cake rounds (cut slightly smaller than the cake with the slice area removed as well) to aid in lifting them.

USEFUL EQUIPMENT WHEN FROSTING WHOLE CAKES

- Cardboard cake rounds (dot with a little frosting to hold the cake to the round)
- Revolving cake stand
- Offset spatulas in a variety of sizes
- Pastry bags and a variety of tips
- A spatula the size of a cake round (I found one from Germany called the Universal-Kuchenlöser, which works beautifully for moving a whole cake to a cake plate; see the photograph on page 113.)

Bundt Cakes

The outside crust color and appearance are important with Bundt cakes, so select a cake pan made of a material that will produce either the dark (heavy nonstick) or light (aluminum) outer cake surface that you are looking for.

To show a cut slice out, start with a small slice and cut until you have an exposed surface you like. Then, slice from the other side (the side the camera will not see) until you have the desired width of the slice.

For the freshest look, glaze the cake just before shooting and do the glazing on the prop plate to be used in the shot. If you move the cake after it is glazed, sometimes the glazing cracks. When frosting a Bundt, protect the plate with strips of waxed paper under the outside edges of the cake; remove the strips before shooting.

Cheesecakes

Cream cheese and other ingredients should be at room temperature.

Keep the baking temperature as low as possible. Overbaking, overbeating, or high temperatures will cause cracks. Use a water bath when possible.

When I take a cheesecake out of the oven, I like to carefully cut around the edge of the cake to release it from the pan so the cheesecake will fall or deflate evenly. I let it cool completely, then, if shooting the next day, I cover the cheesecake (in the baking pan) with plastic wrap stretched across the top of the pan to keep the top surface fresh. Don't let the plastic wrap touch the cake surface, though, or it will leave marks.

If you are using a crumb base that runs up the sides of the cheesecake, it is often more attractive if this crust is a little uneven and casual.

Angel Food Cakes

This is a cake we don't style often today. The main concerns are the outside edges of the cake, so use a very thin sharp knife to carefully cut the sides and bottom of the cake from the pan. A standard tube pan will not work—you must use one especially designed for angel food cakes.

With an angel food cake, the bottom of the cake becomes the top when it is presented for serving. You may want to trim the top baking surface (which becomes the bottom) so that it lies flat on the cake plate.

Add any sauces at the very last minute (there is a reason an angel food cake is sometimes called a sponge cake).

Apply any glazes at the last minute and have the cake on the prop plate before glazing. Use a serrated knife to carefully slice.

Pound or Loaf Cakes

Cakes baked in loaf pans often have a crack down the center of the top. This is natural and often desired. These cakes are often presented as whole cakes with a couple of slices removed and placed in front of the sliced area.

Cupcakes

Find a source for interesting cupcake paper liners. New York Cake and Baking Distributor has a variety of unusual items on its Web site (see Resources, page 384). After baking, a second layer of cupcake liners can be added for more support or visual appeal; sometimes chocolate cake, for example, darkens the liners or the liners become greasy and transparent. Spray the second liner with Spray Mount and attach it

to the first, with a little of the cake showing. Two sources for beautiful cupcake shots and inspirational ideas for decoration and types of shots are *Hello Cupcake!* by Karen Tack and Alan Richardson and *Cupcakes!* by Elinor Klivans (see Resources, page 379).

Cakes That Are Hard to Slice Through

Sometimes cakes contain ingredients, such as nuts or chocolate chips, that don't slice well and just fall out or drag down the side of a slice during cutting. You can freeze these cakes for easier slicing or add back some of the nuts after slicing. Alternatively, you can bake the cake without the nuts or chips and then add them, being careful to make them look realistic.

PIES

Making Them Picture Perfect

I have had to make hundreds of pies over the years for a variety of clients. I made five kinds of ice cream pie for a *Chocolatier* magazine shoot and prepared dozens for a commercial featuring pie fillings. I shot pies for mini cookbooks and promotional material for

TOP ROW:

Cherry pie with a lattice crust. *Dennis Gottlieb*

Grasshopper pie with a whipped cream lattice. *Beth Galton*

BOTTOM ROW:

Coconut cream pie with mile-high meringue and toasted coconut. *Beth Galton*

Rocky Road ice cream pie with a dollop of whipped cream. *Beth Galton*

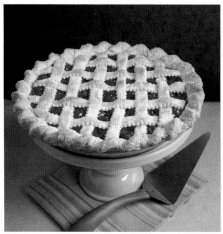
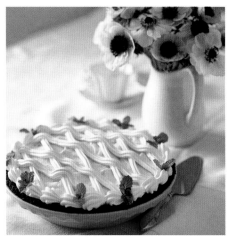
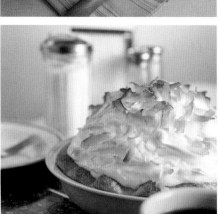

the producers of graham cracker and chocolate crumb crusts, made lemon meringue pies for a sugar company ad, and developed recipes and shot pictures for an apple association and for Combos. I had to prepare the pie for a television interview with the winner of the best pie in the United States contest for *Good Morning America* (see page 264).

I also worked on a cookbook called *Perfect Pies* (a very good reference for both beginning and advanced pie bakers; see Resources, page 379), for which we had to produce fifty different pie shots that demonstrated all the possibilities of pie presentation. We shot pies whole or just as slices, showed them baked or in the process of being put together, and showed them sauced and dolloped. We shot them from overhead to eye level. We shot very tight or with lots of props.

Here's what I learned from this:

- You need to prepare more pies for slice-out shots.

- You probably can't have too many pies to work with.

- You need to develop special techniques for the transportation of fragile pies.

- Food stylists may be the ones responsible for recipe directions that produce pies with the best look (see page 261).

- Crusts are fragile, and when precutting through crusts, you need very sharp, thin knives (sometimes X-Acto knives) so that they don't crack. It is best to use one continuous motion when making the slice. Sushi knives are good for cream pies. Crusts usually slice better the day after they were baked.

- Fruit pies may collapse and the filling will run on the plate unless extra thickeners are added (we have another technique for dealing with this problem; see the photographs on page 256).

- Meringue pies may weep, and cookie crumb and nut crusts can fall apart.

- Crusts may not brown evenly.

- There are many different types of egg washes, and each produces a different look: whole egg, egg yolk and water, egg white, milk or cream (see the photographs at right).

- The type of flute you produce on the edge of the piecrust is determined by how the crust will be shot. Collect and practice a variety of fluting techniques. I like to use a simple flute when shooting a slice, but a rolled flute when shooting a whole pie from overhead.

- Some box mixes or refrigerated prerolled piecrusts work just fine when you are working in volume; you just have to know how to work with them.

When shooting a whole pie, it is important to have an attractive pie plate. When we shot *Perfect Pies*, the prop stylist, Francine Matalon-Degni, did a remarkable job of finding more than a hundred different pie plates for us to bake in. The thing I learned, however, is that the volume of each pie plate is not consistent, so I had to adjust each recipe to fit the pie plate. Most pie recipes are written to work in a typical 9-inch pie plate. You can measure the volume of the pie plate by filling the standard 9-inch glass pie plate with water and measuring the water by pouring it into

TIP *The plastic cover that comes on purchased preformed crumb crusts, cut into wedges, makes good support for the backs of slices.*

TOP: The top pie has been brushed with egg wash on the top half and milk wash on the lower half to test for two different looks. A few fresh cherries tucked between the lattice strips add to the juicy appearance.

BOTTOM: Now the hero pie has been baked with consistent egg wash.

Corinne Colen

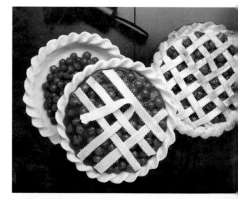

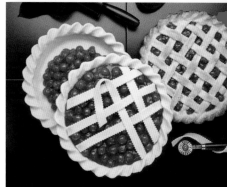

RIGHT: **Practice different pie flutes, and take note of any interesting or unusual fluting techniques you come across.**

BOTTOM ROW:

A classic twisted or rolled flute typically used in overhead shots.

The pie crust is filled with mashed potatotes. Now we add one or two layers of strained fruit filling.

With fruit filling covering the surface, the mashed potatoes are no longer visible. We are ready to add the lattice top.

Dennis Gottlieb

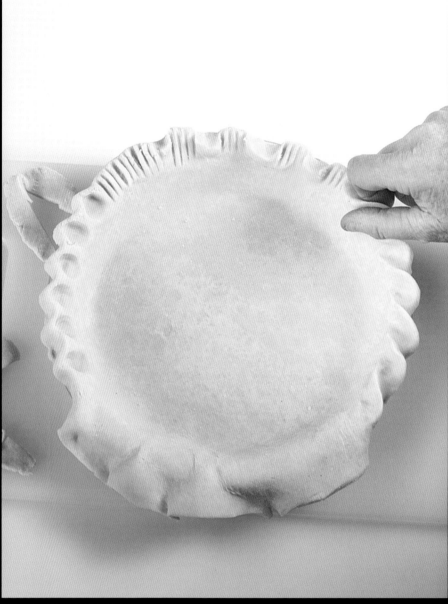

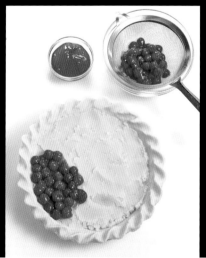

a glass measuring cup. Do the same thing with the pie plate you are shooting and compare the volumes. Depending on the results of the comparison, adjust the recipe for more or less filling.

With whole pies, the part of the pie that is seen most often is the top, so producing a beautiful flute, an evenly browned crust, and the presence of juicy fruit in a fruit pie can be the main concerns. When I am not following a specific recipe, I usually use a boxed piecrust mix (one box for the bottom crust and one for the top). That way I can better control the thickness of the crusts. My mentor, Helen Feingold, used to make batches of her favorite recipe—hot water piecrust, from the old *Joy of Cooking*—and then wrap the batches in plastic, refrigerate them, and use them as needed. It is important for stylists to test a variety of recipes or products to see which works best for them and which gives the look they want.

Another consideration when making a pie is the style of shoot you are doing. Do you want an old-fashioned look (Grandma's kitchen), a contemporary look, or a professional look? Each look requires you to style differently. For the old-fashioned look, I use a simple flute, sprinkle the top crust of the pie with a little granulated sugar, and cut air vents just as my grandmother did. For the contemporary look, I may do a fancier fluting and brush the surface with a light egg wash, possibly sprinkling the surface with coarse sugar. For the professional look, I will use a more controlled and professional fluting design and a heavier egg wash. Again, you will need to adjust what you do according to the client and the art direction.

Fruit Pies

the **Problem**

- The center of many fruit pies is very runny, so that when you take a slice out the fruit runs onto the plate and the top collapses. Some fruit pies are so juicy that the juice runs out and all over the crust. You need juice control!

the **Solution**

To the dismay of the studio staff, who are looking forward to pie at the end of the shoot, if the fruit in the pie is very runny, you can add extra cornstarch (although this may leave a very gummy appearance). One thing that we do for berry or fruit pies is to fill the bottom of the pie with prepared and cooled instant mashed potatoes before adding the filling: I place a bottom crust in the pie plate, trimming the edges with scissors to about 1½ inches from the plate. Next, I place a layer of cooled instant mashed potatoes over the bottom crust.

Make the potatoes by adding warm water to instant mashed potato flakes, being sure to add enough water so that the potatoes are not stiff. If you don't add enough water, the flakes will absorb some of the liquid from the fruit and expand. If the potatoes are too soft, they will not support the top fruit layer and will also make the bottom crust soggy. Fill the pie plate three-quaters of the way to the top. Then put the fruit layer on top.

If it is a canned pie filling, such as cherry, I strain it and place a layer of strained fruit over the potatoes before I top the fruit with the crust. I save the best fruit as well as the strained juice (which I call goo) for later.

If it is a "homemade" apple or peach pie, I layer the fruit over the instant mashed potatoes to an interesting and bumpy height, cover it with a crust, and flute the pie. Let the pie rest in the refrigerator for 30 minutes and then bake it. Put the remaining pie filling in an empty pie plate, cover it with aluminum foil, and bake it with the hero pie. You will use that cooked filling later.

When the pie is cooled and you are ready to slice it, make a template the size of the slice you want, to use as a guide when slicing. Slice through the pie, cleaning the knife with a damp cloth after each cut. Using a flexible pointed spatula, carefully remove the slice. If you are using only the slice and not showing the rest of the pie in the background, you might want to remove slices on either side of your hero slice or the rest of the pie from the plate before removing the hero slice. Then you can lift the hero slice out more easily.

Now you have a slice with a base of instant mashed potatoes. It is quite firm and holds together nicely, but you want fruit there. Dig out some of the instant mashed potato from the side facing the camera and fill it in with leftover fruit from the can or with the separately baked filling. You can then place the slice on a serving plate and add some fruit or juice to suggest a natural look.

Lattice-Topped Pies

the **Problems**

- Pies brown unevenly.

- Exposed fruit dries out.

- When cutting lattice pies, the lattice breaks or the pattern isn't good on the slice or there is a funny small piece of crust at the tip of the slice.

A perfect lattice crust before baking. *Dennis Gottlieb*

the **Solutions**

I often give a lattice pie a light egg wash (1 yolk to about 3 tablespoons water). It seems to help produce even browning. For one pie shot that I did, I baked a stand-in with four different washes the day before, and the photographer and I chose the look we wanted on the hero the day of the shoot (see the photographs on page 255).

If exposed fruit on the lattice pie looks too dried out, I use tweezers and a wooden skewer to carefully remove the dried-out fruit and place my freshly cooked or canned fruit into the empty spaces.

There are many patterns you can make with a lattice pie. The strips can be cut with a straight-edge pastry cutter or a knife or they can be cut with a jagged-edge pastry wheel. You can basket weave or just place strips across one another. The strips can be placed at 90-degree angles to each other for a square opening or they can be placed on a diagonal for a diamond-shape opening. I have also seen the strips twirled for an

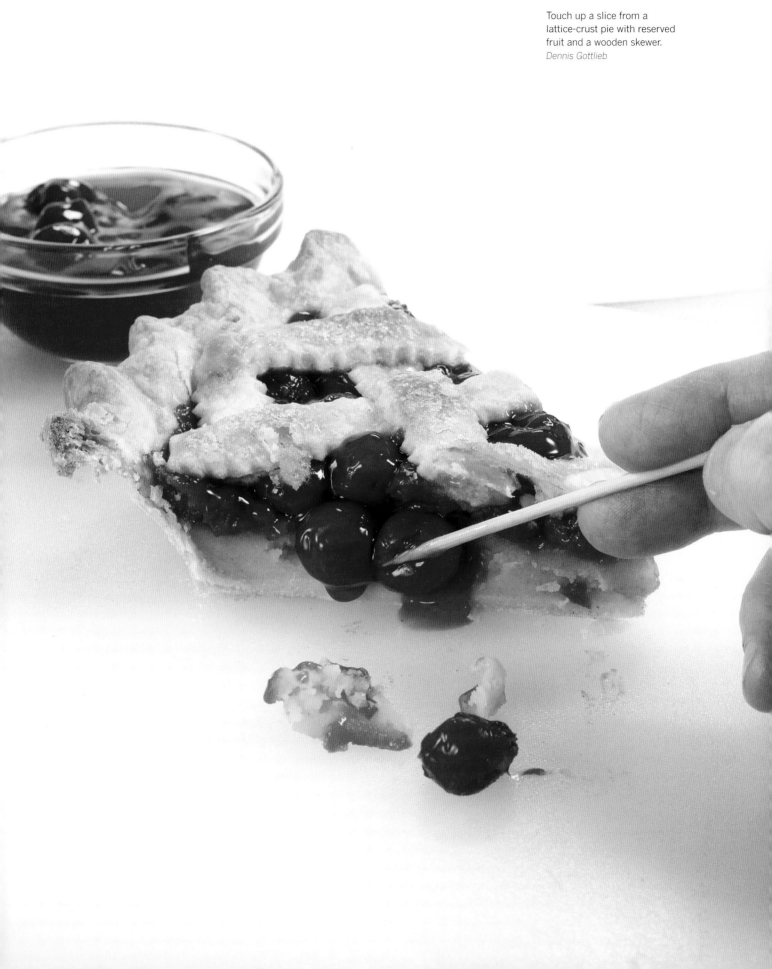

Touch up a slice from a
lattice-crust pie with reserved
fruit and a wooden skewer.
Dennis Gottlieb

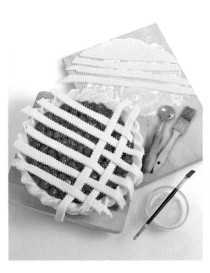
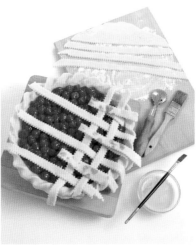
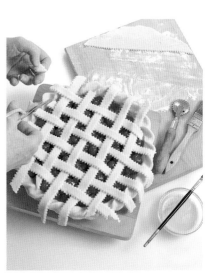

FROM LEFT:

Cut the dough into strips, place one layer evenly over the filling, and begin the lattice crust.

Carefully weave the lattice strips by pulling back every other strip and laying a new strip in place.

Trim the ends of the lattice strips.

Dennis Gottlieb

interesting effect. One thing to be aware of is to not cut the strips too wide in order to leave a nice space for the fruit to show. If I am taking a slice out of the pie, I like to use an even number of strips so I don't have one that is exactly in the middle and thus leaves a little piece of crust at the tip of my slice. Once you've made the lattice design, trim the overhanging strips of dough. Let the pie rest in the refrigerator for 1 hour, brush it with the egg wash, and bake in a 400°F oven until it is the desired brownness. If one area begins to darken too much, cover it with aluminum foil.

One nice thing about lattice pies is that they are often so pretty whole that we leave them that way. But if you have to slice one, use a template as a guide and cut carefully through the top crust with an X-Acto knife first. Then cut out the slice with a thin knife, trying to draw the knife through each side of the slice only once. Clean the knife after each cut.

Tarts

Very simply, a tart is a pastry crust with shallow sides, a filling, and no top crust. The filling can be sweet (such as fruit or sweet custard) or savory (such as meat, cheese, or savory custard). Depending on the type of tart, the pastry shell can be baked and then filled (this is called blind baking), or filled and then baked. Tarts can be bite size (often served as hors d'oeuvres), individual size (sometimes called tartlets), or full size.

the **Problems**

- Tart pastry shells shrink or the sides of the crust slide down when blind baking.

- Fruit doesn't form a consistent pattern or looks dry.

TIP *If you are showing only the slice, you might want to lift out the rest of the pie around your perfect slice so you can remove the slice without damaging it.*

the **Solutions**

Be sure to give pie dough plenty of resting time before and after placing it in a tart pan. Don't stretch the dough when placing it in the pan, but give the pan a little extra dough by pushing the dough toward the

center of the pan before trimming. Prick small holes in the bottom and sides of the shell with a fork. Line the bottom and sides with greased aluminum foil and place pie weights or uncooked rice on the foil. Another alternative is to put a pan of the same size over the dough before baking. Most of the time we work with tart pans with fluted edges. Exaggerate the flutes and also try to hook a little of the dough over the top edge of the pan; this will keep the dough from sliding down the sides.

When you arrange fruits in a fruit tart, try to find pieces that are consistent in size, shape, and color for more visual appeal. Start filling the pan from the outside and work inward. To give fruit a nice glaze, brush it with thinned warmed jelly, such as currant for red pies and apple or apricot for other pies.

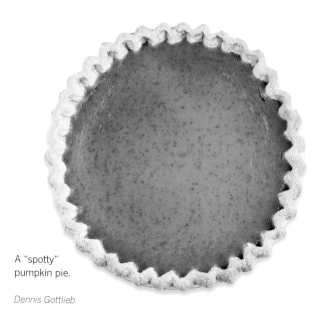

A "spotty" pumpkin pie.

Dennis Gottlieb

Pumpkin Pies

the **Problems**

- The cinnamon and nutmeg tend to clump and form spots on top of the pie.

- The pie filling shrinks in the crust.

- The pie filling cracks.

the **Solutions**

When I used to make pumpkin pies for photography (and at home), one problem I had was that the spices would rise to the top of the pumpkin puree mixture and form spots on top of the pie. Then one year I noticed that the recipe for the pumpkin pie on the can of pure pumpkin puree had changed. Most likely, the recipe procedure was changed for even blending of the spices to result in a better visual appeal. (This is incidentally an example of just the kind of minor recipe adjustments that food stylists come up with on their own when having visual problems with a product—using the same ingredient list but tweaking ingredient quantities and procedure.)

With the improved recipe, you do not get dots of spice on the top of the pie because the spices are blended with the sugar and then the pie mixture. Sometimes I even strain the eggs after beating so there will be even blending of the egg mixture.

This is the original recipe:

2 eggs, slightly beaten
1½ cups solid pack pumpkin
¾ cup sugar
½ teaspoon salt
1 teaspoon cinnamon
½ teaspoon ginger
¼ teaspoon cloves
1⅔ cups evaporated milk
One 9" unbaked pie shell

Mix ingredients in order given and pour into a 9" pie shell.

The new and improved recipe:

¾ cup sugar
½ teaspoon salt
1 teaspoon ground cinnamon
½ teaspoon ground ginger
¼ teaspoon ground cloves
2 eggs
1¾ cups pure pumpkin
1½ cups evaporated milk
1 unbaked 9" pie shell

Combine sugar, salt, cinnamon, ginger, and cloves in a small bowl. Beat eggs lightly in large bowl. Stir in pumpkin and sugar-spice mixture. Gradually stir in evaporated milk. Pour into pie shell.

Pie fillings will shrink if they are overbaked or if they are baked the day before, so it's best to bake this pie the day you need it and just until a quarter-size spot in the middle of the pie is still a bit jiggly.

Pie fillings crack if the mixture is overbeaten or if the pie is baked at too high a temperature or for too long.

Quiches

the **Problems**

- Some quiches have a pale surface.

- The slices can look cold when they are sliced from a quiche made the day before.

the **Solutions**

To get a nicely browned surface, dot the quiche with a little butter and make sure that some of the cheese is slightly exposed before baking. Try to bake the quiche in the studio. If you are showing the quiche whole, slightly underbake it so it doesn't shrink. If you are slicing, bake the quiche the full amount of time and try to slice it after it has rested for 15 minutes, but while it is still warm. This gives the quiche a very natural look. However, you will need to shoot the slice fairly quickly because it does change color.

Pies with Graham Cracker or Crumb Crusts

the **Problems**

- The homemade crumb crust is not even in thickness on the bottom and sides.

- The the crumb breaks apart when we cut a slice and remove it from the pan.

the **Solutions**

If you are making your own crust, add a little extra butter (not margarine) to firm up the crumb base. When you put the crumbs in the pie plate, use the back of a ⅓-cup dry measure to press the crumbs into an even layer on the bottom and sides of the pie plate. Depending on the amount of filling you need, you may want to extend the crumb a little above the top of the pie plate, making an even ridge—this gives the slice a nice appearance.

If you are using a store-bought crumb crust, beat egg whites and carefully brush them on the sides and base of the crust (not on the top edge of the crust because it changes the crust's color). Place the crumb crust in a 350°F oven for 7 minutes. Cool completely before adding the filling. When you use a store-bought crust, it comes in an aluminum pan. If you are showing just a slice, you can cut the edges of the pan with an X-Acto knife where you are removing the slice. Press the cut section of the pan down carefully and slide the pie spatula under the slice. If some of the crust breaks off, use Vaseline mixed with a little of the crust to patch the spots that need filling.

Cream Pies

the Problems

- Cream pies can be soft and may collapse when sliced.

- The tops of the pies may be flat and uninteresting.

- Cream pies may have a layer of fruit that weeps or doesn't slice in a desired pattern.

- There may be several layers of various fillings. Sometimes one filling may drag into the next layer when the pie is sliced.

- You may need to top the pie or slice with a layer or dollop of whipped cream. The whipped cream weeps or doesn't hold well.

the Solutions

You can make a solution of gelatin dissolved in water (1 package gelatin to 3 tablespoons warm water; heat until clear, then cool) and add it to the filling just before pouring the filling into the pie shell. This gives the slice stability. You determine the amount of gelatin mixture to add by the amount of stability you need. If you are adding the gelatin mixture to a cold filling, pour the fortified filling into the shell right away because it will set quickly.

Adding gelatin to a filling will also allow you to form an interesting swirling pattern to the top of the pie, whether it is sliced or whole. Practice the swirls, using the back of a spoon, and don't make them too tall or busy. Try to visualize the shape that will be made if you slice it.

If fruit in a pie may cause problems, add the fruit after the slice has been made. Carefully remove a little of the set filling where you want cut fruit to show on the side of the slice and insert the fruit. Work on this technique so that the fruit looks very natural. I have seen many samples that don't.

If you drag one filling into another when slicing, you might prevent this by lightly oiling the knife or by freezing the pie before slicing it. Try to make the slice in one continuous cutting motion.

If whipped cream is needed for topping, a food stylist often will use a nondairy topping such as Cool Whip, Dream Whip, or Rich's Whip Topping (see pages 180–182).

Ice Cream Pies

the Problems

- One of the problems here is obvious: The ice cream melts. The tip of the slice of pie will melt first.

- Often the ice cream is placed in a cookie crumb crust, which crumbles when we slice into it or the ice cream drags some of the crumb away from the crust when it is put in the shell.

- The crust on the pie can be frozen to the pie plate and doesn't want to release.

the **Solutions**

When showing only a slice of an ice cream pie, line the pie plate with a flat layer of nonstick aluminum foil with the foil extending over the sides of the pie plate. Then fill with the crumb mixture (see page 262) and chill. Next, soften the ice cream so that you can stir it but it still holds its shape. There is a very fine point between too firm and too soft. If the ice cream is too firm, it will drag the crust and may leave holes when put in the shell. If it is too soft, it will have a melted look when refrozen and will not form any interesting swirls on the top but will just lie flat. Practice getting the ice cream to just the right consistency.

Place scoops of ice cream over the entire bottom and use the back of a spoon or an offset spatula to spread to the edges of the crust.

As soon as you have put the ice cream into the shell and given the top some swirls, put the pie in a chest freezer and let it get firm. Once it's frozen to a very solid state, you can remove the pie from the freezer and then remove it from the pie plate by using the overhanging aluminum foil to lift it out. Use a cold cheese knife (this cuts through the pie beautifully) or long slicer to get a slice from the pie. Carefully remove the foil and place the slice on film card; return the slice to the freezer until needed. You may want to prepare several slices and use the worst for a stand-in and the best for the hero. If you have a homemade chest freezer with dry ice in it (see the photograph on page 276), place the slice in that for a short while so it is very firm before bringing it to the set. Put the pie slice on a chilled plate just before shooting.

the all-american pie for good morning america

It was the final round of the Best American Pie Contest. Contestants from all fifty states had won their state's contest and had gathered for the finals. The winner would be announced at 3:00 P.M., and *Good Morning America* had scheduled the winner to appear on the air the next morning with the pie—the best pie in all fifty states! I was asked to prepare the winning pie, but I would not know the winner until 3:30 P.M. It had to be ready for a 6:00 A.M. delivery the next morning at ABC's studios in midtown Manhattan. I had been given the list of the fifty different state pie winners and was hoping that it would be neither the huckleberry pie (where would I get huckleberries?) nor the ice cream pie. I couldn't even get the pie plates I needed until I knew the size of the pie and whether it was deep dish or a regular 8-, 9-, or 10-inch pie.

The winner turned out to be a lemon meringue pie that was decorated in a special way with the meringue. No pictures, just a verbal description was given. So off I went to get the ingredients. I didn't want to bake the pie too far ahead because it might bleed. I also knew it would be sliced on the show and eaten, so I couldn't stabilize it in any way. I baked the crusts and let them cool. Then, about 11 P.M., I made the filling and immediately topped it with what I hoped would be the meringue decoration the winner would have produced. Up at 4:30 A.M. and off to the ABC studio by 5:00. I was offered a hand by the doormen at the studio, but I didn't want to let go of my three carefully packed and fragile pies.

When I got to the green room, the winner was there and waiting to go on the air. She looked at the pies and asked, "How did you do that? I always wanted to make the meringue like that."

Meringue-Topped Pies

the Problems

- The pie has a watery layer between the filling and the meringue.

- Meringue has brown beads of sugar that appear on the surface of the baked meringue.

- The meringue shrinks away from the sides of the pie or slides off the filling when sliced.

- The meringue tears when sliced.

- The bottom filling may not maintain an even flat level when the meringue is placed on top, especially when it is mounded in the middle (the weight of the meringue presses the filling toward the edges).

the Solutions

First, make sure the eggs are absolutely fresh.

Shirley Corriher has tackled this pie's problems in her book *CookWise*. She points out that meringue weeps or separates if overbeaten; it's best beaten not to stiff peaks, but to billowing mounds. The weeping below the meringue layer is caused by undercooked meringue, which frequently occurs if beaten egg whites are spooned onto a cool filling. Prepare the meringue first (once the sugar has been beaten in, it is safe to sit for a while), then make the filling so that you can spoon the meringue onto a hot filling. This cooks the bottom of the meringue and keeps it from weeping. Shirley sprinkles some fine cake or bread crumbs on top of the hot filling, then spoons on the meringue. I place dollops of meringue evenly over the entire surface of the pie, smooth the surface of the meringue, and then, with the back of a spoon, place swirls and peaks where desired, being careful to seal the meringue onto the edges of the crust to prevent it from shrinking.

The little sugar beads are caused by overcooking. Lower the oven temperature or shorten the baking time. I prefer to bake the meringue in the oven, while some stylists use a propane torch to give the meringue a baked look. There is quite a difference in appearance.

Just as starch (cornstarch or flour) in a pastry cream prevents the eggs from curdling, starch added to a meringue can prevent proteins from overcooking and shrinking. You may want to try the following to see if it works for you. Stir 1 tablespoon corn-

Safe Meringue

6 large egg whites
2 tablespoons water
¾ teaspoon cream of tartar
¾ cup sugar
1 tablespoon cornstarch
⅓ cup cool water
⅛ teaspoon salt
1 teaspoon pure vanilla extract

Stir together the egg whites, the 2 tablespoons water, cream of tartar, and sugar in a medium-size stainless steel bowl. Stir well to break up the whites (try not to create foam since it cooks at a lower temperature). Bring 1 inch of water to a simmer in a medium skillet and turn off the heat. Fill a cup with hot tap water, place an instant-read thermometer in it, and place it near the skillet. Place the bowl of egg white mixture into the skillet of simmered water. Scrape the bottom and around the insides of the bowl constantly with a rubber spatula to prevent the whites from overheating. After 1 minute of constant scraping and stirring, remove the bowl from the hot water and place the thermometer in the whites, tilting the bowl so that you have about 2 inches of white covering the thermometer stem. If the temperature is up to 160°F, beat the mixture until peaks form when the beater is lifted. If it hasn't reached 160°F, place the bowl of whites back into the hot water and scrape constantly in 15-second increments until the temperature reaches 160°F. Rinse the thermometer in the hot water in the skillet (to kill salmonella) and return it to the cup of hot water after each use.

Sprinkle the cornstarch into a small saucepan, add the ⅓ cup cool water, and let stand for 1 minute. Stir well. Bring the water and cornstarch to a boil, stirring constantly. The mixture will be thick and slightly cloudy. Let it cool for a couple of minutes, then whisk 1 to 2 tablespoons of the cornstarch mixture into the meringue and continue adding and beating until all is incorporated. Whisk in the salt, vanilla, and any other desired flavorings. Set aside while preparing the pie filling.

starch into ⅓ cup cold water and heat the mixture, stirring until the cornstarch forms a paste. After the sugar has been beaten into the meringue, beat in the paste a tablespoon at a time. You should have a nonshrinking, tender meringue that doesn't pull or tear when cut.

Shirley Corriher's recipe for a tall, unshrinking, easy-to-slice meringue that is safe from salmonella is on page 265.

COOKIES
Aiming for Consistency

When I think of cookies, the word *consistency* comes to mind—consistency in color, shape, and size—because it is the most important issue when photographing cookies.

The ingredients you use will always determine the look of the cookie. Shirley Corriher, in an article called "Better Cookies Through Chemistry" for *Fine Cooking* magazine (December 1997), wrote about the importance of each ingredient in a cookie recipe. Food stylists are often given a recipe to follow, and it may indicate exactly the type of flour, shortening, sugar, and leavener to use. However, if you don't like the results or want to improve on them, it is important to know what each ingredient does to promote a certain look. Writing about working with different flours, Corriher stated that she found that the more protein in the flour, the browner the cookie baked. In other words, if you use unbleached all-purpose or bread flour, the cookie will be browner that that made with bleached all-purpose or cake flour. So, if you are making butter cookies, bleached flour might work best for a very light color, while chocolate chip cookies would be best with unbleached flour since this will aid in the browning. She also found that "higher protein flours absorb more liquid, so cookies spread slightly less."

In addition, Corriher observed that cookies made with corn syrup will be browner than those made with brown sugar, which is slightly acidic, and that you can help to limit the spread of cookies by using an egg, which adds protein. She also found that if baking soda, as opposed to baking powder, is the leavening agent, it will add to the browning. Butter makes cookies spread more than shortening, which melts at a higher temperature. If you want chocolate chip cookies that are thicker and not smooth, you can substitute shortening or margarine for some or all of the butter. Possibly a little extra flour will help as well.

FROM TOP:

With a white background, these cookies look fresh and contemporary. *Kelly Kalhoefer*

With a brown background and a different arrangement, these cookies look homey and old fashioned.
Dennis Gottlieb

Placed in a gift box, these cookies seem special and individual. *Kelly Kalhoefer*

Drop Cookies

the **Problem**

- Cookies are not consistent in size and color.

the **Solution**

Use an appropriate-size ice cream scoop (depending on the size cookies you want) to portion cookies that will have an equal amount of batter. I have found that a digital timer is very helpful in keeping track of the exact baking time needed for even browning. If you are still having trouble, it is probably because the oven has hot spots, so rotate the cookie sheet halfway through the baking time. Bake one sheet at a time—you want consistency rather than volume. The type of cookie sheet you use is critical as well. Some sheets allow the cookies to spread or they darken the bottoms too much (nonstick). Try lining them with parchment or Silpat pads. You will need to experiment until you get the desired look.

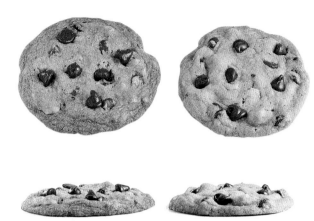

The cookie on the left was made with butter, and the cookie on the right was made with shortening. The shortening gives the cookie more definition. *Dennis Gottlieb*

the **Problems**

- The chips in a chocolate chip cookie burn and blister.

- Cookies sag or bend when arranged on the plate.

- The chips don't have a fresh look, as if they just came out of the oven.

the **Solutions**

Before baking, sort for the best chocolate chips and reserve them. Three to 5 minutes into the baking time, add a few to the tops of the cookies. To make them look as if they belong and are not just placed on top, insert the chips into the partially cooked dough in a random manner.

When arranging cookies for a shot, try to work with cookies that have cooled completely so they don't bend. If bending continues to be a problem, a thin cardboard support under the cookies helps. If they don't want to stay in place, a little Fun-Tak/BlueStik will help hold them. When you are ready to shoot the cookies (after they have been arranged), a heat gun adds a warm "just out of the oven" look to the chips.

When plating the cookies, be aware of the photographer's lighting and place the cookies so they don't produce deep shadows. Do they look best going into the camera or away from it, facing the light or facing away from the light?

A heat gun makes chips glisten. The cookie on the left was warmed gently with a heat source. *Dennis Gottlieb*

267

Decorated Sugar Cookies and Gingerbread Cookies

the **Problems**

- The frosting doesn't get hard so the cookies can't be stacked or arranged easily.

- One frosting color bleeds into another color.

- The client doesn't like the six shapes of gingerbread people cookie cutters that you already have.

the **Solutions**

Finding a good frosting recipe is important—one that dries fairly hard, such as Royal Icing (see the facing page).

If you are using frostings made with confectioners' sugar, you want them not too thin and not too thick; the colored frostings need to be the same consistency if they are

my worst war story:
the $250,000 chocolate chip cookies

Every food stylist has a war story of something that has happened to hero food: the perfect hand-selected strawberries or hamburger buns that got smashed by the checkout person, the beautiful pies that got dropped in transport, or the refrigerator full of chicken that rotted over the weekend when the refrigerator got turned off on Friday for the Monday commercial shoot. This is my worst:

We were shooting a commercial for a boxed chocolate chip cookie mix. The final product shot was to be of an oversize box of the mix with a slot at the bottom. As the announcer stated how easy the cookies were to make, a cookie sheet of perfect cookies would slide out of the slot toward the camera.

The day began by getting ingredients and batters ready to shoot and cookies made for bite shots. Meanwhile, my assistant began the task of making the chocolate chip cookies for the final product shot. For the next six hours we shaped dough, placed beautiful chips in appealing locations, and carefully baked the cookies for even color and a yummy appearance. Once we cooled the cookies, we then had to shave a little off the bottoms of the cookies because the model maker who had made the mock box of mix had made the slit just a little too narrow.

Finally, we had our cookie sheet full of hero cookies that would fit through the slit. I went in to tell the director that we were ready to shoot the product shot whenever he was ready. When I returned to the kitchen, to my horror, I found our cookie sheet completely empty. Someone (or ones) had eaten all our hard-won hero cookies. This meant that we, and the crew, would spend the next five hours in overtime while we made new hero cookies. Overtime on a commercial is very expensive, and thus each bite of those cookies amounted to quite a sum.

The moral of the story: Hide the hero food. Keep your hero food covered or out of sight. Remember that if you feed the crew, they will get used to eating your food, and sometimes that might be the hero bowl of potato chips or the perfect muffins that took you hours to produce. I am always happy to send food home or to feed people when we are finished shooting, but not during the shoot.

to be used together or the colors will bleed into one another. If you have a bleeding problem, you need a thicker frosting—or let one frosting dry before adding another. It is important to add decorations such as colored sugar and decorative candies when the frosting is still soft. Always have a variety of pastry tips to use when decorating. Drawing the borders with frosting first and then filling in the center works best.

Start collecting cookie cutters and know where you can find more. Particular shapes are sometimes hard to find out of season—for example, when you are shooting Christmas in June (see the photographs on page 40).

It is important to communicate with the client and art director *before* the shoot about specific needs, such as the right shape and size cookie cutter, so you have time to shop or search for the desired items.

royal icing

Place 3 large egg whites and 4 cups sifted confectioners' sugar in a large mixing bowl. Beat at low speed with an electric mixer until sugar is moistened. Beat at high speed until the mixture is very glossy and stiff peaks form (5 to 7 minutes). Divide the frosting among several plastic containers. Add food coloring to each container, then press plastic wrap on top of the frosting and cover the containers with plastic lids. Keeps for 3 days at room temperature.

If you are using meringue powder (a mixture of dried eggs and confectioners' sugar found in baking specialty stores), replace the egg whites with 3 tablespoons meringue powder and 6 tablespoons warm water, then proceed as for basic Royal Icing. Keeps for 2 weeks in an airtight container. Rebeat lightly before using. The frosting will harden at the tip of a pastry bag if left uncovered, so I keep the tip covered with plastic wrap when I'm not using the bag.

other BAKED GOODS
Overcoming Unique Styling Obstacles

An understanding of the chemistry of baking applies to many other types of baked foods. Below are our other most frequently styled baked goods.

Bars and Brownies

The main concern with bars and brownies is consistency in size. You need to be able to cut very straight edges and neatly cut through nuts or other add-ins. There are often two different textures within a bar—one softer and one flaky or firmer. Some bars are frosted or have a dusting of confectioners' sugar. If you are stacking the bars, you need to be aware of the risks of damaging the top surface of the bars. Usually the bars will hold up well over time, so you can give the photographer the hero without building a stand-in first, unless you need to work on the arrangement—then use stand-in pieces. If you are working for a food company and the package says it makes eighteen servings or if the recipe says that you get twelve 1-inch square bars, you need to cut the bars accordingly.

the Problems

* Getting the bars out of the pan in good condition.

* Cutting consistent-size bars and bars with four straight sides.

* Finding bars with interesting sides when nuts, chips, or frosting are a part of the bar.

269

the **Solutions**

I always line the pan that I am baking in with a double layer of aluminum foil that comes up and over the long sides of the pan (see the photograph on page 244). After the baked good is out of the oven and cooled, I run a knife between the pan and the bar on the short sides of the pan and then use the aluminum foil as a handle to lift the baked good out of the pan. Once the baked good is on a cutting board, it is much easier to control the cuts. First, I cut off the dry edges around the four sides of the product. (The studio staff and client will love these even if they are not pretty enough for a picture, or you can use these trimmings as stand-ins.)

If the bars will have rough edges when you cut them, such as on the tops of brownies, you can score the baked good as soon as it comes out of the oven or freeze it before slicing. Freezing also works if you have pieces of ingredients, such as nuts or chocolate chips, that resist cutting or will drag through the bar when sliced.

Choose whether to frost before or after slicing, depending on the frosting or glaze. In editorial styling where we want a natural look, I often drizzle or frost before I cut the bars.

I use plastic see-through rulers of different widths for measuring the bars. I mark the width on the bars with straight pins for the least damage to the surface. A sewing gauge, found in notions or sewing stores, works well as a guide for cutting the bars (see the photograph on page 109, number 33).

Sometimes, if the sides of the bars need extra nuts or chocolate chips, I add these after slicing. If you do so, just make sure the bar looks *natural*; show the nuts or particulates sliced and embedded into the side.

Phyllo Pastry

the **Problem**

- Pastry cracks when you're working with it and is difficult to slice.

the **Solution**

Work with fresh rather than frozen phyllo whenever possible, because it's more flexible and produces a fluffier look. (Greek pastry shops are a good source.)

Keep unbaked sheets of phyllo covered with a slightly damp tea towel or plastic wrap. Don't allow them to dry out or they will crack. Brush each sheet with microwaved, very soft, almost runny but not completely melted butter for flakier pastry.

For easier final slicing, score phyllo pastries before baking.

For flakier results and more even browning, use a convection oven whenever possible.

Muffins

You may use muffins in a basket arrangement, whole as the gold standard example on a package, split open on a breakfast plate, or spread with the "perfect" marga-

rine swipe or someone's luscious jam product. Unless you are following an editorial recipe, the art director will likely want tall domed muffins, and they may be hard to come by.

the **Problems**

* Getting tall domed muffins with nicely browned sides.

* Muffins that don't want to come out of the pan.

* Splitting the muffin in the middle with an interesting surface and a goodly number of blueberries, nuts, or other ingredients in just the right places of the split area.

the **Solutions**

Use professional muffin tins whenever possible for taller muffins (the cups are deeper) and because the heavy material they are made of produces nice, evenly browned sides. You will want to get muffin tins in a variety of cup sizes (see the photograph on page 123). Depending on the ingredients, not all muffin recipes will produce domes. You can't make muffins dome more by simply adding more baking powder or baking soda; in fact, the opposite happens. When you add more leaveners, the muffins do a quick rise, but because they have not baked enough to form a support for the rise, they collapse. Two things that may help in producing a domed appearance are to bake the muffins at a slightly higher temperature and to overmix them a little to produce more gluten. However, when you overmix, air tunnels develop. If you are showing the muffin cut or torn in half, you may need to fill the tunnels by using petroleum jelly and crumbs from another muffin. Another tip for taller muffins is to not fill all of the cups with batter. Fill cups alternately with batter and fill the rest with water.

Duncan Hines Bakery-Style Blueberry Muffin Mix makes muffins that dome beautifully. If you are using a package mix, break up lumps with a pastry blender before adding liquid. Do not overmix. If you need another type of muffin, say cranberry nut, just leave out the blueberries from the package and add some spices, cranberries, and nuts. If you are not selling a particular brand of muffin, some premade store muffins can look quite nice.

Prepare a muffin tin by brushing the cups with shortening. To prevent problems with muffins coming cleanly out of the tin, you may want to make parchment or waxed paper rounds for the bottoms of the cups.

For a split-open look, use a wooden skewer to poke a line in the flat base of the muffin where you would like the muffin to break (see the photograph on page 188). Break the muffin in half from bottom to top, not horizontally. When we break open a muffin that has nuts or fruit in it, we often add some hero pieces of these ingredients. It is best to get these pieces from nonhero muffins so that they look real and baked.

covert operations

While working on an advertisement for a blueberry muffin mix, I noticed that I was being carefully watched. How I prepared the batter for photography, compared with the package directions, was quite different. First, I dumped the dry mix into a bowl and broke up all the lumps with a pastry blender. That way, I wouldn't have to overmix the batter when I added the liquid and then tried to get rid of the lumps. Next, I drained and rinsed the blueberries (which came in a can) with the dry mix so that the batter would stay clean and not turn blue. About six months after the shoot, I was working again with the product and I noticed that the directions on the package had been changed to include my two steps. Another six months later, a competitor's package directions were changed to include these two steps as well.

Purchased Baked Goods: Adding Pizzazz to Store-Bought Desserts

Sometimes the client's food is already baked, and it is the food stylist's job to find the best examples and just touch them up. Chocolate chip or other cookies, crackers, prepared cakes or pies, and packaged muffins are a few examples. If you are working with prebaked goods, communicate your needs and any questions to the client.

- Ask for pictures of the client's gold standard look or refer to the picture on the package to see how they like their product presented.

- Ask if the client can get the product taken off a special line where care is taken in making the product or the best is selected and carefully packed for you. If the item is frosted, have the client send it unfrosted and send the frosting separately.

- Get a lot of the product and have the client send it to the studio. Sometimes you will have to find the product yourself, however.

- If the product is a refrigerated or frozen item, make sure there is plenty of storage area in the studio. Chest freezers work best for frozen products.

The Finishing Touches: From Dollops to Dustings

When we have the hero baked good ready, we often have to add the finishing touches, such as a perfect butter spread on a muffin, or ice cream next to or on top of a gingerbread square. It is the finishing touches that can make the shot stand out.

WHIPPED TOPPINGS AND THE DOLLOP

You may lose the hero serving if the dollop you put on it is not acceptable, so be prepared with several heroes. Cool Whip works wonderfully well if it is treated well. Sometimes, if I have to finish a piece of pie or a perfect pudding with a dollop of topping, I will put a variety of dollops on a large cardboard cake round and let the client or art director choose the dollop he or she would like. I then take the dollop with a slightly oiled spatula to the hero dessert, where the photographer directs the placement as he or she looks through the camera. See pages 180–182 for more on whipped cream and toppings.

ICE CREAM AND DESSERTS À LA MODE

Use fake ice cream for stand-ins. You may be able to use fake ice cream for the final shot, but you will probably top or put a scoop of the real thing next to the hero for the final shot. Try to have everything (plate, dessert) as cool as possible before going for real. Bring a variety of sizes of scoops. See pages 274–283 for more on real and fake ice cream.

SAUCES

Getting the sauces to the correct thickness is very important (see page 237). When sauces are thick enough to hold a shape, they have more visual appeal than a puddle of thin sauce does. Just before shooting, use squeeze bottles to add the sauce so that

the sauce holds its shape, looks fresh, and doesn't bleed into the dessert. Today, you can get lots of premade sauces or you can heat jellies to get a topping with a good consistency (very thin or thick, whichever you need). Canned cherry pie sauce hangs forever on the edge of a slice of cheesecake. Just strain out the cherries first. Experiment with different prepared chocolate sauces—they all have different viscosities and shades of brown. A product with general appeal and a good thickness is Smucker's Chocolate Fudge Topping.

DUSTINGS

Dustings of confectioners' sugar, cocoa powder, nutmeg, or cinnamon on a dessert or dessert topping (such as whipped cream or ice cream) or on a dessert plate can add a lovely finish to the presentation. It is very important that you have a wire strainer with the correct-size mesh (available from fine to coarse). Some produce a very fine dusting, while some release larger particles. Choose the size according to how close the camera is to the food and the size of the item to be dusted. For a large tart, you will want a coarser mesh; for a delicate pastry, shot closely, a finer mesh.

Dusting requires a gentle touch and no air circulating in the studio. You can always add more "dust," but you can't take it back. Sometimes you want an even dusting and sometimes a more casual uneven one.

When I sprinkle cinnamon or nutmeg on a whipped cream dollop, I use my fingers and sprinkle a little bit at a time.

GLAZES

Glazes can be purchased or you can make them. Getting them the correct thickness for the look you want is the important element here. Glazes drizzled over Bundt cakes, cinnamon rolls, or pound cakes can be thick or thin; you or the recipe will determine the look. Drizzle with a spoon, squirt bottle, or brush, depending on the glaze, the area to be covered, and the thickness of the glaze.

Glazes for fruit tarts can be made with warm, thinned apple or apricot jelly. Brush the glaze on at the last minute or spray it on with a heat-safe atomizer to avoid moving the fruit. When very fresh, a jelly glaze gives a nice sparkle to the fruit.

GARNISHES

Even if you are not told to bring garnishes to a dessert shoot, do so anyway. Although we use fewer garnishes in photographs than in the past, sometimes they are just the thing needed to pick up the presentation of a dessert. The holy trinity of dessert garnishes is mint, raspberries, and strawberries. Make sure the garnish complements the dish or comes from an ingredient already in the dish. Keep a file of ideas and prepare a small tray of examples at the studio. Art directors, clients, and photographers like choices and need to see what your lemon, orange, or lime twist or twirl looks like. Think of new and interesting ways you can cut or zest that lemon or lime (see athe phtographs on pages 161 and 294).

photographing ICE CREAM
The Differences Between Real and Artificial

There is a reason that recipes for artificial ice cream were developed when we were styling perfect-looking food in the eighties. Now we are enjoying the more natural and melted look, but you still need to know how to work with both real and artificial ice creams.

Real Ice Cream

Ice cream is one of the more difficult foods to work with because it melts so quickly and because it takes special techniques and practice to be able to produce scoops with beautiful, natural bark or ridges (the texture) and collar (the ruffle around the edge of the scoop). Because it is a difficult food, there are people who specialize in working with it. When I first started as a food stylist, I was told there was an "ice cream lady" who worked on all types of food, but who also specialized in ice cream. What I have learned over the years by working with ice cream is that each brand behaves differently, and within the brand, flavors behave differently, with chocolate usually being the most difficult to work with. Before taking on any job working with real ice cream, it would be helpful to assist someone who has worked with ice cream before; at the very least, practice, practice, practice and get to know the brand and flavor. Pay attention to the amount of pressure you need to exert to create the texturing you want in scoops or spades of ice cream. If you are not required to use a particular brand of ice cream, choose a less expensive brand; such brands usually have less fat and are easier to handle. As you gain experience in styling ice cream, you will develop your own techniques and probably design some equipment that works well for you. Ice cream jobs are never easy, but with practice, you will gain confidence.

Here are some general things to consider when you will be working with ice cream:

- Determine the amount of ice cream, sorbet, or frozen yogurt that you will need shipped to the studio. A good rule of thumb is to order a little more than you think you will need. If possible, get at least two to three 3-gallon food-service tubs (they have more scooping surface) for a single shot of vanilla. If you are shooting flavors with swirls or particulates, figure on three to four tubs per shot. If you can't get three-gallon tubs, then get twelve to twenty half-gallons per shot.

- Have the client arrange with the studio for a delivery time for the ice cream, and if they have rented freezers, make sure the studio has them plugged in and set at the correct temperature at least four hours in advance. Keep track of freezer temperatures by leaving mercury freezer thermometers in the freezers. The proper holding temperature for ice cream is −15°F (−26°C). The proper tempering temperature is between 0° and 5°F (−18° to −15°C), although high-butterfat or sorbet products require closer to 10°F. Some stylists use a temperature probe inside the product to check internal temperature.

- Ice cream needs time to temper after it has been shipped to the studio on dry ice. Two days—48 hours—in a chest freezer or upright freezer set at the correct scooping temperature for that brand and flavor is necessary. The reason I prefer chest freezers is that the temperature stays constant even if I open them frequently on

the shoot day. With an upright freezer, each time the door is opened, the cold slips out of the bottom; it soon becomes a "refrigerator" if you open it frequently. Some stylists prefer the upright because different areas of the freezer will have different temperatures and they can move the ice cream to a location where it gets to just the right scooping temperature—which is crucial if you want to get pleasing bark, or ridges, in the ice cream.

- People who work with ice cream a lot have special holders made that are clamped to kitchen counters to hold the blocks or disks of ice cream in place when they scoop. They also use box cutters to cut down the tub and remove the cardboard wrapper.

- Use wires or long, double-handled cheese knives to cut lengthwise through the containers of ice cream to get several good, clean surfaces to scoop from since you need to scoop from a flat surface. Cut three-gallon tubs into four slabs from top to bottom and half-gallon blocks in half horizontally. The goal is to have as much flat ice cream surface as possible for scooping. Wrap slabs of ice cream in aluminum foil and store them in the freezer at tempering temperature until needed.

- Scoops are designed with special handles to help in the pull across the surface. Some stylists use scoops with a release and others prefer to remove the releases, or dishers. Without the release, you may need to bang the scoop on the counter to remove the ice cream. People who work with ice cream a lot often have scoops specially cut and sharpened and use only professional solid stainless steel scoops. It takes a lot of strength to scoop ice cream all day. The "ice cream lady" had an assistant who did the scooping for her while she worked on the finishing touches.

- One technique for forming longer-lasting scoops of ice cream is to make a small half ball of dry ice by lining a small scoop (one or two sizes smaller than the one for the hero ice cream) with aluminum foil and filling it with finely crushed dry ice. For the ice cream, pull a chilled hollow scoop (using a scoop without a release) or a knife across the surface of ice cream, drawing a long ¼-inch-thick textured slice of ice cream. This ice cream is then placed over the dry ice ball and pressed into place with a wooden paddle or Popsicle stick, which keeps the ice cream from melting a little longer. (You can also form a scoop with a collar this way and place it in the freezer or dry ice chest for a little while to firm it up before putting it on the set.) Another technique for scooping ice cream is to scoop it with a chilled regular disher such as the Hamilton Beach scoop with a release; place the best-looking scoops on a film card, thin cardboard covered with plastic wrap, or paper plate; and put them into the chest freezer until needed. Side fringes or collars can be added at this point or later, when the ice cream balls are in place on the set. To form a collar, use a wooden skewer and draw it across the ice cream for a good texture, lift this textured ice cream strip, and press it onto the base of the hero scoop (see the photographs on page 282).

- When spading ice cream, you will need to have the ice cream firmer than when you scoop. Form the petals over a half ball of dry ice, pressing them in place with a Popsicle stick.

- Some stylists build a special freezer or ice house out of a large Styrofoam box. The box is set on its side and a wire cooling rack is hung about four inches from the top. A slab of dry ice is placed on the cooling rack, and then the stylist can work with the ice cream below the dry ice in the cold box. The top is closed down or a

Portable ice house.
Dennis Gottlieb

curtain used when the box is not in use. This box can be placed at a comfortable working level on or near the set. The box is also a comfortable and cold convenient place to work with the ice cream if you must add particulates, stripes of chocolate sauce, or collars to the ice cream. The ice cream becomes very firm in this box when it is closed, so don't keep it in there too long or it will take on a rock-hard appearance. If ice cream needs to soften or have a slightly melted look, blow through a straw onto the area to be softened just before shooting.

- To extend the life of real ice cream on the set, fill a sieve with crushed dry ice and hold it directly above the ice cream until shooting. Some stylists spray ice cream with an upside-down aerosol can of Dust-Off or with air from a can of chewing gum remover or Poop Freeze spray to firm the ice cream before placing it on the set. Be careful not to spray your skin with these products.

WORKING WITH DRY ICE

If working with real ice cream, you will be working with blocks or pellets of dry ice—with the possible exception of some editorial assignments where you want the ice cream to melt. Crushed dry ice is used in a metal bowl to cool scoops and in a wire-mesh sieve to hold over ice cream on the set to slow down the melting. Some photographers form crushed dry ice into balls and wrap real ice cream over them.

Find a good supplier of dry ice that can deliver to the studio. Be sure there will be Styrofoam coolers at the studio to hold the dry ice when it is delivered. Dry ice evaporates quickly, so it should not be exposed to air for long periods of time. *Never put the dry ice in a regular freezer or put it in a sink and run water over it.* Dry ice is much colder than the thermostat of a freezer can withstand, and it will freeze water pipes. If you put dry ice balls in a freezer, don't set them directly on a shelf because they are so cold that they will crack the shelves. *Never handle dry ice with your bare hands; use gloves.* The rule of thumb is to have fifty pounds for each shot, plus a ten-pound package of dry ice pellets. If you have a Styrofoam ice house, order the dry ice in one-inch-thick slabs so that you will be ready to line the inside top and sides. The slabs can also easily be broken up for crushed ice using a hammer and towel.

ICE CREAM SHOOTS: GET EVERYTHING READY

Gather all the information possible about the shoot before prepping. Discuss with the photographer and client the shots to be accomplished. What is the product? How will it be shot? What size is the prop bowl, and so on? How many shots and are there any additional foods or multiples of ice cream? What is the "look" or gold standard for the product? Try to avoid more than two shots a day, especially if there are multiple foods in a shot. Finally, get a very good assistant, possibly someone who has assisted on previous ice cream shoots.

When you are working with ice cream, it is especially important to be very organized and to get everything ready before you start to shoot. Arrange your space for ease in working. Line your ice house with slabs of dry ice. Wrap film cards, cardboard, or paper plates with plastic wrap to hold perfect scoops. Make space in one freezer set at holding temperature (−15°F or −26°C) to hold perfect scoops. Tear paper towels into individual sections and have several stacks ready to use for cleaning and drying scoops after each use. Get some dry ice crushed and in metal bowls to chill scoops and for holding over ice cream on the set. Put any sauces in squeeze bottles and keep all sauces and toppings in the refrigerator and any particulates in the freezer. Having the studio as

cool as possible while shooting frozen products and chilling the prop that is to hold the ice cream will add to the life of the ice cream as well.

ADDITIONAL EQUIPMENT NEEDED FOR ICE CREAM SHOOTS

- Scoops of a variety of sizes (see the photograph below). You need to bring different sizes because just the right size makes all the difference, and sometimes just one size up or down will be exactly right. Scoops are numbered, usually on the release or disher, with the larger scoops having the smaller numbers. The bottom of the handle is also color coded to indicate the size. I prefer professional-quality Hamilton Beach solid stainless steel scoops. If you can, find the older scoops, made in the United States; they behave better than others. Some stylists permanently remove the release or disher and have these scoops sharpened and cut to a shape that produces very round scoops of ice cream.

- Thermometers: mercury freezer thermometers for the freezer and instant-read or probe thermometers to test internal ice cream temperatures

- Ice chests or coolers for holding dry ice

- Gloves for handling dry ice

- Hammer and strong towel for crushing dry ice

- Wire mesh strainers to hold dry ice over ice cream on the set

- Metal bowls to hold crushed dry ice and one filled with dry ice to cool scoops

- C-clamps and boards to build holders for ice cream when scooping, or your own holder boxes

- Film card, thin 4 x 6-inch cardboard (photographers might have these), or small paper plates for holding hero scoops in the freezer

- Offset spatulas for moving scoops of ice cream

- Wooden skewers, dental tools, tweezers, and tooth-brushes for adding particulates, collars, and texture to ice cream. Popsicle sticks for shaping ice cream petals over dry ice balls.

- Squeeze bottles and funnel for sauces

- Straws for blowing air to melt or soften ice cream on the set

- Lots of paper towels, aluminum foil, and plastic wrap

- Styrofoam or Oasis Floral Foam for holding cones upright or water glasses of the correct size and height

- Wire cutters, box cutter, and double-handled cheese knife or strong wire attached to wooden handles to draw through large blocks of ice cream

- Some fake or artificial ice cream of the exact color you will be shooting so you that can work out scoop sizes and build stand-ins for the photographer (see the photographs on page 282)

Bring a variety of scoops to any ice cream job. You will likely need to see the ice cream scooped in several sizes and into different props.
Dennis Gottlieb

working with soft-serve ice cream

Soft serve has its own unique problems and techniques. Sometimes you will work at a location where a soft-serve machine is available and sometimes a machine is rented and brought to the studio. Because it takes lots of practice to get the right look, it is important to have an experienced person make the soft serve and pull it (make the spirals). This person is normally someone who works for the client company. If you have to pull it yourself, practice first. It is best to shoot the product immediately. You can add firmness to the pull by spraying the product with Dust-Off or air from another aerosol can held upside down. To work ahead, you can firm the ice cream spirals in a Styrofoam dry-ice house. Use Styrofoam, Oasis Floral Foam, or a water glass stuffed with cotton balls to hold cones in place, if using, before filling. You can fill the cones almost to the top with cream cheese first to form a base for the soft serve; this saves soft-serve product and gives stability to the cone. Once you have made a cone or serving, put it into a freezer or ice house to firm up prior to placing it before a camera.

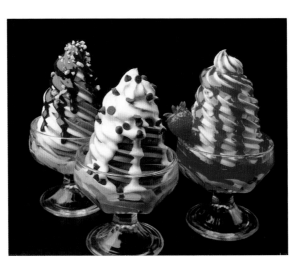

Three soft-serve ice cream sundaes. *Brad Guice*

ICE CREAM TOPPINGS AND SAUCES

Chill any sauce or topping and particulates before adding them to real ice cream. For fake, this is not necessary. If sauces are a little thin, add piping gel to the sauce. Putting a paper towel cut just a little smaller than the desired sauce shape on top of the ice cream before saucing will help hold the sauce in place (see the photographs on page 282).

Chocolate. My favorite chocolate topping is Smucker's Chocolate Fudge (not hot fudge), perfect just out of the jar and into a squeeze bottle. It has a beautiful color and a perfect viscosity for hanging right where you put it. If you chill it for working with real ice cream, you may need to thin it just a little with corn syrup or Hershey's Syrup. Turn a filled squeeze bottle upside down and put it in a glass or cup. This allows the sauce to come to the tip and any air bubbles to go up toward the bottom of the bottle.

Strawberry jam. Use strawberry jam thinned with strawberry syrup, strawberry topping, or strawberry ice cream topping. Try to find the brightest red jam. The sauce in cherry pie filling has a great viscosity for adding to red fruits.

Nuts. Chop nuts to the desired size and put them in a coarse wire-mesh strainer to remove small pieces. For a natural look, just sprinkle them onto the surface of the ice cream. Fill in any holes with a few pieces, using tweezers.

Maraschino cherries. Try different brands to find the one that has cherries that are a bright red, have nice stems, and have perfect sides (without the pit remover scar). You may need to get several jars. If the perfect cherry doesn't have a perfect

stem, borrow one from a cherry that doesn't have a perfect body. Wash and drain the cherries on a paper towel to prevent bleeding. Insert a toothpick into the ice cream where you want the cherry to go and then press the cherry onto the toothpick to hold it in place. Brush the cherry with a little vegetable oil or water just before shooting to produce a shiny, fresh surface.

Fruit. Any fruit added to an ice cream shot should look chilled but not frozen. Use small straight pins or toothpicks to hold the fruit in place, if necessary.

Whipped cream toppings. You can choose to top ice cream sundaes with a spooned dollop of nondairy whipped topping or, for a more professional look, you can pipe the whipped topping (see page 181).

Artificial Ice Cream: Faking the Real Thing

Many years ago, stylists used mashed potatoes for fake ice cream. It was fairly easy to see that it was mashed potatoes. Most of the time, you can spot today's artificial ice cream when it is used in shots, if you know what to look for. It is your job to make the artificial look as real as possible. You can do this by finding a good recipe, having a good scooping technique, knowing how to add collars, and even giving fake ice cream a slightly melted appearance.

Artificial ice cream (AIC), or fake ice cream, should not be used as a substitute for the real thing if you are selling an ice cream product, but it does have many uses. I use it when I need to build a long-lasting stand-in for lighting and arranging the food on a set. It can be used in the editorial world in apple pie à la mode, providing you are not showing a recipe for ice cream. However, today, most magazines and cookbooks like to show the real thing, with a natural melt. If you are building a tall sundae, fake ice cream the same color as the real can be used in the bottom and then topped with a scoop of real. That way, you don't have to worry about the base melting while you are

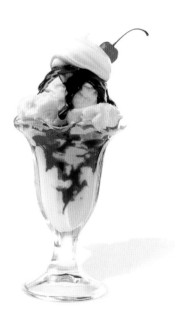
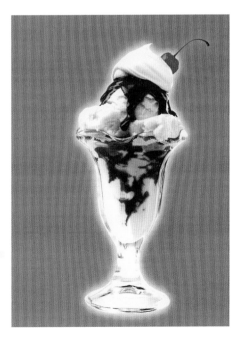

LEFT: We shot this sundae for a job.

RIGHT: Then the photographer used the same sundae, but with a different background, as a promotional piece.

Colin Cooke

Basic White Ice Cream

MAKES ABOUT 2 CUPS

⅓ to ½ cup solid white shortening (Crisco)
⅓ to ½ cup light corn syrup (Karo)
1 pound (453 grams) confectioners' sugar

In a food processor or strong standing mixer (you can also mix this by hand, which is what we did before food processors; yes, there was a time before food processors), blend the shortening, corn syrup, and confectioners' sugar until combined.

Remove the mixture from the bowl and place it on a clean cutting board. Knead until you can shape it into a ball. (Don't overknead because the mixture will become too soft and oily. If this happens, put it into a plastic bag, pressing out all of the air—because if the ice cream is exposed to the air for a period of time, it will get a hard crust—and place it in the refrigerator to firm.)

TIPS *Granita, an Italian ice, can be made with a combination of ice powder and water tinted with food coloring. Use as much water as needed to produce the look you want. The coarseness will be determined by the coarseness of the ice powder you use.*

Keep bowls and piping bags of artificial soft serve refrigerated throughout the process to keep the soft serve at a good consistency.

working with the top, and you have time to marble sauce exactly where it is needed. Fake ice cream can also be used if you are selling chocolate sauce or any other product that needs ice cream in the shot (but it is not part of the product). See a basic recipe for fake white (not vanilla) ice cream at left.

To test to see if your proportions are correct and your recipe produces the desired look, try scooping the ice cream using a scoop with a release or disher in place. Now this is the trick: You need to fill the bowl of the scoop completely, with excess ice cream over the top. If you don't have excess ice cream on top of the scoop, you will be pressing down on a flat surface and not producing pressure on the release, which is what produces the bark. Place the ice cream scoop filled side down on a cutting board and press down as you pull the release across. You will want to get ice cream with a beautiful textured bark. If the bark is too open, the ice cream mixture is too dry, and you need to add equal amounts of shortening and syrup in small increments. If the scoop is too smooth, the ice cream mixture is too moist, and you need to add confectioners' sugar in small increments. Adjust the proportions, clean the scoop, and try again. I have found that if you press down too hard when pulling the release across, the ice cream will be smooth, and if you don't press down hard enough, the bark will be too open (see the photographs on page 282).

The collar on a scoop of ice cream is the excess ice cream left around the base of the ice cream ball (see the photographs on page 282). You can scoop the collar at the same time as forming the ice cream base by putting the scoop into the artificial ice cream and pulling off some extra as you remove the scoop. If there is too much collar, tear some off before forming the scoop; if there is not enough collar, you can add more later. After you have scooped the ice cream, you can add texture to the bark or diminish it using wooden skewers. I also use wooden skewers and dental spatulas to dig into the unscooped artificial ice cream and tear out pieces to add to the collar, if the collar needs to be large. Don't use your hands on the surface of the ice cream or collar because this will take away the texture. When you have the look you want, use a small offset spatula to move the scoop to the prop that will hold it.

Always store artificial ice cream covered in plastic so no air gets to it until needed.

ARTIFICIAL VANILLA ICE CREAM

You can make artificial vanilla ice cream using the basic white ice cream recipe above, or use one of the three recipes at right.

Working successfully with artificial ice creams involves having a combination of the right formula, good ice cream scoops, and the correct amount of pressure pushing down when dragging the release across the ice cream. Practice, practice, practice.

variations on the basic white ice cream

With the basic recipe, you have made white ice cream, not vanilla. You can add food coloring to your basic white recipe to get other "flavors." Add the coloring in very small amounts, knead it in completely, then add more color, if needed. The mixture will probably be overkneaded when you finish, so put it in a plastic bag and refrigerate it for a while. Always store artificial ice cream tightly wrapped in plastic wrap.

VANILLA: Replace a little of the white shortening with the same amount of margarine or butter-flavored Crisco. If the mixture is to have vanilla beans in it, scrape in some of the real things. For a brownish white vanilla, replace just a little of the light corn syrup with dark corn syrup.

CHOCOLATE: Gradually add unsweetened cocoa powder to the basic white recipe. You have added a dry ingredient, so you may need to add an equal proportion of the wet ingredients (shortening and corn syrup). The amount of cocoa powder will be determined by the ice cream you are matching or the richness of the look you want.

STRAWBERRY: In place of the light corn syrup, add ¼ cup of strawberry jam (not jelly); you want the strawberry pieces. You will need less of the jam than the corn syrup because the jam has more water in it and will make the ice cream too soft.

COFFEE: Replace the light corn syrup with dark corn syrup. To make the ice cream more intense in color, add a little Kitchen Bouquet.

CARAMEL: Replace the light corn syrup with dark corn syrup and add some yellow food coloring.

OTHER FLAVORS: If there are particulates to be added, such as chocolate or nuts, chop them fairly fine, place them in a sieve, and shake out the finest pieces. Add the larger pieces while kneading the mixture. Additional particulates can be placed after the scoop has been formed. If I am working with a fruit ice cream and want to add pieces after I have scooped it, I use pieces of the fruit from the jam, not fresh fruit. Fresh fruit tends to "melt" the ice cream.

While attending an international conference for food stylists and photographers and helping with a workshop on ice cream, I learned of other recipes for artificial ice cream. I haven't worked with them yet, but you may want to give them a try.

Recipe I

One 1-pound tub (scant 2 cups) French Vanilla regular ready-to-spread frosting*

1 pound (453 grams) confectioners' sugar

Blend the frosting and confectioners' sugar in a mixer. If the mixture is too stiff, add light corn syrup as needed; if it is too soft, add more confectioners' sugar. Don't overmix. Heat from the motor can make the mixture too soft.

*Play around with a variety of brands. You will probably get different results. Chocolate or strawberry frosting may be substituted.

Recipe II

⅔ cup margarine (Land O'Lakes)

½ cup light corn syrup

2 pounds (906 grams) confectioners' sugar

Mix the margarine and corn syrup in a bowl until well blended. Stir the mixture and knead in the confectioners' sugar.

Recipe III

½ cup (1 stick) margarine, softened

¼ cup light corn syrup (Karo)

1 pound (453 grams) confectioners' sugar

Mix the margarine, corn syrup, and confectioners' sugar in a bowl with a wooden spoon (make this formula by hand only).

step by step: from shortening to sundae

TOP ROW:

CLOCKWISE FROM TOP RIGHT: **Shortening;** coloring agents such as butter, jam, and cocoa; four kinds of artificial ice cream; corn syrup; and confectioners' sugar.

Extra ice cream in the scoop (at top right) gives you enough to press into a surface to form a texture or bark as you release the ice cream from the scoop, and some to form a collar.

The scoop of artificial ice cream on the left is too dry; it needs more shortening and corn syrup. The scoop on the right has the rich look found in premium ice creams with high-butterfat content. The one in the middle has the most sought-after look.

MIDDLE ROW:

After trials with several sizes of scoop, we see that this boat works best with a #10 scoop. The scoop sizes are imprinted on the release and sometimes color coded on the base.

A squeeze bottle was used to add the sauce to the scoop on the left. Squeeze bottles provide better control than spoons for adding sauces.

When building a tall sundae, add sauce as you build. When building a boat, add sauce after all the scoops are in place. A paper towel cut in the shape of the sauce helps hold the sauce in place.

BOTTOM ROW:

Get all the components ready before adding the sauce. Do we like the whole strawberry on the side as a garnish?

Does the strawberry look better fanned? We add the sauce and are ready to shoot.

A mouthwatering sundae.

Dennis Gottlieb

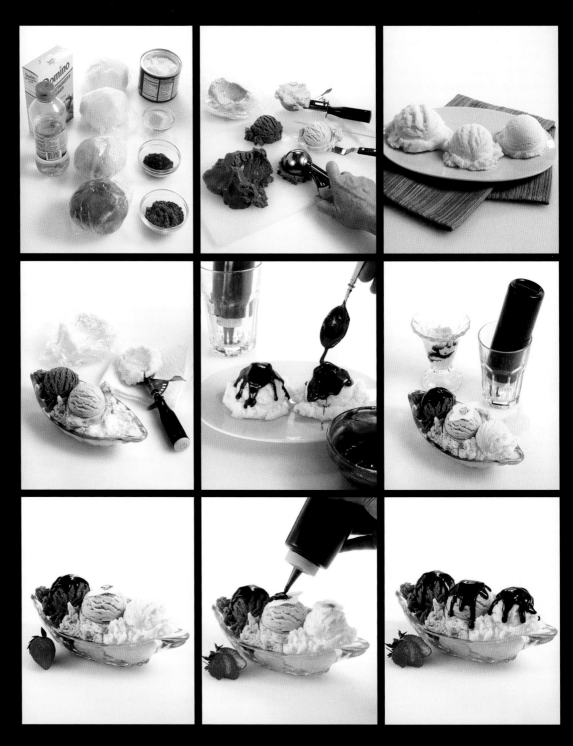

ARTIFICIAL SORBET OR SHERBET

Below are recipes for artificial sorbet or sherbet.

Recipe I

⅔ cup solid white shortening (Crisco)

⅔ cup light corn syrup

1 pound (453 grams) granulated sugar, about 2 cups

1 pound (453 grams) confectioners' sugar, about 3¾ cups

Blend the shortening and corn syrup together. Mix and knead in the granulated and confectioners' sugars. Adjust the amounts of sugars as needed to get the desired look. Tint with a very small amount of food color paste, as needed.

Recipe II

One-half to one 3-ounce box flavored gelatin, such as Jell-O (flavor depending on the color needed)

½ cup solid white shortening (Crisco)

½ cup light corn syrup

1 pound (453 grams) granulated sugar, about 2 cups

Blend together the gelatin, shortening, corn syrup, and sugar in a food processor. Adjust the color with more gelatin or food color paste as needed.

ARTIFICIAL SOFT-SERVE ICE CREAM

I have made artificial soft serve from tubs of chilled ready-to-spread (RTS) frosting piped over Styrofoam cones and then refrigerated. But recipes have been developed for this product, and as prepared frosting formulas change, it is always good to test brands before you arrive at a shoot.

Bring a variety of pastry tips. You may have to have one made to match the client's look.

Recipe I

Three 1-pound tubs (about 6 cups) ready-to-spread frosting*

1 pound (453 grams) cornstarch

Blend together the frosting and cornstarch. Fill a pastry bag fitted with a tip that matches the machine used by the client and pipe the mixture.

*Brands will vary, so try several to find the one that works best for color and thickness.

Recipe II

One 12-ounce tub (340 grams) cream cheese–flavored whipped ready-to-spread frosting*

¼ cup solid white shortening (Crisco)

¾ cup confectioners' sugar

1 teaspoon light corn syrup

Combine the frosting, shortening, confectioners' sugar, and corn syrup in a bowl with a large rubber spatula. Blend until air pockets are at a minimum. (Recipe easily doubles.)

*Chocolate and strawberry frosting may be substituted.

Recipe III

Two 1-pound tubs French Vanilla regular ready-to-spread frosting*

Food coloring (optional)

1 pound (453 grams) confectioners' sugar

Combine the frosting and confectioners' sugar in a food processor. Place in a pastry bag. Refrigerate until needed.

*Don't use the whipped frosting because it will be too soft. If you must use it, add more confectioners' sugar. Food coloring, if used, should be added to the frosting first.

CHOCOLATE
The Problem Child for the Food Stylist

Of all the foods a stylist works with, the one that we deal with most frequently that can become a problem child (besides ice cream and pizza) is chocolate. This is a food that illustrates chemistry in action. It comes in many different forms, ranging from straight chocolate to chocolate mixed with other ingredients, each behaving differently. It is extremely affected by temperature and humidity. It blooms, seizes, and melts at different temperatures. To suggest that everything on the topic of chocolate could be covered in a food styling book would mean that we would be looking at a very long chapter indeed. There are experts who have written books on the subject, and I suggest that you have a couple of good ones for reference (see Resources, page 379). Hands-on classes in working with chocolate are also beneficial, because you will have someone to instruct you as you work.

I once attended an excellent workshop given by Elaine Gonzalez, who has written a book called *The Art of Chocolate*. It was eye-opening for me to watch her demonstrate her technique for tempering chocolate, which goes somewhat against the traditional method often taught in culinary schools. (Classic tempering involves carefully heating, melting, stirring, and cooling chocolate so that it is shiny, firm, and shelf stable.) She produced many wonderful chocolate creations in the two-hour workshop and used just a small microwave oven and a tiny—I mean tiny—refrigerator. At the end of the workshop, her white chef's jacket was spotless, as was her work space. Yet in front of her was an array of perfectly tempered chocolate jewels.

The chocolate information included in this section deals with some of the more common issues we tackle as stylists. It includes melting chocolate, making chocolate curls for garnishes, producing chocolate drips and drizzles over desserts and on plates, and making chocolate-covered fruits.

Melting Chocolate

Melting chocolate can be done in a double boiler over warm, not boiling, water or in a microwave oven at 50% power. If using a microwave, you can melt the pieces in a glass measuring cup. Elaine Gonzalez prefers to use a plastic container and spatula because they don't hold heat. It is important to have the pieces of chocolate chopped evenly and fairly small. Begin by heating for 1 minute, then stir. Continue to heat and stir at 10-second intervals.

It is important that the chocolate never get above 120°F.

When melting chocolate for chocolate curls, use 6 or 12 ounces semisweet chocolate chips or finely chopped chocolate and 1 to 2 teaspoons vegetable oil. Heat them together until most of the chocolate pieces are melted. Remove them from the heat and stir until the carry-over heat of the melted chocolate melts the remaining pieces.

the **Problem**

- It is difficult to get smooth chocolate curls that don't break.

the **Solution**

Pour melted chocolate into a boat shaped from a piece of aluminum foil. Usually making the boat narrow with tall sides is best for getting a chocolate block that pro-

duces nice-size curls. Some stylists like to use the plastic boats that sticks of vegetable shortening come in. When the chocolate has rehardened, either at room temperature or in the refrigerator, remove the aluminum foil and soften the chocolate gently with the heat of your hand until it is soft enough for you to pull nice curls using a vegetable peeler. Have a few different peelers—each will produce a different thickness of curl. The temperature of the chocolate and the pressure of the peeler will affect the look of the curls. An alternative is to purchase a block of good chocolate and warm it slightly with 3-second bursts in the microwave. Remember, any chocolate you use should be hard at room temperature. If it is soft, the curls will collapse if they are on the set for any length of time. If you pull curls that are small and crumble, the chocolate is not soft or warm enough; if you have trouble forming curls, the chocolate is too soft. When you have formed a variety of sizes and shapes on a tray, place the tray in the refrigerator until needed. Use a wooden skewer to place curls on the item to be garnished.

Chocolate Sauces

There are many premade chocolate sauces. Get to know the properties of each. Some are thin and dark; some are light in color and thick. You may need a different type for each job. If I am not selling a chocolate sauce, I like to use Smucker's Chocolate Fudge Topping for ice cream sundaes and drizzles on plates (see the photographs on pages 282 and 314–315). The viscosity is perfect and the chocolate looks dark and rich. I usually put the topping in a squeeze bottle for easier control. Hold the bottle upside down in a tall glass to prevent air bubbles from forming. Sometimes you will need a thinner or thicker sauce than this, so experiment with all of them and also with combining sauces.

the **Problem**

* Chocolate needs to be the right type and consistency for dipping fruit.

LEFT: **Pour melted chocolate into a boat (aluminum foil or plastic container from blocks of Crisco). Let it get firm, remove from container, and using a vegetable peeler, pull curls.**

RIGHT: **You get a variety of looks depending on the vegetable peeler you use, the pressure you apply to the chocolate and the chocolate's firmness. It is important that the chocolate be just the right firmness. If it is too hard, heat it slightly with your hand, or place it in a warmer area.**

John Montana

the **Solution**

You will want the chocolate either soft, as in a chocolate fondue shot, or one that becomes firm (tempered), as in chocolate-covered fruit. For the fondue-like shot, a product such as Baker's dipping chocolate works beautifully. If you need to make chocolate-covered fruit, you will need to use tempered chocolate that will harden as it cools. A good technique for chocolate-covered fruits is to dip them into 8 ounces of melted chocolate that has been combined with 3 tablespoons of paraffin.

Chocolate Candies

If you are working with premade chocolate candy, the surfaces may be slightly marred. Using an extremely soft brush, very gently brush the surface until smooth. I have one brush just for this purpose.

See additional information on working with chocolate: chocolate chip cookies (page 267), chocolate sauces (page 240), and hot chocolate (page 297).

COLD and HOT beverages
Food Styling Techniques in the Presentation

Photographers or clients have called me more than once asking, "Are you a specialist in beverages?" or stating, "We need someone who just does beer." In the food styling business, it is very important to know how to work with beverages, but to try to make a living specializing in just one area would be unrealistic. In fact, the more well rounded you are, the better. It is always good to be very knowledgeable about any of the more "difficult" foods, as well.

Beverages and the styling of them may be a big part of your work. Sophisticated coffees and cocktails, juices, teas, and frozen drinks have become trendy and are advertised everywhere. If you are not advertising a beverage, you are often using one in the shot—a cup of coffee with the dessert recipe, a glass of beer with ribs. "A glass of iced tea or white wine would look nice in the shot," or "How about adding a glass of orange juice near the cereal?"

OTHER USEFUL ITEMS FOR STYLING BEVERAGE SHOTS

- Interesting cocktail picks to hold garnishes, and a variety of swizzle sticks
- Straws as a garnish or for removing or lowering liquids
- Strong professional blender for making frozen cocktails
- Wine bottle opener
- Church key (can opener)
- Wooden skewers for reblending separated drinks, removing air bubbles in thick drinks, moving floating bubbles, ice cubes, or garnishes in a beverage
- Clean cotton swabs for popping unwanted bubbles
- Cotton gloves for handling glasses without leaving fingerprints
- Small bowls and whisks for producing bubbles and froths in a variety of sizes (the more you whisk, the smaller the bubbles)

The blue background makes this drink look even colder.
Nora Scarlett

286

What makes a beverage mouthwatering? It needs to look fresh and just poured. Americans seem to like their beverages either quite hot or quite cold. So beverages need to look hot and steaming or cold and chilled. Finding a beautiful or appropriate glass, cup, or other vessel will enhance any beverage shot.

Cold Beverages 101

Cold beverages can include everything from water and iced tea to orange juice, milk, sodas (or pop, depending on where you live), smoothies, chilled coffees, milk shakes, white wine, beer, and cocktails. With all cold beverages, we identify "cold" when we see moisture or condensation on the outside of the glass or vessel. You can get that naturally by using a very cold beverage on a humid day, but eventually, if the glass sits there and warms or if the weather is not humid, the moisture droplets disappear. Also, if you are shooting on fabric or paper, the moisture from the glass can produce water rings. If you want to control these problems, you can produce your own "moisture" by using one or more of the techniques described below. When water rings were not an issue, some of my most successful beverage shots were made by using a very cold beverage to produce a natural condensation and adding "moisture," if needed (see page 290).

CHOOSING AND PREPARING GLASSES FOR THE CHILLED LOOK

In the best of all possible worlds, if you could shoot all your beverages in crystal, you would get the best results. Any glass other than crystal will not be even in thickness, and the rim of the glass may photograph dark and thick, depending on the camera angle and quality of the glass.

Start with a perfectly clean glass or vessel, being careful not to get fingerprints on the glass. Some stylists wear cotton or surgical gloves when picking up glasses. I like to pick up the glass from camera back with my fingers below the liquid line (the level to which the liquid will be poured in a glass).

Each photographer has his or her own way of prepping beverage glasses and is very protective of that method. Some use a car wax on the glass and then polish it before spritzing so that they get a very beaded effect. Others spray the outside of the glass with Krylon Crystal Clear, which causes a tension and helps the moisture to adhere and form beautiful droplets. Some spray the inside of glasses with Crystal Clear so that the bubbles of carbonated beverages will adhere to the inside surface of the glass as well.

When you are adding moisture droplets to a glass, there are times when you can just spritz the whole surface of a glass with water for the condensation look. In real

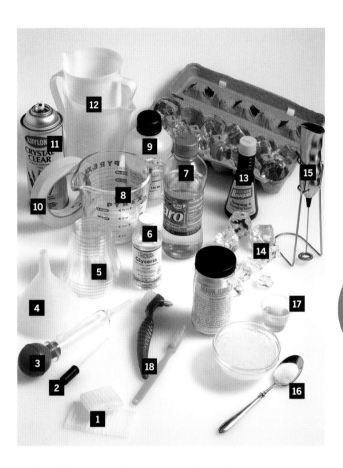

Tools and items used in beverage shots: **1.** Mortician's wax **2.** Eyedroppers **3.** Glass bulb baster **4.** Funnel **5.** Clear plastic cups **6.** Glycerin **7.** Light Karo corn syrup **8.** Glass measuring cups **9.** Photo-Flo **10.** Masking tape **11.** Krylon Crystal Clear **12.** Plastic pouring cups **13.** Kitchen Bouquet **14.** Fake ice cubes of various sizes and shapes **15.** Milk frother **16.** Ice powder **17.** Shot glasses **18.** Stiff toothbrushes. *Dennis Gottlieb*

cool and refreshing

TOP ROW:

The glass on the left has natural condensation and real ice cubes. The glass on the right has condensation added by a food stylist and fake ice cubes.

Neither glass here is high quality, but the glass on the right is better for photography because of its thinner walls.

Reflector cards add sparkle to drinks with clear liquid and fake ice cubes.

BOTTOM ROW:

Use high-quality fake ice cubes and arrange them in an interesting pattern to reach above the liquid line.

On the set, surround the glass with paper towels to absorb any spills or splashes. Pour the liquid through a funnel into the back of the glass.

Paper towels removed and the garnish arranged, the drink is ready to be photographed.

Dennis Gottlieb

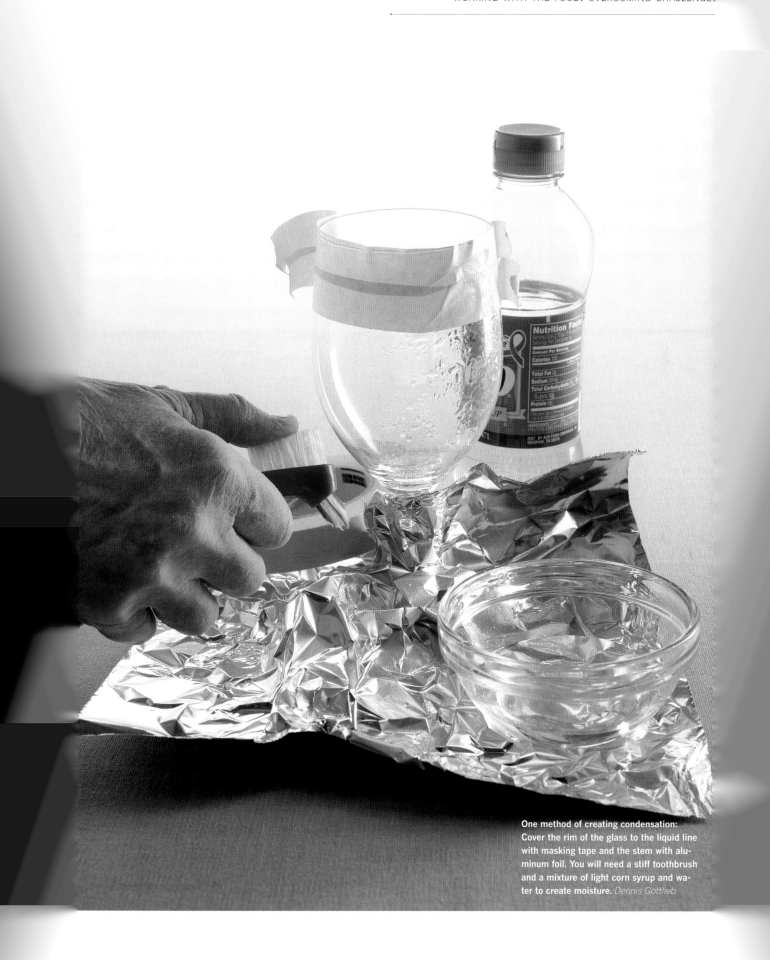

One method of creating condensation:
Cover the rim of the glass to the liquid line
with masking tape and the stem with alu-
minum foil. You will need a stiff toothbrush
and a mixture of light corn syrup and wa-
ter to create moisture. *Dennis Gottlieb*

TIP *Rain Dance and Turtle Wax can be rubbed inside and outside a glass to keep the liquid inside from leaving a line. They also help make good moisture droplets and water beads on the outside of a glass. Caution: toxic; do not swallow.*

life, when we see condensation on a stemmed glass of white wine, for example, the condensation is only where the beverage is; it is not above the liquid line or on the stem or foot of the glass. To prevent your spritzed moisture from going above the liquid line, first check to see the height to which the liquid will be poured. Then, cover the outside top (or empty) portion of the glass with masking tape or painters' blue masking tape. Cover the stem or base with aluminum foil. If you are preparing a lot of glasses, it helps build a three-sided protected area (by using a three-sided box or surrounding the work area with aluminum foil) just for the spritzing, because the droplets tend to spray over a wide area.

PRODUCING ARTIFICIAL CONDENSATION

The simplest, but not necessarily the best, way to produce condensation is with water in a mini spritz bottle or atomizer. It is important that you find a good mister or spritzer. Each spritzer produces a different look. Some produce small droplets in a very limited area; others produce larger droplets and spray a large area or surface with one release. Find one that doesn't spray a large area because the droplets are then on places you have to clean up. Some stylists and photographers use a solution of 50 percent water and 50 percent glycerin to produce droplets that are bolder. The droplets made with the glycerin mixture can take on the color of the item they are sprayed on, so be sure to check this if you are shooting extremely tight in. For example, the glycerin droplets sprayed on a tomato appear orange in color rather than the silver white of water. Another method for producing moisture on bottles, cans, and glasses is to use a mixture of ten parts light Karo syrup (sugar syrup) to one to two parts water, mixed in a small bowl. The more syrup, the thicker the drops; the more water that is added, the more of a dripping appearance that is produced (you determine the look you would like by testing on a non-hero glass). Spritz the container using a stiff toothbrush (found in the denture section of a pharmacy). Different condensation looks will result depending on how stiff the brush is, how quickly you pull your thumb across the brush, and the proportion of syrup to water. Most of the time, I like to have little rivulets running down the glass for a very natural and moist look. I get this effect by having a little more water in the syrup mixture. This is the method I use most frequently (see the photograph on page 293).

When we are shooting opaque beverages and the condensation is harder to see, I use a wooden skewer and straight light Karo syrup, Aqua Gel, or glycerin to form exaggerated droplets along the edges or sides of the glass. Artificial "condensation" will last all day and will wash off easily when you are finished shooting. You can also use a wet Q-Tip to remove droplets if they are covering a label or a necessary highlight.

- Condensation can also be produced by using a steamer machine (or steam iron) and blasting the surface of the container. This gives a very fine, soft, natural look.

- You will have condensation on a glass if you refrigerate it and then take it out of the refrigerator just before shooting. Trengove Studios (see Resources, page 386) also has solutions—Jack Frost and Aqua Frost—that you can spray or brush on mugs to give them a frosted look. Their Crystal Ice water crystals can also be turned into small "ice chips" that can be attached to "chilled" bottles. If possible, it would be

good to visit their studio or go online to view all of their product lines and their suggestions for use.

- Dulling spray can also produce a very fine condensation look.

> **TIP** *Use Arrid Extra Dry spray-on deodorant for creating mist on a glass. The spray-on powdered deodorant can also produce a bloom on grapes.*

ICING THE SIDES OF BOTTLES, CANS, AND GLASSES

There are shots of chilled cans sitting in a mound of ice or of a can alone, and the client would like small pieces of "ice" attached to the cans. The method we use is to spray the container with Krylon Crystal Clear and then add water droplets, or dot places where you want the ice to form with drops of water and place powdered Crystal Ice on the droplets. The powder will grow and form "ice" chunks that adhere to the sides of the can. Spray the can with additional water to make the "ice" grow (but don't overspray or everything will slide down the side of the container). Another approach is to form the "ice" from ice powder or Crystal Ice and then adhere it to the sides of the can with a small smear of light Karo syrup.

WORKING WITH FAKE ICE CUBES

When styling major beverage shots, you will most often use fake ice cubes. There are two major reasons for this. First, they don't melt, and second, they are very clear and produce beautiful highlights and reflections, something homemade ice cannot do.

The best fake ice cubes are made of hand-carved acrylic and are sold or rented (see Resources, page 386). It is good to have cubes in a variety of sizes and shapes for filling any size glass; wedge shapes are particularly useful for showing more interesting arrangements. It is the responsibility of the photographer to supply the fake cubes. Some photographers who shoot a lot of beverages have their own collection stored in special foam containers. Care must be taken with the cubes because they can be scratched and, if left in some beverages too long, they will absorb the color of the liquid.

SPECIAL EFFECTS FOR COLD BEVERAGES

There are other items that can help produce effects needed in beverage shots. These include fake splashes, pours, bubbles, and drips, many of which can be custom made to your desired size, shape, and color (check your area for sources or see Resources, page 386). Other useful products are ice powder, which is used to produce a frozen margarita that lasts all day (see the photographs on page 69), and Crystal Ice, for producing small chunks of ice (see page 135). Other chemical products produce frost, steam, foam, and shiny sauces. All of these effects can be made for real and often look better, but it is a trial-and-error process that takes time. With digital photography, however, you see the results right away and know if you like a particular natural effect.

If you want a splash that results from pouring a liquid into a glass or cup, do this by solidifying the beverage in the container using gelatin. When you pour the liquid form of that beverage onto the firm surface, you will produce a splash. Splashes that are a result of an ice cube dropping into the beverage can be made naturally. It may take several attempts to get the desired effect,

> **TIP** *If you want to shoot real ice, try to purchase sculpting or ice-carving ice because it is very clear and doesn't read "cloudy."*

a cold beverage shot, in nine steps

1. Determine the height of the liquid and cover the glass above liquid line if using artificial condensation.

2. Prepare condensation on the glass if using syrup mixture. Remove the masking tape.

3. Add a straw or swizzle stick, if using, and arrange fake ice (do you want to see ice against the glass and where?). Arrange internal garnishes, such as lemon circles, attractively in the glass.

4. Put the glass on the set and light the shot.

5. Pour the liquid into the glass to the liquid line as seen from the camera angle and light it.

6. Rearrange the ice, if necessary.

7. Add external garnishes, if using.

8. Add bubbles or foam, if desired: Photo-Flo forcefully squeezed into the beverage with an eyedropper, or soap suds mixed with a little of the liquid and spooned onto the surface of the drink for that just-poured look.

9. Shoot the beverage.

but it can be done (see the photographs on pages 84–85). Movement on the surface of a beverage can be made with an air gun or Dust-Off.

Pours are produced by a variety of methods (see page 295). Some are real pours, but at other times, the bottle or container is suspended where it needs to be in the shot and the liquid is poured, on cue, into the back of the container, which is out of camera view. Each attempt is a hit or a miss, and often a mess.

the Problem

- The color of the beverage must be appropriate.

the Solution

Sometimes when you are shooting a beverage— for example, red wine—the beverage looks too dark, even black, on film; you may need to thin it with water to lighten it. If you are shooting iced tea with fake ice, the lighting and ice will make it appear thinner, so you may want to make it richer looking by using Kitchen Bouquet or a tea that has been brewed longer than usual. Always prepare the beverage or cocktail for real first, and then you can make it darker or lighter, depending on the desired look. When the beverage is on the set and lit and you want a change in color, instead of moving the glass and starting all over again, use a medical glass bulb baster to remove some of the liquid. This is a baster with a strong suction, which doesn't dribble. (You can extend the length of the baster by attaching a straw to the base.) Adjust the color of the liquid with a diluted or richer mixture.

Milk can read bluish if it is not whole milk. If the assignment is selling 1 percent milk, use it, but if you are using a generic glass of milk next to some cookies, use whole milk. I sometimes use half-and-half for an even richer look.

the Problem

- If you move some opaque beverages, such as milk or tomato juice, they may leave a ring on the glass, which is not appealing unless it is intended.

the Solution

Bring opaque beverages to the set only three-quarters full and add the remaining beverage on the set.

the Problem

- Beverages can evaporate over time, so you may need to top them off before shooting.

the **Solution**

When you pour any liquid or top off a beverage on the set, have a pouring cup that doesn't dribble. If I am pouring beverages over ice, and using fake ice, I pour into the back of the glass and use a funnel so that there are no splashes.

GARNISHES FOR COLD BEVERAGES

With the increased popularity of cocktails, you need to come up with creative ideas for drink garnishes. Collect beverage pictures showing interesting or unique garnishes. No longer is a circle of lemon or a wedge of orange the only possible garnish. If a garnish is not suggested in a recipe, it will be up to the stylist to offer some options. Presenting four or five visual examples of possible garnishes to the client or art director is helpful.

Garnishes can be anything from umbrellas to mint to star fruit to whipped cream dollops. Try to find books with garnish suggestions to get you thinking. I have used Jenny Ridgwell's *The Book of Cocktails* (see Resources, page 377) as a reference for typical garnishes and types of glassware used for various drinks.

the **Problem**

- You are shooting drinks that need to be topped with a dollop of whipped cream.

the **Solution**

For opaque drinks, use a clear plastic disk that fits just below the liquid line as a support to hold the dollop or other weighty garnishes in suspension. In glasses that diminish in circumference, you can place the disk in the glass after pouring the liquid. If it is a straight-sided glass, use the clear plastic cubes that most photographers have. Place a little Fun-Tak/BlueStik on the bottom of the cube and glue it to a circular disk, slightly smaller than the circumference of the glass. The top cube should be just below the liquid line, acting as support for a garnish.

In clear drinks, a disk that is glued to the back of the glass at the liquid line will work as a support. Other techniques include using a strong glue to attach a straight pin to the back inside surface of the glass where you want an olive or lemon twist to float and attaching the garnish to that. With digital photography, many effects can be added in layers to a photograph of a clear drink.

the importance of having a variety of garnishes

When I mention offering a variety of garnish possibilities to the client or art director, if the budget allows, do bring in a variety. An example: On a recent job, the art director didn't like "the mint with the pointy ends." She wanted "mint with round leaves." Luckily for me, I had three potted varieties of mint for her to choose from.

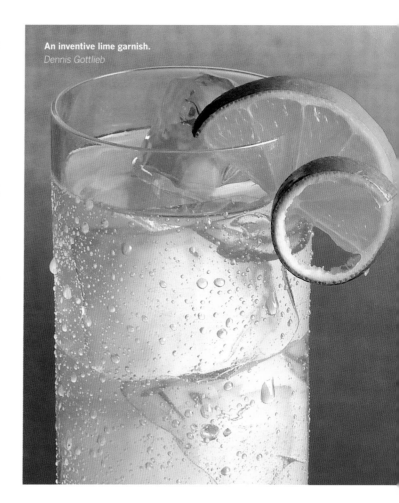

An inventive lime garnish.
Dennis Gottlieb

when only a lemon (or lime) will do

Always consider the size of the glass when you choose the size of lemons or limes for wedges or slices.

When making slices for a garnish, I have found that most of the seeds in a lemon are at the blossom end of the lemon. Therefore, I cut my slices from the stem end and take advantage of the yellow skin, which shows when I cut toward the end of the lemon.

The texture and color of the skin on a lemon needs to be just right for that perfect twist that is just the right thickness, width, and length with the perfect swirl dangling on the edge of the glass.

Sometimes the twist hangs on the glass naturally. When it doesn't, we attach it with mortician's wax or Fun-Tak/BlueStik. For garnishes that will not float, we need to add supports, such as plastic disks or cubes.

Lemon and lime garnishes offer many possibilities.
Colin Cooke

TIP *Add Foam Booster to a beverage and whip or whisk vigorously to create long-lasting foam. When you are using it as a beer foam, make sure it matches the type of foam your beverage produces. Bartender's Friend (foamy) adds a little extra foam.*

Cool Whip works well for whipped cream dollops. Prepare the dollops of choice on a flat movable surface (see the photograph on page 181). When it is time to garnish the drink on the set, use a spatula to lift the dollop from behind and then carefully slide it into the drink. If the dollop is dusted with cocoa powder or garnished with chocolate curls, you may want to do this before putting the dollop on the beverage.

The Major Cold Beverages: What They Are and Their Unique Features

BEER

If you are selling beer, you must, of course, use the brand you are selling. If you are not selling a particular brand, but putting a generic glass of beer in a shot, you can use any beer you choose. Beer comes in many colors, flavors, and types. Each beer produces its particular kind of foam or head; some have very big bubbles that are short lived; others have very small bubbles and a soft and creamy look. Each beer company has a gold standard for the look it wants to accomplish—the height of the foam, the top to the head (flat or rounded), and so on. Usually, for a generic shot, I will use a light, clear beer, such as Budweiser or Amstel Light.

Beer foams best when poured at room temperature and from a slight height into the middle of the glass. You may want to practice with different brands to see which works best for you and how long the bubbles and foam last. Glasses that are not squeaky clean produce carbonation. Thus, some photographers spray the inside of glasses with Krylon Crystal Clear to produce carbonation. Cleaning a glass with a paper towel that leaves lint behind will also produce carbonation. Some companies want the carbonation, while some do not.

If a beer has sat for a while, a small amount of fine salt can be sprinkled in to reactivate the bubbles and foam. Stirring will also reactivate the beer, but stir only once. A powder called Foam Booster is available that can be whipped with a little beer to produce a stable foam that lasts for quite a while. Foam Booster works best with already carbonated beverages. If the beer has become flat and the glass needs to stay in place, use a glass bulb baster to remove old beer and pour a fresh beer. The very best beer looks are usually ones that are poured

anatomy of a pour shot

Pour shots can be liquid pours or pouring food items such as cereal (see Tip on page 186). Pours are a team effort. Liquid pour shots can be done naturally, which usually requires many attempts, the right-shape prop, and lots of cleaning up. There are times we want a pour and splash. With the splash, we firm up the base liquid in the container with gelatin so that when a liquid is poured on, a splash results. You need to play around with the height of the gelled liquid and also the source of the poured liquid (the size of the opening and the distance from the container). For a more controlled shoot, fake splashes and pours can be purchased. Models can be made of food that needs to be shot in specific and unusual ways. It is a myth, however, that food stylists use fake food all the time. We rarely do.

for real and shot right away. The foam is the most natural, as is the crispness of the drink. If you need to have foam going over the side of the glass, break the surface tension of the foam by putting a little vegetable oil on the rim of the glass where you want the foam to flow down. You can also spoon some fresh foam over the edge of the glass.

CARBONATED BEVERAGES

You want to capture the bubbles and fizz of soft drinks, such as Coke or Sprite, when they are poured into a glass. Best is to pour and shoot. Next best is spraying the inside of the glass with Krylon Crystal Clear, which will help hold the bubbles to the side of the glass, and add "foam" just before shooting. Adding a little fine salt can reactivate the carbonation just before shooting.

CHAMPAGNE

Good-quality Champagne has small bubbles and produces a short-lived, white, foamy head when just poured. If you are selling Champagne, use the product. On a low-budget job, I have been known to use ginger ale as a substitute.

TIP *The oil skin that forms on the surface of cooled real coffee can be removed by adding a little Photo-Flo to the surface.*

COCKTAILS

In the 2000s, there has been a resurgence in the consumption of and interest in cocktails, with many new ones being invented all the time. Bartenders are beginning to be known as liquid chefs and mixologists. You will want to learn the typical type of glass a cocktail is served in as well as its typical garnishes. Get recipes. Make the recipe for real, but make four times the amount. This will give you more to work with if the glasses are bigger than usual or if color changes need to be made. Always reserve some of the real drink as a reference. Bring clear plastic cups to use to play with different color possibilities. If you know the size of the glasses, this will help you with the garnish sizes. If you don't have this information, bring a variety of sizes and a variety of garnish ideas.

beer tales

In the early days of my career (we called that time the golden '80s), I worked with photographer and director George Cochran. He had a large beer account and developed a special technique for working with beer shots. He had someone in special effects design a suction pump that would automatically turn on when he put the nozzle down in a glass. He would sit on the set next to the glass, pour the beer, and click the shutter of the camera at the exact moment for just-poured beer. Then he would pick up the suction pump, remove the beer, and begin again, producing twenty or more shots of beautifully foamed beer in an hour's time—all by himself.

TIP *Whisk clear liquid dishwashing detergent to create foam and spoon it onto a beverage. Whisked in with detergent, glycerin makes bubbles larger and foam last longer. Spoon slightly beaten egg whites onto a beverage; watch for possible color change, if it is a clear beverage. If you whisk any of the above with some of the beverage, the foam will take on a little color from that beverage.*

ICED TEA

Bottled iced tea works fine, but if you are making home-made iced tea, there are two problems. First, if you try to cool it too quickly or put it in the refrigerator before it reaches room temperature, it may become cloudy. Second, real tea is produced by extracting the flavor and oils from tea leaves with hot water. As tea cools and sets, often its oils will float to the surface of the beverage. If doing a generic shot of tea, I use bottled or distilled water and a little Kitchen Bouquet for "tea" that doesn't get an oily surface (see also the photographs on page 288 and below.)

SMOOTHIES AND OTHER "FROZEN" OPAQUE BEVERAGES

Smoothies may melt or become thin or separate upon sitting. It is best to get all the details of the shot worked out with a stand-in and then make and shoot the hero quickly. Some thickening agents, such as Styling Starch and Wonder Powder, may prevent separation and thinning. I have used part of a banana to thicken and hold some blended smoothies. The acid in some drinks will affect the way different thickeners work. It is best to practice at home to see what works best.

It is good to have a strong, high-quality blender. Start with crushed ice, if using it in the drink, rather than whole cubes. For drinks such as frozen margaritas, either make them for real and shoot very quickly or use ice powder and mix it with margarita mix for a "frozen" drink that will sit for an hour or more (see the photographs on page 69).

Many drinks in shades of gold and brown can be imitated with a mixture of Kitchen Bouquet and water in different proportions. *Dennis Gottlieb*

WATER

Water from the tap is often not clear and develops bubbles on the inside of a glass if it sits for any time. In the "olden days," photographers used vodka in place of water so that no bubbles would develop as the liquid sat. Today we usually shoot faster, but using distilled water will also prevent bubbles. Distilled water mixed with drinks will improve the clarity of those drinks.

WHITE WINE

White wine varies in color, depending on the grape variety. A chilled white wine poured into a glass on a humid day will produce a beautiful soft condensation. This is the best and the most natural look. Once in a while on a shoot, someone may suggest that a glass of white wine or a cup of coffee would be nice in the shot, and we have not shopped for this. A quick white wine can be made with clear water and a little Kitchen Bouquet. The more Kitchen Bouquet, the richer the wine. We can go from a light sauvignon blanc or fumé blanc to a richer Riesling or port just by adding a little more KB.

The Major Hot Beverages: From Coffee to Tea

The major hot beverages are coffee and tea, with hot chocolate and a few hot cocktails added to the list. Unless the drinks will be sitting on the set a long time before shooting, try to shoot them naturally. Steam is the element that suggests heat (see page 298). However, if you are not shooting with a dark background or if the beverage has foam or a whipped cream topping, you will not see the steam. Steam can be stripped in using Photoshop, or it can be created on set.

COFFEE

As a result of the proliferation of coffee franchises, we are shooting a lot of specialty coffee drinks. Froth on coffee is best produced with skim or 1 percent milk, which hold up better but are a little more white in color than whole milk. It is best to have a good steam machine, but lacking a steam machine, a Froth Wand or Café Milk Frother works very well. Heat the milk to just above room temperature and use the wand to incorporate air into the milk. The milk will thicken and can be spooned onto the beverage. If the froth doesn't hold as long as needed, Photo-Flo added to the warm milk before frothing is helpful. The thickened or aerated milk will stay that way for a short period of time, but sometimes you will need to start again with fresh hot milk because the old frothed milk will not become thick again. Just clean the hero cup and begin again. If frothing produces a few bubbles that are too large, they can be popped with a clean cotton swab. Practice is important for designer looks of froth on lattes and cappuccinos. If you will be topping the froth with cocoa or cinnamon, do it at the last minute.

I do use Kitchen Bouquet in place of coffee for ease of "brew" and color choice. KB coffee doesn't get an oil skin on the surface as it cools. However, I have found that using KB doesn't look as natural as real coffee if you are adding cream. You can produce bubbles in the coffee by using an eyedropper and Photo-Flo forcefully squeezed directly onto the edge of the coffee in a cup, or whisk a little coffee with Photo-Flo and spoon it onto the surface where needed.

TEA

You will show plain tea or tea with milk. A lot of specialty teas are becoming popular, so become familiar with their recipes and how they are made. Kitchen Bouquet can be used to make tea as well.

so you want it to look hot?

There are several ways to produce steam.

- Make a small boat out of aluminum foil. Place a small amount of steam chips such as Z-Smoke Tablets in the boat. Hide within a food or behind beverage. Add drops of water when you want steam. Caution: Z-Smoke Tablets are toxic; do not swallow or inhale fumes.

- Run a hose from a teakettle to a hole in the bottom of the prop.

- Hold the nozzle of a commercial clothes steamer over the food and remove it just as you are ready to shoot to produce natural steam.

- Heat a water-soaked Tampax in the microwave and place it behind the food or beverage.

- Microwave the food or beverage just before shooting for natural steam.

When forcefully squeezed from an eyedropper, Photo-Flo produces bubbles for a "just poured" look. *Dennis Gottlieb*

297

HOT CHOCOLATE

Hot chocolate tends to separate, so it is best stirred and poured just before shooting. It is usually topped with marshmallows or whipped cream. The marshmallows will float and they will melt if the beverage is hot, which can give a nice effect. The whipped cream topping may need a support (see the photographs on pages 286, 293, and 294).

the LOWDOWN on SPREADS
Producing Mounds, Swirls, and Ridges

There is a key to understanding how to present a spread of everything: margarine on an ear of corn, soft cheese on a cracker, cream cheese on a bagel, peanut butter on a slice of toast, or frosting on a cake. The same principle applies for putting a meringue on a pie or baked Alaska, or presenting a dip with crudités, a cup of pudding, or a mound of mashed potatoes as well: Keep it smooth, keep it simple, and create interesting swirls.

Most of the time you will start with a smooth surface on the dip, frosting, or spread and add swirls with the back of a spoon or an offset spatula of the correct size and flexibility. The reason you need to begin with a smooth surface is that the photographer's lights pick up any ridges in the food. You want to keep the ridges and swirls to a minimum and placed just where you want them. This produces a smooth and creamy appearance rather than a busy look that suggests "thick" and "fussy."

Making smooth spread or swirls may seem deceptively simple, but it is always good to practice. Look at shots of similar foods and see what works and is visually appealing and mouthwatering.

To produce a bowl or cup of pudding or a tub of soft margarine, it is important to have the right size spoon and the food at the correct consistency. If the food is too

Smooth, flowing strokes are more mouthwatering and visually appealing than short, busy strokes. *John Montana*

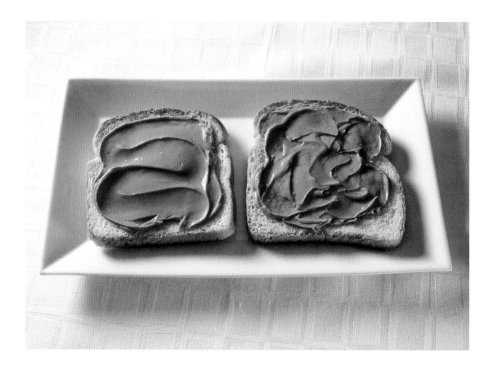

thick, it will not flow smoothly from the spoon and if it is too thin, it will not form ridges or mounds. Fill the container almost to the height you would like. Gather a smooth mound of the food on a spoon and, beginning at camera back, start a round mound along the edge of the container in one continuous motion until you come to where you began. A revolving cake stand with the container placed in the exact center will help produce an even turn of the container. Gather a second smooth mound on the spoon and, again at camera back, start a second mound just inside the first. Continue this process until you have filled the container. Finish with a slight flip in the middle.

Don't be afraid to keep trying until you get mounds, swirls, ridges, and frosting patterns that you like. Put the finished product on the set to see how the photographer's lighting affects the appearance of your work. Soft lighting produces a very smooth appearance, while harsher lighting shows every little bump or nick in the product.

FROM LEFT:

It is important to have a spoon of the right size. Too small or too large can make smooth strokes difficult.

Make sure that the surface of the pudding on the spoon is very smooth before adding it to the bowl.

The smooth chocolate pudding on the left is more appealing than the busy pudding on the right.

Dennis Gottlieb

ETHNIC foods
Doing the Research for Authenticity

If you get an assignment to work on certain ethnic foods that you are not familiar with, you will need to do some research. Textbooks, specialty cookbooks, online information, and friends or chefs who are familiar with the food are all helpful sources of information about unfamiliar cuisines. Often what is necessary is not just following a recipe but also knowing traditional accompanying dishes, beverages, how the food is presented, typical utensils and serving dishes, and any dos and don'ts. Each country has food traditions that are important to understand. The out-of-print Time Life *Foods of the World* series is one very good resource, if you can find it.

Sometimes the food is prepared using unusual equipment or techniques. Sometimes the techniques take practice to perfect. Whenever possible, have someone who is familiar with the food assist you on this type of job. Being Scandinavian, I am very familiar with making *lefser* (a flat, almost tortillalike soft bread made with a potato base) and *aebleskivers* (ball-shaped pancakes) and some other Danish and Norwegian

foods. These foods are not often photographed, but when they are, I can tell if the stylist is familiar with and skilled in making these foods just by looking at the picture. I know it is the same with any other ethnic foods. Do your research, look at pictures, and practice. One of the things that makes our career joyful is that we are always learning and enjoying new tastes.

VOLUME food
Shooting Family Style

When you shoot a large amount of food in one shot, you can treat it in the same way as you would if you were just shooting a plate of food and a beverage. You begin by working with the food that will last the longest and work to the most fragile. As you organize your assignment, always keep this in mind. Shots with volumes of food are the least appealing to me, but when they are assigned—a family sitting around the Thanksgiving dinner table, for example—I start with the bowl of fruit or nuts and work with the fragile garnishes last.

one table, fifty italian cooks

One delightful assignment was to fill a fifteen-foot-long buffet table full of Italian foods for a shot for a credit card company. Behind the table would be fifty of New York's top Italian chefs and restaurant owners. Since we had a large space to fill with food, we decided to feature a whole opened wheel of Parmigiano-Reggiano cheese and a whole prosciutto in a large marble-based prosciutto stand. A convention of fancy food purveyors was happening at the same time as the shoot, so the organizers provided us with the wheel of cheese, and I got the tools and a lesson on how to open or crack the wheel. (I was also given the heart of the cheese as a special treat.)

The group of fifty consisted of men dressed in muted suits, except for the one woman restaurant owner and chef (and the mover and shaker in the group) dressed in a beautiful yellow dress. Women were just beginning to enter the restaurant world. It was an honor to work with one of the pioneers, and a very generous one at that, Lidia Bastianich.

ugly is a whole poached chicken

Our hardest assignments are when we are working with food that is not in itself attractive. Some cultures produce marvelous-tasting foods, but if the foods are in a stewed form or boiled or mashed, they can be a challenge to photograph.

I once had an assignment to prepare a whole boiled chicken on a platter. A whole un-cooked chicken is not that good looking, but boil it covered in a broth and it is worse. The only redeeming part of the shot was that I was able to use side dishes as a garnish around the chicken, and that helped. We shot it from a low angle with lots of garnishes. In the completed shot, only a small part of the chicken was visible.

UNATTRACTIVE food
How to Beautify It for a Shot

Not all foods are naturally visually appealing; in fact some are really ugly. However, we forgive them because they taste delicious. But we still have to style them. So what do we do? Thank goodness for terrific props, beautiful lighting, tight shots, and soft focus. An example of an unattractive food is lasagna. Lasagna, when dished up hot, falls apart and the red sauce combines with the ricotta to form a very unappealing mixture. When we shoot a slice of lasagna, I work with room-temperature food and take it apart and put it back together, building a tall, firm stack. Then I gently microwave it to have it look cooked and to melt the top cheese just before shooting.

Other unattractive foods include oatmeal, a large whole slab of cooked red meat or a meat loaf, the fruit at the bottom of a cup of yogurt, and a chiffonade of basil that is more than three seconds old. Some (certainly not all) packaged cookies are not all that inviting; the contents of a can of salmon, refried beans, a separating smoothie, grilled portobello mushrooms, precooked sausages, and a whole poached chicken can all be included in the list. With any of these foods and others, help from the team (prop stylists and photographer) and skilled food styling can turn "a sow's ear into a silk purse," and this we often do. Remember, there is magic in the camera's eye if we just help (see the photographs on pages 80 and 187).

PULLING IT ALL TOGETHER

There are a few full-time jobs for someone working as a food stylist. Some food companies have in-house stylists; some magazines do as well. Once in a while, if a magazine or company likes your work, it can keep you busy at almost a full-time pace. Usually, however, you will be establishing a business and cultivating clients on your own. This chapter takes a look at how best to get started as a food stylist.

THE BUSINESS
of food styling

the ENTREPRENEUR

Beginning Your Food Styling Business

Starting out as a freelancer can be exciting and sometimes daunting. You are finding or getting work one job at a time. Earlier I wrote about the need for financial support during the start-up time, and I discussed the type of personality that works best with this type of work. The more you know before you step out on your own, be it through books, classes, or assisting, the better.

There is always the temptation to get right out there and make the bigger salary, but whenever you can, try to assist an experienced stylist. Whenever possible, work with a variety of stylists. Each of us works differently, and you will gain skills and knowledge from us all. Even though the pay may not be as great as you might like, the knowledge you gain will be more than worth the lower salary if you are observant. Besides knowledge and skills, you will gain a comfort level and confidence as you get ready to work on your own.

When you assist, you gain experience in how to work in a studio or in production. You gain knowledge of how to organize and pace your work. You learn how to work with a particular food and the importance of visualizing a recipe for presentation. You meet people in the field, clients, and photographers. You learn a vocabulary. You learn how to shop for an assignment. You learn whether you really like this work and would want to be a food stylist. You learn whether you are best suited for production work or for print, or if you prefer a variety. The list is almost endless as to what you can gain as you assist.

Putting together a written plan of action helps. Just the act of writing something down helps you establish your goals and become more directed. While establishing yourself and assisting, you may want to hang on to other food-related "fill-in" jobs, such as working for a caterer, as possible sources of income. Test, test, test with photographers. Think about what you can do on your own or with a photographer to produce promotional material or real work. I have listed a number of areas where you might use your food styling skills (see page 319). Maybe you could volunteer to help create a calendar for a charity, assist a food writer who has to provide photographs for articles, or produce a food poster on nutritional foods for a school. Perhaps a jewelry designer you know is beginning to design food-inspired jewelry. Would this make an interesting gift for potential employers? Could a food company use the jewelry as a marketing gift with their product? Suppose that you make the world's best banana nut bread. Bring a loaf along when you meet with a photographer for the first time. He or she will remember you. Analyze your skills and be creative in thinking of how to use your skills and knowledge to meet people and create jobs. Today, many people are developing interesting food blogs with pictures, which may lead to potential clients. Don't be afraid to think outside the box.

Find support from friends, join organizations where you can network, and remember that it usually takes time to become established. If your skills are good, and people enjoy working with you, and you are persistent even in a tight market, you should be able to step into the field. One of the joys in life is finding a career that you *love*.

How to Be a Good Food Styling Assistant

Below is a list of some of the attributes I like to find in a good assistant. As you look over this list, which I compiled with several of my assistants, remember that we all chuckled as I observed, "It looks like we are asking more from an assistant than from a marriage partner." The list may seem demanding, but lead stylists have all worked as assistants, and these attributes will help you find and retain assisting jobs. To be a good assistant, it is important to be:

- Good at general skills in cooking, and especially baking
- Organized
- Able to take instruction
- Able to anticipate needs
- Neat and a good dishwasher
- Attentive and a good listener
- On time and reliable
- A good shopper, willing to go the extra mile to find just the right item
- Patient
- Good at asking the right questions
- Sociable and aware of others
- Able to accept that you are on the job for the day and sometimes the night
- In good physical condition
- Able to give 150 percent (you are freelance and need to excel, not just get by)
- Careful and precise
- Able to give suggestions when needed
- Careful not to be too talkative
- Able to know when to slip into third gear (in other words, speed things up)

And if you've nailed all of the above, we would also like you to have a good attitude and be fun to be with. You may want to compare the above list with the list of attributes for being a good food stylist (see pages 9–14). Some are the same, while others are different.

Being a good assistant was a topic of a seminar I once attended, and the following were suggestions submitted by other stylists:

- Be pleasant and well rested.
- Dress for the job. We work casually, but if you are working at a food company, the dress may be a little less casual. Be prepared to layer. Some places we work might be quite chilly. Sometimes we are working over a hot stove.
- Have a car and a valid license.
- Have a valid passport.
- Have your own styling kit and knives. Some stylists may want you to bring your own. Others don't mind if you use theirs, as long as you put things back where they belong and you "know which scissors are for food only and which are for fabric or paper only."

- Bring your own apron.

- Know food and prop sources.

- Know how to to pick the best and most appropriate foods, as well as the amounts needed.

- Keep yourself busy on the shoot—there is always work that needs to be done.

- Try to be one step ahead.

- Keep the work area organized and clean.

- Never give the client your résumé or business card on a job. The stylist you work for hired you. Promote on your own time. Don't steal a client from the hand that feeds you.

- Double-check the studio at the end of the shoot to make sure all equipment is packed and the work area is left clean. Leave food at the studio only if the photographer wants it.

- Share your opinions, but remember there is a diplomatic and respectful way to present them.

- A chatty or uninterested assistant reflects poorly on the stylist.

- Send your invoice to the stylist or photographer in a timely fashion. Deal with receipts before you leave the job.

Be readily reachable to accept or refuse an assistant's job. Try your best to be available. If you say no too many times, you will go to the bottom of the list.

How to Find Assisting Jobs: Look for Us in the Gutter

If you live in a large metropolitan area where there is a lot of food photography, it will be relatively easy to gather names of food stylists who work there and to begin making calls, sending out résumés, and following up with "prompting" materials (see page 309) to secure assisting jobs. Gentle persistence is what we call it.

Following are ways to identify the names of and contact information for lead food stylists:

- Go online and search "food stylist"and your geographical location.

- Look at the list of names of food stylists and photographers in the online directory of the International Association of Culinary Professionals (www.iacp.com).

- Get a copy of the *Workbook* (see Resources, page 376), or consult its Web site, and check its lists of professionals in the field.

- Consult local television production guides, which list food stylists who work in TV and film.

- Look for food styling credits in food-related and lifestyle magazines. Food stylists are often given credit for work on the cover and sometimes for the work inside as well. Sometimes the credit is in the "gutter" (the area where two pages of the magazine come together).

- Talk to food photographers when you are approaching them for test work and see which stylists they like to work with.

- Locate local professional culinary organizations, which may have directories.

- Check with culinary schools to see whether they have connections or internships with stylists.

- Network. Join culinary organizations. Take culinary classes. Try to find out who has styled projects for various assignments. Let one contact lead you to another. Try to make it a win-win situation when someone has helped you.

If you live in an area where there are few professional photographers, finding work will be harder. Often, if there are stylists in the area, they don't take on assistants or don't want to share their knowledge. You will need either to be willing to travel to where the work is or to be creative and start small, doing a variety of food assignments (see page 319). Testing with photographers can lead to food styling jobs as well (see page 310).

I have often suggested that on cold calls to stylists, besides sharing information about any assisting work you have done, to "get your foot in the door" you might approach the stylist with this offer: "I know that you probably run across jobs that don't have a budget for an assistant but where you could really use one. I hope you will think of me in that instance. I would love to work with you. I'm a good shopper, love to prep recipes, keep the kitchen organized, and do dishes. If you could use a free hand sometime, please give me a call." Keep in mind that assisting is a learning experience for you, so your willingness to work for free a couple of times might just get you the job.

Once you've made contact with a photographer or stylist, it's a good idea to follow up with prompting materials. These can include:

- Fun food note cards or postcards with a brief message describing work that you have just finished and delivering the "hope you will keep me in mind" message.

- Food articles you think the stylist might find useful or enjoy.

- A recent test shot.

- A coupon with an offer of free help for a day.

- One assistant I know brought smiley-face cookies with a note that said, "This is how I will look if you hire me," to every photographer she approached to test. When you approach a photographer to test, come with ideas and maybe picture samples, but be amenable to what the photographer would like to test.

- A business card–size computer disc that holds your portfolio.

- A clever thank-you note for your interview (Yes, snail mail. It still works).

Remember: This is your chance to be creative.

TESTING
Its Many Values to the Food Stylist

What is testing? Testing is when a photographer, food stylist, and perhaps a prop stylist spend the day shooting photographs of food for themselves, their portfolio, their Web site, or possibly a promotional piece. Each person involved brings his or her ideas and skills for a day of playing.

When I first started out as a food stylist, testing was of little interest to me. Now, it is one of my favorite days spent in a studio. This is my time to be creative, to try different ideas. With digital photography, we don't have to worry about film costs, and we know right away the results of our shots. No money changes hands. As a food stylist, you supply the food and sometimes props. The photographer provides the studio and sometimes props and the final images for each participant to use.

LEFT: Seeing sunflowers at the farmers' market inspired me to create this sunflower tart for a test shot in the 1980s. *Dennis Gottlieb*

RIGHT: In 1999, the *New York Times* contacted me for an article about food styling. They liked the shot of the sunflower tart, but I wanted to update it for a more contemporary look with fewer props. The tart really shines in this single-subject shot. *Corrine Colen*

These test shots produced many shooting assignments with a cereal client for the photographer and myself. The unusually propped cereal (AT LEFT) is more appropriate for an editorial project. The same cereal shot from overhead with different props (AT RIGHT) now looks more suitable for advertising purposes. *Diane Padys*

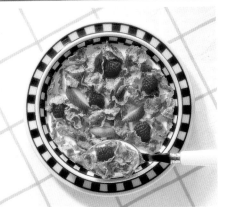

Why Photographers Test

Photographers need to update their Web sites and portfolios because images can become dated.

They may be bidding on a project of specific food images or a particular product and they need examples of that specific food or product in their portfolio.

They may have a client asking them to produce a look that requires a technique they haven't shot before. Testing is a good way to prepare for that.

They may want to try working with a stylist first before hiring him or her for a job, or they may know a stylist who has special techniques they would like to include in their portfolios.

They may have seen a food image that has inspired them and they want to try for something similar.

They may want to create a portfolio that displays several different styles to show their versatility.

They may need more advertising or editorial images.

They may need new shots for promotional materials (thinking outside the box).

They can use test images to sell as stock images.

They may want to donate an image to a community service, such as a food bank or Meals on Wheels.

LEFT: This beverage shot, inspired by an image from a fashion magazine, looks decidedly fresh and youthful.

RIGHT: After shooting the pineapple for an advertising job, the photographer decided to turn it into a promotional photo after I commented that the shot would make a good jigsaw puzzle.

Colin Cooke

Shooting a pineapple this appetizing can be a puzzle.

Why Food Stylists Test

Food stylists need something to begin or update their portfolios or Web sites.

They may want to work with new photographers and let them get to know their work.

They may have seen certain images that inspire them to try something new and exciting.

They may want to show a visual example of a recipe they developed (see the gingerbread dancers below) or produce a visual aid for a presentation.

They may want to promote a certain skill or technique.

TOP: **I made this pasta colander as part of a series of food container shots.**

BOTTOM LEFT: **This is my coffee bean "cup" of coffee. (A cereal bowl was less successful.)**

BOTTOM RIGHT: **A photographer and I created this test shot of gingerbread cookies, and an art director friend used it and my recipe to design a holiday card. That year, we all sent it out to clients and friends.**

Dennis Gottlieb

getting the creative juices flowing

This is an exercise to get you thinking about how to present a food item in a way that is both visually pleasing and mouthwatering.

Think of a food and then think of the visual clues that make it mouthwatering. What are the flavor and color complements? Are there interesting shapes and textures? Then think of six different ways that you could shoot the food.

Food item:

What makes it mouthwatering:

Flavor complements:

Color complements:

Shapes and texture:

Shot ideas:

1.

2.

3.

4.

5.

6.

They may want to develop promotional material (such as a postcard or Christmas card) and need a striking new image.

They may want to do a favor for a friend, client, or charity. They may test just to be testing and get the creative juices flowing.

Shooting pleasing food images gives everyone a chance to grow. We get to try out new ideas in a non-stressful environment. You'll find that your comfort level improves the more you work. Thinking about testing often makes you look at food images for inspiration, seeing things that work and don't work. It is a good idea to start a folder of images from magazines, cookbooks, and advertisements for reference.

The Process of Testing, from Start to Finish

When doing a test shot, often the photographer–food stylist team must also do the work that would normally be done by the creatives, art director, and prop stylist. We come up with the concept for the test shot(s) and decide on the look—from simple and tight to propped environmentally (with lots of props suggesting a theme, mood, or time and place), and then produce it.

When you decide to test, it is important to choose a photographer or food stylist who will produce the result you want. Look at Web sites, books, and credits near photographs before you make any cold calls. Remember that you—as well as the other person—are offering your skills and time (seldom is anyone paid for this day). Work with photographers who are enthusiastic about a project. It should be a total team effort.

Before the shoot, it is wise to do your homework. When I meet with the photographer to discuss ideas, I often bring visual examples (pages from magazines, cookbooks, and sometimes props) and sketch a simple layout of the proposed shot(s). Work with foods you feel comfortable with or are skilled at preparing. A particular food in season may stimulate ideas. Sometimes I begin with a prop and fill in the shot from there.

You and the photographer must decide what kind of a look you want. Do you want an editorial look with a *Donna Hay* or *Gourmet* magazine feel or do you want an advertising look promoting a particular food? Test sessions have also been known to produce something strange, artful, or very creative. What do you need for your portfolios? What excites you? It is important to make the shot mouthwatering and interesting, not just the usual meat and potatoes on a plate. Sometimes you can get creative on the set and try a variety of ideas. I love to try a shot at least two ways and often several more. Remember that you are there, the food is there, and with digital photography, it's fun and easy to play.

step by step: a test shot of chocolate bread pudding

Bread pudding was just coming back into vogue when the photographer and I decided to do a test shot of a chocolate bread pudding. This is how it happened.

TOP ROW:

We begin by testing for props and environments.

A spoon and a dusting of confectioners' sugar add more visual interest.

I try a different ramekin.

MIDDLE ROW:

We like the taller ramekin better. With the addition of chocolate curls, we feel that we're on the right track.

I add chocolate sauce.

Just a little more sauce...

BOTTOM ROW:

We always try to take advantage of any extra studio time by experimenting with other looks. A very traditional chocolate bread pudding is presented here.

This bread pudding appears very playful.

The last shot before the end of the day.

Dennis Gottlieb

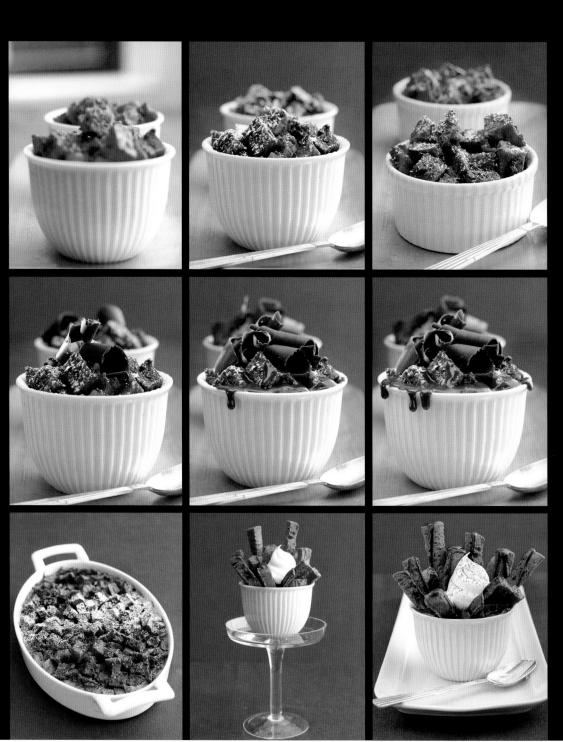

314

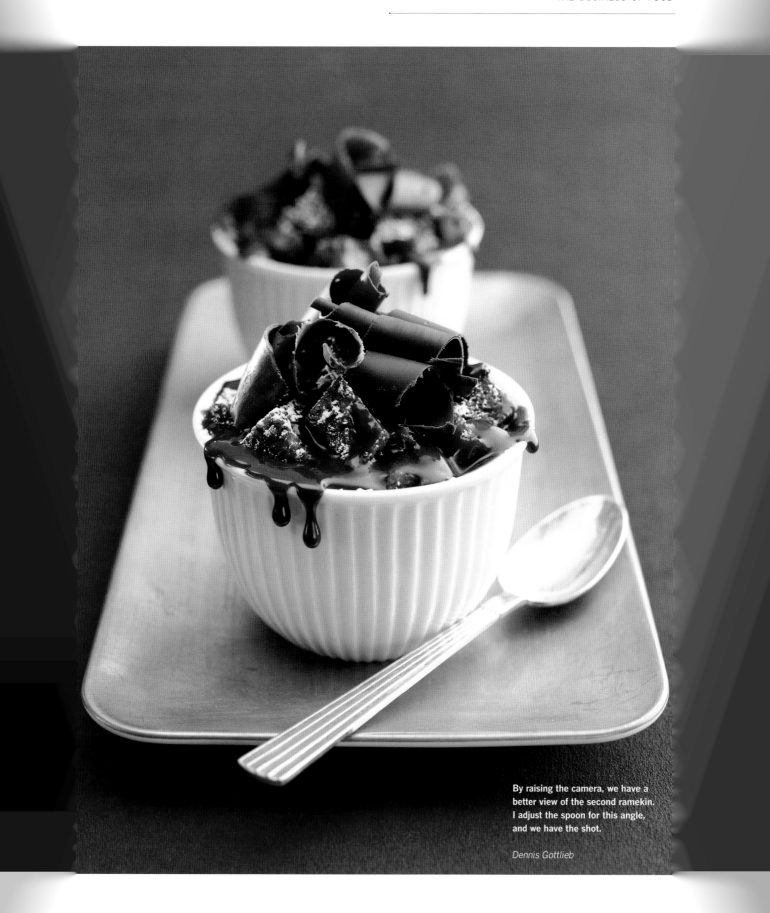

By raising the camera, we have a
better view of the second ramekin.
I adjust the spoon for this angle,
and we have the shot.

Dennis Gottlieb

SELF-PROMOTION

The Five Ps of a Successful Business: Passion, Packaging, Persistence, Promotion, and Production

We will look at what is involved with each of these.

Passion: Food and Working with It Creatively

Lucky are the people who can identify their passions and find careers where they can express those interests. Many are derailed by the lure of going into a profession that is expected of them, or they choose a career they think they will like but later learn they don't. Others choose work that produces a secure income but is unrewarding in most other aspects. Most people who attend my classes are passionate about food and want to see whether food styling fits them. When you are passionate about your work, your work becomes your fun.

Once you choose food styling as a career and gain the skills needed, if you decide to start your own business (as most do), the next step is to promote yourself and your business. As a food stylist, you will readily learn the importance of promotion and marketing. If no one knows you are out there, no one hires you.

Packaging and Marketing Yourself

Before you market yourself, it is important to develop a plan. A few questions begin the process:

- Who are you? What do you do or what do you want to do? Do you want to become a full-time food stylist specializing in editorial work or television production work, or a generalist working in all phases of the industry? Do you want to start with assisting and, if so, how do you find stylists to hire you? Maybe you would like to do some test kitchen work or consult as a recipe developer and include food styling as part of your package. You need to decide and even write down these goals.

- Who buys what you do in your area? Who are your potential clients? As a food stylist, your biggest employers will be photographers, but you might also be hired by public relations firms, food companies, magazines, cookbook packagers, graphic design firms, advertising agencies, and production companies. How can you find these companies and who is the right person to talk to? Remember that you should be talking to a person, not a company, so who is the person who uses food stylists?

- What visuals will attract potential employers? How can you develop a "look" or a style that is different or enticing and speaks of you creatively?

- How do you get these visuals to potential employers? How do you make cold calls and present yourself clearly and effectively?

- Are there promotional materials, such as articles or a cookbook you have written, that you can use to market yourself?

- When you do make contact, how can you leave potential clients feeling comfortable with and confident in you?

- Community service related to food is an excellent way to meet other people in the food world. Think about developing recipes or shooting food photographs for a community cookbook or a fund-raising project, such as Christmas cards or a calendar. Volunteer at local newspapers to help photographers who need food shots but can't afford to hire a stylist. You will probably prop and style. The photographer gets to know you and will use you when a paying job comes along.

Photographers often hire "reps" (representatives) whose job it is to identify potential clients and get the work of that photographer to that client—be it an art director of a magazine, an advertising agency, or a food company. Food stylists in larger cities may be approached by agents wanting to represent them. Some stylists use them, but the numbers who do are very few. Agents have to boost the fee of the food stylist in order to get a percentage for themselves. Often they don't have an understanding of the food demands of the jobs they are assigning or whether they will match the skills of a particular stylist. Most food stylists are freelancers who rely on their skills and creative efforts to bring in work. They prefer to ask the questions themselves and decide if the job is right for them and their schedules.

THREE BASIC SELF-PROMOTION TOOLS

To market yourself, you need to put together visual materials that represent who you are. First of all, you will want to put together:

- **Business card.** You will need a name for your business, even if it is just your own. What do you want that name to represent—you as a food stylist or you as someone who consults, develops recipes, food styles, and provides a variety of services? Will you be working on your own or with a partner? Once you answer these questions, you are ready to make a business card with a look that represents you and your business.

- **Résumé.** Make your résumé as creative and interesting as possible. Say who you are briefly. Highlight important achievements related to food work. The food stylists you approach will be interested in your cooking and baking skills, in particular. You may not use a résumé often, but it is important to have one ready when it is requested. You can put some of this information on your Web site, if you have developed one, but don't overwhelm the site with too much.

- **Portfolio.** Another thing you will need is samples of your work. These can be shown in your portfolio (often called your book) and on a Web site. If you work in television, you will need to put together a "reel," which is a CD/DVD with samples of your commercials. These are all visual representations of your work. This is the "Catch 22" part of the assignment: How do you have work to show without working? Here's the good news. Many food photographers will agree to test with you if they have free time and feel that they will get something interesting for their portfolio as well (see the photographs on page 311). When you do get a request from someone to look at your portfolio, try to learn what kind of food the client wants to shoot and then arrange your portfolio to show off your skills with that kind of work.

YOUR WEB SITE: THE ALL-IMPORTANT SELF-PROMOTION TOOL

Because of the rapid technological changes that have occurred over the last twenty years, a Web site is even more important than a portfolio or book, as more and more jobs are obtained as a result of someone searching Web sites for food stylists and photographers. The most popular site in the field, and one that is used by potential clients, is www.workbook.com. Food stylists are listed there for free but to show examples of their work, they need to pay for the space.

You will want to make your site one that pops up on the first page of search results on Workbook.com or on a search page. You might also want to consider registering with a site such as Google or Yahoo and paying for the privilege of being on the first page. You do this by paying a certain fee for each hit. You receive a monthly bill, and the amount will depend on how many people go to your site. Some stylists feel this works well and some don't. If you have a site, it's very important to update it constantly. It needs to be simple to use and filled with examples that represent a variety of the food styling assignments that you have had. You will want to show shots in an editorial style as well as in an advertising style. If you have a specialty, make it stand out. Standard shots as well as very creative and unusual ones show your flexibility. I know of photographers and stylists who feel that a good Web site is the only way to go, because it gives potential clients an immediate view of your work with no portfolios to mail out. You will want your site to produce a response. State where clients can call or e-mail for more specific information or images. Some photographers custom design their site for a specific client, targeting their work with soups, for example. With a simple plug-and-play program, you can make a template and drop, add, or move images easily. Once potential clients have seen and like your work, they are ready to discuss budgets and dates.

BUILDING YOUR WEB SITE: HOW TO MAKE IT TAKE OFF

When you are building your site, it is good to use your own name in the domain (URL) whenever possible. Unless you're experienced with site building, it is best to hire someone to help put your site together. Prices will vary; anywhere from $600 to $4,000 can be typical, depending on the complexity of your site. Look at Web site examples and at competing stylists' sites. The images you use on your site should be your very best (a few great shots tease and are much better than lots of mediocre shots). Many people make the mistake of putting in too many images; you want potential clients to contact you for more. Try to display the images as large as possible on the screen. Smack the viewer in the face! (Software called Macromedia Flash can resize the image to fit all monitors; many clients now use small laptops for searches.) Have your contact information on every page or a have clickable e-mail link. Make it easy for people to move around in your site. It is usually better to show an image without the copy if it is used in an ad, but if you want to show the work in context, show it as a small thumbnail image next to the clear image. Sound and animation are not suggested unless they are

successful blogging

Heidi Swanson, a photographer in California, has put together an award-winning Web site called www.101cookbooks.com that displays her photographic work, but is also a source of food information. She has combined her skills as photographer, cookbook author, and designer to produce a creative site where cookbooks are reviewed, recipes given, and a huge variety of "foodie" information can be found. She gets thousands of hits a month.

subtle and easy to eliminate. Having forms for people to fill out is considered a negative. It is always good to learn how someone found you, but ask about this once you have the job. Learning how someone searches for you helps you to know where to place your work.

Other things to include on your site are a short biography, a client list that contains food products you have worked on, client names (both agencies and food companies), and a list of magazines and photographers you have worked with, as well as a list of any cookbooks you have worked on. You can offer a link to more images of a particular type and to articles you have written or that have been written about you. If you develop recipes, include this on a page of your site; indicate your clients and show sample recipes and food images.

Persistence in Your Pursuit

As you do with any full-time job, you need to keep finding work and developing your skills. Dedicate a certain amount of time each day or week for cold-calling, follow-up calls, and finding new contacts. Before the use of computer searches, art buyers and art directors relied on three main sources for finding photographers. *The Black Book* was the original source. Published in New York, it listed commercial photographers around the United States and showed the work of those photographers who were willing to buy pages. Later came the *Workbook*. These are both good sources and list photographers by region. The *Workbook* (published in California) has a directory dedicated to everyone related to the art and production world, from advertising agencies, art consultants and artists' representatives to illustrators, photo labs, makeup artists, model makers, and food stylists. The directory is a gold mine of information. The *Workbook* also produces an online portfolio (www.workbookonline.com), where art buyers can look at your work just as they would a Web site. You can find other directories online—for example, the Google ad agency list. This is a directory that is constantly updated.

The reference sections of most libraries contain many directories. The *Advertising Red Books* list advertising agencies and their clients; the *Reader's Guide to Periodical Literature* lists all magazines in print. Periodicals such as *Photo District News* and *Advertising Age* are good sources for what is happening in the advertising world and have information on seminars. *Communication Arts (CA)* is a source for graphic designers. Local directories may be available as well. In New York City, there is the *New York Production Guide* for television and movie work; it lists food stylists who work in production styling. Corporate clients can be found in local newspapers and periodicals.

potential uses for food styling services

Below is a list of possible media that may require the services of a food stylist. They are listed in the hope that they will spark some thoughts about contacts for possible testing or promotional ideas as well as sources for work.

Advertisements	Packaging, food, and cooking equipment
Advertorials	
Billboards	PDF brochures and catalogs
Blogs	Point-of-purchase (POP) displays
Books	
Brochures	Portfolios
Calendars	Posters
Catalogs	PowerPoint presentations
Computer screen savers	
	Press kits
Corporate publications	Stock photography
Desktop publishing	Television (commercials, cooking shows, food segments, satellite media tours)
Direct mail	
Editorial publications	
Gift wrap	Trade show displays
Greeting cards	Transit displays
Newsletters	Web pages
Newspapers	

This postcard is one of my promotional pieces. *Colin Cooke*

Some food stylists are listed in the IACP Membership Directory, production guides of major cities, and at the terrific Web site www.foodesigns.com, which shows the work of food photographers and food stylists. Look for the names of photographers and food stylists in the credits in magazines and books, as well.

Never underestimate the value of word of mouth. It is one of the best ways to get and sustain a good business. If you have been a good assistant, stylists you have worked with will refer you for jobs they can't do or they will refer you to other stylists. Photographers will notice your work and ask you to test or work on jobs with a limited budget.

Other Techniques for Self-Promotion

In addition to the basic ways to package yourself (business card, résumé, portfolio, Web site), you may want to get creative with promotional efforts. Most food stylists and food photographers use promotional postcards that have a favorite image or two on the front and contact information on the front or back of the card (see Resources, page 388). If you are hoping that someone will hang the cards on a wall because of the picture or as a quick reference, then having all the information on the front is helpful. Postcards are good to send out in a mailing, but they are also useful for sending thank-you notes to clients or to people you have worked with on a job. Some photographers and stylists also send out 8½ x 11 photos and recipes that can be put in potential clients' folders for later reference.

Another form of promotion is a CD of your work. I have seen business cards that are CDs as well. Some photographers and food and prop stylists send out e-mail updates periodically. Your hope is that these updates will also go into the files of potential clients, but they at least help the recipient keep you in mind.

Over the years, I have seen many things used as promotional pieces—pencils and pens, notepads, or self-adhesive notes with an image and name on them, for example. I've also seen aprons printed with logos. I have shot calendars and posters for clients and then used them as promotional material. If you shoot a cookbook, make sure you get copies of it to send out to potential or current clients. If you write about food for publications, share those articles. Even reprints of my research thesis, "Visual Preferences of Food," has been of interest to some of my clients. In addition, when you work on a cookbook or produce other editorial material, try to make sure you get a credit for your work. Some publishers will do this, but some won't.

Photographer Woody Woodliff put this promotional piece together with a copywriter friend. This clever idea has been very successful for him. *Woody Woodliff*

I once asked some people at a major food company how they chose their food stylists. They assume that we all have good cooking and baking skills. Besides our presentation skills, they look for "someone who is pleasant to be with." After all, they are spending the day with that person and want the day to be as pleasant as possible. For continued business in the freelance world, it is important to remember that you are only as good as your last job, and one excellent way of promoting yourself is a job well done.

Production: Create Works That Sell You

It is up to you to produce materials that promote you and your work. Sometimes this is straightforward (Web sites, PR materials) and sometimes it involves a more creative approach. For the last thirty years, I have sent Christmas cards that have contained a favorite recipe. Some of my favorite cards have also included photographs that I have helped produce. Sometimes the shot has something to do with the recipe, sometimes not.

NETWORKING and SHARING

Helpful Organizations and Conferences for the Food Stylist

getting known in print, online, and in the classroom

I have had several articles about my work appear in various publications, and all help to promote my work. *I.D.* magazine (*Industrial Design*) wrote an article called "Fashion Plate" in which I showed and talked about how to build the perfect sandwich (see page 198). *Advertising Age* wrote about the career of food styling and featured my work and that of my partner, Fran Shinagel. The *New York Times* wrote about my work. I have been interviewed by many magazines as well as by the Web site CookingSchools.com, and I once appeared on Sara Moulton's *Cooking Live*, discussing food styling as a career. Teaching has also led to many interviews and several jobs. I taught a workshop for food journalists at the Disney Institute, and each journalist went home and wrote an article about the class in the local paper. I often give workshops at the annual IACP convention and also for the International Conference on Food Styling and Food Photography at Boston University. These workshops often lead to consulting work.

There are times when I write the article myself. The *National Culinary Review*, a magazine for food professionals, asked me to write an article for chefs that I called "Preparing and Shooting Beautiful Food Photographs." I have written a brochure and given several workshops called "The Last 50 Years of Food, Food Photography, and Food Styling," which I use as a promotional piece. When I worked at Cary Kitchens, I wrote an article about our facilities for *Photo District News*, promoting us and our facilities to photographers. The career alone interests many producers and writers. How can *you* find an interesting article to write, or be part of one that promotes you?

How does one stay fresh, and what inspires a food stylist or a photographer to produce exciting and mouthwatering food shots? Many people in this business belong to organizations that produce stimulating programs for their members. The IACP, for example, has subgroups for photographers and stylists, and it sponsors seminars on topics of interest. It also has annual conferences that offer tremendous opportunities to network, as well as to show your work in photo contests. The IACP subgroups have monthly teleconferences to generate new ideas and have also organized photography workshops in places such as Mexico, South Africa, and Australia.

On one teleconference, photographers and stylists shared techniques for staying creative. Everyone agreed that with digital photography, we have stepped into a whole new and exciting world. Yes, the joy of digital! One photographer shared how he now takes his camera out and shoots food with natural light and that inspires him to try to duplicate the lights and colors is a studio setting. He said, "When you shoot on location, the whole world is creating possibilities—you just have to see it." Another photographer talked about the fact that instead of working in isolation, having a staff (a digital artist and a studio manager) is great for bouncing ideas around. Photoshop allows for creative postproduction work.

One photographer praised digital work because he could get the shot the client had envisioned, and then he could also do a shot that he would like to try. Often the client enjoys this additional creativity and the opportunity to compare a straight product shot with one that is more interesting.

Still another photographer speaks at conventions and then attends seminars that he might not normally attend, finding that many new ideas emerge from these seminars if he keeps an open mind. One exercise that I have used is to take a photograph, not necessarily food, that I like and think about how food could fit into this color scheme or that setting. I have found that if you have *strong specific reasons* for producing a shot, this directs the creativity.

In classes that I teach at various schools, students are assigned to come up with a shot they will produce with a professional photographer. They act as art directors, producing a vision and a layout; as prop stylists; and as food stylists. They need to decide who the client is; what the purpose of the shot is; the mood of the shot, the season of the shot, and the type of shot they want to produce; and who the audience for this shot is. Defining these parameters helps give a strong direction to their work.

Creativity is stimulated by having a new idea or visual and then taking it further. Stepping outside the normal routine (doing such things as traveling abroad) can be eye opening and keeps us fresh. Whether it is for assigned work, stock photography, or a test for possible promotional material, we need to stay engaged and inspired.

When I teach, I often ask groups of students to prepare an assignment to be photographed by a professional photographer. One group (Natalie Morland, Youn Sook Lee, and Winny Law) at George Brown College in Toronto did a beet appetizer in three lovely variations. *Michael Visser*

Most food stylists I have met find it rewarding to apply their cooking, baking, and artistic skills to other arenas of the food world. The following are some of the careers that relate to food styling and can be areas of additional work if you choose to apply or expand your skills.

BEYOND FOOD STYLING
expanding your options

RECIPE DEVELOPMENT and writing

I cannot stress enough that the ability to develop and write good recipes, as well as to test, rework, and rewrite recipes that you receive in assignments, is an incredibly important skill. It is one that you will use daily. Just how and where do you use these skills?

As a food stylist, you will receive recipes with almost every assignment. Sometimes the recipes are well written, and they work. But it is not infrequent that there is a problem, particularly when you receive recipes written by home cooks or chefs. Chefs were trained to cook by using their eyes, ears, nose, mouth, and sense of touch. Most didn't learn to cook by following recipes, so to produce a good, easy-to-follow home consumer recipe is often difficult for them. They know too much and assume too much. "Bake until done" is not consumer friendly. The home consumer wants to know: at what temperature? for how long? what should it look like? and how do you know if it is done? The directions are much more helpful if they say, "Bake on the middle rack of a preheated 400°F oven for 25 minutes, until it is golden, the top of the cake springs back when lightly touched with a finger, or a toothpick inserted into the center of the cake comes out clean."

In general, when reviewing recipes, give as much guidance to the reader as possible, giving visual cues, technique hints, and guidelines for testing for doneness. Your goal is to make the recipes foolproof for even the first-time cook. As a food stylist, you may need to rewrite or rework a recipe until it meets the taste standards of the client and can easily be followed by the home consumer. I have worked on assignments for cookbooks where I had to fill out a form for any recipe changes, indicating the changes and telling why the changes were made: photo improvement, recipe improvement, or the recipe didn't work.

If you are developing a recipe, you can begin with a good, reliable base recipe and then make changes, additions, and adjustments if needed. You can use a good base recipe to understand such variables as cooking temperatures and time, and proportion of liquid to dry ingredients. Many people are concerned about what makes a recipe their recipe. In my own experience, if you make one major change and two minor changes in the ingredients, retitle the recipe, and rewrite the method in your own words, it has become your recipe.

As a freelance food specialist you may be asked by a client to develop recipes for a product or a piece of food-related equipment. That is one job. You may style the recipes for photography, which is another assignment. This is usually done as a public relations or marketing assignment; the recipes will appear in a brochure or cookbook or newspaper article, or they will be demonstrated in front of an audience. Another type of assignment might be to develop recipes for a new food item so that consumers will know how to prepare the item. Over the years, I have developed recipes for rum beverages, kiwis, dried cherries, packaged products from France and Italy, phyllo dough, pretzels, high-end cooking pans, and food blenders.

You may be asked to test recipes for magazines, cookbook publishers, and the test kitchens of food companies to make sure that the recipes work. If they don't, you can make specific suggestions on how to improve them.

You may want to seek out your own assignments writing articles and recipes for blogs, Web sites, newspapers, magazines, or your own cookbook.

With any of these assignments, you will need to know:

- Who is the audience? Who will be preparing these recipes—the average home cook, skilled cooks, or professional chefs?

- How will the recipes be used? Will they be used in a mini cookbook, as part of a newspaper article, or on a package with limited copy space?

- What is the number of recipes to be developed?

- What type of recipe are they? Baked goods always take longer to develop than beverages or cooked items (we usually charge more for baking recipes).

- Which style of recipe writing is to be used (consumer or food service)? What is the number of servings and amount of product to be used per recipe?

- Are there restrictions, such as the use of alcohol, amount of fat or sodium, or space for the recipe(s)?

- Will a nutritional analysis be needed?

- Is there a budget for a second tester and is a presentation or tasting of the recipes needed for the client?

The answers to the above questions will affect how you work and what you charge (see Resources, page 377, for a list of useful books on recipe writing and development).

Cookbook Writing

Writing cookbooks can fall into many categories—everything from ghostwriting a cookbook for a chef to writing your own classic. You can contribute to cookbooks or help develop recipes for a mini cookbook on a single subject or for a single product. This is work you can do when you have time; it works well with a freelance schedule. You can also assist cookbook writers by testing and typing for them. If you become an author, this often leads to other opportunities, such as lectures on your subject, cooking demonstrations, and spokesperson work.

ARTICLES and other WRITING ASSIGNMENTS

When I started out as a food stylist, little did I think that I would do any writing—teaching maybe but writing, never. This was definitely not a strong skill for me even in high school. I always loved the research, but not the writing. But as time went by and I began teaching and giving presentations on food styling, I was approached by a couple of magazines to write articles. One I wrote was on low-fat chocolate desserts for *Chocolatier* magazine (yes, low-fat *and* chocolate). Along with the presentations I was giving came handouts and also a brochure called "The Art of Food Photography: A Retrospective from the 1950s Through the 1990s" for *Gastronomica*. I have contributed to several cookbooks and written an article on the career of food styling for CookingSchools.com. All of these assignments came to me; I didn't seek them out. Thanks goodness I had a wonderful editor at the time—my husband.

Then I was approached to write a book on food styling. I thought not. Eventually, however, I decided that a book would be a good way to share much of the information I had been teaching over the years.

If you have the skill to write, thank your lucky stars, because it can lead you, or you can lead it, to many interesting assignments. It is a wonderful additional skill, and you can certainly use it in the food world—everything from writing short articles for publications or a blog to writing press releases for food companies to writing product use information to writing a family cookbook. The possibilities are endless. It is always useful for the experienced writer, as well as the inexperienced writer, to take writing classes. Many universities offer writing courses in their continuing education programs; community colleges offer courses for beginners. The Greenbrier hotel in West Virginia holds a symposium for professional food writers each May.

the joys of TEACHING

I have always considered teaching one of the most rewarding things I do, a real win-win situation. I meet interesting people, share knowledge that I hope will enrich others, and have fun at the same time. Analyze your assets. What is it that you know how to do really well and feel there is an audience in need of that information? First, you must have in-depth knowledge of your topic. Next, you must decide how you can best relay that information. Always consider your audience. Who are they and why are they there? Not everyone learns in the same way, so take into consideration a variety of teaching techniques. You may want to demonstrate, but if you have the time and facilities, it is good to offer hands-on experience as well. Comfort in working in front of people comes with practice and a strong knowledge of your subject.

Teaching at the Culinary Institute of America using mushrooms found on the campus by a student.

Teaching can be done as a full-time occupation, but it also works well as part-time work for a freelancer. You can do it in a variety of settings, from home to a university. You can teach on weekends or in the evening so that it doesn't interfere with other job opportunities. It leads to excellent networking opportunities and promotes you as a person knowledgeable about the subject. That just might lead to television appearances or a book on the topic.

Look at CookingSchools.com, Petersons.com, and ShawGuides.com for guides to culinary schools and also for ideas for topics to teach. Never be afraid to create your own topics, however.

Another aspect of teaching that is becoming very popular is being a culinary tour guide, local or international. Being a guide might be as simple as sharing your favorite food, restaurants, and shops in your own town or as ambitious as arranging food-oriented tours of Thailand.

teaching at rikers island

One of the most rewarding and unusual teaching assignments I have ever had was when I was asked to teach at Rikers Island, a men's prison just outside of Manhattan. At the prison, a culinary program and a landscaping program had been started by a group interested in bringing possible career opportunities and training to the men.

I must admit I was a little dumbfounded when I was invited to teach there for a day. Why food styling? I was told that it was important for the inmates to become aware of a variety of careers in the culinary world and that it was equally important that they knew that someone was willing to give a day of his or her time and was interested in them.

I began this assignment just as I do my regular styling classes. I showed slides as a visual introduction to how we work and to highlight our concerns about color, texture, and arrangement. The pictures also showed examples of good and bad food styling and the variety of assignments we get. What was different about this class was that we looked at the slides in the only dark room they had—the storage room. Fifty-pound bags of flour and rice were used as our chairs.

In a kitchen prep area, I demonstrated how we work with certain foods, such as how to build a hamburger, make a beverage, and have success with pizza and ice cream.

Each person was given a hands-on assignment to accomplish and then we critiqued the work. Even if the facilities were not the greatest, everyone made do, shared comments and suggestions, and helped one another out. When we were finished, the one difference I noted was that everyone enjoyed eating the food used for the assignments. I will always remember the wonderful expressions of appreciation as everyone filed out of the room. I am sure that the several guards learned something, too.

media escort or
SPOKESPERSON

Becoming a Food Emissary

If you enjoy working in front of an audience or appearing on radio or television, then promoting a food product as a spokesperson could be another area of freelance employment. As food stylists, we often prepare and prop the foods that are demonstrated by a spokesperson; in that role we are called media escorts. Working as a media escort can help you become familiar with the skills needed for a food demonstration. There may be times as a spokesperson that you would not have the assistance of a media escort and you would need to do everything for yourself, so with the knowledge gained previously as a media escort you understand the importance of clearly communicating your needs to the right people.

Television versus a Live Audience: How to Bring Food to the People

The information below is important not only for the food demonstrator, but also for the person backing the presenter—the food or media escort—who is often a food stylist. Whether you are getting food ready for cooking demonstration in front of a live audience or a cooking demonstration in front of a television camera, there are certain things to take into consideration that will make the demo run more smoothly and effectively.

teaching "u.s. style" around the world

Each time you travel to a foreign country, there is much to experience. Working as a stylist or instructor in a foreign country adds a bonus because we are richly exposed to the foods of that country and work side by side with its food professionals. As a foodie, I consider going to a major grocery store in any foreign city like a trip to a museum. I learn a lot about the country's culture, food preferences, and aesthetic sensibilities.

The very first time I was asked to teach outside the United States was in Norway. I had worked on a packaging assignment with an art director from Oslo. I asked him why he was shooting in the United States, and he said there were no "U.S. style" food stylists in Norway at that time. I asked if they would be interested in sponsoring a class there. In the fall of 1984, I took my parents on a trip to Scandinavia and met with Millie Alstead, a member of the advertising agency interested in producing a two-day seminar. Eight months later, my partner and I were in Oslo giving a seminar on food styling and being treated royally by sponsors and participants. I will never forget our picnic on one of the fjords and the experience later that week of seeing the beautiful costumes that are worn to celebrate Norway's independence each

Food, April 2006. *Mike Cheung*

May. I still meet some of the participants at seminars at the IACP conventions each spring. I also still arrange flowers in the beautiful blue-and-white handcrafted Norwegian glass vase that was a parting gift.

In Norway I learned that many of their ingredients, such as produce, flour and sugar, are very different from those found in the United States. When we worked there, we needed to make adjustments in the recipes and techniques we used for styling. Nowhere else was that more evident than when I taught in the Philippines. At a seminar I taught in Manila, the organizer, Norma Olizon-Chikiamco, the then editor-in-chief of *Food*, the Philippines' largest-selling culinary magazine, and I thought that the audience might like to see a real food shoot as part of the event. Some time before, she had visited my house, and I had served coconut lime bars as a dessert that day. She had loved those bars and thought that they would be a good recipe for the magazine—and a good cover shot as well.

Two wonderful experiences developed from that recipe choice. First, when I got to Manila, my assistant, Mary Grapsas, and I learned that Philippine coconuts and limes are very different from ours. I had brought along U.S.

The first thing you need to consider is, Who is the audience (who will attend or who is likely to watch the TV show)? Next, you will want to think about the facilities you have for your presentation. Do you have, in a best-case scenario, a full working kitchen with a gas stove, a working oven, and plenty of counter space, or, in a worst-case scenario, an empty stage with a table or counter and possibly a refrigerator somewhat near? Next, you must think about the amount of time you will have for your presentation. Last, you need to know if you will be doing the demo alone or if you will be interviewed.

There will likely always be challenges. There is the wonderful tale of James Beard doing a cooking demonstration in the hinterlands using a clothes iron turned upside down as his heat source. It probably won't come to that, but if you don't have a heat source, why not think about demonstrating a salad and making a homemade dressing, or showing maybe an unusual way to frost a cake or ten ways to present brownies at your next party? The demonstration needs to include your message points, whether you are promoting and representing a restaurant, cookbook, food item, cooking utensil, or food company. It must also fit your audience, the facilities, and the time allotted for your demonstration.

ingredients for the shot, but I realized that we would need to make the recipe using native ingredients if the people there were to make it. There are two limes that are commonly used in the Philippines, and neither is like ours. Coconut, of course, comes in many forms, from fresh, young, or mature in the shell to hand-grated dry or moist, as well as others. Mary made the original recipe using our ingredients as the standard and then tried four variations using their ingredients. Second, we had been invited to a potluck dinner given by about twenty former students who had all attended classes that I had taught at the CIA in New York or at the New School at various times. What a treat to see everyone and enjoy all the many delicious and beautiful favorite Filipino foods they brought. At the end of the meal, I asked them to try the five different bars and vote on the one they liked the best, using the original as a standard. Their favorite was a version using calamansi (their small lime). This was the recipe we used when we shot the cover in the seminar and when Norma ran the recipe and wrote about the experience for her magazine audience.

When I taught in Chile, it was to work with food professionals, food companies, agencies, and photographers who would be producing visual material for food promotion and sale outside Chile. Forty people attended the two-day workshop, and it was the first time I was simultaneously translated. The workshop promoters had hired two translators, whose first job was to develop a Spanish word (or words) for *food stylist* because that term didn't exist for them. At one point when I was speaking, everyone laughed (and I had not said anything I thought was funny), so I asked the wonderful, somewhat English-speaking Chilean photographer, Miguel Etchepare, who was helping me photograph the participants' assignments, why everyone was laughing. He said that the translator had said, "I don't have a clue what Delores just said."

In Chile, we visited wineries and huge open food markets with glorious produce and fish. We were invited to a spa in the mountains; we were introduced to pisco sours and taken to the city's best restaurant, which was run by one of the participants. In return, my then assistant Mariann Sauvion produced a delicious typical American banquet for all the participants.

In Japan, I taught another two-day workshop in a large culinary school, and the class was videotaped. In other locations where I had taught, they would ask to record the class and it was always one man with a small video camera. In Japan, they showed up with a whole video crew, two cameras, and a soundman. Thus the videotape *How To Food Styling* was available in Japan for a while.

I have taught in Korea twice, both times with Lisa Homa assisting me and both times in the same culinary school in Seoul. When teaching in culinary schools, you are surrounded by people who adore food and know where all the great food places and restaurants are located. In Seoul, we were treated to the highest forms of Korean food and also to the most typical and everyday foods. Always, everything was wonderful. Once, after a newspaper interview, I turned the tables and asked the delightful young reporter why I was always the last to finish eating, even though my chopstick skills were adequate. He said that it is typical that all of the food is served at once, and if you want something or want it hot (with its energy), it is best to eat first and talk later. Another lesson learned.

COOKING DEMONSTRATIONS: GATHERING INFORMATION

Usually, if you are demonstrating on television, a representative from a public relations firm or a segment producer will gather and relay important information to all the major people involved. However, you will always want to make sure the following items are covered:

- Where will you be doing the demonstration? How do you get there? Is there a contact person when you arrive and someone to help you get set up? All important names, phone numbers, and e-mail addresses should be exchanged.

- What are the facilities, both the demonstration area and the prep area? How much demonstration counter space do you have? Get the dimensions. Also, find out about the cooktop, its size, and whether it is gas or electric.

- How much time is allotted?

- Is there a color theme or a seasonal theme to take advantage of?

- Who is the audience likely to be (if you are unsure of this)?

- If you are demonstrating out of town or on TV, is there a media escort—someone to do the shopping, prepping, propping, and setting up before you arrive? If so, it will be vital for you to get information, recipes, and equipment and prop needs to that person.

STYLING YOURSELF: YOUR PHYSICAL APPEARANCE

You will want your appearance to represent you as an author, chef, or owner of a company. Do you want a casual effect (an apron, perhaps with your logo, if it is allowed) or a more sophisticated and tailored look? A few things to remember: White and red are difficult colors for the television camera. In fact, chefs' jackets are sometimes dulled by first washing them in tea. Clothes and ties with narrow stripes or patterns cause a strobing or dancing effect.

Try not to wear accessories that distract from your demonstration, such as large watches and dangly or splashy jewelry. You may want to overemphasize the makeup a little, since the light in the studio or your distance from the audience may wash you out. It is said that when you are on television, you tend to look ten pounds heavier and you lose half of your personality, so juice up your presentation and your spirits.

PREPPING AND PRESENTING YOUR DEMONSTRATION

What are your talking points? You should have three main ideas that you want to get across: for example, "See how simple, easy, inexpensive, delicious, fun, healthful, comforting, or unusual my recipe is." Or, "Here is the most popular dish in our restaurant." Or, "Only this sauté pan allows you to make this dish successfully." Your goal is for viewers to stay tuned, and also you hope they will want to buy your book, try the recipe using your piece of equipment or food item, or visit your restaurant. If you are promoting something, use a recipe that shows off the best qualities of that item but one that is simple and can be demonstrated well in the time allowed.

Writing out your basic steps and talking points will help you visualize your presentation and make you more comfortable when doing the demonstration. "This recipe appears in this month's issue of our magazine. It is a very unusual way to prepare pizza, and the recipe is particularly child friendly."

Recipes can be broken down into three sections: explanation of the recipe and the ingredients involved, preparation of the dish, and final assembly and presentation. It will be your job to decide what needs to be done ahead so that you can complete the demonstration in the time allowed. You may choose to cook in real time or you may combine steps of the recipes and prepare swap outs (in which you begin a step and then show how it would look after it has baked or cooked for thirty minutes). Practice your demonstration, but also be ready to adjust when you get questions or the time allotment changes.

The audience always loves tips and something different. What can you teach them that they may not know? Television has become more of an entertainment medium than an educational one, but people still love to learn something new. If you have the time, include an interesting short story about the recipe or an explanation of an unusual ingredient or storage or make-ahead tips.

When you get to your demonstration area, check to see that everything is in place and that all the ingredients are there and at the correct temperature (room-temperature butter for creaming, for example). Do you need a hand towel or tasting dishes and forks or an electrical outlet? Run through the demo.

Finally, always test the equipment. Does the food processor or mixer work, and how? How hot does the stove top get and when should you put the pan on to heat up? There is nothing quite as unexciting as watching onions or meat not fry, or more exciting than watching your food go up in smoke.

Be enthusiastic, be passionate, have fun. Remember that you don't get a second chance to make a first impression. Always bring along an extra book, press kit, or the product just in case the one you sent earlier has disappeared.

If you are creative and make it easy for the crew and producer, you will be invited back.

Food Demonstrations: Tips and Techniques

Script yourself or practice what you want to say and share. If you are preparing the food the night before for swap outs and final finished product, collect all the utensils you used; if you are showing a step-by-step demonstration, most likely you will need them for the demo. Don't forget things such as a tasting spoon, a spoon rest where you can put used and food-covered utensils, hot pads, and a damp kitchen towel to keep your cooking area clean and to wipe your hands on. Having a utensil container, such as a four-cup glass measuring cup, holds utensils until you need them and leaves your space less cluttered. A white plastic cutting board acts as a grounding device and central working area, and white shows off your food better than wood. You will need to decide if you will premeasure ingredients and have them ready in bowls (the dump-and-stir technique) or if you will measure as you go. If you will be using specific products, do you want the labels to show or will you put the products in generic containers? Also, have places to put used dishes or garbage. Put together a grocery list, an equipment list, and a prop list of things you will need; either relay that information to your escort or assistant or pack for yourself. After you have received the dimensions of the counter where you will be demonstrating, draw a chart showing where you would like to place each item you will need to use or display.

Will you be working from left to right or right to left? The floor manager or producer may have specific directions or needs concerning this. It is always lovely to have a display of raw ingredients or other items relating to your demonstration, unless it distracts or takes up too much room. You will want to have one area where you can place the finished food. If you can get the finished dish done ahead of time, then you will be able to control the look. However, a plate or bowl of steaming food just delivered from the stove always adds mouthwatering appeal.

If you are promoting a book, send a copy to the studio ahead of time so that the cover can be shot and inserted into the segment.

It is always wise to have a few extra topics to talk about if you are working in front of an audience or an interview goes longer than planned (usually it is the other way around). When you are working in front of a live audience, having a digital timer on the counter helps you pace yourself without having to look at your watch (a no-no) or for a clock. If you are appearing on television, plan an activity for a "tease." This is when you are shot doing something before the show goes to a commercial, indicating that you will be next on the program.

When your segment begins and you are not being interviewed, have something to do—busy work—and then look up and introduce yourself; that way, you don't have empty time where nothing is happening except you staring at the camera (the deer-in-the-headlights look). Usually, don't say things such as "Good morning," because if the show is videotaped people may be seeing it in the evening. Rather, briefly let the audience know

TIP *One enterprising presenter, in addition to sending her cookbook ahead, sends along a press kit and a container of her fantastic brownies, ensuring that the interviewer and staff have had a chance to enjoy one of her recipes before she arrives. They find talking points in the press kit and usually mention how incredible the brownies were.*

what you will be demonstrating and how terrific this recipe is. Entice them to stay with you, but get to the cooking. Talk and work at the same time. This is where practicing comes in handy. What will you say as the onions are taking five minutes to cook? Also, clear off used dishes as you talk. Have a place to put used bowls and other equipment and keep your work area clean and tidy.

When you are working with ingredients, tell the audience the amount you are adding. If you are discussing ingredients ahead of preparation, point to the item rather than lifting it, which allows the cameraperson to do tight shots on the food. When you have a final finished product, leave it in place so a tight shot can bring the segment to a close.

Keep good eye contact with the camera and an "I am just sharing this with a friend" attitude. Smile and enjoy the experience as much as possible. The more you do demonstrations, the more comfortable you will be.

If you are working in front of a live audience, make eye contact with all members of the audience—everyone should be that "friend." Very important, be sure to project your voice if you don't have a microphone attached to the center of your jacket. If someone in the audience asks a question, repeat it for all to hear.

INTERVIEW DEMONSTRATIONS

In an interview setting, you will be demonstrating your recipe with the host of a television show or talking to someone who is presenting you in front of a group of people. Become familiar with the show or the interviewer(s). It is often suggested that you get the interviewer involved in the demo by having him or her do something while you are demonstrating. Think about what steps would be helpful and interesting for a possible noncook to accomplish. Listen to the questions. It is best to let the host lead. The audience is there because of the host, and if you correct or try one-upsmanship with the host, you will lose the audience. For television, always be prepared to shorten your demonstration; try to get into the demonstration as quickly and as naturally as possible. With luck, you will have time to run through the demonstration with the interviewer before you go on, but this is often not possible. Try to be flexible and enjoy the process. Your enjoyment always shows. Look at the interviewer rather than the camera if you are on television; look at both the interviewer and the audience if you are in front of a live audience. Have plates and utensils ready for the interviewer to taste the final food. The *mmmmm* response is very powerful, and while the interviewer is eating, you can get in your final message points.

SATELLITE MEDIA TOUR

The satellite media tour (SMT) is a very different type of presentation and involves giving the same demonstration repeatedly. You will be talking to a variety of interviewers, one at a time, through a satellite hookup. You will be listening to interviewers and the director through earphones. Some interviews will be short, some long. Some will be live, some will be taped for later use, if all goes well. When you set up your demonstration, try to think of one that can be cleaned up and replaced in one minute, which is sometimes the amount of time you have between interviews. Try to have several talking points and tips for the longer interview and one major item to demonstrate for all interviews. Having a beautifully arranged collection of finished dishes for the cameras to scan is also enticing and provides additional talking points.

DOS AND DON'TS OF VIDEO PRESENTATION

Doing your homework:

- Do arrive at the studio or location in a timely manner so that you can talk with the segment producer, review notes, and discuss the segment. Allow extra time for traffic or other delays. Being late will put stress on you and your performance and agitate the producer.

- Know the program you are appearing on. Watch previous episodes or segments and pay attention to other demonstrations to get an idea of the show's style and pace. If the show provides makeup and hair touch-ups, take them. The time sitting in the chair will help you focus on what you need to do, and a good appearance is a confidence booster.

- Do feel free to ask your interviewer to cover specific points, although he or she is under no obligation to do so. Review specific points with the producer as well.

- Be sure to record and watch your appearances. They will serve as learning tools for future appearances.

- Choose your clothing carefully. Bright red, black, and white clothes don't translate well when broadcast. The same rule applies to certain patterns. Stay clear of small patterns, such as pinstripes and dots, which cause a strobing effect. Check ahead to see if there are any colors you should avoid wearing since they may clash with the set, or if an effect called chroma-key, where technicians strip in the background, is to be used. Always be prepared by arriving with a change of clothes. Be careful with scarves and jewelry. You want to avoid items that cause the microphone to pick up sounds, such as rustling and dangling.

- Always have a backup plan. If you've been told your segment or interview is five minutes, be prepared by knowing what points you want to make clear. Practice ahead and time yourself. Be prepared for the possibility that at the last minute, your time may be cut to two and a half minutes. If you know ahead of time what you want to say and do, you should be able to make the alteration. Prepare by precooking and measuring items as much as possible. Have a completed dish prepared and one plated. Viewers can't smell or taste, but they see, so your goal is to create a memorable presentation for the camera. Talk with the producer in order to understand the overall look of the segment. Plan ahead what you will want on the counter in terms of visuals. Keep in mind that you don't want to overshadow your space with extra visuals. Keep your demonstration and materials focused. If you're presenting apple pie, you may want to have a variety of apples in a small basket and a few cinnamon sticks and a final finished pie for your introduction or the final shot of the segment.

On the set:

- Pay attention to the floor manager. He or she is the link to your producer and will be telling you what will be taking place.

- Try not to advertise during your interview or segment. Keep logos as discreet as possible. The name of a restaurant written cleanly on a chef's coat is one thing, but to have a blatant brand name on the table or on your clothing is bad form. It's the show's responsibility to highlight your product, cookbook, or restaurant. It's OK for you to mention it if it is appropriate during the interview or segment but don't continually do so. The general rule is that what is being promoted is mentioned in the opening and the closing of the interview or segment.

- Don't try to be overly friendly with your interviewer. He or she is the viewers' friend. You are aiming for a light, easy rapport.

- Don't assume the viewer or the interviewer knows a lot about your subject matter. You are the expert. Explain and give background information as necessary.

- Don't be argumentative with the interviewer, but at the same time, don't appear to be passive or accept rudeness or aggression.

- Try not to take notes with you onto the set or refer to them while on the set. It's not only distracting, but you won't look as if you know what you're doing.

- Don't drink any alcohol or carbonated beverage prior to the interview. Do ask for a glass of water, both as a means of refreshing yourself and as a prop in emergencies.

product DEVELOPMENT

This is a field of employment that takes special skills. You need to have a good understanding of food science and some research and development knowledge. If you do have this knowledge, some companies may hire you as a freelancer. You can also use this knowledge to produce your own products, as a couple of my former students and assistants have done. With your skills in food styling, you understand the importance of beautiful packaging and good marketing and promotion.

FOOD PHOTOGRAPHY and other related careers

Several people who have attended my food styling classes have been photographers or have had a very strong interest in the area. It's not easy to do all the photography, propping, and styling, but it can be done with simple projects. I still feel it is best to specialize in one area. However, with the development of blogs, many bloggers who combine these skills are having varying degrees of success (Foodgawker.com is a gallery of photographs posted by food bloggers).

There are other opportunities for freelance work as a food specialist. Someone with strong baking skills can work for a baker on an as-needed basis or develop his or her own line of specialty cookies. Event planning, catering, and assisting a caterer allow for some flexibility in schedules. Researching for writers and publishers or editing, if you have the skills, can be done freelance. Some stylists have become private chefs or deliver premade meals. If you have a background in nutrition, working as a consultant or coach or doing specialized nutritional analyses are all possible opportunities. Consider approaching public relations firms, marketing firms, magazines, and food companies for part-time freelance work—they take on new clients, test new products, and develop new recipes. Working as a restaurant or food-service consultant can provide freelance assignments as well.

In addition to seeking food styling opportunities, stay open to any possibility where you can find part-time work in order to keep yourself employed and involved. Just remember that you will need to keep your schedule as flexible as possible so that when styling jobs come along, you are available.

Based upon my experience as a consultant to restaurants, caterers, food companies, and public relations firms, I have put together a general summary or outline of materials for consideration when you are planning to produce photographs and materials for these types of businesses.

TIPS FOR CHEFS, CATERERS,
and others who want to style their food

TIPS FOR SMALL BUSINESSES

Creating Visual Materials That Sell Your Food-Related Services

IDENTIFY YOURSELF AND YOUR POTENTIAL CLIENTS

- Who are you? What image do you want to project?
- Who are your potential clients? How can you show them visually that you can meet their needs?

DECIDE WHAT KINDS OF VISUAL MATERIALS YOU WANT TO PRODUCE

- Brochure
- Newsletter
- Public relations packet (press kit)
- Postcards
- Photo labels (photographs on packaging labels)
- Business card and stationery
- Cookbook
- Menu
- Web site
- Portfolio or book

CONSIDER

- What is the volume of material you want to produce?
- What is your budget?
- Can you hire a public relations firm/marketing firm/independent designer, photographer, prop stylist, and food stylist?

DO YOUR HOMEWORK

- Collect samples of photographs that you like from magazines, cookbooks, ads, packaging, etc.
- Note photographers and the style (mood) of the shots. Are the shots simple? Complex? Do the props tell the story?
- Make a list of foods that represent you.
- Decide which of your foods photograph most attractively.

ATTEND THE PREPRODUCTION MEETING

- Discuss the shoot with the designer or marketing firm (if you have a limited budget, you may work directly with a photographer). They need to collect information from you in order to best creatively interpret your needs.

- Determine the type of shot or shots.

 Single food image (bowl of soup, plate of food, beverage)?

 Buffet?

 People, crowd shots (you will need to get release slips)?

- Ask about the size and shape of the shot.

 Horizontal?

 Vertical?

- Do you need to make room for copy on the shot?

- Bring a sample of your logo and any written copy (recipes or other material).

PREPARE FOR THE PHOTO SHOOT

- If providing food, select the hero food (samples of your best-looking product).

- Provide at least four samples each of the product per food shot and often more.

- Be sure to pack and transport your hero product(s) very carefully.

- Try to attend the shoot. Your presence and insight are valuable.

watching your work drive down the road

One of my clients was Sweet Streets, a company that produces delicious upscale desserts for restaurants that don't have a budget to hire a pastry chef but want to sell high-quality desserts. Normally, we shot once a year in New York and produced pictures of Sweet Streets' newly developed desserts in interesting miniature environments created by the photographer, with an artist on the set painting backdrops. The owner had started her business fifteen years earlier by selling chocolate chip cookies to local clients, and her company had grown into a business with refrigerator trucks delivering her desserts, frozen, nationwide. She had discovered a niche where there was a need, and no one else at the time was filling it. Today, there are several companies providing similar products.

Larger-than-life pie

The shots we produced were used in sales folders. They were very creative, of high quality, and very respected in the trade.

On one occasion, the client asked us if we would shoot at her factory in Pennsylvania. As we arrived, I spotted one of the company's refrigerator trucks. There, on a side panel, was a dessert picture that we had shot the previous year, at five hundred times its normal size.

Using food shots this way was something very new at the time, though it is used a lot today. Seeing your work is always a treat, whether it is in cookbooks, magazines, commercials, print ads, or on a Web site. Seeing it five hundred times its normal size on a billboard or on a truck while driving down an interstate highway is a thrill.

The following is from an article I wrote for the *National Culinary Review*. The purpose of the article was to share food styling information with chefs who need to produce pictures of their food for a variety of purposes.

a chef's guide to PREPARING and SHOOTING beautiful FOOD PHOTOGRAPHS

What if:

- A newspaper wants to feature you in an article about your business and wants to shoot some pictures of your food?

- You want to put together a brochure to promote your business and you need to include food photographs?

LEFT: Chef-styled scallop salad.

RIGHT: Same salad, food-styled (with a lighter touch).

Colin Cooke

- You want to create a Web site and you need pictures showing the type of food you prepare and your presentation?

- You want photographs of food on your business card, stationery, or menu?

- You need a portfolio or press kit for your business and you want to include pictures?

- You want to write a cookbook and include photographs of the recipes?

For any of the above assignments, you would like to produce photographs that look as good as the mouthwatering ones you see in magazines and cookbooks. Just how can this be done? On an average food shoot there is a base team of four people: a designer (or art director), a photographer, a food stylist, and a prop stylist. Each professional makes a very important contribution to the final food shot. So my first piece of advice is to hire the *best* photographer you can afford (and possibly a designer, depending on the assignment). If you have money to spare, get a good food stylist and prop stylist. "Food stylist!" you say. "I can prepare food." Of course you can. But preparing food for the camera requires different skills from those necessary for preparing food for the table. You can compare it to repairing your own car. You can drive your car and possibly do routine maintenance. When more complex repairs or maintenance are necessary, however, you go to a professional. I know that many of you will still want to style the food, so I will share some of the knowledge I have acquired after thirty years as a food stylist in New York City.

Do Your Homework Before Taking the Shot

You will produce consistent and superior images by carefully thinking through the way you want to project yourself and your business.

DEFINE YOURSELF

You want the pictures you produce to represent you, your style, and your type of establishment. Are you very upscale and white tablecloth, or casual but sophisticated, or just plain casual? What image do you want to project? Who are your potential clients (or readers) and how can you show them that you can meet their needs? What foods represent you? The food, the environment, and the plates you choose to shoot should all reflect who you are.

LEARN HOW THESE PHOTOS WILL BE USED

Do you need just one shot for a newspaper? Consider a very simple shot because newsprint doesn't show fussy details well. Will the shot be shown in color or black and white? It's up to you to find out which it is, because that information alone should affect the food you choose to shoot. Black-and-white food shots are the most difficult to style. You need to use foods with interesting textures and shapes and foods that produce a strong white and strong black and not just all grays.

Is it an environmental shot (you and your location with some food) or just a close-up of your food? Again, that affects the food you choose. If it is an environmental shot, you will want to fill the tables with food that reads well from a distance and use props, because empty tablecloths look *empty*. In which season will the photos be used? Does the food relate to it? It should. Will you run a recipe with the picture? Is the recipe one that relates well to the article? These are just some of the things to consider.

Now let's look at brochures or assignments that require multiple food shots. Have you chosen foods that photograph well? Your most popular dish may taste the best, but it may not look the best. Really look at your plated food. What do I mean by "look"? The camera sees food differently from your eyes. The camera is two-dimensional, has a limited depth of field, and sees a limited area (a rectangle that is vertical or horizontal). Using your camera or cupping your hands around one eye (not both) will give you a view that will duplicate what the camera sees. And while you're at it, look at the food from overhead and at eye level. We are all used to seeing food from counter height (where we work with it) or from the view of the diner. We don't consider other angles. Both overhead and eye-level food shots are often more dramatic or "artful."

While you are going to the time and expense of taking photographs for one assignment, consider other possible uses for some of those good pictures. You may want to add some shots to the day. As a food professional or business owner, it is smart to have high-quality color photographs (and well-written consumer-friendly recipes) on hand for a variety of publicity purposes.

COLLECT PHOTO SAMPLES

Collect pictures from magazines, cookbooks, ads, brochures, or any visual sample that might help you produce an interesting food photograph. Samples might show an unusual food presentation, beautiful lighting, or a style (mood) or props that you like. Do you like simple shots or ones that are more complex, shots that are close on the food or ones that reveal a lot of food and props? Finding and using the correct props is a very important and underappreciated aspect of the process. You can share these collected visuals with the designer, photographer, or prop stylist, and it will help put you all "on the same page."

As you collect and study pictures that you like, you will become aware of the things that make a picture come together. Take note of the photographer's name. Photographers are often credited for their work. This is one way you can find a photographer whose work you like.

PREPRODUCTION MEETING

When you first meet to discuss the project with the designer, he or she will need to gather other information about you and your needs. He or she may present you with several samples and also hire the photographer, prop stylist, and food stylist, if you need them. The designer will also be involved in photo selection and hiring the printer, and can be on site when the final piece is being printed. Do you need to make room for copy on the shot? Bring a sample of your logo and any written copy (recipes or other material).

AT THE SHOOT

If you are providing the food, select the hero food (samples of your best-looking product). You will either cook at the photographer's studio or the photographer will come to you. You will need to provide at least four samples of the product per each food shot. Be sure to pack and transport your hero product(s) carefully. Try to attend the shoot. Your presence and insight are valuable.

When you are thinking about producing your visuals, you may wish to refer to the dos and don'ts of arranging visually appealing food (see pages 65–68).

This unusual apple crisp and ice cream dish was shot against a trompe l'oeil background, combining real food and illustration. *Nora Scarlett*

TRENDS: FOOD AND FOOD PRESENTATION

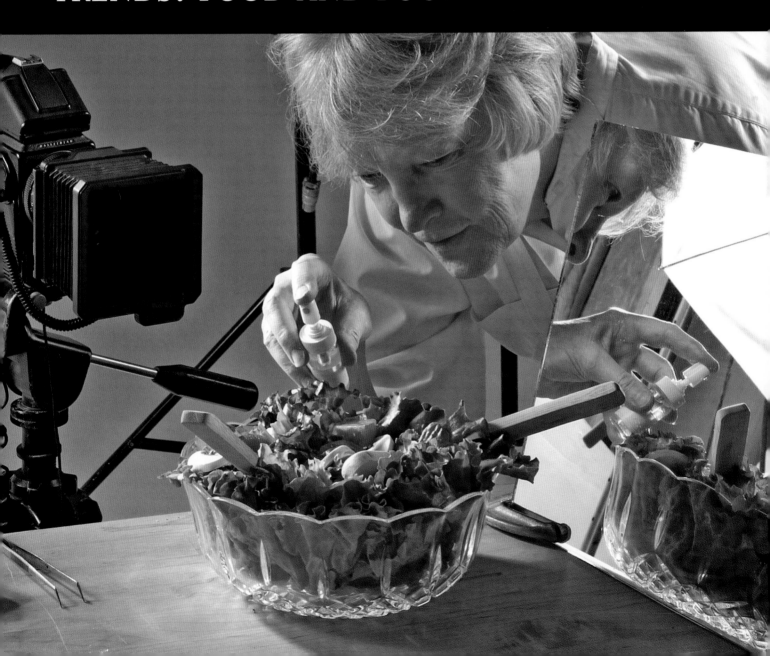

REVIEWING
the last fifty (now sixty) years of food styling and photography

The World Book of
PORK DISHES

Stanley Fortin

An example of early food styling.

Ten years ago, I was asked by friend and fellow food stylist Polly Talbott to share a project with her. She suggested that we prepare a presentation "The Last 50 Years of Food, Food Photography, and Food Styling." (Originally the project covered the years 1950–2000. It has now been updated to include 2000–2010.) Although we thought this would be an entertaining weekend project, we both became so engrossed in the research that we spent more than a month visiting the archives of magazines and researching online and in libraries and culinary schools. Eventually, we put together a talk that included slides and handouts of time lines and charts. It also included a "turkey time line" of November food magazine covers, showing how the presentation of the Thanksgiving turkey had changed over the previous fifty years.

I had the privilege of visiting the archives of *McCall's Magazine* (later *McCall's*), where I was able to look through all the years of its publication (*McCall's* started in 1873 and published its last issue in March 2001). It was dramatic to view in a short time frame (one day) food articles, ads, and products that spanned the last one hundred years—to see how the economy, politics, technology, and fashions of the day influenced the pages. Trends come and go and then return. Food styling techniques and photographers and their equipment improve. Tastes expand as we explore the world and become a smaller planet. I include some of the charts Polly and I put together at the end of this chapter, pages 357–364, showing the changes we saw, along with a written record of the introduction of new food products, magazines, and trends.

Over the last half-century, our favorite foods, their preparation, presentation, and photography have changed dramatically. These strong changes have occurred in part because of the economy, politics, and technology of the time. A number of influential people and our view of time and leisure have also influenced our choices.

LEFT: In 2003, the IACP undertook a project to re-create food photography from the previous five decades. I styled this three-bean salad in the aesthetic of the 1950s: rigid, overgarnished, lots of tablecloth showing, irrelevant props, and harsh, bland lighting.

RIGHT: We took the same props and tablecloth and created a today look: tight on the food, fresh ingredients and herbs, and beautiful lighting. We have come a long way.

Colin Cooke

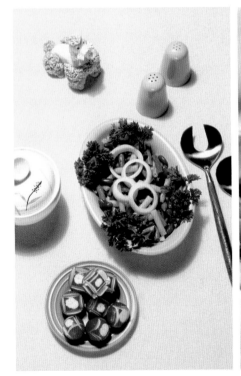

The 1950s

Postwar Conformity, Casseroles, Elvis, and James Beard

The postwar 1950s brought renewed vitality, economic growth, and an improved transportation system. With improved transportation came mass distribution of processed foods and the beginning of an awareness of foreign foods as a result of increased travel and easily reached foreign destinations.

1950s-style grilled cheese sandwich and tomato soup.
Peyton Mitchell, food styling by Diane Long

POPULAR FOODS

Foods of the 1950s included can-opener foods, iceberg lettuce, onion soup and California dip from a dried soup mix, icebox cakes and packaged cake mixes, as well as sloppy joes, meat loaf, and beef stroganoff (we were in the protein age). The three-bean salad was introduced in the fifties, while at special gatherings tomato aspic still ruled—presented, of course, on a large bed of lettuce or in individual cups. Tuna noodle casseroles and frozen fish sticks were familiar items on the table. We enjoyed picnics and entertained at home with the backyard barbecue. Tang was the new breakfast beverage. Soufflés were served sweet and savory and grasshopper pie was introduced as a dessert.

GARNISHES

Typically, garnishes were maraschino cherries, unidentifiable leaves, giant butter pats, parsley, paprika, olives, and iceberg lettuce.

THE LOOK

Layouts were rigid and included illustration, lots of different foods in one shot, foods left whole, overflowing dishes, fully cooked food (wrinkled, overbrowned), melting ice cream, and people in shots. Inconsistency in cooking and baking skills resulted in acceptable and unacceptable images because cookbook authors, chefs, and some inexperienced home economists were styling.

PROPS

Props included artificial and theme-oriented items. Sand, marble, wood, and cloth (pastel yellow, green, blue) were the surfaces. Lots of empty space was shown on tightly stretched tablecloths. Serving utensils were precisely lined up next to a plate. Everyday dishes were used.

PHOTOGRAPHY

In the studio, photographers used hot lights (tungsten). Many shots were done in black and white. Overhead shots were popular and were usually some distance from the food.

347

The 1960s

Convenience, Domestic Engineers, Granola Crunchers, and Julia Child

1960s-style shrimp cocktail.
Todd Trice, food styling by Dan Macey

The Kennedy era and Richard Nixon's presidency reflected a change in food, as well as a change in mood, from the beginning of this decade to its end. With the Kennedys, we were ready to entertain in the French style. Julia Child happened upon the scene and introduced us all to exciting French cooking flavors and techniques. With the civil rights movement and war in Vietnam, we became a nation of unrest and protest.

POPULAR FOODS

The sixties began with one-dish meals, stews, Jell-O molds, and chicken as the most popular protein. We developed an increased interest in foreign dishes and flaming desserts. Stews became ragouts. Freeze-dried foods became available. Red Lobster restaurants and Cool Whip ads appeared. Microwave ovens (invented in 1954) began to take hold. The late sixties brought a rejection of processed foods and a preference for "natural" foods, such as granola, bean sprouts, vegetarian chili, and gazpacho. Lemon bars and carrot cake became new dessert choices.

GARNISHES

Garnishes expanded to include chives, mint, lemon, cherry tomatoes, watercress, and orange slices.

THE LOOK

The look began as cold and impersonal (the buffet table with few single-serving shots), then evolved into a more casual look. Artful and unusual presentations of food were introduced. Food was served in edible cups (tomato, orange, and melon bowls). As home economists became food stylists, a more "styled" appearance of food was taking hold.

PROPS

Props consisted of colorful appliances (blues, pinks, and avocado green). Plates were more decorative, forks were placed on plates, and more accessories were used. Some environments were natural, while others had nothing to do with the food or were very fanciful. We began to see the use of crockery, pewter, and copper.

PHOTOGRAPHY

Professional art photographers began to take an interest in food as a subject and as a source of income as more advertising dollars were spent on food. We began to see mood lighting, some close-ups, and "creative" shots of food. *McCall's* became a coffee-table magazine. The book *Great Dinners from* Life (compiled from the magazine of the same name) was published with "artful" shots of food. The Time Life book series *Foods of the World* began in 1964. Photographer William Penn tooks beautiful arty food shots for *Life*.

The 1970s

Nouvelle Cuisine, the Feminist Revolution, Vegetarianism, and Alice Waters

Women were entering the workplace in greater numbers as the feminist revolution took hold. National and international cooking schools became popular. Tom Wolfe christened the 1970s the "me" decade, with its self-indulgent behavior and eclectic appetites. The word *cholesterol* became part of our vocabulary. Freestanding inserts made us a coupon culture. Nouvelle cuisine and cuisine minceur were introduced, but they were relatively short lived.

POPULAR FOODS

Popular foods that typified the seventies included homemade breads, beef Wellington, and French-style meals, with quiche and crêpes being particular favorites. From fondue and Crock-Pot chili to buffalo chicken wings and pasta primavera, our tastes were varied and ethnic. Szechuan cuisine sparked our love affair with spicy foods. We were introduced to the search for "the new food" by Frieda's in Los Angeles (spaghetti squash and kiwis are well-known examples). Alice Waters brought us fresh and simple from Berkeley, California. For dessert, there were Bundt cakes and cheesecakes.

GARNISHES

Garnishes became more sophisticated. Sliced scallions, cherry tomatoes, chopped parsley, radish roses, and carrot curls appeared. Vegetables were tied into bundles, and desserts were garnished with chocolate leaves and flowers.

THE LOOK

The seventies' look was very manicured. Food was undercooked, and the "perfect" look in styling began to appear. Crumbs were not allowed with sliced foods and no spaghetti ends appeared in pasta shots. There were a lot of oven and appliance shots. Fake ice cream was prevalent, and foods were brushed unsparingly with vegetable oil. We often put a large variety of food in one shot.

PROPS

We mixed colors and patterns and showed whole table settings. Food was placed in environments with lots of accessories. We used seamless Formica and solid-colored fabrics for surfaces. Food and artwork were used in backgrounds. Utensils were placed in the food, and white plates were becoming popular.

PHOTOGRAPHY

Food photography segued into a more "romantic" lighting style. Toward the end of the decade, we were seeing soft focus behind foods and some dappled lighting. We were seeing texture in foods. The look was often achieved with overhead graphic layouts. Photographers still shot some black-and-white images.

1970s-style fondue.
Ed Oullette, food styling by Denise Vivaldo

The new look for the 1980's. *Kathryn Kleinman for Salad, food styling by Amy Nathan*

The 1980s

Decadence, Take-out Gourmet, and Celebrity Chefs

The 1980s were a time of spending and entertaining (in and out of the house). Gourmet foods and gadgets were available from catalogs such as Williams-Sonoma. Extra virgin olive oil and balsamic vinegar became staples. Many chefs (women included) stepped out of their kitchens and found celebrity. Cooking videos and television programs proliferated. The film *Babette's Feast* began a trend in food movies, and the word *foodie* was introduced. The Zagats produced their first restaurant guide. Paul Prudhomme gave us blackened food, while Jean-Georges Vongerichten and Charlie Trotter introduced us to reductions, infusions, and essences. Wolfgang Puck's gourmet pizzas were a hit, while Alfred Portale's architectural presentations influenced chefs' plating techniques for the next decade. We began the decade with oversized plates holding small portions of healthful food and ended it with handcrafted plates holding comfort food.

POPULAR FOODS

Favorite foods included pasta, wild rice, risotto, basmati rice, root vegetables, composed salads, cold soups, and all varieties of mushrooms. Mesclun lettuces, edible flowers, baby vegetables, and vegetable chips became familiar, particularly on restaurant menus. Sushi and sashimi were popular, and it seemed that each nation got its fifteen minutes of fame. Tex-Mex, oat bran, kebabs, and tiramisù added to the eclectic mix. Salad bars, whole fresh meals available in grocery stores (a concept referred to as home meal replacement), and sugar-free foods all came into prominence as we continued to be concerned with issues of time and obesity.

GARNISHES

Chef-style garnishes were ubiquitous—carved vegetable flowers, tomato roses, fluted mushrooms, and onion brushes. Edible flowers appeared on every dish (from soup to dessert) for a while. We used citrus garnishes and twists, mint, and basil. Herbs were used whole or chopped and scattered, while plate painting and dusting came into vogue.

THE LOOK

Food presentation included overlapping plates, precision styling, heavy spritzing, and food that didn't touch other food. Home consumer foods were presented with a "chef's look." Food stylists worked to create more action in shots. We showed bites out, torn bread, sliced foods, pulls and drips (cheese and chocolate), and pour shots. Amy Nathan and Kathryn Kleinman's book, *Salad*, was released with very fresh, artful, underlit photographs that were shot from overhead. It was the new look everyone wanted.

PROPS

Prop stylists came into their own in the 1980s, and props ruled or were at least as important as the food in our shots. A much larger selection of props was becoming available. Black and silver plates suggested elegance. Octagonal, pottery, and earthenware plates became available. Napkins were soft fabric and draped rather than sharply folded. Surfaces could be anything with an interesting texture or pattern: marble, metal (sometimes rusted), barn siding, glossy slates, Lucite, even handmade paper. Heavily draped fabric was also used as a background (see the photograph on page 238).

PHOTOGRAPHY

Photographers' lighting, equipment, and techniques improved. Large-format cameras were commonly used. We saw moody, romantic lighting; studio-created sunlight; dappled light; and backlighting with a glow. Bank lights (large fill lights) were used. Shots became tighter with fewer foods in the shot. Overhead shots, the "Michael Geiger look" (the photographer who shot almost all the food shots for the Sunday *New York Times Magazine*) were very popular. As the decade progressed, images became simpler and cleaner. Available or "natural" light began to be used.

The 1990s
Return to Basics, Fat Reduction, Fusion Cuisine, and Martha Stewart

This decade began with a desire for healthful eating and a personal trainer to assist us at the gym. Reduced fat, low fat, and then fat free became the nutritional goal of many manufacturers. We wanted garden-fresh foods, to which we applied healthful cooking techniques. Grilling made a comeback. Boneless, skinless chicken breasts became the protein of choice. Foreign foods became distinctly regional. Recognizing America's fascination with food, the Food Network was born in 1993, producing more celebrity chefs, who in turn produced cookbook after cookbook. Martha Stewart became the domestic goddess of the nineties, shifting priorities back to the home. As a backlash to fast food, the organization Slow Food began in Italy. Salsa overtook ketchup in popularity. Genetic engineering caused concerns, and organic foods became increasingly available. The Internet allowed us instant access to recipes and information about food.

The 1990s were all about the chef as personality. *Bill Milne*

POPULAR FOODS

Noodles of all kinds, quinoa, salsa, vegetable sandwiches, bruschetta, and focaccia were everywhere. We loved anything "lite," as well as goat cheese, tofu, Asian greens, swordfish, salmon, fajitas, osso buco, flavored oils, lemongrass, and wraps. Beverages blossomed. A new vocabulary for gourmet coffees developed. Bottled water became a sidekick. Microbreweries proliferated,

and smoothies and juice bars were popular. Retro desserts, including cupcakes, chiffon pies, and upside-down cakes, became stylish. We indulged in the new molten chocolate cake.

GARNISHES

Simple fresh herbs, a lemon wedge, or nothing at all were among the choices.

THE LOOK

This decade was strongly influenced by Australian photography and art direction and the books of author and food stylist Donna Hay. The natural quality of *Saveur* magazine's photojournalistic style changed food styling presentations from the "perfect" look to a casual, "real" look—food that looked doable. We showed less food in an image and more single-serving shots. The camera got closer to the food, and the food became the star. Martha Stewart's look and color palette were popular. How-to shots returned to help a population of less-skilled cooks. We moved from chef's controlled architectural presentations to food that was casual and artfully simple. Photos began to be faded or blended into the text.

PROPS

Stacks of simple plates or bowls on a folded napkin were common. White plates were back, as was the Pottery Barn look. Jade greens and turquoise were in the color palette, and there was a return to pastels. At the beginning of the decade, gold-rimmed Annie Glass handmade plates were trendy, and we ironed folds into tablecloths. At the end of the decade, we propped more softly and more casually.

PHOTOGRAPHY

Photography took a big leap with the arrival of digital photography. The decade began with tilted plates, light painting with the Hosemaster, and strong light and shadows (hot tungsten lights versus strobes). Select focus and soft focus were common, and Australia's available-light shots strongly influenced the look of photography. Everyone began to shoot in natural light.

The 2000s emphasized simply presented artisanal ingredients. And fat is back!
Chris Jenkins

The 2000s
Time-Saving Meals, Adventuresome Eating, Green Concerns, and the Internet

The 2000s is a time of information overload. We are a group of information gatherers with more knowledge, but without the time to put the knowledge into practice, and so our cooking skills are technically limited. Learning to cook takes time and help. Many people are going to the Food Network to learn. By 2003, there were seventy cooking shows on television throughout the United States.

We can find anything on the Internet, and publishers are concerned about the sale of newspapers and books. However, cookbooks continue to flourish (about eight hundred are published each year), and many offer easy, convenient, simple, and inspirational recipes. With publishers' budgets becoming tighter, smaller and less expensive single-subject cookbooks (dips, lobster rolls, party nuts, great burgers, pasta salads, or iced teas) have become very popular. If chefs are producing cookbooks, they are more home consumer–oriented—the chef cooks at home or offers restaurant staff meals. Food Network chefs produce a large number of those cookbooks.

Televised food commercials are outnumbered by pharmaceutical and car commercials, but food ads fill the pages of the expanding food magazine market. Some food companies and grocery store chains now produce their own food magazines.

The "food follows fashion" concept, which started in this decade as simple presentations, has become a little more fussy, but not yet outrageous. We have gone from the sixty-minute meals of the eighties to today's ten-minute meals, using four ingredients or less.

Personal chefs or chef-prepared-and-delivered meals are now widely available. Grocery stores are also producing cooked meals or prepackaged, premeasured fresh ingredients. Home delivery is more widespread. Cooking groups meet once a week to cook and prep meals for the week ahead (they do the shopping; you do the prepping). These services have all become common in the first decade of the century to help with producing meals for time-strapped multitasking adults.

LEFT: This 1980s ad took 45 minutes to prepare using a whole cut-up chicken.

RIGHT: The 2000s ad for the same product using the same recipe now takes only 20 minutes to prepare using boneless, skinless chicken breasts. Mesclun has now gone mainstream, replacing the green beans, and the look is bright and light.

The food world is more global, with chefs and food writers traveling and exploring new and unusual foods. Spain's Ferran Adrià and food "technologists" influence the new cooking of young chefs, who as molecular gastronomists are dehydrating, gelling, and transforming foods. At the same time, other chefs are going back to the simple and pure taste of local ingredients. Raw food cookbooks and restaurants have gone upscale and gained recognition.

The decade has added many new terms to the food vocaublary, including *deconstruct, with legs* (meaning it can be taken out), *doable,* and *micro* (referring to baby greens and chefs working with food chemistry). *Organic* and *conventional* are common grocery store terms. *Artisanal* vies with *molecular gastronomy. Culinology* is the new term for the meshing of food science and culinary arts. A strong interest in preserving *heirloom* produce and *heritage* livestock has occurred. Cooking *sous vide* is controversial because of safety concerns about food temperature. We are buying *local* and *sustainable.*

Grocery store shelves explode with new products and formulations—whole grain, low sodium, fat free, and zero trans fats. Obesity is the number one issue of nutritionists. Food companies and restaurants begin to address portion sizes. Packages of 100-calorie snacks find their way onto the shelves.

We are recognizing the importance of buying local and organic. Farmers' markets are gaining strong support and are widely accessible. The United States is becoming green.

POPULAR FOODS

Beef has made a comeback, with new, upscale steak houses becoming trendy and photographs of burgers appearing on the covers of every summer food and nonfood magazine. The slider (a mini burger sandwich) has made it big in restaurants. We are grilling everything. We can find microgreens in grocery stores, and mixed greens are appearing in salad shots for the average home consumer. In restaurants, mac 'n' cheese gets updated with truffle oil, differently shaped pasta, and artisanal cheeses. Cupcakes continue to be popular, but there are now more varieties. Ice cream flavors are more adventurous, and soft-serve goes yogurt-and-green-tea based. Salt is not just salt anymore. We have designer salts and even a book devoted entirely to the subject. Coarse salt is added as a garnish to chocolates. and chocolate is not just chocolate now. It is darker, organic, regional, and has percentages of cacao noted on its packages. Artisanal breads are more widely available.

Alcoholic beverages are increasing in popularity, with new "designer" drinks being invented by mixologists and "liquid chefs." Bottled water is challenged, and tap water is the new "green" water of choice. Breakfast foods have become handheld egg sandwiches and cereal bars so that the multitasking population can eat on the run. While carbs of all types took a hard hit at the beginning of the decade, sugar, especially corn syrup, has become the latest supermarket demon. Flax is the new tofu.

More upscale restaurants offer tasting menus and adventuresome eating with ingredients such as offal, or organ meats. Foams came and went, but a new generation of chefs is producing food based on a strong interest in food science.

GARNISHES

Few garnishes are used in food shots, except in the area of alcoholic beverages, where the food stylist is expected to create unusual but simple garnishes. Most plates of food are presented ungarnished; platters may contain a grouping of fresh herbs or a complementary food item, but painting plates with sauces remains popular. Crumbs, drips, and herb garnishes are used sparingly.

THE LOOK

Food looks mouthwatering and real, clean and very natural. We are shooting very tight on the food with a narrow depth of field at eye level, while everything is in focus with overhead shots. Lifestyle inspires food shots in homes and with people. Strong graphic arrangements are found in both extreme tight shots and distant shots. *Gourmet* magazine becomes "edgy," as it looks to a younger audience. Black and dark blues are commonly used, with some food shots having a grayish cast. Most magazines are taking on stronger visual identities. Seasonal colors are very important. Many magazines use full-page shots of cutting boards or rolled out pizza and pie dough as a base for copy. Images in a photo may fill only one-third of the page, while the rest is left blank or used as space for copy. Fork and spoon shots are coming back. Illustration is mixed with real food. Many ads rely on Photoshop as its use becomes more sophisticated.

PROPS

Props are important again. Varieties of rustic, natural, pristine, and colorful are found even within one issue of a magazine. Color is important, with primary colors returning even as pastels remain popular. Whites and antiques are back as well. Napkins are no longer under every plate, letting us see more surfaces. Backgrounds feature stripes and textures. Black and browns are back in both props and surfaces.

Donna Hay's styling in her magazine revolutionized the food industry. *Con Poulos for News Magazines*

PHOTOGRAPHY

Digital, digital, digital. Digital cameras strongly influence how we shoot. Ease in corrections or additions and the ability to crop and find just the right picture allow everyone to see the final result almost instantly. Digital also allows for ease in transport—to the client's and art director's computers.

Today's trend of presenting very tight shots of food probably started in the studio as the photographer checked a small area of the shot for focus, and everyone loved that shot. With computers and Photoshop, photographers can "improve" or change any shot with ease. The issue becomes one of personal and professional ethics. Most photographers have returned to studio lights rather than using natural light, but the lighting is soft and blue. The horizon line in the background of a shot is back, as is strong side lighting.

INFLUENTIAL MAGAZINES AND BOOKS

Magazines and books are an immediate source of information about the most current trends in food, food styling, and photography. In the 2000s, there have been several that deserve special mention.

- The Australian magazine *Delicious* demonstrates the continued influence of the "Australian look."

- *Real Simple*'s recipe format, which shows pictures of packaged products combined to form a finished dish, is copied by many.

turn simple into special

donna hay
holiday

AUS $7.95 (incl.GST)
NZ $8.95 (incl.GST)
US $7.00
UK £5.00

LAUNCH ISSUE

more than
135
new recipes

An $8000 shopping spree

relax
fast food for easy holiday living

indulge
scoop up summer's most irresistibly cool dessert

party
flirty cocktails

free
gift tags for happy wrapping

Celebrate

your ultimate guide to the season's best food and entertaining

sunny side up: breakfasts, barbecues + blissful bites by the sea

- Martha Stewart's 2005 *Holiday Cookies* magazine brought a much-copied graphic to food presentation. White background and one or two cookies or a stack fill the page. Her recipe index showing a single cookie next to each recipe listing and page number was a new concept.

- *Everyday Food* introduced a digest-size format magazine for today's cook.

- *Chow*, an online magazine, features blog entries and topics that include recipes.

- *Gastronomica*, the journal of food and culture, introduced its first issue in February 2001.

- *Flavor* and *Dish* magazines add a new look to food-service or trade publications.

- *Hot Sour Salty Sweet*, by Jeffrey Alford and Nancy Duguid, combines recipes from the authors' culinary journey through Southeast Asia with stunning food photography.

- *The United States of Arugula*, by David Kamp, is an interesting read on the changes in American eating habits.

- *The Elements of Taste*, by Gray Kunz, explores how tastes intereact and how we experience them.

- *What to Eat: An Aisle-by-Aisle Guide to Savvy Food Choices and Good Eating*, by Marion Nestle, guides you through the American grocery store and tells you how to eat wisely and well.

- *The Ethical Gourmet*, by Jay Weinstein, examines the ethics and politics of what we eat.

- *Alinea*, by Chicago chef Grant Achatz, is a stunning book showing food as we have never seen it before.

- *Ad Hoc at Home*, by Thomas Keller, makes Keller's haute cuisine accessible for the home cook. This cookbook features innovative overhead photography by Deborah Jones.

- *Cooking from Above* series (see page 379).

Culinary Happenings: 1950–1997

Date	Current Events	Countries and Regions of Interest	Products and Equipment	Food and Beverages of Interest	Type of Cooking
1950	**WOMAN IS DEVOTED TO HOME AND FAMILY—PAINSTAKING PREPARATION OF FOODS— POST-WAR MOM AT HOME—CASSEROLES—TV—MEAT**				
	Food rationing ends in France Advertisers are Crisco, Jell-O, Sunkist, Baker's coconut, Minute rice Pillsbury Bake-Off —$25,000 Food additive amendment Advancing of frozen foods Gourmet's first food photo cover '57 High school boys in cooking classes In late 50s Claiborne notes decline in superior American cooking and traditional French cuisine	French Irish White House cooking Chinese	Pressure cooker Rotisserie Bridge Kitchenware '46 Williams-Sonoma '57 Kentucky Fried Chicken '55 McDonald's Inc. '55 Swanson frozen TV dinners '54 Frozen foods Butterball turkeys '54	Soufflés Onion soup and dip Ice box cakes Biscuits Fad diets Meat, beef bourguignonne Iceberg lettuce Chicken not prevalent Sukiyaki Shish kebab Pizza Cake mixes	Canning Economical Casseroles Cream sauces Pressure cooker "Can of soup" recipes Meat loaf
1960	**THE DECADE OF CONVENIENCE—FOODS AND APPLIANCES—THE AGE OF GRANOLA AND TOFU— HOMEMAKERS AS DOMESTIC ENGINEERS**				
	Color additive amendment Marbles in soup mid-60s *Gourmet's* first centerfold March '64 Government links food additives to cancer Fair package labeling act Beginning rise in cooking classes Government probes into processed foods Graham Kerr and Julia Child—TV cooking shows Ban on colored margarine ends '67	Increasing interest in foreign dishes Moroccan French White House cooking Chinese	Nonstick cookware Microwave (very first were '54) Colorful appliances Cool Whip '65 Red Lobster '68	Freeze-dried foods Tarte Tatin Beef stroganoff Flaming desserts Tofu Granola Jell-O molds Spice cake with brown sugar icing Sweet and sour hot dogs	One-dish meals Stews Easy preparation Sales of chicken parts soar
1970	**FOOD REVOLUTION—NOUVELLE CUISINE—CUISINE MINCEUR—ALICE WATERS—VEGETARIANISM—HEALTH AWARENESS**				
	Sophisticated methods of transporting food become standard Nouvelle cuisine Alice Waters opens Chez Panisse '71 Michel Guérard—cuisine minceur Women entering the workplace Freestanding inserts Sept. 7, 1970 International cooking schools for tourists	Hungarian Chinese French Colonial Russian Italian	Crock-Pots Fondue pots Indoor grills Microwave (concerns) Food processor (Cuisinart introduced at Chicago Home Fair in mid-70s; half million sold by 1977) Heavy new product introductions Hamburger Helper '70 Low-salt products Crêpe pans Blush wines '77	Vegetables, sprouts Fruits—kiwi '79 Fondue French-style meals Homemade breads Cheesecakes Quiche, crêpes Shark Flowers '75 Sausages and pâtés Balsamic vinegar Cold soufflés Pasta '79 Spaghetti squash Beef is out, chicken is in Pesto	Vegetarian Spa cuisine Simplistic, lighter home cooking Nouvelle Economical Low cholesterol One-dish meals

Date	Current Events	Countries and Regions of Interest	Products and Equipment	Food and Beverages of Interest	Type of Cooking
1980	**DECADE OF DECADENCE—BEGINS WITH UPSCALE ENTERTAINING AND ENDS WITH CASUAL ELEGANCE, DINING OUT, BAKING**				
	Wolfman-Gold '81 Paul Prudhomme '81 Chef-like presentation of food Women chefs appearing New York Women's Culinary Alliance formed '82 Young Americans choose cooking careers Everyone in family cooks Cooking school vacations Cooking videos and TV programs proliferate Term *foodie* first used Star chefs—Jeff Smith, Julia Child, Madeleine Kamman; chefs become celebrities *Babette's Feast* begins food movies "Grazing" James Beard dies— James Beard House opens Blurring of cooking boundaries as chefs experiment Ethnic splintering Association of Cooking Schools (ACS) becomes International Association of Culinary Professionals (IACP) '87 Zagat—NYC '82	American regional cooking Korean, Moroccan, Portuguese, French Canadian, Southern, Sicilian, Finnish, Spanish, Greek, Chinese, Caribbean, Indian, Cajun, Thai, Tanzanian, Hindu, Arab, Sicilian, American Indian, Southwestern, Japanese, Egyptian, French, Albanian, Mexican, Zen Buddhist, French Bistro	Lean Cuisine '81 Fast-acting yeast '85 Nonstick is accepted Olestra proposed '87 Low-fat products Salad bars	**1980–1985:** Pasta, herbs and condiments, tofu, cassoulet, wild rice, risotto, crab cakes, root vegetables, curry, oxtail, soufflés, composed salads, ratatouille, cold soups, all varieties of mushrooms, fiddlehead ferns, mesclun, flowers **1985–1989:** Homemade pasta, tiramisù, satay, jalapeño peppers, tapas, nuts, polenta, carpaccio, garlic, game meats, mashed potatoes, grits, dim sum, basmati rice, sweet potatoes, oats, meat loaf, cooking with tea, fennel, star anise, chicken soup, baby vegetables, oat bran, vegetable chips	Food as remedies Low sodium Macrobiotic Mixed grill Room-temperature dishes Vegetarian Skewered foods Hot and spicy Steaming Comfort foods Entertaining Grilling Open hearth Low cholesterol
1990	**RETURN TO THE BASICS—GARDEN-FRESH FOODS—SIMPLE HOME COOKING—HEALTHFUL LIFESTYLES**				
	Food Guide Pyramid changed Nutritional Labeling and Education Act Designer chefs' clothes Egg consumption down Food on the Internet, computer disks Antioxidants identified Cooking shows stress entertainment Couples' cooking classes Food Network started '93	Celtic, Spanish, Greek, Italian, Seattle, Pacific Rim, Syrian, Turkish, Jamaican "jerk," Mexican, Thai, German, Trinidadian, Tuscan, Sicilian, immigrant cooking, Puerto Rican, "Nonya cuisine," Indian	Fondue pot returns Microwave column appears regularly Over 12,000 new food products introduced in 90s 70% of pans sold are nonstick Bread machines Clear products Coffee bars	Conch, buckwheat noodles, varieties of potatoes, sausages, salsa, exotic rice, capers, roti, lemongrass, spun sugar, duck, quinoa, hominy, wheat berry, rhubarb, greens, dried fruits and vegetables, sandwiches, herbs, coffee, microbreweries, clear beverages, bruschetta, focaccia, flavored oils, radicchio, kosher foods, exotic juices, seafood stews, goat cheese, return of beef, fajitas	Casual entertaining Cooking while "sporting" Creole Roasting—fish, vegetables, fruit Smoking Sautéing Nostalgia Techniques are stressed Low-fat alternatives for traditional recipes

Date	Current Events	Countries and Regions of Interest	Products and Equipment	Food and Beverages of Interest	Type of Cooking
1995					
	Home baking declines Feminists give greater recognition to the role of cooking in women's lives Chefs devise school lunches Food festivals Celebrity "mothers" cookbooks Egg is back Executives become chefs Cookbooks and magazines look back	Australian, Asian, Iranian, Turkish, Tuscan, Ligurian, Thai, Vietnamese, Indonesian	Pressure cooker returns Olestra approved Salad in bags Juice bars	Aphrodisiacs, light anything, soups, Brussels sprouts, turnips, kale, escarole, chocolate, parsley, artichokes, varieties of rice, game, crayfish, rutabaga, lamb, flavored mashed potatoes, chipotle, jicama, curry, okra, osso buco, sesame noodles, soba noodles, saffron, eggplant varieties, wraps, envelopes for food, fruit tarts, dried fruits, morels, Asian greens, tat soi, mizuna, baby mustard greens, bok choy, napa cabbage, rosemary, sage, swordfish, coq au vin, dessert pudding, octopus, squid, broccoli sprouts	Fusion cooking

"I need an illustrator" . . . becomes "I need a photographer" . . . becomes
"I need an expert on Photoshop" . . . becomes "I need an illustrator"

Date	Look / Food Styling Moments	Type of Styling	Garnishes	Photography and Lighting	Props, Surfaces, and Color
1950	Much illustration Rigid feeling Lots of different foods in one shot—buffet feel Food stylists are home economists with food companies or in test kitchens of magazines	Very full dishes Uneven cooking Not manicured "Home cook" look	Maraschino cherries Unidentifiable leaves Giant butter pats Iceberg lettuce Parsley sprigs	Hot lighting B/W and color 4 x 5s and 8 x 10s are used Many overhead shots as well as side views	Statues in background Props are artificial fish, birds, etc.—theme oriented Sand, marble, cloth, rock Variety of backgrounds
1955	People in shots Disconnected dishes and feeling Foods left whole, not cut or spooned into	Ice cream is real and melted Some food unidentifiable Very full dishes Poultry is well cooked	Grapes Paprika Melon "bowl" Olives Whole cabbage as centerpiece holding meatballs	Hot lighting B/W and color Male photographers (most, if not all)	Sand, marble, flat tablecloths, rock surface Dead chicken, chicken wire—unusual themed background Everyday dishes, baskets Strong surface colors Yvonne McHarg
1960	Cold, impersonal Buffet look—few single-serving shots	Casual styling Food cold, dried Natural preparation	Mint Chives Lemon	B/W and color—B/W Polaroids Hot lighting washes out food Some soft focus in back Location shooting Double-page spreads "Trick" shots—food in trees Bank lighting begins	Wide assortment of props Forks and knives on plates More accessories

Date	Look / Food Styling Moments	Type of Styling	Garnishes	Photography and Lighting	Props, Surfaces, and Color
1965	Casual, but beginning to look controlled Food stylists become freelance *Great Dinners from* Life '69	Casual preparation, becoming more "styled" Clean plates Creative styling—unusual presentations	Cherry tomatoes Watercress Oranges Grilled hot dogs with peaches Macaroni in tomato cups	Cold-looking lighting Some close-ups B/W and color (same book) Hot lights	Blues, greens, and pinks Plates more decorative Pewter, crockery, copper, and wood Natural and unusual environments—fried fish jumping through sautéed almonds
1970	Homey Sept. 7, 1970—first freestanding insert	Perfect poultry begins Very manicured Food is undercooked Panties on poultry and crown roasts	Butter pats Sliced scallions Red peppers Hot food served on leaf lettuce	Beginning to see more romantic lighting	Mixed colors and patterns Whole table settings Lots of accessories Wine and fruit in background Glass
1972	Cozy	The perfect slice	Chopped parsley Orange peel Radish roses Carrot curls Pimiento Tomato wedges	Soft focus behind food Dappled light	Fireplaces Candles
1974	Contrived but casual	Fake ice cream No spaghetti ends Separate rice grains Obvious separate cooking of ingredients Overflowing containers		More texture in food arrangement details 8 x 10 Polaroids	Utensils in the food
1976	Extreme close-up	Perfectionism Oven and appliance shots	Bundles of vegetables Chocolate leaves Watercress	Tungsten lighting Overhead shots Some B/W Geometric layouts	Solid-color fabrics Enameled cast iron Foreign intrigue
1978	Illustrations More how-tos or step by steps Full servings Graphic arrangements Cooking schools Clean and healthy	Heavy oil No crumbs Clean plate Homey	Cherry tomatoes Peppers with hooks Curly lettuce, chicory Flowers		Lineup of same plates Surface is sea of pennies (economical), eggs, beans, lemons, bread sticks, ice, sand, flowers Art in background Seamless and Formica Dishes separated by space
1980	Homey perfection Tomatoes with tops! Grace Manney, Zenja Cary, Sylvia Schur, Helen Feingold, Ann Zekauskas Close-ups Dishes overlap Trengove Studios brings fake drips and drops	Clean food—no herbs Heavy spritzing Raw chicken and shrimp touching vegetable on a board Fork and spoon shots Chef's look	Chives, scallion brushes Paprika Kiwi Cherry peppers Mint	Backlit on Lucite Bank lights Simple and clean 35mm being used more for food	Matching plates Black plates Marble surfaces
1982	Individual portions (with space)	Nouvelle look Foods don't touch	Tomato roses Citrus garnishes Basil Italian garnish Dill Vegetable flowers	Overhead shots	Beginning to see whites Pottery, earthenware Octagonal plates Broken marble

Date	Look / Food Styling Moments	Type of Styling	Garnishes	Photography and Lighting	Props, Surfaces, and Color
1984	No maraschino cherries! Adding people again Formal Red Lobster commercial Amy Nathan and Kathryn Kelienman's *Salad* '85 brings new, cleaner, artful look and approach	Precision! Moisture drops Drips, chopped herbs, crumbs on plate '85	Twists Translucent food Chef-style garnishes	Lucite surfaces and props Backlit with glow behind food "Food in face"	Dinner party look Flowers Oriental plates Year of the black plate (black on black) Textured surfaces Metal surfaces Rough, folded fabrics
1986	Informal Martha Stewart Forks in the food/close-up Cropping into the plates Single portions	Broken pieces Violate edges Bite out Torn bread Pulls—cheese, chocolate, or whatever Pours Real ice cream (Food & Wine) Flowers on the plate Pristine control	Herbs, whole and scattered Flowers Turned mushrooms Mainstream products with very upscale garnishes Mini-vegetables	Low angle from the side begins Selected focus begins Dappled light Studio-created sunlight Michael Geiger—overhead, rustic rusted surfaces	Mixing of the props Black-and-white plates Draped fabrics Linda Cheverton
1988	Advertising—rigid and uptight Single servings Comfort food on magazine covers Glossy paper in magazines Jean-Louis *Cooking with the Seasons* brings new chef's look '89	Absolute perfection Drips Partially eaten food Wedges of onion	Chopped parsley Plate painting Torn piece of bread Herb sprigs—not parsley Plate dusting Edible flowers everywhere	Natural/available light Dappled light Moody, romantic lighting	Geometric-shaped plates Crumbled paper background Rock, marble, anything with texture Fabric with folds
1990	*Martha Stewart Living* magazine Architectural food (Alfred Portelli) Casual preparation Star chefs	Artful Food touches and overlaps Level in dishes is realistic Brown food	Less garnish is used Chives Limes Basil Herbs	Soft focus Gels create a tone More selective lighting Dark, moody lighting	Barn siding Tapestry White dishes on white Broken items on the table Very casual "New" antiques become very battered props

Significant Food Products

Approx. Year	Products
1853	First potato chips
1856	Sweetened condensed milk
1860–1874	Margarine
1866	Breyers ice cream
1870	Fleischmann's yeast Heinz ketchup
1871	Pillsbury yeast
1886	Coca-Cola (became "Coke" in 1955)
1890	Aunt Jemima pancake and waffle mix Peanut butter
1890s	Cracker Jack
1897	Jell-O (bought by General Foods in 1925) Campbell's soup
1900s (early)	Hellmann's mayonnaise
1901	Hydrogenated oil
1903	Sanka
1909	Instant coffee
1918	Pudding mix
1921	Wonder bread Wise potato chips
1925	Jell-O bought by General Foods
1927	Lender's bagels Gerber baby food Kool-Aid Hostess cakes
1928	Velveeta
1929	Chef Boyardee spaghetti and meatballs Birds Eye
1930	Toll House cookie recipe
1931	Bisquick
1932	Best Foods bought Hellmann's mayonnaise
1932	Fritos
1933	Miracle Whip
1934	Ritz crackers
1935	Eggo waffles
1937	Spam Kraft macaroni and cheese
1940s	TV dinners Freeze-drying of foods perfected
1940	Parkay margarine
1942	Arnold Bakeries
1945	Instant pudding mix Baskin-Robbins
1946	Frozen french fries (introduced at Macy's) Instant mashed potatoes
1948	Pillsbury cake mixes
1948 (Incorporated 1955)	McDonald's

362

Approx. Year	Products
1950s (early)	Duncan Hines cake mixes (Procter & Gamble)
1950s–1960s	Convenience foods booming
1950–1970	Margarine sales doubled
1952	Nondairy creamer—Pream Cheez Whiz
1954	Lipton onion soup mix Butterball turkeys
1955	Kentucky Fried Chicken
1956	Sara Lee acquired frozen baked goods
1958	Jiffy Pop
1959	Häagen-Dazs
1960s	End of Automats (began early 1900s)
1964	Freeze-dried coffee
1965	Cool Whip Kraft individually wrapped processed cheese Gatorade
1966	Hawaiian Punch
1967	Ban on colored margarine ended
1968	Red Lobster
1969	Light n' Lively yogurt
1970s	Frozen novelty desserts New products flood the market (easy meals, etc.) Frozen foods booming
1970	Hamburger Helper Breyers frozen yogurt
1973	Squeezable Parkay
1979–1982	Lean Cuisine
1980s	Low-salt Ritz, Wheatsworth
1980s (late)	Hot Pockets
1985	Fleischmann's Rapid Rise Yeast
1987	Perdue cooked chicken products
1990s	Low-fat products flood the market
1990s (early)	Snapple (beginning of New Age beverages)
1993	Fresh salad in bags
1997	Fleischmann's Yeast with Sourdough Starter

Important Food-related Magazines

Year	Magazine
1870–2001	McCall's (large format) began food in 1890. 1960s was the golden age of McCall's. Small format in 1971.
1883	Ladies' Home Journal
1885	Good Housekeeping
1901	House and Garden
1920s–1946	American Cookery (Boston Cooking School magazine)
1922	Better Homes and Gardens
1932	Family Circle
1937	Woman's Day
1941–2009	Gourmet—first cover photo in 1957; first centerfold in 1966; discontinued narrative form of recipe writing in 1984.
1956	Bon Appétit (circulation went from 240,000 in 1975 to 1.3 million in 1980)
1968–1971	The Betty Crocker Magazine (became Sphere in 1971)
1970s (9 months)	Good Food (reestablished in 1984)
1971–1978	Sphere (formerly The Betty Crocker Magazine)
1972	Ms. Home Cooking
1974	Vegetarian Times
1978	Food and Wine
1978–1979	Cooking (forerunner to Pleasures of Cooking)
1978–1984	Cuisine
1979–1987	Pleasures of Cooking (Cuisinart)
1980–1990	Cook's
1984	Chocolatier
1984–1986	Good Food
1986	Art Culinaire
1987	Cooking Light (most popular food magazine by mid-1990s) Chile Pepper
1988	Herb Companion Guide to Cooking Schools Food Arts
1989	Eating Well
1990	Martha Stewart Living
1992	Land O'Lakes Recipe Collection
1993	Cook's Illustrated Country Living Gardener
1994	Fine Cooking Saveur
1996	Great American Home Cooking (testing) Kitchen Garden August Home's Cuisine

Glossary

The Vocabulary of Food Styling

⬤ denotes a TV/film term.

Acetate. A clear, thin sheet of plastic. When we shoot a print ad or a line of packaging, the art director will often draw the layout on the acetate and put it on the back of a large-format camera or over the monitor to make sure everything is consistent and placed correctly according to the original design. Food stylists use acetate underneath a food that needs support or to help transport foods from one surface to another (such as slices of hard-cooked eggs, perfect margarine spreads, and garnishes such as whipped cream that need to float on the surface of liquids).

Ad. Promotes products, services, and ideas through paid media space, such as in a magazine or on television.

⬤ **AD.** Assistant director, when doing production work.

Advertorial. Hybrid of *advertising* and *editorial*. Usually, it is editorial content that has been paid for and contains a sales pitch.

Aerosol. Pressurized container for spraying liquid particles. In the food styling business, we use Preval Spray Gun power units to spray liquid coloring solutions (which are put in a bottle beneath the pressurized container) to enhance the color of poultry, toast, and crackers.

Apple boxes. Solid wooden boxes used for a variety of purposes in studios and on production sets. Standard sizes are one-quarter, half, three-quarters, and full apples (1 x 2 x 1 feet). If you have to style something at eye level, you can place a box on the counter, then place a plate or glass on top to view the food comfortably at eye level while working. When working at standard tables (rather than counters), you can put an apple box under each leg of the table to raise the table to counter (and comfortable) working height. I have also been known to use apple boxes as chairs when I have a moment to rest.

Backup. A second or third hero reserved in case something happens to the first.

Bark. The ridges or texture on the surface of a scoop of ice cream.

⬤ **Beauty shot.** Used in production, referring to the final shot of food in a commercial that shows off the recipe(s) or product and often includes the package.

⬤ **Bite and smile.** Term used in commercials. It means the actor will be taking a bite out of the food. This translates to: You had better have a lot of hero food ready, because one bite and you will need another perfect hero for the next take and the next after that.

Bleed. Term used in print, referring to a shot that will print out to the edges of the page and will not be contained within a vertical or horizontal box or page margin. The shot bleeds on the page.

⬤ **Blocking.** Working through the moves that will happen when a commercial or movie is shot. It is good to provide stand-in food for this process.

Bloom. A powdery substance found on the outside of fruits such as grapes, blueberries, apples, and the underleaves of pineapples. Stylists like to leave this on the fruit, particularly on blueberries, which will look black when printed if they don't

have this white powdery exterior. Handle the fruit carefully and don't wash it so that the bloom stays on. Some food stylists have tried to replace the "bloom look" by spraying aerosol deodorants on the fruit. Chocolate bloom is something we don't want to happen, though. This is when a fine gray film of superfine sugar or fat forms on the dark surface of chocolate due to improper heating or storage. We might be able to temporarily remove the bloom on chocolate chips by gently heating them with a heat gun.

Breakdown. In production, the written format of what will be happening during the shooting of a television segment. It can include a description of the show or segment, the amount of time per segment, the script, guests or talent, recipes, swaps, camera locations and moves, props and set dress, equipment needed by the crew, and opening and closing shots.

B-roll. Two cameras shooting different information on a set. The A camera will shoot the primary talent or subject. The B camera will be on a secondary subject or background. Sometimes B-roll refers to something that is taped earlier or supplied by the talent on the show as additional visual material.

Call sheet. Most often used in production, but also in print. Lists all the people involved in the job, their contact numbers and e-mails, address and phone of shoot location, and the time that each member needs be on location (our call time).

Camera angle. View of the camera, from overhead (90 degrees) to eye level (0 degrees) and anywhere in between. It is imperative that you know the angle at which the camera will be shooting the food before you style it so that you look at and arrange the food from that angle.

Camera format. Type and size of film used or the pixel count in digital. With film, it is large format, meaning 8 x 10 inches; medium, meaning 4 x 5 inches; or small, meaning 2¼ inches, which is also 35mm. With digital, it refers to the file size, such as RAW (high resolution or uncompressed), TIFF (high resolution), JPEG fine or superhigh quality (SHQ), JPEG medium or high quality (HQ), JPEG low or standard quality (SQ).

Camera front. The part of the styled food that is meant to face the camera lens. You will be asked, "Where is camera front?" or you will show the person placing the food in front of the camera. Sometimes we mark the back of the plate or bowl (camera back) with a piece of dark tape so that the plate can be placed exactly where it needs to be.

Camera ready. See also Hero. Means the item is ready to be shot.

Camera right/left. Directions to move an object on the set, such as a plate or glass, in a particular direction. The photographer will say, "Move it to camera right," which means the right as we would see it from the camera's point of view. These directions are often confusing, and I sometimes wish they would just say to move it closer to you or farther away from you or toward the camera or away from the camera. They will also say, "Turn it clockwise or counterclockwise"(to the camera, of course). Whichever directions are given, remember that we move something, move it only slightly and slowly until it looks correct to the photographer, who is viewing it through the camera. We work off to the side of the set rather than in front of the camera.

Cheating to the front or back. Often, when to our eye a food looks centered on a plate or butter appears to be in the center of the pancake, it will not appear that way to the camera because of the camera angle. If we need to move the food closer to the front of the plate to make it appear centered, we call this cheating to the front. We can also cheat to the back without feeling guilty, only centered.

Close-up (CU). When the camera lens allows very tight shots of the food. Items can appear many times larger than they are in reality.

Color-corrected packages or labels. An artist's handmade package or label that simulates the real thing, but color adjustments have been made on it and often unimportant "clutter" information on a package is removed for visual appeal. The packages are used in product shots. These packages and labels are expensive to produce and often end up in your work area. It's best to keep them in an area away from you because in the midst of searching through products, it is easy to rip open a color-corrected package by mistake.

Comp. See also Layout. A drawing sent to the photographer and others working on an assignment as a loose interpretation or reference for the actual shot.

Component parts. Quantities of a company's product separated out and put in individual packages. Often used with frozen entrées or soups. This saves the food stylist a considerable amount of thawing and sorting time. It is essential that when you receive component parts, you also get information on the weight or amount of each component part allowed in a serving. When working with component parts, bring a digital scale to the job.

Conference calls. Also see Pre-pro. Used in place of a lot of preproduction meetings. Instead of everyone showing up at a central location to discuss a cookbook or commercial to be shot, this is now done via the telephone. There are pluses and minuses: The obvious plus is convenience; the minus is that it is sometimes hard to share visuals or to look at the product together, but that will change with improved phone technology. Conference calls are often considered gratis time; we charge for our time at a preproduction meeting.

Craft service. Provides snacks and drinks for the crew throughout a day of shooting commercials and movies. Craft service is separate from the regular meals that the crew is entitled to every five hours. Food stylists should not be responsible for feeding the crew.

Cropping. Occurs when we take a shot of food and then move in tighter on a particular area or reshape the shot (to a very narrow vertical or circle, for example). We usually crop to find the most attractive image within an image.

Desktop publishing (DTP). The use of computers to design text and graphics for printing.

Diffusion. Filter, gel, or material placed in front of a camera lens or lights to soften and color a subject.

Double-page spread. One shot that goes across both pages of an open book or magazine.

Dump and stir. Technique used in television food shows and demonstrations. You have all the ingredients in a recipe premeasured in bowls, and the demonstrator just combines the ingredients and mixes. This allows the demonstration to be done quickly, but the demonstration is usually not as interesting as showing some chopping and measuring techniques when time allows.

Editorial assignment. Photographs produced for print, as in a newspaper, magazine, or cookbook. All work that is directed by an editorial staff.

Film. Photographs shot using film rather that digital; also, a movie.

Format. See Camera format. Refers to vertical or horizontal images, etc.

Freestanding inserts (FSI). Materials produced by marketing groups that use coupons and pictures of products to entice consumers to buy the products. Most often found inserted into the Sunday newspaper.

Garnish. Decorative edible accompaniment to a finished dish. The garnish consists of a food item that is in the dish or complements the dish. In food styling, it is an accent food, such as parsley, while in the professional food world, it may be thought of as part of the dish, such as Parmesan cheese that is sprinkled on top of pasta.

Generic. General name for a product rather than using its brand name. For example, the generic for Tabasco is hot pepper sauce, and the generic for Saran is plastic wrap.

Gold standard or standard of identity. Ideal look of a company's product.

Gutter. Area in a magazine where facing pages come together. You will often find the names of the prop and food stylists in the gutter; sometimes the illustrator or the photographer is credited there as well.

Hero. Final food. The food that has been carefully prepared and arranged and is now ready to have its picture taken. (Other terms I have heard used are the "captain," "champion," or "ultimate.") The hero is the very best example of the recipe or product, such as a perfect potato chip or a perfectly arranged bowl of potato chips.

Horizontal shot. When we shoot film, we shoot in a rectangular format. We can make either a tall shot (a vertical) or a wide shot (a horizontal). We must arrange the items in the shot to work as a vertical or horizontal shot.

Incentive marketing. Examples are GWP (gift with purchase), coupons, and tear-offs, which encourage the consumer to purchase an item.

Industrials. Videos or films that are generally shot for in-house use as training films.

Infomercials. Lengthy fifteen- to thirty-minute commercials that are shown on television. They promote a food item or piece of cooking equipment and show how that product is used.

In-house. Keeping the work within the facilities of a particular group. For example, if magazines shoot in-house, that means that they don't hire freelance workers. They use their own photographers, recipe developers and testers, and stylists. Some food companies have an in-house staff to produce their own photography. This has become more popular over the years for budget reasons.

Layering. Two or more photographs combined to produce one final presentation. With the advent of digital photography, this technique can utilize many shots to produce one look (see the photographs on pages 84 and 85).

Layout. A layout is a drawing, made by the art director, of what we will be shooting. It tells us everything that will be in the shot, what the camera angle will be, how close the food will be to the camera, and where any copy goes. It tells us if we are showing the whole sandwich or if it has a bite taken out. It shows us how tall the sandwich should be and if someone is holding it or if it is sitting on a plate or a cutting board. The layouts answer many questions and are invaluable. Once in a while, we learn that the layout is just a suggestion of the shot. In this case, the photography team (photographer, prop stylist, and food stylist) needs to be creative.

Light corn syrup. Glucose syrup, also known as dextrose, used to make fake ice cream, add shine to some sauces, and create condensation on cold beverage glasses.

Line extension. An addition to a line of a base food product. For example, a company starts with one soup and then adds soups as they are developed. They are extending the line of soups produced by the company. When styling line extensions, it is important for the packaging to stay consistent. If a bowl is sitting on a certain table, then that bowl and table are reused for photos of the new product.

Marketing. Collective plan produced to promote and sell a commodity. A strong understanding of the commodity and its potential audience is necessary.

Media escort or author escort. Person who accompanies a cookbook author, chef, or food-media personality to media events, such as television appearances or satellite media tours. This person may also be in charge of the shopping, preparation, and propping of food for segments for local and national television programs, where the cookbook author, chef, or personality will be cooking on air or doing food demonstrations.

Mise en place. French term that means to have all the ingredients, tools, and garnishes necessary for a dish prepared so that they're ready to use.

Natural light versus studio light. We have always shot with natural light, but in commercial studios natural light predominated in the late 1990s, when Australia produced beautiful food shots using only natural light. Studio lights (strobes, tungstens, etc.) are still used, and sometimes they are used in combination with natural light.

Overpromise. When we work with any product from a food company, it is important not to enhance, stretch, or cheat so that we misrepresent the product or the portion size stated as the serving size. In other words, we don't want to show a cookie with more chips in it than would occur if we followed the recipe or use more meat on a sandwich than that allowed by the sandwich shop. Some companies are very concerned and conservative about overpromising, some less so.

Particulates. Individual pieces of something, sometimes very small, found in a food item, for example, herbs in salad dressings. We may strain a salad dressing or soup and keep the solids (particulates) separate. Then we can place the solids in the soup or on the salad where desired.

PDF (portable document format). Digital image files to be used as visual and written references.

Peripheral vision. Ability to look at a specific item while being able to see things on either side of that object. The camera doesn't have peripheral vision, but it extends its side vision when a wide-angle lens is used. The camera will see only a small area if the lens is very close to an item, and it will see larger areas as it is pulled back. The magic of the camera (and a photograph) is that it has one area of focus and allows us to look at an item without the distractions of peripheral vision.

Photo outline. Written directions given by an editor or art director on the type and style of a featured story to be shot. Considerations will be mood, colors to be used, season, camera angles, and if the shot is to show the food as an individual serving or the entire recipe. The purpose of the shot, objective, and the audience are often included.

Photo styling. Invisible career that involves controlling the physical elements in a photograph to produce an effective image. Some of the areas of photography that use photo stylists are fashion, product styling, food styling, and room set styling. Some stylists specialize and consider themselves prop stylists, hair and makeup artists, or food stylists.

Point-of-purchase (POP) display. Usually, a hybrid of advertising and packaging. The display is located where the food is normally sold and is used to call attention to or dispense goods at the store.

Portfolio or "book." Collection of your very best work put into a folder or photo album. Photographers, prop stylists, and food stylists have one or more portfolios that they show to prospective clients. It is good to have a way to keep these books flexible so that you can add shots or rearrange them according to who is requesting them. With personal Web sites, there are fewer requests to see a portfolio, but it still occurs.

Prep day. Time before a job when we might attend preproduction meetings; organize the job; and shop, cook, or bake. If I need just a half-hour of quick shopping, I don't charge, but if I have to shop and make three pies, which will take the day, I do. Sometimes you can do the baking on the job, but it is best to do it ahead if the food holds. You are more familiar with your own ovens and can concentrate on producing beautiful baked goods. If you are working with a new product or a difficult recipe, you will want to test it. I charge for this time as well. You just have to make it clear ahead of time that you will need a prep day and that this is what you charge. Rates are usually the same as for a shoot day.

Preproduction meeting (pre-pro). A meeting (today, sometimes a conference call) where details of a job are discussed ahead of a shoot day or a television commercial. The meeting usually involves all the "creatives" from the agency: the art director, photographer, prop stylists, and food stylist (and the production team for television). Brand managers from the client side and other key client personnel are also represented. During the pre-pro, a shooting schedule will be discussed. You can go over getting the product (and the amount) and equipment to the set. The selection of talent and wardrobe can be made. Props may be displayed and chosen.

Press or media kit. Folder of information specifically prepared to announce or to inform the media of an event, product, book, or personality. This could include a description of or an article about the product and its uses, pictures of recipes or product, and contact information for samples or more information.

Print. Still shots that will be used in some printed form.

Product. Client's food item that will be shot. It is something that you hope the client will provide, in amounts that should be sufficient to complete the shot or commercial. "Will they be sending product?" is an important question to ask, because the product may be hard or impossible to find in your location, or the client may have improved the formula, or the product may not be available in retail yet. Often you need cases of the product; they are best sent to the shooting location.

Product shots. Found in both print and TV, shots that are tight (close-ups), usually of the prepared product with a package of the product.

Props. Anything that is in a food shot that is not food. This could be anything from a tablecloth, newspaper, or a table that the food will be placed on (referred to as the surface) to a plate or frying pan, napkins and silverware, a wall, or grass at a picnic. The person doing the propping is called a prop stylist. In some situations, food stylists also do the prop styling.

Public relations (PR). Product promotion through the use of the media. Media placement is getting your product to be shown, written about, or talked about by some part of the media. This placement is not paid, but it is solicited by a public relations firm. Public relations firms use press parties and press kits, and send out promotional materials to the media.

Research and Development (R & D). A person or team who develops or improves a product.

Retouching. With the development of digital photography, retouching is commonly and easily applied to most shots. Colors are enhanced or changed, nicks or bruises on products are removed, backgrounds are added in, and reflections are softened.

Satellite media tour (SMT). This is when a chef, cookbook author, or spokesperson goes to a studio that has a satellite hookup to many TV stations around the country from a single location. The person will be interviewed one station at a time, with each station signing up for a specific time and amount of time. Some interviews will be shot live and some taped for later use.

Schlep. Yiddish word meaning to carry heavy bags or packages from one place to another. Picture someone weighed down with two heavy bags on each arm, trudging through the rain or snow, and that is schlepping. It is something food and prop stylists do as part of their job.

Set. Area set up to carry out the shoot. In still photography, the food is usually shot on a table or a covered large sheet of plywood placed across wooden horses (thus the term "tabletop photography"). If the camera angle is overhead or 90 degrees, you will view only the tabletop or surface you are shooting on. As the camera angle is lowered, you view more of the surface and begin to see a background. The set may include walls, windows, and furniture. Alternatively, the food may be shot on something we call a sweep, where the surface just continues until it bends up and is out of camera view. For a movie or television, the set can be anything from the tabletop to something quite massive. It can be a kitchen location or a house, a town or even the whole of outdoors.

Set tray. Tray that is used to transport all food and equipment that will be needed for working on the set to shoot final food. I use an 11 x 15-inch jelly-roll pan lined with aluminum foil (shiny side down). On the tray are tools and any food needed for final or last-minute placement, such as sauces, garnishes, or foods that are fragile or that we might need more of. I also have cups containing water, vegetable oil, and Windex for last-minute touch-ups or clean-ups.

Shoot day. Day when shots of the food are taken or when a commercial is shot. A typical day begins about 9:00 A.M., but it can start earlier, particularly in television. The time you are scheduled to arrive is called the call time. The shoot day lasts until the work is done, which can be eight hours later or twenty hours later. You can charge overtime if you work past a certain hour, which, in TV, is often determined when you schedule the job. In print work, I usually let the photographer know about a half-hour ahead when I will go into overtime (charging time and a half per hour). In TV, a regular day before overtime can be either eight hours or ten hours. In some countries, stylists are paid by the shot; here, we charge by the day. Fees vary from city to city.

Silo. Shot of a food item (such as a slice of pizza, or something in a container, such as a plate of food or a cup of coffee) on a white background that will be used on a print page all by itself, without an environment.

Slow motion (SM). Shooting slow movement requires a type of camera that is able to shoot hundreds of frames per second rather than the usual sixteen. This requires a very bright (and hot) light. Take this into consideration when shooting SM. The hot lights required for this type of shooting can easily destroy the food, so it is important to plan for replacements.

Special effects. People who make difficult or unusual shots happen, or the act of making these things happen. For example, steam has to happen on cue and at just the right density. Chocolate must swirl, cheese singles must fly, food must fall in an exact spot, apples must roll and break open. All these things are made possible by a team of people, and if they are working with food, they will rely on the food stylist for suggestions or help.

Spec sheet. One-page instruction sheet or a small notebook full of information provided by the client. It lets us know how to work with the product, the exact amount of food to use for a serving, and what the product should look like.

Stand. Three-legged pole with arms and clamps that the photographer uses on the set to hold a fork or a reflector card in place or a filter paper in front of a light to produce a richer or warmer effect. To food stylists, these are objects that are in our way and make it difficult to get to the set so that we can work with the food—and they are also something we don't want to touch, kick, or move.

Stand-in. Food that is used for lighting, arrangement, and placement purposes only. It is not shot as final food. The big dilemma is just how good do we make the stand-in look. I can't begin to tell you the number of times I have heard, "Well, we liked the way the pasta was arranged on the stand-in," or "The parsley on the stand-in had a more natural feel." However, it is important that we give the photographer or cameraperson something that closely resembles the hero, or else he or she will have to continue to work on the lighting as our freshly arranged and presented hero begins to fade. Other interesting names used instead of stand-in include "placeholder," "mock-up," and the "first food."

Stock photography. Preexisting images promoted for the photographer by a company that sells them to clients and receives a percentage of the selling price. Some photographers shoot images in their spare time to be used specifically as stock images.

Storyboard. Visual sequence of the action or scene scripted for the shoot. Used for commercials and movies.

Strobe. Type of light used in studios. It is a soft, even light produced in flashes.

Surface. Whatever we put the food on for a shot. This can be anything from a stove top to a slab of marble, a sheet of Plexiglas, or a tablecloth. In the eighties, barn siding and rusty pieces of sheet metal were favorite "found object" surfaces, and black and shiny surfaces were common. Usually, the prop stylist or the photographer furnishes the surface. For the food stylist, the surface is something we don't want to smudge or get moisture circles or oil spots on, so we work carefully with props that are as clean on the bottom as they are on the top. If we do get spots on the surface, this is not an "Oops, I hope they didn't see that" moment; it is confession time. When working with beverages, we prefer vinyl or plastic surfaces to paper or stone, which show moisture rings. The choice of surface can make a big difference to the shot.

Swap out. Finished food used in food demonstrations when the actual baking, cooking, or preparation time is longer that the amount of time allowed for the demonstration. We show the food prepared in stages. For example, we can show everything going into a sauté pan and then swap out the pan and show the completed sautéed food in another pan or even plated, or we can show cake batter in a pan going into the oven and swap out to the already-baked cake.

Sweep. One continuous surface. Often a sweep is made of flexible plastic or paper, but it can also be fabric. It is bent and runs up behind the food being photographed. If we are shooting at a low angle and we don't see anything in the background, we use a sweep.

Swipe (tear sheet). Printed examples of a gold standard or what the client would like the food to look like. When we would like a copy of an ad we have styled, we ask for a tear sheet, which is a clean sample of the printed shot. These are often printed especially for the agency and client and are on heavy paper.

Target audience. The group of people the producer is trying to reach; also called a demographic.

Tease. Just before a television show breaks for a commercial, the tease is used to get the audience to stay tuned for the next segment. If a food demo is scheduled, the director will want to show the chef, cookbook author, or spokesperson doing something with the food. It is often up to the media escort to plan a tease.

Template. Something cut from stiff paper that is in the shape of the food to be presented for a shot. Making several sizes of cake or pie wedges helps us know what size (length and width) piece will fit on a plate. If we have a template cut for brownies, we can use that to get consistent-size brownies for a stack.

Testing. Trying out a shot to see how it works or trying out a new product or a recipe that could be problematic. If you need to test, ask for time before a shoot.

Test shots. Photographs that are produced for personal use. You, the photographer, and sometimes a prop stylist create test shots to be used for promotional purposes or for your portfolio. You each contribute your ideas and efforts. You pay for the food, and the photographer pays for the processing. At the end of the day, you should each have one to several shots to use. This time together is also called testing.

Tie-in. When two or more companies put their monies together to produce one ad. You might find an ad that is selling peanut butter from one company, jam from another, and bread from another. It is our job to represent each of these products equally, which can make for an interesting assignment when each client wants his or her food item to be shown to its best advantage.

Tungsten. Form of lighting used in studios. Tungsten lights produce a strong, warm light. They produce a considerable amount of heat and may make the area around the set very warm, which can be hard on the food.

Vertical shots. Tall shots rather than wide. If you are filling a single page of a magazine, you will shoot a vertical shot. If you are doing a double-page spread, the shot will be horizontal, or shot in a horizontal format.

Violators. These "violate" the package or ad, such as the coupon part of a freestanding insert (FSI) or other text items that cover or break into parts of a picture. The banner slogan "Same Great Taste—Now with Fewer Calories" on a package makes you look at it. Violators on packages are often removed after six months.

"What if." The beginning of a sentence often heard in the studio. When you hear these words from the client, photographer, or art director, what is really being said is, "This is not what I had in mind" or "Could we change this?" or "I think we need to show more product" or "Wow, I really don't like this, and we need to do something else." "What if..." This is your clue to make adjustments.

Win-win. The way we would always like to work, when everyone leaves feeling like a winner. If you are testing with a photographer, it needs to be a win-win situation. You both need or want that shot, and you both equally shared in its concept and production. If you help someone, you hope to be helped in return. In our freelance world, it is always good to keep things on a win-win basis.

Wrap. A popular sandwich. Ingredients are spread on a tortilla and rolled up.

Wrap. As in "It's a wrap." In production, that means we are finished. We also use it in a photo studio, as in "Is that a wrap on the food?" In other words, "Am I finished?" And yes, this is a wrap on the glossary.

Resources

Magazines

Magazines are one of our most up-to-date resources. Like *Cook's Illustrated,* they can be sources of culinary information or, like *Donna Hay,* visual inspiration. They can also illustrate the trends, colors, props, equipment, and foods that are in vogue. It is wise to look at many to see how they are presenting food to their audience.

New magazines are being published in abundance, with grocery stores and food companies now producing them as well. Since my recent move from New York to Portland, Oregon, I have run across three new ones here: *Edible Portland* (part of the *Edible* series of publications in more than fifty locations around the United States); *MIX,* a food and drink magazine; and *Indulge,* produced by Zupan's Markets. I am sure you can find many others in and around major cities. These new magazines could be a source for styling and writing assignments.

FOOD MAGAZINES

Appeal

Best of Fine Cooking: *101 Quick and Delicious Recipes*

Better Homes and Gardens

Better Nutrition

Bon Appétit

Chocolatier

Chow (Internet-based magazine)

Cooking for Two

Cooking Light

Cooking Pleasures

Cooking with Paula Deen

Cook's Illustrated

Cuisine (New Zealand)

Cuisine at Home

Culinary Concierge

Culture

Delicious (United Kingdom)

Delicious Living

Diabetic Cooking Magazine

Diabetic Living

Dine Magazine

Dish

Donna Hay Magazine (Australia)

Easy Home Cooking

EAT Magazine (Canada)

EatingWell

Edible (series of magazines featuring food in specific locales)

Everyday Food

Every Day with Rachael Ray

Fine Cooking

Flavor

Flavours (Canada)

Food and Wine

Food for Thought Magazine

Food Illustrated (United Kingdom)

Intermezzo

Kraft Comida y Familia

Kraft Food and Family

Le Must Alimentaire (Canada)

Longo's Experience Magazine

Nutrition Action Health Letter

Nutrition Health Review

Pillsbury Classic Cookbooks

Practical Gourmet

Real Food

Saveur

Taste of Home (number one selling food magazine)

Taste of Home's *Light and Tasty*

Taste of Home's *Simple and Delicious*

Thinline

Vegetarian Times

Wegmans *Menu Magazine*

What's Cooking/Qu'est-ce qui mijote (Canada)

Where to Eat and Drink

LIFESTYLE MAGAZINES

All You

Canadian Living (Canada)

Chatelaine (Canada)

Cosmopolitan

Essence

Family Circle

First for Women

Harper's Bazaar

InStyle

Ladies' Home Journal

Latina

Marie Claire

Martha Stewart Living

More

Ms.

O, The Oprah Magazine

Real Simple

Redbook

Self

Table

Vogue

Vogue Entertaining + Travel (Australia)

W

Woman's Day

Woman's World

FOOD-SERVICE MAGAZINES

Art Culinaire

Dish

Flavor and the Menu

Food and Drink

Food Arts

Food Management

Restaurant Business

Restaurant Hospitality

R&I (Restaurants and Institutions)

PHOTOGRAPHY MAGAZINES

American Photography

Communication Arts (CA)

Digital Photography

Photo District News (PDN)

Professional Photography

Directories and Books

The following directories will help you find food stylists, photographers, production companies, and food companies.

DIRECTORIES

The Advertising Red Books
121 Chanion Road
New Brunswick, NJ 07974
800-340-3244
www.redbooks.com

Directories listing advertising agencies and their accounts.

American Society of Media Photographers
150 North Second Street
Philadelphia, PA 19106
215-451-2767
www.asmp.org

Database for more than eight thousand professional photographers who photograph primarily for publication.

The Black Book, Inc.
740 Broadway, Suite 202
New York, NY 10003
212-979-6700/800-841-1246
www.blackbook.com

A source for photographers; includes visual examples of some photographers' work.

IACP Membership Directory
International Association of Culinary Professionals
1100 Johnson Ferry Road, Suite 300
Atlanta, GA 30342
404-252-3663/800-928-4227
www.iacp.com

Directory available to members only.

Le Book
552 Broadway
New York, NY 10012
212-344-5252
www.lebook.com

International reference for the creative industry.

New York Production Guide
50 North Main Street
South Norwalk, CT 06854
212-243-0404/203-299-1330
www.nypg.com

Produces a yearly guide that includes listings of food production companies, photographers, and stylists who work in production. Other major cities have production guides as well. Research your area to find your closest resource.

Workbook
6762 Lexington Avenue
Los Angeles, CA 90038
323-856-0008/800-547-4688
www.workbook.com

Includes a national directory and serves as an exceptional and comprehensive source for all information pertaining to print and film production. Lists everything from advertising agencies and prop houses to hair and makeup artists, illustrators, set designers, talent agencies, and food stylists and photographers. They publish two books yearly and provide examples of the work of U.S. photographers.

BOOKS

FOOD STYLING AND PHOTOGRAPHY

Budgen, June. *The Book of Garnishes*. New York: HPBooks, 1986.

Carafoli, John. *Food Photography and Styling: How to Prepare, Light, and Photograph Delectable Food and Drinks*. New York: Watson-Guptill, 1992. Subsequently self-published.

Chalmers, Irena. *Food Jobs: 150 Great Jobs for Culinary Students, Career Changers, and Food Lovers*. New York: Beaufort Books, 2008.

Cox, Susan Linnet. *Photo Styling: How to Build Your Career and Succeed*. New York: Allworth Press, 2006.

Manna, Lou. *Digital Food Photography*. Boston: Thomson Course Technology PTC, 2005.

Pastor, Carol. *Food Magic: Easy Ideas for Pretty Dishes*. New York: Wiley, 1996.

Ridgwell, Jenny. *The Book of Cocktails*. New York: HPBooks, 1986.

Styler, Christopher, and David Lazarus. *Working the Plate: The Art of Food Presentation*. Hoboken, NJ: Wiley, 2006.

Trovato, Rori. *Dishing with Style: Secrets to Great Tastes and Beautiful Presentations*. New York: Clarkson Potter, 2004.

RECIPE WRITING AND DEVELOPMENT

Allen, Gary. *The Resource Guide for Food Writers*. New York: Routledge, 1999.

Anderson, Pam. *The Perfect Recipe*. New York: Houghton Mifflin, 1998.

———. *How to Cook Without a Book: Recipes and Techniques Every Cook Should Know by Heart*. New York: Broadway Books, 2000.

Arno and Schmidt. *The Chef's Book of Formulas, Yields, and Sizes*. 3rd ed. Hoboken, NJ: Wiley, 2003.

The Chicago Manual of Style: The Essential Guide for Writers, Editors, and Publishers. 15th ed. Chicago: University of Chicago Press, 2003.

Gibbs, Barbara Ostmann, and Joan L. Baker. *The Recipe Writer's Handbook*. New York: Wiley, 2001.

Herbst, Sharon Tyler. *The New Food Lover's Companion*. Happaugue, NY: Barron's, 2007.

Jacob, Dianne. *Will Write for Food: The Complete Guide to Writing Cookbooks, Restaurant Reviews, Articles, Memoir, Fiction, and More*. New York: Marlowe, 2005.

Whitman, Joan, and Delores Simon. *Recipes into Type: A Handbook for Cookbook Writers and Editors*. New York: HarperCollins, 1993. Out of print.

Wolf, Burt. *The New Cooks' Catalogue: The Definitive Guide to Cooking Equipment*. New York: Knopf, 2000. Out of print.

WRITING TECHNIQUE

Lamott, Anne. *Bird by Bird: Some Instructions on Writing and Life*. New York: Pantheon, 1994.

Rabiner, Susan, and Alford Fortunato. *Thinking like Your Editor: How to Write Great Serious Nonfiction—and Get It Published*. New York: W. W. Norton, 2003.

Zinsser, William. *On Writing Well: The Classic Guide to Writing Nonfiction*. New York: HarperCollins, 2006.

FOOD SCIENCE

Corriher, Shirley. *CookWise: The Secrets of Cooking Revealed*. New York: Morrow, 1997.

———. *BakeWise: The Hows and Whys of Successful Baking*. New York: Simon & Schuster, 2008.

Editors of *Fine Cooking*. *How to Break an Egg: 1,453 Kitchen Tips, Food Fixes, Emergency Situations, and Handy Techniques*. Newton, CT: Taunton Press, 2005.

Freedland-Graves, Jeanne, and Gladys C. Peckham. *Foundations of Food Preparation*. 6th ed. Englewood Cliffs, NJ: Prentice Hall, 1996.

Maroukian, Francine, ed. *Chef's Secrets: Insider Techniques from Today's Culinary Masters*. Philadelphia: Quirk Books, 2004.

McGee, Harold. *On Food and Cooking: The Science and Lore of the Kitchen*. Rev. ed. New York: Scribner, 2004.

Parsons, Russ. *How to Read a French Fry and Other Stories of Intriguing Kitchen Science*. New York: Houghton Mifflin, 2003.

Pooter, Norman N., and Joseph H. Hotchkiss. *Food Science*. New York: Chapman & Hall, 1995.

Voorhees, Don. *Why Does Popcorn Pop? and 201 Other Fascinating Facts About Food*. New York: Fine Communications, 2001.

Wolke, Robert L. *What Einstein Told His Cook: Kitchen Science Explained*. New York: W. W. Norton, 2002.

———. *What Einstein Told His Cook 2: The Sequel*. New York: W. W. Norton, 2005.

FOOD REFERENCES AND GENERAL COOKBOOKS

Better Homes and Gardens New Cook Book. 12th ed. Hoboken, NJ: Wiley, 2006.

Betty Crocker Cookbook: Everything You Need to Know to Cook Today. 10th ed. Hoboken, NJ: Wiley, 2005.

Bittman, Mark. *How to Cook Everything: 2,000 Simple Recipes for Great Food*. Hoboken, NJ: Wiley, 2008.

Lukins, Sheila, and Julee Rosso. *The Silver Palate Cookbook*. 25th anniversary ed. New York: Workman, 1979, 2007.

Reichl, Ruth, ed. *The Gourmet Cookbook*. New York: Houghton Mifflin, 2004.

Rombauer, Irma S., Marion Rombauer Becker, and Ethan Becker. *Joy of Cooking*. New York: Simon & Schuster, 2006.

Schneider, Elizabeth. *Uncommon Fruits and Vegetables: A Commonsense Guide*. New York: Morrow, 1998.

———. *Vegetables from Amaranth to Zucchini: The Essential Reference*. New York: Morrow, 2001.

The Visual Food Encyclopedia: The Definitive Practical Guide to Food and Cooking. New York: Macmillan, 1996.

Westmoreland, Susan, ed. *The Good Housekeeping Cookbook*. New York: Hearst Books, 2004.

BAKING AND CHOCOLATE

Allen, Beth. *Perfect Pies*. New York: Penguin, 1998. Out of print.

Beranbaum, Rose Levy. *The Cake Bible*. New York: Morrow, 1988.

———. *Rose's Christmas Cookies*. New York: Morrow Cookbooks, 1990, 1998.

———. *The Pie and Pastry Bible*. New York: Scribner, 1998.

———. *Rose's Heavenly Cakes*. Hoboken, NJ: Wiley, 2009.

Bloom, Carole. *All About Chocolate: The Ultimate Resource for the World's Favorite Food*. New York: Macmillan, 1998.

González, Elaine. *The Art of Chocolate: Techniques and Recipes for Simply Spectacular Desserts and Confections*. San Francisco: Chronicle Books, 1998.

Greenspan, Dorie. *Baking with Julia*. New York: Morrow, 1996.

Klivans, Elinor. *Cupcakes!* San Francisco: Chronicle Books, 2005.

Medrich, Alice. *Cocolat: Extraordinary Chocolate Desserts*. New York: Warner Books, 1990.

Tack, Karen, and Alan Richardson. *Hello Cupcake! Irresistibly Playful Creations Anyone Can Make*. New York: Houghton Mifflin, 2008.

Walter, Carole. *Great Cakes*. New York: Ballantine Books, 1991.

BOOKS AND MAGAZINES THAT CHANGED HOW WE PHOTOGRAPH AND PRESENT FOOD

Achatz, Grant. *Alinea*. Chicago: Achatz LLC/Alinea Mosaic, 2008.

Alford, Jeffrey, and Naomi Duguid. *Hot Sour Salty Sweet: A Culinary Journey Through Southeast Asia*. New York: Artisan, 2000.

Black, Keda, and Fred Lucano. *Cooking from Above—Classics*. London, UK: Hamlyn, 2009.

Hay, Donna. *Off the Shelf: Cooking from the Pantry*. New York: HarperCollins, 2001. Any of her books and *Donna Hay* magazine are also noteworthy.

Keller, Thomas. *French Laundry*. New York: Artisan, 1999.

———. *Ad Hoc at Home*. New York: Artisan, 2009.

Kunz, Gray, and Peter Kaminsky. *The Elements of Taste*. Boston: Little Brown, 2001.

Maroon, Fred J., with recipes and styling by Jean-Louis Palladin. *Jean-Louis Cooking with the Seasons*. New York: Lickle Publishing, 1989.

Martha Stewart Holiday Cookies magazine, 2005.

Magnier Moreno, Marianne. *Cooking from Above—Baking*. London, UK: Hamlyn, 2009.

Nathan, Amy, and Kathryn Kleinman. *Salad*. San Francisco: Chronicle Books, 1985. Out of print.

Trotter, Charlie. *Charlie Trotter's Seafood*. Berkeley, CA: Ten Speed Press, 2004. All of his books are noteworthy.

Saveur. The early magazines helped to bring us the "natural" look.

Stewart, Martha. *Martha Stewart's Hors d'Oeuvres Handbook*. New York: Clarkson Potter, 1999.

Vasello, Jody. *Cooking from Above—Asian*. London, UK: Hamlyn, 2009.

Zavan, Laura, and Pierre Javelle. *Cooking from Above—Italian*. London, UK: 2009.

ART AND DESIGN

Albers, Josef. *Interaction of Color.* New Haven, CT: Yale University Press, 2006.

Ames, Jim. *Color Theory Made Easy: A New Approach to Color Theory and How to Apply It to Mixing Paints.* New York: Watson-Guptill, 1996.

Berger, John. *Ways of Seeing.* New York: Penguin, 1991.

Edwards, Betty. *Drawing on the Right Side of the Brain.* New York: Putnam, 1979.

Gair, Angela, ed. *The Artist's Manual: A Complete Guide to Painting and Drawing Materials and Techniques.* San Francisco: Chronicle Books, 1996.

OTHER FOOD-RELATED BOOKS

Kamp, David. *The United States of Arugula: The Sun-Dried, Cold-Pressed, Dark-Roasted, Extra Virgin Story of the American Food Revolution.* New York: Broadway Books, 2006.

Meyer, Danny. *Setting the Table: The Transforming Power of Hospitality.* New York: HarperCollins, 2006.

Nestle, Marion. *What to Eat: An Aisle-by-Aisle Guide to Savvy Food Choices and Good Eating.* New York: North Point Press, 2006.

Weinstein, Jay. *The Ethical Gourmet: How to Enjoy Great Food That Is Humanely Raised, Sustainable, Nonendangered, and That Replenishes the Earth.* New York: Broadway Books, 2006.

SOURCES FOR COOKBOOKS

Kitchen Arts and Letters
1435 Lexington Avenue (93 and 94 streets)
New York, NY 10128
212-876-5550
www.kitchenartsandletters.com

New York City's best source for cookbooks, food-related books, and out-of-print books.

Powell's Books
800-878-7323
www.powells.com

Largest independent seller of new, used, and out-of-print books in the world.

Jessica's Biscuit
800-878-4264
www.ecookbooks.com

Mail-order and Internet source for more than 14,000 cookbooks, often at discounted prices.

Internet

www.101cookbooks.com Recipe journal of blogger, photographer, and cookbook author Heidi Swanson; focuses on natural whole foods and ingredients and includes photographs and book reviews.

www.allrecipes.com Wonderful selection of recipes rated by consumers.

www.burnsautoparts.com Oddly named Web site of Leslie Burns-Dell'Acqua; offers "manual" specializing in creative marketing for commercial photographers.

www.cheftalk.com Food and cooking articles, glossary, recipes, and forums/message boards with professional chefs.

www.CIAprochef.com Chef news, resources, and professional development courses.

www.cookingschools.com List of culinary schools and degrees; interviews with food professionals, including one with me on food styling.

www.delorescuster.com For information on current food styling trends and classes in food styling.

www.epicurious.com Recipes, menus, cooking articles, and food guide from *Gourmet*, *Bon Appetit*, cookbooks, chefs, and home cooks.

www.escoffier.com Chefs' news, resources, career opportunities, and education.

www.foodesigns.com Articles, directory, events, weekly tips, resources, FAQ for food stylists and photographers.

www.foodnetwork.com Recipes and videos featuring cooking techniques and food prep from top chefs and other experts.

www.foodsubs.com Encyclopedic information on all types of foods; includes pictures.

www.iacp.com Food news and events for culinary professionals; members-only section for food stylists and photographers.

www.jamesbeard.org Food news, trends, chef events, courses, and lectures.

www.joyofbaking.com Baking and dessert recipes, including photographs; ingredient information and glossary.

www.lileks.com/institute/gallery James Lileks's "The Gallery of Regrettable Food"; a fun look at some early food shots.

www.tweezertimes.com Online magazine devoted to food styling; affiliated with www.foodesigns.com.

www.webfoodpros.com Discussion forums for food professionals; includes a forum on food styling.

www.worldculinaryinstitute.com Professional associations, culinary schools and courses, mentor center, chat page, and marketplace link for purchasing specialty foods, equipment, and cookbooks.

Organizations and Conferences

International Association of Culinary Professionals (IACP) www.iacp.com

International Conference of Food Styling & Food Photography www.bu.edu/foodandwine/seminars/photography

New York Women's Culinary Alliance www.nywca.org

Sources for Foods, Tools, Equipment, Supplies, and Cookware, and Props

The following is a sampling of the businesses, mostly in the New York area, that food and photography professionals in that area rely on. These names are intended as a place for you to start as you build and develop your own source listing, based upon your location and needs. Additional suggestions can be found in Zagat Survey's *New York City Gourmet Markets* resource guide and at www.zagat.com.

Cross-referenced sources have been listed in full previously on the pages noted.

FOODS

Produce, Meat, Poultry, Seafood, Cheese

Citarella
2135 Broadway (West 75 Street)
New York, NY 10023
212-874-0383
www.citarella.com

Excellent fish and seafood market that also has a butcher, fresh produce, and other specialty items. Consult the Web site for more locations. Online shopping available.

D'Artagnan
280 Wilson Avenue
Newark, NJ 07105
800-327-8246
www.dartagnan.com

Source for natural and organic meats, poultry, foie gras, sausage, mushrooms, and truffles. Online shopping and mail-order catalog available.

Dean & DeLuca
560 Broadway (Prince Street)
New York, NY 10012
212-226-6800
www.deandeluca.com

Upscale specialty store featuring a good selection of meats, poultry, seafood, cheeses, and many imported items. Consult the Web site for more locations. Online shopping and mail-order catalog available.

Eli's Manhattan
1411 Third Avenue (East 80 Street)
New York, NY 10028
212-717-8100
www.elizabar.com

Specialty grocer offering a selection of fresh meat, poultry, seafood, and produce. Consult the Web site for more locations. Some items available online.

Fairway
2127 Broadway (West 74 Street)
New York, NY 10023
212-595-1888
www.fairwaymarket.com

Specialty market offering a butcher, fresh seafood, cheese, fruits and vegetables, and grocery items. Consult the Web site for more locations. Online shopping available.

Garden of Eden Gourmet Market
162 West 23 Street (7th Avenue)
New York, NY 10011
212-675-3365
www.edengourmet.com

Full-service grocer with especially good produce, meats, and cheeses. Consult the Web site for more locations.

Gourmet Garage
453 Broom Street (Mercer Street)
New York, NY 10013
212-941-5850
www.gourmetgarage.com

Grocer specializing in fresh and imported foods and other items, including organics. Consult the Web site for more locations.

Grace's Marketplace
1237 Third Avenue (East 71 Street)
New York, NY 10021
212-737-0600
www.gracesmarketplace.com

Upscale specialty market with fresh meat, poultry, seafood, and other items.

Jefferson Market
450 Sixth Avenue (10 and 11 streets)
New York, NY 10014
212-533-3377

Full-service grocery with especially nice produce and delivery services.

Lobel's
1096 Madison Avenue (East 82 Street)
New York, NY 10028
212-737-1372
www.lobels.com

Source for excellent meat and poultry. Online shopping and mail-order catalog available.

Manhattan Fruit Exchange
Chelsea Market
75 Ninth Avenue (15 and 16 streets)
New York, NY 10011
212-989-2444

Purveyor of excellent fruits and vegetables; also a good source for bulk quantity.

Whole Foods
10 Columbus Circle
New York, NY 10019
212-823-9600
www.wholefoodsmarket.com

World's largest full-service market specializing in organic and natural foods. Consult the Web site for more locations.

Zabar's
2245 Broadway (West 80 Street)
New York, NY 10024
212-496-1234/800-697-6301
www.zabars.com

Longtime specialists in smoked fish, caviar, cold cuts, and cheese. Online shopping and mail-order catalog available.

Breads and Baked Goods

Amy's Bread
www.amysbread.com
Chelsea Market
75 Ninth Avenue (15 and 16 streets)
New York, NY 10011
212-462-4238

Baker of European-style artisanal breads; a variety of baked sweets as well. Consult the Web site for more locations. Online shopping available.

Dean & DeLuca See page 382.

E.A.T.
1064 Madison Avenue (East 80 and 81 streets)
New York, NY 10028
212-772-0022
www.elizabar.com

One of several of Eli Zabar's stores selling Eli's Bread and sweets. Online shopping available.

Gourmet Garage See page 382.

Chocolate, Nuts, Baking, and Bulk Ingredients

A. L. Bazzini & Company
339 Greenwich Street (Jay Street)
New York, NY 10013
212-334-1280/ 800-228-0172
www.bazzininuts.com

A wonderful source for nuts and dried fruits; bulk items as well as retail. Online shopping available.

Jacques Torres Chocolate
350 Hudson Street (King Street)
New York, NY 10014
212-414-2462
www.mrchocolate.com

Offers high-end specialty chocolate and chocolate confections made by chocolatier and former pastry chef Torres. Online shopping available.

King Arthur Flour
The Baker's Catalogue
135 Route 5 South
Norwich, VT 05055
802-649-3361/800-827-6836
www.kingarthurflour.com

Source for specialty flours, chocolate, and other baking ingredients. Also sells a full line of baking equipment and tools. Online shopping and mail-order catalog available.

New York Cake and Baking Distributor
56 West 22 Street (5th and 6th avenues)
New York, NY 10021
212-675-2253/800-942-2539
www.nycake.com

Offers high-quality chocolate, cocoa powder, and extracts, as well as a huge choice of baking equipment and decorating tools.

Whole Foods See page 383.

Spices and Herbs

Aphrodisia Herb Shoppe
264 Bleecker Street
New York, NY 10012
212-989-6440
www.aphrodisiaherbshoppe.com

One of the country's oldest and most complete sources for culinary herbs and spices. Mail-order catalog available.

Dean & DeLuca See page 382.
Garden of Eden See page 382.

Ethnic Foods and Ingredients

Essex Street Market
120 Essex Street
New York, NY 10002

Source for specialty and Asian ingredients.

Kalustyan's
123 Lexington Avenue (28 and 29 streets)
New York, NY 10016
212-685-3451/800-352-3451
www.kalustyans.com

Source for Middle Eastern, Southeast Asian, Indian, and other international ingredients, spices, and foods.

Kam Man Food Products, Inc.
200 Canal Street (Mulberry and Mott streets)
New York, NY 10013
212-571-0330

Source for Asian ingredients and seasonings.

Katagiri & Co., Inc.
224 East 59 Street (2nd and 3rd avenues)
New York, NY 10022
212-755-3566
www.katagiri.com

Best source for Japanese ingredients and equipment.

Sunrise Mart
29 Third Avenue (9 Street and 3rd Avenue)
New York, NY 10003
212-598-3040

Japanese specialty store offering groceries and some housewares. It has no Web site, but the location of its other store is available online.

FOOD STYLING AND PHOTOGRAPHY TOOLS, EQUIPMENT, AND SUPPLIES

Arista Surgical Supply

Alimed Inc.
297 High Street
Dedham, MA 02026
800-223-1984
www.aristacatalog@alimed.com

Source for fine bent-tip dental (college) tweezers, medical suction tools, and syringes.

B&H Photo, Video, & Pro Audio

420 Ninth Avenue (34 Street)
New York, NY 10001
212-239-7765/800-221-5743
www.bhphotovideo.com

Best source for photographic equipment and supplies, including Photo-Flo. Online shopping available.

Calumet

22 West 22 Street (5th and 6th avenues)
New York, NY 10010
212-989-8500/800-225-8638
www.calumetphoto.com

Source for cameras and photography supplies, including Photo-Flo. Consult the Web site for more locations.

Craftics, Inc.

2804 Richmond Drive NE
Albuquerque, NM 87107
866-296-2130
www.craftics.com

Source for 1/2-ounce Plasticator bottle and various needle sizes. Online shopping available.

Gaunt Industries, Inc.

9828 Franklin Avenue
Franklin Park, IL 60131
847-671-0776
www.gauntindustries.com

Supplier of the Hypo 200*1.5 glue applicator with a needle syringe.

Macy's Cellar

151 West 34 Street (Broadway and 7th Avenue)
New York, NY 10001
212-695-4400
www.macys.com

Source for clothes steamers, such as those made by Franzus. Online shopping available.

Master Appliance Corp.

2420 18 Street
Racine, WI 53403
262-633-7791/800-558-9413

Manufacturer of the Master-Mite heat gun. Call the 800 number to locate a distributor in your area.

Red Arrow Products

P.O. Box 1537
Manitowoc, WI 54221
920-683-5500
www.redarrowusa.com

Offers Maillose, as well as products that replicate roasting and grilling flavors.

Set Shop

36 West 20 Street (5th and 6th avenues)
New York, NY 10011
212-255-3500/800-422-7381
www.setshop.com

Source for many supplies used by food stylists and photographers, such as Dust-Off, dulling spray, and special effects.

Solder-It Co.

P.O. Box 360
Chagrin Falls, OH 44022
440-247-6322/800-897-8989
www.solder-it.com

Manufacturer of the Solder-It SolderPro100 pencil torch, which is available through the Web site, as well as from Napa Auto Parts stores.

State Supply Equipment and Props

1361 Amsterdam Avenue (West 128 Street)
New York, NY 10027
212-663-2300

Source for canvas carrying bags; also an extensive supply of props.

T & T Plastic Land, Inc.

315 Church Street (Lispenard and Walker streets)
New York, NY 10013
212-925-6376
www.ttplasticland.com

Source for the glue applicator with a needle syringe.

Trengove Studios, Inc.

247 West 30 Street
New York, NY 10001
212-268-0020/800-366-2857
www.trengovestudios.com

Specializes in model making, styling products, and special effects, such as fake ice cubes, ice powder, chemicals for steam. Trengove also carries some fake foods and makes fake splashes, pours, and drips to order. Online shopping available.

Wesco Industrial Products, Inc.

P.O. Box 47
Lansdale, PA 19446
215-699-7031
www.wescomfy.com

Manufacturer of sturdy rolling carts that are pretty lightweight and fold up completely. Check the Web site to find a dealer.

Wilton Industries

2240 West 75 Street
Woodridge, IL 60517
630-963-1818/800-794-5866
www.wilton.com

Specializes in cake making and decorating supplies, including Bake Even cake strips for placing around the cake pan.

Miscellaneous Food Stylist's Supplies

Mortician's wax and **museum gel** are available online or sometimes in photography supply stores.

Swiss Chalet food stabilizer is available from the manufacturer at 800-347-9477 or www.scff.com/shop.

Many products have been developed to stabilize and thicken foods. The following are some gums and starches that I have not worked with; they are available through the manufacturers. For information on starches and gels and how they work, go to the National Starch Food Innovation Web site at www.foodinnovation.com.

Mira Clear Gel from Glenn's Bulk Food Shoppe, Hutchinson, Kansas, at 620-662-2875.

Ultra Gel (modified food starch), available from the manufacturer at 801-423-7892 or www.carnetfoods.com.

Instant Clearjel is found at www.foodinnovation.com.

Vegalene Pan Coating is a food-service product that is a mixture of three oils. It is available from Par-Way Tryson Company at 636-629-4545/888-434-3470 or www.parwaytryson.com.

Wildroot hair tonic used to be easy to find, but lately I have had trouble finding it. The manufacturer suggests that it is often found in Rite Aid pharmacies, or you can order it at www.americarx.com.

COOKWARE

Bloomingdale's
Lexington Avenue and 59 Street
1000 Third Avenue
New York, NY 10022
212-705-2000
www.bloomingdales.com

Consult the Web site for more locations. Online shopping available.

Bowery Kitchen
Chelsea Market
75 Ninth Avenue (15 and 16 streets)
New York, NY 10011
212-376-4982
www.bowerykitchens.com

Good source for professional cooking equipment and baking items. Consult the Web site for another location. Online shopping available.

Bridge Kitchenware
5630 Eagle Rock Avenue
Roseland, NJ 07068
973-287-6163
www.bridgekitchenware.com

One of the best sources for professional cookware and equipment anywhere. Online shopping available.

Broadway Panhandler
65 East 8 Street (Broadway and Mercer Street)
New York, NY 10003
212-966-3434/866-266-5927
www.broadwaypanhandler.com

An extensive source of knives, bakeware, cooking tools, and equipment. Online shopping available.

Chef Restaurant Supplies
294 Bowery (Houston Street)
New York, NY 10012
212-254-6644/800-228-6141
www.chefrestaurantsupplies.com

Source for professional cooking equipment.

Chefs Catalog
800-338-3232
www.chefscatalog.com

Online and mail-order catalog with an extensive selection of kitchen equipment, tools, cookware, and bakeware.

Dean & DeLuca See page 382.

Henry Westpfal & Co.
115 West 25 Street (6th and 7th avenues)
New York, NY 10001
212-563-5990

Source for professional blade sharpening, knives, and accessories; known as the knife man.

JB Prince
36 East 31 Street (5th and 6th avenues)
New York, NY 10016
212-683-3553/800-473-0577
www.jbprince.com

Great selection of knives, professional cooking and baking equipment, and professional books. Online shopping available.

Korin
59 Warren Street (West Broadway and Church Street)
New York, NY 10007
212-587-7021/800-626-2172
www.korin.com

Source for Japanese knives, tableware, and kitchen items. Online shopping available.

Macy's Cellar See page 385.

New York Cake and Baking Distributor
See page 384.

Zabar's See page 383.

SOURCES FOR PROPS

Prop Houses

Kuttner Prop Rentals, Inc.
601 West 26 Street (11th Avenue)
New York, NY 10001
212-242-7969

Specializing in antique and vintage props.

The Prop Company—Kaplan & Associates
111 West 19 Street (6th Avenue)
New York, NY 10011
212-691-7767

A large selection of props.

Props for Today
330 West 34 Street (8th and 9th avenues)
New York, NY 10001
212-244-9600
www.propsfortoday.com

Try to visit: walls of plates, surfaces, fabrics, etc.

Other Places to Find Props

ABC Carpet & Home
888 Broadway (19 Street)
New York, NY 10003
212-473-3000
www.abchome.com

Consult the Web site for more locations. Online shopping available.

Barney's
660 Madison Avenue (60 Street)
New York, NY 10065
212-826-8900/888-222-7639
www.barneys.com

Features very high-end home furnishings. Consult the Web site for more locations. Online shopping available.

Bergdorf Goodman
754 Fifth Avenue (57 Street)
New York, NY 10019
212-753-7300/800-558-1855
www.bergdorfgoodman.com
Specializes in very expensive and unusual home goods. Online shopping available.

Bloomingdale's See page 387.

The Broadway Panhandler See page 387.

Crate & Barrel
650 Madison Avenue (59 Street)
New York, NY 10022
212-308-0011/800-967-6696
www.crateandbarrel.com

Consult the Web site for more locations. Online shopping and mail-order catalog available.

Henri Bendel
712 Fifth Avenue (56 Street)
New York, NY 10019
212-247-1100/800-423-6335
www.henribendel.com

Offers expensive linens, plates, and accessories. Consult the Web site for more locations. Online shopping and mail-order catalog available.

Macy's See page 385.

The Pottery Barn
600 Broadway (Houston Street)
New York, NY 10012
212-219-0373/888-779-5176
www.potterybarn.com

Consult the Web site for more locations. Online shopping and mail-order catalog available.

Williams-Sonoma
10 Columbus Circle
New York, NY 10019
212-823-9750/877-812-6235
www.williams-sonoma.com

Source for contemporary kitchenware and linens. Consult the Web site for more locations. Online shopping and mail-order catalog available.

Promotional Materials Suppliers

Modern Postcard
1675 Faraday Avenue
Carlsbad, CA 92008
760-431-7084/800-959-8365
www.modernpostcard.com

Favorite source of food stylists and photographers for professional-quality postcards and other promotional materials.

Index

Page numbers in *italics* indicate illustrations.

A

A and B solution, 134
Acetone, 141
Achatz, Grant, 356
Advertising Age, 27, 321
Advertising agency, hierarchy in, 32, 33
Advertising assignments
 client expectations in, 26
 vs editorial, 21–23
 fees, 42
 and government guidelines, 27
 product shots, *22*, 22–23, 29, 42, 44,
 230, 234
 television commercials, 30, 100,
 105–106
 types of, 5–6
Advertising Red Books, 319, 376
Advertising shots vs editorial shots, *20*, 21,
 48, 201, *202*, *310*
Advice for the food stylist, 15
Aerosols, 138–139, 365
Alford, Jeffrey, 356
All-Clad pans, *96*, 96, 97
Aluminum foil, 146
American Society of Media Photographers,
 80, 376
Angel food cake, 243, 253
Angostura bitters, 132, *218*
Apple boxes, 126, 365
Apples, 151–152
 Apple Puff Pancake Pie, Delores's
 (recipe), 94–95, *95*, *96*, *97*
Apricots, 153
Aprons, 119–120
Aqua Frost, 135, 137
Aqua Gel, 131, 290
Armature wire, 125–126, *126*, 140
Armor All Protectant, 136, 189
Art and design books, 380
Art director, 24, 32, 104, 242
Artichokes, 153, 171
Arugula, 159, 171
Asher, Phyllis, *62*
Ascorbic acid, 133
Asparagus, 153, 171
Assistant. *See* Food styling assistant
Assistant director, 33, 104, 106
Atomizer, spray, *109*, 115, 142
Audience, target, 21–22, 373
Avocados, 153
Aykroyd, Dan, 103

B

Background color, 66, *69*, *94*, 94, *266*, *286*
Bacon, 124, *196*, 196, 197, *352*

Bagels, 188
Baked goods, 241–242. *See also* Cakes;
 Cookies; Pies
 bars and brownies, 269–270
 biscuits, baking powder, 12
 finishing touches, 272–273
 muffins, *188*, 188, 270–271
 phyllo pastry, 270
 stand-ins, 63
 store-bought, 272
 type of shot, 242
Baker's Joy, 138
Baking. *See also* Baked goods
 cookbooks, 379
 equipment, 122–124, *123*, 245–247
 preparing baking pans, 243–245, *244*
 preparing baking space, 243
 prep day, 64, 243
 skills of food stylist, 8, 10, 12, 14, 15
 sources for ingredients, 383–384
Baking racks, 127
Baking with Julia [Child], 50, 101
Bamboo skewers, *109*, 111
Bananas, 153
Bars, 269–270
Bartender's Friend, 139, 294
Basil, 171, 174
Baster, glass bulb, 117,142, *287*
Bastianich, Lidia, 300
Beans
 canned, 145, *154*, 154
 fresh, 153–154, 171
Beard, James, 98, 100, 328
Beef, 214–215
 hamburger patties, 203–204, *204*, *214*
 steaks, *71*, 71
Beer, 294–295
Beets, 154–155, 171, *322*
Bell peppers, 165, *171*, 173
Bench scraper, *123*
Best American Pie Contest, 264
Better Homes and Gardens, 23
Beverages, cold, *286*, 286–296, *311*
 background color for, *69*, *286*
 bottles, cans, and glasses, chilled, 291
 equipment and supplies for, 137, 286,
 287
 garnishes for, *240*, *293*, 293–294, *294*
 glass condensation, *287*, *288*, 290
 glass condensation, artificial, *288*, *289*,
 290–291,*293*
 ice cubes, fake, *287*, *288*, 291
 major cold beverages, 294–296, *296*
 pour shot, 292, 295
 shot in nine steps, 292

 special effects for, 291–293
 splashes, *84*, *85*, 144, 291–292
Beverages, hot
 equipment and supplies for, 137
 hot chocolate, *74*, 298
 major hot beverages, *297*, 297
 steam effect, 134–135, 297
Beverage trends, 357–359
Bibb lettuce, *159*, 159
Biscuit cutters, 123
Biscuits, baking powder, 12
Bishop, David, *48*
Blackberries, 155
Black Book, The, 80, 319, 376
Black tape, 139
Blanching vegetables, 169
Blender, professional-grade, 124
Blogging, 318
Blood oranges, 164
Blueberries, 155, 271
BlueStik (Fun-Tak), 114, 126, 130, 140, *236*
Books
 on art and design, 380
 cookbooks, 356, 378–379
 directories, 102, 319–320, 376
 food-related, 380
 on food science, 378
 on food styling and photography, 377
 on food trends, 355–356
 on props, 91
 on recipe writing and development, 377
 on vegetables, 151
 on writing technique, 377
Bottles, chilled look, 291
Bowls, 90, 120, 125
Brand differences, 144, 145
Branding iron, 129, 204
Brand manager, 26, 32, 33
Bread knife, serrated, 119
Bread pudding, chocolate, *314*, *315*
Breads
 bagels, 188
 hamburger buns, 201–202
 hot dog buns, 217
 muffins, *188*, 188, 270–271
 for sandwiches, 39, 200–201
 toasted, 187–188
Breakfast foods. *See also* Eggs
 bacon, 124, *196*, 196, 197
 breads, 187–188, *188*
 cereals, *xvii*, 184–187, *185*, *187*
 pancakes, 188–192, *191*
 sausages, 196–197
 waffles, 192–193
Broccoli, 155, *171*, 171
Brownies, 269–270, 332

Browning effect
 poultry, *218*, *219*, 220
 products for, 117, 127, 132–133
 red meats, 215
Brushes, *109*, 111
Brussels sprouts, 155, 171
Budget. *See also* Costs; Fees
 in production work, 105–106
 questions to ask, 39
Bulb baster, glass, 117, 142, *287*
Bundt cakes, 252–253
Bundt pans, 123, 243, 244
Business. *See* Food styling business
Business card, 317, 320
Business ethics, 16–18
Butane torch, 143
Butcher paper, 133
Butter, 138, , 145, *182*
 melt, 182–183, 184, 192, 231, *233*
 pats, 182–183, *183*, 231–232, *233*
 spreads, *183*, 183

C

Cabbage, 155, 172
Cake lifter, *113*, 114, 252
Cake pans, 122
 preparing, 243–244, *244*, 249
Cakes, 247–254
 angel food, 243, 253
 Bundt, 252–253
 cheesecakes, 253
 Chocolate Mayo, Hellmann's Super-
 Moist (recipe), 249
 cupcakes, 253–254
 layer cakes, 248–249, *250*, *251*, 251
 –252
 packaged mixes, 248, 249
 pound/loaf, 253
 prepping, 46
 with slice out, 252
 slice shot, *5*, *251*, 251
 slicing, 129, 247, 249, *250*, 251, 254
 transporting, 123, 125, 249
Cake slicing guide, 129
Cake stand, revolving, 129, 299
Call time, 40
Camera, 81
Camera angle, *20*, 22, 65, 81, 84–86,
 87–88, *88*, *93*, *185*, 366
Camera front, 65, 72, *88*, *127*, 366
Camera operator, 104
Cameraperson, assistant, 105
Campbell Soup label, *27*, 28
Can opener, *109*, 116
Cans, chilled look, 291
Cantaloupe, 162
Caramel ice cream, fake, 281
Carbonated beverages, 294, 295
Car paint, aerosol, 132, 138
Carrots, *155*, 155, 172
Car wax, 137
Cary, Zenja, xi, xv, xvi, 4

Cary Kitchens, xv, xvi, 4, 321
Catalog assignments, 27–28
Cauliflower, 156, 170, 172
CD, promotional, 320
Celery, 156, 172
Cereal, *xvii*, 184–187, *185*, *186*, *187*, 310
Champagne, 295
Charcoal starter, 128, 142
Cheese
 grated/shredded, 178–179, *179*
 grilled cheese sandwiches, *206*,
 206–207
 in hamburgers, 204–205
 low-fat, 144
 melting, *70*, 179, 206–207
 natural, 178
 pizza, 235, *236*
 processed, 179, 204–205, 206
 pull, 235, *236*
 in sandwiches, 201
 sauces, 237
 selling, *22*
 sources for, 382–383
Cheesecake pans, 244
Cheesecakes, 253
Cheesecloth, 116
Cheese grater, 124, *179*, 235
Cheese knives, 119
Cheese product, 144
Chefs, food styling by, *338*, 338–341
Chef's knife, *118*, 118
Cherries, 156
 maraschino, 156, 240, 241, 278–279,
 279
Cherry goo, 131
Cherry juice, maraschino, 133
Cherry pie, *254*, *255*
Cherry pie filling, 239, 258, 273
Cherry tomatoes, 168
Chervil, 174
Cheung, Mike, *328*
Chewing gum remover, 138, 140
Chicken. *See also* Poultry
 baked pieces, 223, *224*
 boneless skinless breasts, 223, 224–
 225, *353*
 broth, 136, 145
 fried, 6, 63, 223, *224*
 grill marks, 44, 224
 parts, *222*, 222–223
 poached, 301
 whole roasted, 217, 220–222
Chicory, 159
Child, Julia, *xiv*, xv, 14, 49–50, 100, *101*,
 101, 348
Chile peppers, 165–166, 173
Chilled appearance, 135
Chinese herbs and spices, 176
Chives, 174
Chocolate
 bread pudding test shots, *314*, *315*
 candies, 286
 chip cookies, 16, *267*, 267, 268

 chips, *26*
 cookbooks on, 379
 curls, 284–285, *285*, *314*, *315*
 drizzles, 240
 hot chocolate, *74*, 298
 ice cream, fake, 281
 Mayo Cake, Hellmann's Super-Moist
 (recipe), 249
 melting, 284
 Sauce (recipe), 240
 sauce brands, 145
 sauces, 285–286
 sources for, 383–384
 tempering, 284
 topping, 278, *282*
Chocolatier magazine, 66, 254, 325
Chow magazine, 356
Cigar/cigarette smoke, for steam effect, 134
City Harvest, 43, 44, 75
Cleaning agents, 141
Cochran, George, 295
Cocktail picks, 112
Cocktails, 295
Coconut, 156, *328*, 328–329
 cracking, *156*, 156
 cream pie, 254
Coffee, *297*, 297, *312*
Coffee bean cup, *312*
Coffee ice cream, fake, 281
Colanders, 122
 pasta colander, 312
Cold calls, 309
Cold cuts, for sandwiches, 30, 198–199,
 201
Colen, Corinne, *73*, *83*, *187*, *197*, *224*, *238*,
 255, *310*
Color
 background, *69*, 94, 94, *286*
 beverages, 292
 complementary colors, *66*, 66, *94*
 foods, 66–68, *68*
 monochromatic color schemes, 66, 68
 of props, *68*, 68, *92*, 94, *94*, *96*,
 96–97, 97
Color chart, foods, 67
Comb, metal, *109*, 116
Commercials, television, 30, 100, 105–106
Communication Arts, 319
Complementary colors, *66*, 66, *94*
Condensation look, 287, *288*, 290
 artificial, *288*, *289*, 290–291
Conference calls, 51, 367
Conferences, for food stylists, 321, 381
Cookbook publisher, 32, 33
Cookbooks
 assignments for, 5, 24
 as resource, 356, 378–379
 sources for, 380
 writing, 325
Cooke, Colin, *xii*, *22*, 22, *62*, *69*, *71*, *84*, *85*,
 86, *87*, *137*, *158*, *159*, *194*, *195*,
 228, *279*, *294*, *311*, *320*, *338*, *346*
Cookie cutters, 123, 269

Cookies, *80*, *86*, *266*
 bars and brownies, 269–270
 chocolate chip, 16, *267*, *267*, 268
 decorated sugar cookies, 268–269
 drop, *267*, *267*
 gingerbread, *40*, *74*, 268–269, *312*
 ingredients, *266*
Cookie sheets, 122, 244–245
Cooking demonstrations, 327–334
 in interview setting, 49–50, *101*, 101, 332–334
 physical appearance during, 330
 prepping, 41, 49–50, 330–331
 questions to ask, 329–330
 recipes used in, 49–50
 satellite media tour (SMT), 102, 332
 shooting schedule, 63
 time allotment for, 51
 tips and techniques, 331–332
Cooking from Above book series, 356, 379
Cooking methods
 trends in, 357–359
 vegetables, 169–170, *171*, 171
Cooking shows, 100
Cooking skills, of food stylist, 8, 10, 14, 15
Cooking spray, 138
Cookware, 121–122, 387
CookWise (Corriher), 149, 265
Cooling agents, 140–141
Cooling racks, *123*, 123–124, 190, 196
Cool Whip, 144, 180, 181–182, 272, 294
Coriander, 174
Corkscrew, *109*, 116
Corn, 156–157, 172
Corn Huskers Lotion, 136
Corn syrup
 dark, 133
 light, 127, 135, 136, 238, *287*, *289*, 290, 368
Corriher, Shirley, xii, 149, 153, 195, 265, 266
Costs, 41–44. *See also* Fees
 equipment and supplies, 43
 food, *39*, 42–43, 105–106
 miscellaneous, 44
 of props, 44
 transportation, 43
Coulis, fruit and vegetable, 239
Cox, Susan Linnet, 91
Cranberries, 157
Cream cheese, 130, 140
Cream pies, 263–264
Cream sauces, 230, 237
Creative skills, 13
Crêpes suzette, 50, 101
Crumb crust, 262
Crust
 crumb, 262
 piecrust, 255, *256*, 257
 pizza, 234
Crystal Ice, 131, 135, 137, 291
Cucumbers, 157, 172
Cuisine magazine, *23*, *53*, 53
Culinary Institute of America, 87, *88*, *326*

Culinary school, 14
Cupcake pans, *123*, 245
Cupcakes, 253–254
Cups
 measuring, 109, 122, 189, *287*
 plastic, 120, *287*
Currants, 157
Cutting boards, *119*, 120, *123*, 128
Cutting tools, 110–111. *See also* Knives

D

Dairy products, 178–184
 low-fat, 144
Dairy Whip, 181
Decorating gel. *See* Piping gel
Delicious magazine, 355, 374
Delivery charges, 44
Denker, Deborah, 82, *83*
Deodorant spray, for moist appearance, 135
Dessert garnishes, 241, 273
Dessert sauces, 240, 272–273
 chocolate, 285–286
 Chocolate (recipe), 240
 ice cream topping, 278, *282*
Deviled eggs, 195
Digital photography, 17, 72, 81, 352, 355
Digital scale, *123*, 124, 145–146
Digital timer, *109*, *109*, 146
Dill, 174
Director, 103, 106
Directories, as resource, 102, 319–320, 376
Director of photography, 104
Dollops, whipped cream/whipped toppings, *21*, *22*, *181*, 181–182, 263, 272
 dustings on, *21*, 273
Domino Sugar, *40*, *50*
Donna Hay magazine, 313, *355*, 374
Donuts, 188
Drop cookies, *267*, 267
Dry ice, 141, 275, 276
Duguid, Nancy, 356
Dulling spray, 127, 136
Dustings, on dessert plate, 273
Dust-Off, *126*, 127, 138, 276

E

Edible magazines, 374
Editorial food styling, 367
 vs advertising, 21–23
 cookbooks, 5, 24
 credits for, 320
 fees in, 42
 magazines, 5, 21, *23*, 23–24
 newspapers, 24
 teammates in, 33
Editorial shots *vs* advertising shots, 20, 21, *48*, 201, *202*, *310*
Educational experience, 14–15
Eggplant, 157, 172

Eggs
 deviled, 195
 hard-cooked, 194, 195
 Meringue, Safe (recipe), 265
 omelets, *193*, 193
 poached, 194
 quiche, 262
 scrambled, 193–194
 soufflés, 195
 sunny-side up, *194*, 194, *195*
Egg wash, *255*, 258
Egg whites, 139
Electric(gaffer), 33, 104
Elmer's Glue-All, 114, 130, 143, 186, 202
Emery boards, 117
Employee identification number (EIN), 76
Endive, 157, 172
English muffins, toasted, 188
Enhancements, 16
Enoki mushrooms, 83, 163
Equipment and supplies, 107–146
 aerosols, 138–139, 365
 baking, 122–124, *123*, 245–247
 for beverages, 137, 286, *287*
 brand differences, 144–145
 for browning effect, 117, 127, 132–133
 brushes, 111
 checklist, 55
 for chilled/moist appearance, 135
 cleaning agents, 141
 in cooking demonstrations, 331
 cooling agents, 140–141
 costs, 43
 cutting tools, 110–111
 for discoloration prevention, *133*, 133
 for foam effect, 139
 for frosting, 252
 gels and thickeners, 117, 131–132
 heat sources, *142*, 142–143
 for holding things in place, 114–115, 130, 139–140
 homemade, 128–129
 for ice cream shot, *277*, 277
 kit, *108*, 108, *109*
 knives, 110, 112, *118*, 118–119, 245
 in location shoots, 58
 for luster, 135–136
 measuring tools, 109–110
 miscellaneous, 115–118, 119–120, 124–125
 for moistness/freshness, 136–137
 oils and fats, 137–138
 for pancakes, 189–190
 photography, 81, 125–127, *126*
 renting, 43
 set tray, *108*, 108–109
 shopping for, 7–8, 53, 54, 56–57
 skewers and sticks, 111–112
 sources for, 385–387
 spatulas and spoons, 112–113, *113*, 190, 192, 233, 245, 252
 for steaming effect, 134–135
 for touch-ups, 141–142

Equipment and supplies *cont.*
 trends in, 357–359
 turners and lifters, *113*, 113–114
Etchepare, Miguel, 329
Ethics, business, 16–18, 27
Ethnic foods, 299–300, 384
Everyday Food magazine, 356
Executive producer, 103
Expenses. *See* Costs
Eyedropper, *109*, 115, 141, *287*

F

Fake foods, 144
Fees, 41–42
 assistants', 42
 invoice, 76–78
 overtime, 42, 106, 268
 for prep time, 38
 in production work, 42, 106
Feingold, Helen, xi, *4*, 10, 257
Fennel, 157, 172
Ferris, Keith, *5*
Figs, 157
Film assignments. *See* Movie assignments
Film cards, *126*, 126, 277
Fine Cooking magazine, *148*, 266
Fingernail polish, 117, 139
 remover, 126, 141
Fish, 225
 Deep-Fried (recipe), *226*
 grill marks on, *225*
 lox, 103
 sources for, 382–383
 whole, fillets and steaks, 225
Fiskars, 114
Flambé shot, 101, 103, 135
Flame effect, 134
Flexibility, 15, 102–103
Floral foam, 115
Flower-Fix, 114, 130, 140, 236, 252
Flowers, edible, 177, 240
Foam effect, 139, 179, 294, 296
Food. *See also specific foods*
 action happening to, 41, 50, 52, 75
 color chart, 67
 costs, 39, 42–43, 105–106
 discoloration, preventing, *133*, 133
 ethnic foods, 299–300, 384
 hero food, xvii, 7, 231, *232*, 268, 341, 368
 high contrast, 65, *66*
 leftover, 43, 44, 75, 76
 mouthwatering appeal of, *70*, 70–71, *71*, 87, 313
 real vs fake, 144
 shopping for, 7, 53, , 149, 151
 shopping list, *54*
 sources for, 382–384
 stand-in food, xvii, 7, 63, 64, 69, 72, 127, 372
 steaming effect, 134–135, 297
 substitutions, 143–144

touch-ups, *73*, 73, 75, 100, 141–142
 trends in, 347, 348, 349, 350, 351–352, 354, 357–359
 unattractive foods, 301
 visual appeal of, *64*, 64–70, 87, *341*, 341
 volume, 300
Food arrangement, 8, *64*, 64–65, *65*
 and camera angle, *88*, 88, *185*
 color of props, *68*
 color schemes, 66, 68
 food color chart, 67
 on forks and spoons, *70*, *185*
 monitor in, *86*
 props in, 69, *72*
 rules of, 65–66, 68
 step-by-step examples, *72*, *74*, *84*, *87*, *185*, *282*, *314*
 support/base in, *69*, 70, 140
Food coloring, 117, 132–133
Food companies
 assignments for, 5–6, 25
 hierarchy in, 32, 33
 product development jobs, 334
Food demonstrations. *See* Cooking demonstrations
Food magazine, *328*
Food magazines, 355–356, 364, 374
Food preparation, 8
 baking/cooking skills in, 8, 10, 14, 15
 casual approach, 189
 creativity in, 62
 recipe testing, 49
 for shoot, 63–64, 341
Food processor, 124
Food products, 370
 brand differences in, 144–145
 for browning effect, 117, 127, 132–133
 development of, 334
 gold standard, 22, *26*, 26, 65, 184, 368
 low-fat, 144
 pancake mixes, 190
 product shots, *22*, 22–23, 29, 370
 questions to ask, 53
 tear sheets of, 39, 75–76, 184, 272
 timeline, 362–363
Food Professionals Guide, 148
Food science, 149, 241, 334
 books on, 378
Food styling. *See also* Equipment and supplies; Fees; Job assignments
 attributes and skills for, 9–14, 15
 book resources for, 377
 as career choice, 8–9, 316
 by chefs, *338*, 338–341
 contact information, 308–309
 defined, 7
 educational experience for, 14–15
 ethical issues in, 16–18
 history of, 4–5
 and media types, 5–7, 19–30, 319
 overview, 3–18
 and propping, 90, 91

by small businesses, 336–337
 steps in, 7–8
 vocabulary of, 365–373
 work experience, food-related, 15–16, 306, 324–334
 working on the set, 72–75
 and work team. *See* Teammates
Food styling assistant
 advice to, 15
 attributes and skills of, 307
 fees of, 42
 job requirements for, 307–308
 and job search, 308–309
 in location shoots, 57
Food styling business. *See also* Food styling assistant; Promotional tools
 marketing plan, 316–317
 and networking, 309, 321–322
 resources for, 319–320
 starting out, 32, 306
 test shots, *310*, 310–313, *311*, *312*, *314*, *315*
 volunteer opportunities, 24, 306
Food styling trends, 345–364
 1950s, *346*, *347*, 347, 357, 359
 1960s, *348*, 348, 357, 359–360
 1970s, *349*, 349, 357, 360
 1980s, *350*, 350–351, *353*, 358, 360–361
 1990s, *351*, 351–352, 358–359, 361
 2000s, *352*, 352–356, *353*, *355*
Foods of the World series, 299, 348
Foreign locations, prepping for, 57, 58
Fork shots, 70
Freelance personality, 9
Freestanding inserts (FSIs), 25, 367
Freezers
 chest, 127, 274–275, 277
 Styrofoam ice house, 128, 275–276, *276*, 278
French fries, *20*, 232
French herbs and spices, 176
French's mustard, *205*
Frosting
 canned, 251
 for cookies, 268
 equipment, 252
 patterns in, 299
 Royal Icing (recipe), 268, 269
Fruit
 coatings, 239
 cuts for, 66
 food color chart, 67
 information sources on, 151
 out-of-season, *148*, 148
 perfect, 151, 168
 pies, 255, *256*, 257–258
 sauce, smooth (coulis), 239
 seasonal availability, 170
 selecting, 149–168
 sources for, 152
 tarts, 261, 273
 transportation of, 170

Fruit-Fresh, 117, 133
Funnels, 116, *287*
Fun-Tak (BlueStik), 114, 126, 130, 140, *236*

G

Gaffer, 33, 104
Gaffer's tape, 130, 139
Galton, Beth, 5, *95, 152, 205, 254*
Garbage bags, 125
Garnishes, 68, 69, 240–241, *241*, 368
 for beverages, *6, 69, 240, 293*, 293–
 294, *294, 295*
 dessert, *241*, 273
 flowers, edible, 177, 240
 herbs, fresh, 173–174, 240, 293
 lemon/lime, *6, 161, 293*, 294
 for soups, 211
 trends in, *241*, 347, 348, 349, 350, 352,
 354, 359–361
 variety, 293
Gastronomica, 325, 356
Geiger, Michael, 351
Gelatin, 117, 131
 in cream pies, 263
Gels and thickeners, 117, 131–132, 386
German herbs and spices, 176
Ginger ale, 133
Gingerbread cookies, *40, 74*, 268–269, *312*
Glass bulb baster, 117, 142, *287*
Glasses
 chilled, 291
 condensation on, 287, *288, 289*,
 290–291
Glazes, dessert, 273
Glossary, food styling, 365–373
Gloves, white cotton, 117
Glue, 114, 130, 143, 186, 202, 247
Glue applicator with needle syringe, *109*,
 115, 136, 142, *205*
Glue dots and strips, 130
Glycerin, 135, 136, 139, *287*, 290
Gold standard, *22, 26, 26*, 65, 184, 368
Gonzalez, Elaine, 284
Goo Gone, 141
Goo Off, 141
Good Morning America, 264
Gottlieb, Dennis, *iii, x, 5, 20, 21, 48, 69, 70,
 72, 73, 74, 83, 90, 92, 93, 94, 97,
 108, 109, 113, 118, 123,, 126, 127,
 133, 142, 150, 154, 156, 161, 171,
 175, 179, 181, 185, 186, 196, 197,
 204, 205, 206, 212, 213, 214, 218,
 219, 221, 222, 231, 232, 233, 236,
 244, 250, 251, 254, 256, 258, 259,
 260, 261, 266, 267, 276, 277, 282,
 287, 288, 289, 293, 296, 297,
 299, 310, 312, 314, 315*
Gourmet magazine, 243, 313
Graham cracker crust, 262
Granita, fake, 280
Grapefruit, 157–158
Grapes, 158

Grapsas, Mary, 328, 329
Grasshopper pie, *254*
Graters, 117, 124, *179*
 cheese, 124, *179*, 235
Gravy, 238
Gravy Master, 132
Greek herbs and spices, 176
Greens, *158*, 158–160, *159*, 171
Greensman, 104
Griddle, electric, 121, 189, 190
Grill, cast-iron, 121, 171
Grilled cheese sandwiches, *206*, 206–207
Grilled look, simulating, 227
Grill marks
 chicken, 44, 224
 fish, *225*, 225
 hamburger patty, 203–204, *204, 205*
 how to make, *204*, 204, 227–228
 vegetables, *171*, 171
Grip, 105
Grocery list, 54
Guice, Brad, *278*
Gum remover, 138, 140

H

Hamburgers
 additions, *205*, 205–206
 advertising *vs* editorial shots, *20*, 201,
 202
 buns, 201–202
 camera angle, *20, 88*
 cheese, 204–205
 lettuce, 202–203
 meat, 203–204, *204, 205, 214*, 215
 for production, 20–21
Handtrucks, 146
Harris, Michael, *66*
Hay, Donna, 352, *355*
Heat diffusers, 125
Heat gun, *142*, 142, 188
Heating element, *129, 142*, 142, 189
Heating pad, 128
Heat sources, *142*, 142–143
Heavy cream, 180
Herbs
 by country, 176
 glossary of, 173–175
 seasonal availability, 172
 sources for, 384
 storage of, 60
Herbst, Sharon Tyler, xvii, xiii
Hero food, xvii, 7, 231, *232*, 268, 341, 368
Holderer, John, *198*
Holiday Cookies magazine, 356
Hollandaise sauce, 238
Homa, Lisa, 329
Home economists, 4, 14
Home shopping programs, 100–101
Honeydew, 162
Hot chocolate, *74*, 298
Hot dogs, *22*, 216–217
Hot plates, electric, 121

Humorous perspective, of food stylist, 13
Hungarian herbs and spices, 176

I

IACP Membership Directory, 320, 376
Ice
 dry, 141, 275, 276
 fake, 143
 sculpting, 143, 291
Ice chest, 127, 274–275, 277
Ice cream
 brands, 145
 cones, 6
 equipment for, *277*, 277
 low-fat, 144
 à la mode desserts, 272
 pies, *254*, 263–264
 prepping shot, 276–277
 scoops of, 275, *282*
 soft-serve, *278*, 278, 280
 sundae, *282*
 toppings and sauces, 278–279, *282*
 working with, 274–276
Ice cream, fake, *279*, 279–280
 preproduction meeting on, 52
 vs real ice cream, 143
 scoops of, *282*
 Soft-Serve, Artificial (recipe), 278, 283
 as stand-in, 272, 277
 Vanilla, Artificial (recipe), 281
 variations, 281
 White, Basic (recipe), 280, 281
Ice cream scoops, 124–125, 128, 275, *277*,
 277, 282
Ice cubes, fake, *287, 288*, 291
Ice house, Styrofoam, 128, 275–276, *276*
Ice powder, *69*, 131, 135, *137*, 137, *287*, 291
I.D. (International Design) magazine, *198*,
 321
Indian herbs and spices, 176
Indonesian herbs and spices, 176
Industrial films, 102, 368
Infomercials, 101, 368
Information sources. *See* Books; Resources
Instant mashed potatoes, 69, 70
International Association of Culinary
 Professionals (IACP), 308, 320,
 376, 381
 convention, 321, 328
International Conference on Food Styling &
 Food Photography, 321, 381
Internet assignments, 28
Internet resources, 28, 381
Interview demonstrations, 49–50, *101*, 101,
 332–334
Invoice, 76, 77
Invoice log, 76, *78*
Italian food, 300
Italian herbs and spices, 176

J

James Beard Foundation Awards, *98*, 98
Jelly-roll pans, *119*, 120
Jenkins, Chris, 352
Jet Set, 114, 130, 217, 247
Job assignments. *See also* Prepping; Props
 and propping; Shoot
 advertising. *See* Advertising
 assignments
 budgeting. *See* Costs; Fees
 for catalogs, 27–28
 for cookbooks, 5, 24
 food industry, 5–6, 25
 Internet, 28
 invoice, *76*, 77
 invoice log, *76*, 78
 for magazines, 5, 21, *23*, 23–24, 33, 53
 for marketing firms, 25–26
 for movies. *See* Movie assignments
 for newspapers, 5, 24
 production *vs* print, 19–21
 for product packaging, 26–27
 for public relations (PR) agencies,
 24–25
 questions to ask, 38–41
 recordkeeping, 38, 46, 76
 for small business, 337
 for television. *See* Television
 assignments
Job folder, *46*, 46, 76
Job forms
 equipment checklist, *55*
 invoice, *77*
 invoice log, *78*
 shopping list, *54*

K

Kabob-It, 228
Kale, 159, 172
Kalhoefer, Kelly, xii, *26*, *86*, *200*, *266*
Kamp, David, 356
Karo syrup. *See* Corn syrup
Kebabs, *87*, *228*, 228
Kebab skewers, *87*, 111–112
Keller, Thomas, 356
Ketchup, 145, 239
Kit, food stylist's, *108*, 108, *109*
 walnut halves in, 117
Kitchen, Dennis, *199*
Kitchen Bouquet (KB), 127, 132, 137, 143,
 188, 197, *218*, *287*, *296*, 297
Kiwis, 160
Kleinman, Kathryn, 350, 361
Klivans, Elinor, 254
Knife sharpeners, 119
Knives, *60*, 110, 245
 electric, 214
 knife roll, 56, 118, *118*–119
 palette, 112–113
Krazy Glue, 217
Krylon Crystal Clear spray, 127, 137, 138,
 190, *287*, 287, 291, 294, 295

Kumquats, 164
Kunz, Gray, 356
K-Y jelly, 130

L

Lamb, 214–215
Langan, Marianne, xi, xv
Lasagna, 229
Layer cakes, 248–252, *250*, *251*
Layouts, 39, *40*, 40, *50*, 50, 368
Leeks, 160, 172
Lemon, 160, *161*, 162
 garnish, 160, *161*, 293, *294*
 slices, 161
Lemonade, *84*, *85*
Lemon extract, 141
Lemon juice, *133*, 133
Lemon zest, *161*
Lettuce, 66, *71*
 in hamburgers, 202–203
 seasonal availability, 172
 types of greens, *158*, 158–160, *159*
Lifter, cake and pie, *113*, 114
Lighting
 natural light, 81, 86, *87*, 369
 studio lights, 81, 86, *87*, 359–361, 369
Lights, work, 127
Lime, 162, 328–329
 garnish, *293*, *294*
Linke, Ruth, 94–95
Loaf cake, 253
Loaf pans, 244
Lobster, 226
Location manager, 33, 103–104, *105*
Location scout, 105
Location shoot, 56, 57–58, 60, *105*
 checklist, *57*
 foreign, 57, 58, 121
Long, Diane, *347*
Low-fat foods, 144, 239
Luster, appearance of, 135–136

M

Macaroni and cheese, 230
Macey, Dan, *348*
Mâche, 159
Macromedia Flash, 318
Magazine publisher, 33
Magazines
 assignments for, 5, 21, *23*, 23–24, 53
 food-related, 355–356, 364, 374, 379
 as resource, 374–375
 writing for, 321, 325
Maillose, 132, 188
Makeup and hair, 104
Mandarin oranges, 164
Mangoes, 11, 162
Manney, Grace, 4
Maraschino cherries,156, 240, 241, 278–
 279, *279*
 juice, 133

Margarine, 138,, 145, *182*
 melts, 184, 192
 pats, 182–183
 spreads, 183
Margerin, Bill, *48*, *83*, *96*, *98*
Marjoram, 174
Marketing firms, 25, 33
Marketing plan, 316–317, 369
Marketing tools. *See* Promotional tools
Mashed potatoes, 231
 instant mashed potato base, 69, 70,
 140, 195, 256, 257, 258
Masking tape, 126, 127, 130, 139, *200*, 287
Matalon-Degni, Francine, 255
Matches, 112
Materials costs, 43
Mayonnaise, 239
 Chocolate Mayo Cake, Hellmann's
 Super-Moist (recipe), 249
McCall's Magazine, 346
McGee, Harold, 149
Measuring cups and spoons, 109, 122,
 189, *287*
Measuring tools, 109–110
Meat
 bacon, *196*, 196, *352*cold cuts, 30,198–
 199, 201
 hamburger patty, 203–204, *204*, *205*,
 214, 215
 hot dogs, 216–217
 mouthwatering appeal of, *71*, 71
 raw red, 215
 red meats, 214–215
 sausages, 196–197
 sources for, 382–383
 storing, 133, 203, *214*
 white meats, 215–216, *216*
Meatballs, 215
Meat juices, 136, 215
Media, types of, 5–7, 23–30, 319
Media escort, 29, 41, 327–329, 369
Melons, 162
Meringue, Safe (recipe), 265
Meringue-topped pies, *254*, 264, 265–266
Mesclun, 159–160, *353*
Mexican herbs and spices, 176
Micro Brown/Micro Brown Chipotle, 132,
 215
Microplane, 124
Microwave ovens, 121, 134, 228
Microwaving vegetables, 169
Middle Eastern herbs and spices, 176
Milk, 179
 color of, 292
 foam, 139, 179
 low-fat/skim, 139, 144
 splashes, 144, *185*, 186
 substitutions, 143, 186
Milk frother, *287*, 297
Miller, Lynn, 143, 239
Milne, Bill, *351*
Mint, 174
Mise en place, *48*, 64, 369

Misters, 142
Mitchell, Peyton, *347*
Mixers, 124, 248, *250*
Moist appearance, 135
Monochromatic color schemes, 66, 68, *69*
Monitor, 86
Montana, John, *46, 60, 61, 91, 94, 183, 188, 208, 209, 285, 298*
Mortician's wax, 114, *126*, 126, 130, 140, 386
Mouthwatering appeal, *70*, 70–71, *71*, 313
Movie assignments. *See also* Production food styling
 crew involved in, 103–105
 flexibility in, 102–103
 industrial films, 102
 production companies, locating, 102
 production crew in, 33, 103–105
 sequence of shots, 106
 shooting schedule in, 63
 storyboards in, 50–51
 studio *vs* location, 105
 types of, 6–7, 30
Movies, food-themed, 30, 350
Muffins, *188*, 188, 270–271
 blueberry, 271
Muffin tins, *123*, 123, 245, 271
Museum gel, 386
Musgrave, Steve, *27*
Mushrooms, 162–163, 172, *326*
Mussels, 226
Mustard, 239
Mustard squiggle, *205*, 216–217

N

Nathan, Amy, 350
National Culinary Review, 321, 338
Natural light, 81, 86, *87*, 369
Naturalness, standard of, 17
Nectarines, 163
Nestle, Marion, 356
Networking, 309, 321–322
New Cook's Catalogue, The, 125
New Food Lover's Companion, xvii
Newman, Paul, 6, *56*, 56
Newman's Own, *56*
Newspaper assignments, 5, 24
New York magazine, 4
New York Production Guide, 102, 319, 376
1950s trends, *346, 347*, 347, 357, 359
1960s trends, *348*, 348, 357, 359–360
1970s trends, *349*, 349, 357, 360
1980s trends, *350*, 350–351, *353*, 358, 360–361
1990s trends, *351*, 351–352, 358–359, 361
North African herbs and spices, 176
Nuts, sources for, 383–384
Nut topping, 278

O

Oatmeal cereal, *187*, 187
Offset spatula, *113*, 113, 190, 192, *233*, 277
Oils and fats, 137–138
 olive oil, 135, 137
 vegetable oil, 133, 135, 136, 138
Okra, 163, 172
Olive oil, 135, 137
Olizon-Chikiamco, Norma, 328
Omelets, *193*, 193
On Food and Cooking (McGee), 149
Ong, Jim, xii, *74, 127, 191, 193*
Onions, 163–164, 172
 onion rings, 205–206
Orange foods, 67
Oranges, 164
Oregano, 174
Organizations, for food stylists, 321, 381
Organization skills, 9–10
Orlick, Judi, xi, xii, *199*
Oullette, Ed, *349*
Oven, portable, 121
Overtime rates, 42, 106, 268

P

Packager, cookbook, 24
Padys, Diane, *xvii, 80, 310*
Paint, spray, 127, 138
Paint stripper, 142, 189, 192
Palette knives, 112–113
Pancakes, 188–192, *191*
 Apple Puff Pancake Pie, Delores's (recipe), 94–95, *95, 96, 97*
 equipment and tools, 189–190
 mixes, 190
Pancake turner, 113, 189
Panini, 207
Pan juice, 238
Papaya, 164
Paper towels, 137, 141, 170
Paraffin wax, 138, , 202, 247
Parchment paper, 146
Paring knives, *118*, 118
Parsley, 174–175, *175*
Particulates, 116, 278, 281, 369
Pasta, 229–230
 sauce, 230, *238*, 238
 in soups, *211*, 211, *212, 213*
Pastry bag and tips, 116
Pastry blender, *123*
Pastry brush, 111, 190
Pastry glues, 247
Patience, attribute of food stylist, 12–13
Peaches, 164
Peanut butter
 as glue, 130
 sandwiches, 207, 208, 209, 298
 swirls in, 298
Pears, 164–165
Peas, 165, 172
Pea shoots and sprouts, 165
Pea vines, 160

Pencil torch, 122, *142*, 143
Peppers, bell, 165, *171*, 173
Peppers, chile, 165–166, 173
Perfect Pies (Allen), 94–95, 255
Persian melon, 162
Personality attributes, 9–14, 307Pesto, 174
Petroleum jelly, *109*, 114–115, 247
Photo-Flo, *109*, 126, 139, *287, 295, 297*
Photographers, 4–5, 79–88
 assistant for, 24
 contact information, 319, 376
 as food stylists, 334
 hiring of food stylist, 32
 input in food shot, 80, *82, 83*
 networking by, 321–322
 promotional tools of, 317–321
 questions to ask, 38–40
 selecting, 80
 on set, 72–73
 and test shots, 311
 Web site, 28, 318
Photographer's studio
 equipment and tools at, 125–127, *126*
 lighting, 81, 86, *87*, 359–361, 369
 vs location, 105
 set, 72–75, 371
 set up, 39, 40, 41
 storage at, *61*, 61
 teammates at, 32
 work space at, 53, 55, *60*, 60
Photography
 camera angle, *20*, 81, 84–86, 87–88, *88, 93, 185*
 digital, 17, 72, 81, 321–322, 352, 355
 director of, 104
 equipment and tools, 81, 125–127, *126*
 horizontal and vertical formats, *86*
 lighting style, 81, 86, *87*
 Polaroids, 72, 81, 86
 qualities of good food photography, 86–87
 trends in, 347, 348, 349, 351, 352, 355, 359–361
Phyllo pastry, 270
Physical appearance, in television cooking demonstrations, 330
Physical stamina, attribute of food stylist, 13
Pie lifter, *113*, 114
Pie plates, 122–123, 255–256
Pies, *5, 254*, 254–260
 Apple Puff Pancake Pie, Delores's (recipe), 94–97, *95, 96, 97*
 cream, 263–264
 with crumb crust, 262
 with egg wash, *255*, 258
 flutes, *255, 256*
 fruit, 255, *256*, 257–258
 lattice-topped, *254, 255, 258*, 258, *259, 260*, 260
 meringue-topped, *254*, 264, 265–266
 number to make, 53, 255
 prepping, 53

Pumpkin Pie (recipe), *261*, 261–262
 quiches, 262
 shot options, 39, 257
 slice shots, *21*, *254*, 255, 258, *259*,
 260
 tarts, 260–261
 tips for, 255
 transporting, 125
Pineapple, 166
Pins, 112, 140
Pipette, *109*, 115
Piping gel, 130, 131, 135
 recipe, 131
Pizza, 234–237, *236*
 delivery boxes, 128, 236
 sauce, 234, 235
Plastic bags, *119*
Plastic containers, 125, 170
Plastic cubes or blocks, 126, *127*, 140
Plastic wrap, 136–137
Plates
 color of, *68*, 68, *92*, *94*, 94
 eclectic, *98*, 98
 plastic, 120
 size of, 92
Plums, 166
Point-of-purchase (POP) coupons, 25, 369
Polaroids, 72, 81, 86
Poop Freeze, 140, 276
Pork, 215–216, *216*
Portfolio, *62*, 310, 311, 312, 317, 370
Portobello mushrooms, 163
Postcards, promotional, 320, 388
Potatoes, 173, 230–232
 baked, *231*, 231–232, *232*, *233*
 french fries, *20*, 232
 instant mashed potato base, *69*, 70,
 140, 195, *256*, 257, 258
 mashed, 231
 oven-roasted, 232
 varieties of, 166
Pots and pans, 121
Poulos, Con, *355*
Poultry, 217–225 *See also* Chicken; Turkey
 browning effect, *218*, *219*, 220
 partially cooked, 144
 sources for, 382–383
Pound cake, 253
Prep area, in television production, 41
Prep day, 370
Prepping, 45–58, 337
 for baking, 242
 cooking demonstrations, 41, 49–50,
 330–331
 defined, 38, 45
 ice cream shots, 276–277
 job folder in, *46*, 46
 layout visualization, 50
 location shoots, 57–58
 preproduction meeting, 40, 51–52, 92,
 337, 340, 370
 props, 92
 recipe evaluation, 38–39, 47–49

recipe testing, 49
script, breaking down, 51
shopping for food, equipment, and
 props, 7–8, 53–57
storyboards, reading, 50–51
Preproduction meeting, 40, 51–52, 92, 337,
 340, 370
Prep time, fee for, 38
Press packets, 25, 332, 370
Preval sprayer gun, 138
Print media
 vs production, 19–21
 types, 5–6, 23–24
Problem solving skills, 10
Produce. *See* Fruit; Vegetables
Producer, 33, 103
Product development, 334
Production assistant, 104
Production company, 102
Production coordinator, 104
Production crew, 33, 103–105
Production food styling. *See also*
 Movie assignments; Television
 assignments
 fees in, 42, 106
 vs print, 19–21
 studio *vs* location, 105
 types of media, 6–7
Production manager, 33, 40–41, 103, 106
Product packaging, 26–27, 28
Products. *See* Food products
Product shots, *22*, 22–23, 29, 44, 370
Professionalism, 13
Promotional tools
 basic, 317–318
 blogging, 318
 book resources, 319–320
 creative, 309, *320*, 320–321
 press kit, 332
 for small businesses, 336
 sources for, 388
 test shots for, 310, 311, 313, 373
 Web site, 28, 318–319
Propane burners, portable, 121
Propane torch, 121–122, *142*, 227
Prop master, 33, 102, 103
Props and propping, 89–98
 and color, *68*, 68, *92*, *94*, 94, *96*,
 96–97, *97*
 costs, 44
 defined, 370
 and food arrangement, *68*, 68, *72*
 on location, 62
 plates, eclectic, *98*, 98
 preparation for, 92
 questions to ask, 39
 role of prop stylist, 90–91
 shopping for, 7–8, *55*, 57
 sources for, 90, 91, 387–388
 trends in, 347, 348, 349, 351, 352, 355,
 359–361
Prop stylist, 32, 46, 62, 90–91, 92, 94
Prop table, *91*

Public relations (PR) agencies, 24–25, 33,
 370
Publishers, production team of, 32, 33
Puddings, 298–299, *299*, *314*, *315*
Pummelo, 164
Pumpkin, *150*, 167
Pumpkin Pie (recipe), *261*, 261–262

Q
Q-tips, 112, 290
Quiche, 262

R
Radicchio, 160, 173
Radishes, 167, 173
Rain Dance car wax, 137, 290
Raspberries, *5*, *152*, 152, 167, 241
Ravioli, 230
Real Simple magazine, 355
Recipes
 for cooking demonstrations, 41, 49–50,
 330
 development and writing, 25, 49,
 324–325, 377
 evaluating, 38–39, 47–49
 testing, 49
Recordkeeping
 invoice log, 76, *78*
 job folder, *46*, 46
 notebook calendar, 38
Red Lobster, *225*
Red onions, 163
Reichman, Amy, *68*, *83*, *119*, *167*, *182*, *241*
"Reps" (representatives), 317
Resources, 374–381. *See also* Books
 directories, 319–320, 376
 Internet, 28, 381
 magazines, 374–375
 organizations and conferences, 321,
 381
Résumé, 317
Rhubarb, *148*, 148, 167, 173
Ribs, 215
Rice, 145, 232
 Creamy, with Spring Vegetables
 (recipe), 47–49, *48*
Richard, Michel, 13
Richardson, Alan, 254
Ridgwell, Jenny, 293
Roasts, 214–215, *216*
Romaine, 159
Rosemary, 175
Rosie O'Donnell Show, 49–50, *101*, 101
Royal Icing (recipe), 268, 269
Rubber cement, for flame effect, 134
Ruler, *109*, 110, 129, 270
Russian herbs and spices, 176

S

Saffron, 175
 substitute, 175
Sage, 175
Salad dressing, 239
 low-fat, 144, 239
Salads
 greens, 158, 158–160, 159
 mouthwatering appeal of, 71, 71
 propping, 90
 variety of looks, 80, 82, 83
 in wooden bowls, 42
Saliva, 141
Salmon, 225, 225
Salsas, fresh, 238–239
Salt, for foam effect, 139
Sandwiches, 197, 197, 198, 199, 200
 bread, 39, 200–201
 cheese, 201
 cold cuts, 198–199, 201
 grilled cheese, 206, 206–207
 panini, 207
 peanut butter, 207, 208, 209, 298
 wraps, 207
Saran wrap, 133, 136–137
Satellite media tour (SMT), 29, 102, 332, 372
Sauces. See also Dessert sauces
 creamy/white, 230, 237–238
 hollandaise, 238
 pan juices/au jus, 238
 pizza, 234
 steam effect, 134–135
 thickness, 237, 238
 tomato, 238, 238
 vegetable and fruit, smooth (coulis), 239
Sausages, 196–197
Sautéing vegetables, 169
Saveur magazine, 352
Savory, 175
Scales, digital, 123, 124, 145–146
Scallions, 163–164, 173
Scandinavian herbs and spices, 176
Scarlett, Nora, 83, 286, 341
Scheduling, 38
Scherzi, Holly, xiii, xviii, 32, 33
Scherzi, Jim, iii (author on the ladder), 3, xiii, xiv (top left), xviii, 6, 17, 68, 70, 108, 216
Schneider, Elizabeth, 151
Schur, Sylvia, 4
Scissors, 109, 110, 189
Scotchgard, 139, 190
Scripts, breaking down, 51
Script supervisor, 105
Seidman, Barry, 240
Self-confidence, attribute of food stylist, 11
Self-promotion. See Promotional tools
Set, 72–75, 371
Set decorator, 104
Set designer, 104
Set tray, 73, 108, 108–109, 371

Sewing gauge, 109, 110, 270
Sharpie markers, 139
Sheet pans, aluminum, 120
Shellfish, 225–226
 sources for, 382–383
Sherbet, Artificial (recipe), 283
Shiitake mushrooms, 163
Shinagel, Fran, xi, 321
Shocking vegetables, 170
Shoot. See also Food arrangement
 cleanup, 75
 food preparation, 63–64, 341
 location, 57–58, 60, 105
 mouthwatering appeal of food, 70, 70–71, 71
 post-shoot, 76
 propping, 62
 prop stylist at, 91
 sample/tear sheet of, 75–76
 set, 72–75, 371
 setup, 60, 60–62, 61
 shoot day, 75, 91, 371
 visual appeal of food, 64, 64–70
Shooting schedule, 40, 61, 62, 63
Shopping for food, equipment, and props, 7–8, 53–57
Shortening, 138, 140, 267, 282
Shot layout, 39, 40, 50, 368
Shot list, 61, 62
Shot options, questions to ask, 39
Shrimp, 225–226, 348
 Deep-Fried (recipe), 226
Sieves, 116, 123
Silpat baking mats, 122, 244
Skewers, 109, 111–112, 139, 142, 227, 232
Slavin, Neal, 53
Slicers, 118
Smith, Lorna, 88
Smoothies, 296
Snow peas, 165, 171
Sodium bisulfite, 109, 117, 133, 133, 136
Sorbet, Artificial (recipe), 283
Soufflés, 195
Sound department, 104
Soundstage, 100, 105
Soups, 73, 150, 210–211, 212, 213
 alphabet, 211, 211
 steam effect, 134–135
Sources, 382–388
 of cookbooks, 380
 of equipment and supplies, 385–387
 of foods, 382–384
 of promotional materials, 388
 of props, 90, 91, 387–388
Sour cream, 144, 180
Soy sauce, 117, 132, 189
Spaghetti, 230
Spanish herbs and spices, 176
Spatulas, 112–113, 113, 245, 252
 offset, 113, 113, 190, 192, 233, 277
Special effects, 33, 104, 371
 for cold beverages, 291–293
 steam and flames, 134–135

Spices, 176, 384
Spinach, 160, 173
Splashes, 84, 85, 144, 185, 186, 291–292
Spoons, 70, 113, 185, 212
Spray Mount, 127, 130, 138, 202
Spreads, 298, 298–299
Springform baking pans, 123, 244, 244
Spritzers, 142
Squash, summer, 167–168, 173
Squash, winter, 168, 173
Squeeze bottles and tops, 116, 141, 186, 190, 282
Stand-in food, xvii, 7, 63, 64, 69, 72, 127, 372
Steaks, 71, 71, 214–215
Steam chips, 134, 297
Steam effect, 134–135, 297
Steamers, 127, 129, 134, 137, 142, 143, 236–237
 modified, 207
Steaming vegetables, 169
Stewart, Martha, 342, 351, 352, 356
Storyboard, 41, 50–51, 52, 52, 106, 372
Strawberries, 168, 241
Strawberry ice cream, fake, 281
Strawberry jam topping, 278
Straws, plastic, 109, 112
Stress, dealing with, 11
Studio. See Photographer's studio
Sugar, powdered, 145
Sugar cookies, decorated, 268–269
Sugar snap peas, 165
Summer squash, 167–168, 173
Supporting food, 22
Swanson, Heidi, 318
Sweet potatoes, 166, 173
Sweet Streets, xiv, 337, 337
Swipes (tear sheets), 39, 75–76, 184, 234, 372
Swiss Chalet food stabilizer, 132, 386
Syringes, 109, 115
 needle, with glue applicator, 109, 115, 136, 142, 205
Syrup pour, 191–192, 193

T

Tablecloths, plastic, 125
Tack, Karen, 254
Talbott, Polly (CCP), xii, 346, 357–364
Tampons (T-28s), for steam effect, 134, 297
Tangelos, 164
Tape, 139
Tape measure, 110
Target audience, 21–22, 373
Tarragon, 175
Tart molds, 123
Tarts, 260–261
Tea, 297
 iced, 292, 296
Teaching assignments, 321, 326–327
 in foreign countries, 328–329
 in prison, 327

Teammates, 40
 in advertising/marketing assignments, 33
 in editorial assignments, 33
 in photo studio, 32
 in television and movie assignments, 33, 103–105
Team player, attribute of food stylist, , 10–11
Tear sheets, 39, 75–76, 184, 234, 372
Television assignments, *See also* Cooking demonstrations; Production food styling
 commercials, 30, 58, 100, 105–106
 cooking shows, 100
 home shopping programs, 100–101
 infomercials, 101
 live vs videotape, 29–30
 production crew in, 33, 103–105
 questions to ask, 40–41
 satellite media tour (SMT), 29, 102, 332, 372
 sequence of shots, 106
 series television, 102
 storyboards in, 50–51, *52*, 52
 studio vs location, 105
 types of, 6–7, 28–29
Teriyaki sauce, 132, 215
Test kitchen, 25, 32
Test shots, 80, 82, *83*, *96–97*, *310*, 310–313, *311*, *312*, *314*, *315*, 373
Thermometers, 109–110, 277
Thomas, Mark, *148*
Thyme, 175
Timer, digital, *109*, 109, 146
Toasted foods, 187–188
Toaster oven, 121, 187
Tolerance, attribute of food stylist, 12
Tomatoes, 168, 169, 173
Tomato sauce, *238*, 238
Tools. *See* Equipment and supplies
Toothbrush, 111, *287*, *289*, 290
Toothpicks, *109*, 112, 139
Torches, 121–122, *142*, 142, 143, 190, 227
Tortillas, in wraps, 207
Tote bags, *119*, 119, 146, 385
Touch-ups, last minute, *73*, 73, 75, 141–142, 215, 232
Tour guide, culinary, 326
Trading Places, 103
Transportation
 costs, 43
 of fruit and vegetables, 170
 of pies and cakes, 123, 125
 on location, 58

Trengove Studios, 290–291, 386
Trice, Todd, *348*
Truth in advertising, *27*, 27, 28
Turkey. *See also* Poultry
 number of turkeys, 9, 105–106
 platter size, 220
 whole roasted, 217, *218*, *219*, 220–222, *221*
Turners, *113*, 113–114
Turtle Wax, 137, 290
Tweezers, *109*, 115, 142
2000s food styling, *352*, 352–356, *353*, *355*

U

Ultra Gel, 386
Uncommon Fruits and Vegetables (Schneider), 151

V

Vanilla ice cream
 Artificial (recipe), 281
 fake, 280–281
Vaseline, 11 –115, 130, 136, 140
Veal, 215–216
Vegalene pan coating, 386
Vegetable oil, 133, 135, 136, 138
Vegetable peelers, *109*, 110–111
Vegetables. *See also* Herbs; *specific vegetables*
 cooking methods, 169–170, *171*, 171
 cuts for, 66
 food color chart, 67
 grilled look, *171*, 171, 227
 information sources on, 151
 red and white, 170
 sauce, smooth (coulis), 239
 sautéed look, *171*, 171
 seasonal availability, *148*, 148, 170, 171–173
 selecting, 149–168
 shocking, 170
 sources for, 152
 transportation of, 170
Versatility, attribute of food stylist, 13–14, 15
Video assistant, 105
Visser, Michael, *322*
Visual appeal, 64–70
Visual Food Encyclopedia, The, 151
Vivaldo, Denise, *349*
Volume food, 300

W

Waffles, 192–193
Waine, Michael, *73*, *83*, *202*
Wallach, Lou, *40*, *82*, *225*
Wardrobe, 104
Water, distilled, 137, 143, 296
Water bath, 133
Watercress, 160
Watermelon, 162
Water spray, 135, 136, 137
Web sites
 as promotional tool, 28, 318–319
 as resource, 28, 381
 test shots for, 310, 311, 312
Weinstein, Jay, 356
Welch, Jack and Suzy, 16
Whipped cream, 144
 dollop of, *21*, 22, 263
 lattice, *254*
 topping, 279, 297
Whipped toppings, nondairy, 144
 brands of, 180–181
 dollop of, *181*, 181–182, 263, 272
 piping, 180
Whisks, *109*, 117, 124
White sauce, 237
Wildroot hair lotion, 143, 186, 386
Windex, 141
Wine, white, 296
Winter squash, 168, 173
Woodliff, Woody, *320*
Workbook, 80, 319, 376
Work experience, food-related, 15–16, 306, 324–334
Wraps (sandwich), 207, 373
Writing assignments, 321, 325 –326
Writing technique, resources for, 326, 377
Wynn, Dan, *4*

X

X-Acto knife, *109*, 110

Y

Yogurt, 180

Z

Zap-A-Gap, 114, 126, 130, 217, 220
Zucchini, *167*, 167–168, *171*